# ART

## A Community Connection

## Teacher's Edition

# Acknowledgments

## Authors

**Marilyn G. Stewart** is professor of Art Education at Kutztown University in Kutztown, Pennsylvania, where she teaches courses in art criticism, aesthetics, and art education. She was the 1997–1998 Visiting Scholar with the Getty Education Institute for the Arts. Known for her ability to translate difficult art education concepts into practical, inquiry-based activities for the classroom, Marilyn is General Editor of the *Art Education in Practice* series (Davis Publications), and author of *Thinking Through Aesthetics*, one title in the series. Dr. Stewart is a frequent keynote speaker at meetings and seminars around the country, and serves as a consultant in a variety of national curriculum development and assessment projects.

**Eldon Katter** is editor of *SchoolArts* and was president of the National Art Education Association from 1999–2001. He was a professor of art education at Kutztown University for twenty-five years, retiring in 1997. He has taught at the elementary and secondary levels in Illinois, Pennsylvania, and Massachusetts. As a Peace Corps volunteer in the 1960s, Eldon taught art at the Teacher Training Institute in Harar, Ethiopia. He later became an education officer in the Ministry of Education in Kampala, Uganda, while working on the Teacher Education for East Africa Project at Teachers College, Columbia University. Eldon continues to serve as a consultant for school districts on staff and curriculum development and to exhibit his handmade paper works in juried art shows.

## Contributing Author

**Kaye Passmore** is the art teacher at Notre Dame Academy in Worcester, Massachusetts. She is the visual arts director for the Notre Dame Academy Summer Arts Institute (grades 3–10) and an adjunct faculty member in Lesley College's national Creative Arts in Learning Master of Education program. She has been an educational media consultant and junior high art teacher in Texas, and has taught Educational Media Production at Boise State University in Idaho.

## Editorial Consultants

**Kathleen Blum**, Director, Southeast Institute for Education in Theatre, The Southeast Center for Education in the Arts, University of Tennessee at Chattanooga

**Lee Harris**, Assistant Professor of Music Education, University of Tennessee at Chattanooga

**Laurie Krueger**, Special Needs Teacher, Northborough Middle School, Northborough, Massachusetts

**Donna Pauler**, MacLady, Austin, Texas

**Abby Remer**, A.R. Arts and Cultural Programs, New York, New York

**Ann Rowson**, Director, Southeast Institute for Education in the Visual Arts, The Southeast Center for Education in the Arts, University of Tennessee at Chattanooga

**Sharon Seim**, Education Consultant, Bellevue, Nebraska

**Nancy Walkup**, Project Coordinator, North Texas Institute for Educators on the Visual Arts, University of North Texas, Denton, Texas

**Diana Woodruff**, Art Supervisor, Acton-Boxborough Public Schools, Acton, Massachusetts

## Educational Consultants

**Lori Atchue**, West Tatnuck School, Worcester, Massachusetts

**Anita Cook**, Thomas Prince School, Princeton, Massachusetts

**Louisa Brown**, Atlanta International School, Atlanta, Georgia

**Monica Brown**, Laurel Nokomis School, Nokomis, Florida

**Will Caez**, Logan Fontenelle Middle School, Bellevue, Nebraska

**Kate Cross**, Frank Borman Middle School, Phoenix, Arizona

**Cappie Dobyns**, Sweetwater Middle School, Sweetwater, Texas

**Judith Durgin**, Merrimack Valley Middle School, Penacook, New Hampshire

**Suzanne Dyer**, Bryant Middle School, Dearborn, Michigan

**Elaine Gale**, Sarasota Middle School, Sarasota, Florida

**Catherine Gersich**, Fairhaven Middle School, Bellingham, Washington

**Rachel Grabek**, Chocksett Middle School, Sterling, Massachusetts

**Ann Gurek**, Remington Middle School, Franklin, Massachusetts

**Mary Ann Horton**, Camels Hump Middle School, Richmond, Vermont

**Leon Hovsepian**, Burncoat High School, Worcester, Massachusetts

**Anne Jacques**, Hayfield Secondary School, Alexandria, Virginia

**Alice SW Keppley**, Penn View Christian School, Souderton, Pennsylvania

**Bunki Kramer**, Los Cerros Middle School, Danville, California

**Karen Larson**, Plum Grove Junior High School, Rolling Meadows, Illinois

**Marguerite Lawler-Rohner**, Wescott Junior High School, Westbrook, Maine

**Karen Lintner**, Mount Nittany Middle School, State College, Pennsylvania

**Betsy Logan**, Samford Middle School, Auburn, Alabama

**Sara Macaulay**, Winsor School, Boston, Massachusetts

**Patricia Mann**, T.R. Smedberg Middle School, Sacramento, California

**Shannon McBride**, Riverdale Grade School, Portland, Oregon

**Mary Ann McFarland**, City View School, Worcester, Massachusetts

**Karen Miura**, Kalakaua Middle School, Honolulu, Hawaii

**Phyllis Mowery-Racz**, Desert Sands Middle School, Phoenix, Arizona

**Debbie Myers**, Colony Middle School, Palmer, Alaska

**Kaye Passmore**, Notre Dame Academy, Worcester, Massachusetts

**Sandy Ray**, Johnakin Middle School, Marion, South Carolina

**Amy Richard**, Daniel Boone Area Middle School, Birdsboro, Pennsylvania

**Pat Rucker**, Summit Ridge Middle School, Littleton, Colorado

**Susan Rushin**, Pocono Mountain Intermediate School South, Swiftwater, Pennsylvania

**Roger Shule**, Antioch Upper Grade School, Antioch, Illinois

**Betsy Menson Sio**, Jordan-Elbridge Middle School, Jordan, New York

**Sharon Siswick**, Islesboro School, Islesboro, Maine

**Karen Skophammer**, Manson Northwest Webster, Barnum, Iowa

**Evelyn Sonnichsen**, Plymouth Middle School, Plymouth, Minnesota

**Ann Titus**, Central Middle School, Galveston, Texas

**Sindee Viano**, Avery Coonley School, Downers Grove, Illinois

**Karen Watson-Newlin**, Verona Area Middle School, Verona, Wisconsin

**Shirley Whitesides** and **Karen Hawkin**, Asheville Middle School, Asheville, North Carolina

**Cynthia Wiffin**, Roosevelt School, Worcester, Massachusetts

Printed in U.S.A.
ISBN: 87192-492-7
10 9 8 7 6 5 4 3 2 KP 10 09 08 07 06

# Teacher's Edition Contents

## 1

## Art History Lessons

**Short on time, but long for history?**
These lessons extend the CORE with added historical insight. Together, these interrelated lessons provide a chronological study of **American Art History.**

**1.1 Art in Early North America**

**2.1 Art in Colonial North America: 1500–1776**

**3.1 Art and Independence: 1776–1820**

**4.1 The Majesty of Place: 1820–1860**

**5.1 Responding to Beauty: 1860–1900**

**6.1 Confidence and Change: 1900–1920**

**7.1 Art and Pride: 1920–1950**

**8.1 Making a Difference: 1950–1980**

**9.1 New Directions in Art: 1980–?**

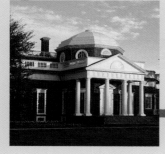

## 2

## Forms and Media Lessons

**Applying Art's Tools and Techniques!**
Individually these lessons reinforce the theme with an exploration of different forms and media. Combined, these design lessons provide an overview of **art's tools and techniques.**

**1.2 Crafts**

**2.2 Drawing**

**3.2 Sculpture**

**4.2 Perspective Drawing**

**5.2 Graphic Design**

**6.2 Painting**

**7.2 Photography**

**8.2 Printmaking**

**9.2 New Media**

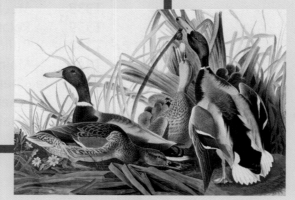

## Foundations

**Begin with a sound foundation in art education.** These chapters set the stage for a comprehensive art program or they can serve as a course in themselves.

## C   C

**Explore Art's Universal Themes.** Each theme opens with a CORE lesson that provides a comprehensive overview of the topic. Together these lessons **highlight and explore art's universal themes.**

### Core Lessons

1 Community Messages

2 Daily Observations

3 Art Shows Community Values

4 Common Places

5 Natural Wonders

6 Art and Change

7 Pride in Community

8 Artists Can Make a Difference

9 Beyond the Present

For a comprehensive art education, teach each theme with its CORE lesson and four follow-up lessons. Or, choose a series of lessons that match your interests and your schedule.

## F

**F1 The Whys and Hows of Art**
**F2 Forms and Media**
**F3 Elements and Principles of Design**
**F4 Approaches to Art**

## 3

# Global View Lessons

**Tour world cultures past and present.**
While supporting the CORE with a global viewpoint, these lessons also collaborate to provide **a multicultural art education**.

**1.3 The Art of Mesoamerica and South America**

**2.3 Painting Life in an Indian Empire**

**3.3 Art of Polynesia**

**4.3 Japanese Places in Art**

**5.3 Scandinavian Art**

**6.3 Changing Perspectives in Russian Art**

**7.3 Caribbean Art**

**8.3 African Art in a Modern World**

**9.3 Meeting Global Challenges**

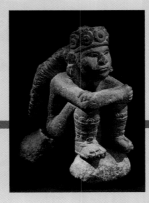

## RE

**Create more with the CORE.**
In addition to concluding the CORE lesson, these art activities **add to your bank of studio opportunities.**

### Core Studios

1  A Telling Collage

2  Create Your Own Pottery

3  Recording a Community Story

4  Drawing a Town Center

5  Stamps Inspired by Nature

6  Making a Skyscraper

7  A Festival in Pastel

8  Making a Collaborative Sculpture

9  Art that Looks Beyond

## 4

# Studio Lessons

**Make the most with hands-on learning.**
Each studio lesson caps off the theme with a summarizing hands-on experience. Together, these activities provide **a bank of art activities that apply a range of media and techniques.**

**1.4 Making Paper**

**2.4 Drawing a Group Portrait**

**3.4 Carving a Plaster Maquette**

**4.4 Perspective in Pastels**

**5.4 A Relief Sculpture**

**6.4 Exploring Styles**

**7.4 3-D Montage**

**8.4 Making Relief Prints**

**9.4 Making a Videotape**

# Chapter Organizer

**At-a-glance chapter organizers help you teach as much — or as little — as you wish.** Teach the entire theme or just a single lesson. Plan for an individual, a small group, or an entire class. This easy-to-use chart allows you to scan the entire chapter and select the topics, activities, and extensions that match your course structure.

Clear lesson objectives and correlations to the **National Visual Arts Standards** are provided both at the *chapter and lesson levels.*

This **quick-check pacing chart** helps you modify lesson plans to meet your individual time constraints.
Choose from:
- nine-week course
- one semester course
- two-semester course

Highlighting the **studio opportunities** that extend each lesson allows you to plan ahead.

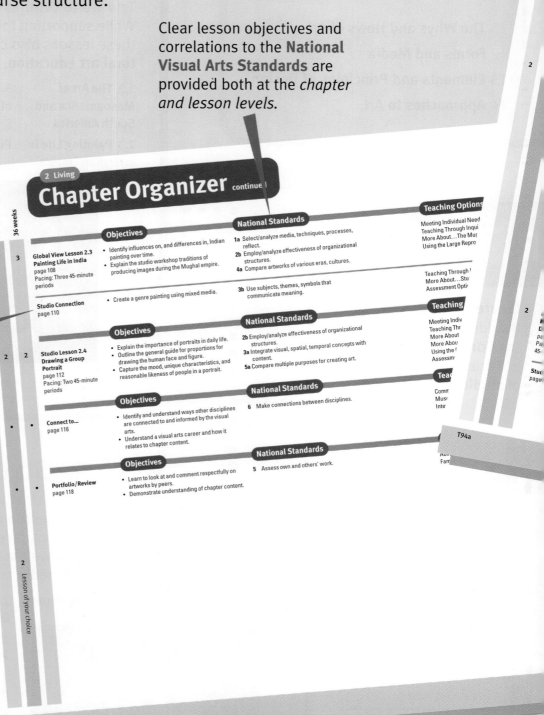

This list of **Featured Artists** helps you quickly review the diverse artists whose works are profiled in the chapter. *An artist profile and pronunciation guide are provided in the back of the Teacher's Edition*

This **Vocabulary** list highlights the key terms taught in each chapter.

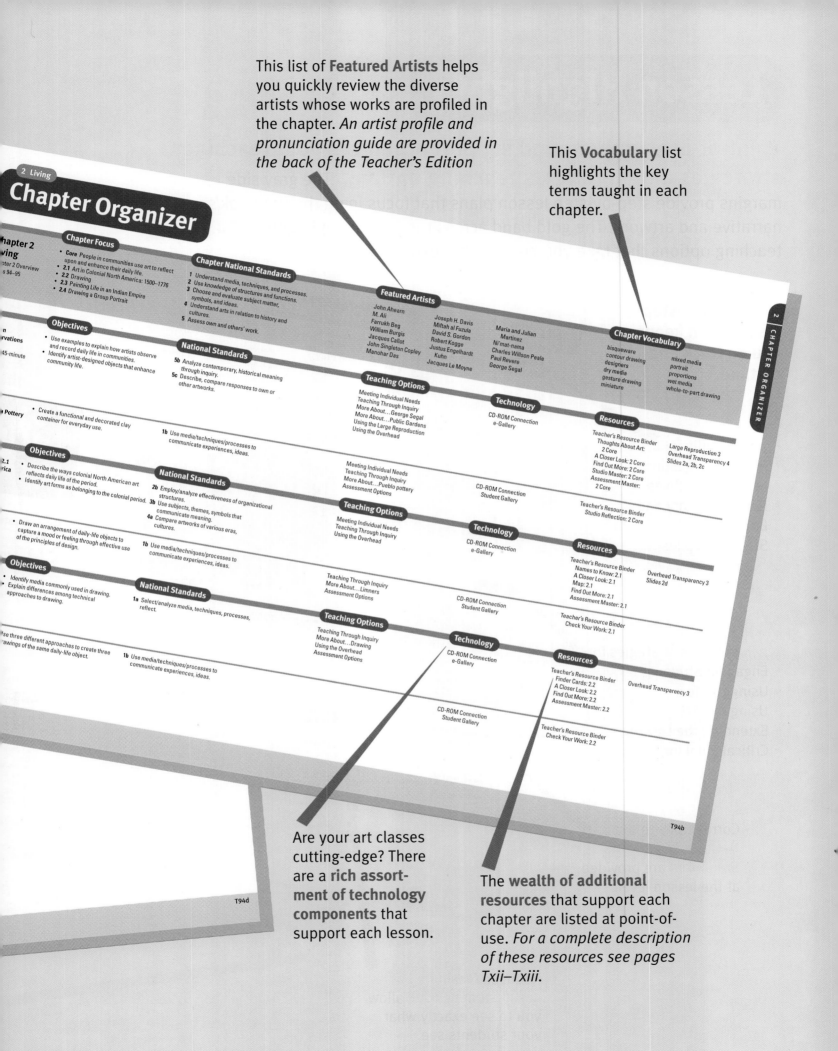

## 2 Living
# Chapter Organizer

### Chapter 2 Living

Chapter 2 Overview
s 94–95

### Chapter Focus
- **Core** People in communities use art to reflect upon and enhance their daily life.
- **2.1** Art in Colonial North America: 1500–1776
- **2.2** Drawing
- **2.3** Painting Life in an Indian Empire
- **2.4** Drawing a Group Portrait

### Chapter National Standards
1 Understand media, techniques, and processes.
2 Use knowledge of structures and functions.
3 Choose and evaluate subject matter, symbols, and ideas.
4 Understand arts in relation to history and cultures.
5 Assess own and others' work.

### Featured Artists
John Ahearn
M. Ali
Farrukh Beg
William Burgis
Jacques Callot
John Singleton Copley
Manohar Das

Joseph H. Davis
Miftah al Fuzula
David S. Gordon
Robert Kogge
Justus Engelhardt Kuhn
Jacques Le Moyne

Maria and Julian Martinez
Ni'mat-nama
Charles Willson Peale
Paul Revere
George Segal

### Chapter Vocabulary
bisqueware
contour drawing
designers
dry media
gesture drawing
miniature

mixed media
portrait
proportions
wet media
whole-to-part drawing

---

### Objectives
rvations
- Use examples to explain how artists observe and record daily life in communities.
45-minute
- Identify artist-designed objects that enhance community life.

### National Standards
**5b** Analyze contemporary, historical meaning through inquiry.
**5c** Describe, compare responses to own or other artworks.

### Teaching Options
Meeting Individual Needs
Teaching Through Inquiry
More About…George Segal
More About…Public Gardens
Using the Large Reproduction
Using the Overhead

### Technology
CD-ROM Connection
e-Gallery

### Resources
Teacher's Resource Binder
Thoughts About Art:
   2 Core
A Closer Look: 2 Core
Find Out More: 2 Core
Studio Master: 2 Core
Assessment Master:
   2 Core

Large Reproduction 3
Overhead Transparency 4
Slides 2a, 2b, 2c

Pottery
- Create a functional and decorated clay container for everyday use.

**1b** Use media/techniques/processes to communicate experiences, ideas.

---

### Objectives
2.1
rica
- Describe the ways colonial North American art reflects daily life of the period.
- Identify art forms as belonging to the colonial period.

### National Standards
**2b** Employ/analyze effectiveness of organizational structures.
**3b** Use subjects, themes, symbols that communicate meaning.
**4a** Compare artworks of various eras, cultures.

### Teaching Options
Meeting Individual Needs
Teaching Through Inquiry
More About…Pueblo pottery
Assessment Options

### Technology
CD-ROM Connection
Student Gallery

### Resources
Teacher's Resource Binder
Studio Reflection: 2 Core

- Draw an arrangement of daily-life objects to capture a mood or feeling through effective use of the principles of design.

**1b** Use media/techniques/processes to communicate experiences, ideas.

### Teaching Options
Meeting Individual Needs
Teaching Through Inquiry
Using the Overhead

### Technology
CD-ROM Connection
e-Gallery

### Resources
Teacher's Resource Binder
Names to Know: 2.1
A Closer Look: 2.1
Map: 2.1
Find Out More: 2.1
Assessment Master: 2.1

Overhead Transparency 3
Slides 2d

---

### Objectives
- Identify media commonly used in drawing.
- Explain differences among technical approaches to drawing.

### National Standards
**1a** Select/analyze media, techniques, processes, reflect.

### Teaching Options
Teaching Through Inquiry
More About…Limners
Assessment Options

### Technology
CD-ROM Connection
Student Gallery

### Resources
Teacher's Resource Binder
Check Your Work: 2.1

se three different approaches to create three
rawings of the same daily-life object.

**1b** Use media/techniques/processes to communicate experiences, ideas.

### Teaching Options
Teaching Through Inquiry
More About…Drawing
Using the Overhead
Assessment Options

### Technology
CD-ROM Connection
e-Gallery

### Resources
Teacher's Resource Binder
Finder Cards: 2.2
A Closer Look: 2.2
Find Out More: 2.2
Assessment Master: 2.2

Overhead Transparency 3

CD-ROM Connection
Student Gallery

Teacher's Resource Binder
Check Your Work: 2.2

T94b

T94d

Are your art classes cutting-edge? There are a **rich assortment of technology components** that support each lesson.

The **wealth of additional resources** that support each chapter are listed at point-of-use. *For a complete description of these resources see pages Txii–Txiii.*

# Lesson Highlights

**Point-of-use wrap-around support organizes your teaching strategies and highlights teaching options.** The gray side margins provide step-by-step lesson plans that focus in on the the book's narrative and artwork. The gold band across the bottom highlights teaching options that take you beyond the text.

**A sensible 3-step lesson plan keeps you on track and on time.**

## 1

**Prepare** outlines:
- Pacing Suggestions
- Lesson Objectives
- Key Vocabulary and Definitions
- Studio Supplies

## 2

**Teach** presents strategies for:
- Engaging Students
- Using the Text
- Using the Art
- Extending the Lesson
- Critical Thinking

Correlations to the **National Visual Arts Standards** are provided at the lesson level.

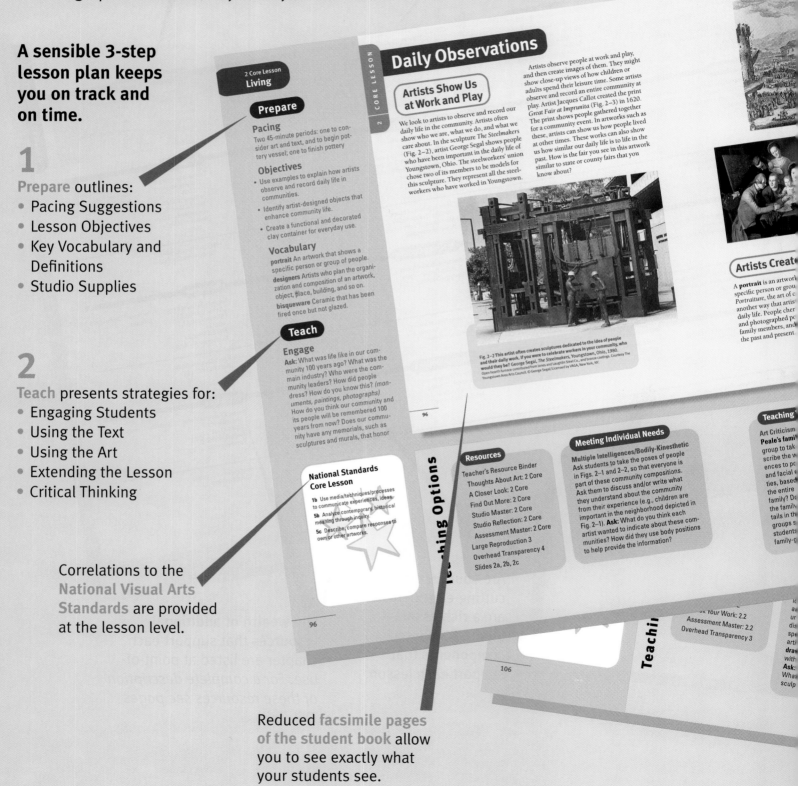

Reduced **facsimile pages of the student book** allow you to see exactly what your students see.

---

*The following text appears within the reproduced sample pages in the image:*

2 Core Lesson
**Living**

### Prepare

**Pacing**
Two 45-minute periods: one to consider art and text, and to begin pottery vessel; one to finish pottery

**Objectives**
- Use examples to explain how artists observe and record daily life in communities.
- Identify artist-designed objects that enhance community life.
- Create a functional and decorated clay container for everyday use.

**Vocabulary**
**portrait** An artwork that shows a specific person or group of people.
**designers** Artists who plan the organization and composition of an artwork, object, place, building, and so on.
**bisqueware** Ceramic that has been fired once but not glazed.

### Teach

**Engage**
Ask: What was life like in our community 100 years ago? What was the main industry? Who were the community leaders? How did people dress? How do you know this? *(monuments, paintings, photographs)* How do you think our community and its people will be remembered 100 years from now? Does our community have any memorials, such as sculptures and murals, that honor

**National Standards Core Lesson**
1b Use media/techniques/processes to communicate experiences, ideas.
5b Analyze contemporary, historical meaning through inquiry.
5c Describe, compare responses to own or other artworks.

**CORE LESSON 2**

## Daily Observations

### Artists Show Us at Work and Play
We look to artists to observe and record our daily life in the community. Artists often show who we are, what we do, and what we care about. In the sculpture *The Steelmakers* (Fig. 2–2), artist George Segal shows people who have been important in the daily life of Youngstown, Ohio. The steelworkers' union chose two of its members to be models for this sculpture. They represent all the steelworkers who have worked in Youngstown.

Artists observe people at work and play, and then create images of them. They might show close-up views of how children or adults spend their leisure time. Some artists observe and record an entire community at play. Artist Jacques Callot created the print *Great Fair at Imprunita* (Fig. 2–3) in 1620. The print shows people gathered together for a community event. In artworks such as these, artists can show us how people lived at other times. These works can also show us how similar our daily life is to life in the past. How is the fair you see in this artwork similar to state or county fairs that you know about?

Fig. 2–2 This artist often creates sculptures dedicated to the idea of people and their daily work. If you were to celebrate workers in your community, who would they be? George Segal, *The Steelmakers*, Youngstown, Ohio, 1980. Open hearth furnace contributed from Jones and Laughlin Steel Co., and bronze castings. Courtesy The Youngstown Area Arts Council. © George Segal/Licensed by VAGA, New York, NY.

### Artists Create
A **portrait** is an artwork that shows a specific person or group... Portraiture, the art of... another way that artist... daily life. People cher... and photographed po... family members, and... the past and present.

96

### Teaching Options

**Resources**
Teacher's Resource Binder
Thoughts About Art: 2 Core
A Closer Look: 2 Core
Find Out More: 2 Core
Studio Master: 2 Core
Studio Reflection: 2 Core
Assessment Master: 2 Core
Large Reproduction 3
Overhead Transparency 4
Slides 2a, 2b, 2c

**Meeting Individual Needs**
**Multiple Intelligences/Bodily-Kinesthetic**
Ask students to take the poses of people in Figs. 2–1 and 2–2, so that everyone is part of these community compositions. Ask them to discuss and/or write what they understand about the community from their experience (e.g., children are important in the neighborhood depicted in Fig. 2–1). Ask: What do you think each artist wanted to indicate about these communities? How did they use body positions to help provide the information?

**Teaching**
Art Criticism
Peale's famil...
group to tak...
scribe the w...
ences to po...
and facial e...
ties, based...
the entire...
family? De...
the family...
tails in th...
groups s...
students...
family-g...

96

...Your Work: 2.2
Assessment Master: 2.2
Overhead Transparency 3

106

Tviii

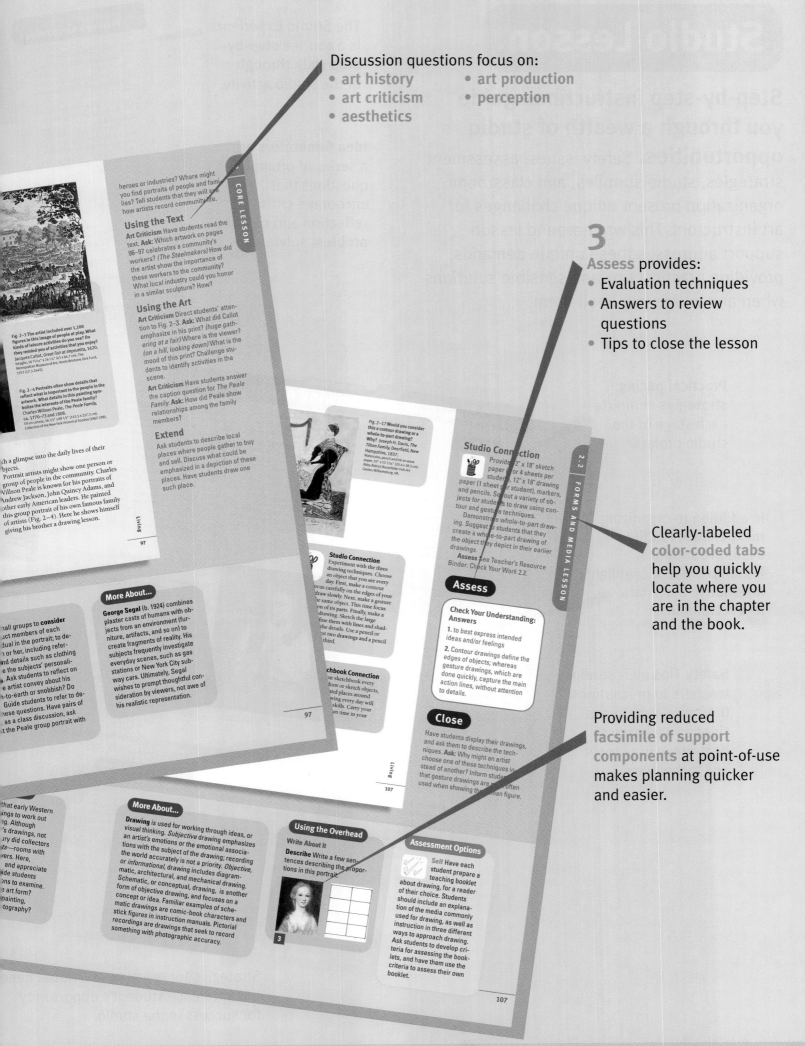

**Discussion questions focus on:**
- art history
- art criticism
- aesthetics
- art production
- perception

**3**

**Assess** provides:
- Evaluation techniques
- Answers to review questions
- Tips to close the lesson

Clearly-labeled **color-coded tabs** help you quickly locate where you are in the chapter and the book.

Providing reduced **facsimile of support components** at point-of-use makes planning quicker and easier.

# Studio Lesson

**Step-by-step instructions guide you through a wealth of studio opportunities.** Safety issues, assessment strategies, studio supplies, and classroom organization present unique challenges for art instructors. This wrap-around lesson support addresses these unique demands, providing practical tips and sensible solutions when and where you need them.

The **Studio Experience** is a concise **step-by-step walk through** of the studio activity.

**Idea Generators** are a series of prompting questions that encourage **critical reflection** and **creative problem solving.**

**Practical pacing strategies** chronicle each stage of the studio project.

In addition to organizing **inexpensive, readily-available supplies,** lesson plans also highlight **alternative materials and techniques.**

**Safety Tips** alert studio teachers to precautions they may want to consider as well as accident-preventing tools and techniques.

Strategies for **meeting individual needs** enhance each student's opportunity for success in the studio.

---

### 2.4 Studio Lesson
### Drawing a Group Portrait

#### Studio Experience
1. After students have read Drawing Your Portrait, have them measure proportions on their own and another's face. Then lead them in drawing light guidelines.

* For a face, draw an oval with a line across the middle. Center the tops of the eyes on this line. Then draw a line halfway between the top of the oval and the middle line. Sketch the forehead area on this line. Draw another line halfway between the bottom of the oval and the middle line. Center the bottom of the nose on this line.

* For a figure, draw guidelines showing the relative proportions of elbows, hips, and knees to head and torso.
2. Demonstrate various techniques of indicating hair texture.
3. Have students do three or four five-minute sketches of student models before beginning the final group portrait.
4. Ask students to write and attach a descriptive title for their completed drawing.

#### Idea Generators
Discuss how students can emphasize their subjects' interests and personality traits. **Ask:** Wh...

---

### 2.4 Studio Lesson
### Drawing a Group Portrait

#### Prepare

**Pacing**
Two 45-minute periods: one to read text and plan; one to do final drawing

**Objectives**
* Explain the importance of portraits in daily life.
* Outline the general guide for proportions for drawing the human face and figure.
* Capture the mood, unique characteristics, and reasonable likeness of people in a portrait.

**Vocabulary**
**proportions** The relation between one part of the body and another in terms of size, quantity, and degree.

**Supplies**
* spotlight
* props such as sports equipment, art supplies, musical instruments
* drawing media: pencils or charcoal
* sketch paper, 18" x 24"
* drawing paper, 18" x 24"
* erasers
* fixative (optional)

**National Standards
2.4 Studio Lesson**

**2b** Employ/analyze effectiveness of organizational structures.

**3a** Integrate visual, spatial, temporal concepts with content.

**5a** Compare multiple purposes for creating art.

---

### Drawing in the Studio
## Drawing a Group Portrait

#### A Picture of Daily Life

**Studio Introduction**
Portrait artists observe the way people sit, stand, and move. They notice the position and placement of their subjects' arms and legs, hands and heads. They study facial expressions and characteristics that are unique to the people they portray. **In this studio experience you will observe classmates or people in your school community and draw a group portrait of them.** Pages 114 and 115 will tell you how to do it.

When artists create portraits, they pay special attention to their subjects' **proportions,** or the relation between one part of the body and another. People are surprisingly alike in their proportions. A good portrait captures a person's general proportions and individuality. (See the diagrams on page 114 to learn about proportions in a face or figure.)

Come up with a plan for your portrait. Do you want your subjects to stand or sit? What view of them will you choose: front, three-quarter, or profile? You may want to observe your subjects in their daily activities. Make sketches of them in your sketchbook to use later in your final drawing. Think about details you will include that will tell about the daily lives of these people.

#### Studio Background

**The Importance of Portraits**
Portraits play an important role in the daily lives of people all over the world. They help people remember loved ones and honor great leaders and heroes (Fig. 2–23). They can give us an idea of what life was like for their subjects. For the North American colonists, having their portraits painted was a sign of success in a growing community. Usually, the style of these portraits was based on what was popular in Europe at the time (Fig. 2–25).

Fig. 2–23 During the American Revolution, Paul Revere made a "midnight ride" to warn his community that the British were coming. What does the artist of this portrait show us about Paul Revere's daily life as a silversmith? Notice the three-quarter view of Revere's face. John Singleton Copley, *Paul Revere,* 1768. Oil on canvas, 35 1/8" x 28 1/2" (89.2 x 72.4 cm). Gift of Joseph W. Revere, William B. Revere and Edward H. R. Revere. Courtesy Museum of Fine Arts, Boston. Reproduced with permission. ©1999 Museum of Fine Arts, Boston. All Rights Reserved.

Fig. 2–25 This a... formal garden se... their children's... nities that pare... Kuhn, *Eleanor D...* Oil on canvas, 54"... Society, Baltimor...

Portrait... Mughal En... and scenes... Persian, H... traits incl... the detail... (Fig. 2–... the daily...

112

---

**Teaching Options**

**Resources**
Teacher's Resource Binder
Studio Master: 2.4
Studio Reflection: 2.4
A Closer Look: 2.4
Find Out More: 2.4
Overhead Transparency 4
Slides 2f

**Meeting Individual Needs**

**Adaptive Materials** Instead of using a model, have students use a photograph or other image. Draw the guidelines for students who have trouble with this step. Have them focus their effort on a single portrait rather than several. Create checklists of facial features. Students can refer to these while creating their portraits.

112

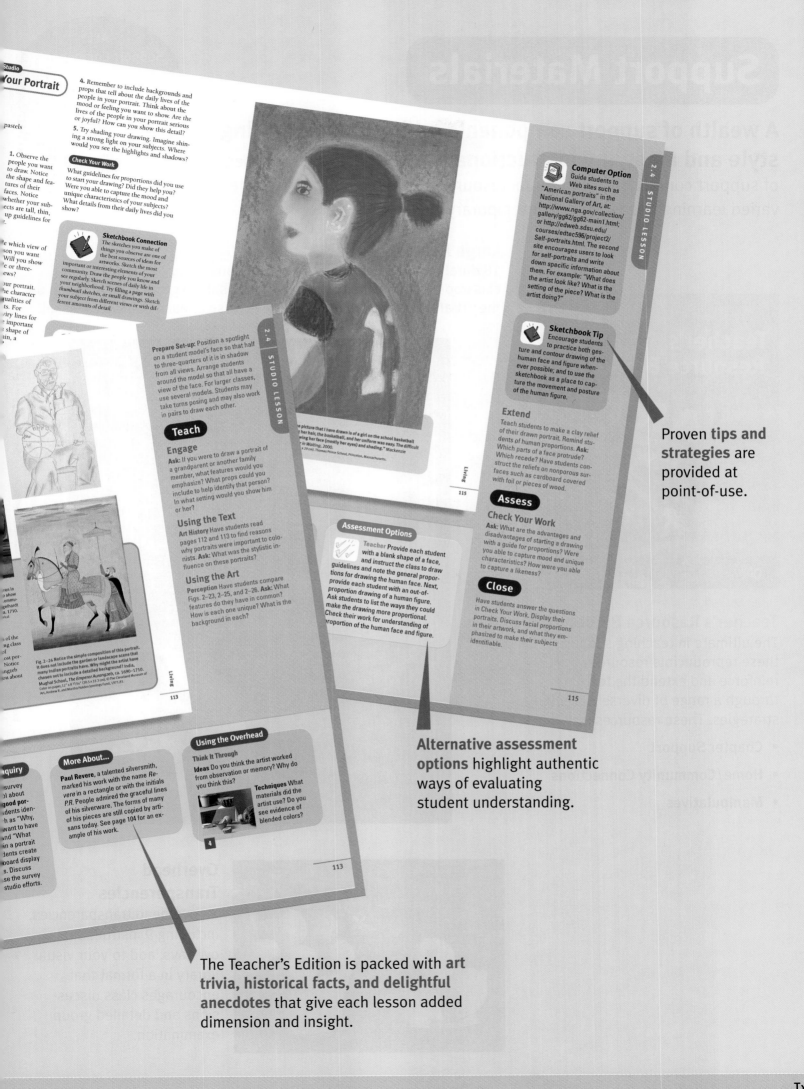

**Studio**
**Your Portrait**

4. Remember to include backgrounds and props that tell about the daily lives of the people in your portrait. Think about the mood or feeling you want to show. Are the lives of the people in your portrait serious or joyful? How can you show this detail?

5. Try shading your drawing. Imagine shining a strong light on your subjects. Where would you see the highlights and shadows?

**Check Your Work**

What guidelines for proportions did you use to start your drawing? Did they help you? Were you able to capture the mood and unique characteristics of your subjects? What details from their daily lives did you show?

**Sketchbook Connection**

The sketches you make of things you observe are one of the best sources of ideas for artworks. Sketch the most important or interesting elements of your community. Draw the people you know and see regularly. Sketch scenes of daily life in your neighborhood. Try filling a page with thumbnail sketches, or small drawings. Sketch your subject from different views or with different amounts of detail.

**Prepare Set-up:** Position a spotlight on a student model's face so that half to three-quarters of it is in shadow from all views. Arrange students around the model so that all have a view of the face. For larger classes, use several models. Students may take turns posing and may also work in pairs to draw each other.

**2·4 STUDIO LESSON**

**Teach**

**Engage**

**Ask:** If you were to draw a portrait of a grandparent or another family member, what features would you emphasize? What props could you include to help identify that person? In what setting would you show him or her?

**Using the Text**

**Art History** Have students read pages 112 and 113 to find reasons why portraits were important to colonists. **Ask:** What was the stylistic influence on these portraits?

**Using the Art**

**Perception** Have students compare Figs. 2–23, 2–25, and 2–26. **Ask:** What features do they have in common? How is each one unique? What is the background in each?

The picture that I have drawn is of a girl on the school basketball [team]... her hair, the basketball, and her uniform was easy. The difficult [part was] drawing her face (mostly her eyes) and shading." Waiting, 2000. ... x 29 cm). Thomas Pence School, Princeton, Massachusetts.

*Living*

**115**

**Computer Option**

Guide students to Web sites such as "American portraits" in the National Gallery of Art, at: http://www.nga.gov/collection/gallery/gg62/gg62-main1.html; or http://edweb.sdsu.edu/courses/edtec596/project2/Self-portraits.html. The second site encourages users to look for self-portraits and write down specific information about them. For example: "What does the artist look like? What is the setting of the piece? What is the artist doing?"

**Sketchbook Tip**

Encourage students to practice both gesture and contour drawing of the human face and figure whenever possible; and to use the sketchbook as a place to capture the movement and posture of the human figure.

**Extend**

Teach students to make a clay relief of their drawn portrait. Remind students of human proportions. **Ask:** Which parts of a face protrude? Which recede? Have students construct the reliefs on nonporous surfaces such as cardboard covered with foil or pieces of wood.

**Assess**

**Check Your Work**

**Ask:** What are the advantages and disadvantages of starting a drawing with a guide for proportions? Were you able to capture mood and unique characteristics? How were you able to capture a likeness?

**Close**

Have students answer the questions in Check Your Work. Display their portraits. Discuss facial proportions in their artwork, and what they emphasized to make their subjects identifiable.

**2·4 STUDIO LESSON**

**115**

**Assessment Options**

**Teacher** Provide each student with a blank shape of a face, and instruct the class to draw guidelines and note the general proportions for drawing the human face. Next, provide each student with an out-of-proportion drawing of a human figure. Ask students to list the ways they could make the drawing more proportional. Check their work for understanding of proportion of the human face and figure.

**Proven tips and strategies are provided at point-of-use.**

**Alternative assessment options highlight authentic ways of evaluating student understanding.**

Fig. 2–26 Notice the simple composition of this portrait. It does not include the garden or landscape scene that many Indian portraits have. Why might the artist have chosen not to include a detailed background? India. Mughal School, *The Emperor Aurangzeb*, ca. 1690–1710. Color on paper, 12" x 8 11/16" (30.5 x 22.1 cm). © The Cleveland Museum of Art, Andrew R. and Martha Holden Jennings Fund, 1971.81.

*Living*

**113**

**More About...**

**Paul Revere**, a talented silversmith, marked his work with the name *Revere* in a rectangle or with the initials *P.R.* People admired the graceful lines of his silverware. The forms of many of his pieces are still copied by artisans today. See page 104 for an example of his work.

**Using the Overhead**

**Think It Through**

**Ideas** Do you think the artist worked from observation or memory? Why do you think this?

**Techniques** What materials did the artist use? Do you see evidence of blended colors?

**4**

**113**

**The Teacher's Edition is packed with art trivia, historical facts, and delightful anecdotes that give each lesson added dimension and insight.**

# Support Materials

**A wealth of support components address any teaching style and meet any instructional need!** This rich assortment of support components and visual resources are designed to meet the varied learning needs of the contemporary classroom.

## Teacher's Resource Binder

The ultimate in teaching support, these reproducible resources reinforce and extend the text through a range of diverse learning strategies. These resources include:

• **Chapter Support**

• **Home/Community Connections**

• **Manipulatives**

## Large Reproductions

18 durable, full-color fine art reproductions (18 x 24 ") are ideal for classroom display or small-group analysis. Background information on the art and artist is provided on the reverse of each laminated visual.

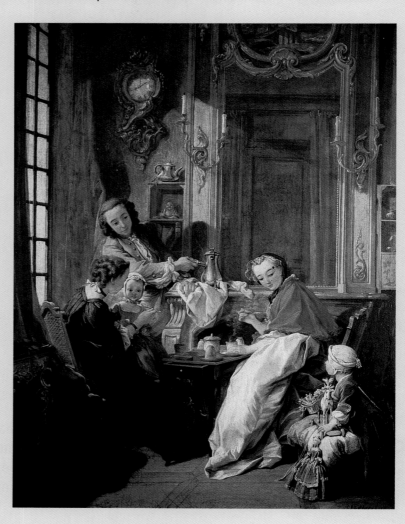

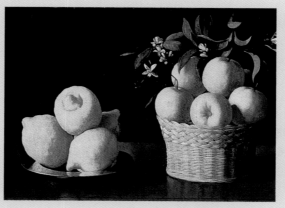

## Overhead Transparencies

27 overhead transparencies, including 9 instructional overlays, add to your visual library in a format that encourages class discussions and detailed group examination.

## Student Art Gallery

This CD-ROM of student art extends the samples of student art provided in the text. Directly inspired by a studio lesson, these samples graphically show the scope of each activity and encourage peer sharing and review.

## Careers Videos

Introduce your students to a variety of art-related occupations. These in-depth interviews with working professionals explore how each person came to their career, their typical workday, and the skills and training their jobs require. *(3 10-minute interviews per tape / 9 interviews per set)*

## Slide Sets

10 correlated slide sets (72 slides total) extend the visuals in each theme with a host of vivid slide images. Each set displays a diverse array of artworks reflecting different artists, styles, periods, cultures, and media.

## The Davis e-Gallery

This electronic museum provides a wealth of images ranging from fine art to architecture to objects designed for everyday use. Easy to search and select, this resource is ideal for lesson support or for individual research.

## The Davis Web Site

The Davis site contains lesson support, links to instructional sites, student art, and much, much more.

# www.davis-art.com

# Scope & Sequence: Foundations

**National Standard 1a** Students select media, techniques, and processes; analyze their effectiveness; and reflect upon their choices.

**National Standard 1b** Students take advantage of qualities and characteristics of art media, techniques, and processes to enhance communication of ideas.

**National Standard 2a** Students generalize about the effects of visual structures and functions.

**National Standard 2b** Students employ organizational structures and analyze their effectiveness.

**National Standard 2c** Students select and use the qualities of structures and function of art to improve communication of ideas.

**National Standard 3a** Students integrate visual, spatial, and temporal concepts with content to communicate intended meaning.

**National Standard 3b** Students use subjects, themes, and symbols that demonstrate knowledge of contexts, values, and aesthetics that communicate intended meaning.

**National Standard 4a** Students know and compare characteristics of artworks in various eras and cultures.

**National Standard 4b** Students describe and place a variety of art objects in historical and cultural contexts.

**National Standard 4c** Students analyze, describe, and demonstrate how factors of time and place influence visual characteristics that give meaning and value to artworks.

**National Standard 5a** Students compare multiple purposes for creating artworks.

**National Standard 5b** Students analyze contemporary and historic meanings in specific artworks through cultural and aesthetic inquiry.

**National Standard 5c** Students describe and compare responses to their own artworks and to artworks from various eras and cultures.

**National Standard 6a** Students compare the characteristics of works in two or more art forms that share similar subject matter, historical periods, or cultural context.

**National Standard 6b** Students describe how the principles and subject matter of other disciplines are interrelated with the visual arts.

## Student Abilities in Art

| | |
|---|---|
| **Perception** | **Using knowledge of structures and functions** |
| | Observing visual, tactile, spatial, and temporal elements in the natural and built environments |
| | Observing visual, tactile, spatial, and temporal elements in artworks |
| | Considering use of elements and principles of design |
| **Art Production** | **Understanding and applying media, techniques, and processes** |
| | Generating ideas for artistic expression |
| | **Choosing and evaluating a range of subject matter, symbols and ideas** |
| | Developing approaches for expressing ideas |
| | Exploring expressive potential of art forms, media, and techniques |
| | Reflecting on artistic process, meaning, and quality of work |
| | Safety in art making |
| **Art History** | **Understanding the visual arts in relation to history and cultures** |
| | Investigating historical/cultural meaning of artworks |
| | Understanding historical/cultural context |
| | Developing global and multicultural perspectives |
| | Considering styles, influences, and themes in art |
| **Art Criticism** | **Reflecting upon and assessing the characteristics and merits of their work and the work of others** |
| | Describing and analyzing details in artworks |
| | Interpreting meanings in artworks |
| | Judging merit and significance in artworks |
| **Aesthetics** | **Reflecting upon and assessing the characteristics and merits of their work and the work of others** |
| | Understanding reasons for valuing art |
| | Raising and addressing philosophical questions about art and human experience |
| | Forming opinions about art |
| **Presentation Exhibition, and Critique** | **Reflecting upon and assessing the characteristics and merits of their work and the work of others** |
| | Keeping a portfolio and sketchbook |
| | Making work public |
| | Evaluating progress and accomplishments |
| **Learning for Life** | **Making connections between visual arts and other disciplines** |
| | Performing arts connections |
| | Daily life connections |
| | Interdisciplinary connections |
| | Careers |
| | Community connections |
| | Parent/home involvement |
| | Technology/internet/computer connections |

| | F1 The Whys and Hows of Art | | | | F2 Forms and Media | | | F3 Elements and Principles | | | F4 Approaches to Art | | | | |
|---|---|---|---|---|---|---|---|---|---|---|---|---|---|---|---|
| | F1.1 The Functions of Art | F1.2 Subjects and Themes | F1.3 Styles of Art | Connect, Portfolio, Review | F2.1 Two-dimensional Art | F2.2 Three-dimensional Art | Connect, Portfolio, Review | F3.1 Elements of Design | F3.2 Principles of Design | Connect, Portfolio, Review | F4.1 Art History | F4.2 Art Criticism | F4.3 Art Production | F4.4 Aesthetics | Connect, Portfolio, Review |
| | 5a 1b | 3b 1b | 6b 1a | 5 6 | 1b 2b | 3a | 5 6 | 2a 2b 2c | 2a 2b 2c | 5 6 | 4b 4c | 5a 5b 5c | 1a | 5a 5b 5c | 5 6 |

## National Standards

**National Standard 1a** Students select media, techniques, and processes; analyze their effectiveness; and reflect upon their choices.

**National Standard 1b** Students take advantage of qualities and characteristics of art media, techniques, and processes to enhance communication of ideas.

**National Standard 2a** Students generalize about the effects of visual structures and functions.

**National Standard 2b** Students employ organizational structures and analyze their effectiveness.

**National Standard 2c** Students select and use the qualities of structures and function of art to improve communication of ideas.

**National Standard 3a** Students integrate visual, spatial, and temporal concepts with content to communicate intended meaning.

**National Standard 3b** Students use subjects, themes, and symbols that demonstrate knowledge of contexts, values, and aesthetics that communicate intended meaning.

**National Standard 4a** Students know and compare characteristics of artworks in various eras and cultures.

**National Standard 4b** Students describe and place a variety of art objects in historical and cultural contexts.

**National Standard 4c** Students analyze, describe, and demonstrate how factors of time and place influence visual characteristics that give meaning and value to artworks.

**National Standard 5a** Students compare multiple purposes for creating artworks.

**National Standard 5b** Students analyze contemporary and historic meanings in specific artworks through cultural and aesthetic inquiry.

**National Standard 5c** Students describe and compare responses to their own artworks and to artworks from various eras and cultures.

**National Standard 6a** Students compare the characteristics of works in two or more art forms that share similar subject matter, historical periods, or cultural context.

**National Standard 6b** Students describe how the principles and subject matter of other disciplines are interrelated with the visual arts.

## Student Abilities in Art

| | |
|---|---|
| **Perception** | **Using knowledge of structures and functions** |
| | Observing visual, tactile, spatial, and temporal elements in the natural and built environments |
| | Observing visual, tactile, spatial, and temporal elements in artworks |
| | Considering use of elements and principles of design |
| **Art Production** | **Understanding and applying media, techniques, and processes** |
| | Generating ideas for artistic expression |
| | **Choosing and evaluating a range of subject matter, symbols and ideas** |
| | Developing approaches for expressing ideas |
| | Exploring expressive potential of art forms, media, and techniques |
| | Reflecting on artistic process, meaning, and quality of work |
| | Safety in art making |
| **Art History** | **Understanding the visual arts in relation to history and cultures** |
| | Investigating historical/cultural meaning of artworks |
| | Understanding historical/cultural context |
| | Developing global and multicultural perspectives |
| | Considering styles, influences, and themes in art |
| **Art Criticism** | **Reflecting upon and assessing the characteristics and merits of their work and the work of others** |
| | Describing and analyzing details in artworks |
| | Interpreting meanings in artworks |
| | Judging merit and significance in artworks |
| **Aesthetics** | **Reflecting upon and assessing the characteristics and merits of their work and the work of others** |
| | Understanding reasons for valuing art |
| | Raising and addressing philosophical questions about art and human experience |
| | Forming opinions about art |
| **Presentation Exhibition, and Critique** | **Reflecting upon and assessing the characteristics and merits of their work and the work of others** |
| | Keeping a portfolio and sketchbook |
| | Making work public |
| | Evaluating progress and accomplishments |
| **Learning for Life** | **Making connections between visual arts and other disciplines** |
| | Performing arts connections |
| | Daily life connections |
| | Interdisciplinary connections |
| | Careers |
| | Community connections |
| | Parent/home involvement |
| | Technology/internet/computer connections |

# 1 Telling

| Core Community Messages | 1.1 Early North America | 1.2 Crafts | 1.3 Pre-Columbian Art | 1.4 Making Paper | Connect, Portfolio, Review |
|---|---|---|---|---|---|
| 3b 5b | 4a 4c 4b 5a | 1a 4a 5a | 2b 4a 3a 5b 2b 4c | 1b 3a | 5 6 |

# 2 Living

| Core Daily Observations | 2.1 Colonial North America | 2.2 Drawing | 2.3 Indian Empire | 2.4 Drawing a Group | Connect, Portfolio, Review |
|---|---|---|---|---|---|
| 5b 5c 1b | 2b 3b 4a | 1a 1b | 1a 3b 2b 4a | 2b 3a 5a | 5 6 |

# 3 Belonging

| Core Community Values | 3.1 Independence: 1776-1820 | 3.2 Sculpture | 3.3 Art of Polynesia | 3.4 Plaster Maquette | Connect, Portfolio, Review |
|---|---|---|---|---|---|
| 2b 3b 5b | 3b 4c 4a 6a | 1b 2b 3b | 2b 4c 4a 5b 4b | 1b 3b | 5 6 |

# Scope & Sequence: Themes 7–9

## National Standards

**National Standard 1a** Students select media, techniques, and processes; analyze their effectiveness; and reflect upon their choices.

**National Standard 1b** Students take advantage of qualities and characteristics of art media, techniques, and processes to enhance communication of ideas.

**National Standard 2a** Students generalize about the effects of visual structures and functions.

**National Standard 2b** Students employ organizational structures and analyze their effectiveness.

**National Standard 2c** Students select and use the qualities of structures and function of art to improve communication of ideas.

**National Standard 3a** Students integrate visual, spatial, and temporal concepts with content to communicate intended meaning.

**National Standard 3b** Students use subjects, themes, and symbols that demonstrate knowledge of contexts, values, and aesthetics that communicate intended meaning.

**National Standard 4a** Students know and compare characteristics of artworks in various eras and cultures.

**National Standard 4b** Students describe and place a variety of art objects in historical and cultural contexts.

**National Standard 4c** Students analyze, describe, and demonstrate how factors of time and place influence visual characteristics that give meaning and value to artworks.

**National Standard 5a** Students compare multiple purposes for creating artworks.

**National Standard 5b** Students analyze contemporary and historic meanings in specific artworks through cultural and aesthetic inquiry.

**National Standard 5c** Students describe and compare responses to their own artworks and to artworks from various eras and cultures.

**National Standard 6a** Students compare the characteristics of works in two or more art forms that share similar subject matter, historical periods, or cultural context.

**National Standard 6b** Students describe how the principles and subject matter of other disciplines are interrelated with the visual arts.

## Student Abilities in Art

| | |
|---|---|
| **Perception** | **Using knowledge of structures and functions** |
| | Observing visual, tactile, spatial, and temporal elements in the natural and built environments |
| | Observing visual, tactile, spatial, and temporal elements in artworks |
| | Considering use of elements and principles of design |
| **Art Production** | **Understanding and applying media, techniques, and processes** |
| | Generating ideas for artistic expression |
| | **Choosing and evaluating a range of subject matter, symbols and ideas** |
| | Developing approaches for expressing ideas |
| | Exploring expressive potential of art forms, media, and techniques |
| | Reflecting on artistic process, meaning, and quality of work |
| | Safety in art making |
| **Art History** | **Understanding the visual arts in relation to history and cultures** |
| | Investigating historical/cultural meaning of artworks |
| | Understanding historical/cultural context |
| | Developing global and multicultural perspectives |
| | Considering styles, influences, and themes in art |
| **Art Criticism** | **Reflecting upon and assessing the characteristics and merits of their work and the work of others** |
| | Describing and analyzing details in artworks |
| | Interpreting meanings in artworks |
| | Judging merit and significance in artworks |
| **Aesthetics** | **Reflecting upon and assessing the characteristics and merits of their work and the work of others** |
| | Understanding reasons for valuing art |
| | Raising and addressing philosophical questions about art and human experience |
| | Forming opinions about art |
| **Presentation Exhibition, and Critique** | **Reflecting upon and assessing the characteristics and merits of their work and the work of others** |
| | Keeping a portfolio and sketchbook |
| | Making work public |
| | Evaluating progress and accomplishments |
| **Learning for Life** | **Making connections between visual arts and other disciplines** |
| | Performing arts connections |
| | Daily life connections |
| | Interdisciplinary connections |
| | Careers |
| | Community connections |
| | Parent/home involvement |
| | Technology/internet/computer connections |

# Correlation Chart

| 7 Celebrating | | | | | | 8 Making a Difference | | | | | | 9 Looking Beyond | | | | | |
|---|---|---|---|---|---|---|---|---|---|---|---|---|---|---|---|---|---|
| Core Pride in Community | 7.1 Art and Pride: 1920–1950 | 7.2 Photography | 7.3 Caribbean Art | 7.4 3-D Montage | Connect, Portfolio, Review | Core Make a Difference | 8.1 Making a Difference | 8.2 Printmaking | 8.3 African Art | 8.4 Relief Prints | Connect, Portfolio, Review | Core Beyond the Present | 9.1 New Directions in Art | 9.2 New Media | 9.3 Global Challenges | 9.4 Making a Video Tape | Connect, Portfolio, Review |
| 2b 4c 5b | 1a 4c 5a | 1a 1b 3b 4a | 1a 3b 1b 4a 2b 4c | 1a 3b 1b 4a | 5 6 | 1a 5a 3b 5b 4c | 1a 3b 1b 4a 2b 5b | 1a 1b 3a | 1b 4b 2b 4c 3b | 1b 4a 2b 6b 3b | 5 6 | 2b 3b 5b | 1a 3b 2b 4c | 1b 4c 2c 5b 3b | 1a 4c 2b 5b 3b | 1b 4c 2b 5b 3b | 5 6 |

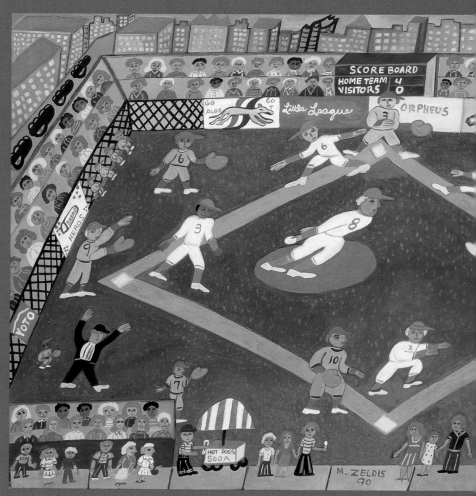

Cover, and above: Malcah Zeldis, *Baseball*, 1990. Oil on board, 24" x 36"
(61 x 91 cm). Courtesy the artist and Art Resource, New York.

Art and the Human Experience

# ART

## A Community Connection

**Eldon Katter**
**Marilyn G. Stewart**

Davis Publications, Inc.
Worcester, Massachusetts

# Foundations **What Is Art?**

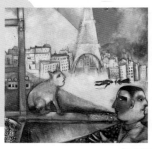

Page 13

Page 27

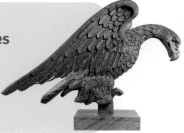

Page 41

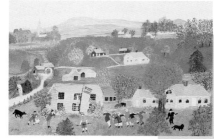

Page 53

# Themes Art Is a Community Connection

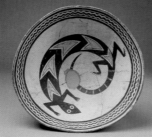

Page 73

Page 104

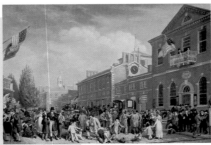

Page 129

Printed in U.S.A.
ISBN: 0-87192-491-9
LC No.: 00-130408
10 9 8 7 6 5 4 3 2 1
WPC 05 04 03 02 01

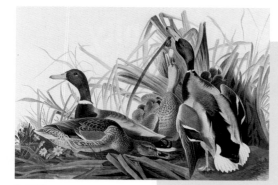
Page 158

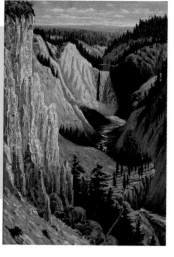
Page 180

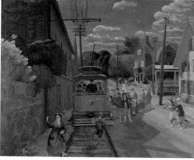
Page 208

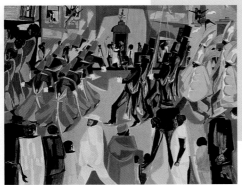

Page 231

Page 259

Page 293

## Resources

**Make the most of your time and your text.** Artists across time and space have celebrated the events and values that unite a community. *Art: A Community Connection* dedicates a chapter to each of these universal, community-building themes.

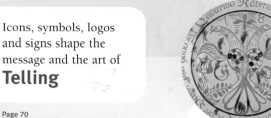

Page

Icons, symbols, logos and signs shape the message and the art of
**Telling**

Page 70

Memorials, monuments, festivals, and plazas express a community's ideals and sense of
**Belonging**

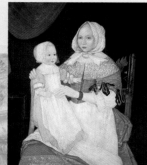

Through landscape paintings, gardens, and parks, artists foster community by
**Connecting to Place**

Page 105

Still life paintings, portraits, and murals chronicle life and celebrate
**Living**

Refining its forms, patterns, and shapes, artists find inspiration
**Responding to Nature**

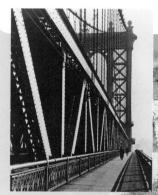

Page 151

Page 184

**A**

# Community Connection

Page 207

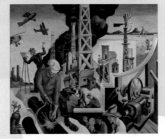

Page 232

Historical photographs, paintings, and sculptures record the **Changing** of landscapes and attitudes

Whether it's carousels, costumes, parades, or posters, the arts build for the future by **Celebrating** the past

Through new materials, techniques, subjects, and styles, artists begin **Looking Beyond**

Page 256

Through installations, murals, woodcuts, and quilts, artists explore ways of **Making a Difference**

Page 292

## Foundations in Art

This text opens with an exploration of the fundamental **hows and whys of art.**

- Why do people make art?
- Does art serve a function?
- How do artists choose their subjects?
- Are there different styles of art?
- What is a 2-D art form?
- Why are the elements of design important?
- How are art historians and critics different?

In answering these questions, these introductory lessons provide a sound foundation on which to build your understanding of art.

**Make the most of each chapter!**
A unique CORE PLUS 4 chapter
organization provides a structured
exploration of art with the flexibility to
zoom in on topics that interest you.

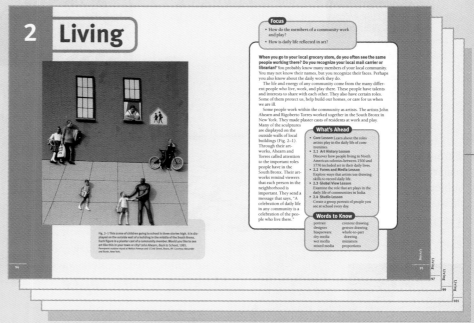

Sample pages from Chapter 2

**Each theme opens with a
CORE Lesson that provides
a comprehensive overview
of the topic.**

*In this theme you will examine how
artists record and shape a community's
daily life.*

**Each theme concludes with a
studio activity that challenges you
to apply what you have learned in
a hands-on art project.**

*In this studio exercise you design and decorate
a clay pot to be used in your daily life.*

4 regular follow-up lessons reinforce and extend the CORE Lesson.

**1** The first lesson examines the theme from the perspective of **art history**. *This lesson studies how the American colonists included art in their daily lives.*

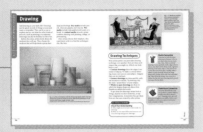

**2** The second lesson explores the theme through different **forms and media**. *This lesson examines how artists use drawing skills to record and document daily life.*

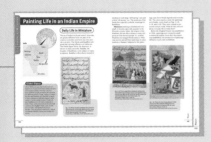

**3** The third lesson looks at the theme from a **global or multicultural viewpoint**. *This lesson considers how artists from India have used a range of art forms to chronicle daily life in their communities.*

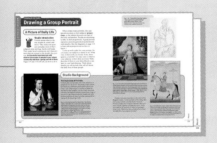

**4** The fourth lesson studies the theme through a **studio activity**. *In this project you will make a portrait of people you see at school every day.*

At the end of each chapter the themes **Connect to...**
- **Careers**
- **Technology**
- **Other Subjects**
- **Other Arts**
- **Your World**

# Make the most of each lesson!

There are a number of carefully-crafted features that will help you read, understand, and apply the information in each lesson.

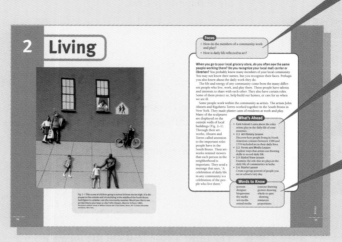

**Read with purpose and direction.**
Thinking about these Focus questions will help you read with greater understanding.

**Prepare for What's Ahead!**
See how all the lessons are related? Like a map, this will help you plan where you want to go.

**Build your vocabulary.**
The first time these key terms are used they are highlighted in bold type and defined. *These terms are also defined in the Glossary.*

**Organize your thoughts.**
By dividing the lesson into manageable sections, these headings will help you organize the key concepts in each lesson.

**"Read" the visuals with the text.**
Note how the visuals are referenced in the text. Following these connections will help you understand the topic.

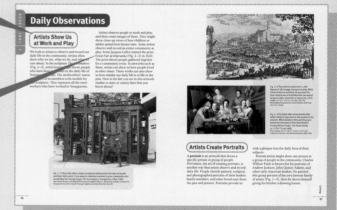

# mages and Ideas

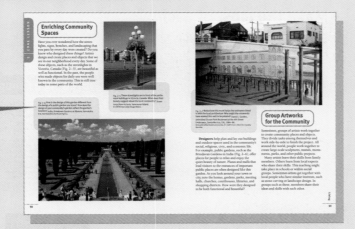

**Use the captions to "see" the art.**

These statements and questions direct you to key aspects of the artwork. Responding to the captions will help you see how the image relates to the text.

**Who made this?**
**When was it made?**
**What is it made of?**

These and other important questions are answered by the credits that accompany each visual. This information will help you appreciate the art more fully.

**Check Your Understanding!**

In addition to helping you monitor your reading comprehension, these questions highlight the significant ideas in each lesson.

## Don't Miss

### Timelines

Each **Art History** lesson is supported by a timeline that locates the lesson in history. As you read this timeline consider how the art reflects the historic events that surround it.

### Locator Maps

Each **Global View** lesson is supported by a map that highlights the lesson's location in the world. As you read this map, consider how the art reflects the geography and culture of the place.

# Work with Your Mind

## Make the most of each studio opportunity!

### Core Studio
An expansive studio assignment concludes and summarizes each CORE Lesson.

### Studio Lesson
A comprehensive studio lesson caps off each chapter by tying the theme's key concepts together.

**Sketchbook Connections**
Quick process-oriented activities help you hone your technical and observation skills.

**Studio Connections**

Practical real-world studio projects explore concepts through hands-on activities.

**Computer Options**

An alternative to traditional art materials, the computer can be used to do all or part of the lesson.

---

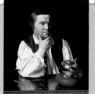

Drawing in the Studio

## Drawing a Group Portrait

### A Picture of Daily Life

**Studio Introduction**
Portrait artists observe the way people sit, stand, and move. They notice the position and placement of their subjects' arms and legs, hands and heads. They study facial expressions and characteristics that are unique to the people they portray. **In this studio experience you will observe classmates or people in your school community and draw a group portrait of them.** Pages 114 and 115 will tell you how to do it.

When artists create portraits, they pay special attention to their subjects' **proportions,** or the relation between one part of the body and another. People are surprisingly alike in their proportions. A good portrait captures a person's general proportions and individuality. (See the diagrams on page 114 to learn about proportions in a face or figure.)

Come up with a plan for your portrait. Do you want your subjects to stand or sit? What view of them will you choose: front, three-quarter, or profile? You may want to observe your subjects in their daily activities. Make sketches of them in your sketchbook to use later in your final drawing. Think about details you will include that will tell about the daily lives of these people.

### Studio Background

**The Importance of Portraits**
Portraits play an important role in the daily lives of people all over the world. They help people remember loved ones and honor great leaders and heroes (Fig. 2–23). They can give us an idea of what life was like for their subjects. For the North American colonists, having their portraits painted was a sign of success in a growing community. Usually, the style of these portraits was based on what was popular in Europe at the time (Fig. 2–23).

Fig. 2–23 During the American Revolution, Paul Revere made a "midnight ride" to warn his community that the British were coming. What does the artist of this portrait show us about Paul Revere's daily life as a silversmith? Notice the three-quarter view of Revere's face. John Singleton Copley, *Paul Revere,* 1768.

112

**Build background knowledge**
Artists regularly draw from the lessons of history. This background information chronicles how artists from the past approached similar artistic endeavors.

**Learn from your peers.**
An example of student artwork allows you to see how others responded to these hands-on exercises.

# Think with Your Hands

## Try This!
These directions and illustrations guide you step-by-step through the studio experience.

## Check Your Work
One way to evaluate your art is through constructive group critiques. These strategies help you organize peer reviews.

### Drawing in the Studio
## Drawing Your Portrait

**You Will Need**
- drawing paper
- charcoal, pencil, or pastels

**Try This**

**1.** Observe the people you want to draw. Notice the shape and features of their faces. Notice whether your subjects are tall, thin, short, or plump. Then set up guidelines for proportion in your portrait.

**2.** Decide which view of each person you want to show. Will you show any profile or three-quarter views?

**3.** Draw your portrait. Work on the character or special qualities of your subjects. For example, you might use thin, wiry lines for a thin, nervous person. Capture important details. These might include the shape of the eyebrows, a dimple in the chin, a sparkle in the eyes, or a unique hair style.

**4.** Remember to include backgrounds and props that tell about the daily lives of the people in your portrait. Think about the mood or feeling you want to show. Are the lives of the people in your portrait serious or joyful? How can you show this detail?

**5.** Try shading your drawing. Imagine shining a strong light on your subjects. Where would you see the highlights and shadows?

**Check Your Work**
What guidelines for proportions did you use to start your drawing? Did they help you? Were you able to capture the mood and unique characteristics of your subjects? What details from their daily lives did you show?

**Sketchbook Connection**
The sketches you make of things you observe are one of the best sources of ideas for artworks. Sketch the most important or interesting elements of your community. Draw the people you know and see regularly. Sketch scenes of daily life in your neighborhood. Try filling a page with *thumbnail sketches*, or small drawings. Sketch your subject from different views or with different amounts of detail.

**Computer Option**
Look at some artists' self-portraits on the Internet. Then use paint or draw software to create your self-portrait. Add symbols that represent your interests, community, and/or culture.

Fig. 2-27 "The picture that I have drawn is of a girl on the school basketball team. Drawing her hair, the basketball, and her uniform was easy. The difficult parts were drawing her face (mostly her eyes) and shading." Mackenzie Granger, *Warrior in Waiting*, 2000. Pastel, 12" x 8" (30.5 x 20 cm). Thomas Prince School, Princeton, Massachusetts.

114    115

**This book shows you how artists across time have celebrated the events and values that unite a community.** Through this study you'll understand your own communities better. You'll also learn how making and perceiving art helps build communty connections.

# Student Gallery

**As you become fluent in the universal language of art, a wealth of studio opportunities will help you find your own voice.** The artworks on these four pages show how students just like you express their own unique insights and concerns.

**Page 30 William C. Tate,** *Large-mouth Bass,* **1998.**
Aluminum wire, 8 ¼" x 3 ¼" x 3 ¼" (21 x 8 x 8 cm). Daniel Boone Area Middle School, Birdsboro, Pennsylvania.

**Page 16 Megan Verhelst,** *Self-Portrait,* **1999.**
Conté crayon, 14" x 20" (35.5 x 51 cm). Verona Area Middle School, Verona, Wisconsin.

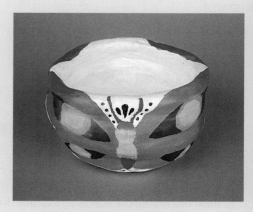

**Page 64 Veronica Martinez,** *Fly Away,* **1999.**
Clay and acrylic, 4" x 5" x 3" (10 x 13 x 7.5 cm). Sweetwater Middle School, Sweetwater, Texas.

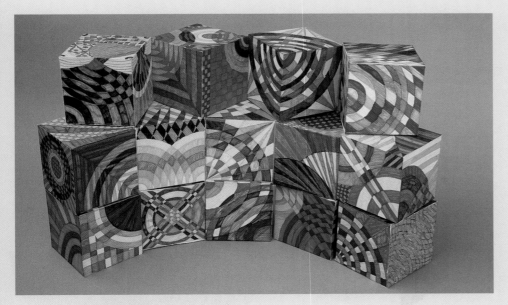

Page 92 **Students from Los Cerros Middle School,**
*Collaborative Sculpture,* **1999.**
Markers, 3 ³/₄" (9.5 cm) cubes. Danville, California.

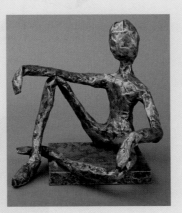

Page 118 **Stacey Fong,** *Contemplation,* **1999.**
Papier mâché, wire, tape, tempera, 8" x 6" x 6" (20 x 15 x
15 cm). Los Cerros Middle School, Danville, California.

Page 127 **Nicolette Schlichting,** *Its Fleece Was White as Snow,* **2000.**
Colored pencil, 12" x 18" (30.5 x 46 cm). Chocksett Middle School, Sterling, Massachusetts.

# Student Gallery

**Page 248 Stephen Torosian,** *Caught in the Act,* **1997.**
Clay. Remington Middle School, Franklin, Massachusetts.

**Page 170 Keith Bush,** *Deep Blue Sea,* **2000.**
Markers, 16" diam. (40.5 cm). Sarasota Middle School, Sarasota, Florida.

**Page 222 Meg Weeks,**
***Twilight Trek to Freedom,***
**1999.**
Construction paper collage, 18" x
24" (46 x 61 cm). Winsor School,
Boston, Massachusetts.

**Page 196 Heidi McEvoy,** *Animal,* **1999.**
Acrylic paint, 8 ½" x 23 ½" (21.5 x 59.5 cm). Fairhaven Middle School, Bellingham, Washington.

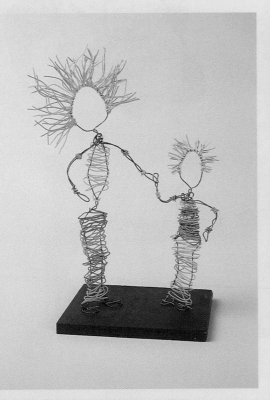

**Page 295 Deborah Mduruwa, Curtis Breer,
Orion Stand-Grai, Noah Abrahams,**
*Low Rider,* **1999.**
Videotape, Samford Middle School, Auburn, Alabama.

**Page 274 Micale Mitchell,** *Mother and Child,* **1999.**
Wire, wood base, 11 ½" (29 cm) high. Desert Sands School, Phoenix, Arizona.

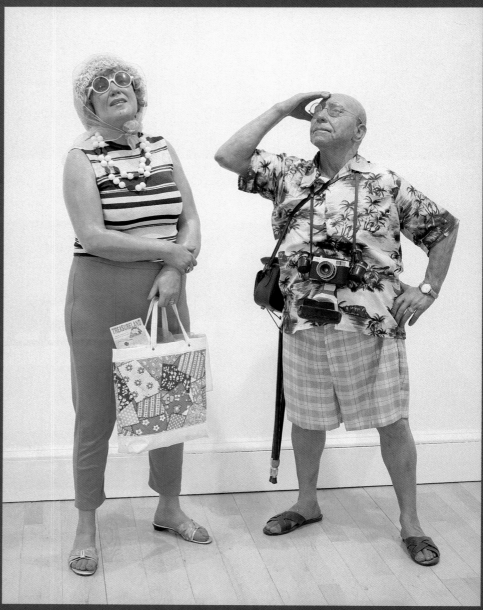

# Foundations

# What Is Art?

**If you ask three friends what art is, they probably won't give the same answer. Throughout history, art has meant different things to different people. And that remains true today.**

Many art museums display beautiful objects from different cultures. Even though we call these objects works of art, the people who made them may not have thought of them as art. In fact, some cultures have no word for art. Yet they take great care in making beautiful pottery, jewelry, and masks.

Whether or not it is intended as art, an object made by a person shows that individual's creativity and skill. The artist, designer, or craftsperson must have thought about why he or she was making the object. Something he or she saw or imagined must have provided inspiration. Once the object is made, other people may see it as a work of art, or they may not. How they see and appreciate the object depends on their sensitivity and their own ideas about what art is.

Look carefully at some of the objects pictured in this book. Write down the names of the ones that interest you, including their page numbers. Which objects do you consider works of art? Why? Why do you feel that other objects are not art? Write down your answers. When you are finished with Part 1 of this book, look at the objects again. How have your opinions changed?

## Chapter Overview

## Foundation 1

If we understand the reasons that humans produce art, we will be better able to understand and appreciate their art. By recognizing both cultural and individual styles in artists' shared themes and subjects, students will appreciate the uniqueness of individual artworks.

## Featured Artists

Marc Chagall
Robert Delaunay
Richard Estes
Grace Hartigan
Marsden Hartley
Sheila Hicks
Joseph Jean-Gilles
William H. Johnson
Ernst Ludwig Kirchner
Robert Lindneux
Archibald Motley
Louise Nevelson
Vincent van Gogh

## Chapter Focus

Universally, people create art for practical, cultural, and personal functions. Although all artworks can be classified by styles—such as expressionism, realism, abstraction, and fantasy—each individual artwork has a style unique to the artist and his or her culture.

FOUNDATION 1

# The Whys and Hows of Art

## Focus

- Why do people all over the world create works of art?
- How do artists make their work unique?

**Do you remember the first time you painted a picture? You might have painted an animal or a scene from nature. Or perhaps you just painted swirling lines and shapes because you liked the way the colors looked together.** No matter what the subject of the painting, there are many questions we can ask about how your first painting came to be. For example, what made you want to create it? How did you use paint to express your ideas? Why did you decide to paint the picture instead of draw it with crayons or a pencil? How was your painting similar to others you had seen?

These are questions we can ask about any work of art, whether it be your creation or someone else's. When artists work, they might not always think about these questions, but the answers are there. And while the answers might differ from one artist to the next, the whys and hows of art can lead us to a world of wonder.

## What's Ahead

- **F1.1 The Functions of Art**
  Learn about the many roles that art plays in peoples' lives.
- **F1.2 Subjects and Themes for Artworks**
  Recognize that objects, ideas, and feelings inspire people to create art.
- **F1.3 Styles of Art**
  Understand why there can be similarities among certain artworks, even though every work of art is different.

## Words to Know

subject
theme
style

2

## National Standards Foundation 1 Content Standards

1. Understand media, techniques, and processes.

3. Choose and evaluate subject matter, symbols, and ideas.

5. Assess own and others' work.

6. Make connections between disciplines.

**Teaching Options**

## Meeting Individual Needs

**English as a Second Language** Ask students for the word in English of the object they are sitting on, and then write "chair" on the chalkboard. Next, have them identify an image of a chair on page 3, and then use English words to describe the difference between this one and their own. Explain that this more than a hundred-year-old chair was for a royal person in Africa. End by having them draw a chair that communicates their own importance.

## Teaching Through Inquiry

**Aesthetics** Ask students to select visually interesting images from magazines and then to sort them into three categories: art; not art; might be art. Encourage students to give reasons for their placement of images. Record key issues raised and any problems that students had in making distinctions among the categories. Continue to discuss these issues throughout the year.

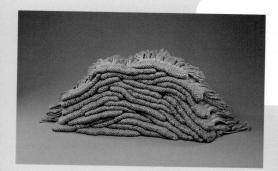

Fig. F1–1 Sheila Hicks piled up separate fiber
bundles for this sculpture. How do you think her
title relates to the artwork? Sheila Hicks,
*The Evolving Tapestry: Blue*, 1967–68.
Linen, silk, 27 pieces, average, each piece: 2" x 23" x 15" (5 x
59 x 38 cm) installed size will vary. Gift of Vivian and Edward
Marrin, 80: 1992.1-.25, The St. Louis Art Museum (Decorative
Arts and Design) [ISN 26181].

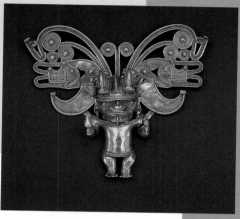

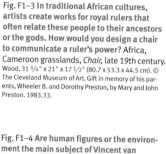

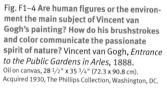

Fig. F1–2 The Tairona of Colombia were known as great
warriors. Can you find the bird and animal heads in the
headdress of the fierce human figure? Colombia, Sierra
Nevada area, Tairona Style, *Pendant Figure with
Headdress*, 14–16th century.
Gold, 5 1/4 " x 6 1/2" (13.4 x 16.5 cm). The Metropolitan Museum of Art,
Gift of H. L. Bache Foundation, 1969. (69.7.10) Photograph © 1982 The
Metropolitan Museum of Art.

Fig. F1–3 In traditional African cultures,
artists create works for royal rulers that
often relate these people to their ancestors
or the gods. How would you design a chair
to communicate a ruler's power? Africa,
Cameroon grasslands, *Chair*, late 19th century.
Wood, 31 3/4" x 21" x 17 1/2" (80.7 x 53.3 x 44.5 cm). ©
The Cleveland Museum of Art. Gift in memory of his par-
ents, Wheeler B. and Dorothy Preston, by Mary and John
Preston. 1983.33.

Fig. F1–4 Are human figures or the environ-
ment the main subject of Vincent van
Gogh's painting? How do his brushstrokes
and color communicate the passionate
spirit of nature? Vincent van Gogh, *Entrance
to the Public Gardens in Arles*, 1888.
Oil on canvas, 28 1/2" x 35 3/4" (72.3 x 90.8 cm).
Acquired 1930, The Phillips Collection, Washington, DC.

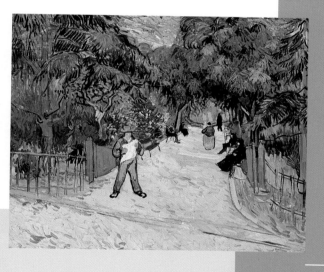

## Chapter Warm-up

Have volunteers describe a favorite
artwork that they have made. **Ask:**
Why did you create this artwork?
What materials did you use? What
were you trying to express? What
artworks would you like to create?
What would you like to paint?
Sculpt? Draw?

## Using the Text

**Aesthetics** Have students read
pages 2 and 3. **Ask:** What questions
should you ask about an artwork in
order to understand it? *(Why was it
created? Why did the artist use a
particular material or media? How is
the art similar to other art?)*

## Using the Art

**Perception Ask:** Why, do you think,
was each of these pieces created?
What materials did each artist use?
What texture and colors did van
Gogh use? Discuss students' an-
swers to the caption questions.

**Aesthetics Ask:** Who might wear a
gold pendant such as the one in Fig.
F1–2? *(someone rich and/or power-
ful)* What do you think the creators of
the jewelry and chair were trying to
express? Do you think that they con-
sidered jewelry and furniture to be
art?

## More About...

During the 1970s, many women artists challenged the art
world's long-established dismissal of fabric as merely
"craft" and its association with female traditions. **Sheila
Hicks** (b. 1934) was one such artist: she rejected the divi-
sion between craft and fine art, and abandoned the loom
to knot, braid, twine, wrap, and crochet woven forms.

# Prepare

## Pacing
One or two 45-minute periods, depending on the scope of Try This

## Objectives
- Understand that art is created for practical, cultural, and personal functions.
- Create from industrial materials, a three-dimensional artwork that has a practical and a cultural function.

### Supplies for Engage
- practical objects (such as mugs, pencils, paperweights, or clothing) that commemorate an occasion

# Teach

## Engage
**Aesthetics** Display the practical objects. **Ask:** What is the function of each object? Why was it created? How did its function determine its design? Explain that the purpose of artworks and objects influence how they are made.

## Using the Text
**Aesthetics** Have students read pages 4 and 5. **Ask:** What are three major reasons for creating art? What artworks have you made for your own personal reasons?

### National Standards
### Foundation 1.1

**1b** Use media/techniques/processes to communicate experiences, ideas.

**5a** Compare multiple purposes for creating art.

# The Functions of Art

Although people create art for many reasons, most artworks belong to one of three broad categories: practical, cultural, or personal. These categories describe the function, or role, of an artwork.

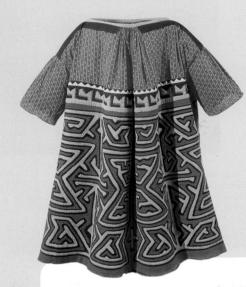

Fig. F1–5 Practical. It takes many years for Kuna women to master the challenging method of reverse appliqué. First they carefully cut through the top layers of cloth. Then they tuck and stitch them under to reveal brilliant, jewel-like fabrics below. Why might reverse appliqué be considered an art technique? Panama, Kuna Yala, *Mola* (woman's blouse), early 20th century.
Length 23 ³/₈" (59.5 cm). Courtesy the National Museum of the American Indian, Smithsonian Institution (16.6425). Photo by David Heald.

## Practical Functions

Much of the world's art has been created to help people meet their daily needs. For example, architecture came from the need for shelter. People also needed clothing, furniture, tools, and containers for food. For thousands of years, artists and craftspeople carefully made these practical objects by hand. Today, almost all everyday objects that are designed by artists are mass-produced by machines.

Think about the clothes you wear and the items in your home and school. How do they compare to similar objects from earlier times or from other cultures? Which do you think are beautiful or interesting to look at? Why?

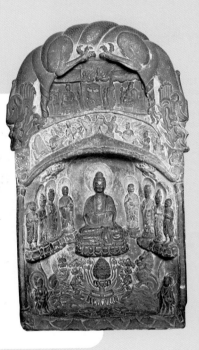

Fig. F1–6 Cultural. Can you locate Buddha in the sculpture? If you were to create a stele such as this, where would you place the most important figure? China, Honan, Wei Dynasty (535–557 AD), *Votive Stela*, 551 AD.
Limestone, 39" x 20" x 11" (99 x 50.8 x 27.9 cm). Courtesy the University of Pennsylvania Museum.

## Teaching Options

### Resources
Teacher's Resource Binder
- Thoughts About Art: F1.1
- A Closer Look: F1.1
- Find Out More: F1.1
- Assessment Master: F1.1
Large Reproduction 1
Overhead Transparency 1
Slides 1, 2, 3

### Teaching Through Inquiry
**Aesthetics** Ask small groups of students to think about different **art forms and their various functions**. Have groups identify where artworks can serve each function. (*Stained-glass windows in a church might teach and inspire.*) **Ask:** How might an artwork's function change when its location or viewing situation changes? What if a mural were used as a carpet? Do responses to art have more to do with their function or with the settings in which they are experienced? Keep a list of issues raised, for discussion throughout the year.

## Cultural Functions

We can learn a lot about different cultures by studying their art and architecture. Some buildings and artworks were made to honor leaders and heroes. Other works help teach religious and cultural beliefs. Sometimes art commemorates important historical events or identifies an important person or group.

Many artists continue to create artworks for cultural reasons. What examples can you think of in your community or state that serve a social, political, religious, or historical purpose? How are they different from artworks that have a practical function?

## Personal Functions

An artist often creates a work of art to express his or her thoughts and feelings. The materials an artist chooses and the way he or she makes the artwork reflect the artist's personal style. The work might communicate an idea or an opinion that the artist has about the subject matter. Or it might simply record something that the artist finds particularly beautiful. Such personal works are created in many forms, including drawing, painting, sculpture,

Fig. F1–8 **What does this artwork express about the student who made it? Why might she have chosen to create a sculpture instead of a painting?** Adrienne Lastoskie, *Untitled*, 1998.
Plaster, 13 1/2" x 5 1/2" x 6" (34 x 14 x 15 cm). Daniel Boone Area Middle School, Birdsboro, Pennsylvania.

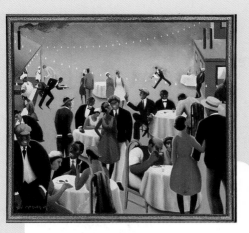

Fig. F1–7 **Personal.** Archibald Motley was one of the leading artists of the Harlem Renaissance (1919–29), a period when art, music, literature, and poetry flourished. **What part of the African-American heritage does Motley seem to care about?** Archibald Motley, *Barbeque*, 1934.
Oil on canvas. 39 1/2" x 44" (100 x 111.8 cm). The Howard University Gallery of Art, Washington, DC.

cartooning, and photography. What artworks do you know about that were created for personal expression or sheer beauty?

### Try This

Create a three-dimensional artwork out of objects, such as hardware, plastics, and other materials found in the modern industrial world. Your artwork should reflect both a practical and cultural function. Write a label for the work that asks viewers to think about how your piece fulfills a practical and cultural purpose.

**Foundation Lesson 1.1**

**Check Your Understanding**
1. What are three broad categories of reasons that art is created? Select an artwork from another lesson in this book to illustrate each of these functions.
2. Name and describe a piece of art in your community that serves a cultural purpose.

*The Hows and Whys of Art*

5

**Computer Option**
Have students use programs such as Photoshop, Dabbler, or Painter. They may also use AppleWorks Paint, although this program is not as flexible.

### Using the Art

**Art Criticism Ask:** What are the functions of the Kuna mola, the Chinese stele, and Motley's *Barbeque*? What did each artist express in the art?

### Try This

Provide students with found materials (wire, wood, plastic tubing, Styrofoam™ packing, sheet metal); joining materials (adhesives, hardware); acrylic paints and brushes; paper and pencils.

Lead students in brainstorming practical and cultural uses of the objects they will create. Discuss what students could do with the available materials. Have students write and attach a label with questions or riddles about the purposes of their piece.

### Critical Thinking

Challenge students to consider the permanence or indestructibility of the materials in the artworks. **Ask:** What does this say about the purpose or function of each piece?

## Assess

**Check Your Understanding: Answers**

1. Three categories of reasons for creating art are practical, cultural, and personal. Selected artworks will vary.

2. Students might describe architecture, paintings, sculpture, and other objects that serve a social, political, religious, or historical purpose.

## Close

Display the objects created in Try This. **Ask:** What are the cultural and practical purposes of each piece? Discuss students' answers to Check Your Understanding.

### Assessment Options

**Self** Ask students to choose something that serves a special function in the community, such as a bus, telephone booth, or billboard. Have students describe what changes they would make so that the object fulfilled a personal function as an artwork, and what changes they would make so that the object fulfilled a cultural function as an artwork. Have students share lists in small groups and, based on peer comments, rate their own performance.

### Using the Large Reproduction

Lead a discussion of how this work might serve practical, cultural, and/or personal functions.

**1**

### Using the Overhead

Consider to what degree this work might serve practical, cultural, and personal functions.

**1**

## Prepare

### Pacing
One or two 45-minute periods, depending on the scope of Try This

### Objectives
- Explain the difference between theme and subject.
- Draw a self-portrait that features personal possessions.

### Vocabulary
**subject** What is shown in an artwork, such as a landscape, people, animals, or objects.

**theme** The overall topic of an artwork. For example, the theme of a landscape might be the need to protect the environment.

## Teach

### Engage
Ask students to name the subject and theme of a movie or of a poem or story that they have recently read in English class. For example, the subject of the movie *Babe* is a little pig who wants to be a sheep herder; the theme is the acceptance of differences in others.

# Subjects and Themes for Artworks

Artists are observers. They find subjects and themes for their work in almost everything they see and do. The **subject** of an artwork is what you see in the work. For example, the subject of a group portrait is the people shown in the portrait. Other familiar subjects for artworks include living and nonliving things, elements of a fantasy, historical events, places, and everyday activities.

You can usually recognize the subject of an artwork. Sometimes, however, an artist creates a work that shows only line, shape, color, or form. The artwork might suggest a mood or feeling, but there is no recognizable subject. This kind of artwork is called *nonobjective*.

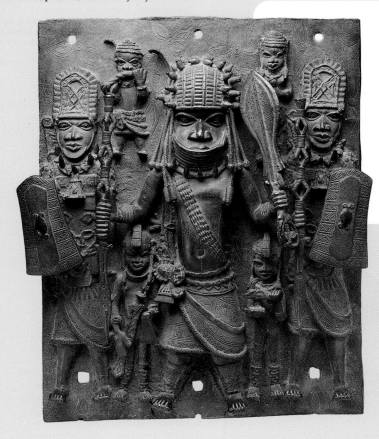

Fig. F1–9 Look carefully at this group portrait. The artist has arranged the figures according to rank. What details did the artist use to help express the ranking of the different people? Africa, Nigeria, Edo, Court of Benin, *Warrior Chief, Warriors, and Attendants*, late 17th century.
Brass, 18 7/8" (47.9 cm). The Metropolitan Museum of Art, Gift of Mr. and Mrs. Klaus G. Perls, 1990. (1990.332) Photograph © 1991 The Metropolitan Museum of Art.

6

## Teaching Options

### Resources
Teacher's Resource Binder
  Thoughts About Art: F1.2
  A Closer Look: F1.2
  Find Out More: F1.2
  Assessment Master: F1.2
Large Reproduction 3, 10
Overhead Transparency 4
Slides 4, 5, 6

### Teaching Through Inquiry
**Art Production** Tell students that one way to get **ideas for making art** is to think about subject matter such as people, places, and things that have special meaning. Identify and examine the subject matter in a variety of artworks and discuss how the artist has used the subject matter to express deeper meanings such as love, friendship, and joy; as well as sadness, dislike, and pain.

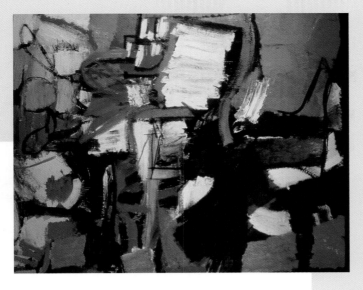

Fig. F1–10 Do you see a restaurant in this painting? Why can this artwork be considered nonobjective? Grace Hartigan, *Broadway Restaurant*, 1957. Oil on canvas, 79" x 62 ¾" (200.7 x 159.4 cm). The Nelson-Atkins Museum of Art, Kansas City, Missouri. (Purchase: Nelson Trust) (F57-56)

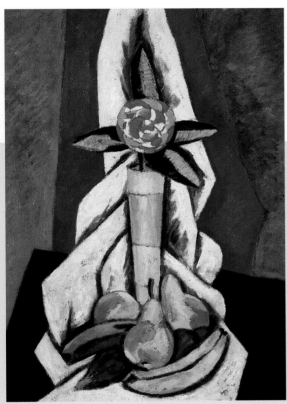

Fig. F1–11 Do you think Marsden Hartley was more interested in realistically showing a *still life*—an arrangement of objects—or exploring shape, line, and color? Why do you think so? Marsden Hartley, *Still Life*, ca. 1929–30. Oil on cardboard, 25 ¾" x 18 ¾" (65.4 x 47.6 cm). Santa Barbara Museum of Art, Gift of Wright S. Ludington. (1950.3)

## Using the Text

**Art Criticism** Have students read pages 6 and 7. **Ask:** What is the subject and the theme of the Benin plaque? *(subject: warrior and attendants; theme: importance of strength)* Have students locate Nigeria on a map of Africa. **Ask:** What do you think is the purpose of this plaque?

**Art Criticism** Have students describe the Jean-Gilles landscape (Fig. F1–13). **Ask:** What is the subject? The theme? Ask students to cite objects and colors in the painting to support their answers.

## Using the Art

**Art Criticism** Explain that the title of Hartley's piece is also a term for an artwork of an arrangement of objects. **Ask:** In what way is *Still Life* different from real life? Discuss how each artwork on these pages is not quite realistic.

## Critical Thinking

Ask students to consider why an artist might want to depict the same subject many times. **Ask:** What reasons might an artist have for specializing in a certain subject matter? (Portrait artists and landscape painters are two examples.)

The Hows and Whys of Art

7

## Using the Text

**Art Criticism** Ask students whether they think an artwork can have more than one theme. **Ask:** What clues in an artwork might guide the viewer in better interpreting the theme?

## Using the Art

**Art Criticism Ask**: What is nonobjective art? Which image on pages 6 through 9 is a nonobjective piece? *(Hartigan's* Broadway Restaurant*)* What are the theme and subject of this piece? How did the artist express her feelings about the restaurant?

**Art Criticism** Have students compare the figures in Johnson's *Soap Box Racing* to those in the Benin plaque (Fig. F1–9). **Ask:** Why are some figures larger than others in each artwork? *(plaque: figure size connotes power and importance in society;* Soap Box Racing: *size indicates distance. In both works, the large, centrally placed figures have compositional importance.)*

## Try This

Provide students with drawing media (pencils, charcoal, pastels, oil pastels, or markers) and drawing paper, 12" x 18".

Have students lay out their possessions. **Ask:** What do these things say about you? Which objects are most important to you? How can you show this in a portrait? Will you draw the important objects large, or place them in the center of the composition? Suggest to students that they might draw the most important objects closest to the viewer.

Have students write their subject and theme on the back of their drawing.

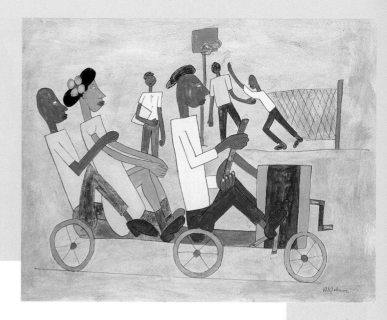

Fig. F1–12 **In 1932, artist William H. Johnson said, "My aim is to express in a natural way what I feel, what is in me, both rhythmically and spiritually." What other theme besides his feelings does Johnson express in this artwork?** William H. Johnson, *Soap Box Racing,* ca. 1939–40. Tempera, pen and ink on paper mounted on paperboard, 14 1/8" x 17 7/8" (35.9 x 45.4 cm). National Museum of American Art, Smithsonian Institution, Washington, DC / Art Resource, NY.

The **theme** of an artwork is the topic or idea that the artist expresses through his or her subject. For example, the theme of the group portrait might be family togetherness or community support. Themes in art can be related to work, play, religion, nature, or just life in general. They can also be based on feelings, such as sadness, love, anger, and peace.

Artworks all over the world can reflect the same theme, but will still look entirely different. Why? Because the subjects used to express the theme probably won't be the same. For example, imagine that an artist in Australia and an artist in Canada each create a painting about natural beauty. Would the Canadian artist show a kangaroo? Probably not.

Look at the artworks in this lesson. What subjects do you see? What themes are suggested?

8

**Try This**

Create a self-portrait by drawing objects you carry around. Empty your school bag and pockets on the desk. Arrange the items you select in a composition that says something important about yourself. Remember: You are the subject of your work. Can you choose objects that suggest a theme?

**Computer Option**

Arrange objects from your school bag, knapsack, or pockets on a flatbed scanner. Scan them into an image-editing or paint program. Use the application's tools to add new elements that represent you. Move and alter all of the elements to create an effective composition.

**Teaching Through Inquiry**

**Aesthetics** Provide groups of students with a variety of postcard-size reproductions of artworks. Ask students to sort them by subject matter and then to list the categories (such as animals, people, and landforms). Have students **consider the themes**, or bigger ideas, expressed in the artworks and then group the artworks by themes (such as friendship, leisure time, and importance of work). Have each group select one artwork and make a generalization about the difference between its subject matter and its theme. Ask groups to present their findings.

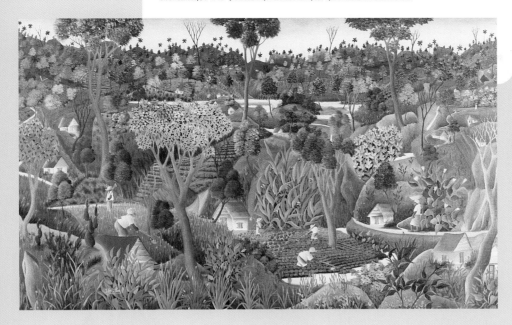

Fig. F1–13 Why might some people say that work is the theme of this painting? Why might others say that community is the theme? Joseph Jean-Gilles, *Haitian Landscape*, 1971. Oil on canvas, 30" x 48" (76 x 122 cm). Purchase Fund, 1974, Art Museum of the Americas.

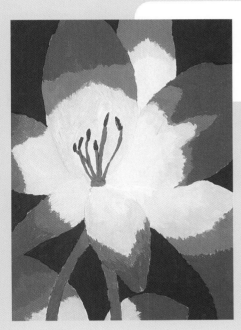

Fig. F1–14 Nature is a popular theme in art. Why might this artist want us to see a close-up view of nature? Tim Barwise, *Untitled*, 1999. Tempera paint, 24" x 18" (61 x 46 cm). Chocksett Middle School, Sterling, Massachusetts.

### Foundation Lesson 1.2

**Check Your Understanding**
1. What is the theme and subject of Fig. F1-7, *Barbeque* by Archibald Motley? How is this similar to Fig. F1-12, *Soap Box Racing* by William Johnson?
2. Identify a nonobjective artwork in another section of this book. Explain why it is nonobjective.

## Extend

- Choose some images in other chapters of this book, and have students state the subject and the theme of each artwork.
- After students have studied *Soap Box Racing*, encourage them to describe favorite activities that they do with friends. Have them create a drawing or painting of an active group of people.

## Assess

### Check Your Understanding: Answers

**1.** Motley's subject is a barbecue; Johnson's is a soap-box race. Both paintings show groups of people and share the theme of the enjoyment of leisure-time pursuits.

**2.** Students should select a work with no recognizable subject matter.

## Close

Discuss students' answers to Check Your Understanding. Display students' art so that their names are hidden. Have students use information from the drawing so as to describe the artist. Ask each artist if the students' descriptions match his or her intent.

The Hows and Whys of Art

9

## Using the Large Reproduction

Compare the subject and theme of this work with Fig. F1-12.

## Assessment Options

**Teacher** Have students demonstrate their understanding of the difference between subject and theme in artworks. Ask them to choose a subject—such as a skyscraper, a park bench, or water fountain—and then use that subject in three drawings, each with a different theme.

## Prepare

### Pacing

One or two 45-minute periods, depending on the scope of Try This

### Objectives

- Learn that art may be created in individual, cultural, or historical styles.
- Compare and contrast expressionism, realism, abstraction, and fantasy art styles.
- Create and describe an artwork in a chosen style.

### Vocabulary

**style** An artist's chosen means of expression through use of materials, design, work methods, and subject matter. In most cases, these choices show the unique qualities of an individual, culture, or time period.

## Teach

### Engage

Show students examples of dated clothing styles in old yearbooks, magazine advertisements, and social-studies books; and discuss how clothing styles change. Explain that art styles, like clothing styles, also change over time; and that, similar to how people express themselves by wearing distinctive clothing styles, artists express themselves by creating artworks in distinctive styles.

### National Standards Foundation 1.3

**1a** Select/analyze media, techniques, processes, reflect.

**6b** Describe ways other disciplines are interrelated to art.

# Styles of Art

A **style** is a similarity you can see in a group of artworks. The artworks might represent the style of one artist or an entire culture. Or they may reflect a style that was popular during a particular period in history.

You can recognize an artist's *individual* style in the way he or she uses art materials, such as paint or clay. An artist can adopt certain elements of design and expression that create a similar look in a group of his or her works. Sometimes an artist uses the same kind of subject matter again and again.

Artworks that reflect *cultural* and *historical* styles have features that come from a certain place or time. For example, Japanese painters often depict scenes from nature with simple brushstrokes. From an historical perspective, the columns used in ancient Greek architecture have characteristics that are immediately recognizable.

As explained in the following sections, there are also four *general* style categories that art experts use to describe artworks from very different times and cultures.

## Expressionism

In an expressionist artwork, the mood or feeling the artist evokes in the viewer is more important than creating an accurate picture of a subject. The artist might use unexpected colors, bold lines, and unusual shapes to create the image. Expressionist artists sometimes leave out important details or exaggerate them. When you look at an expressionist work of art, you get a definite feeling about its subject or theme.

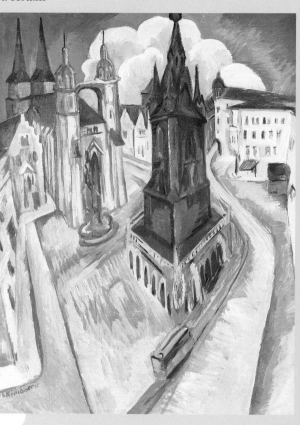

Fig. F1–15 How did the German Expressionist Ernst Ludwig Kirchner use diagonal shapes and lines to create a feeling of tension? Would the painting have the same feeling if his shapes were rounded and scattered throughout the canvas? Ernst Ludwig Kirchner, *The Red Tower in Halle*, 1915.
Oil on canvas, 47 1/4" x 35 5/8" (120 x 90.5 cm). Museum Folkwang Goethestr. 41, D-4300 Essen 1

## Teaching Options

### Resources

Teacher's Resource Binder
  Thoughts About Art: F1.3
  A Closer Look: F1.3
  Find Out More: F1.3
  Assessment Master: F1.3
Large Reproduction 4, 12
Slides 3, 6, 14

### Teaching Through Inquiry

**Aesthetics** Provide students with **Beliefs About Art** statements from the Teacher's Resource Binder. Ask students to consider how their ideas about their agreement or disagreement with these statements might have changed in the course of their art education. Encourage them to give examples of shifts in their beliefs about: (1) Art as imitation; (2) Art as expression; (3) Art as formal order; (4) Art as functional.

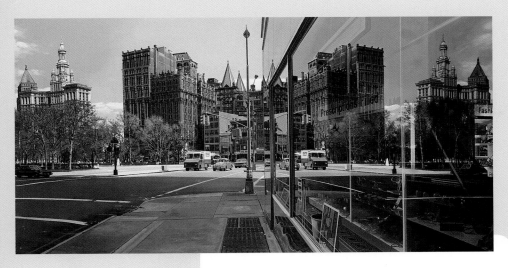

Fig. F1–16 Why might Richard Estes' artwork fall into a style dubbed Photo or Super Realism? How is his work different from a photograph? Richard Estes, *Prescriptions Filled* (Municipal Building), 1983.
Oil on canvas, 36" x 72" (91.4 x 182.9 cm). Private Collection, photo courtesy Allan Stone Gallery, NY. © Richard Estes / Licensed by VAGA, New York, NY/ Marlborough Gallery, NY.

## Using the Text

**Art Criticism** After students have read the first three paragraphs, refer them to *The Red Tower in Halle* (Fig. F1–15), and then *Prescriptions Filled* (Fig. F1–16). Explain that Kirchner and Estes developed their own distinctive styles, and that other works by these artists have similar themes, brushstrokes, and levels of realism.

Have students find in other parts of this chapter, examples of styles from non-Western cultures (such as the Colombian pendant [Fig. F1–2] and the Benin plaque [Fig. F1–9]).

## Using the Art

**Art Criticism** Challenge students to compare and contrast Figs. F1–15, F1–16, F1–18, and F1–19. **Ask:** What do they all have in common? Students should notice that the four pieces are two-dimensional cityscapes.

## Realism

Some artists want to show real life in fresh and memorable ways. They choose their subjects from everyday objects, people, places, and events. Then they choose details and colors that make the subjects look real.

Sometimes a particular mood is suggested in the artwork. Artists who work in this style often make ordinary things appear extraordinary. Some of their paintings and drawings look like photographs.

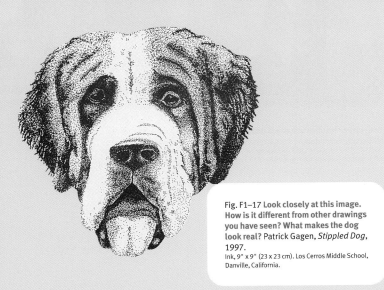

Fig. F1–17 Look closely at this image. How is it different from other drawings you have seen? What makes the dog look real? Patrick Gagen, *Stippled Dog*, 1997.
Ink, 9" x 9" (23 x 23 cm). Los Cerros Middle School, Danville, California.

The Hows and Whys of Art

11

### More About...

**Richard Estes** (b. 1936), fascinated by reflections, includes reflective surfaces of glass and metal in virtually all his urban scenes. Estes works directly from photographs and slides, and uses oil paints to depict visual reality as accurately as possible. Because of its strong adherence to the observable world, his style is often dubbed Super- or Photo-Realism.

### Using the Large Reproduction

4

Compare this artwork with Fig. F1–16 as an example of realism.

## Using the Text

**Art Criticism** After students have read about expressionism, realism, abstraction, and fantasy, have them explain how each image in this lesson fits the definition of its style. Challenge students to list Figs. F1–15, F1–16, F1–17, F1–18 in order, from least to most realistic.

## Using the Art

Discuss students' answers to the caption questions. **Ask:** In each image in this lesson, what do you think the artist was expressing about the city?

## Try This

Demonstrate writing two short sentences about an object in the room by placing each word on a separate card. Distribute ten to fifteen note cards per student. Have students write their sentences, one word per card.

Pass around a box, and have students place their cards in the box and then randomly choose five to eight cards before passing the box to the next student. While they arrange the words as a title for a drawing, tell them they will draw a picture to go with their title in an expressionist, realist, abstract, or fantasy style.

Distribute drawing media (pencils or markers) and 12" x 18" drawing paper. When they have completed their drawings, divide the class into groups according to students who worked in the same style. Each group can discuss how they used features of that art style.

## Critical Thinking

Have students work in small groups to find other images in each of the four style categories in this lesson. Ask students to identify the style of each image and then explain why the image represents that style. **Ask:** Which artworks fit in more than one style category? Allow groups to share their findings with the class.

## Abstraction

Artists who work in an abstract style arrange colors, lines, and shapes in fascinating ways. They find new ways to show common objects or ideas. Their artworks appeal to the mind and senses. For example, most people see and feel flowing curved lines as graceful. Jagged lines remind people of sharp objects or sudden, unexpected events, such as lightning. Nonobjective artworks usually fall into this style category.

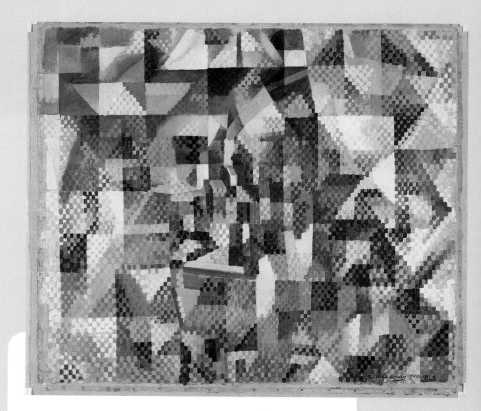

Fig. F1–18 **Can you see features of a city in this painting? How does it make you feel? Why?** Robert Delaunay, *Window on the City No. 3* (La Fenetre sur la ville no. 3), 1911–12. Oil on canvas, 44 3/4" x 51 1/2" (113.7 x 130.8 cm). Solomon R. Guggenheim Museum, New York. Photography by David Heald © The Solomon R. Guggenheim Foundation, New York.

## Teaching Options

### Teaching Through Inquiry

**Art History** Tell students that art historians use the **idea of style** to explain changes in art over time. **Ask:** What are the most obvious or important characteristics of this year's cars? How do these compare to characteristics of cars of ten, twenty, or fifty years ago? What do you think are some reasons that the style of cars has changed? Review the art styles introduced in this lesson. Ask students to identify the characteristics of one style and contrast them with the characteristics of another style. **Ask:** Why do styles of artworks change over time or among cultures?

### More About...

**Marc Chagall's** (1887–1985) childhood was steeped in Russian-Jewish folktales and religion. A deep sense of **fantasy** pervades his work, even after he moved to France and then the United States. Chagall filled his canvases with dreamlike images, fractured views, and objects with multiple perspectives.

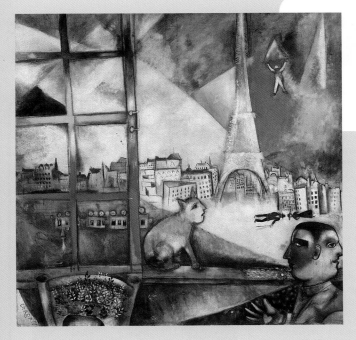

Fig. F1–19 What features of this scene look like they come from a dream? Marc Chagall, *Paris Through the Window*, 1913.
Oil on canvas, 53 1/2" x 55 3/4" (135.8 x 141.4 cm). Solomon R. Guggenheim Museum, New York, Gift, Solomon R. Guggenheim, 1937. Photograph by David Heald © The Solomon R. Guggenheim Foundation, New York (FN 37.438) © 2000 Artist Rights Society (ARS), New York / ADAGP, Paris.

## Fantasy

The images you see in fantasy art often look like they came from a dream. When fantasy artists put subjects and scenes together, they create images that appear unreal. While the subject might be familiar, the details in the artwork might not seem to make sense.

### Try This

Write two short sentences about something you see in the room. Place each word on a separate note card. Mix the cards up and then randomly pick five to eight cards. Place the words in any order to create a title for a drawing. Create the drawing, using one of the styles discussed in this lesson. When you are finished, gather together with the students who worked in the same style as you. As a group, discuss how you captured elements of that style in your drawings.

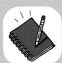

**Sketchbook Connection**
Find a simple object and create several sketches of it. Look at the object from different angles. Experiment with your drawing media and technique. Sketch the object alone or arranged with one or two other objects. When you are finished sketching, write about your experience. What did you learn about your individual style?

### Foundation Lesson 1.3

**Check Your Understanding**
1. Compare and contrast the styles, themes, and subjects of two of the artworks in this lesson.
2. From another section of this book select an example of each of these styles: expressionism, realism, abstraction, and fantasy. Explain why each is a good example of its style of art.

The Hows and Whys of Art

13

**Sketchbook Connection**
Suggest that students draw objects such as shoes, stuffed animals, dishes, or fruit. Encourage them to draw their object from the top, side, and bottom. Suggest that they try drawing it using different art styles and art media.

## Assess

**Check Your Understanding: Answers**
1. Look for a thorough description of two styles, themes, and subjects of the chosen images.
2. Look for appropriate selection of images and corresponding explanations of style.

## Close

Review expressionism, realism, abstraction, and fantasy art styles. Discuss students' answers to Check Your Understanding. Allow students to arrange a display of their artworks according to style.

### Using the Large Reproduction

Ask students where this work might fit in the four general style categories discussed in this chapter.

12

### Assessment Options

**Teacher** Have students group, by written list, each image in Foundation 1.1, 1.2, and 1.3, for a museum with four galleries: one for expressionist art, one for realistic art, one for abstract art, and one for fantasy art. Ask students to write an explanation of each style and why the artworks in each group are good examples.

## Daily Life

Explain to students that a class in art is designed to make them more aware of their visual environment and to help them develop an appreciation of the artistic expression of others and the aesthetic nature of everyday life. To discover students' levels of direct experience with art, ask them to identify museums they have visited, especially locally. Include art, history, and natural-history museums in the discussion.

## Social Studies

Direct students to look for artworks in their social-studies or history text, and ask them to give reasons for the works' inclusion. Remind students to consider ideas common to both art history and social studies. Ask students each to choose a history painting, from a non-art text, that they think is particularly appropriate. Have students research the work and then share their findings in a class discussion.

## Mathematics

Have students work in small groups, taking turns using a digital or instant camera, to participate in a mathematics scavenger hunt. Direct students to photograph both natural and human-made examples of geometric concepts. Display and discuss the resulting photographs after all the groups have "collected" their images. If possible, have students develop the project further, and post it on the school's Web site.

# Connect to...

## Careers

Who is most likely to influence your beliefs about and responses to art? For most students, that person is an elementary- or secondary-school **art teacher**. Teachers of art provide meaningful opportunities and experiences for students to respond to art creatively, think about art, interpret art, and take part in artistic expression. Along with a solid foundation in art criticism, aesthetics, and art history, art teachers must be familiar with a wide variety of forms of visual expression and have a working knowledge of a broad range of media. Art teachers select themes, subjects, styles, media, and techniques to help students explore many ways to communicate. Art teachers also plan, lead discussions, demonstrate, evaluate, and display the work of students while also remaining life-long learners in the visual arts. The program of study for an art teacher includes both education and art; most state colleges and universities offer an art-education degree through their education department.

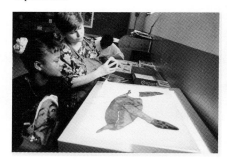

F1–20 Many art teachers are also practicing artists. Not only do they help you look at art and interpret what you see, they also help you create art that is meaningful to you.
Photo courtesy *SchoolArts*.

F1–21 Imagine walking past this sculpture. What might be your first impression? How could you learn more about why the artist created it for this site? What function does it serve? Louise Nelson, *Dawn Shadows*, 1983.
Painted steel, height: 30' (9.15 m). Madison Plaza Building, Chicago. ©2000 Estate of Louise Nevelson/Artists Rights Society (ARS), New York.

## Daily Life

Just as taking math is unlikely to make you a mathematician, there is no guarantee that taking art will turn you into an artist. But taking art classes can make you more aware of your visual environment and help you develop an appreciation of the artistic expression of others. If you approach the **study of art** with an open mind, the experience may heighten your perceptions and broaden your **personal concepts of art**. Think about the following questions as you begin your experiences in art, and return to them at the end of your course to see if your thoughts about art have changed: Is there a certain artist or artistic style you prefer? Does art play any part in your daily life? Do you ever visit museums on your own or with your family?

14

## Teaching Options

### Resources

Teacher's Resource Binder
Using the Web
Interview with an Artist
Teacher Letter

### Video Connection

Show the Davis art careers video to give students a real-life look at the career highlighted above.

## Other Subjects

### Mathematics

Can you think of any parallels between mathematics and art? **Mathematical concepts that connect to art** include measurement, symmetry, scale and proportion, congruent shapes and tessellations, and technical drawing. Geometry connects to art through two-dimensional shapes and three-dimensional forms, perspective, and geometric patterns. Look around you. What examples of these concepts can you identify?

### Social Studies

Have you noticed that your social-studies text is illustrated with artworks? How can works of art teach us about a culture? If we are to explore artworks fully, we must consider **ideas common to both art history and social studies**. Concepts of history, stories of people and places, cultural practices, traditions, and beliefs all contribute to an understanding of both social studies and art. Choose a work of art from your social-studies book. Do you think its choice for use in the book was appropriate?

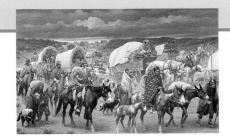

F1–22 This painting's subject is an historical event: the forced march of the Cherokee tribe from Georgia to Oklahoma in 1838. The route became known as the Trail of Tears. Why might it be important to include this work in a social-studies or history book? Robert Lindneux, *The Trail of Tears*, 1942.
Oil on canvas, 42" x 64" (106.6 x 162 cm). From the collection of the Woolaroc Museum, Bartlesville, Oklahoma.

### Language Arts

**Art and language arts share—or have parallel—concepts and terms.** How are theme, subject, style, composition, mood, sequence, balance, and unity similarly expressed in both subjects? What are the parallels between meaning and main idea? Artist and author? Portrait and biography? Drawing and writing? How can these ideas extend your thinking about art?

## Other Arts

### Music

If someone asks you to define *art*, you might have to stop and think. Are you able to give a definition after studying this chapter? Take music. We all know what music is…don't we?

Is your **definition of music** "sounds that I like"? Is there a difference between noise and music? Between speech and music?

Listen to a CD of environmental sounds, such as the ocean or bird songs. Is this music? If so, what makes it music? If not, what would it take to turn these sounds into music? What about whales' "songs"? These have been recorded and made into CDs. Are these sounds music? Is music something made only by people?

## Other Arts

Discuss whether sounds recorded from the environment—such as waves reaching a shoreline—are music. Then have students listen to "Midtown Higashi," the first track on the recording *East,* by Hiroshima. **Ask:** Is this music? Why or why not? What are the musicians trying to say by including these sounds?

Play John Lennon and Paul McCartney's "Revolution 9" from *The Beatles* (the so-called "White Album"). **Ask:** Is this considered music because it is on a Beatles album? Is it rock 'n' roll? What point do you think Lennon and McCartney were trying to make? Or *is* there a point?

**Internet Connection**
For more activities related to this chapter, go to the Davis website at **www.davis-art.com.**

The Hows and Whys of Art

15

## Talking About Student Art

When talking with students about their art, remind them to consider each artwork relative to other works. **Ask:** How is this artwork similar to or different from other works you have made, in terms of subject matter as well as media and techniques?

## Portfolio Tip

Help students understand the importance of reflecting on their own learning. Emphasize that their portfolio is a place to keep evidence of what they have learned, not simply a place for storing artworks.

## Sketchbook Tip

Remind students that a sketchbook is much like a journal—a place to record thoughts and ideas—and that a sketchbook filled with both images and text demonstrates, in many different ways, what they "think."

# Portfolio

"Our work of art was intended to be a dragon, but as we worked it seemed to transform right in front of our eyes into something that looked like a warrior."
**Frederick Ceratt and Jason Lewis**

F1–24 Frederick Ceratt and Jason Lewis, *Dark Knight*, 1999. Wood, tempera, 24" tall (61 cm). Jordan-Elbridge Middle School, Jordan, New York.

F1–23 Megan Verhelst, *Self-portrait*, 1999. Conté crayon, 14" x 20" (35.5 x 51 cm). Verona Area Middle School, Verona, Wisconsin.

"I enjoyed using the medium of colored pencil for this piece. You work with the colors much like you would in a painting. It helped me expand from using just ebony pencil, which I had been mainly using up to that point."
**Heather Waldeck**

**CD-ROM Connection**
To see more student art, check out the Community Connection Student Gallery.

F1–25 Heather Waldeck, *Invented Insect*, 1996. Colored pencil, 12" x 18" (30.5 x 46 cm). Verona Area Middle School, Verona, Wisconsin.

## Teaching Options

### Resources

Teacher's Resource Binder
  Chapter Review F1
  Portfolio Tips
  Write About Art
  Understanding Your Artistic Process
  Analyzing Your Studio Work

### CD-ROM Connection

For students' inspiration, for comparison, or for criticism exercises, use the additional student works related to studio activities in this chapter.

# Foundation 1 Review

**Recall**

Define expressionism and realism.

**Understand**

Explain the difference between subjects and themes.

**Apply**

Design a functional piece of clothing that also relates something about the culture from which your family originates (*see example below*). How can the piece's material, colors, purpose, and design reflect ideas about your heritage?

Page 4

**Analyze**

Classify the works on page 3 and pages 6–13 according to their function, as discussed in Foundation 1.1. Then compare and contrast selected examples within each group. What similarities and differences can you find among the items?

**Synthesize**

Find and read poetry that reflects something about the land or nature. Use the examples as the basis for your own artwork that reflects a landscape theme, with the specifics of the subject matter inspired by the poem itself.

**Evaluate**

Select the reproduction from this chapter that best illustrates expressionism, supporting your answers with what you see in the art itself.

**Keeping a Sketchbook**

Most artists fill many sketchbooks over the course of their careers. You can fill your own sketchbook pages with ideas for your artworks, notes about artworks you have seen, and pasted images from magazines and other sources. You can practice drawing and write your thoughts about art. When you fill the pages of one sketchbook, date it, and begin filling the pages of another!

**Keeping a Portfolio**

Many artists create portfolios to showcase their best works. Think of your portfolio as evidence of your learning in art. Provide evidence that you are learning to make art and that you are learning about the history and meaning of art. Keep your completed and dated artworks, essays, reports, and statements about art. On occasion, take a look at what you have placed in your portfolio and reflect on what you have accomplished.

**For Your Portfolio**

After completing each chapter of your book, insert a page into your portfolio, telling about what you have learned. Get into the habit of comparing your new artworks and ideas to those of the past.

The Hows and Whys of Art

**Community Involvement**

Keep a list of the names of local artists and craftspeople willing to share their expertise with your classes. Record their kind of art, materials and techniques, and subjects or themes.

**Family Involvement**

Let parents and other family members know that you are interested in learning about community resources having to do with art. Invite them to keep you informed of special exhibits; arts events; and reduced prices on art materials, books, and other teaching resources.

**Advocacy**

Make sure that the faculty and administrators in your school are aware of the themes and topics you will consider in your art program for the year. Invite them to visit the art classes to observe your students as they work.

# Foundation 1 Review Answers

**Recall**

Expressionism is the use, for instance, of unexpected colors, bold lines, and unusual shapes to create an image in which mood or feeling is more important than visual accuracy. Realism is the presentation of a recognizable subject from the observable world.

## Understand

The subject of an artwork is what the viewer sees. The theme is the broader topic or idea that the artist expresses through the subject.

## Apply

Look for a perceivable reflection of cultural identity.

## Analyze

Look for an understanding that artworks within the same classification also have differences. For example, artworks that have a practical function can vary in terms of cultural meaning, use of media, or personal expression.

## Synthesize

Students might examine haiku or poems by Robert Frost. Look for evidence that students relied on the poem's imagery to inspire their artistic expression.

## Evaluate

Look for an understanding of the evocative quality of expressionist art and students' use of visual evidence to back up their opinions.

## Reteach

Have students create, conduct, and tabulate a survey of fellow students, teachers, people in the neighborhood, and family members about a definition of art and the reasons that people create art. Have students read Foundation 1 again and then decide, as a class, what questions to ask. After students gather and tabulate their information, have them develop an illustrated poster.

# Foundation Organizer

| 9 weeks | 18 weeks | 36 weeks | | | |
|---|---|---|---|---|---|

## Foundation 2 Forms and Media
Foundation 2 Overview
page 18–19

### Foundation Focus
- Understand why artists choose to use two-dimensional or three-dimensional media.
- **2.1** Two-dimensional Artworks
- **2.2** Three-dimensional Artworks

### National Content Standards
1 Understand media, techniques, and processes.
2 Use knowledge of structures and functions.
3 Choose and evaluate subject matter, symbols, and ideas.

---

| 9 weeks | 18 weeks | 36 weeks |
|---|---|---|
| 2 | 1 | 1 |

**Foundation 2.1 Two-dimensional Artworks**
page 20
Pacing: One or two 45-minute periods

### Objectives
- Identify two- and three-dimensional art forms.
- Explain the difference between art forms and art media.

### National Standards
**1b** Use media/techniques/processes to communicate experiences, ideas.
**2b** Employ/analyze effectiveness of organizational structures.

---

**Try This Mixed-media**
page 22

- Create a two-dimensional artwork based on a three-dimensional piece.

**1b** Use media/techniques/processes to communicate experiences, ideas.

---

| 9 weeks | 18 weeks | 36 weeks |
|---|---|---|
| 2 | 1 | 1 |

**Foundation 2.2 Three-dimensional Artworks**
page 24
Pacing: One or two 45-minute periods

### Objectives
- Understand that three-dimensional art forms have height, width, and depth.
- Recognize that architecture, environmental design, sculpture, crafts, and industrial design are three-dimensional art forms.

### National Standards
**3a** Integrate visual, spatial, temporal concepts with content.

---

**Try This Drawing**
page 26

- Sketch imagined interior scenes.

**3a** Integrate visual, spatial, temporal concepts with content.

---

**Connect to...**
page 28

### Objectives
- Identify and understand ways other disciplines are connected to and informed by the visual arts.
- Understand a visual arts career and how it relates to chapter content.

### National Standards
6 Make connections between disciplines.

---

**Portfolio/Review**
page 30

### Objectives
- Learn to look at and comment respectfully on artworks by peers.
- Demonstrate understanding of chapter content.

### National Standards
5 Assess own and others' work.

## Featured Artists

Romare Bearden
Alexander Calder
Girolamo de Cremona
Sam Francis
David Hockney

Florence Lundborg
Richard Meier &
    Partners
Henry Moore
Diego Rivera

## Vocabulary

art form
art media
ceramics
fresco

montage
mobile
mosaic
relief sculpture

## Teaching Options

Teaching Through Inquiry
More About… Diego Rivera
Using the Large Reproduction
Using the Overhead

## Technology

CD-ROM Connection
    e-Gallery

## Resources

Teacher's Resource Binder
    A Closer Look: F2.1
    Find Out More F2.1
    Assessment Master:
        F2.1

Large Reproduction 8
Overhead Transparency 14
Slides 2, 3, 7, 8, 13, 16

---

Meeting Individual Needs
Teaching Through Inquiry
More About…Photography
Assessment Options

CD-ROM Connection
    Student Gallery
    Computer Option

Teacher's Resource Binder
    Thoughts About Art: F2.1

## Teaching Options

Teaching Through Inquiry
More About…Richard Meier
Using the Overhead

## Technology

CD-ROM Connection
    e-Gallery

## Resources

Teacher's Resource Binder
    A Closer Look: F2.2
    Find Out More F2.2
    Assessment Master:
        F2.2

Large Reproduction 5
Overhead Transparency 6
Slides 9, 10, 11, 15, 17, 18

---

Teaching Through Inquiry
More About…Mosaic
Using the Large Reproduction
Assessment Options

CD-ROM Connection
    Student Gallery
    Computer Option

Teacher's Resource Binder
    Thoughts About Art: F2.2

## Teaching Options

Museum Connection
Interdisciplinary Planning

## Technology

Internet Resources
Video Connection
CD-ROM Connection
    e-Gallery

## Resources

Teacher's Resource Binder
    Using the Web
    Interview with an Artist
    Teacher Letter

## Teaching Options

Advocacy
Family Involvement
Community Involvement

## Technology

CD-ROM Connection
    Student Gallery

## Resources

Teacher's Resource Binder
    Chapter Review F2
    Portfolio Tips
    Write About Art
    Understanding Your Artistic Process
    Analyzing Your Studio Work

FOUNDATION 2

# Forms and Media

## Chapter Overview

### Foundation 2

Depending on the function of their art and their message, artists use either two-dimensional or three-dimensional art forms. To select the most appropriate materials for their expression, artists know about and understand how to use a wide variety of media.

### Featured Artists

Romare Bearden
Alexander Calder
Girolamo de Cremona
Sam Francis
David Hockney
Florence Lundborg
Richard Meier
Henry Moore
Diego Rivera

### Chapter Focus

Art forms may be two-dimensional (with height and width) or three-dimensional (with height, width, and depth). Artists consciously choose to use either two-dimensional art media, such as paint, drawing materials, collage, printmaking, and photography; or three-dimensional media, such as architecture, sculpture, or crafts.

### Chapter Warm-up

Lead students in categorizing objects in the art room as two- or three-dimensional.

When you tell someone that you just created a painting or a sculpture, you are naming the art form you used to express yourself. **Art forms** can be two-dimensional, as in painting, drawing, printmaking, and collage. Or they can be three-dimensional, as in sculpture, architecture, and even furniture.

When artists plan a work of art, they decide which art form will best express their idea. Then they work in that art form. For example, an artist who wants to express an opinion about nature might create a painting or a drawing. An artist who wants to honor an important person might create a sculpture.

The differences you see between artworks of any one form are vast. This is because artists use a wide variety of materials, or **art media,** to create their artworks. For example, a painter might choose to use oil paints or watercolor. He or she might paint on paper, canvas, or even glass. Similarly, a sculptor might work with clay, stone, or any object that best expresses his or her idea. Imagine seeing a sculpture made from a beach umbrella or a car!

The lessons in this chapter explore art forms and the media most commonly used by artists.

### Focus

- What are the differences between two-dimensional art forms and three-dimensional art forms?
- What materials do artists use to create two-dimensional and three-dimensional artworks?

### What's Ahead

- **F2.1 Two-dimensional Artworks**
  Explore a variety of two-dimensional art forms and the media artists use to create them.
- **F2.2 Three-dimensional Artworks**
  Explore a variety of three-dimensional art forms and the media artists use to create them.

### Words to Know

| | |
|---|---|
| art form | mobile |
| art media | relief sculpture |
| fresco | ceramics |
| montage | mosaic |

## Teaching Options

### National Standards Foundation 2 Content Standards

1. Understand media, techniques, and processes.
2. Use knowledge of structures and functions.
3. Choose and evaluate subject matter, symbols, and ideas.

### Teaching Through Inquiry

**Art Criticism** Discuss the importance of describing the technical features of an artwork and explaining how the artwork is made. Share examples of original artworks made with different media (such as a watercolor, an oil painting, a collage, and so on). On the chalkboard, list some technical qualities, and have students choose from them to describe the materials and techniques in the artworks. Challenge students to compare and contrast the effects achieved with each medium (such as wet-on-wet brushwork, built-up paint, and torn or cut edges).

Fig. F2–1 What ideas are expressed in this computer-generated artwork? How might the work look different if it was created as a painting? Do you think it would have the same kind of feeling? Why or why not? Adam Hahn, *The Things I Thank*, 1999. Computer art, 6 ½" x 9" (16.5 x 23 cm). Plymouth Middle School, Plymouth, Minnesota.

Fig. F2–2 Artist Romare Bearden focused on daily and seasonal rituals, including family meals, planting, and listening to jazz or blues music. What ideas might he be expressing in this collage? Do you see any photographs that represent daily life? Romare Bearden, *Mysteries*, 1964. Collage, 11 ¼" x 14 ¼" (28.6 x 36.2 cm). Ellen Kelleran Gardner Fund. Courtesy Museum of Fine Arts, Boston. Reproduced with permission. ©1999 Museum of Fine Arts, Boston. All Rights Reserved. © Romare Bearden Foundation / Licensed by VAGA, New York, NY.

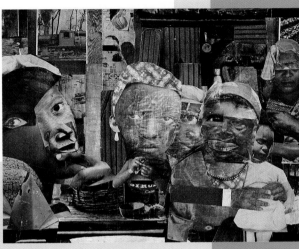

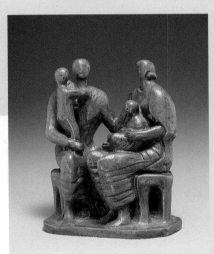

Fig. F2–3 British artist Henry Moore used bronze to create this sculpture of the family group. How has he simplified the features of each person in the sculpture? Henry Moore, *Family Group*, 1944. Bronze, 5 ⅞" x 5" x 2 ¾" (14.9 x 12.7 x 7 cm). The Metropolitan Museum of Art, Anonymous Gift, in honor of Alfred H. Barr, Jr., 1981 (1981.488.4) Photograph © 1997 The Metropolitan Museum of Art.

## Vocabulary

**art form** A category of art, either two-dimensional (painting, photography, collage, and the like) or three-dimensional (sculpture, architecture).

**art media** The materials used to create artworks.

## Using the Text

**Art Criticism** Have students read the text. **Ask:** Which art on these pages is two-dimensional? Three-dimensional? From what media was each artwork created?

## Using the Art

**Art Criticism** Discuss students' answers to the caption questions for Bearden's *Mysteries* and Moore's *Family Group*. **Ask:** How are these works alike? What do you think was each artist's message about family? How did each artist create a sense of depth in his art? Which piece has more details?

## Teaching Tip

Review important points about the careful use and maintenance of art materials and tools.

## Extend

Develop a class list of daily, weekly, and seasonal rituals in students' lives. Have students create photo collages of their family and community rituals, which might include eating breakfast, attending sports events, and participating in a neighborhood cleanup.

Forms and Media

19

## More About...

The word *collage* comes from the French *colle,* for "glue." Starting in the early 1900s, European artists would sometimes attach cut or torn pieces of wallpaper, newspaper clippings, and product labels to their canvases. Today, artists might include bits of existing art, fabric, corrugated cardboard, metallic paper, and anything else to add interest and perhaps another layer of meaning.

## Prepare

### Pacing

One or two 45-minute periods, depending on the scope of Try This

### Objectives

- Identify two- and three-dimensional art forms.
- Explain the difference between art forms and art media.
- Create a two-dimensional artwork based on a three-dimensional piece.

### Vocabulary

**fresco** Painting technique in which pigments are applied to a thin layer of wet plaster.

**montage** A special kind of collage, made from pieces of photographs or other pictures.

### Supplies for Engage

- several examples of two-dimensional artworks (such as your drawings, paintings, prints, collages, or photographs, or student works)

# Two-dimensional Artworks

Drawing, painting, and other two-dimensional (2-D) art forms have height and width but no depth. To create 2-D artworks, such as those you see in this lesson, artists work with different types of art media.

## Drawing and Painting

The most common media for drawing are pencil, pen and ink, crayon, charcoal, chalk, pastel, and computer software programs. Artists who draw choose from a wide range of papers on which to create their images.

Although many artists use drawing media to plan other artworks, drawings can also be finished works of art.

Oils, tempera, watercolor, and acrylics are common media used to create paintings. An artist might apply paint to a variety of surfaces, including paper, cardboard, wood, canvas, tile, and plaster. A **fresco**, for example, is a tempera painting created on a wet plaster surface.

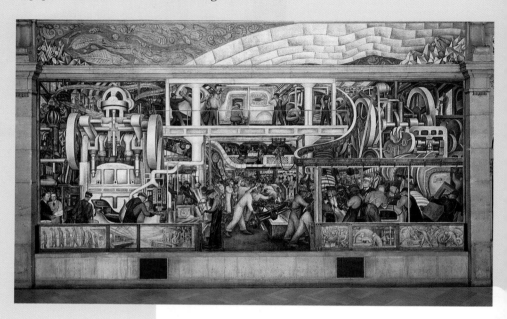

Fig. F2–4 Artist Diego Rivera was involved in the Mexican mural movement, which revived the art of fresco painting. What does this fresco tell you about the city of Detroit? Diego M. Rivera, *Mural: Detroit Industry*, South Wall (detail), 1932–33. Fresco. Gift of Edsel B. Ford, Photograph © The Detroit Institute of Arts.

### National Standards Foundation 2.1

**1b** Use media/techniques/processes to communicate experiences, ideas.

**2b** Employ/analyze effectiveness of organizational structures.

## Teaching Options

### Resources

Teacher's Resource Binder

  Thoughts About Art: F2.1

  A Closer Look: F2.1

  Find Out More: F2.1

  Assessment Master: F2.1

Large Reproduction 8

Overhead Transparency 14

Slides 2, 3, 7, 8, 13, 16

### More About...

In 1932, **Diego Rivera** (1886–1957) was commissioned to paint twenty-seven mural panels for the garden court of the Detroit Institute of Arts. As a young man, he learned the ancient **Italian fresco method** of painting on the extremely durable medium of damp lime plaster, in which the brushed-on pigments bind with the lime.

Fig. F2–5 **Notice the strong geometric elements in this print. How did artist Sam Francis keep this artwork from looking strictly geometric? What material did he use to create the work? How can you tell?** Sam Francis, *Untitled*, 1982.
Woodcut monotype, oil and dry pigment on paper, 43" x 78 1/2" (109.2 x 199.4 cm). Santa Barbara Museum of Art, Museum purchase, Vote for Art Fund. © 2000 Estate of Sam Francis / Artists Rights Society (ARS), New York.

## Collage

To create a collage, an artist pastes flat materials, such as pieces of fabric and paper, onto a background. Some artists combine collage with drawing and painting. Others use unexpected materials, such as cellophane, foil, or bread wrappers. Look back at Fig. F2–2, the collage created by Romare Bearden, on page 19. A collage made from photographs is called a **montage.** How does Bearden's montage compare with the montage in Fig. F2–7?

## Printmaking

This form of art can be broken down into several different kinds of processes. The main idea is the same for all: transferring an inked design from one surface to another. The design itself might be carved into wood or cut out of paper before it is inked. Then it is pressed by hand onto paper, fabric, or some other surface.

The most common printmaking processes are gadget, stencil, relief, and monoprint. Other more complex processes include lithography, etching, and silkscreen. An artist can print a single image many times using any printmaking process, except monoprinting; as the "mono" in its name suggests, an image can only be printed once.

Forms and Media

21

### Engage

Display the two-dimensional artworks. Explain that these are essentially flat, with only height and width.

### Using the Text

**Art Criticism** After students have read about the three art forms, ask them to find an example of each in other lessons in the book.

### Using the Art

**Art History** Ask students to describe the technique that Rivera used for the Detroit mural. *(tempera on damp plaster)* Explain that this technique was used in ancient Greece and Rome during the Renaissance and in the twentieth century by Rivera and other muralists.

### Teaching Tip

Remind students that experimenting with media and techniques is important for achieving the desired expression of ideas.

### Extend

Have students research the fresco technique. Students may work in pairs to create posters that illustrate the fresco technique. After the posters are completed, encourage a discussion exploring the challenges of using this painting technique.

## Teaching Through Inquiry

**Art Production** Explain that a **collage** is a way of creating new meaning by putting two or more things next to one another. An image of a cat, for instance, takes on different meaning if placed next to an image of a dog, a bird, or a house. Artists also explore the new meaning created by combining images and text. An image of a cat accompanied by the word "dog," for instance, has a different meaning than the image of a cat with the word "friend." You might introduce the term *juxtaposition* when referring to such combinations of images or words. Have students create a series of three collages in which they combine an image of something (an animal, person, or object) with other images or words to convey different meanings. Ask them to share their collages and discuss the different meanings conveyed by each combination.

## Using the Large Reproduction

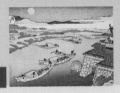

8

Use as an example of printmaking. Discuss technical aspects of the process.

## Using the Overhead

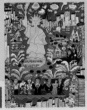

14

Use this work as an example of painting. Discuss technical aspects of the process.

## Using the Text

**Art Criticism** Have students read page 22, and then identify examples of graphic design. *(layout of this book, posters, signs, logos on their clothing)* After reading page 23, ask volunteers to describe their favorite computer art. Remind students that much of what they see on TV is created with computers.

## Using the Art

**Art Criticism** Discuss students' answers to the caption questions for Hockney's photomontage. **Ask:** How does Hockney's artwork compare with Bearden's (Fig. F2–2)? Which is more realistic? What did each artist express about his subject?

## Try This

Offer students a variety of two-dimensional media. Explain that they are to select a three-dimensional artwork from this book and create a similar two-dimensional piece. **Ask:** What shapes can be made from these forms? Which objects are farthest from the viewer? How can you create the illusion of depth in your art?

## Graphic Design

Graphic designers create original designs. Some of them print their designs by hand. They combine type and pictures to create posters, signs, corporate logos or symbols, advertisements, magazines, and books.

Most graphic designs are mass-produced on high-speed printing presses. Look around you. What examples of graphic design can you find in your classroom?

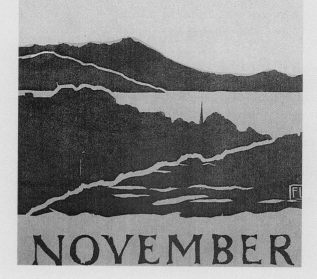

Fig. F2–6 Sometimes a graphic designer will hand-print a small edition and from one of those prints, a commercial printer will produce hundreds or thousands of copies using a high-speed press. What effect do you think such a process might bring to the finished, printed piece? How do you think a literary magazine such as *The Lark* might have benefitted from such an effect? Florence Lundborg, *Cover illustration for* The Lark, *November 1895.*
Woodcut, green and blue on Japanese paper, 16 3/8 x 9 7/8" (41.5 x 25.1 cm). Metropolitan Museum of Art, Gift of David Silve 1936. (36.23.14) Photograph by Bobby Hansson. Photograph © 1986 The Metropolitan Museum of Art.

22

## Teaching Options

### Meeting Individual Needs

**Multiple Intelligences/Spatial Ask:** Is Fig. F2–7 a two or three-dimensional work? Although it is flat (two-dimensional), how does Hockney create an illusion of space? Have students test whether he is successful by trying to set up the scene themselves, arranging people in the artroom according to their locations within the work.

### Teaching Through Inquiry

**Perception** Have students work in small groups to sort reproductions of two-dimensional artworks into categories of deep space, shallow space, and flat space. Have students then experiment with cut-paper shapes to create three distinct two-dimensional images—one with the deep space, one with shallow space, and one with flat space.

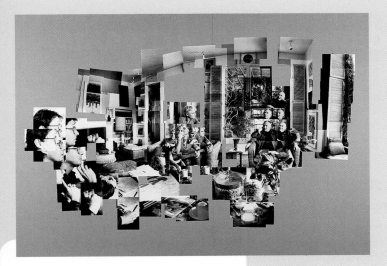

Fig. F2–7 Did David Hockney take only one photograph of each element in his composition? Why might he include multiple views of the same subject? How does this affect your sense of time and perception? David Hockney, *Christopher Isherwood Talking to Bob Holman, (Santa Monica, March 14, 1983) #3*, 1983. Photographic collage, 43 1/2" x 64 1/2" (110.5 x 163.8 cm). © David Hockney.

## Photography, Film, and Computer Art

These 2-D art forms are fairly new in the history of art. The camera was invented in the 1830s, followed by moving pictures about sixty years later. Since their invention, photography and film have become two of the most popular media. Today, video cameras and computers offer even more media for artists working in the film or TV industry. Although individuals may use a single camera or computer to create art, feature films and television shows are usually created by a team of artists.

### Try This

Artists face a certain set of challenges when creating work in two dimensions and different ones when working in three dimensions. Choose a three-dimensional artwork that is shown in this book. Recreate it as a two-dimensional artwork. When you are finished, ask yourself what surprised you most about the process. Compare your experience with classmates.

**Computer Option**
Choose an artwork that you have completed, and try to reproduce it on the computer. Compare the processes. How was one easier to create or change than the other?

---

**Foundation Lesson 2.1**

**Check Your Understanding**
1. Give an example of an art form. Then list the media that are often used in this art form.
2. Explain the difference between a fresco and an oil painting.

Forms and Media

23

---

**Computer Option**
Guide students to choose a painting or drawing, and then to use paint software to re-create not only the composition, but also the "look and feel" of its original medium. Dabbler, Painter, Deep Paint (plug-in for Photoshop), or Studio Artist are paint programs that optimize the paint and draw effects of traditional media. Other programs that students may use are AppleWorks (Claris) paint, Paintshop, and PC paint.

## Critical Thinking

**Art Criticism** Challenge students to compare the styles and themes of artworks in this lesson. Tell them to pretend that they are museum curators arranging an exhibit, and they must display together two of these works with similar themes or styles. Have students explain the reasons for their choice.

## Teaching Tip

Provide each student with an artwork or reproduction. Ask students to role-play the part of the artist and describe the process he or she used to make the work.

## Assess

**Check Your Understanding: Answers**

**1.** Answers may vary. Possible answers: art forms—sculpture, drawing, weaving; media—clay, pencils, reeds, respectively

**2.** A montage is a collage made with photographs or other pictures.

## Close

Display students' artworks with reproductions of the art that they changed. **Ask:** What challenges did you have in making these designs two-dimensional? Discuss students' answers to Check Your Understanding.

---

### More About...

Modern **photography** has its roots in the sixteenth-century **camera obscura**, a small box with an opening on one side, through which an image was transferred in reverse onto the opposite wall of the box. Artists could draw or trace the projected scene. At the time, no one had yet invented light-sensitive paper to capture the image photographically.

### Assessment Options

**Peer** List the following on the chalkboard, or use an overhead:
*Shelf 1: cameras, film; Shelf 2: pencils, charcoal, chalk; Shelf 3: watercolors, oils, acrylics; Shelf 4: rulers, markers, letter guides; Shelf 5: carving tools, wood, ink, press; Shelf 6: glue, scissors, assorted materials.*

Ask students to imagine that they work in an art store. They organize art materials on shelves and label each shelf with the appropriate art form, such as drawing, painting, collage, printmaking, graphic design, and photography. **Ask:** What label would you use for each shelf? Have students meet with a peer to review and discuss their responses.

## Prepare

### Pacing

One or two 45-minute periods, depending on the scope of Try This

### Objectives

• Understand that three-dimensional art forms have height, width, and depth.

• Recognize that architecture, environmental design, sculpture, crafts, and industrial design are three-dimensional art forms.

• Sketch imagined interior scenes.

### Vocabulary

**mobile** A hanging sculpture with movable parts.

**relief sculpture** A three-dimensional artwork that includes a raised surface that projects from a background.

**ceramics** Artworks made from clay, fired at high temperatures in a kiln.

**mosaic** Artwork made by fitting together tiny pieces of colored glass, tiles, stones, paper, or other materials, all known as tesserae.

## Teach

### Engage

Discuss examples of local architecture that are new or have been recently renovated. Explain that the architects and designers of these projects create three-dimensional works.

# Three-dimensional Artworks

Architecture, sculpture, and other three-dimensional (3-D) art forms have height, width, and depth. To create 3-D artworks, such as those you see in this lesson, artists work with different types of art media.

## Architecture and Environmental Design

Architects design the buildings in which we live, work, and play. They think about what a building will be used for, how it will look, and the way it will relate to its surroundings.

Architects combine materials such as wood, steel, stone, glass, brick, and concrete to create the buildings they design. Then interior designers plan how spaces inside the buildings will look. They choose paint colors or wallpaper, carpeting, and upholstery fabrics. They also suggest how the furniture should be arranged.

Environmental and landscape designers plan parks, landscape streets, and design other outdoor spaces. They use trees, shrubs, flowers, grasses, lighting fixtures, and benches. They also use materials such as stone, brick, and concrete to create paths, sidewalks, and patios.

Fig. F2–8 Whereas painters might use sketches, architects use models to work out their plans. How does Richard Meier make use of a mountain in his 110-acre building complex? Richard Meier & Partners, model of *The Getty Center*, 1991.
© J. Paul Getty Trust and Richard Meier & Partners. Photo by Tom Bonner.

24

### National Standards Foundation 2.2

**3a** Integrate visual, spatial, temporal concepts with content.

## Teaching Options

### Resources

Teacher's Resource Binder
  Thoughts About Art: F2.2
  A Closer Look: F2.2
  Find Out More: F2.2
  Assessment Master: F2.2
Large Reproduction 5
Overhead Transparency 6
Slides 9, 10, 11, 15, 17, 18

### Teaching Through Inquiry

**Aesthetics** Choose two different art forms (such as architecture and sculpture), and engage students in a discussion in which they consider the similarities and differences between the two forms. Encourage students to categorize the differences: by the way they are made, what is represented, and what we expect. Throughout the year, return to the issues raised in the discussion.

Fig. F2–9 Alexander Calder specialized in making sculptures that move. Why might you react differently to a sculpture that moves than you would to one that doesn't move? Alexander Sterling Calder, *Tricolor on Pyramid*, 1965. Painted sheet metal and steel wire, 48" x 78" (121.9 x 198 cm). North Carolina Museum of Art, Raleigh, Purchased with funds from the National Endowment for the Arts and the North Carolina Art Society (Robert F. Phifer Bequest) © 2000 Estate of Alexander Calder / Artists Rights Society (ARS), New York.

## Sculpture

Sculptures come in many forms. Most are designed to be viewed from all sides. You are probably most familiar with statues. A statue is a sculpture that stands alone, sometimes on a base. It can be life-size, as are the monuments you see in some parks. Or it can be small enough to place on a table or mantelpiece. A **mobile** is a hanging sculpture that has moving parts. The design on a **relief sculpture** is raised from a background surface and is intended to be viewed from only one side.

In addition to having many forms of sculpture to choose from, a sculptor can select from a great variety of media. Traditional materials include wood, clay, various metals, and stone such as marble. Sculptors also work with glass, plastic, wire, and even found objects.

Forms and Media

25

## Using the Text

**Art Criticism** After students have read page 24, have them answer the caption question. Explain that the Getty Center sits on a hill overlooking Los Angeles. If students are familiar with this area, have them describe the climate, plants, and lack of water. Explain that the L.A. climate is dry, making water a precious commodity, and that water is channeled through a series of fountains down the hill.

Have students read page 25, study Calder's sculpture, and answer the caption question. **Ask:** What type of sculpture is this? *(mobile)* With what media did Calder make this sculpture? *(metal and wire)* How does the height of the actual sculpture compare to your height?

## Using the Art

**Perception Ask:** What geometric shapes do you see in Fig. F2–8? Which shapes were repeated? How does the form of the complex echo the landscape?

**Art Criticism** What shapes and colors did Calder use in his sculpture? How did he arrange the shapes? *(in a progression)*

## Extend

Encourage students to select a theme of interest and create their own mobile from cardboard shapes, coat hangers, wire, photographs, found objects, and/or clay shapes.

### More About...

Architect **Richard Meier** (b. 1934) designed the **Getty Center**, located in the Santa Monica hills outside Los Angeles. The center consists of six separate buildings, one of which is the J. Paul Getty Museum. The buildings were designed to take advantage of the surrounding views of the city, the mountains, and the Pacific Ocean. The center is made from a kind of stone called travertine, brought from a quarry in Italy. The same stone was used in buildings such as the Colosseum and St. Peter's Basilica in Rome. When Meier's team found that many of the travertine pieces revealed fossils of leaves, feathers, fish, and shells, they decided to place these in locations where visitors could readily see them. Meier placed the Getty Center on two hilltop ridges. Visitors take a five-minute tram ride to make the 3/4-mile trip from the bottom of the hill to the top.

### Using the Overhead

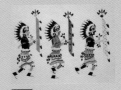

6

Compare this work with Fig. F2–9 and discuss static and mobile qualities of sculptural forms.

## Using the Text

**Aesthetics** Have students read pages 26 and 27. Ask: How are the objects that industrial designers create different from those that crafts-people make? *(industrial designs: usually mass-produced; crafts: usually created individually, by hand)* Is the Roman mosaic two- or three-dimensional? *(two-dimensional; but because the tiles are not exactly flat, a shallow three-dimensional depth is created)*

## Using the Art

**Art Criticism** Have students study the Roman mosaic and discuss answers to the caption questions. Explain that the tesserae (tiles) were created by craftspeople for others to place into patterns. Note the background pattern, and discuss mosaics and tile work familiar to students.

**Perception** Ask: How did the industrial designers of the bullet train make it look different from more common trains? How might this design influence the traveling experience?

**Sketchbook Tip**
Remind students that sketchbook exercises are like practice sessions—they generate ideas and develop an artist's work habits. They are not assignments to be graded, nor are they usually expected to result in finished projects.

## Try This

Discuss how a walk through the Getty Center (Fig. F2–8) might feel, with the walls of glass and views down the hill. Remind students that the building complex is sleek and modern on the outside, and that it is probably so on the inside as well. Distribute drawing paper (9" x 12"), pencils, and erasers. Have students select a building, imagine walking through it, and then sketch what they "see." Remind students to consider the needs of the people who use the structure and the specific uses or functions of the structure.

26

## Crafts

The term *crafts* applies to artworks made by hand that are both practical and beautiful. Among the many crafts are ceramics, fiber arts, mosaics, and jewelry making. **Ceramics** are objects that have been made from clay and then fired in a kiln. Fiber arts include objects that have been woven, stitched, or knotted from materials such as wool, silk, cotton, and nylon. A **mosaic** is a design made of tiny pieces of colored glass, stone, or other materials. Artists who make crafts such as jewelry and other personal adornments might use gold, silver, wood, fabric, leather, and beads. Look at the clothing and jewelry your classmates are wearing. What materials are they made of?

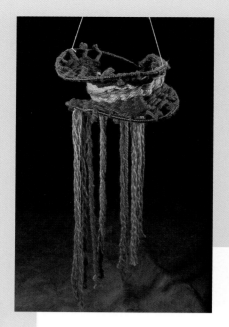

Fig. F2–10 This example of fiber art is intended to hang from a hook. Why might the artist have named this *The Hat?* Danielle McConaghy, *The Hat*, 1999. Wire, yarn, 10" x 10" x 22" (25.5 x 25.5 x 56 cm). Penn View Christian School, Souderton, Pennsylvania.

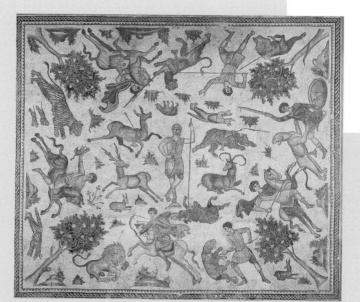

Fig. F2–11 This mosaic shows the hunting of dangerous animals. Why might artists choose to create a mosaic instead of a painting? Would you? Why or why not? Roman, Antioch, *Hunting Scene*, 6th century AD. Mosaic, 96 1/2" x 110 2/3" (245.5 x 281 cm). Worcester Art Museum, Worcester, Massachusetts, Museum Purchase.

26

### Teaching Through Inquiry

**Aesthetics** Ask students to consider visual, aesthetic, and practical features of both handmade and machine-made objects. Discuss advantages and disadvantages of handmade vs. machine-made, or mass-produced, objects.

### More About...

The floor **mosaic** from a villa in ancient Antioch (an area of present-day southwestern Turkey) illustrates the influence of Greco-Roman and eastern Persian cultures that flowed through the city. The dress of the figures is that of Hellenistic Greece, while the stiffness of their bodies and the use of nature and animals to fill voids comes from ancient Parthia (now northern Iran). The overall flat, two-dimensional decorative quality stems from Antioch.

## Industrial Design

Artists who design three-dimensional products for mass production are called industrial or product designers. They design everything from spoons and chairs to bicycles and cruise ships. Industrial designers pay great attention to a product's function and appearance. They use materials such as metal, plastic, rubber, fabric, glass, wood, and ceramics. The next time you're in a grocery or department store, note the many examples of industrial design all around you.

### Try This

Although we often study architecture from the outside, real people live and work inside these structures. Find an image in this book of a building façade (exterior) you like. Imagine walking through the building itself. What do you think its light, space, colors, and so forth are like? Make sketches of what you think the building's interior looks like.

**Computer Option**
Create an electronic representation of a three-dimensional space. Place a figure in the space, and imagine what the figure would "see." Draw the scene from the perspective of the figure.

**Sketchbook Connection**
Sketch a design for a ceramic object, fiber work, or piece of jewelry. Then write a brief paragraph about how your creation would look as a finished work of art. What materials would you use to create the piece? What function would your piece serve? How would you make it beautiful?

### Foundation Lesson 2.2

**Check Your Understanding**
1. Why is a "bullet" train featured in an art book?
2. What two types of artwork form Calder's *Tricolor on Pyramid*, Fig. F2-9?

Fig. F2–12 Can you tell why this locomotive is called a "bullet" train? If you had to design a moving vehicle, how would you convey a sense of speed? *Bullet Train Between Paris and Lyon.*
© Chuck O'Rear, Courtesy Woodfin Camp.

Forms and Media

27

**Computer Option**
Poser (MetaCreations) allows for figures to be posed and animated. AliasSketch, Exteme 3D, Infini-D, Pixel Putty Solo, Ray Dream Studio, Sculpt 3D, Vision 3D can do modeling, rendering, and animation. These programs are expensive, so check for school discounts or scaled-down/demo product versions.

### Extend

Use photographs in car advertisements to discuss how designers have created various car styles. **Ask:** How was the form of each vehicle influenced by its function? Challenge students to design a vehicle that suits their needs.

### Close

Ask students to name several three-dimensional art forms. **Ask:** Which three-dimensional forms in the text were you surprised to consider as art? Discuss students' answers to Check Your Understanding. Have students explain their architecture sketches to one another.

### Assess

**Check Your Understanding: Answers**
1. The train is an example of an industrial design.
2. a mobile, or kinetic sculpture

### Using the Large Reproduction

Use this shirt as an example of crafts.

**5**

### Assessment Options

**Peer** On the chalkboard, list the following:
*Courses: sculpture, environmental design, industrial design, architecture, crafts*
*Careers: carpenter, hair stylist, horticulturist, automobile body-shop owner, cabinetmaker*

Ask students to pretend that they are art-career advisors helping students select an art course to help prepare them for their chosen career. Have "advisors" choose one art course for each career and explain why that area of study would benefit the student. Have students meet in groups of three to discuss their responses.

**Peer** Ask students to write at least five ways that three-dimensional art forms serve a practical function in their home, school, or community. Have students meet in groups of three to review their responses, then share their conclusions with the class.

## Careers

Collect newspaper and magazine articles about the intentional damage of artworks in a museum or on public display. Discuss with students why, in recent times, artworks have been deliberately damaged. Point out that museums are faced with a difficult choice when such an incident occurs: should they restore the work with the help of a conservator, or should they leave the damage unrepaired? Distribute the collected articles to small groups of students, and ask them to discuss and take a position for or against restoration in their group's case. After the small-group discussions, ask groups to share their reflections with the rest of the class. A resource for discussions of such cases is *Puzzles About Art: An Aesthetics Casebook,* by Margaret Battin (St. Martin's Press, 1990).

## Daily Life

On the board, list the kinds of things that students collect. Have students sort the list and then compare and contrast the similarities and differences among the categories. Ask students to share their reasons for collecting particular items and their criteria for selecting them. Direct students to write an explanatory statement that could accompany a museum display of their collection.

# Connect to...

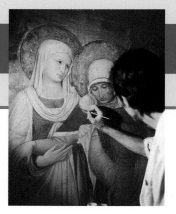

## Careers

What news stories can you recall about the deliberate damage of an artwork? In recent times, a few artworks in museums have been splattered with paint, struck with hammers, or scratched or torn. After an incident like any of these, museums rely on conservators to repair the damage. Though such an effort draws the attention of the press, most restoration work by conservators goes on quietly behind the scenes. Every major museum employs or works with a conservator who is responsible for the protection, authentication, cleaning, restoration, and repair of the museum's artworks on a regular basis. As a result of study and training in art history and in specialized areas, such as painting, conservators fully understand art forms and media, techniques, and styles. Only a few universities offer pro-

F2–13 Conservators carefully repair damage caused by weather, vandalism, or the effects of time. How could an understanding of the orginal artist's style and techniques help the conservator pictured here do a good job? Conservator working on Fra Angelico's San Marco fresco, ca. 1974.
Photo © David Lees/CORBIS.

grams in conservation, but extensive training is a prerequisite for success in this demanding career.

## Other Arts

### Music

Some people feel that all music may be classified as either song or dance. Do you agree? Your opinion probably depends on your definition of song and dance. Some people refer to any music they hear as a "song," but, technically, a song is music performed by the voice. The main feature of a song is its melody or tune. We listen to the words to understand what the song is about. A dance is music performed by instruments. The main feature is the rhythm, the way the music moves in time. We don't think about words; we may just want to get up and move!

Music, like art, is created in many forms. Each type of music is related to a purpose: to tell a story, for religious ceremonies, for public events, for entertainment. The media of music are instruments and voices. The specific instruments and types of voices fulfill the purpose of the music, and also provide important clues about its cultural background.

**Internet Connection**
For more activities related to this chapter, go to the Davis website at **www.davis-art.com**.

## Teaching Options

### Resources

Teacher's Resource Binder
Using the Web
Interview with an Artist
Teacher Letter

### Video Connection

Show the Davis art careers video to give students a real-life look at the career highlighted above.

## Daily Life

Do you collect something? Baseball or other trading cards? Stuffed toys? CDs? What are some other collectibles? Although adults are more likely than you to collect artworks, stamps, coins, or antiques, the desire to acquire objects seems to appeal to people of all ages. Why, do you think, do people have a desire to collect and display things? What does a collection tell us about the collector's life?

F2–14 How are personal collections different from collections found in museums? How are they similar?
Photo courtesy H. Ronan.

## Other Subjects

### Language Arts

Do you prefer a certain type or form of art? Just as art has various forms, so does litera-ture. The literary form, or genre, called narra-tive is sometimes accompanied by illustrations. Do you think literary and art forms are more

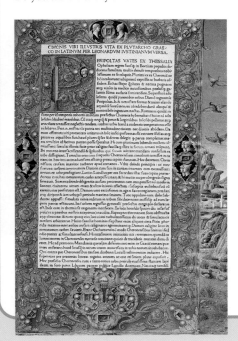

meaningful alone, or together? How else could a literary genre be improved by visual art?

### Social Studies

Have you ever constructed and used a time line in your social-studies class? In your art class? A time line is a graphic form for studying dates and events in chronological sequence. It might span centuries, or just a few years. You can use textbooks and other reference materials to identify and order events and then place them on a time line. How does the time line on page 76 help you to understand art in early North America?

### Science

Are you familiar with the chemical elements? Use a table of the elements as a guide to names of colors, by determining what elements are associated with a color. Why would this infor-mation be of interest to artists today? Why might such knowledge have been of interest to artists of the past?

F2–15 This book was printed in Italy in 1478. Could this page be considered an early example of graphic design? Why or why not? Girolamo da Cremona, frontispiece for the *Vitae illustrium virorum* (Lives) by Plutarch.
Text printed in Venice by Nicolas Jenson, 2 January 1478. (Vol. II, fron-tispiece. PML 77565) The Pierpont Morgan Library/Art Resource, NY.

## Social Studies

The addition of historical artworks, maps, and drawings to time lines of-ten makes them more meaningful and visually interesting. Help stu-dents create blank time lines at the beginning of the course, and instruct them to add to it throughout the year. Encourage students to design visu-ally creative time lines—ones that are interdisciplinary and multicul-tural—that include parallel strands for language arts, mathematics, his-tory, and science; and different cul-tures or continents. As an alternative to a handmade time line, set up, on classroom computers, a technology-based template in a graphics or word-processing document. For ei-ther kind of time line, have students use their textbooks and other refer-ence materials to place artworks, people, and events on the time line.

## Other Arts

Lead a discussion about the pur-poses of kinds of music. Ask stu-dents what they think of when they use the word "dance." Then have students compare two performances of the rock 'n' roll song "Purple Haze"—the Jimi Hendrix original version, performed on electric guitar; and the Kronos Quartet version, per-formed by a string quartet. **Ask:** How does the use of different instruments change the effect of the music? Which piece of music would you pre-fer to dance to?

Forms and Media

29

## Internet Resources

### Art Learner Guides

http://schools.brunnet.net/crsp/general/art/
Developed for secondary students, these extensive PDF files cover a wide variety of media and techniques.

### Art>online: Printmaking Techniques

http://www.nwu.edu/museum/artonline/resources/prints.html
This site offers an explanation of printmaking processes.

### Hints and Tips from Grumbacher

http://www.sanfordcorp.com/grumbacher/hints_and_tips_from_grumbacher.htm
This site gives advice on using watercolor, oil, and acrylic paints.

## Museum Connection

Before a field trip to a local museum, ask the education staff to help you identify artworks in the forms discussed in this chapter, and to plan activities during the visit that can reinforce stu-dents' understanding of the various forms.

## Interdisciplinary Planning

Work with the science teacher to plan for stu-dents to investigate the characteristics and origins of some of the natural and synthetic materials used in making art.

## Talking About Student Art

When talking with students about their artworks, have them use the Expressive Word Cards from the Teacher's Resource Binder so as to encourage them to focus on the expressive content. Some students are self-conscious about their skills and technique, but when they hear others refer to their work as "proud," "intense," "delicate," or "bold," for example, they understand that, even with what they consider flaws, their artworks have meaning.

## Portfolio Tip

If you plan to have students keep portfolios, be clear about your purposes, and share these with students and their family. Knowing the purposes helps students determine the portfolio contents. Possible purposes are: monitoring student progress; communicating to family about student learning; evaluating the intended outcome of the teaching; providing information to the next teacher; exhibiting accomplishments; assigning a grade for the course.

## Sketchbook Tip

To encourage students to use their sketchbooks to generate ideas, guide them to use brainstorming—avoiding internal monitoring—to get ideas out for later consideration. Help students practice brainstorming with "silly" sketchbook assignments, such as "Write fifty ways for a chicken to cross the road" or "List eighty ingredients for a stew of leftovers."

# Portfolio

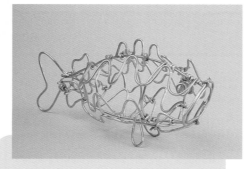
"For eighth grade art class we were required to create a wire sculpture of an animal. I really like fishing, so I chose my favorite fish, the large-mouth bass. I drew several sketches that showed how the bass would be constructed. I used my sketches to recreate the fish using wire."
**William C. Tate**

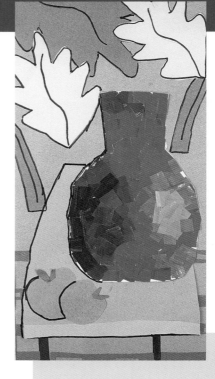

F2–17 William C. Tate, *Large-mouth Bass*, 1998.
Aluminum wire, 8 1/4" x 3 1/4" x 3 1/4" (21 x 8 x 8 cm). Daniel Boone Area Middle School, Birdsboro, Pennsylvania.

F2–16 Alicia A. Bartholemew, *Still Life with Mosaic Vase*, 1999.
Construction paper, painted paper, marker, 18" x 10" (46 x 25.5 cm). Roosevelt School, Worcester, Massachusetts.

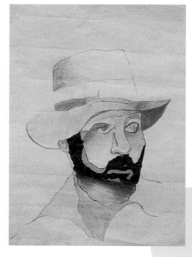

**CD-ROM Connection**
To see more student art, check out the Community Connection Student Gallery.

F2–18 Emma Berkey, *William H. Johnson*, 1999.
Colored pencil, 11" x 8 1/2" (28 x 21.5 cm). Asheville Middle School, Asheville, North Carolina.

30

## Teaching Options

### Resources

Teacher's Resource Binder
  Chapter Review F2
  Portfolio Tips
  Write About Art
  Understanding Your Artistic Process
  Analyzing Your Studio Work

### CD-ROM Connection

For students' inspiration, for comparison, or for criticism exercises, use the additional student works related to studio activities in this chapter.

# Foundation 2 Review

### Recall

Define two-dimensional and three-dimensional artworks.

### Understand

Explain why architecture is a three-dimensional art form whereas a photograph of a building is not.

### Apply

Search through magazines for what you think is a successful advertisement for sneakers. Describe what makes the advertisement appealing. How did the graphic designer catch your attention and get you to want the product? How could you alter the advertisement to make it even better?

### Analyze

Write a label as a curator of an exhibition of three-dimensional artwork that explains why the bullet train (Fig. F2–12) is an example of industrial design while the mosaic and fiber artworks (Figs. F2–10 and F2–11) are examples of craft.

### Synthesize

Transform either Fig. F2–4 or Fig. F2–5 into a three-dimensional artwork. What materials will you use to translate the flat image to one with actual depth?

### Evaluate

Describe the problem with identifying the ancient Roman mosaic (Fig. F2–11, below) as a two-dimensional rather than a three-dimensional artwork.

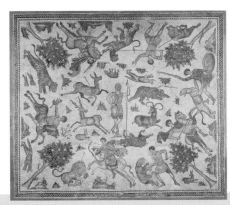

Page 26

### For Your Sketchbook

Review the art forms you have studied in this chapter. Write a statement about each art form in your sketchbook, using this form: "If I could make a _____ (sculpture, painting, etc.), I would make it out of _____ (wood, watercolor, etc.) and it would be about _____ (animals, people, swimming, etc.)." For each statement, make a quick sketch of how the artwork might look. This will help you think of ideas for future artworks.

### For Your Portfolio

Whenever you add an artwork to your portfolio, make sure to sign and date it. Attach a page to the artwork, explaining the assignment, what you learned, and why you have selected this artwork for your portfolio. This information will be useful when you return to consider how you have developed as an artist.

## Foundation 2 Review Answers

### Recall

Two-dimensional artworks have height and width but not depth. Three-dimensional artworks have height, width, and depth.

### Understand

Architecture has real depth. A photograph, even of a three-dimensional object, is flat.

### Apply

Look for careful description and explanation of the graphic artist's specific use of design to create a successful advertisement.

### Analyze

Look for an understanding of each art form and an explanation of why the works are good examples. The designer of the train carefully considered the locomotive's function and appearance, and used industrial materials. The mosaic and fabric artists crafted their works to be both practical and beautiful.

### Synthesize

Look for inventive use of materials in a fully three-dimensional form.

### Evaluate

The mosaic, although flat, is constructed of tiny bits of three-dimensional ceramic tiles, thus creating a work that has a bumpy surface and shallow depth.

### Reteach

For a classroom exhibition, have students curate a small collection of two- and three-dimensional artistic objects from the art room. Guide a group of students to write a label for each work, in which they describe what makes the work two- or three-dimensional. Have another group install the show. Encourage a third group to write press releases for the exhibition.

### Family Involvement

Inform family members that your class is learning about different art forms, and provide them with a list of two- or three-dimensional artworks that they might have in their home (such as hand-woven baskets, drawings, prints, wooden toys, paintings, wood carvings, ceramic bowls or statues, and hand-crafted jewelry). Encourage students' family members to bring these works to share with students.

### Community Involvement

Post a map of the community on a bulletin board. As students learn of special local buildings, parks, plazas, and public sculptures, ask them to use a pushpin to identify each location, write a descriptive label, and tie a lightweight string from the pushpin to the label.

### Advocacy

As students become more familiar with the many art forms they encounter every day, have them create a large display with the theme "Art Is All Around Us." Locate the display in a place within the school where many people will see it.

# Foundation Organizer

| 9 weeks | 18 weeks | 36 weeks | | | |
|---------|----------|----------|---|---|---|

## Foundation Focus

## National Content Standards

**Foundation 3
Elements and
Principles**
Foundation 3 Overview
page 32–33

- Understand that artists choose and manipulate the elements and principles to best express their ideas.
- **3.1** Elements of Design
- **3.2** Principles of Design

**2** Use knowledge of structures and functions.

---

| 2 | 2 | 2 | | | |
|---|---|---|---|---|---|

### Objectives

### National Standards

**Foundation 3.1
Elements of Design**
page 34
Pacing: Two or more
45-minute periods

- Perceive and identify the art elements line, shape, form, color, value, space, and texture in artworks.

**2a** Generalize about structures, functions.
**2b** Employ/analyze effectiveness of organizational structures.

---

**Try This
Drawing**
page 40

- Create two drawings of the same subject, each drawing with emphasis on a different pair of art elements.

**2c** Select, use structures, functions.

---

| 2 | 2 | 2 | | | |
|---|---|---|---|---|---|

### Objectives

### National Standards

**Foundation 3.2
Principles of Design**
page 42
Pacing: Two or more 45-minute periods

- Recognize and identify the principles of design in artworks.

**2a** Generalize about structures, functions.
**2c** Select, use structures, functions.

---

**Try This
Painting or Drawing**
page 42

- Create a series of artworks incorporating both unity and variety.

**2b** Employ/analyze effectiveness of organizational structures.

---

### Objectives

### National Standards

**Connect to...**
page 48

- Identify and understand ways other disciplines are connected to and informed by the visual arts.
- Understand a visual arts career and how it relates to chapter content.

**6** Make connections between disciplines.

---

### Objectives

### National Standards

**Portfolio/Review**
page 50

- Learn to look at and comment respectfully on artworks by peers.
- Demonstrate understanding of chapter content.

**5** Assess own and others' work.

---

## Featured Artists

Isabel Bishop
John Brack
Roy de Maistre
Alberto Giacometti
Ann Hanson
Duane Hanson
Prudence Heward
Franz Kline

Amanda Lehman
Oscar Martinez
Nelson Rosenberg
Heather Skowood
Niles Spencer
Paolo Uccello
Grant Wood
Alfredo Zalce

## Vocabulary

| Elements of Design | Principles of Design |
| --- | --- |
| line | balance |
| shape | unity |
| form | variety |
| color | emphasis |
| value | proportion |
| space | pattern |
| texture | movement and rhythm |

## Teaching Options

Teaching Through Inquiry
More About…Isabel Bishop
More About…Regionalism
Meeting Individual Needs
Using the Large Reproduction
More About…Landscape painting
Using the Overhead

## Technology

CD-ROM Connection
e-Gallery

## Resources

Teacher's Resource Binder
  A Closer Look: F3.1
  Find Out More F3.1
  Assessment Master:
    F3.1

Large Reproduction 13, 14
Overhead Transparency 4, 11
Slides 2, 3, 9, 11, 12

---

Meeting Individual Needs
Teaching Through Inquiry
Using the Overhead
Using the Large Reproduction
Assessment Options

CD-ROM Connection
Student Gallery

Teacher's Resource Binder
  Thoughts About Art: F3.1

## Teaching Options

Teaching Through Inquiry
More About…Franz Kline
More About…Planned patterns
Using the Large Reproduction

## Technology

Computer Option
CD-ROM Connection
e-Gallery

## Resources

Teacher's Resource Binder
  A Closer Look: F3.2
  Find Out More F3.2
  Assessment Master:
    F3.2

Large Reproduction 6
Overhead Transparency 8
Slides 1, 4, 5, 13, 14, 15, 17

---

Teaching Through Inquiry
More About… Alberto Giacometti
Using the Overhead
Assessment Options

CD-ROM Connection
Student Gallery

Teacher's Resource Binder
  Thoughts About Art: F3.2

## Teaching Options

Museum Connection
Interdisciplinary Planning
Curriculum Connection

## Technology

Video Connection
Internet Resources
CD-ROM Connection
e-Gallery

## Resources

Teacher's Resource Binder
  Using the Web
  Interview with an Artist
  Teacher Letter

## Teaching Options

Advocacy
Community Involvement
Family Involvement

## Technology

CD-ROM Connection
Student Gallery

## Resources

Teacher's Resource Binder
  Chapter Review F3
  Portfolio Tips
  Write About Art
  Understanding Your Artistic Process
  Analyzing Your Studio Work

## Chapter Overview

### Foundation 3

Artists use the elements and principles of design to create their art. To communicate effectively through art, artists must understand these characteristics and how they work together.

### Featured Artists

Isabel Bishop
John Brack
Roy de Maistre
Alberto Giacometti
Ann Hanson
Duane Hanson
Prudence Heward
Franz Kline
Amanda Lehman
Oscar Martinez
Nelson Rosenberg
Heather Skowood
Niles Spencer
Paolo Uccello
Grant Wood
Alfredo Zalce

### Chapter Focus

The elements of design are line, shape, form, color, value, space, and texture. The principles of design are balance, unity, variety, emphasis, proportion, pattern, and movement and rhythm.

By understanding the characteristics of the design elements and how they work together as design principles, artists can choose and manipulate the elements and principles to best express their ideas.

### National Standards Foundation 3 Content Standards

**2.** Use knowledge of structures and functions.

**FOUNDATION 3**

# Elements and Principles of Design

### Focus

- What are the elements and principles of design?
- How do artists use the elements and principles of design in their artworks?

**Artists use their imagination when they work. They experiment with ideas and art media, and invent new ways to create artworks.** But before they actually get down to making a work of art, they must have a plan, or design, in mind.

In art, the process of design is similar to putting a puzzle together. The basic pieces or components that an artist has to choose from are called the *elements of design*. Line, shape, form, color, value, space, and texture are the elements of design. The different ways that an artist can arrange the pieces to express his or her idea are called the *principles of design*. Balance, unity, variety, movement and rhythm, proportion, emphasis, and pattern are the principles of design. When an artist is happy with the arrangement, the design is complete.

As you learn about the elements and principles of design, think about how they can help you plan and create your own art. Soon you will see that they can also help you understand and appreciate the artworks of others.

### What's Ahead

- **F3.1 Elements of Design**
  Learn how artists can use the elements of design to create certain effects in their artworks.
- **F3.2 Principles of Design**
  Learn ways that the principles of design can make an artwork exciting to look at.

### Words to Know

| Elements of Design | | Principles of Design | |
|---|---|---|---|
| line | value | balance | pattern |
| shape | space | unity | proportion |
| form | texture | variety | movement |
| color | | emphasis | rhythm |

32

## Teaching Options

### Teaching Through Inquiry

**Art Criticism** Distribute one set of Descriptive Word Cards or Expressive Word Cards among students. Have them identify artworks in this lesson that have lines, shapes, and/or colors that correspond to the words on the cards. Ask students to state their responses in complete sentences and then to extend the description with more adjectives.

Fig. F3–1 Duane Hanson's sculptures look so real that at exhibitions viewers sometimes nearly bump into them, mistaking the figures for actual people. What elements and principles of design do you think add to the realistic look of this sculpture? Duane Hanson, *Tourists*, 1990. Bondo and mixed-media, life-size. Courtesy Mrs. Duane Hanson.

Fig. F3–2 How does this mural, painted in 1974 by Latino artist Oscar Martinez, compare to the fresco that Diego Rivera painted in 1933 (Fig. F2–4)? Consider both the style and subject matter. Chicago Mural Group, *Latino and Asian-American History*, 1974, Left: *Hispanic Immigration* by Oscar Martinez. (912 West Sheridan, Chicago) Courtesy the Chicago Public Art Group.

Fig. F3–3 What elements and principles of design do you think you see in this artwork? Write down your answers. When you are finished with this chapter, see if you want to change your list. Kelly Bass, *Exploration of Art Elements*, 1999. Pencil, colored pencil, computer art, markers, 18" x 25" (46 x 63.5 cm). Verona Area Middle School, Verona, Wisconsin.

## Chapter Warm-up

Have students look at a designed item in the room, such as a student's jacket, a flag, or the cover of this textbook. Ask students to describe the item's lines, shapes, forms, colors, textures, emphasis, and patterns. Tell students that these are some of the art elements and principles that they will study in this chapter. **Ask:** How did the artist's choices affect how you feel about this item?

## Using the Text

**Art Criticism** Have students read pages 32 and 33. **Ask:** How are the principles related to the elements? *(The principles of design have to do with the different ways that an artist arranges the elements.)*

## Using the Art

**Perception** Have students study Hanson's *Tourists*. **Ask:** What in this composition probably was most important to the artist? *(the figures)* How do colors, patterns, and forms add to the message?

## Critical Thinking

Challenge students to compare Martinez's and Hanson's attitude towards their subject. **Ask:** How did Hanson poke fun at his figures? How did Martinez honor his?

## Teaching Tip

As students discuss artworks, guide them to elaborate and expand on the words they use to describe line, shape, and color.

**More About...**

**Duane Hanson** (b. 1926) meticulously captures the seemingly ordinary. He uses Fiberglas™, vinyl, hair, and clothes to re-create his real-life models. Hanson's exacting realism relies on the mundane, everyday world for inspiration, suggesting that anything is a worthy art subject.

## Prepare

### Pacing
Two or more 45-minute periods: one to discuss the art elements; one or more for Try This

### Objectives
- Perceive and identify the art elements—line, shape, form, color, value, space, and texture—in artworks.
- Create two drawings of the same subject, each drawing to emphasize a different pair of art elements.

### Vocabulary
**elements of design** The ingredients that artists use to create an artwork (line, shape, form, color, value, space, texture). For individual defini-

## Teach

### Engage
Show students an artwork or reproduction, and lead them in describing its line, shape, form, color, value, space, and texture. Explain that these are the elements of design that artists use to create art.

# The Elements of Design

### Line

Many people think of a **line** as the shortest distance between two points. To artists, a line is a mark that has length and direction. Lines can have many different qualities that help artists express their ideas. They can be thick or thin, wavy, straight, curly, or jagged. Artists use lines to outline shapes and forms or to suggest different kinds of movement. Sometimes artists use *implied* line. An implied line is not actually drawn, but is suggested by parts of an image or sculpture, such as a row of trees or a path of footprints.

If you look closely, you can find examples of line in every work of art you see. Notice how they affect the mood of an artwork. For example, how might a drawing with thick, zigzag lines be different from one with light, curved lines?

Fig. F3–4 Isabel Bishop's varied lines create a sense of solid three-dimensional form. How did she also use line to suggest motion? Isabel Bishop (1902–88), *Waiting*, 1935.
Ink on paper, 7 ½" x 6" (18 x 15 cm). © 1997: Whitney Museum of American Art, New York. Purchase.

Fig. F3–5 Notice how this student has used lines to create this portrait. How many different line qualities do you see? Do any suggest movement? Therese Ruhde, *Face with Line Patterns*, 1999.
Marker on brown paper, 14" x 20" (35.5 x 51 cm). Verona Area Middle School, Verona, Wisconsin.

34

**Teaching Options**

### Teaching Through Inquiry

**Art Production** Provide scissors and an assortment of colored papers, and have students work individually or in small groups to experiment with arrangements of cut-paper shapes. Ask students to complete a series of small works to show how changes in value, shape, color, and line can create different visual effects. Discuss how these different effects could be used for expressing specific ideas.

Fig. F3–6 Think about the sound of a clock ticking. Why might this artist's use of shape make you think of a ticking clock? Niles Spencer, *The Watch Factory*, 1950. Oil on canvas, 28" x 42" (71.1 x 106.7 cm). Courtesy The Butler Institute of American Art, Youngstown, Ohio.

## Shape and Form

A line that surrounds a space or color creates a **shape.** Shapes are flat, or two-dimensional. A circle and a square are both shapes. A **form** is three-dimensional: It has height, width, and depth. A sphere and a cube are examples of forms.

Shapes and forms may be organic or geometric. *Organic* shapes and forms—such as leaves, clouds, people, ponds, and other natural objects—are often curved or irregular. *Geometric* shapes and forms—such as circles, spheres, triangles, pyramids, and cylinders—are usually precise and regular.

Most two-dimensional and three-dimensional designs are made up of both *positive* shapes and *negative* shapes. The figure in a painted portrait is the painting's positive shape. The pieces of fruit in a still-life drawing are the positive shapes in the drawing. The background or areas surrounding these objects are the negative shapes. The dark, solid shape of a statue is a positive shape. The area around and inside the forms of the statue make the negative shapes. Artists often plan their work so that the viewer's eyes move back and forth between positive and negative shapes.

Elements and Principles of Design

35

## Supplies for Using the Text

- red, yellow, and blue paint, brush, water, and paper
- pencils and scrap paper for students

## Using the Text

**Art Production** After students have read pages 36 and 37, have a volunteer mix the primaries to create the secondary colors. Guide him or her in mixing adjacent primary and secondary colors to create tertiary, or intermediate, colors.

**Art Production** Have students make a value chart by drawing, in pencil, a row of three postage-stamp-size squares. Instruct students to leave the first square white; make the third square very dark; and make the center square an in-between value. Have students compare their values to those in the value scale.

## Color and Value

Without light, you cannot experience the wonderful world of **color.** The wavelengths of light that we can see are called the color spectrum. This spectrum occurs when white light, such as sunlight, shines through a prism and is split into bands of colors. These colors are red, orange, yellow, green, blue, and violet.

In art, the colors of the spectrum are re-created as dyes and paints. The three *primary hues* are red, yellow, and blue. *Primary* means "first" or "basic." *Hue* is another word for "color." You cannot create primary colors by mixing other colors. But you can use primary colors, along with black and white, to mix almost every other color imaginable.

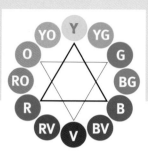

Fig. F3–7 Locate the primary and secondary colors on the color wheel. Why do you think the intermediate colors are also called tertiary colors? (See also page 308.)

**Key to the Color Wheel**

Y=yellow     V=violet
G=green     R=red
B=blue     O=orange

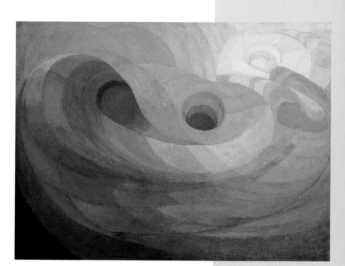

Fig. F3–8 Australian artist Roy de Maistre was fascinated by the way music could suggest different colors. What type of music is suggested by the colors and shapes in this painting? Roy de Maistre, *Rhythmic Composition in Yellow Green Minor,* 1919. Oil on paperboard, 33 ⅝" x 45 ⅜" (85.3 x 115.3 cm). Purchased 1960, The Art Gallery of New South Wales (photo: Jenni Carter for AGNSW).

36

## Teaching Options

### Meeting Individual Needs

**English as a Second Language** Ask students to use a dictionary, that translates their native language into English, to identify the names of the colors on the color wheel. Next have them describe in English the main colors in Fig. F3–8. Tell students to create their own landscape with just a few colors from the color wheel, and write its title in English.

### Teaching Through Inquiry

**Perception** Have students work in small groups. Provide each group with an assortment of art reproductions, and ask students to sort the images into categories of mostly dark values with little contrast; mostly dark values with high contrast; mostly light values with little contrast; and mostly light values with high contrast. Discuss the different moods and feelings created in the artworks by the use of the various **value categories**.

Fig. F3–9 This value scale shows a range of grays between white and black. Hues can also be arranged by their value.

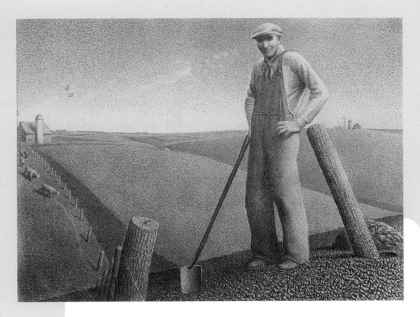

Fig. F3–10 How does American artist Grant Wood use value to suggest the forms of a midwestern landscape? Notice the smooth transition between the light and dark areas of this drawing. Grant Wood, *In the Spring*, 1939.
Pencil on paper, 18" x 24" (45.7 x 61.0 cm). Courtesy of The Butler Institute of American Art, Youngstown, Ohio.
© Estate of Grant Wood / Licensed by VAGA, New York, NY.

## Using the Art

**Art Criticism** Focus students' attention on de Maistre's *Rhythmic Composition* (Fig. F3–8). Discuss their answers to the caption questions. **Ask:** What do you think was de Maistre's message?

**Art Criticism** Ask students to study the value range in Wood's *In the Spring* (Fig. F3–10). **Ask:** Where is the light source? Which side of the figure and objects are darkest? How many different values can you identify? Where are the lightest and darkest values? *(dark in the foreground and light in the background)* How do the values help create a sense of depth?

## Extend

Have students create a design with colors arranged as in the spectrum. They may mix red, blue, and yellow watercolors or tempera to create secondary and intermediate colors.

---

The *secondary* hues are orange, green, and violet. You can create these by mixing two primary colors: red and yellow make orange; yellow and blue make green; red and blue make violet.

To create *intermediate* hues, you mix a primary color with a secondary color that is next to it on the color wheel. For example, mixing yellow and orange creates the intermediate color of yellow-orange.

**Value** refers to how light or dark a color is. A light value of a color is called a *tint*. A tint is made by adding white to a color. Pink, for example, is a tint made by adding white to red. Artworks made mostly with tints are usually seen as cheerful, bright, and sunny.

A dark value of a color is called a *shade*. A shade is made by adding black to a color. For example, navy blue is a shade made by adding black to blue. Artworks made mostly with dark values are usually thought of as mysterious or gloomy.

Elements and Principles of Design

37

---

## Using the Overhead

**4**

Compare light, value, contrast, and color in this work with Fig. F3–10.

## Using the Text

**Perception** After students have read the text, have them identify the complement of each primary color. **Ask:** What color scheme are the school colors? Help students analyze the color schemes of the clothes they are wearing.

## Using the Art

**Art Criticism** Have students identify the color schemes in the artworks on page 39. **Ask:** How do colors set the mood in each work? Call attention to the repetition of colors and shapes. Discuss students' answers to the caption questions.

## Teaching Tip

Remind students that changes in value affect the appearance and expressive features of an artwork.

The intensity of a color refers to how bright or dull it is. Bright colors are similar to those in the spectrum. You can create dull colors by mixing complementary colors. *Complementary* colors are colors that are opposite each other on the color wheel. Blue and orange are complementary colors. If you mix a small amount of blue with orange, the orange looks duller. Many grays, browns, and other muted colors can be mixed from complementary colors.

When artists plan an artwork, they often choose a *color scheme*—a specific group of colors—to work with. An artist might use a primary, secondary, intermediate, or complementary color scheme. Or the artist might choose any of the color schemes illustrated in the chart below.

### Common Color Schemes

**warm:** colors, such as red, orange, and yellow, that remind people of warm places, things, and feelings.

**cool:** colors, such as violet, blue, and green, that remind people of cool places, things, and feelings.

**neutral:** colors, such as black, white, gray, or brown, that are not associated with the spectrum.

**monochromatic:** the range of values of one color (monochrome means "one color").

**analogous:** colors that are next to each other on the color wheel; the colors have a common hue, such as red, red-orange, and orange.

**split complement:** a color and the two colors on each side of its complement, such as yellow with red-violet and blue-violet.

**triad:** any three colors spaced at an equal distance on the color wheel, such as the primary colors (red, yellow, blue) or the secondary colors (orange, green, violet).

38

## Teaching Options

### Teaching Through Inquiry

**Art Production** Provide students with 9" x 12" manila paper, pencils, rulers, tempera (black, white, and one color of their choice), brushes, water, and palettes. Instruct them to use a ruler to draw a pencil grid of approximately 1½" squares on their paper. After they have painted several of the squares white, they should mix a few drops of a color into white on their palettes and paint several more sections with this tint. Have them continue adding color, gradually making darker tints, and painting grid squares with the new tints. Encourage them to experiment further by starting with a color and adding small amounts of black to fill in other squares. They might try painting their grids to suggest gradual value changes from one section to another.

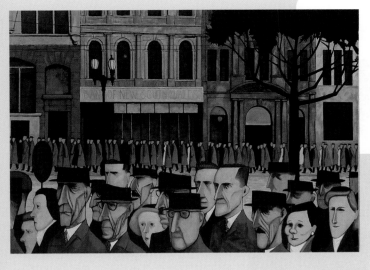

Fig. F3–11 Australian artist John Brack mixed different amounts of yellow, brown, and black to create a monochromatic color scheme. What qualities of a neutral color scheme does this painting have? John Brack, *Collins Street, 5 PM,* 1955. Oil on canvas, 45 ¼" x 64 ⅛" (114.8 x 162.8 cm). Purchased, 1956. National Gallery of Victoria, Melbourne, Australia.

## Extend

- Encourage students to experiment with color schemes. Have students use colored paper, pastels, or paints to create two similar designs—one with complementary colors and one with analogous colors. Discuss how each color scheme creates a different mood.

- Challenge students to paint a value scale of tints and shades of a color.

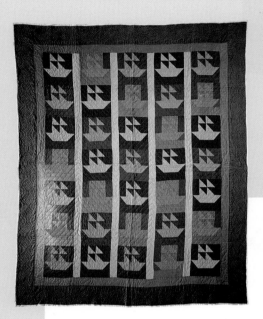

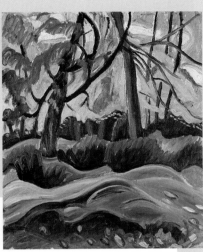

Fig. F3–13 Prudence Heward uses mainly primary and secondary colors to suggest the time of year in her landscape. How would the painting be different if she had used blues, grays, and whites? Prudence Heward, *Autumn Landscape,* c. 1932–46. Oil on plywood, 14 ¼" x 12" (36.2 x 30.5 cm). National Gallery of Canada, Ottawa. Gift of the Heward family, Montreal, 1948.

Fig. F3–12 What cool colors do you see in this quilt? Would you consider this an example of an analogous color scheme? Why or why not? Amanda Lehman, *Sailboats Quilt,* 1955–65. Cotton, 86 ¼" x 72" (219.1 x 182.9 cm) framed. Collection of the Museum of American Folk Art, New York. Gift of David Pottinger. (1980.37.26)

Elements and Principles of Design

39

## More About...

Before the seventeenth century, **landscape painting** in Western art generally included figures: elements of the land usually served as background for scenes. In Asia, however, Chinese, Japanese, and Korean artists painted images just of the land for centuries before doing so became fashionable in the West. Since the fourth century, landscape painting has dominated Chinese art. Dutch seventeenth-century artists were the first European painters to produce the genre for its own sake.

## Using the Overhead

**11**

Compare use of color with Figs. F3–11 and F3–13.

## Using the Text

**Art Criticism** After students have read page 40, discuss the illusion of space in Alfredo Zalce's *Lumber* (Fig. F3–15). Ask: How does the size of the nearest part of the logs compare to the distant ends? What other means did Zalce use to indicate distance? *(overlapping; size of figures; distant objects are higher on the page, have less detail)*

After students have read page 41, discuss their answers to the caption question for the eagle (Fig. F3–16). **Ask:** Which pieces of art on these two pages have implied textures? Which have actual texture? *(sculptures: actual texture; painting: implied)*

## Using the Art

**Art Criticism** Have students identify the positive and negative space in the statue of Shiva. Encourage them to try drawing just the shapes between the figure and the circle. Explain that this is one way to draw negative shapes in complicated subjects.

## Try This

Supply students with paper and pencils or markers, and discuss possible subjects for their drawings. For example, students might draw their pet. In one sketch, they could emphasize the texture and color of the pet; in the other, shapes and lines.

## Teaching Tip

Inform students that imagining stepping into a painting and thinking about how far you could walk before bumping into something—or how long it would take to walk to the farthest thing you see—is one way to understand how the artist has created an illusion of space. Students may wish to try this with Fig. F3–15 or other reproductions of paintings.

## Space

Sculptors and architects work with actual **space.** Their designs occupy three dimensions: height, width, and depth. *Positive* space is filled by the sculpture or building itself. *Negative* space is the space that surrounds the sculpture or building.

In two-dimensional (2-D) art forms, artists can only show an illusion of depth. They have simple ways of creating this illusion. For example, in a drawing of three similar houses along a street, the one closest to the viewer appears larger than the middle one. The house farthest away appears smaller than the middle one. Artists can also create the illusion of depth by overlapping objects or placing distant objects higher in the picture.

Artists working in two dimensions also use linear perspective, a special technique in which lines meet at a specific point in the picture, and thus create the illusion of depth.

Fig. F3–14 The figure of the Hindu god, Shiva, and the circle of fire that surrounds him fill the positive space of this figure. Where do you see negative space? India, Tanjore district, Chola-Dynasty (846–1173 AD), *Shira Nataraja*, 11–12th century.
Bronze, height: 32 1/4" (81.9 cm). Museum Rietberg Zurich, Eduard von der Heydt collection.

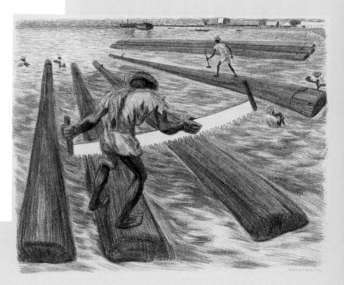

Fig. F3–15 In this picture, the artist has used linear perspective to create the illusion of space. If you were to extend the outlines of the lumber, they would meet in the upper left corner area. In what other ways has the artist created the illusion of space? Alfredo Zalce, *Lumber*, 1946.
Color lithograph, 11" x 14" (28 x 36 cm). Metropolitan Museum of Art, The Elisha Whittelsey Collection, The Elisha Whittelsey Fund, 1950.

## Teaching Options

### Meeting Individual Needs

**Multiple Intelligences/Bodily-Kinesthetic** Ask students to take the pose of Shiva in F3–14 (choosing two of the arm positions). **Ask:** As the artist, how would you bring a sense of unity to this composition in which limbs are sticking out in all different directions? Have students look at the circle in the sculpture, which encases the figure's dynamic movement. How might a square, triangle, or diamond shape create a different sense of unity?

### Teaching Through Inquiry

**Art Production** Display artworks depicting cityscapes, community scenes, and/or crowds of people; and discuss ways that **deep space** is represented. Have each student select one of the images and use simple cut-paper shapes to analyze how the artist used placement of large and small shapes, overlapping, and dark and light to create an illusion of space.

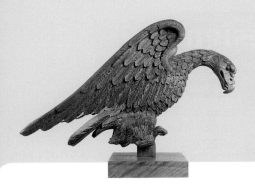

Fig. F3–16 Notice how carefully this artist carved the details and textures of an eagle. If you could run your hands over this bird, what would it feel like? American, *Eagle* (architectural ornament), ca. 1810.
Pine with gilt and gesso, 37" x 26 1/2" x 60" (94 x 152.5 x 67.3 cm). Smith College Museum of Art, Northampton, Massachusetts. Gift of Dorothy C. Miller, class of 1925 (Mrs. Holger Cahill), 1969.

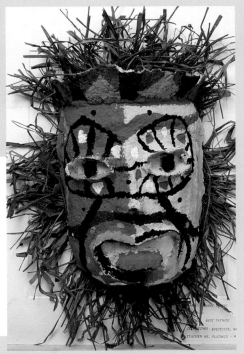

Fig. F3–17 Where do you see real and implied textures in this mask? How did this student use art materials to create texture? Charde Powers, *Mask*, 1997.
Mixed media, paper. West Tatnuck School, Worcester, Massachusetts.

## Texture

**Texture** is the way a surface feels or looks, such as rough, sticky, or prickly. *Real* textures are those you actually feel when you touch things. Sculptors, architects, and craftspeople use a variety of materials to produce textures in their designs. These textures can range from the gritty feel of sand to the smooth feel of satin.

Artists who work in the two-dimensional art forms can create *implied* textures, or the illusion of texture. For example, when an artist paints a picture of a cat, he or she can create the look of soft fur by painting hundreds of tiny fine lines. What kinds of implied texture have you created in paintings or drawings of your own?

### Try This

Create a quick sketch focusing on two elements of art described in this lesson. Next, choose two other elements of art. Use the new elements to redo the same composition. How do your two drawings compare? Which works better and why?

### Foundation Lesson 3.1

#### Check Your Understanding
1. How do artists use the elements and principles of design?
2. Select a piece of art in this book that has a monochromatic color scheme. Are its colors warm or cool? Describe the mood of this piece in one or two words.
3. Describe implied textures in a piece of art in this lesson.
4. What is the difference between positive and negative space?

Elements and Principles of Design

41

## Using the Large Reproduction

13

Compare real and implied texture in this work with Fig. F3–16.

## Assessment Options

**Peer** Ask each student to select from this chapter any two artworks that seem very different from each other. Have students describe each work to a peer group, without naming the work they are describing. Instruct students that their description should be one-sentence clues about line, shape, form, color, value, space, and texture. Have peers try to name the works being described and then give feedback on the accuracy and clarity of the description.

## Extend

Challenge students to draw negative space around human figures. Have volunteers pose with their hands on their hips or feet spread wide. Demonstrate how to locate negative space by viewing the body through a viewfinder (an empty slide frame, or poster board with a small cutout). Guide students in drawing the negative shapes formed between the body and an inside edge of the viewfinder, and the interior negative shapes formed by the arms and legs with the body.

## Assess

### Check Your Understanding: Answers

1. Artists arrange elements (line, shape, form, color, value, space, and texture) in different ways to create their art. The ways that they arrange them are called the principles of design.

2. Check for a monochromatic color scheme and an accurate description of the colors and mood.

3. Look for appropriate descriptive words, such as *bumpy, smooth,* and *rough.*

4. Positive space is filled by the object or subject. Negative space surrounds the subject.

## Close

Have students identify and describe each of the elements in an artwork. Review their answers to Check Your Understanding. Display students' drawings, and discuss which elements were emphasized.

## Prepare

### Pacing
Two or more 45-minute periods: one to discuss the art principles; one or more to create a painting or drawing

### Objectives
- Recognize and identify the principles of design in artworks.
- Create a series of artworks incorporating both unity and variety.

### Vocabulary
**principles of design** The different ways in which artists combine the elements to achieve a desired effect (balance, unity, variety, emphasis, proportion, pattern, movement and rhythm). For individual definitions, see the glossary on page 312.

### Supplies for Engage
- paper shapes, about 3" x 4", 3 per student
- paper, 9" x 12", 1 piece per student

### National Standards
### Foundation 3.2

**2a** Generalize about structures, functions.

**2b** Employ/analyze effectiveness of organizational structures.

**2c** Select, use structures, functions.

---

F3.2 FOUNDATION LESSON

# Principles of Design

## Balance

Artists use **balance** to give the parts of an artwork equal "visual weight" or interest. The three basic types of visual balance are symmetrical, asymmetrical, and radial. In *symmetrical* balance, the halves of a design are mirror images of each other. Symmetrical balance creates a look of stability and quiet in an artwork.

In *asymmetrical* balance, the halves of a design do not look alike, but they are balanced like a seesaw. For example, a single large shape on the left might balance two smaller shapes on the right. The two sides of the design have the same visual weight, but unlike symmetrical balance, the artwork has a look of action, variety, and change.

In *radial* balance, the parts of a design seem to "radiate" from a central point. The petals of a flower are an example of radial balance. Designs that show radial balance are often symmetrical.

### Try This
Create a 2-D or 3-D artwork that shows unity and variety. When you are finished, gather together with classmates who created the same kind of artwork as you. Discuss the challenges you faced when you created your artwork. Which examples of unity and variety work the best? Why?

**Computer Option**
Choose a drawing or painting of your own that shows unity. Scan and import a copy of your work to an image-editing program. Save the document. Change the artwork electronically so that it shows variety. Save this new work as a separate document, and print. Return to your original document. Add some of your variety ideas to make an artwork that shows both unity and variety. Save and print this new design.

Fig. F3–18 What kind of balance did Franz Kline create in his composition? How did he create it? Franz Kline, *Hazelton*, 1957.
Oil on canvas, 41 ¼" x 78" (104.8 x 198.1 cm). The Panza Collection. Museum of Contemporary Art, Los Angeles. © 2000 The Franz Kline Estate / Artist Rights Society (ARS), New York.

---

## Teaching Options

### Resources
Teacher's Resource Binder
  Thoughts About Art: F3.2
  A Closer Look: F3.2
  Find Out More: F3.2
  Assessment Master: F3.2
Large Reproduction 6
Overhead Transparency 8
Slides 1, 4, 5, 13, 14, 15, 17

### Teaching Through Inquiry

**Art Criticism** Have students work in groups of three to create a "sketch" (a short skit) that tells about the importance of describing the way an artwork is organized and arranged—such as focusing on balance, unity, and variety—when trying to understand the deeper meaning of an artwork.

# Unity

**Unity** is the feeling that all parts of a design belong together or work as a team. There are several ways that visual artists can create unity in a design.

- repetition: the use of a shape, color, or other visual element over and over
- dominance: the use of a single shape, color, or other visual element as a major part of the design
- harmony: the combination of colors, textures, or materials that are similar or related

Artists use unity to make a design seem whole. But if an artist uses unity alone, the artwork might be visually boring.

Fig. F3–19 In what ways has this student artist created unity? What kind of balance do you see? Jenna Skophammer, *Stella's Dream*, 1999.
Marker and tempera, 12" x 18" (30.5 x 46 cm). Manson Northwest Webster, Barnum, Iowa.

# Variety

**Variety** adds visual interest to a work of art. Artists create variety by combining elements that contrast, or are different from one another. For example, a painter might draw varying sizes of circles and squares and then paint them in contrasting colors such as violet, yellow, and black. A sculptor might combine metal and feathers in an artwork or simply vary the texture of one material. Architects create variety when they use materials as different as stone, glass, and concrete to create the architectural forms of a building.

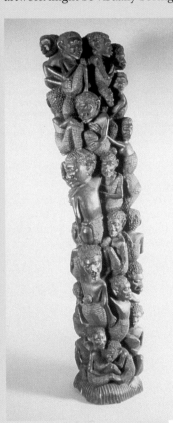

Fig. F3–20 In this sculpture, generations of family members surround the main figure of an ancestor. In what ways has the artist created unity? Where do you see variety? Makonde, Tanzania, *Family Group*, 20th century.
Wood, 31" (78.7 cm). Gift of Nancy Gray, Collection Bayly Art Museum of the University of Virginia, Charlottesville. (1981.94.75)

Elements and Principles of Design

43

## More About...

**Franz Kline** (1910–62), like other Abstract Expressionist artists, worked large. He often tacked unstretched canvases to the floor and applied commercial paints with house-painting brushes to create slashing, energetic gestures. Early in his career, Kline depicted buildings in a realistic style, but in his later abstract work, he captured the essence of these urban structures without their representational detail.

## Teach

### Engage

Distribute supplies, and ask students to place the shapes on the paper so that they seem balanced. Display and discuss different arrangements, some symmetrical (the same on both halves of the paper) and some asymmetrical (off-center). **Ask:** How would you arrange the shapes to create a feeling of unity? Explain that the different ways of arranging art elements are known as the principles of design—balance, unity, variety, emphasis, proportion, pattern, movement, and rhythm. List these on the chalkboard.

### Using the Text

**Art Criticism** After students have read pages 42–43, have them identify ways the artists created unity in the Tanzanian sculpture (Fig. F3–20) and in de Maistre's *Rhythmic Composition in Yellow Green Minor* (Fig. F3–8).

### Using the Art

**Art History** Lead students in imagining how Kline moved his brush as he created this painting. **Ask:** Why, do they think, is this called an Abstract Expressionist painting? When was this painted? Explain that Abstract Expressionism was a 1950s art style.

### Teaching Tip

Remind students that attending to and describing the way an artwork is organized and arranged—such as focusing on balance, unity, and variety—is helpful when trying to understand the deeper meaning of the work.

### Computer Option

For image-editing software, students may use Color It, Photoshop, Painter, and Paint Shop Pro. If these programs are not available, students may use AppleWorks paint and PC paint, which are simpler programs.

When each student has two printouts, display all the work. Lead a class discussion about the ways that unity and variety can be manipulated, and the effect that these design principles have on students' compositions.

## Using the Text

**Art Criticism** After students have read page 45, divide the class into four groups. Have each group describe the patterns in the Kuna mola (Fig. F1–5), the Benin plaque (F1–9), the Hanson sculpture (F3–22), and the Brack painting (F3–11). Discuss groups' findings as a class.

## Using the Art

**Art Criticism Ask:** How did Rosenberg emphasize the catch in *Out at Third*? *(made the mitt large, in a central location, with contrasting values and colors, and lines leading to it)* How did he indicate speed? *(use of line and shape)* Note how the artist divided the background into shapes.

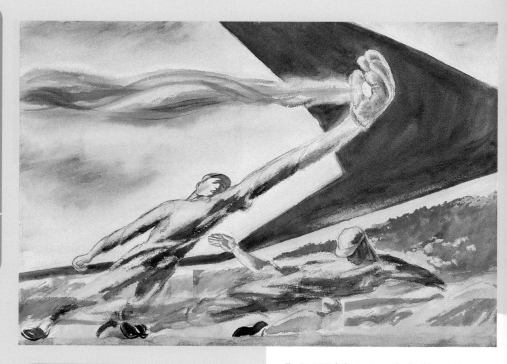

Fig. F3–21 To help create emphasis, this artist has exaggerated the limbs of the ballplayers. How does the placement of the mitt add to the feeling of emphasis? Nelson Rosenberg, *Out at Third,* undated. Watercolor and gouache on paper, 15" x 21 7/8" (38.1 x 55.5 cm). Acquired 1939, The Phillips Collection, Washington, DC.

## Emphasis

Look at *Out at Third* (Fig. F3–21). What is the first thing you see? You might say you see the baseball and mitt first. Now see if you can explain why you notice them first. Here are some clues.

When artists design an artwork, they use **emphasis** to call attention to the main subject. The size of the subject and where it is placed in the image are two key factors of emphasis. Sometimes artists group certain objects together in the design. In this case, however, the artist created emphasis by arranging other elements in the picture to lead the viewer's eyes to the subject. What elements lead your eyes to the ball and mitt?

44

### Teaching Through Inquiry

**Art Criticism** Provide students with several magazine advertisements. Ask them to work in small groups to analyze them in terms of emphasis and pattern. For each advertisement, students should indicate the center of interest, explaining how the artist draws the viewer's attention; and identify the places where pattern is used, noting the features repeated to create the pattern.

# Pattern

An artist creates a **pattern** by repeating lines, shapes, or colors in a design. He or she uses patterns to organize the design and to create visual interest. You see patterns every day on wallpaper, fabric, and in many other kinds of art.

Patterns are either planned or random. In a *planned* pattern, the element repeats in a regular or expected way. A *random* pattern is one that happened by chance, such as in a sky filled with small puffy clouds or in the freckles on a person's face. Random patterns are usually more exciting or energetic than planned ones.

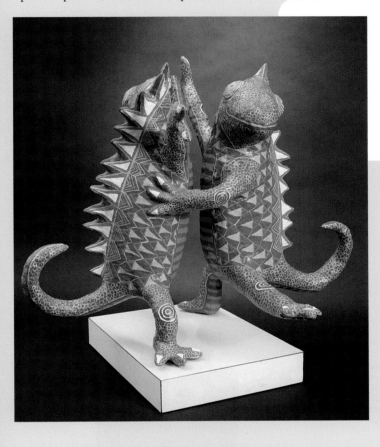

Fig. F3–22 This artist has used pattern to create the look of scales on the lizards. What other examples of pattern do you see in this artwork? Ann Hanson, *Dancing Lizard Couple*, 1985. Celluclay, 16 ½" x 20 ½" (41.9 x 52.1 cm). The National Museum of Women in the Arts. On loan from the Wallace and Wilhelmina Holladay Collection.

**Ask:** How did Grant Wood create emphasis in *In the Spring* (Fig. F3–10)? *(made the figure huge, isolated against the sky, with fence poles and shovel handle pointing toward him)*

**Ask:** What are the patterns in Duane Hanson's *Tourists* (Fig. F3–1)? What message does this mix of patterns create?

## Extend

Challenge students to depict a memorable moment when something very good or bad happened. Discuss ways to emphasize the special meaning of that moment. **Ask:** What will you emphasize? How can you draw attention to this?

---

## More About...

There are several basic types of **planned patterns**. The simplest pattern is achieved by repeating a motif in *rows* or columns. A *grid* pattern is formed by intersecting vertical and horizontal lines or shapes. Grid patterns can also be diagonal or circular. *Half-drop* designs lower each row of motifs half the height of the row above it, like scales on a fish. *Alternating* patterns are similar to half-drop designs, but less rigid. *Radial* patterns branch out from a central point, usually in a way that speeds up our eye movement. Finally, patterned *borders* or *bands* are often used to enrich a surface.

## Using the Large Reproduction

Use as an example of symmetrical balance, unity, variety, and pattern.

**6**

### Using the Text

**Perception** After students have read page 46, lead them in discovering proportions in the human body.

**Art Criticism** After students have read page 47, ask them to find, in this book, an image of a kinetic sculpture. *(Calder's* Tricolor on Pyramid, *Fig. F2–9)* **Ask:** How were rhythm and movement created in *The Wedding Procession*? What elements were repeated? *(colors, shapes)*

### Using the Art

**Perception** Ask students to study Fig. F3–24. **Ask:** Which is stronger, the sense of movement in this work or the sense of rhythm? Students should explain their answers, using examples from the image.

### Critical Thinking

Inform students that many people associate Alberto Giacometti's art with a sense of loneliness. **Ask:** Do you agree or disagree with this association? Have students give reasons for their answers.

**Sketchbook Tip**

Ask the language-arts teacher to provide several poems, each with a different rhythm. As students take turns reading these aloud, encourage others to tap the rhythm. Discuss how students might repeat shapes, forms, and lines to sketch this rhythm.

## Proportion

*Foundation Lesson*

**Proportion** is the relationship of size, location, or amount of one thing to another. In art, proportion is mainly associated with the human body. For example, even though your body might be larger, smaller, or shorter than your best friend's, you both share common proportions: Your hips are about halfway between the top of your head and your heels; your knees are halfway between your hips and your feet; and your elbows are about even with your waist.

*Scale* is the size of one object compared to the size of something else. An artist sometimes uses scale to exaggerate something in an artwork. In a painting, for example, he or she might place a giant coffee mug in the middle of a busy freeway.

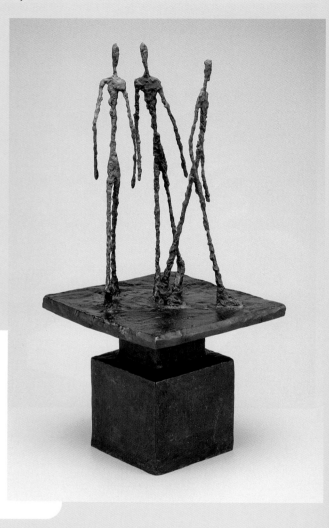

Fig. F3–23 Are human beings actually as stick-thin as those shown in this sculpture? How is the proportion of these figures different from the proportion of the human body? Alberto Giacometti, *Three Men Walking*, 1948–49. Bronze, height: 29 1/2" (74.9 cm). Edward E. Ayer Endowment in memory of Charles L. Hutchinson, 1951.256. Photograph courtesy The Art Institute of Chicago. © 2000 Artists Rights Society (ARS), New York / ADAGP, Paris.

46

## Teaching Options

### Teaching Through Inquiry

**Art Criticism** Have students make a list of movies, illustrated books, television shows, and commercials in which **changes in proportion** are important. Commercials with the Jolly Green Giant, the book *James and the Giant Peach*, and the film and illustrated versions of *Alice in Wonderland*, for example, all include dramatic differences in proportion. Ask students to imagine the items on their list without such differences.

### More About...

Born in Switzerland, **Alberto Giacometti** (1901–66) joined the Paris Surrealists in the early 1930s, but left them after several years to focus on developing his own style of presenting the human figure. Giacometti's sculptures are often referred to as indicative of the isolation of humankind within the vastness of space. He sculpted tall, thin figures by adding clay or plaster to a metal armature.

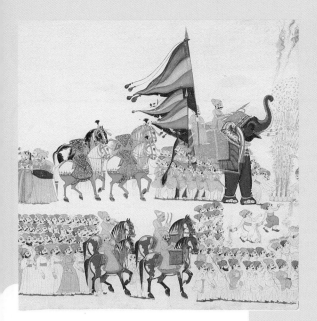

Fig. F3–24 When you look at this image, do you get the feeling that the people and animals are moving left to right? What creates that feeling? India, Rasjasthan, Jaipure, *The Wedding Procession of Prince Bakhtawar Singh*, late 18th century.
Opaque watercolor, gold and silver on paper, 18 9/16" x 11 5/8" (47.1 x 29.5 cm). Cincinnati Art Museum, Gift of Mr. and Mrs. Carl Bimel, Jr. 1982.251.

## Movement and Rhythm

**Rhythm** is related to both movement and pattern. Artists use rhythm, like pattern, to help organize a design or add visual interest. They create rhythm by repeating elements in a particular order. Rhythm may be simple and predictable, or it may be complex and unexpected.

For example, look at *The Wedding Procession of Prince Bakhtawar Singh* (Fig. F3–24). The repetition of faces in the lower left area creates a predictable rhythm. The rhythm of the fountain-like object in front of the elephant is more complex. What other examples of predictable and complex rhythm do you see in this painting?

### Sketchbook Connection
Read aloud a piece of poetry that you particularly like. Listen for the rhythm of the words. Create a sketch that conveys the same sense of rhythm. Try to visually communicate the poem's tempo. Discuss with classmates how rhythm in poetry and art are similar and different.

### Foundation Lesson 3.2

#### Check Your Understanding
1. Select a piece of artwork from the foundation chapters that has symmetrical balance and another that has asymmetrical balance. Which one has more movement?
2. How did Giacometti alter proportions in Fig. F3-23?
3. Explain how Rosenberg emphasized his message in *Out at Third*, Fig. F3-21. What is the most important part of the picture?
4. From this chapter, choose a piece of art that appeals to you. Describe the art elements and principles that seem most important in this piece of art.

Elements and Principles of Design

47

## Extend
- Have students analyze the art elements and principles in magazine advertisements. **Ask:** How do the advertising artists catch the viewer's attention, lead the eye through the composition, and emphasize the product?
- Invite students to take, and then display, photographs in a visual essay on the elements and principles of design.

### Assess

#### Check Your Understanding: Answers

**1.** Most of the artworks are asymmetrical, with more movement than symmetrical pieces such as the African chair (Fig. F1–3), the Kuna mola (Fig. F1–5), or the Benin plaque (Fig. F1–9).

**2.** He elongated the bodies and made them thin.

**3.** Rosenberg exaggerated the size of the baseball mitt and emphasized this focal point with contrasting values and lines leading toward it.

**4.** Look for an understanding of the elements and principles within the chosen artwork.

### Close

Review the elements and principles of design. Have cooperative-learning groups select artworks that exemplify each principle. Discuss the groups' choices. Display students' art, and ask students to identify two of the most important art elements in each artwork.

### Using the Overhead

Compare use of pattern, rhythm, and movement with Fig. F3–23.

8

### Assessment Options

**Teacher** Ask students to write ten descriptive statements about artworks in this chapter so as to demonstrate their understanding of the principles of design. For each sentence, have students use a different word or phrase from the following list: symmetrical balance, asymmetrical balance, radial balance, unity, variety, emphasis, proportion, pattern, rhythm, and movement.

## Language Arts

Discuss the impact of color on the senses and emotions, and have students brainstorm a list of adjectives and adjective phrases that use color to convey mood and feeling. Ask students each to select a color adjective or phrase as the inspiration for a monochromatic painting based on the emotional impact of that one predominant color. Have pairs of students exchange paintings and write an interpretation of the emotion shown in their partner's work.

## Mathematics

Review the principles of perspective— the illusion of three-dimensional depth and space on a two-dimensional surface. Show and discuss examples of one- and two-point perspective. Collect and distribute magazine photographs that depict deep space, and have students use markers and rulers to draw in the horizon lines, converging lines, and vanishing points.

## Science

Demonstrate the separation of light into the colors of the rainbow by holding a prism in front of a white light. Display the spectrum on a white piece of paper so that all students can see it. Instruct students to compare the position of the colors in the spectrum with the placement of colors on the color wheel.

## Other Arts

Introduce students to the basic elements of blocking and stage picture. Use masking tape to create a stage

# Connect to...

## Careers

Do you have a piece of jewelry that you wear every day, jewelry that has become your own personal "signature"? From prehistoric times, jewelry has been a source of identity and pleasure—and, often, a sign of wealth and rank. People originally made ornaments for body adornment from such materials as shells, feathers, teeth, ivory, and metal. With the development of new tools and techniques, jewelry makers used gems and precious metals, like gold and platinum. A **jewelry designer** today—either working alone or in a jewelry-manufacturing company—must be skilled in drawing and in the use of many specialized materials, tools, and processes. Training for jewelry design is available in art schools, colleges, and technical institutes. Whether making necklaces, earrings, rings, pins, or bracelets, jewelry designers use the elements and principles of design on a miniature scale that requires great care and attention to detail.

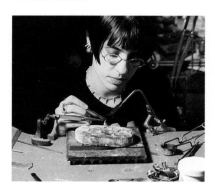

F3–25 **"For me, jewelry design is a wonderful way to show my love for self-expression and to celebrate everyone by decorating them."** —Heather Skowood, jewelry designer, Philadelphia, Pennsylvania.
Photo © George Costa. Courtesy Heather Skowood.

## Daily Life

Many of the **elements and principles of design have parallels in daily life**. Can your family tell the time by the repeated pattern of your daily schedule, especially during the school week? Does your day follow a regular pattern? Do you wake up, eat, go to school, change classes, come home, watch TV, and go to bed? How is your pattern different on the weekend? In visual art, pattern is a principle of design in which the repetition of elements forms a recognizable organization. Does that definition seem to relate to your schedule? What are some other ways that you encounter patterns in your day?

F3–26 As you walk down the street, notice the patterns and designs created by reflections on buildings and in windows. What other elements or principles of design do you see? *Façade, Pacific Design Center, Los Angeles, California.*
Courtesy Davis Art Slides.

**Internet Connection**
For more activities related to this chapter, go to the Davis website at **www.davis-art.com.**

## Teaching Options

### Resources

Teacher's Resource Binder
Using the Web
Interview with an Artist
Teacher Letter

### Video Connection

Show the Davis art careers video to give students a real-life look at the career highlighted above.

# Other Subjects

## Language Arts

Do you think **color has an important impact** on your senses and emotions? In theory, colors are considered to be warm or cool; tints or shades; and black or white or neutral. In literature, descriptions—in the form of adjectives and adjective phrases—can convey mood and emotion. "In the pink," "blue mood," "green with envy," "red hot," and "black heart" all carry emotional associations. What are some other examples?

## Science

Have you ever observed the visible **spectrum**, or the colors, when white light is passed through a prism? The individual bands of color separate within the prism as the different wavelengths of the white light are bent, or refracted. To make your own rainbow at home, use a sprinkler or water hose on a sunny day. Face away from the sun, and spray a thin mist in front of you. Adjust the position of the spray until you can see the rainbow.

## Mathematics

Have you ever tried to create a perspective drawing? **Perspective** is the illusion of three-dimensional depth and space on a two-dimensional surface. The use of perspective developed from Renaissance artists' fascination with math-

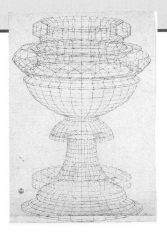

F3–27 What techniques of perspective has this Renaissance artist used to show a 3-D object on a flat surface? What principles of mathematics must he have known? Paolo Uccello, *Perspective Drawing of a Chalice*, 15th century. Ink on paper. Gabinetto dei Disegni e delle Stampe, Florence, Italy. Scala/Art Resource, NY.

ematics. Linear perspective uses sets of implied lines that move closer together in the distance until they merge at an imaginary vanishing point on the horizon. One-point perspective uses lines that lead to a single vanishing point, whereas two-point perspective uses lines that lead to two different vanishing points. Why, do you think, do parallel lines converge in perspective drawings, but they do not converge in terms of mathematics?

grid on the floor similar to that in Fig. F3–28. Ask two volunteers to stand on the grid, according to the following instructions:

- One person stands downstage center and faces the audience; the other stands downstage right and also faces the audience.
- One person stands downstage center, with back to the audience; the other stands upstage left and faces the audience.
- One person kneels center stage and faces the audience; the other stands upstage right and also faces the audience.

Ask students to observe the two people, and decide which person takes focus in each instance. **Ask:** Why is your eye drawn to one person over the other? Now have one person walk from upstage right to downstage left. Then have that same person walk from upstage left to downstage right. Which movement was stronger? Why?

Inform students that in general, downstage center is the strongest area of the stage, because the audience is drawn to look at an actor who stands in this area. However, through the use of body position and level, actors may take focus in other stage locations. For example, if one actor stands in downstage center and looks toward a second actor who is facing the audience and standing upstage right, the focus will move from the first to the second actor. Have students experiment with different body positions and different stage areas to identify some of these possibilities for focus.

# Other Arts

| UP STAGE RIGHT | UP CENTER STAGE | UP STAGE LEFT |
|---|---|---|
| STAGE RIGHT | CENTER STAGE | STAGE LEFT |
| DOWN STAGE RIGHT | DOWN CENTER STAGE | DOWN STAGE LEFT |
| | PROSCENIUM | |

## Theater

Directors of **stage productions** take into consideration **elements and principles** of design, such as space, line, balance, unity,

and variety. They also look carefully at the principle of emphasis, which, in theater, is called focus; and the principle of movement, which is called blocking. To block for focus, a director places actors in different areas of the stage and in different body positions.

F3–28 The nine basic stage positions are shown here. Notice that the right and left sides of the stage are identified from the actor's perspective. The proscenium (*pro-SE-ne-um*) is the wall that separates the stage from the auditorium. Courtesy Andrew Harris, The Southeast Institute for Education in Theatre.

Elements and Principles of Design

49

## Internet Resources

### Drawing in One-Point Perspective

http://www.olejarz.com/arted/perspective/

A step-by-step guide with interactive features and explanatory text.

### Color Theory

http://www.presscolor.com/library/ctindex.html

This site presents information about the physics of color theory and concepts of light.

## Museum Connection

Find out if museums in your area sponsor educational programs to highlight their collections. Make a point to attend these and to meet other art educators to learn how they use the museums in their art program.

## Interdisciplinary Planning

As an initial step toward interdisciplinary planning, invite a colleague who has a special interest in art to accompany you to an event at your local art museum, such as an introductory art-history course for the public.

## Curriculum Connection

**Science** If students have learned in physical science about additive, or light, color theory (in which all colors mixed together make white), ask a volunteer to describe it. Explain that blending pigments is different. If all pigment colors are mixed, the result is a muddy gray.

## Talking About Student Art

When engaging students in discussions about artworks, have one student say one thing about his or her artwork. Have two other students summarize what the first student said. Then ask the first student to decide which summary better captures the intended meaning.

## Sketchbook Tip

 Emphasize that advertising artists are skilled in creating images to attract attention. Remind students that catalogue pages and magazine advertisements are designed to get consumers to desire something so much that they will buy it. Ask students to create diagrams or layouts of advertisements in their sketchbook, and to write notes about how design elements and principles are used.

## Portfolio Tip

 A portfolio is often the best way to represent students' understanding of your art program's content and the skills needed in the program. Help students select items for the portfolio that will provide evidence of the range of learning—through thinking, talking, writing, and making art—that occurs within the program.

# Portfolio

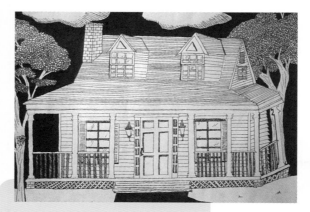

F3–29 Casey Cahill, *Tree Phase*, 1999.
Black marker, 18" x 24" (46 x 61 cm). Laurel Nokomis School, Nokomis, Florida.

"I got the idea to make this drawing from the many 'home style' magazines I read in my spare time. Various times I pretended I was Leonardo da Vinci just to achieve the difficult tasks on the house." **Casey Cahill**

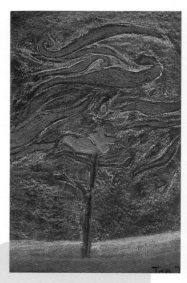

F3–31 Jonathan Davis, *Windy Day*, 1998.
Chalk pastel, 12" x 18" (30.5 x 46 cm). Remington Middle School, Franklin, Massachusetts.

F3–30 Tracy M. Dupuis, *Flaming Dragon Tessellation*, 1999.
Marker, metallic pen, 12" x 18" (30.5 x 46 cm). City View School, Worcester, Massachusetts.

 **CD-ROM Connection**
To see more student art, check out the Community Connection Student Gallery.

50

## Teaching Options

**Resources**

Teacher's Resource Binder
Chapter Review F3
Portfolio Tips
Write About Art
Understanding Your Artistic Process
Analyzing Your Studio Work

**CD-ROM Connection**

 For students' inspiration, for comparison, or for criticism exercises, use the additional student works related to studio activities in this chapter.

# Foundation 3 Review

### Recall

Define the elements and principles of design.

### Understand

Identify two major elements of design in *Autumn Landscape*, Fig. F3–13 *(see below)* and explain your answers.

### Apply

Create a bulletin board with visual examples for each of the elements and principles of design.

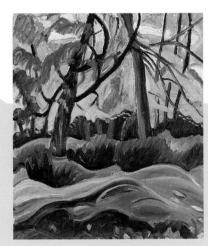

Page 39

### Analyze

Compare and contrast the way the artists in Figs. F3–16, F3–20, and F3–22 used texture. What do the works have in common in this regard, and how are they different?

### Synthesize

Research eagles in science and natural history resources. After, discuss with a partner how the artist of Fig. F3–16 used texture to create a sense of the bird's power. Select another animal to research, and produce an artwork with texture that also conveys something about this creature's qualities.

### Evaluate

Choose which artwork—Figs. F3–23 or F3–24—is a better example of emphasis, and write a label for the work defending your selection.

**For Your Sketchbook**

Search through magazines and catalogues for good examples of the use of elements and principles of design. Paste these images on pages in your sketchbook. Make notes about how the elements and principles are used and why you selected these images. Return to these pages when you are arranging design elements in future artworks.

**For Your Portfolio**

Select an artwork reproduced in your textbook that you think is a good example of the use of elements and principles of design. Write a short essay in which you describe the way the artist has arranged the elements of design to achieve certain results. Your essay will provide evidence that you can analyze the design of artworks.

Elements and Principles of Design

51

## Foundation 3 Review Answers

### Recall

Look for a clear understanding of each concept, as provided in the chapter.

### Understand

The artist relied primarily on shape, color, and line. Students should point out the strength of these as compared to other art elements.

### Apply

Look for a clear visual illustration of each element and principle.

### Analyze

All the artists incorporated texture as an important part of the design, but the actual textures of the sculptures are different. Fig. F3–16 emphasizes the actual texture of carved feathers; Fig. F3–20 shows a dramatic contrast in textures throughout the sculpture; and Fig. F3–22 is a good example of implied texture.

### Synthesize

Look for an imaginative and skillful use of materials to communicate something about the animal's personality or being.

### Evaluate

Look for an understanding of emphasis in the selected artwork. For example, Giacometti's repetition of the three similarly sized and shaped sticklike figures underscores the haunting mood of the sculpture.

### Reteach

Have students review the images in Foundation 3. Explain that each image illustrates an element of art or a principle of design. Ask students to imagine that they are book publishers about to create a new edition of this chapter. **Ask:** What reproductions or other images from the rest of the book would you select to illustrate each element or principle? Ask students to explain their choices by making specific reference to the artwork.

## Family Involvement

Suggest to students that they teach family members how to look for the elements and principles of design in artworks.

## Community Involvement

Encourage students to look for the use of elements and principles of design when they visit their local supermarket. Suggest that they pay particular attention to the design of items in the cereal aisle, produce section, and dairy case.

## Advocacy

People generally enjoy seeing artworks made by young people in the community. For exhibits of artworks in a local library or business, include examples of your students' art—along with their writing—to highlight the comprehensive nature of your art program.

51

# Foundation Organizer

## Foundation 4 Approaches to Art

Foundation 4 Overview
pages 52–53

### Foundation Focus

- Understand that asking questions can guide us to better understand and appreciate artworks.
- **4.1** Art History
- **4.2** Art Criticism
- **4.3** Art Production
- **4.4** Aesthetics

### National Content Standards

1 Understand media, techniques, and processes.
4 Understand arts in relation to history and cultures.
5 Assess own and others' work.

---

| 9 weeks | 18 weeks | 36 weeks | | | |
|---------|----------|----------|---|---|---|
| 1 | 1 | 1 | **Foundation 4.1 Art History** page 54 Pacing: One 45-minute period | **Objectives** • Explain the role of art historians in art inquiry. | **National Standards** 4b Place objects in historical, cultural contexts. |
| | | | **Try This Art-historical questions** page 55 | • Generate art-historical questions about artworks. | 4c Analyze, demonstrate how time and place influence visual characteristics. |
| 1 | 1 | 1 | **Foundation 4.2 Art Criticism** page 56 Pacing: One 45-minute period | **Objectives** • Explain the role of art critics in art inquiry. | **National Standards** 5a Compare multiple purposes for creating art. 5c Describe, compare responses to own or other artworks. |
| | | | **Try This Finding meaning** page 57 | • Generate questions about the meaning of art. | 5b Analyze contemporary, historical meaning through inquiry. |
| 2 | 1 | 1 | **Foundation 4.3 Art Production** page 58 Pacing: One or two 45-minute periods | **Objectives** • Explain the role of artists in art inquiry. | **National Standards** 1a Select/analyze media, techniques, processes, reflect. |
| | | | **Try This Generate questions** page 59 | • Generate questions about the production of artworks. | 1a Select/analyze media, techniques, processes, reflect. |

## Featured Artists

Deborah Butterfield
Frank Gehry
Kirby, Smith, Wilkins
Khem Karan
A. A. Lamb
Berta Margoulies

Jim Reinders
Anna Mary Robertson
  Moses
William Wegman
Yellow Nose
Qui Ying

## Vocabulary

aesthetician
art critic
art historian
artist

## Teaching Options

Meeting Individual Needs
Teaching Through Inquiry
Using the Overhead
Using the Large Reproduction
Assessment Options

## Technology

CD-ROM Connection
  e-Gallery

## Resources

Teacher's Resource Binder
  A Closer Look: F4.1
  Find Out More: F4.1
  Assessment Master:
    F4.1

Large Reproduction 18
Overhead Transparency 18
Slides 13, 15, 17

CD-ROM Connection
  Student Gallery

Teacher's Resource Binder
  Thoughts About Art: F4.1

## Teaching Options

Teaching Through Inquiry
More About… Chinese painting
Using the Large Reproduction
Using the Overhead
Assessment Options

## Technology

CD-ROM Connection
  e-Gallery

## Resources

Teacher's Resource Binder
  A Closer Look: F4.2
  Find Out More: F4.2
  Assessment Master:
    F4.2

Large Reproduction 7
Overhead Transparency 15
Slides 2, 7, 16

CD-ROM Connection
  Student Gallery

Teacher's Resource Binder
  Thoughts About Art: F4.2

## Teaching Options

Teaching Through Inquiry
More About… Gouache
Using the Large Reproduction
Using the Overhead
Assessment Options

## Technology

CD-ROM Connection
  e-Gallery

## Resources

Teacher's Resource Binder
  A Closer Look: F4.3
  Find Out More: F4.3
  Assessment Master:
    F4.3

Large Reproduction 4
Overhead Transparency 5
Slides 14, 17

CD-ROM Connection
  Student Gallery

Teacher's Resource Binder
  Thoughts About Art: F4.3

# Foundation Organizer continued

| 9 weeks | 18 weeks | 36 weeks | | Objectives | National Standards |
|---|---|---|---|---|---|
| 1 | 1 | 1 | **Foundation 4.4 Aesthetics** page 60 Pacing: One 45-minute period | • Explain the role of aestheticians in art inquiry. | **5c** Describe, compare responses to own or other artworks. **5b** Analyze contemporary, historical meaning through inquiry. |
| | | | **Try This Generate questions** page 61 | • Generate aesthetics questions about artworks. | **5a** Compare multiple purposes for creating art. |

| | | | | Objectives | National Standards |
|---|---|---|---|---|---|
| • | • | • | **Connect to...** page 62 | • Identify and understand ways other disciplines are connected to and informed by the visual arts. • Understand a visual arts career and how it relates to chapter content. | **6** Make connections between disciplines. |

| | | | | Objectives | National Standards |
|---|---|---|---|---|---|
| • | • | • | **Portfolio/Review** page 64 | • Learn to look at and comment respectfully on artworks by peers. • Demonstrate understanding of chapter content. | **5** Assess own and others' work. |

## Teaching Options

Teaching Through Inquiry
More About... Frank Gehry
Using the Large Reproduction
Using the Overhead
Assessment Options

## Technology

CD-ROM Connection
  e-Gallery

## Resources

Teacher's Resource Binder
  A Closer Look: F4.4
  Find Out More: F4.4
  Assessment Master:
    F4.4

Large Reproduction 17
Overhead Transparency 17
Slides 9, 18

---

Computer Option
CD-ROM Connection
  Student Gallery

Teacher's Resource Binder
  Thoughts About Art: F4.4

## Teaching Options

Museum Connection
Interdisciplinary Planning

## Technology

Internet Resources
Video Connection
CD-ROM Connection
  e-Gallery

## Resources

Teacher's Resource Binder
  Using the Web
  Interview with an Artist
  Teacher Letter

## Teaching Options

Advocacy
Family Involvement
Community Involvement

## Technology

CD-ROM Connection
  Student Gallery

## Resources

Teacher's Resource Binder
  Chapter Review F4
  Portfolio Tips
  Write About Art
  Understanding Your Artistic Process
  Analyzing Your Studio Work

## Chapter Overview

### Foundation 4

Asking questions from the disciplines of art history, art criticism, art production, and aesthetics can guide us in developing and understanding an appreciation of artworks.

### Featured Artists

Deborah Butterfield
Frank Gehry
Kirby, Smith, Wilkins
Khem Karan
A. A. Lamb
Berta Margoulies
Anna Mary Robertson Moses
Jim Reinders
William Wegman
Yellow Nose
Qui Ying

### Chapter Focus

As people study artworks, they become curious about them. The types of questions usually asked in the study of art may be categorized into art history, art criticism, art production, and aesthetics.

### Supplies for Warm-up

- an obsolete manufactured object (78 or 45 rpm record, glass soda bottle, 5" floppy computer disk, manual typewriter, bonnet hairdryer)

### National Standards Foundation 4 Content Standards

**1.** Understand media, techniques, and processes.

**4.** Understand arts in relation to history and cultures.

**5.** Assess own and others' work.

**Teaching Options**

# Approaches to Art

### Focus

- What do people want to know about art?
- What kinds of questions do people ask about art?

**Imagine finding an object that's unlike anything you've ever seen before. You turn the object over in your hands and ask yourself, "What is this? Who made it? How was it made?"** Suppose something about the object suggests that it was made a long time ago. You might wonder why the object was important to the people who lived at that time. What did they use it for? How is it different from objects that you normally see or use?

For thousands of years, people have wondered where objects and artworks come from and why they were made. It's human nature to be curious. We can be as curious about the function of an artwork as we are about its meaning. Asking questions about the artwork helps us understand it. The information we learn about the artwork can also teach us something about the times and cultures of our world and where we fit in.

This chapter will introduce you to the kinds of questions people ask about artworks. As you read the chapter, you will see that the questions fall into four categories: art history, art criticism, the making of art itself, and the philosophy of art.

### What's Ahead

- **F4.1  Art History**
  Learn how to find the story behind an artwork.
- **F4.2  Art Criticism**
  Explore ways to find the meaning of a work of a[rt]
- **F4.3  Art Production**
  Learn more about yourself as an artist.
- **F4.4  Aesthetics**

### Words to Know

art historian        artist
art critic           aesthetician

### Meeting Individual Needs

**Gifted and Talented** Have students examine the images on pages 52–55 and then research each artist's era and culture. **Ask:** How does the culture reveal itself in the work?

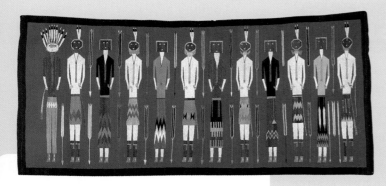

Fig. F4–1 Notice how the figures on this textile alternate to create a pattern. What might the figures represent? *Navajo ye ii bicheii (yeibechai)* textile, 20th century.
Wool, 42 1/2" x 91 1/2" (107.3 x 232.5 cm). Collected from Mrs. Fione Warnoff. Photo by Katherine Fogden. Courtesy National Museum of the American Indian, Smithsonian Institution.

Fig. F4–2 Grandma Moses is probably the most famous American folk artist. What clues suggest that this scene might have been painted in the 1940s? Anna Mary Robertson Moses, called Grandma Moses, *Summer Party*, 20th century.
Oil on masonite, 23 9/16" x 15 3/4" (59.9 x 40 cm). The Museum of Fine Arts, Houston; Wintermann Collection of American Art, gift of Mr. and Mrs. David R. Wintermann.

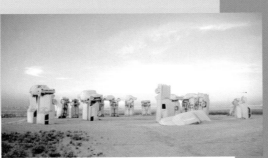

Fig. F4–3 Artists often think about point of view, or the angle from which they will show their subject. How would you describe the point of view in this drawing? Melissa Reilly, *Patchwork Kitten*, 1999.
Collage, marker, 16" x 20" (40.5 x 51 cm). Laurel Nokomis School, Nokomis, Florida.

Fig. F4–4 The design of this modern artwork recalls Stonehenge from prehistoric times, or ancient Greek or Roman ruins. When you look at this, do you see it as an artwork or just a bunch of cars? Why? Jim Reinders, *Carhenge*, Alliance, Nebraska, 1982.
33 cars. © 1999, www.roadsideamerica.com, Kirby, Smith, Wilkins.

## Chapter Warm-up

Discuss with students what the object is, how it works, and how it differs from similar objects currently in use. **Ask:** How have design styles and materials changed since this was made? Do you like the way this looks? Why or why not? Explain that these are the types of questions that are often asked about artworks.

## Using the Text

**Aesthetics** After students have read page 52, ask them to study the images on page 53. **Ask:** What do Figs. F4–1, F4–2, and F4–4 have in common? *(They are American artworks based on cultural icons.)* Are there any works here that you do not consider to be art? Why?

## Using the Art

**Art Criticism** Discuss students' answers to the caption questions. Have students write a question that they would like to ask one of these artists. Have students set aside a question for later when the chapter has been completed.

## Teaching Tip

Discuss the different ways that people can approach the study of art: by inquiring about the artist, the artwork, the viewer of the work, the time and place in which a work was created, and theories or ideas about art.

## Extend

Show students various images of Stonehenge. **Ask:** In what ways is *Carhenge* similar to and different from Stonehenge?

## Teaching Through Inquiry

**Art Criticism** Have student pairs look at Fig. F4–3 and list questions they have about the work. Challenge them to come up with their own answers by thinking particularly about the artist's decisions regarding the work's materials, location, positioning, and size. Finally, tell them to consider how the title relates to the artwork. Have teams go back over their initial lists and see if they have answered all their own questions through the process of careful looking and thinking.

## More About...

The United States government forced the **Navajo** (Diné) to leave their homeland in 1873. When permitted to return, traders encouraged the women to weave rugs and blankets for sale to the growing tourist and commercial market. Yeibechai textiles are part of the large Diné spirit world.

## Prepare

### Pacing
One 45-minute period, if research sources are provided

### Objectives
- Generate art-historical questions about artworks.
- Explain the role of art historians in art inquiry.

### Vocabulary
**art historian** A person who researches the history of art and then synthesizes the information.

### Supplies for Engage
- flag of the United States

## Teach

### Engage
Ask the art-inquiry questions, on page 54, about the flag. Tell students that they will use these questions to learn about the history of artworks.

### Using the Text
**Art Criticism** Have students read the text. **Ask:** What does the study of art history involve?

### Using the Art
**Art Criticism** Discuss students' answers to the caption questions for Lamb's *Emancipation Proclamation* (Fig. F4–6). Ask students to analyze

### National Standards
### Foundation 4.1

**4b** Place objects in historical, cultural contexts.

**4c** Analyze, demonstrate how time and place influence visual characteristics.

# Art History

## The Stories Behind Art

Art history is just what you'd expect: the history of art. **Art historians**—people who study the history of art—want to know where artworks began. They research the cultures from which artworks spring. They learn about the people, the politics, and the economic conditions at the time and place where artworks were made. They try to figure out why artists created artworks and how the artworks are different from others. And finally, when all of their research is done, they piece together the stories of art.

Do you ever wonder where artworks come from or what their story is? If you do, then you have begun investigating their history.

### Looking at Art
There are certain basic questions that will get you started on the search for an artwork's story.
1. What is the artwork? What is it about? What is its purpose?
2. When and where was it made?
3. Has the artwork always looked like this? Or has it changed somehow over time?

### Finding the Story
The next set of questions will help you find out what an artwork meant to the artist and to the people who lived at the time it was made. By asking these questions, you can learn how the artwork reflects the cultural traditions of the time. Your answers will also help place the artwork in history.
1. What was happening in the world when the artwork was made? How is the world different now?
2. How do the customs and traditions of the artist's family or culture add to the meaning of the artwork?
3. What other kinds of art did people make at that time?

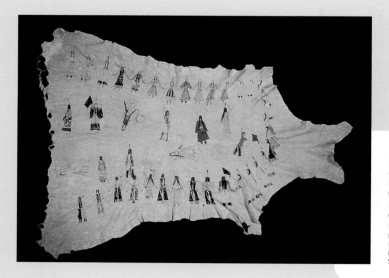

Fig. F4–5 What do the figures in this artwork appear to be doing? Why might it have been important for the artist to show this scene? Yellow Nose, *Ghost Dance*, Cheyenne-Arapaho Reservation, 1891. Deerskin, ink and pigment, width: 50" (127cm). Courtesy the National Museum of Natural History/ Smithsonian Institution.

54

## Teaching Options

### Resources
Teacher's Resource Binder
  Thoughts About Art: F4.1
  A Closer Look: F4.1
  Find Out More: F4.1
  Assessment Master: F4.1
Large Reproduction 18
Overhead Transparency 18
Slides 13, 15, 17

### Meeting Individual Needs
**Multiple Intelligences/Interpersonal** Explain the Emancipation Proclamation as students examine Fig. F4–6. Have them imagine being the artist who created this painting, which visually communicates the message of the proclamation and its place in American history. Why might Lamb have selected these particular images to portray? What message did he likely want us to understand? How might students have portrayed the subject differently?

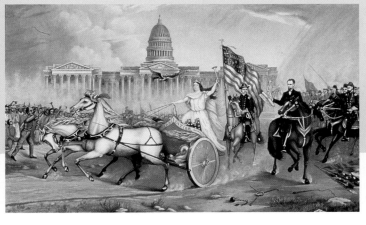

Fig. F4–6 How did this artist show the importance of the Emancipation Proclamation to the United States? Would everyone living at the time have felt the same way about this artwork? Why or why not? A. A. Lamb, *Emancipation Proclamation*, 1864 or after. Oil on canvas, 32 3/8" x 54" (82.2 x 137.2 cm). Gift of Edgar William and Bernice Chrysler Garbisch, © 1999 Board of Trustees, National Gallery of Art, Washington, DC. (1955.11.10. (1428) / PA)

Fig. F4–7 What decisions do you think artists make when they create seascapes? How does this artwork compare to other seascapes you've seen? Ashley Jacques, *Stormy Night*, 1999. Tempera, 24" x 16" (61 x 40.5 cm). Camels Hump Middle School, Richmond, Vermont.

the piece by answering the questions in the text. Remind students that the civil rights movement was beginning when Lamb created the painting.

## Try This
Provide students with art and history books and/or Internet access. You may wish to have students do this activity outside of class.

## Assess

### Check Your Understanding: Answers
**1.** Art historians ask such questions as when and where an artwork was made; how it has changed; what it meant when it was created; and what style the artist used, what decisions he or she made, what his or her role was in the community, and so on.

**2.** Look for thoughtful consideration of the history of the art.

## Introducing the Artist
As the story of an artwork unfolds, questions about the artist begin to surface. Some art historians focus their investigations mainly on the life and work of a single artist. Imagine the challenge of discovering something new and interesting about an artist!
1. Who made this artwork?
2. What role did artists play in the community in which this work was made?
3. How does this artist's style compare to the style of other artists during that time?
4. What decisions was the artist faced with as he or she created this artwork?

You can ask any of these sample questions about a specific artwork or artist. You can also ask similar questions about an entire art period or about the value and use of artworks in general.

See if you can find out what art historians have said about artworks and artists that interest you or about when and where the artworks were created.

### Try This
Choose an artwork in this chapter. Investigate the culture and period of time in which it was made. Using the information, re-title the artwork with words that convey what you have learned. Compare your solutions with others by students who chose the same artwork.

#### Foundation Lesson 4.1
**Check Your Understanding**
1. What are some questions that art historians ask as they study artworks?
2. Imagine that a committee has asked you to select an artwork to be placed in a public building in your community. Choose a piece from this lesson. Use the questions in "Finding the Story" to help you write an explanation for your choice.

## Close
Remind students that to engage in art-historical inquiry, they need to practice skills that include describing the work (what it is about, what its purpose was or is, when and where it was made); explaining if and how the work has changed over time; imagining the work's restoration, if applicable; and gathering information about the artist, the style, and artistic decisions.

Approaches to Art

55

## Teaching Through Inquiry
**Art History** Have small groups of students create a **chronology of community architectural styles.** They should research the origins and traditions of buildings and take photographs or make sketches. Direct students to arrange the images by the creation dates of the structures. Then challenge students to group the buildings stylistically within each decade. Ask students to review significant issues and events in the decades represented, and then explain how and why the appearance of community buildings changed through the years.

Alternatively, have students do a photo essay on the history of the community's gravestone styles.

## Using the Overhead

18

Discuss art form, materials, and time period of this work.

## Using the Large Reproduction

18

Compare images, style, and time period with Figs. F4–5 and F4–6.

## Assessment Options

**Teacher** Imagine that a citizen group wants to restore a section of your community to the way it looked when the buildings were new. What advice could you give this group regarding the role an art historian could play in helping their cause and the kinds of questions they would be seeking answers to?

## Prepare

### Pacing
One 45-minute period

### Objectives
- Generate questions about the meaning of art.
- Explain the role of art critics in art inquiry.

### Vocabulary
**art critic** A person who expresses a reasoned opinion on any matter concerning art.

## Teach

### Engage
Provide students with short newspaper or magazine reviews of art shows. Ask them to explain what they think they would see at the show. Discuss why certain reviews make them want, or not want, to see a show.

### Using the Text
**Art Criticism** Have students read pages 56 and 57 and then use the text questions to critique Fig. F4–9. **Ask:** Have any of you photographed your pet? How is your photograph different from this artwork? So that students will understand the reference, show some of Picasso's Blue Period artworks, especially *The Old Guitarist*.

# Art Criticism

## Searching for Meaning

**Art critics** want to know what artworks mean. They can help us learn about artworks by describing them and pointing out interesting things to look for. They judge the quality of artworks and suggest why they are valuable or important. Art critics often write about art in newspapers or magazines. Their views can influence the way we look at and think about artworks.

You have already asked questions like an art critic, perhaps without even realizing it. You may have looked at artworks in this book and wondered about their meaning. You have expressed your thoughts and opinions about objects and artworks around you. And you have compared them to other objects or artworks you're familiar with. Your views may have affected the way your classmates or others think about artworks.

### Finding Clues
As an art critic, you need to observe certain things about an artwork before you can begin to think about its possible meaning. Here are some questions that will help get you started.
1. What does the artwork look like?
2. How was it made?
3. How are the parts of the artwork arranged?
4. Does it seem to suggest a mood or feeling? An idea or theme?

Fig. F4–8 Imagine walking through this landscape. What does the artist show about the relationship between people and nature? What clues do you see that support your ideas? Qui Ying, *The Emperor Guang Wu Fording a River*, Ming Dynasty (1368–1644 AD). Ink and color on silk, 67 ¼" x 25 ¾" (170.8 x 65.4 cm). National Gallery of Canada, Ottawa. Purchased 1956. Acc. # 6485

### Making Connections
Once you understand how the artwork is put together, you can focus more on its meaning and ask questions such as these:
1. What is the artwork about?
2. What message does it send? How does it make me think, feel, or act when I see it?
3. How is the artwork related to events in the artist's life? How is it related to events that happened at the time it was made?

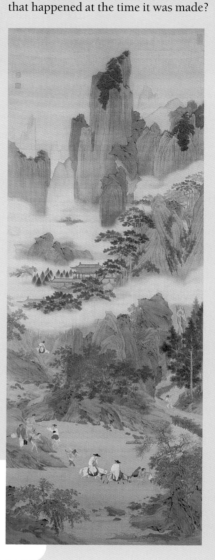

## National Standards
## Foundation 4.2

**5a** Compare multiple purposes for creating art.

**5b** Analyze contemporary, historical meaning through inquiry.

**5c** Describe, compare responses to own or other artworks.

## Teaching Options

### Resources
Teacher's Resource Binder
  Thoughts About Art: F4.2
  A Closer Look: F4.2
  Find Out More: F4.2
  Assessment Master: F4.2
Large Reproduction 7
Overhead Transparency 15
Slides 2, 7, 16

### Teaching Through Inquiry
**Art Criticism** Provide students with the Art Criticism Inquiry cards from the Teacher's Resource Binder. Have small groups of students use these questions to **describe, analyze, interpret, and judge artworks** in this chapter. Encourage students to discuss the questions; and to generate, refine, and discuss additional questions to display on a colorful classroom poster of their design.

Fig. F4–9 William Wegman includes a photograph of Pablo Picasso's famous painting within his own artwork. Wegman's arrangement of the dog and guitar recalls Picasso's style. Why might Wegman have made this visual connection to Picasso's work? William Wegman, *Blue Period*, 1981. Color Polaroid, 24" x 20" (61 x 50.8 cm). Courtesy of the artist.

## Judging Importance

Suppose you have learned enough about the artwork to decide that it is important. Next, you need to support your judgment. Ask yourself:
1. What aspects of the artwork—such as artist, culture, message, or function—make it important? Why?
2. What sets this artwork apart from similar artworks?
3. How is my response to this artwork different from my response to similar artworks?

You can see the kinds of things art critics say about art when you read a review of an art exhibit in your local newspaper. Try to visit the exhibit yourself. Do you agree with what the critic says about it? Why or why not?

### Try This

Be a critic of one of your own artworks. Ask yourself the four questions in "Finding Clues." After writing your responses, read over what you have said. Describe to a partner what new ideas you learned about your own art or thinking process.

**Sketchbook Connection**
Sketch an idea for a painting or sculpture that you would like to create. Then exchange sketches with a classmate. Write comments about the sketch you receive. What good qualities do you see in the sketch? How might your partner change the sketch to make the artwork better?

### Foundation Lesson 4.2

#### Check Your Understanding
1. How does an art critic help us understand works of art?
2. Why might you consult an art review?

Fig. F4–10 What makes this artwork interesting? How would you describe it to someone who is about to see it for the first time? Lisa Rivoir, *Conviviality*, 1999. Cardboard and silver spray paint, 36" x 28" x 16" (91.5 x 71 x 40.5 cm). Mount Nittany Middle School, State College, Pennsylvania.

## Using the Art
**Art Criticism** Discuss students' answers to the caption questions. Encourage students to describe the "path" that the artist created to guide the viewer through the Chinese scroll painting. **Ask:** Does this work suggest a mood or feeling? A theme or idea?

## Try This
Help students locate an appropriate artwork. After students have described their work to a partner, have them work in groups to discover common insights.

## Assess

### Check Your Understanding: Answers

1. Art critics study art, discovering connections between art, viewer, and artist; and they judge the quality and importance of artworks.

2. An art review might help me decide whether to go to an art exhibit or to learn the significance of a piece before purchasing it.

## Close

Remind students that to understand the nature of art criticism, they need to practice describing the sensory, formal, technical, and expressive qualities of artworks; offering interpretations; and giving well-supported evaluations by using a variety of standards.

### More About...

In traditional **Chinese painting**, artists historically studied previous masterpieces. They practiced for years to create fluid marks of different intensities to capture nature's essence while also communicating something about their own character. Bamboo, for instance, represented the qualities of uprightness, strength, and moral integrity, as well as the flexibility to bend with prevailing social and political change.

### Using the Large Reproduction

Use this image for the application of questions in "Finding Clues."

7

### Using the Overhead

Use this work for the application of questions in "Judging Importance."

15

### Assessment Options

**Teacher** Imagine that your local newspaper has expressed an interest in featuring a regular column on the art and architecture of the local community. What would you say in a letter to the publisher to support hiring an art critic to write the column, and to explain to the publisher the kinds of things the critic might write about?

## Prepare

### Pacing
One or two 45-minute periods, depending on the scope of Try This

### Objectives
- Generate questions about the production of artworks.
- Explain the role of artists in art inquiry.

### Vocabulary
**artist** A person who makes artworks.

## Teach

### Engage
Ask students to consider some of the various reasons for producing artworks. Discuss where artists might get their ideas and inspiration.

### Using the Text
**Art Criticism** After students have read pages 58 and 59, have them answer the text questions in regard to their own artwork. They may use the same piece that they critiqued in the preceding lesson.

### Using the Art
**Art Criticism** Discuss students' answers to the caption questions for *Mine Disaster,* and ask students to compare the size of the sculpture to something in the room. **Ask:** What medium did Margoulies use? What recent news events could you express your feelings about in an artwork?

### National Standards
### Foundation 4.3

**1a** Select/analyze media, techniques, processes, reflect.

# Art Production

## Making Art

**Artists** all over the world make artworks for decoration, to celebrate important events, and to communicate ideas or feelings. When artists plan a work of art, they think about its purpose and meaning. As they create the work, they explore their ideas and sometimes test the limits of the materials they use. In the end, they create a work that satisfies their personal and social needs, interests, values, or beliefs.

You think like an artist every time you explore the things you can do with pastels, a lump of clay, or any other art material. You might have an idea when you start, or your exploration might lead you to one. When you are finished expressing your idea, you have a work of art that is all your own.

### Reflecting on Your Art and Yourself
As you create art, you will begin to realize what art and making art mean to you. Asking questions about your art-making experience will help you uncover that meaning.
**1.** What artworks are important to me? How do they affect the way I make art?
**2.** What feelings or ideas do I like to express in my artwork? What does my art say about me?
**3.** What process do I go through when I make art?

### Considering Your Art and the World
When you have a better understanding of your own art, you can think about how it fits into the big picture. Ask yourself:
**1.** What does my artwork tell others about the place and time in which I live? What special events, people, or things does it suggest?
**2.** What do my choices of materials and techniques tell others about my world?
**3.** How is my artwork similar to or different from art that was made in other times and places?

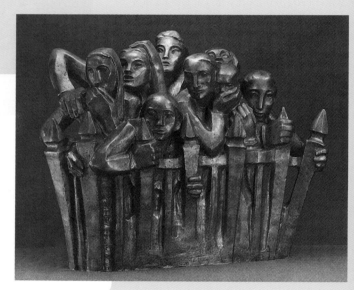

Fig. F4–11 This sculpture shows family members waiting for news of loved ones after a mine disaster. How does the artist show the fear and anxiety felt by the families? Would the work have the same feeling if the fence were made with rounded edges or the people stood apart? Berta Margoulies, *Mine Disaster,* 1942. Bronze, 23" x 29 1/2" x 12 1/2" (58.4 x 74.9 x 31.8 cm). Collection of the Whitney Museum of American Art, Purchase. Acq. #45.10.

58

## Teaching Options

### Resources
Teacher's Resource Binder
  Thoughts About Art: F4.3
  A Closer Look: F4.3
  Find Out More: F4.3
  Assessment Master: F4.3
Large Reproduction 4
Overhead Transparency 5
Slides 14, 17

### Teaching Through Inquiry
**Art Production** Have students work individually or in small groups to plan, but not glue, a design of cut-paper shapes on the theme of community spirit. Then provide students with a list of questions from the Teacher's Resource Binder. Have students revise their design in response to the questions, noting that even small changes can result in big differences.

Fig. F4–12 Why might this student have chosen ceramic clay and glazes to make this sculpture? How would the work look different if it were carved from wood? Jeff Warner, *Hedgehog*, 1999.
Ceramic clay, 8" x 4" x 3" (20 x 10 x 7.5 cm). Colony Middle School, Palmer, Alaska.

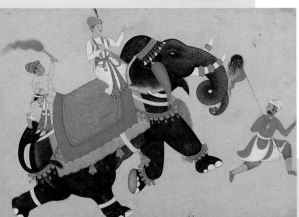

Fig. F4–13 Notice how simple this image is. It is mainly made with areas of pure color. There is no detail in the background. Why might the artist have created the painting this way? How might the feeling of the painting be different if it were filled with intricate detail? Khem Karan, *Prince Riding an Elephant*, ca. 1600.
Ink, opaque watercolor and gold on paper, 6 7/8" x 7 5/8" (17.4 x 19.4 cm). The Metropolitan Museum of Art, Rogers Fund, 1925. (25.68.4) Photograph © 1988 The Metropolitan Museum of Art.

## Comparing Your Art to Other Art

As an artist, you are probably aware of ideas and concerns that other artists have. When you compare your work to theirs, you might see a connection.
1. How is my artwork similar to or different from artworks made by others? How has their work affected my work?
2. If I could create an artwork with another artist, whom would I choose to work with? Why?
3. What materials and techniques have other artists used that I would like to explore? Why?

The next time you create a work of art, ask yourself the questions in this lesson. See what answers you come up with. You'll probably learn something surprising about the artist in you!

### Try This

Select one of the images in this lesson and consider why the artist might have chosen to work in that particular medium. Next, create your own art on the same subject, using a different medium. Answer the questions posed in the section "Comparing Your Art to Other Art." What is the most fascinating thing you learned from this comparison?

**Foundation Lesson 4.3**

**Check Your Understanding**
1. Why do artists create art? List some of the common reasons.
2. Use the questions in this lesson to write about a piece of your art. How do you feel about it? How does it fit into the world? How does it compare to other art?

Approaches to Art

59

**Art Criticism** Have students compare the mood of *Mine Disaster*, Fig. F4–11, to that of *Prince Riding an Elephant*, Fig. F4–13. **Ask:** What was each artist's message? What types of lines and forms did each artist use? How would you describe the movement in each piece?

### Try This

Provide students with a choice of media. If students select *Mine Disaster*, suggest that they paint or draw a similar subject; whereas if they select *Prince Riding an Elephant*, suggest a three-dimensional medium, such as clay or papier-mâché.

### Critical Thinking

**Ask:** If you could collaborate with an artist in this chapter to create an artwork, whom would you choose? Why?

## Assess

### Check Your Understanding: Answers

1. for decoration, to celebrate important events, to communicate ideas or feelings
2. Look for a thoughtful review based on the questions in the text.

## Close

Remind students that to produce artworks, they need to explore and consider ideas, media, techniques, personal fulfillment and expression, problem solving, and the art of others.

### More About...

The gum substance added to the mixture of ground pigment and water in **gouache** makes the medium heavier and more opaque than watercolors. The development of gouache technique began in the mid-1800s and continued until the mid-1900s. Use of the medium, like watercolor, is quick and direct, but easier to control.

### Using the Large Reproduction

Compare this work with Fig. F4–13.

4

### Using the Overhead

Compare with Fig. F4–11 in terms of art form, materials, and message.

5

### Assessment Options

**Teacher** Imagine that an advocate group for the elderly is concerned about the quality of life of senior citizens and the nature of programs offered at the local community center. Based on your understanding of art production as explained in this lesson, what would you want to say to convince the advocate group to consider engaging senior citizens in art production, and the value of art production in the life of all people?

## Prepare

### Pacing

One 45-minute period

### Objectives

- Generate aesthetics questions about artworks.
- Explain the role of aestheticians in art inquiry.

### Vocabulary

**aesthetician** A person who investigates art, how it came to be, why it is made, and how it fits into society.

## Teach

### Using the Text

**Aesthetics** After students have read pages 60–61, challenge them to define *aesthetics* in their own words.

### Using the Art

**Aesthetics Ask:** What is the subject of Fig. F4–14? What is its media? What might be the artist's message? Is the work beautiful? Where would you display this sculpture? Do you like it? Why or why not? Is it a good work of art?

### Try This

Ask for volunteers to explain to the class some highlights of their discussions.

# Aesthetics

## Investigating Art

Aesthetics is the philosophy, or investigation, of art. **Aestheticians** (*es-the-TI-shens*) can be called art philosophers. They ask questions about why art is made and how it fits into society. They're interested in how artworks came to be.

Every time you wonder about art or beauty, you think like an aesthetician. The questions that come to your mind about art are probably like the questions that aestheticians ask. All you need is a curious mind and probing questions to be an art philosopher yourself.

### Thinking About Artworks

At some time or another, you have probably wondered what artworks are. Like an aesthetician, you can ask certain questions that will help you think more carefully.
1. Are all artworks about something?
2. In what ways are artworks special? What makes some artworks better than others?
3. Do artworks have to be beautiful or pretty? Why or why not?
4. What makes one kind of artwork different from another?

### Thinking About Artists

As an aesthetician, you might wonder about the people who make art, why they make it, and why some people, but not all, are called artists. You might ask:
1. What do artworks tell us about the people who made them? What do they tell us about the world in which they were made?
2. What do people express through making art? Do artworks always mean what the artist intends them to mean?
3. Should there be rules that artists follow to make good artworks?

### Thinking About Experiences with Art

When you talk about art, you probably discuss whether you like an artwork or not. And you probably talk about how an artwork makes you feel. These questions will help you dig deeper into your experience with an artwork.
1. How do people know what an artwork means?
2. Is it possible to dislike an artwork and still think it is good?

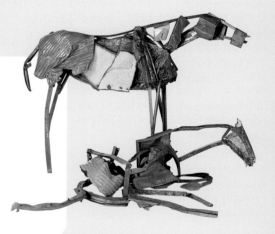

Fig. F4–14 Deborah Butterfield is best known for her skeletonlike horses. She creates them from scrap metal, wire, tree branches, clay, and twigs. Butterfield sees the structures as vessels for the horses' spirit. Why might some people find this artwork beautiful? Why might others be disturbed by it? Deborah Butterfield, *Eclipse,* 1986 (standing).
Rusted metal, steel, 80" x 110" x 24" (203.2 x 279.4 x 61 cm).
*Mardi,* 1986.
Rusted metal, steel, 32" x 103" x 65" (81.3 x 261.6 x 165.1 cm). Both works courtesy SOMA Gallery, La Jolla, CA.

### National Standards Foundation 4.4

**5a** Compare multiple purposes for creating art.

**5b** Analyze contemporary, historical meaning through inquiry.

**5c** Describe, compare responses to own or other artworks.

## Teaching Options

### Resources

Teacher's Resource Binder
   Thoughts About Art: F4.4
   A Closer Look: F4.4
   Find Out More: F4.4
   Assessment Master: F4.4
Large Reproduction 17
Overhead Transparency 17
Slides 9, 18

### Teaching Through Inquiry

**Aesthetics** Have students imagine that the art in this chapter is in a show. **Ask:** To which piece would you award first place? Which piece do you like most (this piece is not necessarily the first-place piece)? Which piece would you not include in the show? Why might others consider that piece to be excellent art? Have students compare their selections, and defend their choices.

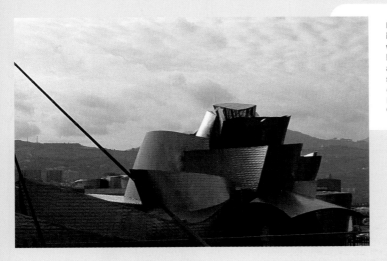

Fig. F4–15 If you saw this image in a photo album, would you guess that it's a building? How is it unlike any other building you've seen? Frank Gehry, *Guggenheim Museum*, Bilbao, Spain, 1997. Courtesy Davis Art Slides.

**Computer Option**
Have each student use a copy of the group-generated file and re-arrange elements for a more successful composition. Share results with classmates, and discuss how each person treated the same subject matter. This activity may also be done as an Internet exchange between art classes from two schools.

3. How is the experience of looking at an artwork like the experience of looking at a beautiful sunset? Or are these experiences completely different?
4. How do beliefs about art affect the way people look at and explore artworks?

The questions that aestheticians ask do not necessarily investigate a specific artwork. Instead, they investigate the larger world of art in general.

**Computer Option**
Have a volunteer begin an artwork on the computer by drawing a few lines. Then transfer the file from student to student. Have each person add to the artwork. After everyone has contributed, discuss how the artwork changed as it was passed along. Did the computer drawing gain a sense of unity? Why or why not?

**Try This**

Show one of your finished artworks to a partner. Ask what she or he thinks it might be about. Have your partner point to specific details to support the answer. Does your partner understand the work in the way you wanted? Or does the piece mean something else to your partner? Do you think it's okay for people, including the artist, to have different interpretations of the same artwork? Discuss your answers to these questions with your partner.

**Foundation Lesson 4.4**
**Check Your Understanding**
1. Explain what aesthetics is. What type of questions do aestheticians ask?
2. Why is it important to learn about art?

**Assess**

**Check Your Understanding: Answers**

1. Aesthetics is the philosophy, or investigation, of art. Students should cite one of the text questions or another, similar question.

2. Beliefs about art affect the way that someone might look at and produce art.

**Close**

Review the four areas of art inquiry. Provide small groups with an art reproduction. Instruct group members to take the roles of art historian, art critic, artist, and aesthetician; and to ask questions from their area of inquiry. Have students share their analysis with the class.

**More About...**

American architect **Frank Gehry** (b. 1929) was hired by the Guggenheim to design a building—in Bilbao, Spain—that would be so unusual that the world would come to see it. In the Basque city on Spain's north coast, Gehry created the **Museo Guggenheim Bilbao**, a dazzling building of interconnected blocks of Spanish limestone united by glass walls and a sculptural titanium roof crowned by a metallic "flower." The structure incorporates the Puente de la Salve, one of the city's busiest bridges.

**Using the Large Reproduction**

17

Use to discuss questions in "Thinking About Experiences with Art."

**Using the Overhead**

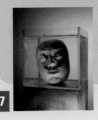
17

**Ask:** Do artworks have to be beautiful or pretty? Should there be rules to follow?

**Assessment Options**

**Teacher** Imagine that community leaders have announced a plan to redesign an area of your community blighted by vacant and structurally unsound buildings. Write a short letter to the community leaders in support of including an aesthetician on the planning and redesign team. The letter should state what the concerns of an aesthetician would be, what kinds of questions she or he might ask, and why this would be important for the community.

## Daily Life

Collect contemporary movie and music reviews, and distribute them to pairs of students. Have each pair read and discuss the review, identify criteria used for evaluation by the critic, and agree or disagree with the critic's evaluation. Have students share their reflections with the rest of the class.

## Social Studies

Ask students to consider if and how artworks can serve as primary sources and if both original artworks and reproductions, such as posters and slides, can be considered primary sources.

## Mathematics

Explain to students that mathematics, like art, has a history, and that the two fields might, at times, be connected. The Renaissance development of the mathematical system of perspective is one example. Have students work in small groups to research an assigned historical period to discover milestones in mathematics. Assign chronological periods so that a span, perhaps, of several centuries is represented. Challenge students to discover connections between math and the arts. Instruct groups to use their findings to create an illustrated time line of their assigned period. Display and discuss all the finished sections together.

# Connect to...

## Careers

One approach to art is art therapy. In this field, **art therapists** encourage people with certain emotional or physical problems, who are in counseling or psychotherapy, to express their emotions through drawing, painting, or other forms of artwork. The art is then used as a way to diagnose and treat the problems. Art therapists try to encourage their clients' self-awareness and personal growth. These art specialists work with people of all ages in hospitals, clinics, community centers, drug and alcohol treatment centers, schools, and prisons, and through individual or family counseling. Art therapists must understand a wide range of art forms and visual expression, psychology, and psychiatry; and must train extensively in specialized art-therapy programs, which are offered by a small number of colleges and universities.

F4–16 Art therapists can work with people of any age. They use art materials for painting, sculpting, and drawing as a way for people to express and communicate their feelings and emotions about difficult situations and problems. An art therapist with artwork by patients.
Photo courtesy Milissa Hicks.

## Daily Life

Do you think you come across **artistic criticism in your daily life**? Do you ever read movie, music, or software reviews in magazines or newspapers? If so, you are reading journalistic criticism, written for the general public about newsworthy subjects. Some newspapers publish reviews that target a student audience. Do you find such reviews to be generally positive? Or negative? Most people think of criticism as negative, but journalistic criticism is more likely to present both pros and cons. Through the approach of persuasive writing, the critic wants to convince you to share his or her opinion, whether good, bad, or indifferent. A good review might convince you, for instance, to go to a particular movie or buy a certain CD or piece of software; a bad review may convince you to stay home and save your money!

F4–17 What would convice you to see a movie or buy a CD? When you give a friend your opinion about a movie or a song, are you acting like a critic? Gene Siskel and Roger Ebert.
Photograph © David Allen/CORBIS.

**Internet Connection**
For more activities related to this chapter, go to the Davis website at **www.davis-art.com.**

## Teaching Options

### Resources

Teacher's Resource Binder
    Using the Web
    Interview with an Artist
    Teacher Letter

### Interdisciplinary Planning

Let language-arts teachers know of your efforts to have students write art criticism. With the assistance of your colleagues, students could write their first drafts in art class, and revise them in language arts.

### Video Connection

Show the Davis art careers video to give students a real-life look at the career highlighted above.

## Other Arts

### Dance

In this chapter, you learned about the types of questions people ask about a work of visual art. The same questions can be asked about a work of dance. Dance communicates our questions and ideas about who we are and how we can understand our relationship to others and to the world. **People dance for many reasons:** to communicate cultural identity, to provoke discussion, to tell a story, and so on. Think about the role that dance plays in your life. What kind of dance do you do? Why do you dance? Why does dancing feel good?

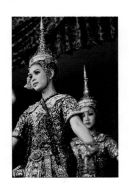

F4–18 Traditional Thai dance dates back to 650 AD and is still performed today. Each dance tells a story and the characters in the story have special costumes worn by the dancers. Why do people keep these dances alive by performing them? Classic Thai dance performed in Thailand.
Courtesy Davis Art Slides.

## Other Subjects

### Social Studies

As an approach to research, historians use **primary and secondary sources**. Do you know the difference between them? Primary sources are original materials, like diaries, letters, artifacts, artwork, photographs, and personal interviews. Secondary sources, such as your textbooks, are considered to be interpretations of primary sources. Which do you think would be more reliable? Why?

### Language Arts

Literary criticism is writing that explains or judges works of literature. Such criticism is written for a scholarly audience and appears in published, professional reviews of literature, such as academic journals. **Literary criticism** may also be published in other print media or online, or shared with colleagues through presentations at conferences and seminars. Critics of literature are often college or university professors with knowledge about a particular style, period, form, or writer. Can you find examples of literary criticism in your language-arts book? If you have ever written a book review, you have engaged in literary criticism.

### Mathematics

Have you ever wondered why we tell time in increments of 60? More than 5000 years ago, the ancient Babylonians used a **system of numbers** based on the concept of 60. This is the origin of our familiar 60-second minute and 60-minute hour. Although you may never have thought about math as having a history, it does have one—and it still affects us. Have approaches to math changed over time? How could you learn more about the history of math?

### Science

The **comprehensive approach** to art presented by this text actually developed, in part, from the launching of a Russian satellite. In 1957, the Russians launched the first *sputnik*, an artificial satellite. In America, the sputnik launchings heightened fears of world communism and nuclear war. In response, American schools put a **new emphasis on learning**, and encouraged hands-on approaches, instead of memorization of facts and figures. This approach was also used in art classes. For instance, students no longer studied only artists, but also the **roles and ideas of art historians, art critics, and aestheticians**.

Approaches to Art

63

## Other Arts

Select classroom-appropriate music videos (such as those by Mariah Carey, Jennifer Lopez, and Will Smith) in which the musician also dances.

Ask students to work in small groups to imagine that they have been hired to review the video for a national dance magazine. Guide group members to write answers to each section, based on the dance in the video and on outside research. Have each group assemble the individual pieces into one article and then share with the rest of the class.

**History** Who is the musician/dancer? Who choreographed this? What story is told through the dance? To further extend research, ask students to determine how this dance is similar to and different from other dances performed by this artist in other videos.

**Aesthetics** People dance for many reasons: Why does this artist use dance in this video? What do we learn about the artist through the dance? How does this dance compare to dances that you and your friends do? If you were to name this dance, what would you call it? Why?

**Criticism** Describe the physical movements that the musician/dancer uses. Describe the setting and costumes. What makes the dance in this video successful? Overall, what message does this video convey to an audience?

---

## Talking About Student Art

When talking with students about their art, philosophical questions often emerge. For example, students might ask, "What makes an artwork good?" or "Should artworks always be realistic?" Take advantage of the opportunity to talk about such questions, or write them on the board and discuss them at another time.

## Sketchbook Tip

Emphasize the importance of recording questions in sketchbooks. Suggest to students they get in the habit of completing prompts such as "I wonder how____." "I wonder if____." "I wonder why____." "I wonder about____." "I wonder who____."

## Portfolio Tip

Have students help you develop criteria and rubrics. Students take their work more seriously and are better equipped to select work for their portfolio when they are involved in the process of determining criteria and evaluating their performance.

# Portfolio

"This assignment revolved around a jazz theme my art teacher chose. While creating my composition, I concentrated on keeping it clean and in proportion. I had fun creating it, and it gave me a chance to work on some different techniques." **Shaun Berhow**

F4–19 Shaun Berhow, *Untitled*, 1998.
Stippled ink, 6" x 9" (15 x 23 cm). T.R. Smedberg Middle School, Sacramento, California.

"My pot symbolizes my freedom more than my Hispanic culture. I picked an object I liked and designed it like Mexican pottery. I chose colors that would catch a person's eye. Our culture is important, but with wings you can fly away from your troubles." **Veronica Martinez**

F4–21 Veronica Martinez, *Fly Away*, 1999.
Clay and acrylic, 4" x 5" x 3" (10 x 13 x 7.5 cm).
Sweetwater Middle School, Sweetwater, Texas.

**CD-ROM Connection**
To see more student art, check out the Community Connection Student Gallery.

F4–20 Kaare Patterson, *Just Chill*, 1998.
Colored pencil, 12" x 18" (30.5 x 46 cm). Plymouth Middle School, Plymouth, Minnesota.

"I thought it would be cool and weird to see penguins on a beach instead of in the arctic. While I was drawing, I was thinking of how I wanted the penguins to act on the beach. The part I like the most is the colors and how I shaded different parts. Also, I like the penguin in the center lying down with his glass in one flipper and his other one sprawled out." **Kaare Patterson**

64

## Teaching Options

### Resources

Teacher's Resource Binder
Chapter Review F4
Portfolio Tips
Write About Art
Understanding Your Artistic Process
Analyzing Your Studio Work

### CD-ROM Connection

For students' inspiration, for comparison, or for criticism exercises, use the additional student works related to studio activities in this chapter.

# Foundation 4 Review

### Recall
Define art history, art criticism, art production, and aesthetics.

### Understand
Explain the major difference between an art critic and an art historian.

### Apply
Make a list of questions you might pose for *Carhenge*, Fig. F4–4 *(see below)*, if you were an art critic, and then try answering them.

### Analyze
Compare and contrast the message the artists of Figs. F4–11 and F4–14 wanted to convey. How did their choice of materials help communicate their ideas? Although both works are constructed from metal, how did the artists use the medium differently?

### Synthesize
Research the two works and the societies that produced the Native American art in Fig. F4–1 and Fig. F4–5. Prepare a display with photographs, maps, illustrations, and explanatory labels that compares and contrasts the two pieces—their meaning, use, and relationship to the cultures from which they stem.

### Evaluate
Consider the different approaches to art discussed in Foundation 4 and select the one that you think is most important. Alternatively, create an argument for the necessity of combining all the approaches when examining any work of art.

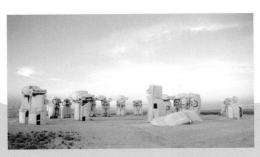

Page 53

### For Your Portfolio
Select one of your completed artworks to insert in your portfolio. Using your own artwork as the focus, write what you think an art historian, a critic, a philosopher, and an artist might wonder about when looking at it. What would they look for? What questions might they ask? Date your writing and your artwork and put both into your portfolio.

### For Your Sketchbook
Select an artwork from any chapter in your textbook. Write at least fifty questions about your selected artwork. Review your list of questions and indicate those that might be asked by an artist, a critic, an art historian, and a philosopher of art (aesthetician). Create a symbol for each of these four art professionals as a way of marking your questions.

Approaches to Art

65

## Family Involvement
Plan a "Local History Day," and invite family members to tell their stories about life in the community in times past. Have students record important parts of the stories and create a bulletin board of their writing.

## Community Involvement
Invite members of the local historical society to talk about objects, documents, and other community artifacts. Also ask that they tell about their work and how students can become involved.

## Advocacy
For a special visit or event such as a "Local History Day," invite an interested family member to arrange appropriate media coverage, such as photography of the event.

## Foundation 4 Review Answers

### Recall
the story behind art; the search for meaning in art; the making of art; the investigation into why art is made and what its context is in society

### Understand
An art critic looks at a work for clues about its meaning and importance. An art historian looks at culture/context in which art was produced and its relationship to other works.

### Apply
What does the artwork look like? *(Its form recalls the ruins of prehistoric or ancient sites.)* What is it about? *(The artist might have been asking the viewer to consider metal cars as a modern equivalent of ancient stone, and to be aware of the contrast between the urban world and nature.)* Who made the work, and when and where did they do so? *(Kirby, Smith, and Wilkins, contemporary artists, "planted" manufactured, industrial materials in a huge, empty landscape.)*

### Analyze
Answers will vary. Check to see that students support their ideas with what they see in the art.

### Synthesize
Look for an understanding of the difference between the Native cultures and the way each culture was expressed. For example, although the Navajo rug depicts spirits and the Plains robe describes a spiritual dance, the materials are different: the wool of the rug reflects an agricultural society; the buffalo hide represents a hunting society.

### Evaluate
Look for thoughtful and thorough articulation of ideas and preferences.

### Reteach
Have students write an explanation about an artwork of their own that they like. Then ask them to review the information in Foundation 4, and to write answers, about their work, to the text questions for each approach. Afterward, ask students to use these answers to revise their original explanation. Have them also describe what surprised them most about the process of approaching their own art from four different angles.

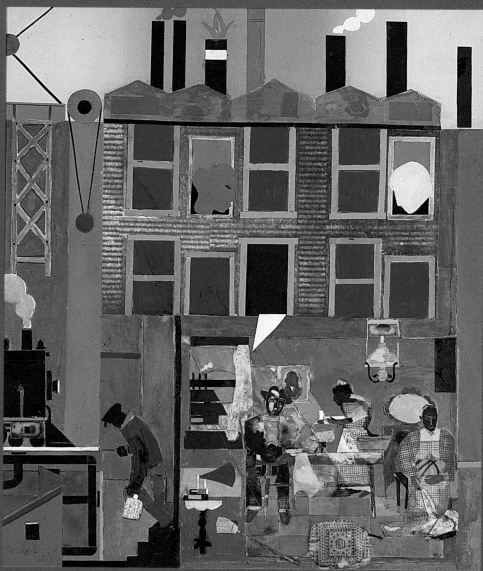

Page 74

# Art Is a Community Connection

**If someone were to ask you to talk about your community, what would you say? First of all, what is your community? You may be surprised to learn that you have more than one!**

Do you live in a city neighborhood, a town, or a village? One way to identify a community is by its geographical boundaries—that's probably the kind of community you think of first. But community can mean more than the return address on your letters. Think about the things you like to do. You might belong to a sports team, go to church or a synagogue, or be a part of a club at school. All those groups are communities, too.

People everywhere like to tell others about their communities. They like to celebrate what is special about where they live or what they do. They like to let other people know about their heroes, their history, and the things they believe. All over the world, art helps people tell these things.

In this part of this book, you'll learn about the many different ways that communities have used art to communicate. You'll learn that throughout recorded history, people everywhere have used art to teach each other, to keep records of their lives, to celebrate during good times and express feelings in times of sorrow.

As you look at and read about the artworks on these pages, think about the communities you belong to. How is art a part of those communities? How can art help connect your communities to other communities around you? And why is that community connection so important to human beings?

# Chapter Organizer

## Chapter Focus

**Chapter 1 Telling**
Chapter 1 Overview
pages 68–69

- **Core** Art helps people communicate stories, lessons, important ideas, and feelings.
- **1.1** Art in Early North America
- **1.2** Looking at Craft Traditions
- **1.3** The Art of Mesoamerica and South America
- **1.4** Making Paper

## Chapter National Standards

1  Understand media, techniques, and processes.
2  Use knowledge of structures and functions.
3  Choose and evaluate subject matter, symbols, and ideas.
4  Understand arts in relation to history and cultures.
5  Assess own and others' work.

---

**9 weeks: 2  18 weeks: 2  36 weeks: 2**

### Objectives

**Core Lesson
Community Messages**
page 70
Pacing: Two 45-minute periods

- Identify the information that artworks can give about a community.
- Explain how communities use artworks for communication.

### National Standards

**5b** Analyze contemporary, historical meaning through inquiry.

---

**Core Studio
A Telling Collage**
page 74

- Create a collage that tells about membership in multiple communities.

**3b** Use subjects, themes, symbols that communicate meaning.

---

**36 weeks: 3**

### Objectives

**Art History Lesson 1.1
Art in Early North America**
page 76
Pacing: Three 45-minute periods

- Describe unique features of art forms made in early Native American communities.
- Attribute art forms to cultural communities.

### National Standards

**4a** Compare artworks of various eras, cultures.
**4b** Place objects in historical, cultural contexts.
**4c** Analyze, demonstrate how time and place influence visual characteristics.
**5a** Compare multiple purposes for creating art.

---

**Studio Connection**
page 78

- Design a fiber artwork that shows group membership.

**3b** Use subjects, themes, symbols that communicate meaning.

---

**36 weeks: 2**

### Objectives

**Forms and Media
Lesson 1.2
Crafts**
page 80
Pacing: Two 45-minute periods

- Explain how people use natural materials to make useful objects within local craft traditions.

### National Standards

**1a** Select/analyze media, techniques, processes, reflect.
**4a** Compare artworks of various eras, cultures.
**5a** Compare multiple purposes for creating art.

---

**Studio Connection**
page 81

- Use natural materials to create a piece of jewelry.

**1a** Select/analyze media, techniques, processes, reflect.

## Featured Artists

Romare Bearden
Luis Jiménez
Maya Lin
Clark Mills
Jeanne Petrosky

Kevin Warren Smith
Rebecca Fisher
Stoltzfus
Kara Johns Tennis

## Chapter Vocabulary

codex
communication
collage
crafts
geometric

organic
pre-Columbian
pueblo
pulp
slurry

## Teaching Options

Teaching Through Inquiry
More About…Native-American war shields
More About…Southwest Pietà
More About…Luis Jiménez
Meeting Individual Needs
Using the Overhead
Using the Large Reproduction

## Technology

CD-ROM Connection
e-Gallery

## Resources

Teacher's Resource Binder
Thoughts About Art:
1 Core
A Closer Look: 1 Core
Find Out More: 1 Core
Studio Master: 1 Core
Assessment Master:
1 Core

Large Reproduction 1
Overhead Transparency 2
Slides 1a, 1b, 1c

---

Meeting Individual Needs
Studio Collaboration
Teaching Through Inquiry
More About…Communities
Assessment Options

CD-ROM Connection
Student Gallery

Teacher's Resource Binder
Studio Reflection: 1 Core

## Teaching Options

Meeting Individual Needs
Teaching Through Inquiry
More About…The Hohokam
Using the Overhead

## Technology

CD-ROM Connection
e-Gallery

## Resources

Teacher's Resource Binder
Names to Know: 1.1
A Closer Look: 1.1
Map: 1.1
Find Out More: 1.1
Assessment Master: 1.1

Overhead Transparency 1
Slides 1d

---

Teaching Through Inquiry
More About…Pueblos
Assessment Options

CD-ROM Connection
Student Gallery

Teacher's Resource Binder
Check Your Work: 1.1

## Teaching Options

Teaching Through Inquiry
More About…Kara Tennis
Using the Overhead
Assessment Options

## Technology

CD-ROM Connection
e-Gallery

## Resources

Teacher's Resource Binder
Finder Cards: 1.2
A Closer Look: 1.2
Find Out More: 1.2
Assessment Master: 1.2

Overhead Transparency 1

---

CD-ROM Connection
Student Gallery

Teacher's Resource Binder
Check Your Work: 1.2

# Chapter Organizer continued

9 weeks | 18 weeks | 36 weeks

| | | 36 weeks | | **Objectives** | **National Standards** |
|---|---|---|---|---|---|
| | | 3 | **Global View Lesson 1.3 Meso/South American Art** page 82 Pacing: Three 45-minute periods | • Describe features of art/architecture in early Mesoamerican and South American communities. <br>• Explain the importance of paper and symbol systems in early Mesoamerica. | **3a** Integrate visual, spatial, temporal concepts with content. <br>**4a** Compare artworks of various eras, cultures. <br>**5b** Analyze contemporary, historical meaning through inquiry. |
| | | | **Studio Connection** page 84 | • Create a modular sculpture that communicates ideas and feelings. | **2b** Employ/analyze effectiveness of organizational structures. |

| | | | | **Objectives** | **National Standards** |
|---|---|---|---|---|---|
| | 3 | 3 | **Studio Lesson 1.4 Making Paper** page 86 Pacing: Three 45-minute periods | • Explain the history and importance of papermaking. <br>• Outline the steps in a simple papermaking process. <br>• Create a handmade-paper artwork that has a message about community. | **1b** Use media/techniques/processes to communicate experiences, ideas. <br>**2b** Employ/analyze effectiveness of organizational structures. <br>**3a** Integrate visual, spatial, temporal concepts with c● <br>**4c** Analyze, demonstrate how time and place influenc● visual characteristics. |

| | | | | **Objectives** | **National Standards** |
|---|---|---|---|---|---|
| • | • | • | **Connect to...** page 90 | • Identify and understand ways other disciplines are connected to and informed by the visual arts. <br>• Understand a visual arts career and how it relates to chapter content. | **6** Make connections between disciplines. |

| | | | | **Objectives** | **National Standards** |
|---|---|---|---|---|---|
| • | • | • | **Portfolio/Review** page 92 | • Learn to look at and comment respectfully on artworks by peers. <br>• Demonstrate understanding of chapter content. | **5** Assess own and others' work. |

2

Lesson of your choice

## Teaching Options

Teaching Through Inquiry
More About...The Olmec, Maya, Aztec
Using the Large Reproduction

## Technology

CD-ROM Connection
  e-Gallery

## Resources

Teacher's Resource Binder
  A Closer Look: 1.3
  Map: 1.3
  Find Out More: 1.3
  Assessment Master: 1.3

Large Reproduction 2
Slides 1e

---

Meeting Individual Needs
Teaching Through Inquiry
More About...Chichen Itza
Assessment Options

CD-ROM Connection
  Student Gallery

Teacher's Resource Binder
  Check Your Work: 1.3

## Teaching Options

Meeting Individual Needs
Teaching Through Inquiry
More About...Papermaking
More About...Recycling
Studio Collaboration
Assessment Options
Wit and Wisdom
Using the Overhead

## Technology

CD-ROM Connection
  Student Gallery
Computer Option

## Resources

Teacher's Resource Binder
  Studio Master: 1.4
  Studio Reflection: 1.4
  A Closer Look: 1.4
  Find Out More: 1.4

Large Reproduction 2
Slides 1f

## Teaching Options

Community Involvement
Interdisciplinary Planning

## Technology

Internet Resources
Video Connection
CD-ROM Connection
  e-Gallery

## Resources

Teacher's Resource Binder
  Using the Web
  Interview with an Artist
  Teacher Letter

## Teaching Options

Advocacy
Family Involvement

## Technology

CD-ROM Connection
  Student Gallery

## Resources

Teacher's Resource Binder
  Chapter Review 1
  Portfolio Tips
  Write About Art
  Understanding Your Artistic Process
  Analyzing Your Studio Work

# 1 Telling

## Theme

People in communities devise symbols and other ways to communicate with one another. A powerful way in which people in communities may tell about their ideas and feelings is through art.

## Featured Artists

Romare Bearden
Luis Jiménez
Maya Lin
Clark Mills
Jeanne Petrosky
Kevin Warren Smith
Rebecca Fisher Stoltzfus
Kara Johns Tennis

## Chapter Focus

This chapter introduces students to various ways that communities use art to tell about their common ideas and feelings, and shows that inferring such ideas and feelings is often possible through careful observation of artworks. Students are asked to consider the multiple communities of which they are members, how the art of early Native-American communities was used for communicating ideas, and how people in communities use jewelry and other craft traditions for telling about themselves. In considering the art of Mesoamerica and South America, students learn how people used symbols to convey what was important to them. Students also make handmade paper and use this medium for telling about their community identity.

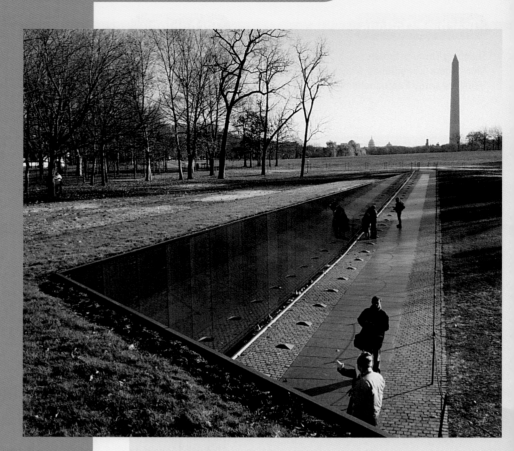

Fig. 1–1 On any day at the *Vietnam Veterans Memorial* in Washington, DC., you can see someone slowly touching a name, remembering a loved one, and perhaps leaving a token—a flower, a poem, or other special object. Maya Lin, *Vietnam Veterans Memorial*, Washington, DC, 1982. Black granite, 493' long (150 m). Constitution Gardens, Washington, DC. Photo by Robert Hersh.

68

## National Standards Chapter 1 Content Standards

1. Understand media, techniques, and processes.
2. Use knowledge of structures and functions.
3. Choose and evaluate subject matter, symbols, and ideas.
4. Understand arts in relation to history and cultures.
5. Assess own and others' work.

**Teaching Options**

### Teaching Through Inquiry

**Art History** Ask students to compile information about the **Vietnam Veterans Memorial**, and to discover why the memorial was, and continues to be, controversial. Suggest to students that they interview friends and family members about their reaction to the memorial. Students may display or otherwise share their work.

### More About...

**Maya Lin** submitted the design for "The Wall" while studying at Yale. Both this and her Civil Rights Memorial are known for their power to evoke deep emotion. Speaking about her work, which often includes names and time lines, Lin said "I want a little kid to go to the place and question what this history was about, understand a little bit more, maybe read more. I'm not trying to dictate what people think; I'm just trying to present some facts and allow you to think."

## Focus

- How do people communicate their ideas and feelings to others in a community?
- How is art a way to express ideas and feelings?

**From the air, it looks like a large V-shaped gash in the ground. As you approach it on foot, you see a gently sloping walkway beside a smooth dark wall.** Up close, you can read the names of all the Americans who died or were reported missing in the Vietnam War. The *Vietnam Veterans Memorial* (Fig. 1–1) has become a national symbol for the loss of human life due to war of any kind. As of 1997, there were 58,209 names on the wall. Artist Maya Lin designed the memorial in 1982 to communicate a message about war. Visitors read the names engraved in the wall. Some people touch the names. They see their own reflections in its surface. What message might the wall give them? Visitors may think that ordinary people like themselves are not only affected by wars, but are also responsible for them. Do you agree?

Artworks play meaningful roles in communities because they communicate important ideas. The message of the *Vietnam Veterans Memorial* has been sent throughout this nation and around the world. Messages from artworks are also sent within smaller areas. Artworks can tell about the interests and concerns that community members share. They can tell about what is important to the community.

### What's Ahead

- **Core Lesson** Learn more about how people use art to send important messages.
- **1.1 Art History Lesson** Discover how early Native North American people used art for communication.
- **1.2 Forms and Media Lesson** Focus on ways that craft traditions began and continue within communities, with special attention to jewelry.
- **1.3 Global View Lesson** Explore how early cultures in Mesoamerica and South America used art to tell about what was important to them.
- **1.4 Studio Lesson** Investigate ways to tell about your community through handmade paper.

### Words to Know

| | |
|---|---|
| communication | craft |
| collage | pre-Columbian |
| geometric | codex |
| organic | slurry |
| pueblo | pulp |

## Chapter Warm-up

Ask students to develop a set of symbols with which they identify. Perhaps they belong to, or are fans of, clubs, sports teams, or religious groups that have special symbols. Remind students that when they wear or display these symbols, they send signals, or communicate with others, about themselves and their identity.

## Using the Text

Have students read the text to learn more details about the Vietnam Veterans Memorial. **Ask:** What message does the memorial communicate to people who visit it?

## Using the Art

**Perception** Ask students if any of them have visited the Vietnam Veterans Memorial or if they have a relationship to anyone whose name is on the wall. Ask volunteers to share their memories of their visit or information about the soldiers. Have students fill a sheet of paper with half-inch block-lettered names, and explain that on the memorial, this size of lettering extends for almost 500 feet. Discuss the powerful impact of so many names representing fallen soldiers.

### Graphic Organizer
### Chapter 1

**1.1 Art History Lesson**
Art in Early North America
page 76

**1.2 Forms and Media Lesson**
Crafts
page 80

### Core Lesson
Community Messages

### Core Studio
**A Telling Collage**
page 74

**1.3 Global View Lesson**
The Art of Mesoamerica and South America
page 82

**1.4 Studio Lesson**
Making Paper
page 86

### CD-ROM Connection

For more images relating to this theme, see the Community Connection CD-ROM.

# Community Messages

## Prepare

### Pacing

Two 45-minute periods: one to consider art and text, and to begin collage; one to complete collage

### Objectives

- Identify the information that artworks can give about a community.
- Explain how communities use artworks for communication.
- Create a collage that tells about membership in multiple communities.

### Vocabulary

**communication** A spoken, written, or visual means of expressing information; communication requires a sender and a receiver.

**collage** A work of art created by gluing bits of paper, fabric, scraps, photographs, or other materials to a flat surface.

### Supplies for Using the Art

- large reproduction, slide, or computer image of Michelangelo's Vatican *Pietà*

### National Standards Core Lesson

**3b** Use subjects, themes, symbols that communicate meaning.

**5b** Analyze contemporary, historical meaning through inquiry.

## Understanding Meaning

**Communication** is the exchange of information, thoughts, feelings, ideas, opinions, and much more. It can be spoken, written, or take an artistic, visual form. To communicate, you need a sender (someone who expresses ideas or feelings) and a receiver (someone who understands the message). As you have grown up, you have learned how to speak and write the language of your community. You have also learned how to understand visual messages. Messages are usually understood when the sender and receiver use the same spoken, written, or visual language.

Many of the artworks we see were made in communities that flourished hundreds and even thousands of years ago. Some of these artworks were made in faraway places. Because of this, we may never know the full meaning of the artworks. However, we might understand an artwork better by looking at its details and learning about the community in which it was made. Sometimes it helps to see other artworks from the same place or made by the same artist. For example, an object or symbol that is repeated in the artworks might mean something special to the community. We interpret the meaning of an artwork by finding such clues. They help us connect what we see to what we have learned from other sources.

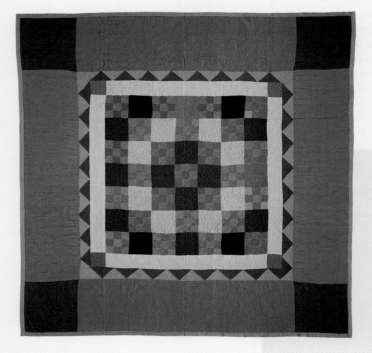

Fig. 1–2 The main design of this quilt is a pattern of squares, triangles, and rectangles. If you look closely, however, you will also see several stitched designs of stars, flowers, and leaves. Which of the quilt's designs represent the Amish ideas of simplicity? Of quality? Anonymous Amish quiltmaker, member of the Zook family, American, *Ninepatch*, Lancaster County, Pennsylvania, ca. 1930. Pieced wools, 80" x 80" (203.2 x 203.2 cm). Private Collection, Photo courtesy The Quilt Complex.

70

## Teaching Options

### Resources

Teacher's Resource Binder
  Thoughts About Art: 1 Core
  A Closer Look: 1 Core
  Find Out More: 1 Core
  Studio Master: 1 Core
  Studio Reflection: 1 Core
  Assessment Master: 1 Core
Large Reproduction 1
Overhead Transparency 2
Slides 1a, 1b, 1c

### Teaching Through Inquiry

**Art Criticism** Have students find **examples of quilts**, made in various parts of North America, that reflect different cultural traditions. Ask students to note the differences in design and propose how each design reflects community ideas and values. For example, African-American quilts reflect a sense of lively improvisation; these quilts and others reflect a concern for "making do," because of the use of recycled fabric pieces to create items for protection and warmth. To highlight the **communicative power of quilts**, have students create a display called "If Quilts Could Talk."

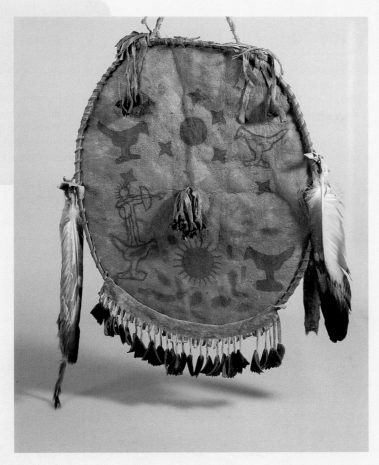

Fig. 1–3 Artists from Native-American cultures often use natural materials to create objects. They also decorate their objects with symbols that represent elements of nature. What might this suggest about the beliefs of Native-American cultures? Canada, *Thompson Indian River Shield*, no date. Deer skin stretched on a wooden hoop. Peabody Museum, Harvard University, Photograph by Hillel Burger.

## Communicating Beliefs and Values

Artworks often tell about a community's beliefs and values. The quilt in Fig. 1–2 was made by members of the Amish community in North America. The Amish are a religious group whose members often live close by each other. They believe in living simple, quiet lives. This is reflected in their quilt-making traditions. Amish quilts are beautifully crafted. They communicate the ideas of simplicity and quality through the use of solid colors and geometric shapes. It is sometimes easy to see the connection between the artwork and the beliefs of a community. In artworks such as the Native-American shield (Fig. 1–3), the meaning of the materials and images is not as clear. We might guess what the symbols mean, but we need to know more about the community to understand the artwork's message.

Telling

71

## Using the Text

**Art History** After students have read the text, discuss the ways that communities use artworks. *(show everyday lives; tell of exceptional people, historical events, special places; change ways of thinking; inspire)* **Ask:** What are the functions of the art on these pages? *(codex tells historical event; Southwest Pietà inspires)*

## Using the Art

**Art Criticism** Challenge students to decode the Aztec codex. The blue lines represent a lake. Images of warriors and skulls might indicate the Aztec practice of human sacrifice. Aztec artists often used these "long papers" to tell about spiritual matters, events, and everyday community life.

**Art History** Show students Michelangelo's *Pietà,* and discuss the similarity in pose to that of *Southwest Pietà,* and the cultural differences in attire. The *Southwest Pietà* is based on a traditional Aztec legend about two lovers. (See More About, below.)

## Teaching and Telling

Communities rely on artworks to show how their members work and play during their daily lives. People use art to tell stories about heroes, historical events, and special places. These stories are often told and retold in the community. Artworks can teach people different ways to think about the world around them. People depend on artists to observe life and, through their artworks, show others what they see.

People also use artworks for inspiration. An artwork might inspire them to reach for goals, to be quiet and reflective, or to do good deeds. Or an artwork might prompt

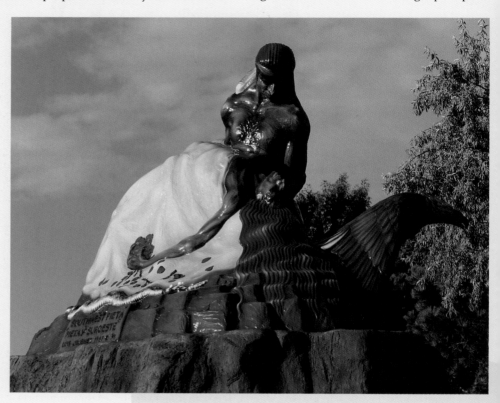

Fig. 1–4 The name of this artwork is *Southwest Pietà.* "Pietà" can mean mercy or pity. The word often brings to mind Michelangelo's sculpture of the Virgin Mary cradling the body of Christ. How is the subject of this sculpture different from Michelangelo's? What legend might this sculpture represent? Luis Jiménez, *Southwest Pietà,* Albuquerque, New Mexico, 1983. Fiberglass. Photograph by Bruce Berman. © 2000 Luis Jimenez/Artist Rights Society (ARS), New York.

## Teaching Options

### Meeting Individual Needs

**Multiple Intelligences/Interpersonal** Break the class into small groups, each electing one person to be the team leader, who will record, organize, and facilitate the tasks. Challenge students in each group to jointly select a theme for an artwork they will create together that relates to an important event in the school or community. The leader should make sure that everyone's voice is heard when the group plans, researches, and executes its artwork.

### Teaching Through Inquiry

**Art History** So that students may gain a better understanding of the message sent by the codex, have them work in groups to investigate the production and use of **Aztec codices.** Have groups record information under these headings: What We Know; What We Suppose; What We Still Need to Know. Have pairs of groups discuss their findings and how their research increased their understanding and appreciation of the artwork.

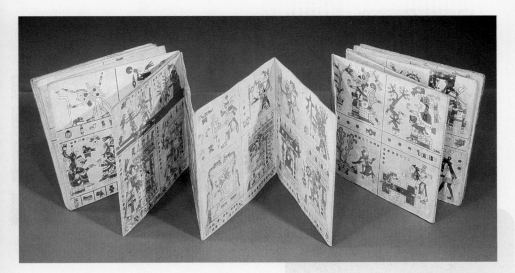

## Extend

• Encourage students to draw a set of symbols to tell the story of a local event. Ask students to consider who they think are the heroes, and then to develop symbols for them. For a story about a fire, for instance, a fire helmet with stylized flames and water hoses might represent the firefighters.

• Have students examine the images on pages 70–73 and then research each artist's era and culture. **Ask:** How does the culture reveal itself in the work?

people to rally around a cause. Artworks such as the *Vietnam Veterans Memorial* (Fig. 1–1, page 68) teach community values, such as peace. Some teach or tell about the religious beliefs of a community. Ancient cultures, such as the Aztec, used picture writing on painted animal hides to communicate important messages (Fig. 1–5). Other artworks, such as Luis Jiménez's *Southwest Pietà* (Fig. 1–4), show figures from a community's legends.

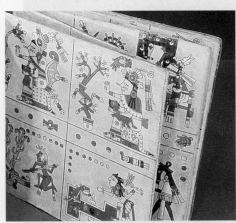

Fig. 1–5 We can learn a great deal about the Aztec culture from its visual language and its books, called *codices*. In what way is Aztec picture writing like the pictures you see in comics? Mexico, Mixtec style, *Codex Fejervary-Mayer* (shown partially unfolded). Beaten deer skin and limewash. Liverpool Museum, Liverpool, Great Britain. Werner Forman/Art Resource, NY.

Telling

## More About...

The ***Southwest Pietà*** is based on the Aztec story of Popocátepetl (Popo) and Ixtaccíhuatl (Ixta). Popo goes to war to prove to Ixta's father, the emperor, that he is worthy of Ixta. A rival of Popo's sends word to Ixta that her lover has been killed in battle. Ixta is so grief-stricken that she dies during her wedding to the rival. When Popo returns, he takes Ixta's body to the mountains, but he cannot bear to leave. The gods feel sorry for the lovers and turn them into twin mountains, near present-day Mexico City.

## More About...

**Luis Jiménez** was born in 1940 in El Paso, Texas. In the 1960s, Jiménez traveled to Mexico to reaffirm his ancestry and his commitment to figurative art. Jiménez's art is often compared to Diego Rivera's and Thomas Hart Benton's because it concerns working-class people and those who suffer from discrimination. Jiménez creates public sculpture by casting fiberglass around steel armatures and then airbrushing. He develops his ideas in detailed drawings, cutouts, and models.

## Supplies

- magazines
- envelopes
- paper, drawing or construction
- pencils, markers
- glue
- paint (optional)

### Safety Note

- Caution students to use knives and scissors carefully. If they use knives, have them cover their work area with cardboard.
- Avoid rubber cement—its fumes are toxic. Instead, use school glues, white glues, glue sticks, or other adhesives that have been certified safe for school use.

## Using the Text

**Art Production** After students have read the text to understand the type of collage they will create, lead them in developing lists of geographical communities (region, town, country, state, neighborhood) and shared-interest communities (clubs, sports teams, music or dance groups, religious groups, friends).

Have students work in groups to share magazines. Encourage students to cut out most of the photographs and experiment with different designs. Discuss how to emphasize students' most important communities.

## Using the Art

**Perception Ask:** How did Bearden indicate a community in *Pittsburgh Memories?* What scale relationships did he use? What is in the background? The foreground? What patterns, textures, shapes, and colors were repeated?

---

**1 CORE STUDIO**

**Drawing in the Studio**

## A Telling Collage

In this studio experience, you will use collage techniques to tell about the communities you know best. Think about the communities to which you belong. They might be geographical communities, or clubs and groups. Ask yourself: Which of these communities influence the decisions I make? Which ones affect my behavior, my clothing, or the way I spend my time? Rank the communities in terms of their importance. This will help you plan your collage.

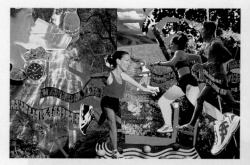

Fig. 1–6 This collage shows the artist's love of running, and her connection to others who run. Kristina Sacovitch, *Cross-Country Runners*, 2000. Collage, 10" x 15" (25.5 x 38 cm). Notre Dame Academy, Worcester, Massachusetts.

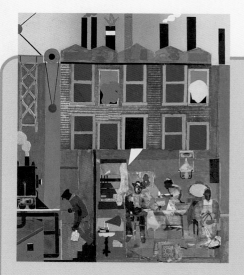

Fig. 1–7 Romare Bearden's artworks show his interest in his own African-American culture. What thoughts and feelings might he be expressing in this collage? Why do you think so? Romare Bearden, *Pittsburgh Memories*, 1984. Collage on board, 28 5/8" x 23 1/4" (72.7 x 59.7 cm). The Carnegie Museum of Art, Pittsburgh (Gift of Mr. and Mrs. Ronald R. Davenport and Mr. and Mrs. Milton A. Washington) © Romare Bearden Foundation/Licensed by VAGA, New York, NY.

## Studio Background

### Collage Techniques

**Collage** is a French word for pasted paper. In a collage, flat materials such as paper, fabric, news-clippings, or photographs are pasted on a background. Collage artists may also use pieces of natural materials (twigs, seashells) and other odds and ends. They might add details, shapes, and colors with markers, crayons, or charcoal. Artists use collage to express thoughts, feelings, and ideas about a subject.

Romare Bearden created many collages about life in big cities. In *Pittsburgh Memories* (Fig. 1–7), he remembers his grandmother's boardinghouse in Pittsburgh, Pennsylvania. With shapes, colors, and details, he shows a picture of the community there. For *Cloak of Heritage* (Fig. 1–8), artist Kevin Warren Smith chose photographs of American Indians to help express ideas about his heritage.

---

## Teaching Options

### Meeting Individual Needs

**Assistive Technology** Provide a graphic organizer to help students organize their thoughts about communities.

**Adaptive Materials** Rather than using bottles of glue, provide glue sticks.

### Studio Collaboration

Student pairs may work together to make their collages. Suggest that partners help select images and evaluate each other's collages.

### Teaching Through Inquiry

**Art Production** Invite pairs of students to interview each other about their **membership in various communities**. Suggest categories—such as family, recreation, gender, religion, geographical location, age group, and ethnicity. Ask students to consider how membership in the groups helps create their identity. **Ask:** What do you do with your time? What do you care about? How do you dress? Have students each create a graphic organizer to show what they discovered about themselves.

## You Will Need

- magazines
- drawing paper
- pencils
- glue
- markers
- paint (optional)

## Try This

**1.** Look for and cut out magazine images that symbolize your membership in multiple communities. You may wish to include your own drawings or cut-paper designs. Do not use letters or words.

**2.** Arrange the images on a background using the principles of design: balance, rhythm, proportion, emphasis, pattern, unity, and variety. Try different arrangements before pasting the images. Choose an arrangement that expresses a message about your community memberships and their rank.

**3.** Glue the images to the background. Use markers, colored paper, or paint to add meaning to your collage.

## Check Your Work

Display your completed collage with those of your classmates. Take turns describing what you see in each other's artworks. Can you name the communities to which each student belongs? Discuss how each artist has arranged pictures to express a message.

### Sketchbook Connection

In your sketchbook, write about your experience of creating a collage. Describe the process you used to select images. Tell how you organized the images. What did you think about as you organized your collage? When you create another collage, what might you do differently?

### Core Lesson 1

#### Check Your Understanding

**1.** What can artworks tell about a community?
**2.** How can we learn about artworks created long ago or far away?
**3.** How do people in a community use artworks?
**4.** What materials do artists use to create collages?

Fig. 1–8 The subject matter of Kevin Warren Smith's work often focuses on Native-American themes. Why might the woman who wears the cloak be important? Kevin Warren Smith, *Cloak of Heritage*, 1991. Acrylic and collage on canvas, 24" x 36" (61 x 91.4 cm). © 1991 Kevin Warren Smith.

Telling

75

## Sketchbook Connection

Encourage students to use tracing paper to analyze the organization of artworks from their text and other sources. Suggest to students that they tape the diagrams into their sketchbook, along with comments about the organizational schemes that they particularly like and hope to use in their own artworks.

## Assess

### Check Your Work

**Ask:** How does each collage tell about the communities you know? Was it easy or difficult to tell about them without using words? Why? Lead a discussion of how various principles of design were used by students.

### Check Your Understanding: Answers

**1.** Artworks can communicate a community's important ideas, interests, concerns, beliefs, and values.

**2.** by looking carefully at details, using other sources to find out more about the community, and by examining other artworks made within the community

**3.** People use artworks to communicate ideas and feelings, to show aspects of community life, to tell stories, to teach, and to inspire.

**4.** photographs, colored paper, fabric, news clippings, other odds and ends, drawing materials

## Close

Discuss students' answers to Check Your Understanding. **Ask:** Of all the art in this chapter, which do you think tells us the artist's message most effectively? Have students explain their choices.

## More About...

Geographical **communities** are identified by physical boundaries or characteristics. Neighborhoods, villages, boroughs, towns, counties, and cities, for example, are geographical communities, as are lake, mountain, forest, ocean, and desert areas. Communities are also identified by shared interests and experiences. Members share such things as school, athletics, religion, recreation, and professions. Shared-interest communities might also be based upon ethnic or racial heritage. A person can be a member of many different communities—some defined by geographical boundaries and some defined by special interests, background, or experiences.

## Assessment Options

**Teacher** Have students select one artwork in this lesson and write a short essay about how it communicates. They should include what the artwork tells about the community in which it was created, and explain how the work was or is used within the community: to communicate ideas and feelings, to show aspects of community life, to tell stories, to teach, and/or to inspire.

## Prepare

### Pacing
Three 45-minute periods: one to consider art and text; two to make art

### Objectives
- Describe unique features of art forms made in early Native-American communities.
- Attribute art forms to cultural communities.
- Design a fiber artwork that shows group membership.

### Vocabulary
**geometric** A shape or form that has smooth, even edges.

**organic** A shape or form that is irregular in outline, such as things in nature.

**pueblo** Community dwellings of stone or adobe built by the indigenous peoples of the southwestern United States and northern Mexico.

### Using the Time Line
Ask students to consider the age of the designed objects shown on this time line. Encourage a discussion of how artworks such as these might have survived, intact, until today.

### National Standards
### 1.1 Art History Lesson

**4a** Compare artworks of various eras, cultures.

**4b** Place objects in historical, cultural contexts.

**4c** Analyze, demonstrate how time and place influence visual characteristics.

**5a** Compare multiple purposes for creating art.

# Art in Early North America

| | ca. 1100 AD | |
|---|---|---|
| ca. 1000–1200 AD Anasazi pitcher | Classic Pueblo Period pottery | ca. 1100–1400 AD Hohokam red-on-buff bowl |

Prehistory · Ancient North America · Colonial North America page 102

| ca. 400–500 AD Anasazi woven objects | ca. 1100 AD *Cliff Palace* | 1200s *Lizard Bowl* Mimbres People |

### History in a Nutshell

North America includes Canada, the United States, and Mexico. During the Ice Age, between 30,000 and 10,000 years ago, small groups of people began populating the North and South American continents. Most historians believe these people came from Asia across the frozen Bering Strait. They migrated slowly eastward into what are now Canada and the northern United States. Eventually, people moved further south. The ancient southwestern part of the United States became the home of three Native-American cultures—the Hohokam, the Mogollon, and the Anasazi—each with its own special way of life.

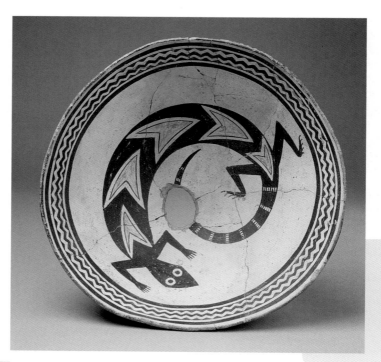

Fig. 1–9 This painted bowl shows a lizard. How is the decoration on this vessel different from the others shown in this lesson? Mimbres People, *Lizard Bowl*, 13th century. Polychrome. Peabody Museum, Harvard University, Photograph by Hillel Burger.

## Teaching Options

### Resources

Teacher's Resource Binder
- Names to Know: 1.1
- A Closer Look: 1.1
- Map: 1.1
- Find Out More: 1.1
- Check Your Work: 1.1
- Assessment Master: 1.1

Overhead Transparency 1

Slides 1d

### Meeting Individual Needs

**English as a Second Language** Conduct a discussion with students in English about the image within the bowl in Fig. 1–9. **Ask:** How has the artist shown a lizard? Do lizards really look like this? Have students draw their own image of a lizard, and then either write about or discuss in English the choices they made in their artwork.

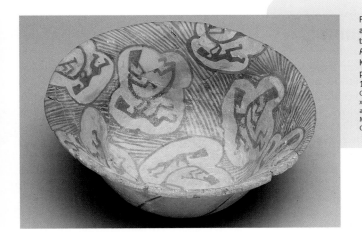

Fig. 1–10 Do you see why early archaeologists called the Hohokam the "red-on-buff culture"? Hohokam, *Red-on-Buff Bowl*, 9 panels with Kokopeli ("Hump-backed flute player") design, classic period 1100–1400 AD. Ceramic, diam. 6 ¾" (17.2 cm) x d. 2 ¾" (17.2 x 7 cm). Gift of Paul Clute. Museum of Indian Arts and Culture/Laboratory of Anthropology, Museum of New Mexico. Photograph by Blair Clark.

## Community Messages

Archaeologists and art historians can often tell where an ancient pottery jar or bowl or woven basket came from by studying its form and decoration. Each ancient Native-American community used colors, lines, shapes, and patterns in unique ways. The designs and patterns meant something special to the people who lived at the time. They were often symbols of nature.

The Hohokam lived in what is now Arizona. They created red-on-buff painted designs that showed symbols of animals, masked dancers, and gods (Fig. 1–10). The Mimbres were a Mogollan people who lived in the high mountains of what is now New Mexico. They created elegant black-on-white designs on pottery bowls. These designs were both **geometric** (using shapes

such as squares and triangles) and **organic** (using shapes from nature) (Fig. 1–9). Anasazi potters lived in large apartment-like complexes in the Four Corners region of Utah, Colorado, Arizona, and New Mexico. The Anasazi also used black-on-white patterns, but they were very different from the patterns of the Mimbres (Fig. 1–11).

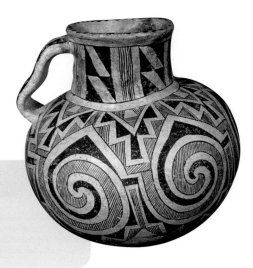

Fig. 1–11 The Anasazi painted their pottery with a dye made by boiling shoots of woodland aster. The pattern surrounds the pot. What repeated elements can you see in this pattern? Native American, Tularosa, *Black-on-White Pitcher*, ca. 1000–1200 AD. Ceramic, h. 7 ⅛" (18 cm) x d. 6 ⅞" (17.5 cm) x circum. 23" (58.4 cm). Courtesy the Maxwell Museum of Anthropology, University of New Mexico, Albuquerque, NM.

Telling

77

## Teach

### Engage

Locate the Four Corners region of the United States, and tell students that they will study art from this area. Ask students to tell what they know about this region, and to describe the climate, landscape, and animal life. *(dry; deep gorges, cliffs, mesas; rattlesnakes and other desert animals)*

### Using the Text

**Art History** Have students read History in a Nutshell. **Ask:** When did people most likely first migrate to the Americas? *(between 30,000 and 10,000 years ago)* What three Native-American cultures lived in the ancient southwestern part of the United States? *(Hohokam, Mogollon, Anasazi)*

**Art Production** Have students read the text to find evidence of the materials and techniques that early Native-American artists used.

### Using the Art

**Perception** Ask students to describe the lines, shapes, and patterns in each artwork on pages 76 and 77. **Ask:** In what ways are the patterns and the visual elements arranged? Although each group's pottery is similar, what distinguishes the pottery of one culture from that of another culture?

## Teaching Through Inquiry

**Art History** Provide several unlabeled images of **Mimbres, Hohokam, and Anasazi pottery**. Have groups of students sort the images into three style groups, describe the features of each style, and attribute each style to a cultural community. Discuss students' conclusions as a class.

## More About...

**The Hohokam**—called the "vanished ones" by their descendants, the Pimas and Papagos—were expert irrigation farmers who made the desert region of present-day Arizona bloom. Their culture flourished for nearly 2000 years, until about 1500 AD. The Hohokam were probably descendants themselves, of the Cochise, who may have settled in the Southwest as early as 13,000 BC.

## Using the Overhead

**Investigate the Past**

**Describe** What materials were used?

**Attribute** What clues might help you identify where and by whom this was made?

**Interpret** What purpose does this seem to serve? What kind of message might it send?

**Explain** Knowing more about the art-making  traditions in early Native-American cultures might help you to explain why this work looks the way it does.

1

## Using the Text

**Art History** After students have read the text, ask them to make a list of the different messages that early North American people communicated through their art. *(status, rank, identity, group membership, stories, instruction, communication with the spirit world)*

## Using the Art

**Art Production** Ask students to identify questions about the working methods of Anasazi artists that they might wish to explore through further library research.

**Perception Ask:** How are the Anasazi pottery designs similar to those of the Mimbres?

**Art History** Discuss students' answers to the caption questions for Fig. 1–12. Explain that the circular, recessed kivas were once covered with flat roofs, and were entered by ladders through holes in the roofs.

## Studio Connection

 Provide students with fabrics, threads, yarn, scissors, fabric glue, and large-eye needles. Show examples of flags, banners, badges, or patches. Ask students who are or have been members of a scout troop, 4-H Club, or any other such group, to bring their badges to class. Discuss various other groups that students belong to, and possible symbols for each group. Have students sketch their design.

Demonstrate appliqué and the use of found materials. If students use heat-bonding adhesives, demonstrate safe use of an iron, and caution students to follow package instructions. Demonstrate several types of stitches and the use of an embroidery hoop for holding the cloth flat.

**Assess** See Teacher's Resource Binder: Check Your Work 1.1.

## An Early Community

The Anasazi, or the "ancient ones," were some of the first people in the southwestern United States to live in caves and rocky cliffs. After living in pit houses, they established communities along the canyon walls of a huge plateau in southwestern Colorado. Some of their buildings are still standing after almost 1000 years (Fig. 1–12). The structures, called **pueblos**, are much like a modern apartment building with sections two, three, and four stories high. One dwelling contains more than 200 rooms and probably housed 400 people.

The Anasazi were skillful weavers and sophisticated potters (Figs. 1–13 and 1–14). They also made beautiful turquoise jewelry. Anasazi art forms are highly decorated. Most of the decorations are based on symbols and patterns used on baskets. Some are similar to pictographs that people painted on cliff walls long ago. To the Anasazi, these symbols told about identity, status, or group membership. Early artworks were used to tell stories, to teach young children about adult roles, and to communicate with the spirit world.

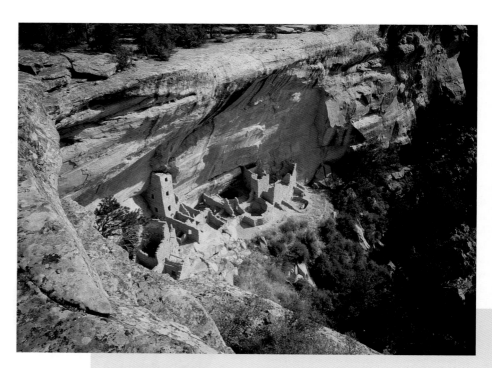

Fig 1–12 The Anasazi pueblo had rounded ceremonial rooms, called *kivas*, which were decorated with murals. What do you think this structure might have looked like when it was first built? How easily could this structure have been seen from a distance? Do you think the design of the structure made it easy for people to communicate with one another? Colorado, Mesa Verde National Park, *Cliff Palace*, ca. 1100 AD. © David Muench Photography.

## Teaching Options

### Teaching Through Inquiry

**Art Production** Have students select one artwork from pages 76–79 and list the steps they believe the artist took to make it. Instruct students to start by identifying the materials used, and then proceed by considering how the artist prepared the materials, manipulated them, and refined the artwork to complete it. Ask students to make their best guess about any steps they are unsure of, and to think about where they might learn more. Ask pairs of students to share and discuss their lists, and to help each other do additional research.

**Art History** On the chalkboard, make a chart entitled "Style Characteristics of Early North American Art." Include three columns—Anasazi, Hohokam, Mimbres/Mogollan—and make a four-section grid in each column. Down the side, label the four sections: art forms, materials/techniques, patterns/decoration, location of artwork. Help students fill in the grid with information from this lesson's text, images, and captions. Review and summarize the completed chart, and have students record questions for further research.

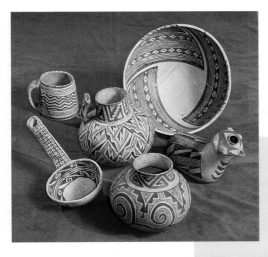

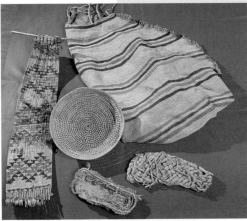

Fig 1–13 This collection of Anasazi pottery was made during the classic Pueblo Period (ca. 1100–1400). What does the variety of pottery forms tell you about the cooking and eating habits of the Anasazi? American, New Mexico, Anasazi, Pueblo Period (1100–1400 AD), *Mug, pitcher, large bowl, effigy vessel, large dipper, pottery jar.*
Courtesy Department of Library Services, American Museum of Natural History.

Fig 1–14 Early archaeologists called the early period of Anasazi culture the "Basket Maker" phase. In addition to baskets, these artists wove sacks, sandals, and other useful objects. Do you see any similarities between these woven designs and the painted decorations on the pottery vessels? American, New Mexico, Anasazi, *Bruden band, silver basket, sack, cliff dwellers sandal, and sandal made of unsplit yucca blades,* ca. 400–500 AD.
Courtesy Department of Library Services, American Museum of Natural History.

### Studio Connection

Design a fiber artwork that shows group membership (such as a class banner or school flag), or a small artwork that reveals your own membership in a community (such as a patch or badge). You might use *appliqué* (fabrics stitched to a background), or combine stitchery and appliqué techniques with beads, buttons, old jewelry, faucet washers, or other found materials. Plan your design by sketching the main shapes first and then adding details.

### 1.1 Art History

### Check Your Understanding
1. Who were among the early settlers in the southwestern United States? How did they build their communities?
2. How were early messages communicated through art?
3. How did the Anasazi use art in their community?
4. What do the artworks on this page tell you about the materials that were available to the Anasazi?

Telling

79

## Extend

Show the video *Maria! Indian Pottery of San Ildefonso* (produced by the National Park Service), or demonstrate how to create a coil pot. Guide students in building their own coil pot with a painted symbol of their membership in a particular group.

## Assess

### Check Your Understanding: Answers

**1.** the Hohokam, Mogollan, and Anasazi; lived in pit houses and eventually built pueblos in communities along canyon walls

**2.** Messages were communicated through an object's form and decoration.

**3.** to tell about status, rank, identity, group membership; to tell stories, to instruct; to communicate with the spirit world

**4.** The Anasazi used local materials to build and make their artworks, including earth (clay, bricks) and plants (weaving).

## Close

Review the kinds of art created in early Native American communities. Ask students to describe the pottery and weaving of these communities. Suggest that they further research whichever community interests them most.

## More About...

**Pueblos,** built of boulders or adobe bricks set in mud mortar, consist of terraced rooms. The roofs of the lower rows of rooms form porches for the rooms above. Some of the houses have four or five stories. Each pueblo structure contains at least one *kiva,* or ceremonial chamber. To enter a traditional pueblo, people climbed a ladder to the roof, and then went down another ladder through a hatchway into the room below.

## Assessment Options

**Peer** Provide students with a template of a pottery shape, and have them outline the shape three times. Instruct students to use markers or colored pencils to decorate in the style of each of the three southwestern cultural groups. Then have students write and attach a brief description of the characteristics of each style. Have students work in small groups to share their projects and check one another's work.

## Prepare

### Pacing
Two 45-minute periods

### Objectives
- Explain how people use natural materials to make useful objects within local craft traditions.
- Use natural materials to create a piece of jewelry.

### Vocabulary
**crafts** Works of art, decorative or useful, that are skillfully made by hand.

## Teach

### Engage
Ask volunteers to describe jewelry they are wearing, and the materials it is made from. Discuss why people wear jewelry.

### Using the Text
**Aesthetics** Have students read the text to learn what materials early artists used to create useful objects. Discuss what many people say is the difference between craft and fine-art traditions. *(Crafts are usually useful objects.)* **Ask:** Do you believe this is a good way to categorize art?

### Using the Art
**Art Criticism** Encourage students to describe the designs in the mola and to compare the message of this mola to the one in Fig. F1–5, page 4.

### National Standards 1.2 Forms and Media Lesson

**1a** Select/analyze media, techniques, processes, reflect.

**4a** Compare artworks of various eras, cultures.

**5a** Compare multiple purposes for creating art.

---

# Crafts

Since the earliest times, people have needed shelters, various types of supports, and containers to help them survive. Early people used caves and cliff overhangs for shelters, tree branches or large rocks for supports, and gourds or birds' nests for containers. Eventually, they learned to use natural materials, such as grass, wood, and clay, to make containers, furniture, and other useful objects.

When people make useful objects out of natural materials, they are working in the **craft** traditions. Craft traditions vary from community to community depending on the needs of the people and the materials available. One generation often teaches a craft to another and passes along ideas about how handmade objects should look and work. The Cuna Indians of the San Blas Islands are known for their colorful blouses, or *molas*. Molas show scenes from nature, daily life, and traditional legends of the Cuna community (Fig. 1–15).

## Experimenting for Beauty

People in almost every community decorate useful objects, such as clothing and pottery, so that they are pleasing to see and touch. These artists make careful decisions about form, color, texture, and pattern. Sometimes they decorate objects with designs and symbols that mean something to their community. Such designs might reflect religious beliefs or tell about other important community ideas. Artists also explore different ways to use craft materials to create new, or nontraditional, forms.

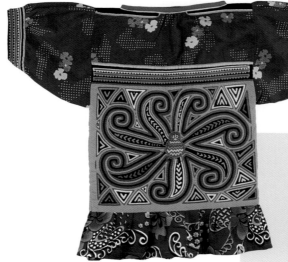

Fig. 1–15 The Cuna Indians live on the San Blas Islands off the coast of Panama. Cuna women are famous for their molas. Molas are blouses with brightly colored panels on the front and back. Each panel is made of many rectangular pieces of fabric of different colors and textures sewn together.
*Octopus Mola* (back view), 1997. Cotton reverse applique. Carti Suitupo Chapter Cooperative, Carti Suitupo Islands, San Blas Islands. Courtesy of Raul E. Cisneros.

80

---

### Resources

Teacher's Resource Binder
- Finder Cards: 1.2
- A Closer Look: 1.2
- Find Out More: 1.2
- Check Your Work: 1.2
- Assessment Master: 1.2
- Overhead Transparency 1

### Teaching Through Inquiry

**Aesthetics** Provide students with a collection of **handcrafted, useful objects**. Have them note the function of each object and how well the design contributes to the object's usefulness. Have students look for aspects of the objects that are only decorative, such as carved or inscribed patterns, painted motifs, and added three-dimensional elements. **Ask:** Does the decoration add to the beauty of the object? Should useful objects always be decorated? Are there times when the decoration takes away from an object's beauty? Ask students to create craft-making guidelines regarding the addition of purely decorative elements.

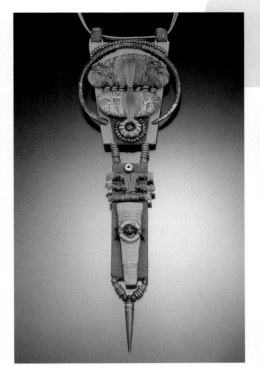

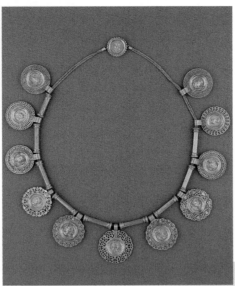

Fig. 1–16 Look closely at this pendant. What materials do you see? What ideas do the materials and the design of the pendant suggest? Kara Johns Tennis, *Untitled*, 1999. Hand-sewn mixed-media collage pendant, with fabric, linen, and nylon thread, coconut palm twigs, pebbles, polymer clay, African brass, and other found objects, 2" x 5 1/2" (5.1 x 14 cm). Courtesy the artist.

Fig. 1–17 The artist who made this necklace included portraits of community leaders. How could you show community membership in the jewelry you create? Roman jewelry, *Necklace of Coins Bearing Imperial Portraits*, 238–43 AD. Gold, 30 1/4" x 1/2" (76.8 x 3.8 cm). The Nelson-Atkins Museum of Art, Kansas City, Missouri (Purchase: Nelson Trust) (34-147).

### Studio Connection

Jewelry-making is one of the many craft forms that people use to express ideas. In places where people live close to nature, shells, beads, feathers, and other natural objects are valued for jewelry-making (Fig. 1–16). Jewelry is often made from precious gems, silver, gold, and other costly materials. Try to make your own jewelry with inexpensive materials, such as clay, paper, wood, wire, or leather. You can combine the materials or use only one. You might even recycle parts of old jewelry, toys, or other objects. What can your piece of jewelry say about you? What materials will best express your ideas?

### 1.2 Forms and Media

#### Check Your Understanding

**1.** How do people in communities learn to make useful objects? What materials do they use?
**2.** Why do people decorate useful objects?

### Studio Connection

Assemble an assortment of materials: clay or papier-mâché beads, found objects, thin wire or string, craft adhesives, jewelry findings (such as pin backs, chain clasps, jump rings), needle-nose pliers and wire cutters, a punch or drill.

Demonstrate how to create beads; punch or drill holes in wood, rocks, and shells; combine textures and media; string beads and other objects; attach clasps, jump rings, and pin backs; and wrap and form wire and string decoratively.

**Assess** See Teacher's Resource Binder: Check Your Work 1.2.

### Assess

#### Check Your Understanding: Answers

**1.** People learn to make useful objects from other members of their community. These traditions are often passed along through generations. They use local natural materials.

**2.** People decorate useful objects to make them pleasing to see and touch.

### Close

Ask students to look again at the images in this lesson and offer their ideas about what the artist of each was attempting to communicate about the community for which it was created.

Telling
81

---

### More About...

As a young girl, **Kara Tennis** painted tiny pebbles for necklaces and glued seeds to plywood to make designs. She developed her hand-sewn collages, for which she uses fabric; mat board; beads; metals; clay; paper; acrylics; and ancient, industrial, or found natural objects. Tennis—who loves to work with color, shapes, pattern, and texture—finds inspiration in shells, rocks, leaves, shadows, feathers, bark, sand swirls, cornrows, sidewalk cracks, Amish quilts, African beads, and lots of other things.

### Using the Overhead

**Write About It**

**Describe** What symbols do you  recognize? How have the parts been arranged?

**Analyze** How do the patterns on  this pottery vessel compare with those in the text?

### Assessment Options

**Teacher** Ask students to imagine being cultural anthropologists who want to know about a particular craft tradition in a selected community; for example, the basket-making tradition in island communities of South Carolina. Ask students to list questions about this craft tradition and its role in the community. (*How did the people learn to make the objects? How are the objects used? What natural materials are used? How and why do the people decorate the objects?*)

# The Art of Mesoamerica and South America

## Prepare

### Pacing

Three 45-minute periods: one to consider art and text; two to make art

### Objectives

- Describe features of the art and architecture in early Mesoamerican and South American communities.
- Explain the importance of paper and symbol systems in early Mesoamerica.
- Create a modular sculpture that communicates ideas and feelings.

### Vocabulary

**pre-Columbian** An art history term used to describe the art and civilizations in North and South America before the time of the Spanish conquests.

**codex** A type of book in which the pages are hinged together at both sides, similar to an accordion.

### Using the Map

Have students look at the world map on page 306 to name and locate the regions of Mesoamerica and South America. Ask if students know of any indigenous cultures from this area of the world and encourage them to research native peoples (such as the Mixtec of Mexico or the U'wa of Colombia) on the Internet.

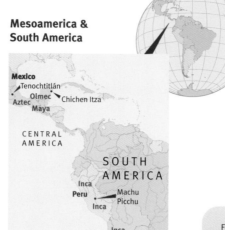

Mesoamerica & South America

### Global Glance

Mesoamerica extends from present-day Mexico south to Honduras. Further south lies the vast continent of South America. Over 3000 years ago, the people in these areas developed communities. Some of the world's great civilizations developed here. Between 1492 and 1521, much of Mesoamerica and South America was conquered by Spain. Art historians use the term **pre-Columbian** (meaning before Columbus) to describe the art of this region that was made before the Spanish conquered it.

Fig. 1–18 The surfaces of this Mayan platform pyramid are carved with decorations representing Quetzalcoatl, the sun god. What do the decorations suggest about the purpose of the pyramid? Pre-Columbian Mexico, *Chichen Itza Castle*, from Northeast, ca. 12th–13th century. Courtesy Davis Art Slides.

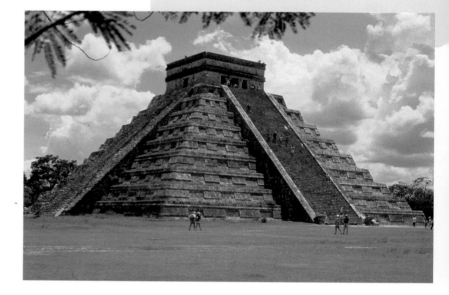

82

### National Standards 1.3 Global View Lesson

**2b** Employ/analyze effectiveness of organizational structures.

**3a** Integrate visual, spatial, temporal concepts with content.

**4a** Compare artworks of various eras, cultures.

**5b** Analyze contemporary, historical meaning through inquiry.

## Teaching Options

### Resources

Teacher's Resource Binder
 A Closer Look: 1.3
 Map: 1.3
 Find Out More: 1.3
 Check Your Work: 1.3
 Assessment Master: 1.3
Large Reproduction 2
Slides 1e

### Teaching Through Inquiry

**Art Production** Have students work in groups to research early Mesoamerican communities and then design and make a three-dimensional **paper model of an ancient city**, using forms such as pyramids, cubes, and cylinders. Students may also make stand-up cutouts of sculptures. Ask each group to explain the features of their community and what they learned about community planning.

## Planned Communities

Beginning around 1500 BC, the people in the Mesoamerican region built a civilization based on agriculture. Throughout history, several different cultures or groups formed within this area. The Mesoamericans were skilled in city planning and architecture. They designed cities with markets, plazas, and temples. They also developed skills in sculpture, painting, pottery, and jewelry-making.

Each of these groups built planned communities that met the specific needs of their belief systems and daily lives. People of the Olmec culture created ceremonial centers with large sculptures of warriors, priests, and athletes. The Mayans built cities, such as Chichen Itza, with pyramids, palaces, courts, and many dwellings. Paintings and relief sculptures on buildings tell stories of animals, people, plants, and gods. The Aztecs, the last group to control the region before it was conquered by Spain, borrowed many ideas from Mayan art. One of their largest cities, Tenochtitlán, was destroyed in 1521. Present-day Mexico City was later built on this site.

In South America, the Andean cultures of Peru also developed large public architecture and sculpture. Their planned communities filled the needs of their military rule, and provided space for their religious and agricultural ceremonies.

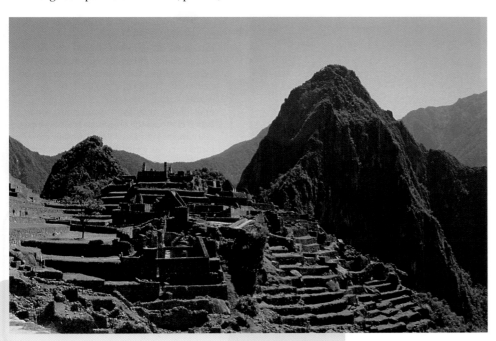

Fig. 1–19 The Inca city of Machu Picchu was built as a royal estate and religious center. The techniques used to create its buildings were as sophisticated as the techniques used by the ancient Egyptians. The carefully cut stones fit together so well that mortar was not necessary. Pre-Columbian Peru, *Machu Picchu* (General View), 15th century. Photograph by David DeVore.

Telling

83

## Prepare

### Pacing

Three 45-minute periods: one to consider art and text, and to cut stencil (optional); one to form paper; one to iron and assess

### Objectives

- Explain the history and importance of papermaking.
- Outline the steps in a simple paper-making process.
- Create a handmade-paper artwork that has a message about community.

### Vocabulary

**slurry** A watery mixture used to make paper.

**pulp** Mashed up material, usually wood or plant fibers, used to make paper.

### Supplies

- shredded scrap paper, soaked in water overnight
- blender
- water
- fine strainer and dishpan
- cardboard or cookie cutters
- X-acto knives
- felt or pieces of old blanket
- paint, ink, or dyes
- flower petals or bits of grass
- paper towels

### National Standards 1.4 Studio Lesson

**1b** Use media/techniques/processes to communicate experiences, ideas.

**2b** Employ/analyze effectiveness of organizational structures.

**3a** Integrate visual, spatial, temporal concepts with content.

**4c** Analyze, demonstrate how time and place influence visual characteristics.

**Teaching Options**

# Making Paper

## A Handmade Message

### Studio Introduction

Have you ever thought about what you could do with all the scraps of paper that people throw away every day? When paper was invented, it was a precious item because it was made by hand in small quantities. Today, many people take paper for granted.

**In this studio lesson, you will make your own paper from recycled paper scraps. The paper you make will communicate something about your community.** Pages 88 and 89 will tell you how to do it. Paper is made with a **slurry** (watery mixture) of the soft, moist, formless **pulp** that comes from wood and plant fibers. After the slurry is strained through a wire screen, the pulp that remains is carefully spread and shaped on blotters. Areas of the pulp can be stained with ink or paint. Natural materials such as leaves and flowers can be mixed or pressed into the damp pulp. Torn pieces of candy bar wrappers, newspaper, or images from comic strips can also be dipped in water and pressed into the molded pulp. When the pulp is completely dry, it is a sheet of paper.

Think about the paper you create as a kind of collage of found materials. How can the materials you choose to put in your paper help tell about your community?

## Studio Background

### Inventing Paper

When paper was invented, communication among people was greatly improved. People could keep records of their history. With paper, people could send messages to each other more easily and carry information with them. Eventually, paper allowed people's language to travel far beyond their communities.

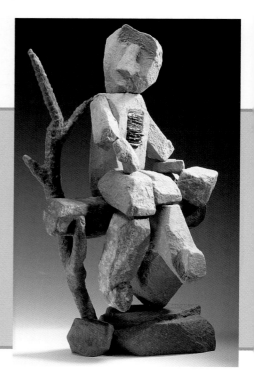

Fig. 1–23 You have to look very carefully at this sculpture to see that it's made of paper. How has the artist used paper to create the look of stones and twigs? Jeanne Petrosky, *Untitled*, 1999. Handmade paper, 36" x 20" x 10" (91.4 x 50.8 x 25.4 cm). Courtesy the artist.

### Resources

Teacher's Resource Binder
  Studio Master: 1.4
  Studio Reflection: 1.4
  A Closer Look: 1.4
  Find Out More: 1.4
Overhead Transparency 2
Slides 1f

### Teaching Through Inquiry

**Art History** Have student groups investigate the history of **writing surfaces**, including the development of paper in its various forms (papyrus, bark cloth, paper made from various plant fibers, and recycled paper). Have groups make a time line of surfaces for sending messages.

Fig. 1–24 Five students worked together on this large, horizontal strip of hand-made paper. One of them commented, "As I was helping make it, I was thinking how weird it was to turn this 'glop' into a pretty collage. Gathering the 'glop' onto screens and molds was easy, but transferring it to the base sheet was very hard to do. I like how we did the tree and the grass with the border." Bailey Isgro, Jessica Lynema, Lisa Poszywak, Leslie Savage, and Betty Shreve, *In Touch with Nature*, 2000. Recycled paper made into a collage, 12" x 40" (30.5 x 101.5 cm). Bryant Middle School, Dearborn, Michigan.

The Egyptians made a writing surface by joining together thin strips of papyrus. The process of making paper from chopped up plant fibers was invented in China about 2000 years ago. This same process is used around the world today.

Mesoamericans developed their own kind of paper by soaking and pounding the inner bark of certain trees. Similar traditions of making paper, sometimes called bark cloth, can be found in parts of Africa and Oceania.

Today, artists create and use handmade papers in artworks such as original books and greeting cards, molded relief sculptures, and prints. Think about things made from paper that you see every day. How many different kinds of "messages" can paper send?

Telling

87

## Supplies for Engage
- sample of handmade paper
- books and cards made from handmade papers

## Teach

### Engage
Show students handmade paper, books, and cards. **Ask:** Where would we be without paper? Generate a list of the many ways paper impacts daily life and communication.

### Using the Text
**Art History** Ask students to read Studio Background to find out when and where various types of paper were developed and what impact paper has had on human communities. **Ask:** What uses of paper are likely to remain inside your school community? *(test papers, reports, library books)* Can you name a use of paper that comes into your school from a different community? *(cardboard cartons that hold food or school supplies, mail delivered to teachers and administrators)*

### Using the Art
**Aesthetics** Discuss how the visual qualities of the handmade-paper pieces compare to the machine-made paper of the pages of this book. **Ask:** How does the choice of paper affect the way we respond to the artwork?

## More About...

The **papermaking** developed by the Maya differed from the method developed in China. The Maya made their paper, which is more appropriately called bark cloth, from the bark of the *Ficus* tree. They cut the bark with a sharp stone knife and then peeled it from the tree. They next soaked the bark in water, and then boiled it in water and lime to soften the fibers and make them easy to separate. The Maya then overlapped the bark strips on a hard surface and beat them with a ridged stone until the fibers were merged into one long, thin sheet. They trimmed and polished the sheet, and then sealed the surface with white lime.

## Using the Overhead

**Think It Through**

**Ideas** Do you think the artist was inspired by the visual and textural qualities of handmade paper? Explain.

**Materials** What materials were used in this piece?

**Techniques** What evidence can you find of any special techniques the artist might have used?

**Audience** Do you think it's important to think about an audience for your art while you are working on it?

**2**

## Wit and Wisdom

Did you know that the oldest papermakers in the world are wasps? Female wasps chew up bits of wood and shape the substance into horizontal tiers of hexagonal cells, where they lay their eggs. As the cells dry, they become strong and safe for the wasp larvae.

## Studio Experience

1. Show students the paper that you created or other examples of hand-made paper, and note how the texture differs from that of commercial papers. Tell students that they will create paper that—by its color, shape, and added materials—indicates something about their community.

2. Demonstrate cutting a stencil, making the pulp, pressing the pulp inside the stencil, and adding color and bits of natural materials.

3. Have students work in pairs to help each other create their paper.

## Idea Generators

Discuss with students how they can use shape—such as that of their state, an animal, plant, building, or monument—to indicate something about their community. **Ask:** What shape reminds you of your community? What local materials, such as plants or newspaper articles, tell about your community? Which of these could you press into the pulp?

## Extend

Have students create a collage that expresses the emotion of a special moment in their life. After students have made a variety of handmade papers, encourage them to share and trade their papers to create collages with a range of textures and colors of paper. They may add string, photographs, ribbons, buttons, feathers, pressed flowers, scraps of printed type, and other objects. Challenge students to identify the emotion in each collage.

**Sketchbook Tip**
Remind students that a sketchbook is a place to collect things: it can be a storage bin of ideas for future artworks, as well as a compilation of impressions.

**Crafts in the Studio**

# Making Your Paper

### You Will Need

- scrap paper
- a blender
- water
- fine strainer and dishpan
- old nylon stocking
- cardboard
- felt or blanket scraps
- paint, ink, or dyes
- natural and printed materials
- paper towels
- an iron

### Try This

1. To make pulp, soak bits of scrap paper in water overnight.

2. Mix two cups of pulp in a blender half-filled with water. Run the blender for about thirty seconds. After blending the pulp, carefully mix in leaves, petals, and other natural materials by hand, if you wish.

3. Line a fine strainer with a nylon stocking and hold it over a dishpan. Pour the pulp into the strainer.

4. Choose a shape for your new sheet of paper. Cut a cardboard stencil in this shape. Place the stencil on top of several layers of felt or blanket scraps.

5. Press the pulp flat inside the stencil. Add color with ink, paint, or dyes. Press newspaper clippings or other materials that tell about your community into the paper form.

6. Cover the form with paper towels and allow it to dry. Remove towels, stencil, and blanket carefully.

7. Place the newly formed sheet of paper between paper towels and press with a warm iron.

### Check Your Work

Discuss your work with your classmates. What materials did you add to your hand-made paper? What message does your paper communicate about your community? While you were creating your paper, did you think about it as a collage?

**Computer Option**
Make a collage of images about your community by using paint or image-editing software. Create "texture" and "patterns" that simulate various paper surfaces, and then apply selected texture filters to the images.

**Sketchbook Connection**
Observe your community's environment and note colors, fibers, and shapes that you could use in your handmade paper. Attach samples of natural materials to your sketchbook pages. Experiment with colors and designs that say something about your community. After your handmade paper is dry, slip a small sheet inside your sketchbook or use it to make a new sketchbook cover.

## Teaching Options

### Meeting Individual Needs

**Sharing Tasks** Divide tasks for making paper among the students, each student being responsible for one or two tasks. There are also switches (Assistive Technology) available for blenders that will allow students with severe physical disabilities to participate in a task.

### Teaching Through Inquiry

**Art Production** Have students create a display and plan a demonstration to teach children about the **process of making paper**. Have students research simple papermaking processes and experiment with techniques before finalizing the display and creating visual aids for the demonstration.

**Computer Option**
To obtain digital images of the community, have students scan photos or use a digital camera. Students may use Painter, in which they select textured "papers" that can be applied to any electronically drawn or painted image; or they may use Photoshop and Photo Deluxe, in which they apply texture with selected filters.

A Web site for making paper is http://www0.delphi.com/crafts/papermake.html.

A history of paper is at http://members.aol.com/Ppreble2/history2.html#top

Fig. 1–25 **This artist used natural materials to add texture and interesting shapes to her paper work.** Kelsey Shuhart, *Spring*.
Handmade paper, 7" x 4 1/2" (17 x 11 cm).
Kutztown University Lab School, Kutztown, Pennsylvania.

Fig. 1–26 **Architectural shapes were cut from old photographs and added to handmade paper in this abstract artwork.** Sam Billingslea, *My Neighborhood's Different!*
Handmade paper, 4" x 7" (10 x 20 cm).
Kutztown University Lab School, Kutztown, Pennsylvania.

## Assess

### Check Your Work

Display the handmade paper pieces, and have students work in pairs to discuss each other's work. Have them note the design choices that contributed most to a successful work of art.

## Close

Review the history and importance of papermaking. Ask students to explain the steps they used in making their paper and then to make a step-by-step chart of their papermaking process.

Telling

89

## More About...

**Recycling** is one way to give new life to old paper. Almost everywhere, something is made of paper—in a variety of shapes, sizes, and textures. Because paper is so cheap, we usually think nothing of discarding it, and throw away vast amounts of reclaimable paper. Each week, the average urban or suburban household receives twenty to thirty pounds of newspapers that could be recycled into new products such as paperboard packaging for foods, household and other consumer items, newsprint, and construction and building materials.

## Studio Collaboration

Encourage students to collaborate on a handmade-paper piece by combining individually made sheets or shapes of paper into a unified whole that would tell a story. Students might use a variety of cookie cutters for molds, and could attach individual papers with glue or stitchery.

## Assessment Options

**Peer** Have student pairs observe each other making paper and comment on the steps in the process that seemed the easiest and most difficult to do. Encourage them to provide suggestions to each other for ways to be creative with their papermaking.

**Self** Provide students with a studio reflection worksheet from the Teacher's Resource Binder. Have students comment on their artwork's process, its quality, and its message about community.

## Daily Life

To illustrate how many television programs are aimed at teenagers, ask students each to make a list of their five favorite shows. Compile the results on the board, and then have students graph and discuss the results.

## Social Studies

Have students identify any public statues or monuments near the school. Ask students to choose a local monument to "adopt," conduct research to learn more about it, and write and publish a printed or online newsletter about the endeavor, including digital photographs of the monument. SOS!, Save Outdoor Sculpture, a national preservation and restoration effort, offers assistance for such projects on its Web site, at:

http://www.nic.org/sos/sos.html.

## Language Arts

Discuss the oral traditions of storytelling, and invite students to share tales from any of their family members who are known for their storytelling ability. Ask volunteers to present the results of their audio- or videotape to the class.

# Connect to...

## Careers

Imagine making a scene from the past or future "come alive." The world of theater presents many opportunities for a visual artist who is interested in drama. One of the careers in theater arts is that of scenic designer. The **scenic designer** is responsible for the appearance of the stage, and ultimately creates a convincing reality.

To achieve what are often extremely elaborate stage sets, much planning is required. Lighting and the use of space are important considerations. The scenic designer reads the script, and makes sketches and models to present to the production's director. When final designs are decided upon, the designer provides working plans for the set-construction crews. Set design includes not only the backdrop and walls, but all furniture and other objects within the space. How might a scenic designer become aware of the ways actors would move throughout the stage area? How important would it be to have this information before making final design decisions?

## Daily Life

What are your favorite **television programs**? Do you prefer factual shows or fictional ones? Humor or drama? Through both programs and commercials, television presents a **view of contemporary life** that may or may not be true. Much of what we see on TV is directed at a teenage or young-adult audience. How accurately do such shows tell stories that reflect your life and the life of your community? Do you think television can create unrealistic expectations of you and your peers? How might that be a danger?

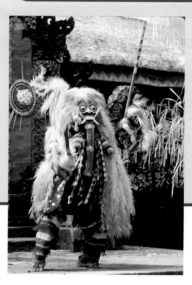

## Other Arts

### Theater

You know that visual art communicates important messages about communities. The same is true of theater and the theatrical **tradition of storytelling**. Within the Cherokee culture of the Southeast, stories are used to educate children in the values of the Cherokee culture and to review those values for adults. Stories are told at family gatherings, community events, and during everyday conversation.

Fig. 1–27 Many cultures use music and dance as a way to tell stories. The Balinese dance called *Barong* tells the story of good versus evil. The witch *Rangda* represents evil, while the half-lion, half-dog creature called *Barong* represents good. Bali, Indonesia, Barong Play: *Rangda, the Witch, Appears.*
Courtesy Davis Art Slides.

90

## Teaching Options

### Resources

Teacher's Resource Binder
Using the Web
Interview with an Artist
Teacher Letter

### Video Connection

Show the Davis art careers video to give students a real-life look at the career highlighted above.

## Other Subjects

### Social Studies

**Outdoor sculpture and monuments** may take the form of statues made of stone or metals, relief sculptures, painted murals, or commemorative plaques. Americans build monuments to tell and honor our nation's history. Are the monuments in your community well preserved, or are they in need of repair? What stories do they tell? How could you find out? What could your school do to "adopt" a monument?

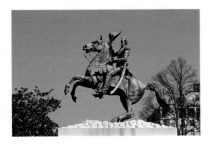

Fig. 1–28 This sculpture was made from melted down cannons from the War of 1812. Jackson was a hero of this war. What does this sculpture say about Andrew Jackson? Clark Mills, *Andrew Jackson Equestrian Statue*, 1853. Courtesy Davis Art Slides.

### Language Arts

Have you ever attended a family reunion or holiday gathering of several generations of your family? Do the older members of your family like to tell stories about their life? To maintain these **oral traditions of storytelling**, ask an older relative for permission to record his or her memories on audio- or videotape. Record and then write down their stories, and share them with the rest of your family.

Fig. 1–29 This Amish quiltmaker chose the primary colors and geometric shapes to create a powerful work of art. What type of symmetry do you see in this quilt? Rebecca Fisher Stoltzfus, *Diamond in the Square Quilt*, 1903. Wool with rayon binding added later, 77" x 77" (195.6 x 195.6 cm). Collection of the Museum of American Folk Art, New York; Gift of Mr. and Mrs. William B. Wigton. 1984.25.1

### Mathematics

Have you seen **patchwork quilts** that are based on geometric shapes? Amish quilts, for example, contain only the most basic geometric shapes—squares, triangles, and rectangles. Amish quilters are restricted, by their religious beliefs, to the use of only simple shapes and solid colors. The use of printed fabrics or too many pieces of patchwork is considered "too worldly." Despite the restrictions, Amish quilts are powerful in their simplicity. The quilts' design characteristics—distinctive patterns, the width of borders and bindings, the size of blocks—"tell" their origins to fellow Amish by revealing the community from which they came. How intricate a geometric design could you make by using only squares, rectangles, and triangles?

### Mathematics

Compile and display reproductions of Amish patchwork quilts and nonobjective paintings. Direct students' attention to an Amish quilt, and review the use of simple geometric shapes and solid colors.

### Other Arts

Have students read "How the Possum Lost His Tail" which can be found in introductory books on Cherokee storytelling. The story instructs us not to brag about our abilities: "If a child starts bragging . . . the story about the possum losing his tail will come up—told in a way that doesn't embarrass the child with a direct rebuke, but in a way that makes the child understand that the moral of the story is meant to apply to him or her." (Barbara Duncan, *Living Stories of the Cherokee,* University of North Carolina Press, 1998, p. 15.)

Encourage students to pay attention to how the moral is woven into the story. In small groups, have them come up with a moral—such as "It is better to give than to receive" or "Treat others as you'd like to be treated"—and create a story, with animal characters, for this moral. Students might dramatize their story for the rest of the class, and ask classmates to identify the moral.

**Internet Connection**
For more activities related to this chapter, go to the Davis website at **www.davis-art.com.**

Telling

---

### Internet Resources

**Vietnam Veteran's Memorial Homepage**
http://www.nps.gov/vive/index2.htm
This site offers detailed information about the Vietnam veterans' memorials in Washington, DC.

### Community Involvement

Invite local craftspeople to show their artworks and demonstrate their craft processes. Talks by potters, papermakers, fiber artists, and jewelry makers would be especially appropriate to extend student understanding of the crafts in this chapter.

### Community Involvement

Invite a local official to talk to students about the recycling program in your community, and how students can become involved in recycling efforts.

### Interdisciplinary Planning

Make copies of these Connections pages, and share them with appropriate faculty. Meet with faculty members on a regular basis so as to share activities and ideas. Arrange with the administration to allow occasional visits to one another's classes.

## Talking About Student Art

Have students work in pairs to practice their skills in describing each other's art. Ask students to describe the work as if they were having a telephone conversation with a friend.

## Portfolio Tip

Remind students that their portfolio is a record of not only their artistic production, but also their creative processes, art-historical knowledge, and aesthetic understandings; and it holds both artworks and written reflections.

## Sketchbook Tip

Remind students that their sketchbook is a place not only for working out ideas, but also for use as a journal. Encourage students to divide pages in their sketchbook for new vocabulary, important questions, things to remember, assignments, and so on.

# Portfolio

"We were given the assignment to create an identity pennant. I sketched many different ideas about which of my interests would truly identify me. I finally settled on an outline of Martha's Vineyard island and goggles: the island because it's probably my favorite place on earth, and goggles since swimming is my favorite sport." **Katherine McCord**

Fig. 1–30 Katherine McCord, *Representing Me*, 1998. Felt, 8" x 14" (20 x 35.5 cm). Winsor School, Boston, Massachusetts.

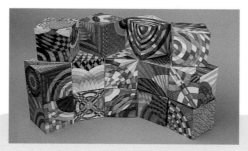

Fig. 1–31 Each student in a California art class colored and cut out a cube from a template, taking inspiration from the brilliant colors in artwork by Victor Vasarely. The colors, lines, and textures interact in different ways depending on how the cubes are arranged. Students from Los Cerros Middle School, *Collaborative Sculpture*, 1999.
Markers, 3 3/4" (9.5 cm) cubes. Danville, California.

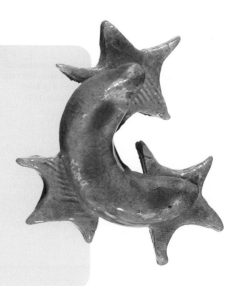

Fig. 1–32 When asked to create wearable art that represented something she liked about Alaska, this student chose the sun, stars, and moon that are out on clear nights during the winter. For most of the school year Alaskan students go to school in the dark, and it's dark soon after they come home. Thus, the night sky is a favorite topic. Kelsey Johnson, *Moon and Stars*, 2000.
Egyptian paste, 2" x 2" (5 x 5 cm). Colony Middle School, Palmer, Alaska.

**CD-ROM Connection**
To see more student art, check out the Community Connection Student Gallery.

92

## Teaching Options

### Resources

Teacher's Resource Binder
   Chapter Review 1
   Portfolio Tips
   Write About Art
   Understanding Your Artistic Process
   Analyzing Your Studio Work

### CD-ROM Connection

For students' inspiration, for comparison, or for criticism exercises, use the additional student works related to studio activities in this chapter.

# Chapter 1 Review

### Recall
Identify two of the many ways that artworks can be used for communication in a community.

### Understand
Describe what viewers can do when they wish to "receive" an artworks message.

### Apply
Imagine that you and a friend are exploring an old barn, hoping to learn about the people who owned it. Suppose you find a trunk filled with quilts. Your friend dismisses these as "just a bunch of blankets" and moves on in search of other evidence. Would you agree with your friend? Why?

### Analyze
Compare the codex in the Core Lesson (Fig. 1–5) to the sculpture fragment (Fig. 1–22) in Lesson 1.3. In what ways are these similar? How are they different?

### Synthesize
Create a worksheet that someone could use to identify membership in various communities. Your worksheet might include questions, sentences with blank spaces, diagrams and/or charts to complete.

### Evaluate
Of the two pieces of jewelry shown in Lesson 1.2 (Figs. 1–16 and 1–17, *shown below*), which do you believe communicates the clearest message? Why?

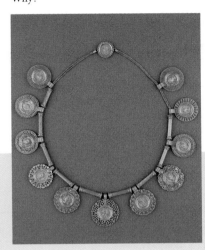

Page 81

### For Your Portfolio
You can keep your artworks, essays, and other work you have accomplished in a portfolio. Your portfolio can help you reflect on how you have developed as a maker and viewer of art. For an artwork you made in this chapter, create an artist's statement form. Include a place for your name and date, the media and techniques used, how your artwork sends a message, how satisfied you are with this completed artwork and why. Remember to include similar forms when you insert artworks into your portfolio in the future.

### For Your Sketchbook
Your sketchbook is a good place to explore the themes studied in each chapter of your book. This chapter explored the theme of art and communication. Fill some sketchbook pages with different visual ways you can tell about the communities of which you are a member. You might, for example, develop a symbol for each geographical and shared interest community.

Telling

93

### Advocacy
Have students work with you to develop a brochure about the art program, by using easy-to-understand terms that state the program goals, purposes, rationale, and how it achieves the national, state, and local standards. Ensure that students, as well as members of the school and local communities, understand that the work in the program is serious and consistent with externally established criteria.

### Family Involvement
Newsletters are an effective means for maintaining communication between school and home. In them, you might include reminders and requests, along with information about what students are learning in art. Have students play an active role in your newsletters' production and distribution.

## Chapter 1 Review Answers

### Recall
Artworks can show aspects of ordinary life, tell stories, teach people different ways to think about the world, show careful observations of life, or inspire.

### Understand
Viewers carefully note details in an artwork, study about the community in which the artwork was made, look at other artworks from the same time and place, and make connections among the information gathered from these sources to propose an interpretation.

### Apply
The quilts might be a source of information about the people who owned them. The colors and patterns might say something about what the people believed or valued.

### Analyze
Differences include materials (paper vs. stone), number of figures, color, texture. The figures have similar shapes and are stylized.

### Synthesize
The worksheet should include references to geographical as well as shared-interest communities.

### Evaluate
Answers will vary. Students may judge the clearer message with the necklace of coins, because it shows the likeness of community leaders. The contemporary necklace shows use of natural and found materials, suggesting that these materials are valued, but its meaning is less clear.

### Reteach
Have students create a large bulletin-board display for the school, titled "Get the Message!" Have students select an artwork, make a line drawing or photocopy of it, and write a statement that explains its message. Display the artworks and statements, and summarize that art can be a powerful way for people in communities to communicate ideas and feelings.

# Chapter Organizer

| 9 weeks | 18 weeks | 36 weeks | | | |
|---|---|---|---|---|---|

## Chapter Focus

## Chapter National Standards

**Chapter 2
Living**

Chapter 2 Overview
pages 94–95

- **Core** People in communities use art to reflect upon and enhance their daily life.
- **2.1** Art in Colonial North America: 1500–1776
- **2.2** Drawing
- **2.3** Painting Life in an Indian Empire
- **2.4** Drawing a Group Portrait

1 Understand media, techniques, and processes.
2 Use knowledge of structures and functions.
3 Choose and evaluate subject matter, symbols, and ideas.
4 Understand arts in relation to history and cultures.
5 Assess own and others' work.

---

| 9 weeks | 18 weeks | 36 weeks | | Objectives | National Standards |
|---|---|---|---|---|---|
| 2 | 2 | 2 | **Core Lesson
Daily Observations**
page 96
Pacing: Two 45-minute periods | • Use examples to explain how artists observe and record daily life in communities.
• Identify artist-designed objects that enhance community life. | **5b** Analyze contemporary, historical meaning through inquiry.
**5c** Describe, compare responses to own or other artworks. |
| | | | **Core Studio
Create Your Own Pottery**
page 100 | • Create a functional and decorated clay container for everyday use. | **1b** Use media/techniques/processes to communicate experiences, ideas. |

---

| | | | | Objectives | National Standards |
|---|---|---|---|---|---|
| | | 3 | **Art History Lesson 2.1
Colonial North America**
page 102
Pacing: Three to four 45-minute periods | • Describe the ways colonial North American art reflects daily life of the period.
• Identify art forms as belonging to the colonial period. | **2b** Employ/analyze effectiveness of organizational structures.
**3b** Use subjects, themes, symbols that communicate meaning.
**4a** Compare artworks of various eras, cultures. |
| | | | **Studio Connection**
page 104 | • Draw an arrangement of daily-life objects to capture a mood or feeling through effective use of the principles of design. | **1b** Use media/techniques/processes to communicate experiences, ideas. |

---

| | | | | Objectives | National Standards |
|---|---|---|---|---|---|
| | | 2 | **Forms and Media
Lesson 2.2
Drawing**
page 106
Pacing: Two 45-minute periods | • Identify media commonly used in drawing.
• Explain differences among technical approaches to drawing. | **1a** Select/analyze media, techniques, processes, reflect. |
| | | | **Studio Connection**
page 107 | • Use three different approaches to create three drawings of the same daily-life object. | **1b** Use media/techniques/processes to communicate experiences, ideas. |

## Featured Artists

John Ahearn
M. Ali
Farrukh Beg
William Burgis
Jacques Callot
John Singleton Copley
Manohar Das

Joseph H. Davis
Miftah al Fuzula
David S. Gordon
Robert Kogge
Justus Engelhardt
   Kuhn
Jacques Le Moyne

Maria and Julian
   Martinez
Ni'mat-nama
Charles Willson Peale
Paul Revere
George Segal

## Chapter Vocabulary

bisqueware
contour drawing
designers
dry media
gesture drawing
miniature

mixed media
portrait
proportions
wet media
whole-to-part drawing

---

### Teaching Options

Meeting Individual Needs
Teaching Through Inquiry
More About…George Segal
More About…Public Gardens
Using the Large Reproduction
Using the Overhead

### Technology

CD-ROM Connection
   e-Gallery

### Resources

Teacher's Resource Binder
   Thoughts About Art:
      2 Core
   A Closer Look: 2 Core
   Find Out More: 2 Core
   Studio Master: 2 Core
   Assessment Master:
      2 Core

Large Reproduction 3
Overhead Transparency 4
Slides 2a, 2b, 2c

---

Meeting Individual Needs
Teaching Through Inquiry
More About…Pueblo pottery
Assessment Options

CD-ROM Connection
   Student Gallery

Teacher's Resource Binder
   Studio Reflection: 2 Core

---

### Teaching Options

Meeting Individual Needs
Teaching Through Inquiry
Using the Overhead

### Technology

CD-ROM Connection
   e-Gallery

### Resources

Teacher's Resource Binder
   Names to Know: 2.1
   A Closer Look: 2.1
   Map: 2.1
   Find Out More: 2.1
   Assessment Master: 2.1

Overhead Transparency 3
Slides 2d

---

Teaching Through Inquiry
More About…Limners
Assessment Options

CD-ROM Connection
   Student Gallery

Teacher's Resource Binder
   Check Your Work: 2.1

---

### Teaching Options

Teaching Through Inquiry
More About…Drawing
Using the Overhead
Assessment Options

### Technology

CD-ROM Connection
   e-Gallery

### Resources

Teacher's Resource Binder
   Finder Cards: 2.2
   A Closer Look: 2.2
   Find Out More: 2.2
   Assessment Master: 2.2

Overhead Transparency 3

---

CD-ROM Connection
   Student Gallery

Teacher's Resource Binder
   Check Your Work: 2.2

| 9 weeks | 18 weeks | 36 weeks | | | |
|---|---|---|---|---|---|

| | | **36 weeks: 3** | **Global View Lesson 2.3 Painting Life in India** page 108 Pacing: Three 45-minute periods | **Objectives** • Identify influences on, and differences in, Indian painting over time. • Explain the studio workshop traditions of producing images during the Mughal empire. | **National Standards** **1a** Select/analyze media, techniques, processes, reflect. **2b** Employ/analyze effectiveness of organizational structures. **4a** Compare artworks of various eras, cultures. |

**Studio Connection**
page 110

**Objectives**
• Create a genre painting using mixed media.

**National Standards**
**3b** Use subjects, themes, symbols that communicate meaning.

---

**18 weeks: 2   36 weeks: 2**

**Studio Lesson 2.4 Drawing a Group Portrait**
page 112
Pacing: Two 45-minute periods

**Objectives**
• Explain the importance of portraits in daily life.
• Outline the general guide for proportions for drawing the human face and figure.
• Capture the mood, unique characteristics, and reasonable likeness of people in a portrait.

**National Standards**
**2b** Employ/analyze effectiveness of organizational structures.
**3a** Integrate visual, spatial, temporal concepts with content.
**5a** Compare multiple purposes for creating art.

---

**Connect to...**
page 116

**Objectives**
• Identify and understand ways other disciplines are connected to and informed by the visual arts.
• Understand a visual arts career and how it relates to chapter content.

**National Standards**
**6** Make connections between disciplines.

---

**Portfolio/Review**
page 118

**Objectives**
• Learn to look at and comment respectfully on artworks by peers.
• Demonstrate understanding of chapter content.

**National Standards**
**5** Assess own and others' work.

Lesson of your choice

## Teaching Options

Meeting Individual Needs
Teaching Through Inquiry
More About…The Mughal Empire
Using the Large Reproduction

## Technology

CD-ROM Connection
  e-Gallery

## Resources

Teacher's Resource Binder
  A Closer Look: 2.3
  Map: 2.3
  Find Out More: 2.3
  Assessment Master: 2.3

Large Reproduction 4
Slides 2e

---

Teaching Through Inquiry
More About…Studio workshop of Akbar
Assessment Options

CD-ROM Connection
  Student Gallery

Teacher's Resource Binder
  Check Your Work: 2.3

## Teaching Options

Meeting Individual Needs
Teaching Through Inquiry
More About…Paul Revere
More About…Proportions
Using the Overhead
Assessment Options

## Technology

CD-ROM Connection
  Student Gallery
Computer Option

## Resources

Teacher's Resource Binder
  Studio Master: 2.4
  Studio Reflection: 2.4
  A Closer Look: 2.4
  Find Out More: 2.4

Overhead Transparency 4
Slides 2f

## Teaching Options

Community Involvement
Museum Connection
Interdisciplinary Planning

## Technology

Internet Resources
Video Connection
CD-ROM Connection
  e-Gallery

## Resources

Teacher's Resource Binder
  Using the Web
  Interview with an Artist
  Teacher Letter

## Teaching Options

Advocacy
Family Involvement

## Technology

CD-ROM Connection
  Student Gallery

## Resources

Teacher's Resource Binder
  Chapter Review 2
  Portfolio Tips
  Write About Art
  Understanding Your Artistic Process
  Analyzing Your Studio Work

## Chapter Overview

### Theme

People living in communities develop ways to enhance the quality of their daily work and play. Art provides a way for people to reflect upon and improve the quality of their daily life.

### Featured Artists

John Ahearn
Mir Sayyid Ali
Farrukh Beg
William Burgis
Jacques Callot
John Singleton Copley
Manohar Das
Joseph H. Davis
Miftah al Fuzula
David S. Gordon
Robert Kogge
Justus Engelhardt Kuhn
Jacques Le Moyne
Maria and Julian Martinez
Ni'mat-nama
Charles Willson Peale
Paul Revere
George Segal

### Chapter Focus

This chapter looks at the ways that people in communities use art to reflect upon and enhance their routines. Students create a clay container for use in daily life, and they learn about the artworks made and used in the early North American colonies. Students focus on drawing as a way to record people, objects, and events they encounter; and they consider the art created for daily life in India, with special attention to the Mughal period. Students learn that

### National Standards Chapter 2 Content Standards

1. Understand media, techniques, and processes.

2. Use knowledge of structures and functions.

3. Choose and evaluate subject matter, symbols, and ideas.

4. Understand arts in relation to history and cultures.

5. Assess own and others' work.

## 2 Living

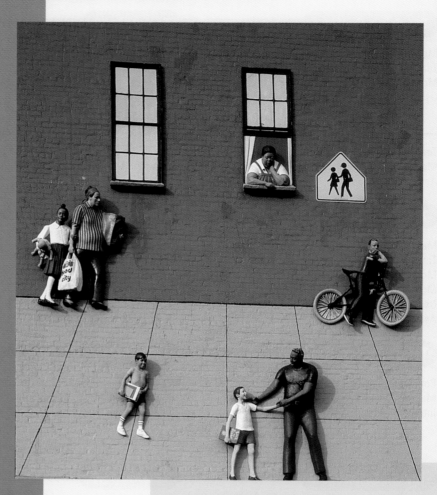

Fig. 2–1 **This scene of children going to school is three stories high. It is displayed on the outside wall of a building in the middle of the South Bronx. Each figure is a plaster cast of a community member. Would you like to see art like this in your town or city?** John Ahearn, *Back to School*, 1985. Permanent outdoor mural at Walton Avenue and 172nd Street, Bronx, NY. Courtesy Alexander and Bonin, New York.

94

**Teaching Options**

### Teaching Through Inquiry

**Art Production** Have students brainstorm a list of ways to **use art publicly to celebrate community members**. Remind students that Ahearn made plaster casts of real people who lived in a geographical community and then displayed the sculptures where all could see them. Ask students to choose a particular community to celebrate, and to consider what kinds of artworks they could make and where they would be displayed. Encourage students to keep notes about these ideas in their sketchbook or journal. Explain that artists and writers often fill pages of their notebooks with ideas, never knowing if or when they will use them.

### More About...

Throughout the 1980s, **John Ahearn** and **Rigoberto Torres** made many community sculptures. They sometimes set up their artmaking on the sidewalk, where people would wait their turn to "become" a sculpture. Ahearn reconstructed some sculptures in fiberglass, and cast others in bronze.

## Focus

- How do the members of a community work and play?
- How is daily life reflected in art?

**When you go to your local grocery store, do you often see the same people working there? Do you recognize your local mail carrier or librarian?** You probably know many members of your local community. You may not know their names, but you recognize their faces. Perhaps you also know about the daily work they do.

The life and energy of any community come from the many different people who live, work, and play there. These people have talents and interests to share with each other. They also have certain roles. Some of them protect us, help build our homes, or care for us when we are ill.

Some people work within the community as artists. The artists John Ahearn and Rigoberto Torres worked together in the South Bronx in New York. They made plaster casts of residents at work and play. Many of the sculptures are displayed on the outside walls of local buildings (Fig. 2–1). Through their artworks, Ahearn and Torres called attention to the important roles people have in the South Bronx. Their artworks remind viewers that each person in the neighborhood is important. They send a message that says, "A celebration of daily life in any community is a celebration of the people who live there."

### What's Ahead

- **Core Lesson** Learn about the roles artists play in the daily life of communities.
- **2.1 Art History Lesson** Discover how people living in North American colonies between 1500 and 1776 included art in their daily lives.
- **2.2 Forms and Media Lesson** Explore ways that artists use drawing skills to record daily life.
- **2.3 Global View Lesson** Examine the role that art plays in the daily life of communities in India.
- **2.4 Studio Lesson** Create a group portrait of people you see at school every day.

### Words to Know

| | |
|---|---|
| portrait | contour drawing |
| designer | gesture drawing |
| bisqueware | whole-to-part |
| dry media | drawing |
| wet media | miniature |
| mixed media | proportions |

portrait artists depict people in their community. Students create portraits of members of their school community.

## Chapter Warm-up

Discuss various professions in the community that involve art: newspaper layout designers, architects, interior decorators, photographers, craftspeople, graphic artists, art teachers, clothing designers. Tell students that they will study the role of artists in communities and the ways that they show daily life.

## Using the Text

After students read the text on page 95, ask them to list, in writing, the occupations of some people they know from their neighborhood, church, or other community to which they belong. **Ask:** Can you identify any artists or craftspeople?

## Using the Art

Perception **Ask:** How did John Ahearn identify the roles of the figures in his mural? How did he "trick" your eye to make this look real? *(use of simulated textures, casts of actual people, linear perspective)*

## Graphic Organizer
## Chapter 2

**2.1 Art History Lesson**
Art in Colonial North America: 1500–1776
page 102

**Core Lesson**
Daily Observations

**Core Studio**
**Create Your Own Pottery**
page 100

**2.2 Forms and Media Lesson**
Drawing
page 106

**2.3 Global View Lesson**
Painting Life in an Indian Empire
page 108

**2.4 Studio Lesson**
Drawing a Group Portrait
page 112

### CD-ROM Connection

For more images relating to this theme, see the Community Connection CD-ROM.

## Prepare

### Pacing

Two 45-minute periods: one to consider art and text, and to begin pottery vessel; one to finish pottery

### Objectives

• Use examples to explain how artists observe and record daily life in communities.

• Identify artist-designed objects that enhance community life.

• Create a functional and decorated clay container for everyday use.

### Vocabulary

**portrait** An artwork that shows a specific person or group of people.

**designers** Artists who plan the organization and composition of an artwork, object, place, building, and so on.

**bisqueware** Ceramic that has been fired once but not glazed.

## Teach

### Engage

**Ask:** What was life like in our community 100 years ago? What was the main industry? Who were the community leaders? How did people dress? How do you know this? *(monuments, paintings, photographs)* How do you think our community and its people will be remembered 100 years from now? Does our community have any memorials, such as sculptures and murals, that honor

### National Standards Core Lesson

**1b** Use media/techniques/processes to communicate experiences, ideas.

**5b** Analyze contemporary, historical meaning through inquiry.

**5c** Describe, compare responses to own or other artworks.

# Daily Observations

## Artists Show Us at Work and Play

We look to artists to observe and record our daily life in the community. Artists often show who we are, what we do, and what we care about. In the sculpture *The Steelmakers* (Fig. 2–2), artist George Segal shows people who have been important in the daily life of Youngstown, Ohio. The steelworkers' union chose two of its members to be models for this sculpture. They represent all the steelworkers who have worked in Youngstown.

Artists observe people at work and play, and then create images of them. They might show close-up views of how children or adults spend their leisure time. Some artists observe and record an entire community at play. Artist Jacques Callot created the print *Great Fair at Imprunita* (Fig. 2–3) in 1620. The print shows people gathered together for a community event. In artworks such as these, artists can show us how people lived at other times. These works can also show us how similar our daily life is to life in the past. How is the fair you see in this artwork similar to state or county fairs that you know about?

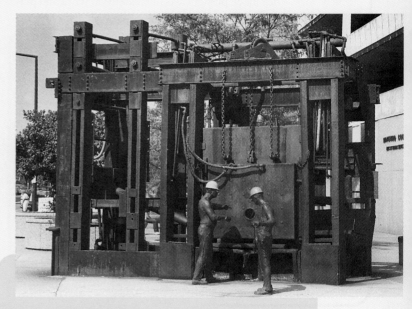

Fig. 2–2 This artist often creates sculptures dedicated to the idea of people and their daily work. If you were to celebrate workers in your community, who would they be? George Segal, *The Steelmakers*, Youngstown, Ohio, 1980. Open hearth furnace contributed from Jones and Laughlin Steel Co., and bronze castings. Courtesy The Youngstown Area Arts Council. © George Segal/Licensed by VAGA, New York, NY.

96

## Teaching Options

### Resources

Teacher's Resource Binder
    Thoughts About Art: 2 Core
    A Closer Look: 2 Core
    Find Out More: 2 Core
    Studio Master: 2 Core
    Studio Reflection: 2 Core
    Assessment Master: 2 Core
Large Reproduction 3
Overhead Transparency 4
Slides 2a, 2b, 2c

### Meeting Individual Needs

**Multiple Intelligences/Bodily-Kinesthetic** Ask students to take the poses of people in Figs. 2–1 and 2–2, so that everyone is part of these community compositions. Ask them to discuss and/or write what they understand about the community from their experience (e.g., children are important in the neighborhood depicted in Fig. 2–1). **Ask:** What do you think each artist wanted to indicate about these communities? How did they use body positions to help provide the information?

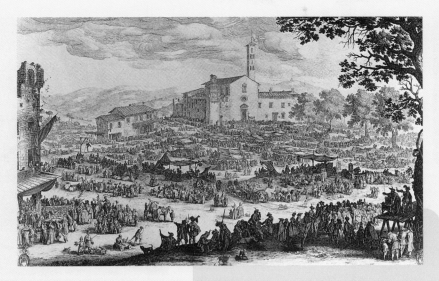

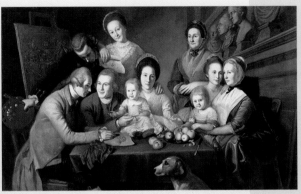

Fig. 2–3 The artist included over 1,100 figures in this image of people at play. What kinds of leisure activities do you see? Do they remind you of activities that you enjoy? Jacques Callot, *Great Fair at Imprunita*, 1620. Intaglio, 16 15/16" x 26 1/4" (43 x 66.7 cm). The Metropolitan Museum of Art, Harris Brisbane Dick Fund, 1917 (17.3.2645).

Fig. 2–4 Portraits often show details that reflect what is important to the people in the artwork. What details in this painting symbolize the interests of the Peale family? Charles Willson Peale, *The Peale Family*, ca. 1770–73 and 1808. Oil on canvas, 56 1/2" x 89 1/2" (143.5 x 227.3 cm). Collection of the New York Historical Society (1867.298).

## Artists Create Portraits

A **portrait** is an artwork that shows a specific person or group of people. *Portraiture*, the art of creating portraits, is another way that artists observe and record daily life. People cherish painted, sculpted, and photographed portraits of their leaders, family members, and other loved ones from the past and present. Portraits provide us with a glimpse into the daily lives of their subjects.

Portrait artists might show one person or a group of people in the community. Charles Willson Peale is known for his portraits of Andrew Jackson, John Quincy Adams, and other early American leaders. He painted this group portrait of his own famous family of artists (Fig. 2–4). Here he shows himself giving his brother a drawing lesson.

Living

97

heroes or industries? Where might you find portraits of people and families? Tell students that they will see how artists record community life.

## Using the Text

**Art Criticism** Have students read the text. **Ask:** Which artwork on pages 96–97 celebrates a community's workers? *(The Steelmakers)* How did the artist show the importance of these workers to the community? What local industry could you honor in a similar sculpture? How?

## Using the Art

**Art Criticism** Direct students' attention to Fig. 2–3. **Ask:** What did Callot emphasize in his print? *(huge gathering at a fair)* Where is the viewer? *(on a hill, looking down)* What is the mood of this print? Challenge students to identify activities in the scene.

**Art Criticism** Have students answer the caption question for *The Peale Family*. **Ask:** How did Peale show relationships among the family members?

## Extend

Ask students to describe local places where people gather to buy and sell. Discuss what could be emphasized in a depiction of these places. Have students draw one such place.

### Teaching Through Inquiry

**Art Criticism** Have students work in small groups to **consider Peale's family portrait** (Fig. 2–4). Instruct members of each group to take turns to select an individual in the portrait; to describe the way the artist depicted him or her, including references to position within the group, and details such as clothing and facial expression; and to imagine the subjects' personalities, based on details in the painting. Ask students to reflect on the entire portrait. **Ask:** What did the artist convey about his family? Does the family seem down-to-earth or snobbish? Do the family members seem artistic? Guide students to refer to details in the work as they address these questions. Have pairs of groups share their findings. Then, as a class discussion, ask students to compare and contrast the Peale group portrait with family-group photographs.

### More About...

**George Segal** (b. 1924) combines plaster casts of humans with objects from an environment (furniture, artifacts, and so on) to create fragments of reality. His subjects frequently investigate everyday scenes, such as gas stations or New York City subway cars. Ultimately, Segal wishes to prompt thoughtful consideration by viewers, not awe of his realistic representation.

## Using the Text

**Aesthetics** Have students read the text to learn about types of community art. **Ask:** What have artists designed in our community? Encourage students to cite specific examples in churches, parks, civic centers, and architecture. Remind them to look at parts of the community they may not have thought of as "art" before this time. **Ask:** Can you think of spaces that may have been designed by a landscape architect? What about objects, such as playground equipment, that have been planned by a product designer?

## Using the Art

**Art Criticism Ask:** How does the artist's design of this garden (Fig. 2–6) lead people through the garden? How did the artist create variety in the design? What impressions might a visitor have upon entering the park?

## Enriching Community Spaces

Have you ever wondered how the streetlights, signs, benches, and landscaping that you pass by every day were created? Do you know who designed these things? Artists design and create places and objects that we see in our neighborhood every day. Some of these objects, such as the streetlights in Victoria, Canada (Fig. 2–5), are beautiful as well as functional. In the past, the people who made objects for daily use were well known in the community. This is still true today in some parts of the world.

Fig. 2–5 These streetlights are in front of the parliament buildings in Victoria, Canada. What does their beauty suggest about the local community? *Street lamp from Victoria*, Vancouver Island. © 1999 Reimut Lieder/Image Makers.

Fig. 2–6 How is the design of this garden different from the design of a public garden you know? How does the design of your community's garden reflect the garden's function? India, *Brindavan Gardens at Mysore*, Karnataka. © M. Amirtham/Dinodia Picture Agency.

### Teaching Through Inquiry

**Art History** Ask students to discover how a local public garden or other **community space** came to be: who, if anyone, commissioned it; who designed it; how it is maintained. Challenge students to locate original drawings or plans, correspondence, news articles, and any other primary documents related to its history. Students might display their findings in the school or community.

### More About...

**Public Gardens** Ancient Egyptians built formal walled gardens, and the Mesopotamians constructed private parks with lush plantings. The Roman Empire saw architect-designed landscaped gardens dotted with marble statues and fountains. In the East, Buddhists from India to China established naturalistic gardens. The Japanese adapted the idea, but developed a spare, elegant style.

Fig. 2–7 Notice how this mural helps the underpass blend in with the local architecture. Why might the community have wanted this wall to be painted? David S. Gordon, *Unbridled* (Ocean Park Boulevard at the 4th Street Underpass, Santa Monica, CA), 1984–86. Keim paint (silica based) on concrete, 25' x 600' (7.62 x 182.9 m). Courtesy the artist.

**Art Production** Discuss how the work of creating a public mural, such as that in Fig. 2–7, might be organized. Brainstorm with students a variety of ways to gather artists and ideas, to choose locations and obtain permissions from property owners, and to obtain materials that are inexpensive yet durable. **Ask:** What are some obstacles you might encounter? How can you overcome such problems? Encourage students to think about other types of community art as well, and how sculptures, parks, and other art-making projects might be handled.

## Extend

Compile a list of historic events and places in your community. Assign each student one event or place to research and depict in a square cut-paper collage or cloth appliqué. Then have students join their squares with borders to form a quilt.

Designers help plan and lay out buildings and outdoor spaces used in the community's social, religious, civic, and economic life. For example, public gardens, such as the Brindavan Gardens in India (Fig. 2–6), offer places for people to relax and enjoy the quiet beauty of nature. Plazas and malls that lead visitors to the entrances of important public places are often designed like this garden. As you look around your town or city, note the homes, gardens, parks, meeting halls, churches, courthouses, libraries, and shopping districts. How were they designed to be both functional and beautiful?

## Group Artworks for the Community

Sometimes, groups of artists work together to create community places and objects. They divide tasks among themselves and work side-by-side to finish the project. All around the world, people work together to create large-scale sculptures, murals, monuments, parks, and other public projects.

Many artists learn their skills from family members. Others learn from local experts who share their skills. This teaching might take place in schools or within social groups. Sometimes artists get together with local people who have similar interests, such as stone carving or landscape design. In groups such as these, members share their ideas and skills with each other.

Living

99

## Using the Large Reproduction

### Talk It Over

**Describe** Look at the painting and identify the subject matter. What did the artist depict?

**Analyze** How has the artist arranged the important parts of this painting? How has she used art elements and principles to direct your attention?

**Interpret** What is this painting about? What does it say about the way people go about their daily lives?

**Judge** Is this painting a good artwork? Why?

**3**

## Using the Overhead

### Think It Through

**Ideas** How do you think the artist came up with the idea to depict watermelons and the other objects in this artwork?

**Materials** What materials did the artist use to show these things?

**Techniques** How did she use the materials to create the special effects in this artwork?

**Audience** Who might especially enjoy viewing this artwork? Who might not like it?

**4**

## Supplies

- clay, ceramic or self-hardening, at least 1 lb/student
- water, slip
- containers for slip
- clay tools including forks, carving and shaping tools
- sheets of plastic (or large bags)
- rolling pins
- burlap or canvas
- wire to cut clay

### Safety Note

Use only clay and glazes approved for school use. Many glazes contain toxins such as lead and cadmium.

## Using the Text

**Art Production** Tell students that they will form a clay vessel, and lead them in considering uses for their pots. **Ask:** How will the function of your vessel affect its form? Demonstrate making a base: either flatten clay on thick fabric with a rolling pin, and cut out its shape; or press a ball of clay flat with your hands.

Instruct students to roll coils about as thick as their thumb. Guide them in scoring the outer edge of the base, adding slip, and pressing on the coil; repeat until the desired height is reached. Emphasize that a little of each new coil must be smoothed onto the adjoining clay to join pieces securely: clay shrinks as it dries and is fired, and any piece not firmly connected will pop off. When finished, have students carve their name on the bottom of their pot.

**Pottery in the Studio**

# Create Your Own Pottery

Think of how often you use boxes, bags, and plastic storage bins at home and at school. What do you think people living in earlier times used for containers? Many made clay pots in hundreds of different shapes and sizes. They added decorative features to make the pots both functional and beautiful. The forms and features of the pots varied depending on where the people lived, what they needed, and how they passed along their culture's traditions.

**In this studio experience, you will create a clay container that can be used in daily life.** Like generations of pottery makers, you will explore the coil method to make a decorated and functional object. What uses will your container have? How will you decorate it? What local pottery traditions might you follow?

### You Will Need

- clay
- rolling pin
- two flat sticks
- water
- slip
- paintbrush
- clay tools, such as a fork, spoon, wooden dowel
- sheet of plastic or large plastic bag

### Try This

**1.** Cut a ¾"-thick slab of clay into a shape for the base of your pot. Roll out coils of clay about ¾" (2 cm) thick. These will be used to build up the sides of the container.

**2.** Scratch the edge of the clay slab with a fork. Apply slip (a thick liquid made of clay mixed with water) on top of the roughened clay. Press the first coil to the base. Blend the coil to the base. Continue building, coil upon coil. Scratch the clay and use slip before you blend the coils together.

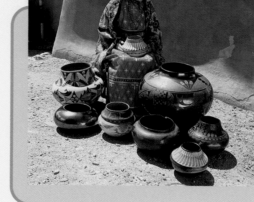

## Studio Background

**Techniques and Traditions in Pottery**
For thousands of years, people all over the world have made beautiful clay pots for cooking, storing food and water, and other everyday purposes. They form the pots with their hands and allow them to

Fig. 2–8 Traditional Pueblo pottery is decorated with simplified shapes of animals, birds, or other elements of nature, and geometric shapes. What words can you use to describe the form, color, and decorative elements of this pottery? Maria Martinez of San Ildefonso Pueblo, New Mexico, April 1976.
Photo by Jerry Jacka.

## Meeting Individual Needs

**Adaptive Materials** Prepare coils in advance. Use a softer clay (or add water to regular clay to make it softer). Have students wrap the coils of clay around another bowl. This provides those students with limited dexterity a "model" to work from.

## Teaching Through Inquiry

**Art Production** Invite a local potter to class. Prior to the visit, show examples of the potter's artworks. Have students generate questions to ask the artist, focusing on such topics as how the artist learned to make pottery, how he or she follows or breaks from tradition, the importance of creating a useful object, and what makes a good pot. If video technology is available, encourage students to document the visit and edit the tape to show to another class.

**3.** As you work, look at the pot often from all sides. Try to keep its shape symmetrical. Cover your finished pot loosely with plastic. Allow it to dry slowly.

**4.** When your pot is dry, you may wish to smooth the surface with the edge or back of a spoon.

**5.** Decorate your pot before firing. You can add small balls or coils of clay for a relief design. You might also carve a design directly into the surface of the clay.

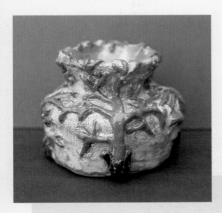

Fig. 2–9 **"This pot was inspired when I looked out the window of our art class and saw a tree with no leaves."** Danielle Zoe Rivera, *Untitled*, 2000. Clay, glaze. 5" x 6 ½" (12.7 x 16.5 cm). Mount Nittany Middle School, State College, Pennsylvania.

dry, creating what is called *greenware*. Greenware is fragile and must be handled with care. It is often baked in a fire or a kiln until the clay is hard and strong. The once-fired clay is called **bisqueware**. Bisqueware can be made waterproof by applying glaze with a brush and firing again.

Techniques and traditions in making clay pots are often passed down through generations in a family. Maria Martinez, a Native-American artist, learned to make pottery by watching and imitating her aunt in the pueblo of San Ildefonso, New Mexico. Maria learned the ancient method of building pots and plates from coils of clay. She is known and honored for having revived the finest traditions of pottery among the Pueblo community.

**Check Your Work**

Display your completed work. Think about the form and decoration of your pot. Does the form fit its intended use? Why? How do your decorative features add to the pot? What changes would you make, if any?

**Sketchbook Connection**

Carry your sketchbook with you and pay attention to the shapes and designs of the pottery you see in your community. Make sketches of these shapes and designs to refer to later.

Core Lesson 2

**Check Your Understanding**

**1.** Name two ways artists contribute to daily community life.
**2.** What is a portrait?
**3.** Identify a skill that is taught within your family or local community, much like the pottery skills that are taught within the Pueblo community.
**4.** Suppose that traditions of making objects were not passed along to future generations. What would people need to do to set up a new tradition for making a particular kind of useful object for their community?

## Using the Art

**Perception Ask:** Can you tell, by looking, which of the pots in Fig. 2–8 were produced using the coil technique? *(all of them)* What advantage does the coil method have compared to creating pottery on a wheel?

## Assess

### Check Your Work

Ask volunteers to describe how the forms of their pots fit the intended uses. **Ask:** Are your clay vessels symmetrical?

**Check Your Understanding: Answers**

**1.** Answers may vary. Possible responses: observe and record daily life—work and play—within the community, create portraits of community members, design objects that we see and use in everyday life.

**2.** Traditionally, a portrait is a likeness of a specific person or group.

**3.** Answers will vary.

**4.** Answers will vary.

## Close

Display the students' pottery and hold a class discussion about function and beauty.

**More About...**

**Pueblo pottery** is one of the oldest continuing Native-American arts. Traditionally, potters soaked their clay, removed any stones, and eventually put it through a sieve to ensure a consistent medium. Artists built vessels with rolls of coiled clay, smoothed the walls inside and out, added incisions, and, after firing, often glazed and refired their pieces to make the colors permanent.

**Assessment Options**

 **Peer** Have students design poster-size graphic organizers to demonstrate that they know how artists observe and record daily life in a community, and how artworks and designs enhance community life. Before students begin, have them create a list of criteria for the assignment. Exhibit the completed posters, and have students rank the posters according to the agreed-upon criteria. Ask students to choose some of the posters for display in public areas of the school.

## Prepare

### Pacing

Three to four 45-minute periods: one to consider art and text; three to make art

### Objectives

- Describe the ways colonial North American art reflects daily life during that period.

- Identify art forms as belonging to the colonial period.

- Draw an arrangement of daily-life objects to capture a mood or feeling through effective use of the principles of design.

### Using the Time Line

**Ask:** What historical events in colonial North America were occurring at the time these artworks were created? Challenge students to list events that occurred close in time to the dates of each work.

---

# Art in Colonial North America: 1500–1776

**1585**
White, *Indians Fishing*

**1674**
*Mrs. Freake and Baby Mary*

**1768**
Revere, *Sons of Liberty Bowl*

Ancient North America page 76

Colonial North America

American Neoclassicism page 128

**1565**
Le Moyne, *Rene Goulaine de Laudonniere and Chief Athore*

**1630**
*Bradford Chair*

**1716**
Burgis, *View of New York*

### History in a Nutshell

During the sixteenth century, Europeans made important progress in navigation. As a result, many Europeans boarded ships and crossed the oceans to establish new communities in Asia, Africa, and the Americas. In North America, three major colonies began: New Spain, New France, and New England.

The colonial period in North America began in 1521, when the Spaniard Hernando Cortes conquered the region of present-day Mexico. A century later, the first English, Dutch, and French colonists settled along the east coast region of what are now the United States and Canada.

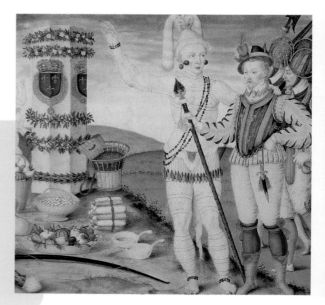

Fig. 2–10 Jacques Le Moyne used watercolor to record the early settlement of colonies in Florida. What does this painting suggest about the relationship between European settlers and Native Americans in the Florida colonies? Jacques Le Moyne, *Rene Goulaine de Laudonniere and Chief Athore* (detail), 1565.
Gouache and metallic pigments on vellum, with traces of black chalk outlines. Prints Collection, Miriam and Ira D. Wallach Division of Art, Prints and Photographs, The New York Public Library, Astor, Lenox and Tilden Foundations. Bequest of James Hazen Hyde.

102

---

### National Standards
### 2.1 Art History Lesson

**2b** Employ/analyze effectiveness of organizational structures.

**3b** Use subjects, themes, symbols that communicate meaning.

**4a** Compare artworks of various eras, cultures.

---

## Teaching Options

### Resources

Teacher's Resource Binder

  Names to Know: 2.1

  A Closer Look: 2.1

  Map: 2.1

  Find Out More: 2.1

  Check Your Work: 2.1

  Assessment Master: 2.1

Overhead Transparency 3

Slides 2d

### Meeting Individual Needs

**Multiple Intelligences/Linguistic and Intrapersonal** Have students research what life was like for women of European descent, such as the one pictured in Fig. 2–15, and for native women in tribes inhabiting the eastern seaboard. Encourage children to write an imaginary discussion between a native woman and the mother in the painting, about their daily activities and life in their respective communities. Have students share their writing and discuss how the artist's portrayal of Mrs. Freake influenced their perception of her character.

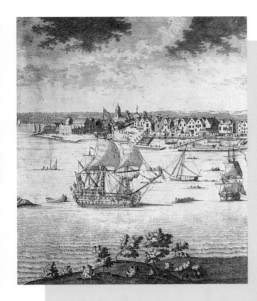

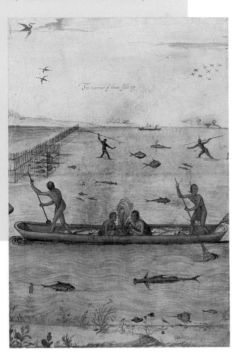

Fig. 2–11 In the early 1700s, when this engraving was created, New York was the third largest city in the colonies. What does this image tell you about daily life in New York at that time? How is it different today? William Burgis, *View of New York from Brooklyn Heights* (detail: section one), 1716–18. Engraving after drawing, 20 7/8" x 17 15/16" (53 x 44.7 cm). Collection of the New York Historical Society.

Fig. 2–12 This watercolor painting shows one glimpse of what life was like in Virginia during Sir Walter Raleigh's colonial venture there. What details from daily life do you see? After original watercolor by John White, *Indians Fishing*, Virginia, 1585. Watercolor touched with gold. Courtesy the Trustees of the British Museum. © Copyright The British Museum.

## A Common Art Heritage

Meeting basic needs in their new land challenged North American colonists. They had to make the things they could not bring from Europe. Those who knew a craft tradition helped by making things that were needed. Artworks by European printmakers, engravers, and painters are visual records of the colonists' early settlements. The artworks shown in Figs. 2–11 and 2–12 are scenes of daily life in early communities in New York and Virginia.

Colonial art owes much to the memories and experiences of the first settlers. The people who built the colonies were familiar with art created during the European Renaissance. Some were also familiar with art from ancient Greece and Rome. This common heritage is one reason why we can see similarities in the crafts, painting, sculpture, and architecture created by different North American communities.

Living

103

## Teach

### Engage
Ask students to list five things they would carry with them if they were going for an extended visit to a part of the world unfamiliar to them. Tell them to assume there will not be electricity, plumbing, or pre-built shelters at their destination. Lead a class discussion about why students chose the items they did. **Ask:** How might you spend your time while away?

### Using the Text
**Art History Ask:** In what ways did the artists of colonial North America have a common art heritage?

### Using the Art
**Art History** Ask students to describe visual details that support their answers to the caption questions.

### Extend
• As a group collaboration, have students create an installation, drawings, or paintings showing their community's past, present, and future.

• Arrange a trip to a local museum so that students may draw historical everyday objects in their sketchbooks. They may use these sketches as the basis for paintings of their community's past.

## Teaching Through Inquiry

**Art History** Ask students to imagine a journey back in time to a North American **colonial settlement**, to find what was important to the people living there. Have students work individually or in small groups to create an account of their findings about the art that the people made and lived with. Instruct students to use images in the text and from other sources to explain how the artworks reflected the settlers' daily life. Students may present their accounts as scripts for a TV travel show.

## Using the Overhead

**Investigate the Past**

**Describe** What do you see in this artwork?

**Attribute** What, if anything, might suggest the place and time it was created?

**Interpret** What do you think this artwork might have meant to the people who lived at the time it was made? What does it mean to you now?

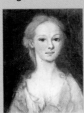

**Explain** What art-making tradition is this artwork a part of?

3

103

## Using the Text

**Art History Ask:** What was Paul Revere's trade? *(silversmithing)* In this piece, how was Revere influenced by Chinese art? *(The bowl's form is similar to that of imported Chinese porcelain.)* Why would it be considered one of the most famous pieces of American silver?

## Using the Art

**Perception** Ask students to observe and comment on the details of Figs. 2–13 and 2–14. **Ask:** How are the bowl and chair different from objects we use today?

As students study *Mrs. Elizabeth Freake and Baby Mary* (Fig. 2–15), **ask:** What are the textures in this work? How did the artist emphasize the figures? *(by making them large and centering them against a plain background)*

## Extend

Assign students to draw a self-portrait in which they depict themselves in clothes they would like to wear, but do not necessarily own, and in a place they would like to be.

## Studio Connection

 Provide the following supplies: still-life objects; drawing media (pencils, charcoal, or pastels); 18" x 24" or 9" x 12" drawing paper; erasers; fixative (optional).

## Art for Living

Colonists along the east coast created decorative items for daily use in wood, silver, and other metals. Women created fine quilts, needlework, and homespun weaving. The major influences on art in the thirteen colonies came from England. The silver bowl in Fig. 2–13 was made by the same Paul Revere who warned that the British were coming in the Revolutionary War. Paul Revere was a silversmith as well as a hero in his community. The form of the bowl is similar to Chinese porcelain bowls that traders brought to America by ship.

In these New England colonies, portraits for the home were popular. Many portraits show settlers in fine clothes, posed as if they were European aristocrats. Although the portrait in Fig. 2–15 was painted by a trained artist, most painters were self-taught. *Limners* traveled from one town to another to paint signs and houses. In their spare time, they painted portraits of the colonists. Eventually, some artists moved beyond portrait painting and created historical paintings as well.

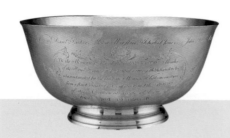

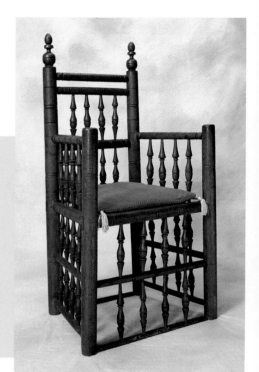

Fig. 2–13 **This punch bowl is one of the most famous pieces of American silver. The artist, Paul Revere, was an important figure in the Boston community. For whom might he have made this bowl? On what occasions might a bowl like this be used?** Paul Revere, *Sons of Liberty Bowl*, Boston, 1768. Silver, 5 ½" x 11" (14 x 27.9 cm). Gift by Subscription and Francis Bartlett Fund. Courtesy Museum of Fine Arts, Boston. Reproduced with permission. ©1999 Museum of Fine Arts, Boston. All Rights Reserved.

Fig. 2–14 **Chairs were luxury items in many early New England homes. Would you consider this a luxury chair? Why or why not?** Massachusetts Bay Colony, *Bradford Chair*, 1630. Black ash, seat: wood, 46" x 24" x 19" (116.8 x 61 x 48.3 cm). Pilgrim Society, Pilgrim Hall Museum, Plymouth, MA.

104

## Teaching Through Inquiry

**Art History** Have student groups look through magazines and furniture and housewares catalogs to find examples of current everyday objects that are reproduced in the **colonial style**. Discuss the characteristics of these objects that are consistent with those of the colonial period. Have each group select a household object, such as a chair; research its various colonial styles; and prepare a display showing the variations on the reproduction of that style over the years.

### Studio Connection

Observe and draw an arrangement of objects, such as dishes, chairs, or tools, that are an important part of your everyday life. Choose drawing media and arrange the objects to bring out the main visual differences between them. Study the objects carefully before making your decisions.

Plan your composition by using the principles of design. What will you emphasize? Are there rhythms you can show? Will you use normal, ideal, or exaggerated proportions? Why? How can you use other principles of design to create a definite mood or feeling?

### 2.1 Art History

#### Check Your Understanding

1. How did art play a part in the daily life of the North American colonists?
2. What is the common artistic heritage of colonial communities?
3. What decorative items were made for the homes of the early colonists?
4. What are limners and what role did they play in colonial life?

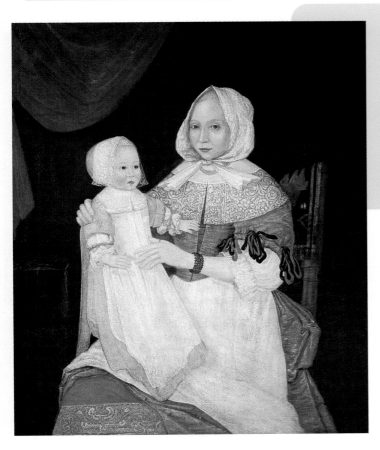

Fig. 2–15 In this portrait, the artist uses the elegant, embroidered style of the Tudor period in England (1485–1603). The delicate treatment of lace and fabric help soften the stiffness of the figures. Anonymous, *Mrs. Elizabeth Freake and Baby Mary*, portrait, ca. 1671–74.
Oil on canvas, 42 1/2" x 36 3/4" (108 x 93.4 cm). Worcester Art Museum, Worcester, Massachusetts, Gift of Mr. and Mrs. Albert W. Rice.

Living

Demonstrate drawing a still life, lightly sketching the whole composition before shading and adding details. Allow students to work in groups to select and arrange objects into still lifes. As students plan their drawing, **ask:** Where should you place your most important object? What size will it be? Encourage students to fill the page with their drawing.

**Assess** See Teacher's Resource Binder: Check Your Work 2.1.

### Safety Note

If students use fixative, have them do so in a well-ventilated area or outdoors.

## Assess

### Check Your Understanding: Answers

**1.** Art—in the form of useful objects—fulfilled basic, daily needs.

**2.** the craft traditions of Europe and European art inspired by the Renaissance and classical Greece and Rome

**3.** items (such as bowls) in wood, silver, and other metals; quilts, needlework, and homespun weaving; portraits and historical paintings

**4.** Limners were itinerant, self-taught painters of signs and houses. In their spare time, they painted portraits of colonists.

## Close

Have student pairs answer the questions in Check Your Understanding. Discuss their answers. Ask students to return to the first question and add three specific ways they think art may have played a role in daily life. **Ask:** Are these similar or dissimilar to the role art plays in daily life today?

### More About...

In North America, from colonial times to the nineteenth century, the term **limner** named an itinerant and untrained painter, especially of portraits. In the Middle Ages in Europe, a limner was an illuminator of manuscripts; in seventeenth-century Europe, a limner was a painter of miniatures and of watercolors. The term *limning* is sometimes used in place of *painting,* especially for a miniature portrait.

### Assessment Options

**Teacher** Have students write a conversation between a colonial limner and a craftsperson, in which the two describe their efforts to create artworks that reflect people's daily life and that appeal to their daily needs. Instruct students to include reference to influences from abroad, materials, and methods of working.

**FORMS AND MEDIA LESSON**

**2.2**

# Drawing

Add drawing to your daily life! Drawings can be quick records of things you see and want to remember. They can be a way to explore and try out ideas for other kinds of artwork, such as paintings or sculptures. Drawings can also be finished works of art.

Before they draw, artists think about the medium they will use. They choose the medium that will help them express their ideas and feelings. **Dry media** include pencils, charcoal, pastels, and crayons. **Wet media** include inks applied with a pen or a brush. In a **mixed-media** artwork, artists combine drawing with painting, collage, or printmaking.

Once artists choose their medium, they experiment with it to find the techniques they like best.

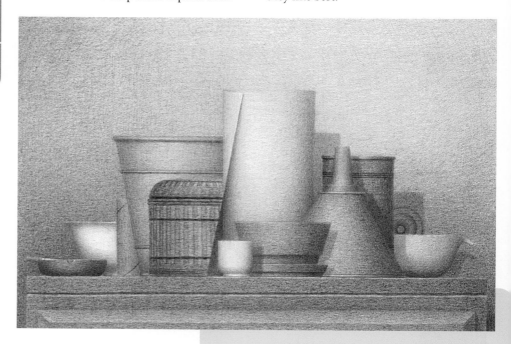

Fig. 2–16 **This artist created a still life of everyday objects. Notice how carefully he has drawn the shapes and forms. What drawing technique do you think he used?** Robert Kogge, *Untitled*, 1989.
Graphite on canvas, 20" x 30" (50.8 x 76.2 cm). Courtesy O.K. Harris Works of Art, New York, NY.

## Prepare

### Pacing
Two 45-minute periods

### Objectives
- Identify media commonly used in drawing.
- Explain differences among technical approaches to drawing.
- Use three different approaches to create three drawings of the same daily-life object.

### Vocabulary
For definitions, see the glossary on page 312.

**dry media, wet media, mixed media, contour drawing, gesture drawing, whole-to-part drawing**

## Teach

### Engage
Demonstrate contour and gesture drawing in several media.

### Using the Text
**Art Production** Have students read about dry and wet drawing media. **Ask:** Which of these media have you used in your own artworks?

### Using the Art
**Art Criticism Ask:** What did each artist emphasize? What are the shapes, textures, contrasts, and patterns in each artwork?

### National Standards 2.2 Forms and Media Lesson

**1a** Select/analyze media, techniques, processes, reflect.

**1b** Use media/techniques/processes to communicate experiences, ideas.

## Teaching Options

### Resources
Teacher's Resource Binder
- Finder Cards: 2.2
- A Closer Look: 2.2
- Find Out More: 2.2
- Check Your Work: 2.2
- Assessment Master: 2.2
- Overhead Transparency 3

### Teaching Through Inquiry

**Aesthetics** Tell students that early Western artists mostly made drawings to work out ideas or to study something. Although artists valued one another's drawings, not until the seventeenth century did collectors display drawings in *cabinets*—rooms with specially built storage drawers. Here, artists could take out, study, and appreciate **drawings as artworks**. Provide students with drawings or reproductions to examine. **Ask:** How is drawing a unique art form? What makes it different from painting, sculpture, printmaking, or photography?

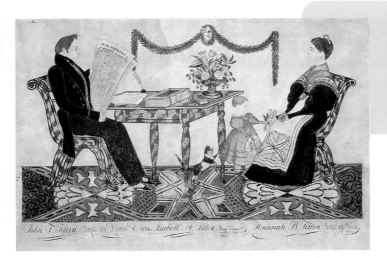

Fig. 2–17 Would you consider this a contour drawing or a whole-to-part drawing? Why? Joseph H. Davis, *The Tilton Family*, Deerfield, New Hampshire, 1837. Watercolor, pencil and ink on wove paper, 10" x 15 ¹/₁₆" (25.4 x 38.3 cm). Abby Aldrich Rockefeller Folk Art Center, Williamsburg, VA.

## Drawing Techniques

Most artists prefer one particular drawing technique over another. Here are three techniques that you might try. Which one feels best to you?

- **Contour drawings** show the edges (contours) of objects. To make a contour drawing, keep your eyes on your subject. Imagine that you are tracing it.
- **Gesture drawings** are done quickly, without attention to details. Try drawing only the main "action lines" of your subject.
- **Whole-to-part drawings** are those in which the largest shapes are drawn first. Details are added afterwards.

To get ideas for drawings, artists look at things, depend on their memories, or tap their imaginations. Sometimes they get ideas from art that was created by other artists.

### 2.2 Forms and Media

**Check Your Understanding**
1. Why might an artist want to mix media in a drawing?
2. What are the main differences between contour drawings and gesture drawings?

**Studio Connection**
Experiment with the three drawing techniques. Choose an object that you see every day. First, make a contour drawing. Focus carefully on the edges of your object, and draw slowly. Next, make a gesture drawing of the same object. This time focus on the direction of its parts. Finally, make a whole-to-part drawing. Sketch the large shapes first. Refine them with lines and shading. Then fill in the details. Use a pencil or marker for the first two drawings and a pencil and eraser for the third.

**Sketchbook Connection**
Use your sketchbook every day to draw or sketch objects, people, and places around you. Drawing every day will help you strengthen your skills. Carry your sketchbook with you or plan time in your daily schedule to draw.

Living

## Studio Connection

Provide 12" x 18" sketch paper (3 or 4 sheets per student), 12" x 18" drawing paper (1 sheet per student), markers, and pencils. Set out a variety of objects for students to draw using contour and gesture techniques.

Demonstrate whole-to-part drawing. Suggest to students that they create a whole-to-part drawing of the object they depict in their earlier drawings.

**Assess** See Teacher's Resource Binder: Check Your Work 2.2.

## Assess

### Check Your Understanding: Answers

1. to best express intended ideas and/or feelings

2. Contour drawings define the edges of objects; whereas gesture drawings, which are done quickly, capture the main action lines, without attention to details.

## Close

Have students display their drawings, and ask them to describe the techniques. **Ask:** Why might an artist choose one of these techniques instead of another? Inform students that gesture drawings are most often used when showing the human figure.

## More About...

**Drawing** is used for working through ideas, or visual thinking. *Subjective* drawing emphasizes an artist's emotions or the emotional associations with the subject of the drawing; recording the world accurately is not a priority. *Objective,* or *informational,* drawing includes diagrammatic, architectural, and mechanical drawing. Schematic, or conceptual, drawing, is another form of objective drawing, and focuses on a concept or idea. Familiar examples of schematic drawings are comic-book characters and stick figures in instruction manuals. Pictorial recordings are drawings that seek to record something with photographic accuracy.

## Using the Overhead

**Write About It**

**Describe** Write a few sentences describing the proportions in this portrait.

**3**

## Assessment Options

**Self** Have each student prepare a teaching booklet about drawing, for a reader of their choice. Students should include an explanation of the media commonly used for drawing, as well as instruction in three different ways to approach drawing. Ask students to develop criteria for assessing the booklets, and have them use the criteria to assess their own booklet.

## Prepare

### Pacing
Three 45-minute periods: one to consider art and text; two to make art

### Objectives
- Identify influences on, and differences in, Indian painting over time.
- Explain the studio workshop traditions of producing images during the Mughal Empire.
- Create a genre painting, using mixed media.

### Vocabulary
**miniature** A very small, detailed painting.

### Using the Map
Have students locate India on the world map (page 306). **Ask:** What is India's geographic relationship to China, Africa, Southeast Asia, Polynesia, and Europe? What separates India from China? What is India's size and latitude relative to the United States? Which country is warmer? *(India)*

---

# Painting Life in an Indian Empire

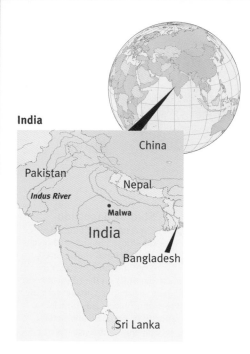

India

China

Pakistan

Nepal

*Indus River*

Malwa

India

Bangladesh

Sri Lanka

## Global Glance

About 5000 years ago, the first known civilization developed in the Indus Valley, the area now known as India. Over the centuries, many different people settled in this vast land for different periods of time. Aryans, Persians, Greeks, and Muslims each blended elements of their civilizations with the original Indian culture. For thousands of years, Hinduism and Buddhism were the native religions in India. Then, in the sixteenth and seventeenth centuries, the Mughal Empire came to rule most of India. The Mughal rulers were Muslim. They developed a distinctive culture that blended Middle Eastern and Indian elements.

## Daily Life in Miniature

The art of India is rich and varied. Artworks are greatly different from one part of the country to another and from one time period to another. The Hindu and Buddhist religions had a strong influence on Indian art. The Hindu figure Shiva, the destroyer, is shown in many artworks. Buddha, the founder of Buddhism, is the subject of many sculptures. Buddha is often shown seated in

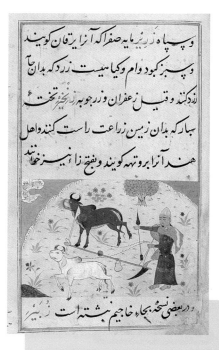

Fig. 2–18 **Many miniature paintings were created as illustrations for manuscripts. What does this image tell you about farming practices in India?** Miftah al Fuzula, *Oxen Ploughing*, 15th century. Gouache on paper. British Library, Oriental and India Office Library.

---

### National Standards
### 2.3 Global View Lesson

**1a** Select/analyze media, techniques, processes, reflect.

**2b** Employ/analyze effectiveness of organizational structures.

**3b** Use subjects, themes, symbols that communicate meaning.

**4a** Compare artworks of various eras, cultures.

## Teaching Options

### Resources

Teacher's Resource Binder
  A Closer Look: 2.3
  Map: 2.3
  Find Out More: 2.3
  Check Your Work: 2.3
  Assessment Master: 2.3
Large Reproduction 4
Slides 2e

### Meeting Individual Needs

**Gifted and Talented** Ask students to research, examine, and compare Figs. 2–18 through 2–22 to *Yamato-e*, Japanese paintings from the Heian era (794–1185) that also depict everyday scenes. **Ask:** Did the two cultures share anything in common? Do the artworks—in terms of size, media, or style—have any similarities?

meditation with large "all-hearing" ears and a third "all-seeing" eye. The positions of his hands have special, symbolic meanings for Buddhists.

**Miniature** painting is detailed and very small. It became especially popular in the fifteenth century. Islam, the religion of the Muslims, did not allow artists to create religious art that showed people. So, wealthy Muslims encouraged Hindu artists to illustrate stories and sell their paintings in street markets or bazaars. Subjects for the paint-

ings came from Hindu legends and everyday life. The colors used to create the paintings were bright. Look closely at Figs. 2–18, 2–19, and 2–20. They were created in sixteenth-century India. What do they tell you about everyday life in India then?

Before the Mughal Empire was established in 1526, paintings were created in small commercial studios. Soon after the empire was established, the production of paintings shifted to royal court workshops.

Fig. 2–19 This is a page from a sixteenth-century cookbook. Notice how drawings of grass and vegetation decorate the page. Why, do you think, did the sultan want this book illustrated for his son? Ni'mat-nama, *The Preparation of Hare Soup*, 1500–10.
Gouache on paper. British Library, Oriental and India Office Library.

Fig. 2–20 There are many things going on in this camp scene. What features of daily life in sixteenth-century India do you see? M. Ali, *Camp Scene*, Khsa of Nizami, 1539–43.
Gouache on paper. British Library, Oriental and India Office Library.

Living

## Teach

### Engage
Ask students what they know about India and its culture, and if any of them have seen henna body painting. Explain that, for special occasions, such as weddings, Indian women have traditional designs drawn on their hands and feet. This is one of many Indian customs involving art and design.

### Using the Text
**Art History** Ask students to read the text to find what religions had an influence on Indian art. For an image of Shiva, have students look at Fig. F3–14, on page 40.

### Using the Art
**Art History** Call on volunteers to describe what the images tell about daily life during past centuries in India.

## Teaching Through Inquiry

**Art History** Have students do library research on **art during the Mughal Empire**, including miniature painting. Have them use a Guide to Inquiry from the Teacher's Resource Binder, either "Investigating Art of a Cultural Group" or "Thinking Historically About Time and Place."

## More About...

In 1526, Babur, a Central-Asian, Turkish-Mongol prince, conquered Ibrahim Lodi, the sultan of Delhi. Babur thus realized the unfinished dream of his ancestors Timur and Genghis Khan: the rule of the Indian subcontinent. In his four-year reign, Babur founded the **Mughal Empire,** which dominated India for more than three centuries. In the sixteenth century, the Mughal emperors were renowned rulers of the East, and the arts of painting and architecture flourished. The Mughal kingdoms comprised both Muslim and Hindu lands.

## Using the Large Reproduction

**Consider Context**

**Describe** How is this work organized?

**Attribute** What clues might help you identify the culture that produced this artwork?

**Understand** How could you find out more about the daily-life event shown here?

**Explain** Research painting in the Mughal Empire to help you explain why this work looks the way it does.

4

# Painting Life in India

## Using the Text

**Art Production** Ask students to read the text for an understanding of how court artists worked together in a workshop. Ask volunteers to give examples of a time they or others have worked together in a similar way, and whether or not they think this is the best way to create an artwork.

## Using the Art

**Art Criticism** Discuss Figs. 2–21 and 2–22. Ask students, in turn, to describe one thing in the works that no one else has mentioned yet. Then discuss what each image shows about the way people lived. **Ask:** How did the artists indicate depth? Which patterns and shapes did they repeat in their designs? How do the compositions help convey mood, feelings, or ideas?

## Studio Connection

Provide the following materials: pencils; sketch paper; a painting surface (15" x 20" illustration board, 1 per student or 4' x 8' Masonite sheet, 1 per 4–6 students); paints (tempera for illustration board or flat white latex house paint and acrylics for Masonite); brushes.

Organize students into workshop-community collaborative groups of four to six. Group members assign their own art tasks and responsibilities. Each member should draw or paint his or her specialty. Then have groups discuss a design and sequencing of their works so that the combined work reflects daily life at the school.

**Assess** See Teacher's Resource Binder: Check Your Work 2.3.

## The Court Workshop

Emperor Akbar ruled the Mughal Empire in India from 1556–1605. At the start of his reign, Akbar the Great set up a workshop for court artists. He employed Muslim artists from Persia to instruct Hindu artists from India. The workshop community grew to more than 100 artists. It produced images of daily court life and garden scenes that told the story of Akbar's reign (Figs. 2–21 and 2–22).

Muslim and Hindu artists often worked together on paintings. One artist might create the general outline. Another might create the portrait heads, another the landscape, and yet another the coloring. The paintings of this workshop are a blend of beautiful color, perfect calligraphy, and detailed realism. The artists developed a unique style that combined Hindu ideas, European realism, Persian composition, and Muslim discipline.

The court workshop tradition continued during the reigns of the next two emperors, Jehangir and Shah Jahan. But the famous workshop was abolished at the end of Shah Jahan's rule in 1658. After that, the artists had to make their livings selling their art on the streets and in the marketplaces of large cities.

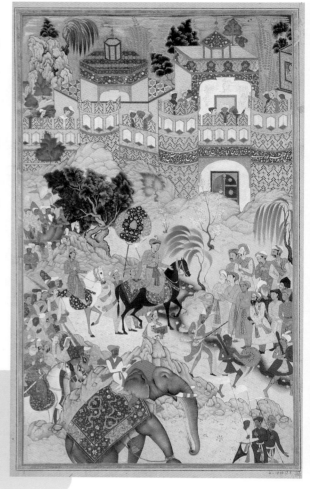

**Fig. 2–21** Akbar paid his workshop artists to record daily events. Notice the detail and the rich decoration in this painting. Do you think the artists might have glorified or exaggerated the reality of this event? What makes you think so? Farrukh Beg, *Akbar's Entry Into Surat*, Akbar-nama, ca. 1590.
Gouache on paper, 14 7/8" x 9 9/16" (37.9 x 24.3 cm).
Trustees of the Victoria & Albert Museum.

## Teaching Options

### Teaching Through Inquiry

**Art Production** Tell students that many artists in a **studio workshop** may work on the same artwork. For a landscape, one artist might paint the sky; another, the trees; another, the leaves; someone else, the figures; and so on. Have student groups each produce a series of small paintings. The group is to decide what will be in the painting, and who will paint what parts. Guide students to keep the works small and simple, and to create a series of paintings that look as much alike as possible.

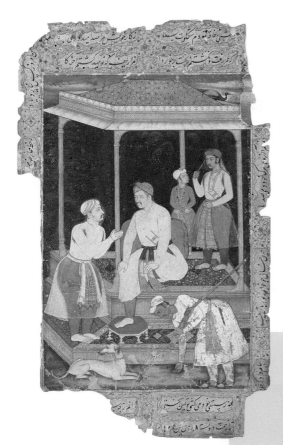

Fig. 2–22 **In this scene, Akbar is shown greeting an old friend in a garden pavilion. Do you think daily life in Akbar's court was formal or informal? What makes you think so?** Manohar Das, India, *Akbar Receives Mirza 'Aziz Koka,* 1602. Opaque watercolor and gold on paper, 7 1/4" x 4 3/4" (18.4 x 12.1 cm). Cincinnati Art Museum, Gift of John J. Emery 1950.289a.

### Studio Connection

Organize a workshop community of artists in your classroom. Plan a series of paintings together that tell about daily life at your school. Talk about the images you will show. For example, you might include morning bell, homeroom, first period, and the like. Assign parts of the paintings to different artists in your workshop. Who likes to draw or paint portraits? Who likes to draw or paint landscapes or indoor scenes? Who likes to add details? Set up work stations and work together to create your paintings.

### 2.3 Global View

#### Check Your Understanding
1. How did the religions of India's communities influence art?
2. What outside influences changed the direction of art in Indian painting?
3. How did art relate to daily life during the Mughal Empire?
4. How was art created in the royal court workshops?

Living

111

## Assess

### Check Your Understanding: Answers

**1.** Depictions of Buddha and the rich symbolism of Buddhist art influenced Indian painting. Because Islam forbade representations of people in religious art, wealthy Moslems encouraged Hindu artists to illustrate scenes from daily life and Hindu legends. Hindu art often depicted Shiva.

**2.** Persian artists influenced the composition of paintings. European art influenced realistic representation. The Muslim way of life influenced discipline in working methods.

**3.** Much of the art depicted everyday court life and garden scenes.

**4.** Art was created by court artists in workshops. Several artists often worked together on paintings.

## Close

Have the studio groups answer the questions in Check Your Understanding. Discuss the answers with the whole class. Ask students to write a description of their pictures and experience to share in small groups.

## More About...

The **studio workshop of Akbar** involved more than 100 papermakers, binders, gilders, calligraphers, and painters in the production of books. Two master artists from Persia, Abd us-Samad and Mir Sayyid Ali, supervised the workshop. Their influence, traditional Hindu artistic influence, and influence that resulted from the study of Western religious works given to the emperor by Jesuits all worked together to produce an original illustration style. A painting was the work of several artists. On the advice of the emperor, the master of the studio began by drawing the model. Various artists, each with a specialty, carried on from there. Craftsmen made the paper. Then the sketch was traced either in black ink or in graphite. Next, a layer of translucent white was applied over the composition. Details were added with red lines. Colors, made of plant or animal-based pigments mixed with gum arabic, were then applied.

## Assessment Options

**Teacher** Ask students to write one paragraph describing how paintings were produced in a royal studio workshop, and another paragraph identifying the different religious influences that contributed to the artistic style of the Mughal Empire.

**Peer** Have students meet in pairs to discuss the influence on, and difference in, Indian painting over time. Each peer partner is responsible for helping the other provide accurate and comprehensive explanations.

111

## Prepare

### Pacing

Two 45-minute periods: one to read text and plan; one to do final drawing

### Objectives

- Explain the importance of portraits in daily life.
- Outline the general guide for proportions for drawing the human face and figure.
- Capture the mood, unique characteristics, and reasonable likeness of people in a portrait.

### Vocabulary

**proportions** The relation between one part of the body and another in terms of size, quantity, and degree.

### Supplies

- spotlight
- props such as sports equipment, art supplies, musical instruments
- drawing media: pencils or charcoal
- sketch paper, 18" x 24"
- drawing paper, 18" x 24"
- erasers
- fixative (optional)

### National Standards 2.4 Studio Lesson

**2b** Employ/analyze effectiveness of organizational structures.

**3a** Integrate visual, spatial, temporal concepts with content.

**5a** Compare multiple purposes for creating art.

---

STUDIO LESSON

2.4

Drawing in the Studio

# Drawing a Group Portrait

Drawing a Group Portrait

## A Picture of Daily Life

### Studio Introduction

Portrait artists observe the way people sit, stand, and move. They notice the position and placement of their subjects' arms and legs, hands and heads. They study facial expressions and characteristics that are unique to the people they portray. **In this studio experience you will observe classmates or people in your school community and draw a group portrait of them.** Pages 114 and 115 will tell you how to do it.

When artists create portraits, they pay special attention to their subjects' **proportions,** or the relation between one part of the body and another. People are surprisingly alike in their proportions. A good portrait captures a person's general proportions and individuality. (See the diagrams on page 114 to learn about proportions in a face or figure.)

Come up with a plan for your portrait. Do you want your subjects to stand or sit? What view of them will you choose: front, three-quarter, or profile? You may want to observe your subjects in their daily activities. Make sketches of them in your sketchbook to use later in your final drawing. Think about details you will include that will tell about the daily lives of these people.

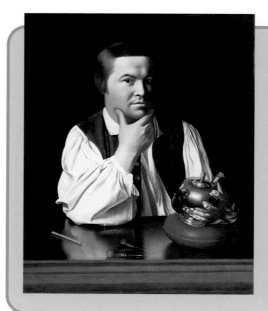

## Studio Background

### The Importance of Portraits

Portraits play an important role in the daily lives of people all over the world. They help people remember loved ones and honor great leaders and heroes (Fig. 2–23). They can give us an idea of what life was like for their subjects. For the North American colonists, having their portraits painted was a sign of success in a growing community. Usually, the style of these portraits was based on what was popular in Europe at the time (Fig. 2–25).

Fig. 2–23 During the American Revolution, Paul Revere made a "midnight ride" to warn his community that the British were coming. What does the artist of this portrait show us about Paul Revere's daily life as a silversmith? Notice the three-quarter view of Revere's face. John Singleton Copley, *Paul Revere*, 1768. Oil on canvas, 35 1/8" x 28 1/2" (89.2 x 72.4 cm). Gift of Joseph W. Revere, William B. Revere and Edward H. R. Revere. Courtesy Museum of Fine Arts, Boston. Reproduced with permission. ©1999 Museum of Fine Arts, Boston. All Rights Reserved.

112

## Teaching Options

### Resources

Teacher's Resource Binder
Studio Master: 2.4
Studio Reflection: 2.4
A Closer Look: 2.4
Find Out More: 2.4
Overhead Transparency 4
Slides 2f

### Meeting Individual Needs

**Adaptive Materials** Instead of using a model, have students use a photograph or other image. Draw the guidelines for students who have trouble with this step. Have them focus their effort on a single portrait rather than several. Create checklists of facial features. Students can refer to these while creating their portraits.

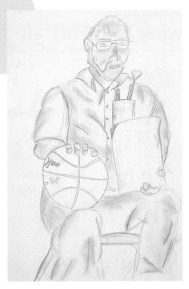

Fig. 2–24 "I drew this of my shop teacher. I was experimenting with shading." James Mast, *Many Talents*, 1999. Pencil, 16" x 10 ½" (40.5 x 26.5 cm). Penn View Christian School, Souderton, Pennsylvania.

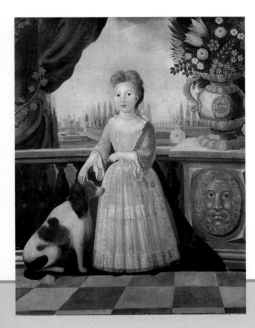

Fig. 2–25 This artist painted full-figure portraits of children in formal garden scenes. Parents wanted these portraits to show their children's pleasures. The backgrounds recall the communities that parents had left behind in Europe. Justus Engelhardt Kuhn, *Eleanor Darnall* (Mrs. Daniel Carroll—1704–96), ca. 1710. Oil on canvas, 54" x 44 ½" (137.2 x 113 cm). Courtesy Maryland Historical Society, Baltimore, Maryland.

Portraits were also important to the rulers of the Mughal Empire. Formal portraits of the ruling class and scenes of daily court life show a blend of Persian, Hindu, and European elements. Most portraits include a garden or landscape scene. Notice the details in the portrait of Emperor Aurangzeb (Fig. 2–26). What does this portrait tell you about the daily life of an emperor in India?

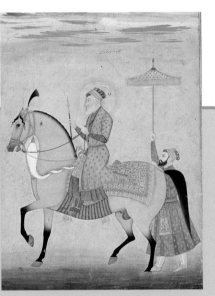

Fig. 2–26 Notice the simple composition of this portrait. It does not include the garden or landscape scene that many Indian portraits have. Why might the artist have chosen not to include a detailed background? India, Mughal School, *The Emperor Aurangzeb*, ca. 1690–1710. Color on paper, 12" x 8 ¹³/₁₆" (30.5 x 22.3 cm). © The Cleveland Museum of Art, Andrew R. and Martha Holden Jennings Fund, 1971.81.

**Prepare Set-up:** Position a spotlight on a student model's face so that half to three-quarters of it is in shadow from all views. Arrange students around the model so that all have a view of the face. For larger classes, use several models. Students may take turns posing and may also work in pairs to draw each other.

### Teach

## Engage

**Ask:** If you were to draw a portrait of a grandparent or another family member, what features would you emphasize? What props could you include to help identify that person? In what setting would you show him or her?

## Using the Text

**Art History** Have students read pages 112 and 113 to find reasons why portraits were important to colonists. **Ask:** What was the stylistic influence on these portraits?

## Using the Art

**Perception** Have students compare Figs. 2–23, 2–25, and 2–26. **Ask:** What features do they have in common? How is each one unique? What is the background in each?

### Teaching Through Inquiry

**Aesthetics** Have students survey people at home and school about what they think makes a **good portrait**. As a class, have students identify questions to ask, such as "Why, do you think, do people want to have their portraits made?" and "What would you want to see in a portrait of yourself?" Have students create an illustrated bulletin-board display to record their findings. Discuss how students could use the survey results to guide their studio efforts.

### More About...

**Paul Revere**, a talented silversmith, marked his work with the name *Revere* in a rectangle or with the initials *P.R.* People admired the graceful lines of his silverware. The forms of many of his pieces are still copied by artisans today. See page 104 for an example of his work.

### Using the Overhead

**Think It Through**

**Ideas** Do you think the artist worked from observation or memory? Why do you think this?

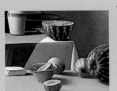

**Techniques** What materials did the artist use? Do you see evidence of blended colors?

4

## Drawing a Group Portrait

## Studio Experience

1. After students have read Drawing Your Portrait, have them measure proportions on their own and another's face. Then lead them in drawing light guidelines.

- For a face, draw an oval with a line across the middle. Center the tops of the eyes on this line. Then draw a line halfway between the top of the oval and the middle line. Sketch the forehead area on this line. Draw another line halfway between the bottom of the oval and the middle line. Center the bottom of the nose on this line.

- For a figure, draw guidelines showing the relative proportions of elbows, hips, and knees to head and torso.

2. Demonstrate various techniques of indicating hair texture.

3. Have students do three or four five-minute sketches of student models before beginning the final group portrait.

4. Ask students to write and attach a descriptive title for their completed drawing.

## Idea Generators

Discuss how students can emphasize their subjects' interests and personality traits. **Ask:** Will you show the subjects in special clothes? Holding significant objects? In an area where they work or play?

### Drawing in the Studio
## Drawing Your Portrait

### You Will Need

- drawing paper
- charcoal, pencil, or pastels

### Try This

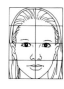 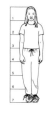

**1.** Observe the people you want to draw. Notice the shape and features of their faces. Notice whether your subjects are tall, thin, short, or plump. Then set up guidelines for proportion in your portrait.

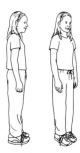

**2.** Decide which view of each person you want to show. Will you show any profile or three-quarter views?

**3.** Draw your portrait. Work on the character or special qualities of your subjects. For example, you might use thin, wiry lines for a thin, nervous person. Capture important details. These might include the shape of the eyebrows, a dimple in the chin, a sparkle in the eyes, or a unique hair style.

**4.** Remember to include backgrounds and props that tell about the daily lives of the people in your portrait. Think about the mood or feeling you want to show. Are the lives of the people in your portrait serious or joyful? How can you show this detail?

**5.** Try shading your drawing. Imagine shining a strong light on your subjects. Where would you see the highlights and shadows?

### Check Your Work

What guidelines for proportions did you use to start your drawing? Did they help you? Were you able to capture the mood and unique characteristics of your subjects? What details from their daily lives did you show?

**Sketchbook Connection**

The sketches you make of things you observe are one of the best sources of ideas for artworks. Sketch the most important or interesting elements of your community. Draw the people you know and see regularly. Sketch scenes of daily life in your neighborhood. Try filling a page with *thumbnail sketches*, or small drawings. Sketch your subject from different views or with different amounts of detail.

**Computer Option**

Look at some artists' self-portraits on the Internet. Then use paint or draw software to create your self-portrait. Add symbols that represent your interests, community, and/or culture.

## Teaching Options

### Studio Collaboration

Have students create a life-size class portrait by working with a partner and tracing around each other's body on large paper. Have students decide on various poses before they paint, decorate, and cut out shapes. Have the class assemble their work into a large collage.

### Teaching Through Inquiry

**Art Production** Have students find pictures of faces and figures in magazines. Make photocopies of these images, or have students cut the images from the magazines. Have students use a ruler and pencil to determine typical **proportions** and establish guidelines for drawing. Ask students then to compare their findings with those in this text.

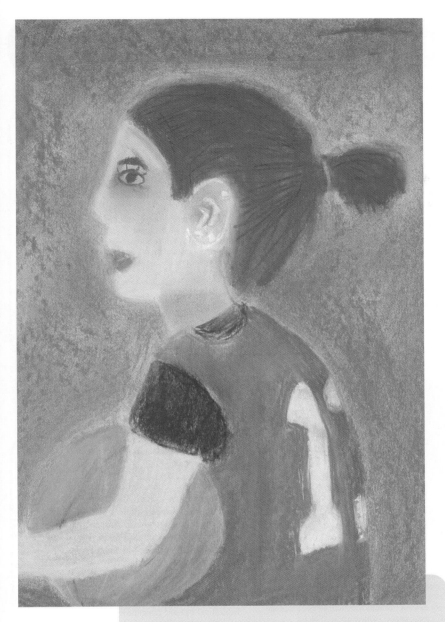

Fig. 2–27 "The picture that I have drawn is of a girl on the school basketball team. Drawing her hair, the basketball, and her uniform was easy. The difficult parts were drawing her face (mostly her eyes) and shading." Mackenzie Granger, *Warrior in Waiting*, 2000.
Pastel, 12" x 9" (30.5 x 29 cm). Thomas Prince School, Princeton, Massachusetts.

Living

115

**Computer Option**
Guide students to Web sites such as "American portraits" in the National Gallery of Art, at: http://www.nga.gov/collection/gallery/gg62/gg62-main1.html; or http://edweb.sdsu.edu/courses/edtec596/project2/Self-portraits.html. The second site encourages users to look for self-portraits and write down specific information about them. For example: "What does the artist look like? What is the setting of the piece? What is the artist doing?"

**Sketchbook Tip**
Encourage students to practice both gesture and contour drawing of the human face and figure whenever possible; and to use the sketchbook as a place to capture the movement and posture of the human figure.

## Extend
Teach students to make a clay relief of their drawn portrait. Remind students of human proportions. **Ask:** Which parts of a face protrude? Which recede? Have students construct the reliefs on nonporous surfaces such as cardboard covered with foil or pieces of wood.

## Assess

### Check Your Work
**Ask:** What are the advantages and disadvantages of starting a drawing with a guide for proportions? Were you able to capture mood and unique characteristics? How were you able to capture a likeness?

## Close
Have students answer the questions in Check Your Work. Display their portraits. Discuss facial proportions in their artwork, and what they emphasized to make their subjects identifiable.

### More About...
**Full-Figure Proportions** (1) The height of most adults is about seven or eight times the height of the head. (2) The knees are about halfway between the heel and the middle of the hip. (3) The hip is about halfway between the heel and the top of the head. (4) The bend of the elbow is at the waistline. (5) An outstretched hand is about as large as the face.

### Assessment Options

**Teacher** Provide each student with a blank shape of a face, and instruct the class to draw guidelines and note the general proportions for drawing the human face. Next, provide each student with an out-of-proportion drawing of a human figure. Ask students to list the ways they could make the drawing more proportional. Check their work for understanding of proportion of the human face and figure.

115

## Careers

Invite an interior designer to explain how he or she works with clients to select appropriate furniture, fabrics, wall and floor coverings, and art and accessories, for particular environments. Afterwards, have students create a detailed perspective drawing or painting of their (real or imagined) bedroom, including color schemes and furnishings, as a proposal for a client.

## Social Studies

Provide artworks of scenes from everyday life, and explain that these are genre scenes. Ask students to think about activities in their neighborhood community, choose a genre scene, and create a painting about it.

# Connect to...

## Careers

Were you the one to choose the color scheme and furniture in your bedroom? Are you allowed to paint and decorate your room as you choose? Many teenagers serve as their own interior decorators; but professional **interior designers** work with clients, and generally on a much larger scale. Interior designers are responsible for planning and coordinating the design, decoration, and functionality of interior spaces—spaces where we live, work, and play. They may work with either residential or commercial clients to select furniture, fabrics, wall and floor coverings, accessories, and art elements appropriate for each client's individual characteristics and needs. Interior designers have to be skilled at working with color, fabric, and furniture, and

Fig. 2–28 Do certain rooms make you feel calm or happy? Have you ever thought about why? Is it the color of the walls or the way things are placed? This woman thought about these kinds of things when she decorated the living areas for NASA astronauts on a space station. NASA space station decorator, 1988.
Photograph ©Roger Ressmeyer/CORBIS.

they must have good communication and budgeting skills. Interior design is demanding—and fulfilling—especially for those who do it well.

Fig. 2–29 During a perfomance of *STOMP*, cast members create music using a variety of everyday objects such as brooms, sink plugs, and plastic containers. What object do you use every day that could be transformed into a musical instrument? *Cast members of the musical* STOMP.
Photo ©Junichi Takahashi. Courtesy Takahashi Studios, New York.

## Other Arts

### Dance

Visual art may depict scenes of daily life or may be directly involved in daily activities or rituals. Likewise, **dance can be a part of daily life**. What movements can you associate with specific activities you participate in every day? Is it possible that those movements could be considered dance? Why or why not?

Think of some chores or other responsibilities you have. If you were to create a dance to help you with your daily work, what would it look like? Would your dance involve other people, or would you dance alone?

### Resources

Teacher's Resource Binder
   Using the Web
   Interview with an Artist
   Teacher Letter

### Video Connection

Show the Davis art careers video to give students a real-life look at the career highlighted above.

### Museum Connection

Arrange for a member of the local or regional historical society to talk with students about the design and use of ordinary objects in colonial North America.

## Other Subjects

### Social Studies

What are some everyday outdoor activities that take place in your neighborhood after school or on the weekends? Perhaps people sit on the front steps and chat, walk their pet, mow their yard, or play games on the sidewalk. Did you know that such **ordinary subjects** are found in art? In art, a representation of a scene from everyday life is called a **genre scene**. How could the daily life of your neighborhood be depicted through art? What subject would you choose for a genre painting?

### Language Arts

Have you read any **books that were told from several perspectives**, or points of view? Perhaps two narrators took turns telling interlocking stories of their lives. Perhaps the book was about a community in which a number of people had individual versions of the same story, as is common in many mysteries. How might this be possible in the visual arts?

### Science

Each **Native-American pueblo** in New Mexico traditionally uses a particular **color of clay for its pottery**. For example, the pueblo San Ildefonso is famous for its heavy-walled black pottery, and Acoma is known for its creamy-white clay. What are the reasons, do you think, for differences among pueblos? Each pueblo gathers the natural materials—gypsum, sand, and clay—only from its own reservation, which individualizes their pottery.

Fig. 2–30 **Maria Martinez invented the technique of black-on-black pottery you see pictured here. She made the pots and her husband, Julian, decorated them.** Maria and Julian Martinez, *Bowl*, n.d.
Clay, height: 7" (17.8 cm). National Museum of American Art, Smithsonian Institution, Washington, DC/Art Resource, NY.

**Internet Connection**
For more activities related to this chapter, go to the Davis website at **www.davis-art.com.**

Living

117

### Language Arts

Ask students to choose an artwork from this text that features a number of people, and to write dialogue for the characters' thoughts or words. Discuss the results, and have students compare dialogue written by different students for the same characters.

### Other Arts

Encourage students to consider some of their daily activities that involve body movements, and to discuss how these movements might become a dance. Sweeping the floor, washing windows, walking a dog, and flipping hamburgers are actions that might be choreographed for individual dancers. Lining up to shoot baskets, opening and closing lockers between classes, and getting on or off the bus are movements that might be developed for a group of dancers.

### Internet Resources

**MuralArt.com**
http://www.MuralArt.com/
Murals are presented in various categories—a great community site.

**Pueblo Cultural Center**
http://www.indianpueblo.org/
Visit the eight northern pueblos in New Mexico and compare their cultural traditions. See twelve outstanding artworks (with explanations) completed for the Mural Project.

### Community Involvement

Have students select sites in the community that they think should be designated as historically and artistically significant. Have them photograph the sites and design certificates of "designation and appreciation" for the property owners.

### Interdisciplinary Planning

Invite colleagues in other disciplines to visit your artroom to see your program in action. Ask them to suggest ways for working together on common goals. Show them this text, and offer to share other books and articles on art that might support what they are doing in their classroom.

117

## Talking About Student Art

Lead a discussion about the formal arrangement of visual elements in student artworks. Have students volunteer to describe the use of particular art elements in a work of their choice.

## Portfolio Tip

Have students use the art-criticism questions on pages 56 and 57 as guides for writing about artworks.

## Sketchbook Tip

Suggest to students that they use their sketchbook for writing notes and comments about the materials and techniques they have used and the specific effects they have achieved.

# Portfolio

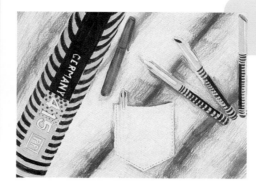

Fig. 2–31 Ben Lewis, *Staetler Scatter*, 1998. Colored pencil, 9" x 12" (23 x 30 cm). Samford Middle School, Auburn, Alabama.

"My teacher taught me a lot of methods to shade with colored pencil. When I had to come up with an idea for a final drawing I looked by my sketchbook and saw all my pens scattered over the table. I thought that would make a neat design. The hardest part was making it look real and coming up with a background." **Ben Lewis**

Fig. 2–32 A'lise Havemeister, *Athletes Only*, 1999. Tempera, 12" x 18" (30 x 46 cm). Colony Middle School, Palmer, Alaska.

"This is a self-portrait because I love sports. Basketball is my favorite sport, and that is why it is the largest. I like to compete and practice with my friends." **A'lise Havemeister**

**CD-ROM Connection**
To see more student art, check out the Community Connection Student Gallery.

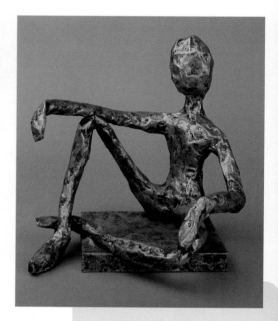

Fig. 2–33 Stacey Fong, *Contemplation*, 1999. Papier- mâché, wire, tape, tempera, 8" x 6" x 6" (20 x 15 x 15 cm). Los Cerros Middle School, Danville, California.

118

## Teaching Options

### Resources

Teacher's Resource Binder
Chapter Review 2
Portfolio Tips
Write About Art
Understanding Your Artistic Process
Analyzing Your Studio Work

### CD-ROM Connection

For students' inspiration, for comparison, or for criticism exercises, use the additional student works related to studio activities in this chapter.

# Chapter 2 Review

### Recall

Name at least two ways that artists contribute to the daily life of communities.

### Understand

Explain why the artworks produced in widespread North American colonies have a similar look.

### Apply

Produce a visual aid that you could use for teaching a younger child or an older adult how to observe and capture the proportions in a human figure at work and play.

### Analyze

Compare the way artists worked in the royal studio workshops of the Mughal emperors in sixteenth-century India (described in Lesson 2.3; *see example below*) with the group artworks for communities today as discussed in the Core Lesson. Note similarities and differences.

### Synthesize

Propose an idea for an artwork that you would like to see designed for your community based on a perceived need or to send an important message to community members. Look to the artworks and ideas presented in this chapter as a springboard for your sketch and written description of what you think the finished piece should look like.

### Evaluate

Select one artwork from this chapter that you think would be the best cover image for a book entitled "Art in Community Life." Select a second image as an alternate. Give reasons for your choices and justify your number-one choice by describing features of the work.

**For Your Sketchbook**

Design a page in your sketchbook for writing visually descriptive impressions of daily life scenes in your community. Refer to these poetic descriptions for the development of ideas for future artworks.

**For Your Portfolio**

Select an artwork in this book that sends a clear message about daily life in a community. Describe the work in detail. Tell how the arrangement of the parts helps to convey the message. Date your written response and add it to your portfolio.

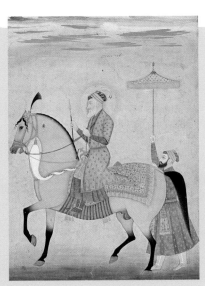

Page 113

Living

119

### Advocacy

In the school lobby, display student art with statements that support the importance of art in daily life.

### Family Involvement

Invite family members to assist in creating a display of antique everyday objects related to colonial or early pioneer life. Display, in a locked case, objects that parents and others loan, complete with labels and a catalogue of short descriptions of the objects.

## Chapter 2
## Review Answers
### Recall

Artists observe and record community members at work and at play. Artists design community spaces such as parks, playgrounds, and malls; and they design functional objects, such as benches and signs, to serve community needs.

### Understand

Whether they came from Spain, Holland, France, or England, the early colonists shared a European heritage of artistic traditions influenced by the Renaissance and ancient Greece and Rome.

### Apply

Look for evidence that guides are understood for drawing figures in proportion.

### Analyze

Answers will vary. Possible response: Both groups of artists worked/work together to get work done more efficiently and to develop ideas in steps toward completion. Labor was/is divided into specialties. Most community artworks today are large-scale and are for community members. Mughal artworks were miniature paintings for the illustration of books for limited readership.

### Synthesize

Look for evidence of an awareness of the chapter's artworks and an understanding of the important role that art can play in a community.

### Evaluate

Look for connections to the theme of daily life, and for evaluation based on objective evidence in the artwork.

## Reteach

Provide students with a numbered list of all of the artworks in this chapter, identified by artist and title. Ask students to study each image. Then, so that students connect each artwork to daily life and community, have them identify which of the following words or phrases match each piece: *work, play, school, family, city planning, shared spaces, basic needs, remembrance.*

Summarize by indicating that art is an important part of the daily life of a community.

# Chapter Organizer

## Chapter 3 Belonging
Chapter 3 Overview
pages 120–121

### Chapter Focus
- **Core** Art helps people to identify with beliefs and values cherished by their community, and to honor events and people.
- **3.1** Art and Independence: 1776–1820
- **3.2** Sculpture
- **3.3** Art of Polynesia
- **3.4** Carving a Plaster Maquette

### Chapter National Standards
1 Understand media, techniques, and processes.
2 Use knowledge of structures and functions.
3 Choose and evaluate subject matter, symbols, and ideas.
4 Understand arts in relation to history and cultures.
5 Assess own and others' work.
6 Make connections between disciplines.

---

**9 weeks** 2 · **18 weeks** 2 · **36 weeks** 2

### Core Lesson
**Community Values and Beliefs**
page 122
Pacing: Two or three 45-minute periods

#### Objectives
- Explain how public monuments convey ideas about belonging to a community.
- Use examples to explain how artworks give tribute to individuals who have promoted the ideals of the community.

#### National Standards
**2b** Employ/analyze effectiveness of organizational structures.
**5b** Analyze contemporary, historical meaning through inquiry.

---

### Core Studio
**Recording a Community Story**
page 126

#### Objectives
- Create a drawing to illustrate a story important to the community.

#### National Standards
**3b** Use subjects, themes, symbols that communicate meaning.

---

**36 weeks** 3

### Art History Lesson 3.1
**Art and Independence**
page 128
Pacing: Three 45-minute periods

#### Objectives
- Describe how art in the United States following independence reflected the identity and ideals of the new nation.
- Explain how Pennsylvania German folk art reflects the identity and ideals of a community.

#### National Standards
**4a** Compare artworks of various eras, cultures.
**4c** Analyze, demonstrate how time and place influence visual characteristics.
**6a** Compare characteristics of art forms.

---

### Studio Connection
page 130

#### Objectives
- Design and letter a decorative statement that expresses identity and ideals.

#### National Standards
**3b** Use subjects, themes, symbols that communicate meaning.

---

**36 weeks** 2

### Forms and Media Lesson 3.2
**Sculpture**
page 132
Pacing: Two 45-minute periods

#### Objectives
- Identify the characteristics of sculpture, and the materials and methods used to create it.

#### National Standards
**2b** Employ/analyze effectiveness of organizational structures.

---

### Studio Connection
page 133

#### Objectives
- Use the method of modeling to create a sculpture of a hero.

#### National Standards
**1b** Use media/techniques/processes to communicate experiences, ideas.
**3b** Use subjects, themes, symbols that communicate meaning.

## Featured Artists

Richmond Barthe
Dennis Malone Carter
Horatio Greenough
George Huebner
Thomas Jefferson
John Lewis Krimmel
Paratene Matchitt

MetaForm/Rathe/D&P
Isamu Noguchi
Auguste Rodin
Augustus Saint-
   Gaudens
Wang Tianren, Ge
   Demao, Meng Xiling

Miere Laderman
   Ukeles
Elisabeth Waner
Benjamin West
Grant Wood

## Chapter Vocabulary

commemorate
earthworks
found objects
maquette
monument
motif
Neoclassical
sgrafitto

## Teaching Options

Teaching Through Inquiry
More About…Auguste Rodin
Using the Large Reproduction
Using the Overhead
Meeting Individual Needs
More About…Richmond Barthe

## Technology

CD-ROM Connection
   e-Gallery

## Resources

Teacher's Resource Binder
   Thoughts About Art:
      3 Core
   A Closer Look: 3 Core
   Find Out More: 3 Core
   Studio Master: 3 Core
   Assessment Master:
      3 Core

Large Reproduction 5
Overhead Transparency 6
Slides 3a, 3b, 3c

---

Meeting Individual Needs
Teaching Through Inquiry
Assessment Options

CD-ROM Connection
   Student Gallery

Teacher's Resource Binder
   Studio Reflection: 3 Core

## Teaching Options

Meeting Individual Needs
Teaching Through Inquiry
Using the Overhead

## Technology

CD-ROM Connection
   e-Gallery

## Resources

Teacher's Resource Binder
   Names to Know: 3.1
   A Closer Look: 3.1
   Map: 3.1
   Find Out More: 3.1
   Assessment Master: 3.1

Overhead Transparency 5
Slides 3d

---

Meeting Individual Needs
Teaching Through Inquiry
More About…Pennsylvania Dutch
Assessment Options

CD-ROM Connection
   Student Gallery

Teacher's Resource Binder
   Check Your Work: 3.1

## Teaching Options

## Technology

CD-ROM Connection
   e-Gallery

## Resources

Teacher's Resource Binder
   Finder Cards: 3.2
   A Closer Look: 3.2
   Find Out More: 3.2
   Assessment Master: 3.2

Overhead Transparency 5

---

CD-ROM Connection
   Student Gallery

Teacher's Resource Binder
   Check Your Work: 3.2

# Chapter Organizer continued

| | | | | | |
|---|---|---|---|---|---|
| | | **3** | **Global View Lesson 3.3 The Art of Polynesia** page 134 Pacing: Three 45-minute class periods | **Objectives** • Explain how Polynesian art shows membership in communities. • Identify materials used by artists in South Pacific communities. | **National Standards** 4a Compare artworks of various eras, cultures. 4b Place objects in historical, cultural contexts. 4c Analyze, demonstrate how time and place influence visual characteristics. 5b Analyze contemporary, historical meaning through inquiry. |

**Studio Connection**
page 136

**Objectives**
- Create a patterned design with repeated elements that symbolize group membership.

**National Standards**
2b Employ/analyze effectiveness of organizational structures.

---

**Studio Lesson 3.4 Carving a Plaster Maquette**
page 138
Pacing: Four 45-minute periods

*(18 weeks: 4 | 36 weeks: 4)*

**Objectives**
- Explain the purpose of a maquette when creating a large sculpture.
- Practice safe carving techniques.
- Carve a model for a sculpture that honors an event, person, or group in the local community.

**National Standards**
1b Use media/techniques/processes to communicate experiences, ideas.
3b Use subjects, themes, symbols that communicate meaning.

---

**Connect to...**
page 142

**Objectives**
- Identify and understand ways other disciplines are connected to and informed by the visual arts.
- Understand a visual arts career and how it relates to chapter content.

**National Standards**
6 Make connections between disciplines.

---

**Portfolio/Review**
page 144

**Objectives**
- Learn to look at and comment respectfully on artworks by peers.
- Demonstrate understanding of chapter content.

**National Standards**
5 Assess own and others' work.

## Teaching Options

Meeting Individual Needs
Teaching Through Inquiry
More About…Hawaiian society
Using the Large Reproduction

## Technology

CD-ROM Connection
  e-Gallery

## Resources

Teacher's Resource Binder          Large Reproduction 6
  A Closer Look: 3.3                Slides 3e
  Map: 3.3
  Find Out More: 3.3
  Assessment Master: 3.3

---

Teaching Through Inquiry
More About…The Maori
More About…Polynesia
Studio Collaboration
Assessment Options

CD-ROM Connection
  Student Gallery

Teacher's Resource Binder
  Check Your Work: 3.3

## Teaching Options

Teaching Through Inquiry
More About…Augustus Saint-Gaudens
More About…The Shaw Memorial
Meeting Individual Needs
More About…Maquettes
Studio Collaboration
Assessment Options

## Technology

CD-ROM Connection
  Student Gallery
  Computer Option

## Resources

Teacher's Resource Binder          Slides 3f
  Studio Master: 3.4
  Studio Reflection: 3.4
  A Closer Look: 3.4
  Find Out More: 3.4

## Teaching Options

Community Involvement
Interdisciplinary Planning

## Technology

Internet Resources
Video Connection
CD-ROM Connection
  e-Gallery

## Resources

Teacher's Resource Binder
  Using the Web
  Interview with an Artist
  Teacher Letter

## Teaching Options

Family Involvement
Advocacy

## Technology

CD-ROM Connection
  Student Gallery

## Resources

Teacher's Resource Binder
  Chapter Review 3
  Portfolio Tips
  Write About Art
  Understanding Your Artistic Process
  Analyzing Your Studio Work

## Chapter Overview

### Theme

Community members share values and beliefs. Art expresses the idea that we belong to a community.

### Featured Artists

Richmond Barthe
Dennis Malone Carter
Pablo Delano, MetaForm/Rathe/D&P
Horatio Greenough
George Huebner
Thomas Jefferson
John Lewis Krimmel
Paratene Matchitt
Isamu Noguchi
Auguste Rodin
Augustus Saint-Gaudens
Wang Tianren, Ge Demao, Meng Xiling
Miere Laderman Ukeles
Elisabeth Waner
Benjamin West
Carol Wickenhiser-Schaudt
Grant Wood

### Chapter Focus

How does art help people identify with beliefs and values cherished by their community? Students examine monuments and other artworks to discover how they commemorate and honor events and people. They learn how art helped early colonists in North America create community and a sense of belonging. They explore sculpture as a well-suited art form for public tribute. For a global perspective, students examine these ideas while viewing the art of Polynesia. In the studio lesson, they create a model for a sculpture to honor an event, person, or group within their community.

### National Standards Chapter 3 Content Standards

1. Understand media, techniques, and processes.
2. Use knowledge of structures and functions.
3. Choose and evaluate subject matter, symbols, and ideas.
4. Understand arts in relation to history and cultures.
5. Assess own and others' work.
6. Make connections between disciplines.

# 3 Belonging

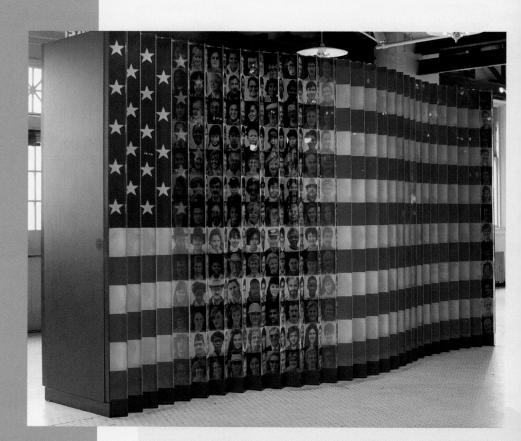

Fig. 3–1 The many different faces in this flag say to viewers, This is who we are as a nation— people from every kind of background joined together as Americans. We belong to this community. Does your community have an artwork that suggests the idea of belonging? Pablo Delano (photographer of faces), Installation designed by MetaForm/Rathe/D&P (The Liberty/Ellis Island Collaborative), *Flag of Faces*, Ellis Island, 1990.
8' 8" x 16' 6 3/4" x 2" (264.2 x 504.8 x 5.1 cm). Exhibit installation at the Ellis Island Immigration Museum, National Park Service / Statue of Liberty National Monument.

120

## Teaching Options

### Teaching Through Inquiry

**Art Production** Have collaborative-learning groups design a display, for the school lobby, that conveys ideas important to the school community. **Ask:** What ideas might be the focus of your display? How could you show these ideas? Have each group explain its design to the class. Hold a discussion in which students analyze the designs, making suggestions for improvement. If possible, select a design and have students create the display.

### More About...

**Ellis Island** was the **immigration** entry point for over twelve million people from the early 1890s until the mid-1950s. Before 1890, individual states regulated immigration into the United States. For New York, people entered through what was then called Castle Clinton, on the tip of Manhattan. In 1890, the site could not hold the growing number of immigrants, and the government constructed a new, federally-operated station on Ellis Island.

**Focus**

• What does it mean to belong to a community?
• How does art help us belong?

Do you know where your ancestors are from? Ireland? Jamaica? Poland? China? Spain? Iran? India? Italy? South Africa? Peru? How did your family arrive in America? In the late 1800s and early 1900s, millions of people from around the world came to live in the United States. These people came from many different places and for lots of reasons. The one thing they all had in common was a belief that life in America would be better than it was in the country they came from.

People who move from one country to another are called *immigrants*. At the turn of the twentieth century, most immigrants to the United States arrived in New York City, America's busiest port. One of their first sights was the Statue of Liberty. The *Flag of Faces* (Fig. 3–1) is on display at the Statue of Liberty National Monument/Ellis Island Immigration Museum, a museum that tells how new citizens arrived in America. The *Flag of Faces* shows people whose ancestors journeyed here seeking a new home. The faces are seen through the stars and stripes of the American flag, our national symbol.

Artworks can express what it means to belong to a community, whether that community is as large as a country or as small as a neighborhood. Although the Statue of Liberty and *Flag of Faces* send messages about a whole nation, other artworks tell about belonging to local communities throughout the world.

**What's Ahead**

• **Core Lesson** Discover how art can express the idea that we belong to a national community of people from all over the world.
• **3.1 Art History Lesson** Learn how art helped new nations in North America establish their own identities and a sense of belonging.
• **3.2 Forms and Media Lesson** Learn about sculpture and how it can symbolize the idea of belonging.
• **3.3 Global View Lesson** Explore how Polynesian art shows people's individual importance within their communities.
• **3.4 Studio Lesson** Make a plaster model of a large sculpture that honors an event, person, or group.

**Words to Know**

| | |
|---|---|
| monument | found objects |
| commemorate | earthworks |
| Neoclassical | motif |
| sgrafitto | maquette |

Belonging

121

**Chapter Warm-up**

**Ask:** Have you seen the Statue of Liberty, Washington Monument, or local memorials? Why, do you think, were these made? What do you think of when you see them? How do you feel?

**Using the Text**

**Art History** Have students read the text to understand why the Statue of Liberty was important to immigrants. **Ask:** How does *Flag of Faces,* on Ellis Island, honor immigrants?

**Using the Art**

**Art Criticism Ask:** What is the size of *Flag of Faces*? How does this compare to your height? What makes this art interactive? *(When the viewer looks at it from different angles, different faces are visible because of the vertical folds.)* What is the double meaning of this art? *(It is an American flag, with stars and stripes, but it is also a flag of faces. The nation is made of states and of people from many heritages.)*

**Extend**

Allow students to create their own "double-meaning" artwork on accordion-folded paper. Have them cut two pictures into strips the width of the folds, and then glue pieces of one picture on the left of each fold, and pieces of the other picture on the right of each fold. Show them how to re-crease the paper and then spread it out so the folds stand out. When viewed from the left, one picture shows; and when viewed from the right, the other one shows.

**Graphic Organizer**
**Chapter 3**

**3.1 Art History Lesson**
Art and Independence:
1776–1820
page 128

**Core Lesson**
Art Shows Community
Values and Beliefs

**Core Studio**
**Recording a Community Story**
page 126

**3.3 Global View Lesson**
Art of Polynesia
page 134

**3.2 Forms and Media Lesson**
Sculpture
page 132

**3.4 Studio Lesson**
Carving a Plaster Maquette
page 138

## Prepare

### Pacing

Two or three 45-minute periods: one to consider art and text; one or two to draw

### Supplies for Engage

- slides or photographs of a local monument or memorial (optional)

### Objectives

- Explain how public monuments convey ideas about belonging to a community.

- Use examples to explain how artworks give tribute to individuals who have promoted the ideals of the community.

- Create a drawing to illustrate a story important to the community.

### Vocabulary

**monument** An artwork created for a public place that preserves the memory of a person, event, or action.

**commemorate** To honor or remember a person or event.

# Art Shows Community Values and Beliefs

## Public Monuments

Look around your town or city. Do you see artworks in public places that mean something special to the local people? Perhaps there is a sculpture that reminds people of an event in the area's history. Is there a statue or a plaque on a building that honors a person or group? Many artworks are created for public places—places where people gather or pass by every day. These artworks are public **monuments**. They represent ideas that are important to the people who live in the area. The Statue of Liberty is such a monument. Public monuments remind us that we belong to communities because we share certain beliefs and values.

Fig. 3–2 The Qin Dynasty lasted only 15 years—from 221 BC until 206 BC. During this time, the Chinese people living north of the Yellow River were united for the first time. How does this sculpture commemorate this important event in China's history? The monument is over 300 feet long and was made by over 100 stone carvers. Wang Tianren, Ge Demao, Meng Xiling, *Emperor Qin Unifying China*, Xi'an, 1993. Granite. Reprinted by permission of the University of Washington Press. Photo by John T. Young.

122

### National Standards Core Lesson

**2b** Employ/analyze effectiveness of organizational structures.

**3b** Use subjects, themes, symbols that communicate meaning.

**5b** Analyze contemporary, historical meaning through inquiry.

## Teaching Options

### Resources

Teacher's Resource Binder
  Thoughts About Art: 3 Core
  A Closer Look: 3 Core
  Find Out More: 3 Core
  Studio Master: 3 Core
  Studio Reflection: 3 Core
  Assessment Master: 3 Core
Large Reproduction 5
Overhead Transparency 6
Slides 3a, 3b, 3c

### Teaching Through Inquiry

**Art History** Ask groups of students to select a sculpture shown in Figs. 3–2, 3–3, or 3–4, and to divide a paper into four columns with the headings: What We Know; What We Want to Know; Our Best Guess; and How We Might Find Out More. Students complete the first column with a description, the second column by posing questions, the third column by proposing an answer for each question, and the last column with specific resources. Have groups exchange papers and discuss their findings.

## Public Tributes

Public monuments can also remind us of events, time periods, or people that are important to the community. They allow people to express their sense of belonging. They **commemorate**, or honor, the events and people that have shaped the histories of towns, cities, and even countries. The monument *Emperor Qin Unifying China* (Fig. 3–2) reminds the people of China about an important event. Under the rule of Emperor Qin, all the people of China were first united as one country. This large sculpture was created in 1993. It is located on an important road between the city of Xi'an and third century BC tombs from the Qin dynasty. The sculpture sends a message about the people's sense of pride in their community.

Some public monuments express thanks to groups of people who have helped a community. The sculpture of *The Burghers of Calais* (Fig. 3–3) was created for the town of Calais, France. The burghers, or leaders, of the town offered their lives in exchange for the town's safety during the Hundred Years' War. The sculpture shows the six men facing death. It tells us that the people of this town value bravery and feel bound together by their beliefs.

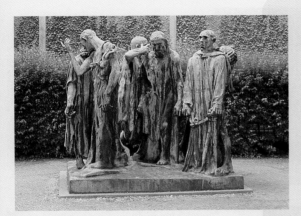

Fig. 3–3 Are these men heroes? Auguste Rodin, *The Burghers of Calais*, 1884–85. Bronze, 81 7/8" x 55 1/8" x 74 3/4" (208 x 140 x 190 cm). Musee Rodin, Paris, France. Courtesy Art Resource, New York.

Fig. 3–4 This monument honors African-American soldiers of the Civil War. How does it compare to Fig. 3–3? Augustus Saint-Gaudens, *Shaw Memorial* (Final Version), 1900. U.S. Department of the Interior, National Park Service, Saint-Gaudens National Historic Site, Cornish, NH.

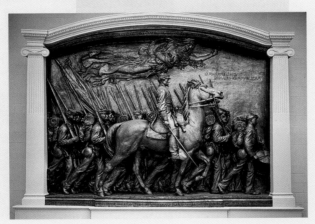

Belonging

123

123

## Teach

### Engage

Show students pictures or slides of a local memorial, and discuss it. **Ask:** When and why was it created? What events or persons would you like to memorialize? Where would you place your monument? Would you make it realistic or abstract? How large would it be? What materials would you use? Explain that Maya Lin was given such an assignment when she was an architecture student at Yale. (See her *Vietnam Veterans Memorial* on page 68.)

### Using the Text

**Art History** Have students read the text to learn how communities in China and France commemorated events and heroes. Challenge students to name the community beliefs and values that are emphasized by the artworks shown on pages 122 and 123.

### Using the Art

**Art Criticism** As students study the artworks, ask them to note how the size of each piece affects its message. For instance, Rodin made the burghers (Fig. 3–3) into heroic giants. Ask students to position their hands in the same poses as the hands of the burghers, and to describe the body language of the figures.

Have students compare the surface texture of the two bronze sculptures. **Ask:** How did Saint-Gaudens indicate depth in this relief that commemorates Col. Robert Gould Shaw and the Union Army's 54th Massachusetts Colored Regiment?

### More About...

**Auguste Rodin** (1840–1917) captured fleeting moments and gestures in solid material. His figures could be "larger than life," in their actual size as well as their emotional impact. Rodin was interested in the way light played off the uneven surfaces of his art, and he investigated the play of shadow and highlights, as the Impressionist painters did on their canvases.

### Using the Large Reproduction

**Talk It Over**

**Describe** Identify the parts in this piece of clothing.

**Analyze** How are colors, lines, and patterns used?

**Interpret** How might this item convey the idea of "belonging"?

**Judge** What criteria could be used to determine the quality of this artwork?

5

### Using the Overhead

**Think It Through**

**Ideas** What may have been the source of the idea for this artwork?

**Materials** What materials did the artist use?

**Audience** For whom do you think this artwork was created? Why?

6

123

## Using the Text

**Art History** Have students read the text to learn of memorials that communities have created to honor their heroes. Ask students to cite three examples described in the text. *(Molly Pitcher, George Washington Carver, Quetzalcoatl)* **Ask:** Where, do you think, would be the best place to display art that reminds us of heroes and leaders? Encourage students to discuss how publicly-displayed art can lead to a sense of belonging within one's community.

## Using the Art

**Art Criticism** Ask students to study the artworks. **Ask:** How did the artists make each figure important? How did they emphasize the subjects? What are the important ideas?

## Art Honors Heroes and Leaders

Who are your heroes? Professional basketball players? Actresses? Someone in your neighborhood? Heroes and leaders are people who do things that represent the values and beliefs of a community. People look to them as examples of strength and courage. Local heroes are an important source of pride for the people who live in the area. They help create a sense of belonging because everyone honors or respects them for the same reasons. What do you admire most about your heroes?

Stories of heroic actions and deeds are often told and retold within a community. Artworks help record these stories. The painting of Molly Pitcher tells the story of an American Revolutionary War heroine (Fig. 3–7). Molly Pitcher's birth name was Mary Ludwig McCauley. She earned the nickname Molly Pitcher because she carried pitchers of water to soldiers during the Battle of Monmouth.

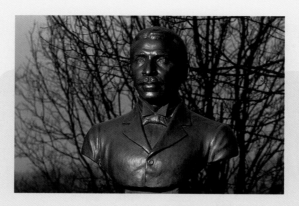

Fig. 3–5 This sculpture commemorates George Washington Carver, who developed agricultural products that could be grown in the South. What commemorative sculptures have you seen? Richmond Barthe, *George Washington Carver,* 1977. Hall of Fame, Bronx Community College, New York City. Bronze. Photo © 1999 Frank Fournier.

Fig. 3–6 Quetzalcoatl is a cultural hero in Mesoamerican history. The limestone sculpture stands about five feet tall. What cultural hero in your community would you like to be remembered hundreds of years from now? Mexico, Mayan, *Head of Quetzalcoatl* at the Temple of Quetzalcoatl, Teotihuacan, ca. 150–200 AD. Limestone. Photograph © 1999 Entrique Franco Torrijos

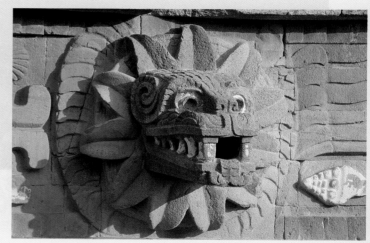

124

### Meeting Individual Needs

**Multiple Intelligences/Logical-Mathematical** Ask small groups of students to select, as a team, a theme for a monument they will create to honor something important that has occurred in America during the year. Challenge them to map out the artroom, drawing plans for where they will locate the sculpture, its size in proportion to the surroundings, and what materials they will use to convey their message of tribute.

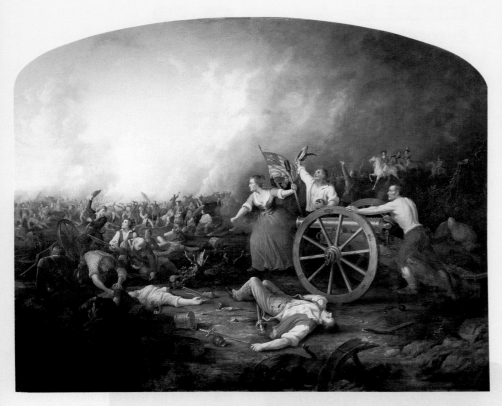

Fig. 3–7 How does this painting commemorate Molly Pitcher's bravery? Can you name other important women in history? How might they be shown in commemorative artworks? Dennis Malone Carter, *Molly Pitcher at the Battle of Monmouth*, 1854. Oil on canvas, 42" x 56" (106.7 x 142.2 cm). Gift of Herbert P. Whitlock, 1913. Courtesy Fraunces Tavern Museum, New York City.

All kinds of communities have heroes and leaders. For example, groups of scientists, politicians, writers, and artists each have their own heroes. These heroes represent ideas and beliefs that each group values most. Artists sometimes create artworks to help people remember and honor their leaders and heroes. We can relate to great individuals through these artworks. They help us feel that we belong together. For example, the sculpture of George Washington Carver (Fig. 3–5) commemorates his importance as a great scientist.

Other public artworks remind us of people, such as firefighters and nurses, who have served a community with heroic deeds. The sculpture of Quetzalcoatl was created many years ago by the Toltec community of Mexico (Fig. 3–6). Quetzalcoatl was a Mesoamerican prince who supported art and learning. Legend says that he was banished from the community but promised to return at the dawn of a new golden age. Whether he did or not is a mystery, but the sculpture reminds us of him. Are there sculptures of heroes in your community? What stories do you know about them?

Belonging

125

**Extend**
- Have students research botanist George Washington Carver and then create an artwork that illustrates one of his achievements.
- Challenge students to find other sculptures by August Saint-Gaudens (one of the most famous is a monument to Admiral David Farragut in New York's Central Park) and then to create posters about his life and art.

### Teaching Through Inquiry

**Art Criticism** Have pairs of students describe, in notes, the three artworks and how each artist showed the subject. **Ask:** Does the subject look like a hero? Which of the three subjects do you think best displays heroic characteristics? Have students write at least three questions they have about the artworks. Have each pair of students meet with another pair to share findings and questions. Make a list of all the questions, and explain that some are easily answered, whereas others require research or additional discussion. Encourage students to select questions and do further research.

### More About...

**Richmond Barthe**, a popular African-American portrait sculptor in the early 1900s, focused on members of the African-American community as his subjects. Barthe's artworks were often reproduced in the press, where they helped tell about the strength of character of the individuals portrayed.

### CD-ROM Connection

For more images relating to this theme, see the Community Connection CD-ROM.

125

3 CORE LESSON

## Supplies

- sketchbook or sketch paper
- drawing paper, 12" x 18"
- pencils
- colored pencils or markers
- eraser

**Safety Note**
Use only markers that are labeled nontoxic: many markers have toxic fumes that can be harmful if used in poorly ventilated areas.

## Using the Text

**Art History** Have students read Studio Background. Discuss answers to the question about *Parson Weems's Fable.*

**Art Production** Ask students to suggest community stories that they might draw. **Ask:** Who are some regional heroes? (Students' social-studies teacher and the local historical society may have information and photographs of past events.) Discuss possible viewpoints of historical events. **Ask:** Who would various groups consider to be heroes?

## Using the Art

**Art Criticism Ask:** What is in the foreground of Wood's fable of George Washington? *(Parson Weems and a curtain)* Why did Wood frame this scene with a curtain? What meaning does this add to the story? What are the workers in the background doing? *(gathering fruit)* How could you describe Washington's face? *(adult, as on the dollar bill)* How did Wood create a sense of distance? What shapes did he repeat? *(balls in curtain fringe, trees)* How did Wood blend colors? How did West do so? How did each artist emphasize his main subject?

---

**Teaching Options**

# Recording a Community Story

Many towns and cities have an interesting and unique story that tells about the place's history. Sometimes these stories describe an exciting event or involve a local hero. **In this studio experience, you will make a drawing that shows the main event from an important community story.** What stories are important to your town or city? What characters or heroes are in the stories? Brainstorm ideas with your classmates about the main event from a story you might show and the heroes who are involved. Find out as much as you can about the event. How did it affect the people in your community? What does the story tell about your community's beliefs and values?

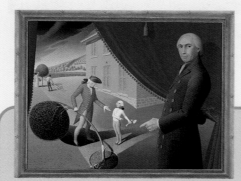

Fig. 3–8 A clergyman named Mason Weems invented the story of George Washington and the cherry tree. He wanted to convince people of the value of telling the truth. What is the irony, or funny part, of the story you see in this painting? How did artist Grant Wood use point of view to show the main idea? Grant Wood, *Parson Weems's Fable*, 1939.
Oil on canvas, 38 3/8" x 50 1/8" (97.5 x 127.3 cm). Courtesy Amon Carter Museum, Fort Worth, Texas. © Estate of Grant Wood / Licensed by VAGA, New York, NY.

### You Will Need

- sketch paper
- drawing paper
- pencil and eraser
- colored pencils or markers

**Try This**

**1.** Determine what the main event of your story is. This will be the focus of your drawing. What people will you include? Will you create a particular setting? From what point of view will you draw the scene?

**2.** Sketch your ideas. Think about how you will organize your work. Where will you place the figures and objects? What action will you show? What details will help viewers identify the community, event, and people in the story?

**3.** Select your best sketch and use it to create your final drawing. Sketch the large areas first. Then add smaller features and details. Think about the lines and colors you can use to create mood or add meaning to the work.

## Studio Background

**Artworks that Tell a Story**
Not all artworks that reflect the stories and beliefs of a community were created for public spaces. Smaller artworks, such as paintings and sculptures, help create a strong and positive image of the early Americans.

With photography, video, and film, we view historic events almost immediately as they occur. In the past, many stories were passed along by travelers telling one person, who then told another, and so on. The stories probably changed each time they were retold. Artists who recorded important events

---

### Meeting Individual Needs

**Focusing Ideas** Brainstorm with students, and provide newspaper articles on a variety of important community events.

**4.** If necessary, use your eraser to lighten pencil marks before using your colored pencils or markers.

### Check Your Work

Show your drawing to a small group of classmates. Ask them to describe what they see. Ask them which parts of the drawing help them recognize the community, event, or hero you have shown. Is your point of view about the story clear?

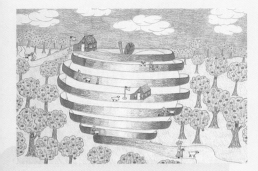

Fig. 3–9 **"My picture represents my town. It shows the story of 'Mary Had a Little Lamb,' which actually took place in Sterling. The apples represent all the orchards found in the area."** Nicolette Schlichting, *Its Fleece Was White as Snow*, 2000.
Colored pencil, 12" x 18" (30.5 x 46 cm). Chocksett Middle School, Sterling, Massachusetts.

had to rely on the information available to them, whether it was accurate or not.

Artists also have their own points of view or opinions about events. *Parson Weems's Fable* (Fig. 3–8) shows a unique point of view on the story of George Washington and the cherry tree. *Penn's Treaty with the Indians* (Fig. 3–10) records a true story that is important to people from Pennsylvania. Look at artworks in your own community. What events do they show? From what point of view do they tell a story?

### Sketchbook Connection

Experiment with your colored pencils or markers before you use them in your final drawing. Make different kinds of marks with them: thin, thick, curved, jagged, light, and dark. Which marks will express the point of view you want to show in your drawing?

### Core Lesson 3

#### Check Your Understanding

1. Use examples to explain how public monuments can show ideas about belonging to a community.
2. Select one artwork from this lesson and tell how it honors or gives tribute to an individual who has promoted the ideals of a community.
3. Name one of your heroes and tell how you might show this person in a sculpture.
4. Do you think it is ever a good idea to "stretch the truth" when showing historical events that are important to a community? Why or why not?

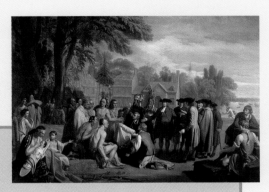

Fig. 3–10 **William Penn was guided by his Quaker belief that all people should be treated fairly and with respect. He paid the Lenape and Delaware Indians for their land and made a treaty of friendship with them. Do you think this artwork accurately depicts the way this event took place? How has the artist expressed a point of view?** Benjamin West, *Penn's Treaty with the Indians*, 1771–72. Oil on canvas, 75 1/2" x 107 3/4" (191.9 cm x 273.7 cm). Courtesy of the Pennsylvania Academy of the Fine Arts, Philadelphia. Gift of Mrs. Sarah Harrison (The Joseph Harrison, Jr. Collection)

Belonging

127

### Assess

#### Check Your Work

Ask students to point out how their classmates created moods and emphasized their viewpoints using line and color.

#### Check Your Understanding: Answers

**1.** Monuments remind community members of the values and beliefs they share. For instance, the Statue of Liberty reminds people of the value of freedom; *Burghers of Calais* reminds people of the value of self-sacrifice for the common good.

**2.** Answers will vary. For example, the sculpture of George Washington Carver pays tribute to a man who represents scientific achievements.

**3.** Answers will vary. Look for a description of an appropriate sculpture.

**4.** Answers will vary. Look for evidence of understanding that artworks, because they convey important values and beliefs, can inspire community members.

### Close

Discuss students' answers to Check Your Understanding. Have students write the community story that goes with their art and display the writing with their drawing.

### Teaching Through Inquiry

**Aesthetics** Have students work in groups to consider the question **"What is a hero?"** Instruct them to use the following process: (1) Make a list of people who all of you agree are heroes. If a name is suggested but all group members do not agree, record the names on a list of possible heroes. (2) Consider the people on the first list, and then identify at least three characteristics, or criteria, of *all* heroes. (3) To see if the individuals on both lists are heroes, apply the criteria. (4) As a class, discuss findings, and raise new questions.

### Assessment Options

**Teacher** Present students with this scenario:

There is a monument in our community dedicated to a group of firefighters who lost their lives saving an entire block of buildings in 1903. The monument is now in disrepair. Restoration would be expensive, and our town is now debating whether to spend the money. Those who oppose restoration say that, since the honored firefighters have been deceased for so long, there is no longer any reason to give tribute. They say that the money should be spent on today's community, perhaps on schools and playgrounds.

Have students each write a letter to the editor of the local newspaper, in which they state their position on this issue and try to persuade readers to agree. (Look for evidence that students understand that monuments can give a community a sense of pride and belonging; that tributes to heroes remind people of shared values and beliefs.)

127

## Prepare

### Pacing

Three 45-minute periods: one to consider art and text; two to make art

### Objectives

- Describe how art in the United States following independence reflected the identity and ideals of the new nation.

- Explain how Pennsylvania German folk art reflects the identity and ideals of a community.

- Design and letter a decorative statement that expresses identity and ideals.

### Vocabulary

**Neoclassical** A style of art inspired by ancient Greek and Roman art.

**sgrafitto** A pottery technique in which designs are scratched onto a clay object through a thin layer of colored slip before the pottery is glazed and fired.

### Using the Time Line

**Ask:** Which artworks shown in this lesson were created near the time of the American Revolution? Have students look at other artworks shown in the chapter and list those that would fit into the dates shown on the time line. *(Figs. 3–10, 3–19, 3–20, and 3–21)* Guide them to see similarities and differences in the styles of these works.

### National Standards
### 3.1 Art History Lesson

**3b** Use subjects, themes, symbols that communicate meaning.

**4a** Compare artworks of various eras, cultures.

**4c** Analyze, demonstrate how time and place influence visual characteristics.

**6a** Compare characteristics of art forms.

---

# Art and Independence: 1776–1820

| | 1770 Jefferson, *Monticello* | 1788 *Marriage Chest of Margaret Kernan* | 1817 Waner, *Sampler* | |
|---|---|---|---|---|
| Colonial North America page 102 | American Neoclassicism | | | Realism and Romanticism page 154 |
| | 1786 Huebner, *Earthenware Plate* | 1815 Krimmel, *Election Day in Philadelphia* | 1840 Greenough, *George Washington* | |

### History in a Nutshell

The years between 1776 and 1867 gave birth to three nations within North America: the United States, Canada, and Mexico. In 1776, the United States declared its independence from England. In 1821, Mexico became a nation, and the region of New Spain north of the Rio Grande became part of the United States. Canada set up its national government in 1867.

## A Classical Nation

When people form new groups, they often try to create a style that identifies the group. For example, when the new nation of the United States formed, artists tried to capture the spirit of its national identity. Portraits of leaders and paintings about historical events became popular subjects. In their artworks, artists recorded the nation's fight for independence. Many artists looked to the classical art and architecture of ancient Greece and Rome for

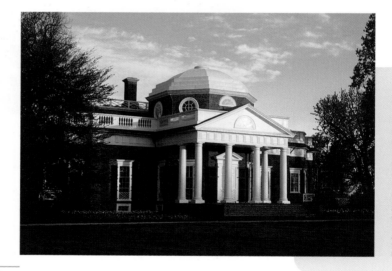

Fig. 3–11 Thomas Jefferson designed his own house. Most Neoclassical-style buildings are symmetrical and have the same number of windows on each side of a center door. What other elements of classical architecture can you identify? Thomas Jefferson, *Monticello*, Charlottesville, Virginia, 1769–84. 44.7' x 87.9' x 110' (13.6 x 26.8 x 33.5 m). Photograph by Robert Llewellyn.

## Teaching Options

### Resources

Teacher's Resource Binder
- Names to Know: 3.1
- A Closer Look: 3.1
- Map: 3.1
- Find Out More: 3.1
- Check Your Work: 3.1
- Assessment Master: 3.1
Overhead Transparency 5
Slides 3d

### Meeting Individual Needs

**Multiple Intelligences/Musical** Have students discuss how the information on page 128 relates to Fig. 3–13. Next, challenge them to identify existing, or create their own, musical compositions that will evoke the same heroic emotions as the sculptor's work. How might the use of, or references to, past "grand" forms of music (e.g., Classical or Romantic) stir similar feelings as the sculpture?

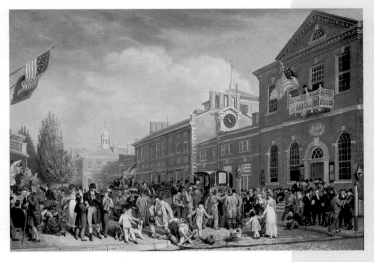

Fig. 3–12 This painting is a celebration of community. It is crowded with figures representing several social classes. In this picture of an election, what important ideal of government is being celebrated? John Lewis Krimmel, *Election Day in Philadelphia*, 1815. Oil on canvas, 16 3/8" x 25 5/8" (41.6 x 65.2 cm). Courtesy The Henry Francis Du Pont Winterthur Museum.

Fig. 3–13 Can you explain why the sculptor portrayed a national leader in a Roman toga? Horatio Greenough, *George Washington*, 1840. Marble, 133 7/8" (340 cm) from back to front of base. National Museum of American Art, Smithsonian Institution, Washington, DC./Art Resource, NY.

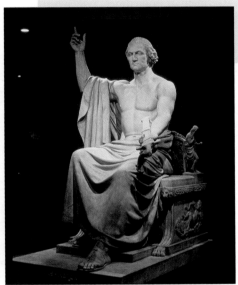

inspiration. A new style in art, known as **Neoclassical**, became popular in the United States. The sculpture of George Washington (Fig. 3–13) reflects the nation's adoption of Greek and Roman ideals.

The Neoclassical style included painting, sculpture, and architecture. Some sculptures of human figures express ideals such as truth and justice. Other artworks show important historic events. Artworks such as *Election Day in Philadelphia* (Fig. 3–12) document the workings of democracy in the United States. As large cities developed, sculptures appeared in community parks and public buildings for all to see.

Buildings in the Neoclassical style include features of Greek and Roman architecture. Some have the large Doric, Ionic, or Corinthian columns seen in Greek structures. These buildings are sometimes called *Greek Revival style*, which is a fancier version of the Neoclassical style of architecture. Large Greek Revival homes became popular in the southern United States. Thomas Jefferson promoted the Neoclassical style through the design of his own home in Virginia (Fig. 3–11).

Belonging

129

# Teach

## Engage

Brainstorm with students to create a list of symbols or icons that identify the United States. Explain that many of these symbols evolved as people created an identity for their nation.

## Using the Text

**Art History** Have students read the text to learn how artists used the Neoclassical style as they developed civic art and architecture. **Ask:** What features do Neoclassical-style buildings include? *(Greek columns, dome, pediments)*

## Using the Art

**Art Criticism** What do you see in *Election Day in Philadelphia?* How did the artist idealize the democratic process in this painting? *(by depicting a beautiful day, with flags flying and all classes of people joining to vote)*

Discuss how Greenough idealized George Washington. **Ask:** Why did Greenough put Washington in a toga? *(to show that Washington was a wise, classical subject)* Have students study the clothing in *Election Day in Philadelphia* (Fig. 3–12) so as to see how Washington might have dressed.

---

## Teaching Through Inquiry

**Art Criticism** Have students work in small groups to examine ***Election Day in Philadelphia*** (Fig. 3–12), make notes of the details and how people are dressed, and then discuss possible reasons why this painting has been described as a celebration of community. Ask each group to come up with a new title of the work, to better describe the feeling and mood expressed.

## Using the Overhead

5

### Investigate the Past

**Describe** What is going on here? Take all details into account.

**Attribute** Both the artist and date are unknown, although the work is thought to be nineteenth-century.

**Interpret** Consider the personification of Liberty and the symbolism of the eagle *(American spirit)*, the crown *(royalty)*, and the pedestal *(elevation)*. What does this artwork say about belonging in the United States around the time the work was created?

**Explain** What previous artworks and styles might have influenced this sculpture?

## Art and Independence

### Using the Text

**Art History** Have students read the text to discover subjects and techniques used in Pennsylvania Dutch folk art. **Ask:** On what traditions did Pennsylvania German artists base their art? What is the sgrafitto technique that was used to create the plate? *(designs scratched into clay through a thin layer of slip)*

### Using the Art

**Art Criticism Ask:** What symbols can you identify in these artworks? How are the pieces similar? How are they typical of Pennsylvania Dutch folk art?

**Sketchbook Tip**
Have students use their sketchbook to experiment with ornamental alphabets and decorative letters appropriate for stitchery samplers or house blessings.

### Studio Connection

Provide the following supplies: pencils, erasers, colored markers or crayons, rulers, 12" x 18" drawing paper, books of quotes, font catalogs (optional).

After students have studied the sampler, ask them to recall other similar artworks that they have seen. Discuss possible wording for a house blessing. Suggest to students that they study computer fonts and type catalogs to see a variety of lettering, and emphasize that the lettering should enhance the meaning of their saying. Discuss significant symbols of their home and family that they might include in the border.

## Signs of Belonging

A nation is made up of many different smaller communities, each with its own unique style and identity. Designs seen in local art are often connected to the region's weather or to the background of the people who live there. For instance, winter scenes are common in the art of New England. What designs do you think identify the Southwest? Why? What designs identify the region where you live?

In the years following American independence, rural Pennsylvania was home to a rich folk art tradition. The European settlers in Pennsylvania were called Pennsylvania Germans or, sometimes, Pennsylvania Dutch. They made furniture, pottery, and glassware based on the traditions of their homelands. In their craft, they used a decorative style that goes back to the Middle Ages. Their style continues to identify this region of the United States today.

Wooden chests were painted in vivid colors with simplified tulips, birds, and prancing unicorns (Fig. 3–14). Marbleized effects were produced by rubbing wet paint with a corncob. The same rich floral patterning is also seen in pottery and glass. Potters used the **sgrafitto** technique to decorate plates and jars (Fig. 3–15). In sgrafitto, designs are scratched onto a clay object through a thin layer of colored slip. Then the pottery is glazed and fired. In Pennsylvania, unfired pottery is called *redware* because of the red color of the natural clay in this region.

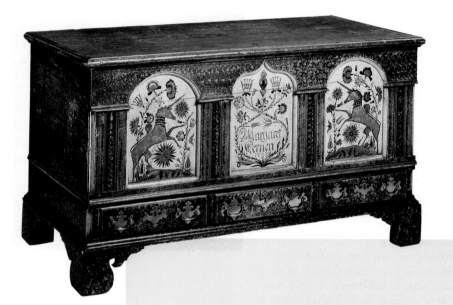

Fig. 3–14 Chests of this kind are decorated with icons, lettering, and calligraphy. What do the decorations on this chest suggest about the Pennsylvania Germans? Pennsylvania German, *Marriage Chest of Margaret Kernan*, 1788.
Painted tulipwood, 28 3/8" x 50" x 24" (72.1 x 127 x 61 cm). Courtesy The Henry Francis Du Pont Winterthur Museum.

## Teaching Options

### Meeting Individual Needs

**Multiple Intelligences/Logical-Mathematical** Ask small groups of students to select, as a team, a theme for a monument they will create to honor something important that has occurred in America during the year. Challenge them to draw plans for where they will locate the sculpture, its size in proportion to the surroundings, and what materials they will use to convey their message of tribute.

### Teaching Through Inquiry

**Art History** Ask students to work in small groups to **compare the three artworks**. Have groups make notes of the details, materials, and functions. Ask each group to write a one-page description of the similarities and differences of the works and to suggest why these artworks look the way they do.

Fig. 3–15 The inscription on this plate reads, "Catharine Raeder, her plate. Out of the earth with understanding the potter makes everything." Can you see the heart shape that is formed by the bodies of the two doves? George Huebner, *Plate*, inscribed to Catharine Raeder, 1786. Earthenware, 2" x diam. 12 5/8" (5 x 32 cm). Philadelphia Museum of Art: Gift of John T. Morris.

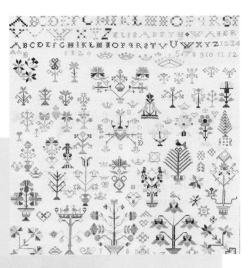

Fig. 3–16 Notice the simplified plant and bird designs on this sampler. What elements and principles of design do you think the Pennsylvania Germans were interested in? Elisabeth Waner, *Sampler*, 1817–20. Linen, silk, and cotton, 17 1/4" x 16 3/8" (43.8 x 41.6 cm). Courtesy The Henry Francis Du Pont Winterthur Museum.

For the Pennsylvania Germans, the home was valued as a special place. Sharing and working together as a family were important ideals. This was reflected in framed "blessings" or sayings for the home. These richly decorated sayings were often painted or embroidered by young women to show off their handwriting and needlework skills.

**Studio Connection**

Make your own house blessing. Look at the embroidered sampler shown in Fig. 3–16 and then write a saying for your home. Decide how the words will look best. Using pencil and drawing paper, write the letters in your best handwriting. Trace your letters in marker. Decorate the letters, especially the first letter of the first word. Create a border. Think about visual symbols you might include. What design elements and principles will help you express your idea?

---

**3.1 Art History**

**Check Your Understanding**

1. How did art in the decades following independence reflect the identity of the United States?
2. How did sculptures call attention to ideals in the new United States communities?
3. What are the characteristics of the Neoclassical style of architecture?
4. How did Pennsylvania German folk art reflect the identity and ideals of that region of the country?

Belonging

131

---

Demonstrate how to lay out a design by drawing light guidelines with a ruler and centering the letters. Discuss negative space around and in the saying. Urge students to consider how much space to leave between lines so that the text will be readable.

**Assess** See Teacher's Resource Binder: Check Your Work 3.1.

## Extend

Suggest to students that they embroider their blessing on cloth. Have students research early American embroidery samplers, and demonstrate various stitches, such as the cross-stitch and the running stitch.

## Assess

**Check Your Understanding: Answers**

1. Portraits were of government leaders, patriots, and soldiers; paintings were about historical events related to independence.

2. Sculptures in the Neoclassical style reflected the nation's adoption of Greek and Roman ideals.

3. features of Greek and Roman temples; Doric, Ionic, and Corinthian columns

4. Folk art such as samplers, furniture, pottery, and glassware reflected the importance of family.

## Close

Discuss students' answers to Check Your Understanding. Ask students to discuss how post-Revolutionary War art reflected the identity and ideals of the new nation. Ask students to consider how their lettered saying reflects their home's ideals and identity.

---

## More About...

**Pennsylvania Dutch,** or Deutsche ("German"), refers to the people who left the German Rhineland in the 1600s and 1700s to escape persecution. They were called "the church people" and came to Pennsylvania because of the promise of religious freedom. They invented the Conestoga wagon, which helped immigrants settle the American West.

## Assessment Options

**Teacher** Ask students to imagine that they are curators of the exhibition "Identity and Ideals of a New Nation." Ask them to select five artworks from this book, each as a visual representation of loyalty, liberty, justice, freedom, or courage. For each artwork, have students write a caption that explains how the artwork illustrates the ideal.

**Peer** Have students work in pairs. Have each student identify one artwork from this lesson and, without revealing what artwork it is, explain to his or her partner how it reflects the identity and ideals of the Pennsylvania Dutch. Have partners rate the explanation and suggest why it was or was not helpful in identifying the work.

# Sculpture

## Prepare

### Pacing
Two 45-minute periods

### Objectives
- Identify the characteristics of sculpture, and the materials and methods used to create it.
- Use the method of modeling to create a sculpture of a hero.

### Vocabulary
**found objects** Materials that artists find and use for artwork, such as scraps of wood, metal, or manufactured objects.

**earthworks** Any work of art in which land and earth are important media.

## Teach

### Engage
Write "sculpture" on the chalkboard. Ask students how sculpture differs from drawing or painting.

### Using the Text
**Perception** Have students read pages 132–133. **Ask:** What are some two- and three-dimensional objects in the classroom?

### Using the Art
**Perception Ask:** What are the positive and negative spaces in Fig. 3–18, the fountain? How would you describe the forms? How did the artist create movement?

Have you ever picked up a rock or a piece of wood because you liked its shape or texture? Nature creates beautiful forms. Since the earliest times, people have used their own methods and tools to shape materials into beautiful forms. Forms have three dimensions: height, width, and depth. Artworks that have three dimensions are called *sculpture*. Traditional materials for sculptures include stone, wood, clay, ivory, and cast metal, such as bronze. Traditional ways to create sculpture involve carving, modeling, and casting. Today, many sculptors combine discarded materials, called **found objects**, to create sculptures. Some use construction equipment to create sculptural forms from the environment. These forms are called **earthworks**. Sculptures can be made to last for centuries or for only a short time.

Communities throughout history have created sculptures for different reasons.

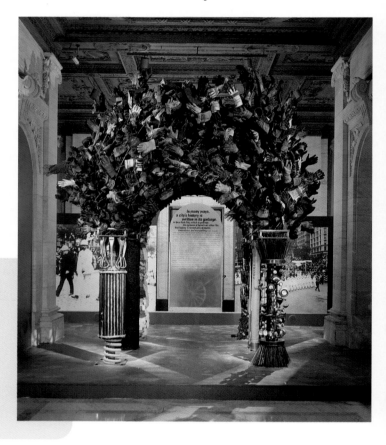

Fig. 3–17 **What ideals do you think are represented by this tribute to community workers? How does the form of this sculpture convey these ideals?** Miere Laderman Ukeles, *Ceremonial Arch Honoring Service Workers in the New Service Economy,* 1988.
Steel arch with materials donated from New York City agencies, 11' x 12' 4" x 9' 1" ( 335.3 x 148 x 109 cm). Courtesy Ronald Feldman Fine Arts, New York.

### National Standards 3.2 Forms and Media Lesson

**1b** Use media/techniques/processes to communicate experiences, ideas.

**2b** Employ/analyze effectiveness of organizational structures.

**3b** Use subjects, themes, symbols that communicate meaning.

## Teaching Options

### Resources
Teacher's Resource Binder
Finder Cards: 3.2
A Closer Look: 3.2
Find Out More: 3.2
Check Your Work: 3.2
Assessment Master: 3.2
Overhead Transparency 5

### Teaching Through Inquiry

**Art Criticism** Provide students with photocopies of sculptures in this chapter. Ask students to sort the images by subject matter and then write three general statements about the groups. Have them also write at least one question about the sculptures. Next, sort them by materials used. Have them proceed as before, recording general statements and at least one question. Finally, have students sort the images by methods used, proceeding as before. Have students summarize their findings and discuss their questions, noting how they might find answers to each.

Ancient people created sculptures of their gods and ancestors. These were used in community rituals, worship, or celebrations. More recent sculptures often show leaders or individuals and groups that people admire. The ceremonial arch in Fig. 3–17 honors the people who work for the city of New York. Each city agency donated materials related to the services they provide. What items do you recognize in the sculpture?

Some sculptures are requested by a city or town to show something special or unique about the community. These sculptures can also be useful, such as fountains or shelters. The sculpture of a fountain in Fig. 3–18 is at the center of an eight-acre plaza in Detroit. The artist designed the plaza downtown next to the Detroit River. It includes restau-rant and performance facilities, a large outdoor amphitheater, walkways, green areas, and, in the center, the fountain.

**Studio Connection**
Create a clay sculpture of one of your heroes. Think about a person you admire. Your hero might be someone who lives in your community or someone who lives elsewhere in the nation or world. You may choose to depict a hero from the past or present. Give your finished sculpture a title that indicates what you admire about your hero.

### 3.2 Forms and Media

#### Check Your Understanding
**1.** How is sculpture different from paintings and drawings?
**2.** What materials and methods are commonly used to create sculpture?

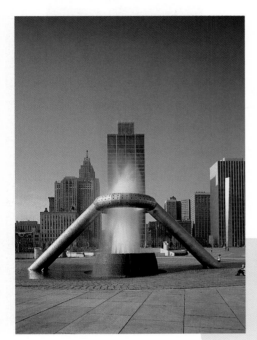

Fig. 3–18 The flow of water in this fountain is computerized and creates patterns that change constantly. How does the look of the fountain convey the importance of the city as the home of the automobile industry? Isamu Noguchi, *Horace E. Dodge and Son Memorial Fountain*, 1978.
Stainless steel with granite base, height: 24' (7.3 m). Philip A. Hart Plaza, Detroit, Michigan. Courtesy Balthazar Korab Ltd.

Belonging

---

## Studio Connection
Assemble the following: oil-based or modeling clay (at least 1 lb/student); clay-shaping tools, wire for cutting clay, armatures (optional), plastic bags for clay storage, water or slip.

**Ask:** How will you make your subject identifiable? What objects will you include? Remind students that sculptors must make decisions about subject matter, materials, and the arrangement of a sculpture's different parts.

**Assess** See Teacher's Resource Binder: Check Your Work 3.2.

**Sketchbook Tip**
Tell students that artists often use presentation drawings to show their ideas or plans for a project to the people who will fund it. Have students work out ideas for their sculpture by making thumbnail sketches. Students may refine a sketch into a presentation drawing for their sculpture.

## Assess

#### Check Your Understanding: Answers

**1.** Sculptures are artworks that have height, width, and depth. Paintings and drawings have only height and width.

**2.** Traditional materials include stone, wood, clay, ivory, and cast metal. Recent sculptures are sometimes made from "found" materials. Methods include carving, modeling, and casting. Recent methods include combining found materials and using equipment to change the environment.

## Close

Display students' sculptures with their titles. Encourage students to explain how they emphasized their subject's features. Lead a discussion about the various sculptural materials artists might use to create a sense of belonging to a community.

---

### Using the Overhead

**Write About It**

**Describe** Write three or more words to describe this sculpture.

**Analyze** How did the artist organize the forms using informal and asymmetrical balance?

**5**

### Assessment Options

**Peer** Have students prepare a triptych "teaching board" (a small, portable bulletin board) about sculpture, for an audience of their choice. They must include ways to identify an artwork as a sculpture, and explanations of the media and methods commonly used for making sculpture. Ask students to develop additional criteria for assessing the teaching boards, then to use the established criteria to assess each other's work.

## Prepare

### Pacing

Three 45-minute periods: one to consider art and text; two to make art

### Objectives

- Explain how Polynesian art shows membership in communities.
- Identify materials used by artists in South Pacific communities.
- Create a patterned design with repeated elements that symbolize group membership.

### Vocabulary

**motif** A single or repeated design or part of a design or decoration.

### Using the Map

Ask students to locate New Zealand, Fiji, Hawaii, and Papua New Guinea on the map and to note the vast distances encompassed by Polynesia. Lead students in imagining how early settlers of this region might have migrated in canoes from one island to the next. **Ask:** What type of climate might one expect to find in each of these locations?

# Art of Polynesia

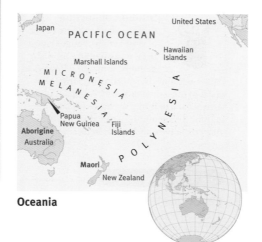

**Oceania**

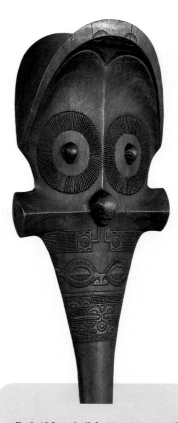

### Global Glance

The term *Polynesia* comes from the Greek *polus* (many) and *nesos* (island). The waters of the South Pacific Ocean surround thousands of diverse and isolated islands. The South Pacific Rim, as it is sometimes called, includes six major cultures. One of these cultures is Polynesia.

Polynesia is a vast triangle about 5000 miles along each side with corners at New Zealand, Hawaii, and Easter Island. Tahiti, in the Society Islands, marks the geographic center of Polynesia. Polynesian art reflects the people of the South Pacific. Many of these people were explorers who set out on unknown seas to find and settle new lands.

Fig. 3–19 **Carved relief patterns appear on all old clubs like this. The patterns in the lower half are different on each club. They probably identified the owners. What do you think the tattoos of the owner of this club might have looked like?** Marquesas Islands, *Head detail of war club*, late 18th century. Hardwood, length: 63" (160 cm). Peabody Essex Museum, Salem, Massachusetts.

134

## Teaching Options

### National Standards 3.3 Global View Lesson

**2b** Employ/analyze effectiveness of organizational structures.

**4a** Compare artworks of various eras, cultures.

**4b** Place objects in historical, cultural contexts.

**4c** Analyze, demonstrate how time and place influence visual characteristics.

**5b** Analyze contemporary, historical meaning through inquiry.

### Resources

Teacher's Resource Binder
   A Closer Look: 3.3
   Map: 3.3
   Find Out More: 3.3
   Check Your Work: 3.3
   Assessment Master: 3.3
Large Reproduction 6
Slides 3e

### Meeting Individual Needs

**English as a Second Language** Examine the cape in Fig. 3–20, and explain how such a magnificent piece of clothing indicated the owner's importance in the community. Have students then draw someone they believe is important in their neighborhood, using clothing and/or objects to communicate the person's status. Have students discuss or write something about their work in English.

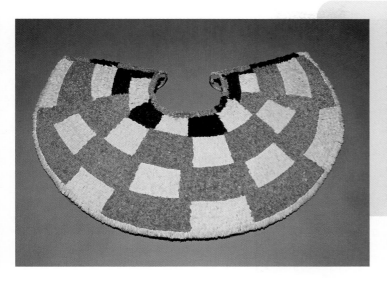

Fig. 3–20 The Hawaiians, who originally came from the Marquesas and Society islands, crafted beautiful objects, including spectacular featherworks. Men and women of the privileged noble class wore feather capes such as this one. Why might feathers have symbolized importance in this community? Hawaii, *Starbuck Cape*, ca. 1824. Red, yellow, and black feathers, length 16.5" x front 14.5" x neck 21.5" x base 85" (42 x 36.8 x 54.6 x 216 cm). Courtesy Bishop Museum, Seth Joel.

## Art and Community Life

People around the world have different ways of showing that they belong to a community. Many have also found ways to show their status, or importance, in that community. In the South Pacific region, people show their importance through the objects they use and things they give to others.

Much of the art in Polynesia is created for ceremonial use. Decorations can symbolize a person's status or identity. In some island cultures, people wear jewelry and body tattoos to show identity and status. Figure 3–19 shows the head of a war club from the Marquesas Islands. Notice its tattoo pattern. This pattern identifies the owner of the club.

Traditionally, the quality and craftsmanship of a Polynesian man's weapons, clothing, and tattoos reflected his place in the community. So did the size and height of his house. Women didn't have as much need for status symbols. However, if they owned certain fans and ornaments, they were important in the community.

Polynesian artworks were originally made from natural materials without the use of metal tools. Local materials such as raffia, bark cloth, tusks, shells, and feathers are often combined in dramatic ways. Look at the Hawaiian feather cape in Fig. 3–20. Feathers are highly valued in Hawaiian culture. Feather capes were one way people showed that they belonged to this community.

**Studio Connection**

Make a list of your characteristics. What's your astrological sign? What talents do you have? What are your favorite things? Think about yourself as a shape, a color, a line, a flower, an insect, or an animal. Plan a cut-paper collage in the form of a manuscript page with figures and a patterned background. Use colored and textured papers to create a collage that teaches others something about yourself.

Belonging

135

## Teach

### Engage

**Ask:** How do you identify community leaders or people in certain professions? How can you tell a teacher from a student? Do they dress differently? How can you distinguish an airline pilot from a passenger? *(A person's clothing usually identifies his or her position.)* In what other ways can you identify people's position and status in the community?

### Using the Text

**Aesthetics** Have students read the text to learn how dress and possessions reflect a person's position in Polynesian society. **Ask:** What might we wear to show what the feathered cape showed in its community?

### Using the Art

**Perception** Challenge students to find two faces in the Marquesas Islands war club, and to describe its textures and patterns.

**Art Criticism Ask:** What are the most important art elements in the Hawaiian cape? *(color, texture)*

### Teaching Through Inquiry

**Art History** Tell students that many objects that were made to show the importance of the people who owned or used them are now considered artworks. Ask students, working in groups, to identify such objects that they have seen in museums (or know to be in museums); and to identify objects in our culture that serve similar purposes. Have groups then write descriptive labels for today's objects, as though they were on display in a museum 100 years from now.

### More About...

Traditionally, **Hawaiian society** was divided into four levels: the *ali'i*, or ruling chiefs and nobles; the *kahuna*, or priests and master craftsmen; the *maka'ainana*, or commoners, cultivators, and fishermen; and the *kauwa*, or slaves and outcasts. Only the *ali'i* could wear items such as the feather cape.

### Using the Large Reproduction

**Consider Context**

**Describe** What is this? How was it made? From what materials?

**Attribute** What traditions is this artwork a part of? If someone were unfamiliar with such traditions, what clues might he or she use to

identify where it was made?

**Understand** How might this have been used?

**Explain** How does this artwork reflect the place where it was made?

6

135

## Using the Text

**Art History** Have students read the text to learn the types of art that *tohungas* made, and that Maori houses indicated community standing. Ask a volunteer to explain the symbolism in the houses.

## Using the Art

**Perception** Ask students to identify the motifs on the carved wooden pieces (Figs. 3–22, 3–23) and then to compare the designs to the tattoo on the carved portrait (Fig. 3–21). Discuss what all the designs have in common.

**Art Criticism Ask:** What types of lines were used in Fig. 3–21? *(curved, swirling, repeated)* What shapes do these lines mimic? *(the facial features)*

## Studio Connection

Provide the following: 6" x 6" tag board or stencil paper, pencils, erasers, markers, X-acto knives, scissors, rulers, scrap cardboard, 12" x 18" drawing paper.

List communities and groups that students belong to, and demonstrate the pattern that you yourself would create to symbolize your membership among art teachers. Demonstrate the use of a pencil or marker to blacken areas to cut out, and safe cutting techniques with the X-acto knife. Have students trace the openings in the stencil to draw the motif and then color the shapes with markers. Call attention to ways that negative spaces in repeated motifs can form designs.

**Assess** See Teacher's Resource Binder: Check Your Work 3.3.

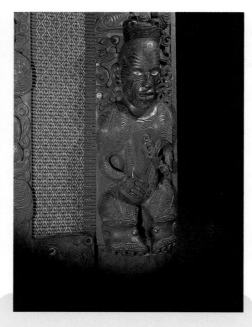

Fig. 3–21 **Precise tattoo markings on the face show that Raharuhi Rukupo, the man in the sculpture, belongs to the Maori community. What else might the tattoo pattern say about him?** New Zealand, Gisborne, Manutuke, *Carved figure of Raharuhi Rukupo*, from the carved house Te Hau ki Turanga, ca. 1835–42.
Wood, red and black paint, and paua shell, 42 1/8" (107 cm). Photography Museum of New Zealand Te Papa Tongarewa, Wellington, New Zealand. (B.15448)

Fig. 3–22 **There are two masks at the peak of this house. Where else do you see masks?** *Maori House.* The Field Museum of Natural Histroy, Chicago, Illinois.

## Maori Master Carvers

Some areas of Polynesia are famous for artworks created in particular art forms. The Maori of New Zealand are excellent carvers. A great master carver is called *tohunga*, meaning craftsman-priest. Tohungas have high social rank and special status in the community.

Some of the most spectacular works by tohungas are prow and stern ornaments used to decorate their canoes. Notice the open spiral **motif**, or pattern, that is skillfully carved on the example in Fig. 3–23. These elegant and open shapes help the canoes move swiftly through water.

Master carvers are also skilled at carving house decorations. Among the Maori, houses indicates the status of their owners. The size, height, and decoration of the house are related to the owner's importance in the community. The wood carving in

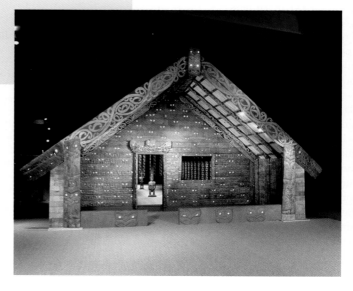

**Teaching Options**

### Teaching Through Inquiry

**Art Production** Have students work in groups to outline the steps taken to create each artwork on pages 136 and 137, and to identify the power tools that they themselves would use if they were to produce similar works. Then have students research Maori carving techniques.

### More About...

The **Maori** are ethnic Polynesians who arrived on New Zealand around 800 AD. Maori art is created for one's ancestors or for village chiefs and highborn individuals—the finest cloaks, ornaments, weapons, decorated houses, and household items distinguish the upper class. The Maori believe that elaborate surface ornamentation is the essence of beauty, and they use it in three art forms: the canoe, the meeting house, and body art.

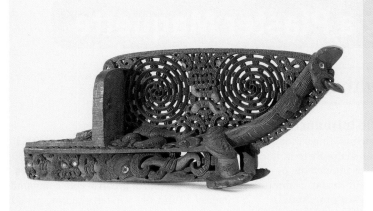

Fig. 3–23 The prow is the front end of a boat. This prow ornament was designed to help a canoe move swiftly through the water. What other functions might this prow ornament have served? Why do you think so? New Zealand, Maori, East Coast, North Island, *Canoe Prow*, ca. 1800–1900. Wood and paua shell, 19 3/4" x 16 1/8" x 46 5/8" (50 x 41 x 118.5 cm). Photography Museum of New Zealand Te Papa Tongarewa.

## Extend

Show examples of different types of repeat patterns, such as row, drop, alternating, and border. Ask students to experiment with creating several of these with their stencil motif, and then to select one pattern to stencil onto fabric with textile paint.

Fig. 3–21, for example, portrays the carving master Raharuhi Rukupo, who built the ceremonial house in which the sculpture is located.

All houses of importance have a name and are highly respected as symbols of living beings. Community meeting houses, in particular, are symbolic of a community ancestor. The ridge beam of the house represents the ancestor's backbone, and the rafters stand for his ribs. The face boards on the front of the house represent his outstretched arms. A mask at the peak of the face boards symbolizes his face. Notice the many pairs of eyes on the Maori house shown here (Fig. 3–22). What might they symbolize?

### Studio Connection

How can you create a richly patterned design that symbolizes your membership in a group or community? Think of all the communities you belong to. Select one and design a motif that represents your membership. Cut a stencil from tag board or stencil paper. You can use both positive and negative stencils. Try outlining and decorating a repeated pattern on paper. Try different ways of repeating the basic pattern. Think about various ways you can use your motif: on a skateboard, as a backpack label, or stitched onto a shirt or jacket.

### 3.3 Global View

**Check Your Understanding**
1. How does Polynesian art show ways that people belong to their communities?
2. What kinds of materials are used by artists in the South Pacific island groups?
3. What do tattoo patterns symbolize?
4. What is a tohunga?

## Assess

### Check Your Understanding: Answers

**1.** through designs and patterns on the objects they use and the things they give away

**2.** natural materials such as raffia, feathers, shells, barkcloth, and tusks

**3.** identity and ownership

**4.** a Maori master carver

## Close

Remind students that the art of Polynesia shows how an island culture developed creative ways to show group identity and status. Ask if they can name other cultural groups, and ways another group uses artworks to indicate their identity and status.

Belonging

137

### More About...

**Polynesia**, the eastern-most Pacific island group, spreads from Hawaii in the north, through the Marquesas and the Cook Islands in the east, to New Zealand in the south. Polynesian artworks include carved ceremonial clubs, decorative wooden furniture, finely woven mats, and barkcloth.

### Studio Collaboration

Challenge student groups to design and create appropriate "feather" capes for school administrators. Have students layer pieces of colored construction or tissue paper and then glue the "feathers" to a paper cloak shape. Display the capes in the school lobby.

### Assessment Options

**Teacher** Ask students to imagine that they are in a museum with a friend who is unfamiliar with Polynesian art. **Ask:** What would you tell your friend so that he or she would understand how Polynesian art shows membership in communities? What would you say to describe the art's materials and processes? Ask students to write their responses. Look for accurate information and appropriate examples.

Sculpture in the Studio

# Carving a Plaster Maquette

## Prepare

### Pacing
Four 45-minute periods: one to consider art and text, and to mix plaster; one to sketch ideas and begin carving; one to complete carving; one to paint

### Objectives
- Explain the purpose of a maquette when creating a large sculpture.
- Practice safe carving techniques.
- Carve a model for a sculpture that honors an event, person, or group in the local community.

### Vocabulary
**maquette** A small model of a larger sculpture.

## Teaching with Symbols

### Studio Introduction
Imagine building a monument or sculpture to honor a special event, person, or group within your community. Where might such a sculpture stand? How big might it be? What materials could you use to create it?

Traditionally, large sculptures are carved from stone or wood. Artists must plan their sculptures carefully before they actually create them. They sketch their ideas first and often make small-scale models, called **maquettes**, of the larger sculpture. **In this studio lesson, you will carve a plaster maquette for a large sculpture that honors an event, person, or group in your community.** Pages 140 and 141 will tell you how to do it.

Visit a large sculpture or monument that already exists in your town or city. Spend some time walking around it. Look at every side of the sculpture and notice how each side flows into the next. When you think about your own sculpture, imagine it from every side.

## Studio Background

### Planning Large Sculpture
Carving and cutting are called *subtractive processes* in sculpture, because you take away material with cutting tools. Large monuments and sculptures are often carved from blocks of stone or wood. Sometimes they are cut from cast metal. The planks of wood and corrugated iron works used to create *City to Sea Bridge* (Fig. 3–24) were shaped with tools before they were assembled.

Fig. 3–24 This contemporary sculpture in New Zealand includes the forms of birds, a whale, and the ribs of a ship. Poles bearing hearts and stars stand over these forms. How might these forms relate to life in this Maori community? What might the sculpture symbolize? Paratene Matchitt, *City to Sea Bridge*, Wellington, New Zealand, 1993.
Museum of New Zealand Te Papa Tongarewa. Photograph by Michael Hall.

138

## National Standards
### 3.4 Studio Lesson

**1b** Use media/techniques/processes to communicate experiences, ideas.

**3b** Use subjects, themes, symbols that communicate meaning.

## Teaching Options

### Resources
Teacher's Resource Binder
- Studio Master: 3.4
- Studio Reflection: 3.4
- A Closer Look: 3.4
- Find Out More: 3.4
Slides 3f

### Teaching Through Inquiry

**Art Production** Ask students to list ways, other than sculpted monuments, that we remember public or civic events (*parades, celebrations, mosaics, murals, songs, slogans, legends*) and also to list the kinds of public moments and public figures that we commemorate. Have the class select a historical or contemporary event to commemorate, work in small groups to develop a design or plan for it, and then vote for and create one or several of the commemorations.

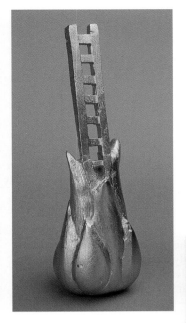

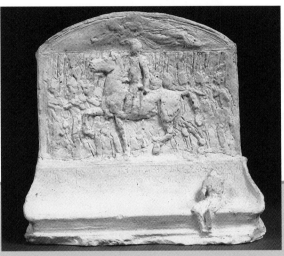

Fig 3–25 In December, 1999, a tragic fire in Worcester, Massachusetts, resulted in the death of six firemen. A procession to honor those men was seen across the country on television. The plaster maquettes in this lesson represent ideas for sculptures to honor the bravery of firemen everywhere. Julian Wade, *Untitled*, 2000.
Plaster, gold spray paint, 9" (23 cm) high. Forest Grove Middle School, Worcester, Massachusetts.

## Supplies

- plaster of Paris, 1 to 2 lb/student
- water
- plastic bucket
- waxed milk or juice cartons or quart-size waxed paper cups
- pencils
- sketch paper
- newspaper
- dust masks or respirators
- disposable gloves
- knives, files, chisels, rasps
- sandpaper
- acrylic paints and brushes (optional)
- vermiculite (optional)

Large sculptures must be carefully planned, because mistakes in carving or cutting are difficult or impossible to correct. Maquettes allow artists to try out and develop their ideas first. Artists carve maquettes from inexpensive material, such as plaster or Styrofoam™. Then they refer to their maquettes when they create the actual sculpture.

Artist Augustus Saint-Gaudens created many monuments in his lifetime. The *Robert Gould Shaw Memorial* (Fig. 3–4, page 123) in Boston, Massachusetts, is considered to be his finest work.

Fig. 3–26 This maquette is called a sketch. How does this remind you of sketches you have made when planning a two-dimensional artwork? Augustus Saint-Gaudens, *Maquette for the Robert Gould Shaw Memorial*, 1883.
Plaster, 15" x 16" (38.1 x 40.6 cm). U.S. Department of the Interior, National Park Service, Saint-Gaudens National Historic Site, Cornish, NH.

This monument of the Civil War honors African-American soldiers. How might the maquette for this monument (Fig. 3–26) have helped the artist shape his ideas?

Belonging

139

## Teach

### Engage

Ask students to think about public sculptures and monuments they have seen. **Ask:** How might the artists of these works have designed and planned the way they look? Explain that sculptors work from models before creating their full-size artworks.

### Using the Text

**Art Production** Have students read the text and comment about ways artists might use maquettes. Ask if they can think of ways to use a maquette other than what is listed here. *(to show others how the sculpture will look when completed)*

### Using the Art

**Art Criticism** Have students compare Saint-Gaudens's maquette to the finished sculpture on page 123. **Ask:** What significant differences do you see? What kinds of detail did the sculptor add in the final version? Why do you think it is called a "sketch"?

## More About...

**Augustus Saint-Gaudens** earned his fame by producing two kinds of art—monumental public sculpture and small-scale **portrait reliefs**. At thirteen, as an apprentice to a maker of cameos, Saint-Gaudens was introduced to the art of relief: in making cameos, he learned to create the impression of full three-dimensional form in very shallow space. During his career, he produced more than 200 works in marble and bronze.

## More About...

**The Shaw Memorial** exists in three versions. Saint-Gaudens had his full-scale plaster work of twenty-one pieces cast in bronze; that version stands today on the Boston Common. In France, the artist exhibited a plaster cast (which differed in some details) of a second version; it is now on display at the National Gallery of Art, in Washington, DC. During a restoration of the plaster piece, a new bronze casting was made; that version is on display in a museum in Cornish, New Hampshire.

# Carving a Plaster Maquette

## Studio Experience

1. Demonstrate safely mixing plaster and pouring it into a waxed carton. The plaster will set up in about thirty minutes to an hour, depending on the ratio of plaster to water. Caution students not to pour any plaster into the sink.

2. At least a day later, have students tear the carton away from the hardened plaster. Then have them use pencil to draw their sculpture on the sides and top of their form. Remind students that plaster sculptures should have thick forms.

3. As students begin to carve, instruct them to turn their sculpture often and to carve on all sides. After students have carved the basic form, have them sand or carve textures into the surface.

4. Students may paint their sculpture with acrylic paint.

## Idea Generators

Lead students in developing a list of people and events they would like to commemorate. Discuss materials, size, and an appropriate location for each.

**Safety Note**
Review safe carving practices with students. If any students have a skin rash, cuts, or sores, do not let them use plaster; instead, have them carve Styrofoam.

## Studio Tips

- You can mix plaster in bulk, as much as one week in advance, by adding vermiculite (a soil additive) to create a softer medium for carving. Thoroughly mix equal parts of water, plaster, and vermiculite in a plastic bucket; and pour into waxed cartons.

- To reduce dust and make cleanup easier, have students keep their work damp, and carve the form in a shallow box or a tray lined with a damp cloth or newspaper.

---

**Sculpture in the Studio**

## Carving Your Maquette

### You Will Need

- sketch paper
- pencil
- waxed carton
- plastic bucket
- plaster powder
- rubber gloves and dust mask
- water
- carving tools
- paint and paintbrush

**Safety Note**
Always wear rubber gloves and a dust mask or respirator when mixing plaster. Wear protective goggles and a dust mask while carving plaster. Always carve away from your body. Hold the work securely.

### Try This

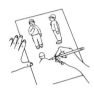

**1.** Sketch your ideas on paper. The idea for your sculpture must be suitable for carving. Think about a basic shape that you can use for your maquette. Imagine all sides of your sculpture and sketch each one. Keep your idea simple.

**2.** Cut a waxed container to the basic dimensions you want for your maquette. Will it be tall and thin? Or short and stout? What other dimensions can you think of?

**3.** Fill a plastic bucket about halfway with warm water. Sift the plaster powder through your fingers into the water until an island forms in the middle of the bucket. After a few minutes, stir the mixture slowly with your hand. Break up any lumps. If your mixture is too thick, add a little more water.

**4.** Pour the plaster into the prepared carton. Gently tap the carton to pop any air bubbles that may have formed. Let the plaster harden; then remove the carton.

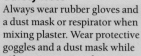

**5.** Use a chisel to carve the rough forms first. Then use a rasp or file to smooth and define the edges of your forms. To carve small details, use a paint scraper or sandpaper. Remember that your sculpture will be seen from all sides. Every view should be interesting and flow into the next view. Work slowly and carefully. Look at your work often as you carve.

**6.** You might choose to paint your maquette. Imagine how a large sculpture made from your maquette would look. Choose colors that will best represent your subject.

### Check Your Work

Display and discuss your work with your classmates. Are all sides of your work interesting? What does your sculpture tell about the event, person, or group that you wish to honor? What messages about your community's values and beliefs do the sculptures convey?

---

## Teaching Options

### Meeting Individual Needs

**Adaptive Materials** Instead of plaster, have students use balsa foam or a modeling compound.

**Focusing Ideas** Have any less-able student work with a peer tutor. Ask each pair to brainstorm appropriate subjects. Give students an idea from each category (event, person, or group) to choose from.

### Studio Collaboration

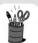

Have students work in groups to create a sculpture that pays tribute to their community. They may make a sculpture of individual figures, each created by a group member.

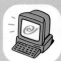

## Sketchbook Connection

Study and draw the light and shadow areas of three-dimensional forms. Include different values or shades from white to black. How can you change the values gradually to suggest forms, textures, and space? Sharp contrasts in value will create a dramatic effect.

## Computer Option

Use a 3-D program to create a model of a sculpture. Print out different angles or views of the sculpture, and then use the model as a reference for creating the sculpture in another medium.

## Studio Collaboration

Work with your classmates. Use objects and materials found in your community to construct a monument representing your community. Your monument might be an assemblage made by attaching found materials to an armature or base. Or it might be planned as an installation.

Fig. 3–27 **"My artwork is a sculpture of an axe used by a fireman. Before I started carving, I brainstormed to come up with the idea. It was fun to make!" A layer of gold spray paint gives the impression of a gold or bronze metal. What material would your sculpture be made of?** Michael J. Gasperski, *Fireman Axe*, 2000. Plaster, gold spray paint, 6" (15 cm) high. Forest Grove Middle School, Worcester, Massachusetts.

## Tips for Safe Carving

Students: If you are unsure about any of the tips listed below, ask your teacher for help.

- Learn how to use sharp tools properly.
- Make sure you are using the right tool for the job.
- Sharpen your tools, if necessary. Dull tools slip more easily and cause painful cuts.
- Hold or clamp your form tightly to prevent it from slipping as you work.
- Always carve away from your body. Keep your fingers and hands clear of the carving tool.
- Wear goggles to protect your eyes.
- Keep a safe distance from other students to avoid injury from flying chips.
- Properly clean and store tools when they are not in use.

## Extend

Have students create an environment for their sculpture. They may either create a diorama, or draw their sculpture in its intended setting.

## Computer Option

With Photoshop, students can use a 3-D filter that allows for outlined shapes to be converted to 3-D forms and then rotated. Some true 3-D programs are Ray Dream 3-D (novice), Painter 3-D, Ray Dream Studio 5, (includes animation), Poser 3 (for figures), Bryce 4, and Canoma—all from MetaCreations.

## Sketchbook Tip

Suggest to students that they create a value scale in their sketchbook.

## Assess

### Check Your Work

Ask students to discuss how this Studio Experience has contributed to their understanding of the importance of monuments and memorials.

## Close

Display the sculptures, and have students describe the significance of one another's maquettes.

## Teaching Through Inquiry

**Art Production** Have students do research to find an image of a well-known monument or large-scale sculpture, and an image of its maquette. Ask students to describe both versions and suggest how the maquette might have helped the artist develop or change ideas.

## More About...

An artist will make a **maquette** to present to a client for approval of a proposed work, or to enter in a competition for the awarding of the contract or a prize. Artists create maquettes from such inexpensive material as wax, clay, or balsa wood.

## Assessment Options

**Self** Have students create a checklist of safe working techniques for carving and rate themselves from 1 to 5 (with 5 as the highest rating) on how well they practiced those techniques.

**Peer** Have students work in pairs to use the questions in Check Your Work to critique each other's work.

## Careers

Direct students to look for examples of the use of the Statue of Liberty's image or name in advertisements, business logos, magazine illustrations, or souvenirs. Ask students to discuss their findings in class.

## Language Arts

Help students determine which aspects of *Parson Weems's Fable* are based on fact and which are based on fiction. Ask students each to research other American myths and folklore, choose one, and create an artwork based on the myth. Possibilities are the tales about Pecos Bill, Paul Bunyan, John Henry, Annie Oakley, and Br'er Rabbit.

## Science

Have students conduct research on the Internet to discover botanical art, both historical and contemporary, that is available online. If possible, arrange an online interview between the class and a botanical artist.

# Connect to...

## Careers

Do you know who designed the Statue of Liberty? How do you think such monumental works are created? Frédéric-Auguste Bartholdi, one of the foremost sculptors in France in the late 1800s, designed Liberty Enlightening the World (Liberty's original name) and worked within a process still used by sculptors today. Like Bartholdi, most **sculptors** design a public work to fit a specific place for a particular purpose. Sculptors develop initial sketches into small-scale models, and then into larger fabrications. Sculptors need the services of many other people to complete monumental works. For instance, Bartholdi enlisted Gustave Eiffel to design Liberty's interior structure, and he employed a legion of workers to build, pack, ship, unpack, and install Liberty.

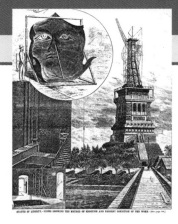

Fig. 3–28 Sculptors often have many details to work out when creating "site-specific" sculptures. To help them find potential problems, many build small-scale models first before undertaking the final sculpture. *Statue of Liberty Under Construction*, 1886. Illustration from "The Scientific American," August 14, 1886. Courtesy the Statue of Liberty National Monument, New York.

## Other Arts

### Dance

Like art, **dance can also tell about communities** of many cultures and periods. Through dance, we can explore who we are and the communities we belong to.

Dance can represent different aspects of belonging to a community. For instance, an Italian tarantella, during a wedding celebration, is sometimes performed by the older women of the community as a way to honor the newlyweds. Dance can define membership in a specific generation: young people of the 1920s danced the Charleston; those of the1930s through the 1950s danced the jitterbug. Dance can educate people about a community: during Native American powwows, both younger members of the community and outsiders can learn certain cultural traditions through dance.

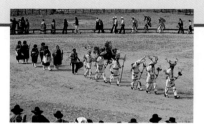

Fig. 3–29 The Native-American powwow is a celebration of culture and shared history. You can see many different styles of dance at a powwow. Each dance has special regalia (costumes) that the dancers wear and often make themselves. Native American, Pueblo (New Mexico), *Deer Dancers Inter-tribal Ceremony.* Courtesy Davis Art Slides.

Choreographers combine dance elements (time, the body, space, and energy), and sometimes music and costumes, to communicate a message symbolically. If you were to create a dance that defined your generation, what would it look like?

## Teaching Options

### Resources

Teacher's Resource Binder
    Using the Web
    Interview with an Artist
    Teacher Letter

### Video Connection

Show the Davis art careers video to give students a real-life look at the career highlighted above.

### Interdisciplinary Planning

Use the reproducible story map in the Teacher's Resource Binder to help students classify artworks' main and supporting ideas. Students may also use the map to classify literature.

## Other Subjects

### Language Arts

Do you think *Parson Weems's Fable* (*see page 126*) is based on fact or fiction? Grant Wood painted it in 1939, during the Great Depression, to "help awaken interest in the cherry tree and other bits of **American folklore** that are too good to lose." *Parson Weems's Fable* was the first painting in a series of American myths and stories the artist wanted to create. Wood had planned the second painting to be the legend of Pocahontas, but he died before he could produce it. Why, do you think, did the artist show Parson Weems pulling back a curtain? What do you think George's father is saying? Why, do you think, did Wood put the head of the adult George Washington on the body of a young boy?

### Science

Do you know the biological classification to which human beings belong? Thanks to Carl Linnaeus, a Swedish botanist who lived from 1707 to 1778, the modern scientific world still benefits from his **biological classification system** of plants and animals. Linnaeus developed binomial nomenclature, in which each species

Fig. 3–30 Notice details this botanical artist includes in her paintings of flowers. She also has a background in biology, or the study of plant and animal life. How do you think this knowledge helps her in her art? Carol Wickenhiser-Schaudt, *Blc. Malworth D'or "Pinkie" (Hybrid Orchid)*, 1992. Transparent and iridescent watercolor on paper, 28" x 35" (71.1 x 89 cm). ©1992 Carol Wickenhiser-Schaudt. Courtesy the artist.

has a two-term biological name. The terms are in Latin, the universal language of science. The first term identifies the genus or class to which a living thing belongs; the second term names the species itself. In part because Linnaeus classified plants by their flowers and system of reproduction, botanical illustrators began to create more realistic and accurate drawings, depicting all parts of a plant, including the stalk, leaf, flower, fruit, and seed.

## Daily Life

**To which groups do you belong?** Do you belong to school groups? Religious groups? Community groups? Do you think that you relate well to different generations? Or are you more comfortable being with friends your own age? Young people have an extraordinary impact on popular culture today, but the word *teenager* was not established in print until about 1941. In earlier times, adults paid little attention to the stage between childhood and adulthood. As a result, teenagers were usually treated like adults. With both good and bad results, teens made their own decisions. Do you think being a teenager is difficult today? For many teens, school can be very isolating and alienating. How might others help teenagers feel that they belong—in their family, in school, and in the community?

**Internet Connection**
For more activities related to this chapter, go to the Davis website at **www.davis-art.com.**

## Other Arts

You may wish to show examples of dance that reflect various cultures.

Have students try the following:

1. Create a movement pattern that reflects some aspect of a community—one identified by school, generation, or family. For a document, or record, of the movement pattern, draw or write a description of the steps.

2. Teach your pattern to a partner. Use both patterns to create a partner dance. How will you combine the two patterns?

3. Select music and costumes that will enhance your dance.

4. Perform your dance for the class. As you watch other pairs' dance combinations, consider the following:

- What were the strongest images?

- How did the movement, costumes, and music contribute to the meaning of the work? What parts of the choreography identify the dance as belonging to a specific community?

Belonging

143

## Internet Resources

### The Electric Franklin

http://www.ushistory.org/franklin/index.htm

This site lets you browse for resources, interactive games, a time line, and streaming videos about Benjamin Franklin. See Franklin's print shop, artworks, and other artifacts at Franklin Court.

## Community Involvement

Organize a community arts-resource center for lending student artwork for display in local restaurants and businesses. Have students prepare work for presentation, and use informative labels to call attention to the value of art in the community.

## Community Involvement

Have students research the folk-art traditions of their community or state. **Ask:** What cultural groups came to the region, and what artistic traditions did they bring? How do the groups reflect the identity and ideals of the community?

## Talking About Student Art

Display all of the student artworks. Write expressive words such as "exciting," "lonely," "joyous," and "peaceful" on cards and give each student two or three cards. Ask students to place each card next to an artwork they believe the word describes. Discuss students' reasons for their choices.

## Portfolio Tip

Remind students that their portfolio is not only a collection of artworks but also a reflection of their learning.

## Sketchbook Tip

Explain to students that the design of a sketchbook page can help them recall information and make sense of it in the future. To help students generate ideas for a page design, provide one or more of the reproducible graphic organizers.

# Portfolio

"I did this for my grandmother because she is always so happy when she can see my drawings." **Aaron Mast**

Fig. 3–31 Aaron Mast, *Proverbs 31:28* (Fraktur), 1998. Watercolor, ink, 11 ½" x 14 ½" (29 x 37 cm). Penn View Christian School, Souderton, Pennsylvania.

"I was thinking about Abraham Lincoln giving his speech. There were some parts that were easy. The difficult parts were the eyes and the beard. I like that he looks alive." **Julian Wade**

Fig. 3–32 **A portrait doesn't need to be 100 percent realistic to convey the identity of the subject. This work is more like a caricature.** Julian Wade, *Abraham Lincoln*, 1999.
Clay, 5 ½" (14 cm) high. Forest Grove Middle School, Worcester, Massachusetts.

Fig. 3–33 **Belonging can be expressed through a sport, club, or body image. What is important to this artist?** Tyrone Nixon, *Gym Workout*, 1999.
Crayon, 12" x 18" (30.5 x 46 cm). Johnakin Middle School, Marion, South Carolina.

**CD-ROM Connection**
To see more student art, check out the Community Connection Student Gallery.

144

## Teaching Options

### Resources

Teacher's Resource Binder
  Chapter Review 3
  Portfolio Tips
  Write About Art
  Understanding Your Artistic Process
  Analyzing Your Studio Work

### CD-ROM Connection

For students' inspiration, for comparison, or for criticism exercises, use the additional student works related to studio activities in this chapter.

# Chapter 3 Review

**Recall**

Identify the characteristics of sculpture and the common materials and methods used in making sculpture.

**Understand**

Explain, using examples, how some artworks remind people that they belong to a community.

**Apply**

Suppose that the school administration asks students to submit suggestions for ways to create a stronger spirit of community within the school. How might you respond to this request? Make sure that your suggestion demonstrates what you know about how art can promote a sense of belonging.

**Analyze**

Select one artwork from the chapter (*see example below*) and tell how its parts are organized to convey an important idea about belonging to a community.

**Synthesize**

Imagine that you have been asked by a local community group such as an athletic team or a scouting organization to help them brainstorm ideas for a sculpture. They want the sculpture to communicate the ideals and beliefs of their group. What questions would you ask the group members to help them get ideas?

**Evaluate**

Which do you think would be a better way to communicate what it means to belong to a school community—school uniforms or a sculpture placed in the school lobby? Why?

Page 131

**For Your Portfolio**
Look through this chapter and select one artwork from the past. Write a two-part essay. In the first part, describe the work with careful attention to detail. In the second part, summarize how this artwork suggests group membership and ideals. Write your name and date your essay to include in your portfolio.

**For Your Sketchbook**
Design a page in your sketchbook for generating a list of words that are associated with belonging: words that describe friendship, responsibility, loyalty, ownership, for example. Create visual symbols, or icons, for each of these words.

Belonging

145

## Chapter 3
## Review Answers
### Recall

Sculptures are artworks that have height, width, and depth. Traditional materials are stone, wood, clay, ivory, and cast metal, although many recent sculptures have been made from "found" materials. Traditional methods are carving, modeling, and casting. Recent methods include the combining of found materials and the use of equipment to change the environment.

### Understand

Answers and examples will vary. Look for evidence that students understand that art can be used as monuments, memorials, historical markers, and so on, thereby commemorating or giving tribute to people or events that have special significance to the values and beliefs of a community.

### Apply

Answers will vary, but students should indicate that artworks can be made to communicate the important values and beliefs of a community.

### Analyze

Answers and examples will vary. Make sure that students correctly identify the parts of the artwork and that they give persuasive interpretations of how, together, these parts convey ideas about membership in a community.

### Synthesize

Students might ask the group to tell its history, and to identify group values and beliefs, special events or people associated with the group, any symbols that represent group identity.

### Evaluate

Answers will vary. Make sure that students provide reasons.

### Reteach

Have students recall colors and symbols that identify membership on various sports teams. Have them also find symbols that are associated with states and communities. Then help students create an interactive display titled "Where Do I Belong?" or "Match Me Up with My Symbol."
    Summarize by explaining that artworks can play an important role in creating a sense of belonging among community members.

**Advocacy**

Put together a scripted slide presentation for parent groups and civic organizations.

**Family Involvement**

Identify family members who can commit to a regularly scheduled time for helping with a variety of classroom activities.

# Chapter Organizer

## Chapter Focus

**Chapter 4 Connecting to Place**

Chapter 4 Overview
pages 146–147

- **Core** Art helps people understand the history and characteristics of special places in their community.
- **4.1** The Majesty of Place: 1820–1860
- **4.2** Drawing
- **4.3** Japanese Places in Art
- **4.4** Perspective in Pastels

## Chapter National Standards

1 Understand media, techniques, and processes.
2 Use knowledge of structures and functions.
3 Choose and evaluate subject matter, symbols, and ideas.
4 Understand arts in relation to history and cultures.
5 Assess own and others' work.
6 Make connections between disciplines.

---

**3   3   3**

### Objectives

**Core Lesson
Common Places**
page 148
Pacing: Three 45-minute periods

- Use examples to explain how artists create special places for community use.
- Understand how artists highlight important characteristics of community places.

### National Standards

**4c** Analyze, demonstrate how time and place influence visual characteristics.
**5b** Analyze contemporary, historical meaning through inquiry.

---

**Core Studio
Drawing a Town Center**
page 152

- Create a drawing that shows the special character of a community place.

**3b** Use subjects, themes, symbols that communicate meaning.

---

**3**

### Objectives

**Art History Lesson 4.1
The Majesty of Place**
page 154
Pacing: Three to four 45-minute periods

- Identify characteristics of Romanticism and Realism in American artists' interpretations of place.
- Explain how art contributed to the geographical expansion of North American communities.

### National Standards

**1b** Use media/techniques/processes to communicate experiences, ideas.
**4c** Analyze, demonstrate how time and place influence visual characteristics.
**5b** Analyze contemporary, historical meaning through inquiry.

---

**Studio Connection**
page 156

- Capture the beauty of a place in a realistic painting.

**2b** Employ/analyze effectiveness of organizational structures.
**3b** Use subjects, themes, symbols that communicate meaning.

---

**3**

### Objectives

**Forms and Media
Lesson 4.2
Perspective Drawing**
page 158
Pacing: Three 45-minute periods

- Identify two ways to change the mood of a drawing.

### National Standards

**6b** Describe ways other disciplines are interrelated to art.
**2b** Employ/analyze effectiveness of organizational structures.

---

**Studio Connection**
page 159

- Use perspective techniques to make a drawing of a natural community in an underground or underwater environment.

**1b** Use media/techniques/processes to communicate experiences, ideas.
**3a** Integrate visual, spatial, temporal concepts with content.

## Featured Artists

Bernice Abbott
John James Audubon
Albert Bierstadt
Sally Cover
Robert Scott Duncanson
Asher Brown Durand
Ando Hiroshige

Katsushika Hokusai
Andrew Leicester
Okumura Masanobu
Blackwell Meyer
Thomas Otter
Linnea Pergola
Frank Romero

David Schofield
Saul Steinberg
Sesson Suikei
Wayne Thiebaud
Jorn Utzon

## Chapter Vocabulary

document
linear perspective
memorials
Realistic style
Romantic style
two-point perspective
ukiyo-e

| Teaching Options | Technology | Resources | |
|---|---|---|---|
| Teaching Through Inquiry<br>More About...The Sydney Opera House<br>Using the Large Reproduction<br>Using the Overhead<br>Meeting Individual Needs<br>More About...Bernice Abbott | CD-ROM Connection<br>  e-Gallery | Teacher's Resource Binder<br>  Thoughts About Art:<br>    4 Core<br>  A Closer Look: 4 Core<br>  Find Out More: 4 Core<br>  Studio Master: 4 Core<br>  Assessment Master:<br>    4 Core | Large Reproduction 7<br>Overhead Transparency 8<br>Slides 4a, 4b, 4c |
| Meeting Individual Needs<br>Teaching Through Inquiry<br>More About...The history of public places<br>Assessment Options | CD-ROM Connection<br>  Student Gallery | Teacher's Resource Binder<br>  Studio Reflection: 4 Core | |

| Teaching Options | Technology | Resources | |
|---|---|---|---|
| Teaching Through Inquiry<br>More About...Robert Duncanson<br>More About...Romanticism/Realism | CD-ROM Connection<br>  e-Gallery | Teacher's Resource Binder<br>  Names to Know: 4.1<br>  A Closer Look: 4.1<br>  Map: 4.1<br>  Find Out More: 4.1<br>  Assessment Master: 4.1 | Overhead Transparency 7<br>Slides 4d |
| Meeting Individual Needs<br>Teaching Through Inquiry<br>More About...The Hudson River School<br>Assessment Options<br>Using the Overhead | CD-ROM Connection<br>  Student Gallery | Teacher's Resource Binder<br>  Check Your Work: 4.1 | |

| Teaching Options | Technology | Resources | |
|---|---|---|---|
| Teaching Through Inquiry<br>More About...John James Audubon<br>Using the Overhead<br>Assessment Options | CD-ROM Connection<br>  e-Gallery | Teacher's Resource Binder<br>  Finder Cards: 4.2<br>  A Closer Look: 4.2<br>  Find Out More: 4.2<br>  Assessment Master: 4.2 | Overhead Transparency 7 |
| | CD-ROM Connection<br>  Student Gallery | Teacher's Resource Binder<br>  Check Your Work: 4.2 | |

# Chapter Organizer continued

| 9 weeks | 18 weeks | 36 weeks | | **Objectives** | **National Standards** |
|---|---|---|---|---|---|
| | | 3 | **Global View Lesson 4.3 Japanese Places in Art** page 160 Pacing: Three 45-minute periods | • Identify similarities and differences in the styles of Japanese printmakers Hiroshige and Hokusai. <br> • Explain how the subject matter of ukiyo-e printmakers changed over the centuries. | **4a** Compare artworks of various eras, cultures. <br> **2c** Select, use structures, functions. |
| | | | **Studio Connection** page 162 | • Create relief prints that show moods and feelings in two different views of a special place in the community. | **1b** Use media/techniques/processes to communicate experiences, ideas. <br> **2c** Select, use structures, functions. |

| | | | | **Objectives** | **National Standards** |
|---|---|---|---|---|---|
| | 3 | 3 | **Studio Lesson 4.4 Perspective in Pastels** page 164 Pacing: Three 45-minute periods | • Understand the historical significance of postcards as documents of place. <br> • Explain various ways to create the illusion of space/distance on a two-dimensional surface. <br> • Create the illusion of space and distance by using two-point perspective in a pastel drawing of a special place. | **1b** Use media/techniques/processes to communicate experiences, ideas. <br> **2b** Employ/analyze effectiveness of organizational structures. <br> **3b** Use subjects, themes, symbols that communicate meaning. |

| | | | | **Objectives** | **National Standards** |
|---|---|---|---|---|---|
| • | • | • | **Connect to...** page 168 | • Identify and understand ways other disciplines are connected to and informed by the visual arts. <br> • Understand a visual arts career and how it relates to chapter content. | **6** Make connections between disciplines. |

| | | | | **Objectives** | **National Standards** |
|---|---|---|---|---|---|
| • | • | • | **Portfolio/Review** page 170 | • Learn to look at and comment respectfully on artworks by peers. <br> • Demonstrate understanding of chapter content. | **5** Assess own and others' work. |

2

Lesson of your choice

## Teaching Options

Teaching Through Inquiry
More About...Hokusai
More About...Hiroshige
Using the Large Reproduction

## Technology

CD-ROM Connection
  e-Gallery

## Resources

Teacher's Resource Binder
  A Closer Look: 4.3
  Map: 4.3
  Find Out More: 4.3
  Check Your Work: 4.3
  Assessment Master: 4.3

Large Reproduction 8
Slides 4e

---

Meeting Individual Needs
Teaching Through Inquiry
Assessment Options

CD-ROM Connection
  Student Gallery

Teacher's Resource Binder
  Check Your Work: 4.3

## Teaching Options

Meeting Individual Needs
Teaching Through Inquiry
More About...Angular perspective
Using the Overhead
More About...Pastels
Assessment Options

## Technology

CD-ROM Connection
  Student Gallery
Computer Option

## Resources

Teacher's Resource Binder
  Studio Master: 4.4
  Studio Reflection: 4.4
  A Closer Look: 4.4
  Find Out More: 4.4

Overhead Transparency 8
Slides 4f

## Teaching Options

Community Involvement
Interdisciplinary Planning

## Technology

Internet Resources
Video Connection
CD-ROM Connection
  e-Gallery

## Resources

Teacher's Resource Binder
  Using the Web
  Interview with an Artist
  Teacher Letter

## Teaching Options

Advocacy
Family Involvement

## Technology

CD-ROM Connection
  Student Gallery

## Resources

Teacher's Resource Binder
  Chapter Review 4
  Portfolio Tips
  Write About Art
  Understanding Your Artistic Process
  Analyzing Your Studio Work

## Theme

People develop connections to their community's special places. Art helps communities create, use, and appreciate these places.

## Featured Artists

Berenice Abbott
John James Audubon
Albert Bierstadt
Sally Cover
Robert Scott Duncanson
Asher Brown Durand
Ando Hiroshige
Katsushika Hokusai
Torii Kiyotada
Andrew Leicester
Okumura Masanobu
Blackwell Meyer
Thomas Otter
Linnea Pergola
Simon Rodia
Frank Romero
David Schofield
Saul Steinberg
Sesson Suikei
Wayne Thiebaud
Jorn Utzon

## Chapter Focus

Art helps people understand the history and characteristics of special places in their community. This chapter focuses on ways that artists create and depict these places; in particular, how North American artists between 1820 and 1860, especially artists of the Hudson River School, documented and romanticized areas of the expanding country. Students return to the art form of

# 4 Connecting to Place

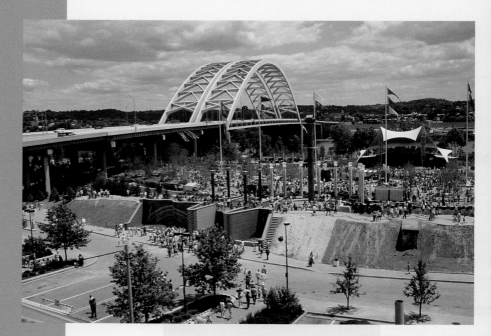

146

Fig. 4–1 Imagine seeing this gateway, with its sculpted features and decorative tiles. Now imagine designing a gateway to your own town or city. What features would you include to remind people of its history? Andrew Leicester, *Cincinnati Gateway*, 1988. Bronze, steel cast iron, polychrome masonry, stone, water and plant materials 480' x 145' x 65' (146.3 x 44.2 x 20 m). Sawyer Point Park, Cincinnati, Ohio. Photo copyright Andrew Leicester.

*Cincinnati Gateway* (detail).

### National Standards Chapter 4 Content Standards

1. Understand media, techniques, and processes.

2. Use knowledge of structures and functions.

3. Choose and evaluate subject matter, symbols, and ideas.

4. Understand arts in relation to history and cultures.

5. Assess own and others' work.

6. Make connections between disciplines.

**Teaching Options**

### Teaching Through Inquiry

**Art Production** Have students work in groups to **design a gateway** for the artroom, or another room; for the school itself; or for a place in the community. Encourage students to think, like Leicester, about the history and use of the place to be entered. Have them brainstorm ideas, do research, and make sketches from which they choose an idea for a presentation drawing (see Sketchbook Tip in Lesson 3.2). Display and discuss the drawings.

### More About...

**The Cincinnati Gateway** includes references to a Cincinnati canal, as well as the city's famous suspension bridge. A flood column marks the level that the Ohio River reached in three twentieth-century floods. Leicester kept a notebook in which he recorded Cincinnati's political, commercial, and cultural past; and the geology and topography of the area. He used this information to plan and to inspire ideas.

## Focus

- What do places mean to groups of people?
- How do artworks help connect people to places?

**Every place has a history. Think about one of your favorite places—maybe a park, a library, or a farm.** Who were the people who created that place? What did they do there? How did they feel about the place? There are many ways for you to find out. Artworks can often provide some of the clues.

The people of Cincinnati, Ohio, asked artist Andrew Leicester to create an entrance to Sawyer Point Park, a downtown riverfront park. The artist learned as much as he could about the city's history and the Ohio Valley in which it is located. The completed gateway includes tall riverboat smokestacks topped with sculpted winged pigs. These forms refer to the city's history as a river port and a major producer of pork. The artist also learned that groups of Native Americans once lived where Cincinnati is built. As a reminder of this, he created a wall that includes glazed ceramic "fossils" and reproductions of Native American artifacts found in the Ohio Valley.

*Cincinnati Gateway* (Fig. 4–1) inspires new ways to think about the city's history. This lighthearted entrance to a riverside park tells all who visit that special places have stories to tell about their past.

### What's Ahead

- **Core Lesson** Learn how art celebrates community places and spaces.
- **4.1 Art History Lesson** Discover how mid-nineteenth-century artists recorded the expansion of the United States.
- **4.2 Forms and Media Lesson** Explore ways that artists create the illusion of space in drawings.
- **4.3 Global View Lesson** Learn about Japanese respect for places in nature and the role of art in Japan.
- **4.4 Studio Lesson** Make a pastel drawing of a special place using perspective techniques to show space and distance.

### Words to Know

| | |
|---|---|
| memorial | linear perspective |
| document | ukiyo-e |
| Romantic style | two-point perspective |
| Realistic style | |

drawing, focusing on ways to create the illusion of space in depictions of community places. Students are introduced to the art of Japan and learn how Japanese artists showed their respect for special places in nature. Students use two-point perspective to make a pastel drawing of a special place in their community.

## Chapter Warm-up

Tell students that they will consider how people and artists connect to special places. **Ask:** Why, do you think, do ball teams feel that playing a game "at home" is an advantage? *(knowing the idiosyncrasies of the playing field or court, having the support of local fans, a feeling of belonging)*

## Using the Text

**Art Criticism** Have students read the text to learn how an artist designed an entrance for a particular place. **Ask:** How did Andrew Leicester tie his design to Cincinnati's history and to the riverfront location?

## Using the Art

**Art Criticism Ask:** How did Leicester create a light-hearted, fun feeling in his design? *(flags, colors, winged pigs)*

**Aesthetics Ask:** What must an urban designer consider when developing a site such as this? *(its fit with the rest of the community, advantageous use of terrain and setting, honoring local history and cultures, enhancement of the environment, ability to handle crowds)*

---

## Graphic Organizer
### Chapter 4

### CD-ROM Connection

For more images relating to this theme, see the Community Connection CD-ROM.

## Prepare

### Pacing

Three 45-minute periods: one to consider art and text; two to draw

### Objectives

- Use examples to explain how artists create special places for community use.

- Understand how artists highlight important characteristics of community places.

- Create a drawing that shows the special character of a community place.

### Vocabulary

**memorials** Artworks or other objects that help people remember things, such as important events or people.

---

# Common Places

People need places for public meetings, shopping, entertainment, and community celebrations. Artists and architects design and create places such as plazas, town squares, shopping malls, gardens, parks, and cultural centers. Sometimes, the places they design become famous and symbolize the community. The Sydney Opera House (Fig. 4–2) is a cultural center for the performing arts. Does it look familiar to you? It has come to represent the city of Sydney, Australia, much like the Eiffel Tower represents Paris, France, and the Golden Gate Bridge represents San Francisco, California.

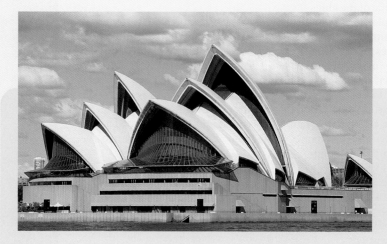

Fig. 4–2 Joern Utzon, a Danish architect, designed the Opera House to blend in with Sydney Harbor. The curved roofs look like the sails of boats. What special meaning might the design of the roof have for the residents of Sydney, Australia? Joern Utzon, *Sydney Opera House*, 1973. Courtesy Woodfin Camp.

Fig. 4–3 Saul Steinberg is known for his humorous style. His drawing is not of a Main Street in a particular place. The title suggests that this is a place where people meet and lots of action takes place. How has the artist used lines to show action in this artwork? Saul Steinberg, *Main Street*, 1972–73. Lithograph, printed in color, 15 ¾" x 22" (40 x 56 cm). The Museum of Modern Art, New York. Gift of Celeste Bartos. Photograph © 1999 The Museum of Modern Art, New York. © 2000 Estate of Saul Steinberg / Artist Rights Society (ARS), New York.

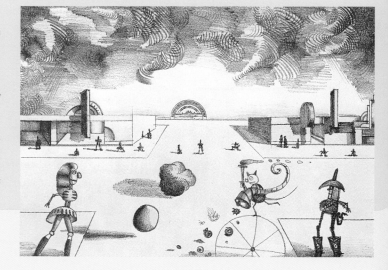

148

---

### National Standards Core Lesson

**3b** Use subjects, themes, symbols that communicate meaning.

**4c** Analyze, demonstrate how time and place influence visual characteristics.

**5b** Analyze contemporary, historical meaning through inquiry.

## Teaching Options

### Resources

Teacher's Resource Binder
  Thoughts About Art: 4 Core
  A Closer Look: 4 Core
  Find Out More: 4 Core
  Studio Master: 4 Core
  Studio Reflection: 4 Core
  Assessment Master: 4 Core
Large Reproduction 7
Overhead Transparency 7
Slides 4a, 4b, 4c

### Teaching Through Inquiry

**Art History** Have students work in pairs to select and **learn more about a building** in the community's center. Tell students that the historical society or chamber of commerce may provide information. Have each pair contribute to a class time line of construction dates from the oldest to the most recent buildings.

## A Place Called Main Street

Most towns and cities grew up around a place where people gathered to exchange goods and ideas. This central place may have been a crossroads, general store, trading post, or railroad station. It may have been wharves or docks along rivers or seacoasts. Most towns have a "Main" Street, the first street that grew up with the town. Some of the oldest buildings in a town or city might still stand on this first street. What was the first street in your city or town?

When we think of a town or city, we think of its center. Many postcards feature photos of Main Street to show the life and personality of a place. When drawing or painting an image of a city or town, artists often show its center because that's where things happen and people gather.

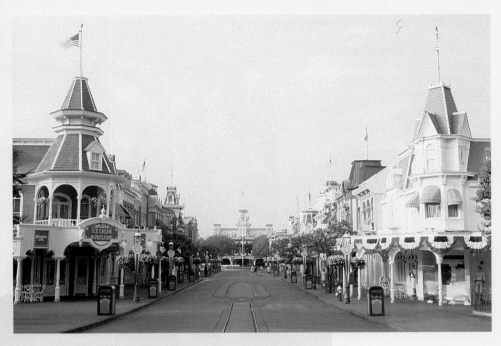

Fig. 4–4 The Main Street that Walt Disney designed resembles the main streets found in most small towns in late nineteenth-century America. How does Disney's Main Street look like the main street in your town or city? *Panoramic view of Main Street, U.S.A.*, in the Magic Kingdom Park at the Walt Disney World Resort. © Disney Enterprises, Inc.

## Teach

### Engage

Ask students to name public places where they shop, meet friends, are entertained, or have community celebrations. Have them choose one and consider how designers made the space inviting and functional. **Ask:** How could you improve its beauty and function?

### Using the Text

**Art History** Have students read the text to learn about public places designed by architects. Lead students in developing a list of cities and representative structures, other than those in the text. *(Seattle: Space Needle, San Antonio: Alamo, New York: Empire State Building)* **Ask:** What is the "main street" or center of your town? Is there something memorable about this area? Do people gather there for celebrations or parades? Does it have a memorable landmark? If the area has none, have students suggest features for landmarks to represent their region.

### Using the Art

**Perception Ask:** How is the Sydney Opera House similar to and different from a traditional building?

**Art Criticism Ask:** In Fig. 4–4, what seems to be most important—showing a realistic picture, or an idea? What type of art does this remind you of? Why is Walt Disney's vision of Main Street idealistic? Have students compare this to their own town's center.

---

### More About...

The **Sydney Opera House**—which includes a concert hall, an opera theater (also used for ballet), a drama theater, and a playhouse—took fourteen years to build. The structure, with a roof that echoes the sails of boats, was built to blend in with the harbor. More than one million glazed ceramic tiles form the roof. Yearly, more than two million people attend performances here. The design by Danish architect Jorn Utzon was selected from more than 230 international entries.

### Using the Large Reproduction

**Talk It Over**

**Describe** What subject matter did the artist include in this painting?

**Analyze** Use descriptive words to tell how the artist used colors, values, and shapes.

**Interpret** What feelings or moods did the artist convey about the place she painted?

**Judge** What features of this artwork make it special or significant?

**7**

## Using the Text

**Art Criticism** Have students read pages 150–151 to learn how artists show places that are significant to them. **Ask:** How did each artist show a community from his or her own point of view? What feature did each artist emphasize in his or her art? *(Thiebaud: San Francisco's hills; Romero: L.A. traffic, freeways; Abbott: sky, strength of bridge)*

## Using the Art

**Perception** Challenge students to describe how each artist created a sense of depth in these city views. **Ask:** What are the main lines in each piece? Which artwork has the greatest feeling of depth? Where is the viewer located in each piece? What lines and shapes were repeated in each to form patterns?

## Showing Places in New Ways

People tend to mark places that mean something to them. Sometimes they erect **memorials**—artworks or other objects that help people remember where important events took place or where famous individuals lived. People have also marked burial sites throughout history. Artists all over the world create grave markers, memorials, and other kinds of artworks that celebrate special places. By doing so, they help people remember the history and significance of these places.

Artists look at our communities carefully, then show us new ways to see them. They think about what makes a place unique and interesting, and use their ideas to create artworks. Andrew Leicester created *Cincinnati Gateway* (Fig. 4–1, page 146) to provide the people of Cincinnati with a historic view of their city.

Artists also make paintings, drawings, prints, and photographs of places. Sometimes, they show what is most common about the place. Wayne Thiebaud's *Downgrade* (Fig. 4–5) shows a steep hill, a landscape feature that is common in the San Francisco Bay area. Thiebaud uses the San Francisco area as subject matter for many of his artworks. In

*Downtown* (Fig. 4–7), California artist Frank Romero highlights the importance of cars and freeways in the Los Angeles area.

We often think that photographers show us things exactly as they look in real life. But photographers also show us certain views to express ideas about the places they photograph. Bernice Abbott spent several years photographing the city of New York. Sometimes, she photographed New York City from the air at night or during different times of the day. Other times, she focused on details of buildings and bridges. How did she call attention to the awesome strength and size of a city bridge in Fig. 4–6?

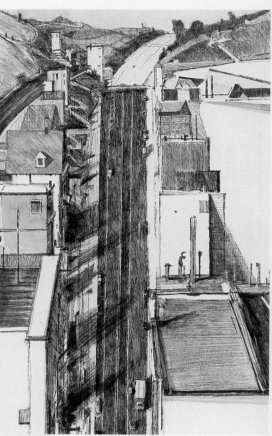

Fig. 4–5 The artist has exaggerated certain parts of this artwork to highlight landscape features of the San Francisco Bay area. How has he used line to convey the idea of a place with long, steep hills? Wayne Thiebaud, *Downgrade*, 1979. Aquatint and watercolor over hard-ground etching, 20" x 30" (50.8 x 76.2 cm). Image courtesy the Campbell-Thiebaud Gallery, San Francisco, CA. © Wayne Thiebaud/Licensed by VAGA, New York, NY.

150

### Meeting Individual Needs

**Multiple Intelligences/Interpersonal** Ask cooperative-learning groups to create a display or presentation designed to help people view their school in a new way. They may sketch or photograph views of the school to show unusual viewpoints or details that may often go unnoticed. Groups should designate a team leader and assign responsibilities. Help them choose who their audience will be, and suggest ways they might think about assembling and presenting their work.

### Teaching Through Inquiry

**Perception** Have students create **viewfinders** to use when looking at parts of their community. A viewfinder is a piece of sturdy paper, such as tag board, with an open area through which to look for composition ideas. Invite students to experiment with viewfinder openings of different sizes and shapes. Tell students that Abbott used her camera's viewfinder to find interesting angles and close-up and distant views of her city. Have students use the viewfinder, moving it until they find a view to record.

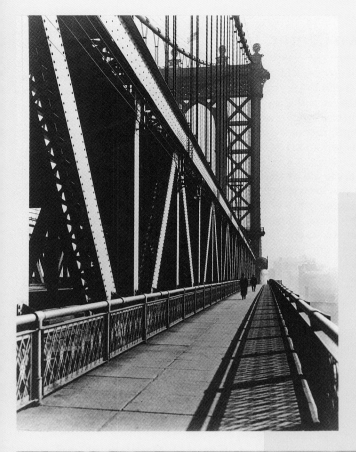

Fig. 4–6 In crowded cities, people often look up to the sky to feel a sense of space in their environment. How does this artist capture the feeling of great space in Manhattan? Bernice Abbott, *Walkway, Manhattan Bridge, New York*, 1936. Silver gelatin print. Museum of the City of New York.

Fig. 4–7 California is known for its many cars and freeways. It was the first state to have drive-through banks, restaurants, and even funeral parlors. In what ways does the artist capture the spirit of Los Angeles? Frank Romero, *Downtown*, 1990. Oil on linen, 24" x 48" (61 x 121.9 cm). Courtesy of the artist.

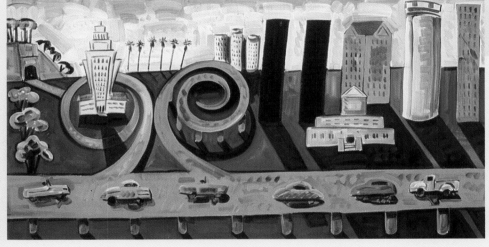

## Extend

- Have students photograph public areas of their community from various viewpoints. Suggest that they look up at and, if possible, down on buildings and structures. Ask students what they would like to communicate about their area. Arrange a display of their photographs in a public area.

- Show students some travel brochures. Discuss their layout and how the graphic artists emphasized certain features. Have students create travel brochures for their community, by hand and/or computer. They may create drawings, photographs, headlines, and captions. **Ask:** What will you highlight? What can people see and do in your area?

Connecting to Place

151

### More About...

**Berenice Abbott**, born in Ohio in 1898, established herself in commercial portraiture in Paris and New York, invented photographic equipment, and was a pioneer in the teaching of photographic techniques. Abbott was influenced by Man Ray, with whom she studied, and by French photographer Eugène Atget, whose photographs included Parisian streets, architectural details, and gardens. For years, Abbott worked on "Changing New York," capturing the spirit and characteristics of the city.

### Using the Overhead

**Investigate the Past**

**Describe** What details are important in this work? Do you consider this to be a realistic image?

**Attribute** What earlier artist influenced this artist? To what other work would a comparison be important? (See Fig. 4–15 on page 158.)

**Interpret** What does this artwork tell about a place?

**Explain** What might have been the purpose for making an artwork so similar to that of another artist?

7

151

## Supplies

- drawing pencils, #2
- erasers
- drawing paper, 12" x 18"
- viewfinders
- drawing boards
- masking tape

## Using the Text

**Art Production** Have students read about drawing a feature of their community's center. Discuss what they might draw. **Ask:** What do you want to emphasize about your community? If possible, take students to their community's center to do their sketch. Alternatively, have students photograph or videotape to remind them of details; or, lead students in discussing and remembering significant features.

Demonstrate using a viewfinder, and encourage students to be selective in what they show from a scene. Have students experiment with various line and shading techniques. Demonstrate sketching large shapes before working on the details.

When students are almost finished, suggest that they study their drawing from a distance. **Ask:** Do you need to create greater contrasts so that viewers will understand your message? How will the details change as viewers move nearer or farther from the work?

## Using the Art

**Perception Ask:** What is the center of interest in Fig. 4–8? *(tepee)* How did Meyer emphasize it? *(centered it, used contrasting values)* How did he create a sense of depth? *(over-lapped objects; made distant objects smaller and higher on the page, with fewer details)*

**Aesthetics Ask:** What might have been Meyer's purpose in creating his drawing? Would the style used by Steinberg in Fig. 4–3 have achieved the same purpose?

**Drawing in the Studio**
# Drawing a Town Center

Think about the center of your town or city. What buildings, streets, parks, and plazas are there? Is your town or city the birthplace of someone famous? Is it known as a vacation resort or place of industry?

In this studio experience, you will create a drawing that shows why your town or city center is special. Decide whether you will include many buildings or just one. Perhaps instead you will focus on an interesting detail, such as a window, sign, doorstep, or chimney. Draw the feature of your town or city that you think expresses why it is special.

### You Will Need

- viewfinder
- sketch paper
- pencil
- eraser
- drawing paper

### Try This

1. Choose a scene or object that expresses why your town or city is special. Then choose a viewpoint from which to create your drawing. Will you show your subject up close or far away? Use a viewfinder to help you, if you wish.

2. Sketch your ideas. Experiment with different lines and ways to make marks. Think about which marks will work best in your drawing.

3. When you are happy with your sketch, begin your final drawing on drawing paper. Draw the largest shapes first. Then add details and shading.

### Check Your Work

Display your drawing. How did you use subject matter, viewpoint, and marks to express why your town or city is special? Talk to your classmates about their drawings. What do all of your drawings together say about your town or city?

Fig. 4–8 Notice how this artist has used simple marks and lines to show a quiet scene. How many different effects has he created with pencil? How would you describe the textures you see? Blackwell Meyer, *Treaty Site of Traverse des Sioux*, 1851. Pencil drawing, 10" x 13" (25.4 x 33 cm). Edward E. Ayer Collection, The Newberry Library, Chicago.

## Studio Background

**Making Marks**
Drawing begins with making marks. The first marks were probably made long ago by people who scratched the dirt with sticks. You can use many different tools, such as pencils and crayons, to make marks on lots of different papers and other materials. Look at the way you make marks and decide what effects you like.

The objects shown in drawings don't have to look exactly like the real objects. Drawings have personality when certain parts are exaggerated or simplified. Look at the drawings in Figs. 4–8 and 4–9. How many different kinds of lines or marks have the artists used? How do the lines help us see what the artists saw?

## Teaching Options

### Meeting Individual Needs

**Alternative Assignment** Have students draw a map of their town and identify important landmarks.

**Adaptive Materials** Provide photographs, history books, or other materials that illustrate the town's features.

### Teaching Through Inquiry

**Art Criticism** Have groups of three students **select one artwork** from page 152 or 153 and **consider its message**. Encourage students to describe what they see, analyze how the elements and principles were used, and interpret the message. Instruct students to take and use notes to write an essay explaining the message, and remind them to use the artwork's details to support their interpretation. Have students share and discuss their essay with group members.

Ratedrála sv Vita
~Czech~

Fig. 4–9 **What features did this student explore in her artwork? How might you describe her viewpoint?** Erisa Dilo, *Katedrala sv. Vita*, 1998.
Colored pencil, calligraphy, 20" x 25 ¾" (51 x 65.5 cm). Burncoat School, Worcester, Massachusetts.

### Sketchbook Connection
Experiment with making marks on paper. Use different media, such as crayons, markers, pastels, pencils, pens, and paint. Try using the tips and sides of different media. What kinds of lines can you make? How might you use lines to show texture? Practice shading with the different media. Which medium do you feel most comfortable using? Why?

### Core Lesson 4

#### Check Your Understanding
1. What are some kinds of places that artists and architects create for people in communities to use together?
2. Why is the main street of a town important?
3. What kinds of artworks might mark a place as having a special meaning in a community?
4. Why might an artist make an artwork that shows a close-up view of a place?

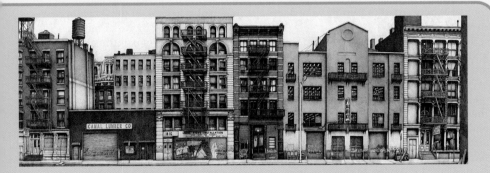

Fig. 4–10 **This artist has created a detailed ink drawing of a city street. How does the quality of this drawing compare to the quality of** *Treaty Site of Traverse des Sioux* **(Fig. 4–8), which was drawn in pencil?** David Schofield, *Wooster Street, North of Canal*, 1997.
Ink on parchment. 36" x 108" (91.4 x 274.3 cm). Courtesy Gallery Henoch.

Connecting to Place

153

## Assess

### Check Your Work
As students display their work for the class, facilitate a discussion by encouraging individuals to point out ways their classmates used viewpoint. Ask which of the artists used viewfinders to make compositional choices. **Ask:** Are these artworks different from the others?

#### Check Your Understanding: Answers

**1.** Artists and architects create plazas, town squares, shopping malls, gardens, parks, and cultural centers.

**2.** The main street is usually where a town began, so it has some of the oldest buildings.

**3.** Memorials mark where natural or human-caused disasters occurred. Historical markers, grave markers, and memorials indicate where important events occurred, or where famous people lived, worked, or died.

**4.** A close-up view can highlight features and convey important ideas about a place.

## Close

Have students title and display their drawing, and, as a class, answer the questions in Check Your Work. As students answer, create a list of words that describe their community. Display the list with their art.

### More About...

**The history of public places,** places in communities where the public can gather, dates to ancient cultures, such as Greek and Roman, where special areas were set aside to meet, shop, and play. In the Middle Ages and the Renaissance, public marketplaces served similar purposes. In the late 1600s in Europe, and later in America, pleasure grounds—places with gardens, ponds, and elaborate architectural features—were where people went for fun. Today, amusement and theme parks follow the tradition of the pleasure parks.

### Assessment Options

**Peer** Have students create a concept map (see Teacher's Resource Binder for blank maps) to demonstrate how art helps communities use and appreciate places. For example, radiating from *Art and Places* (a topic in the map's center), would be *Sydney Opera House* (a place for community use), *Cincinnati Gateway* (a work to help use a place), and *historical markers* (indicators to help appreciate a place). Students may also use examples from their own community. Upon completion, have student pairs exchange maps and complete and discuss responses to these prompts: "I like the way you___; I have questions about___; To improve your map, I suggest ___."

# The Majesty of Place: 1820–1860

1851
Duncanson, *Blue Hole*

CA. 1880–90
*Homestead*

| American Neoclassicism page 128 | Realism and Romanticism in America | Late 19th Century page 180 |
|---|---|---|

1849
Durand, *Kindred Spirits*

CA. 1859
Bierstadt, *Wolf River*

## History in a Nutshell

Between 1820 and 1860, the United States grew rapidly in size. Many individuals became wealthy very quickly, but a population of poor people also developed. Communities began to group people into upper or lower classes based on the level of their wealth. Some of the poor moved west to search for their own fortunes. This search for a better life often led to conflict between settlers and Native-American cultures.

## Documenting Place

The period between 1820 and 1860 was a time of discovery and exploration for artists in the United States. Much of the North American landscape was still unknown. Yet artists set out to **document**, or record, the place they now called home. They also looked at how artists in Europe were documenting places.

Two major styles of art—Romanticism and Realism—influenced the way American artists created pictures. Art in the **Romantic style** shows foreign or exotic places, myths and legends, and imaginary events. Art in the **Realistic style** shows people, scenes, and events of the artist's own time. Realistic artworks show their subjects clearly, much like the way we see them. American artists blended the two styles. In this way, they tried to show an accurate view of the landscape, yet still inspire a sense of awe.

Photography also influenced American art at this time. It offered yet another way to document places and events. It changed the way artists thought about realism in painting. It also helped set the stage for new styles of painting in the twentieth century.

One new style of painting was developed by a group of American artists known as the Hudson River School. These artists were inspired by the beauty and majesty of the landscapes around them. Many artists traveled west and painted the unknown American landscape. Their artworks document the settlement of western territories (Figs. 4–11 and 4–12).

154

---

## Prepare

### Pacing

Three to four 45-minute periods: one to consider art and text; three to make art

### Objectives

- Identify characteristics of Romanticism and Realism in American artists' interpretations of place.
- Explain how art contributed to the geographical expansion of North American communities.
- Capture the beauty of a place in a realistic painting.

### Vocabulary

**document** To make or keep a record of something.

**Romantic style** A style of art in which foreign places, myths and legends, and imaginary events were popular subjects.

**Realistic style** A style of art that shows people, scenes, and events as the eye sees them.

### Using the Time Line

Using your knowledge of United States history, offer suggestions as to why the subject of landscape would have been so popular in the mid-nineteenth century.

### Supplies for Engage

- picture postcards of places

### National Standards
### 4.1 Art History Lesson

**1b** Use media/techniques/processes to communicate experiences, ideas.

**2b** Employ/analyze effectiveness of organizational structures.

**3b** Use subjects, themes, symbols that communicate meaning.

**4c** Analyze, demonstrate how time and place influence visual characteristics.

**5b** Analyze contemporary, historical meaning through inquiry.

## Teaching Options

### Resources

Teacher's Resource Binder
  Names to Know: 4.1
  A Closer Look: 4.1
  Map: 4.1
  Find Out More: 4.1
  Check Your Work: 4.1
  Assessment Master: 4.1
Overhead Transparency 8
Slides 4d

### Teaching Through Inquiry

**Art Criticism** Use the **Interpretation Statements** in the Teacher's Resource Binder, and have students work in groups to select one or more statements that they believe to be appropriate for Figs. 4–11 to 4–14. Using the statements as prompts, they can develop an interpretive label for each artwork. Guide students to refer to details and evidence in the artwork. Have each group share responses with the whole class, looking for similarities and insights.

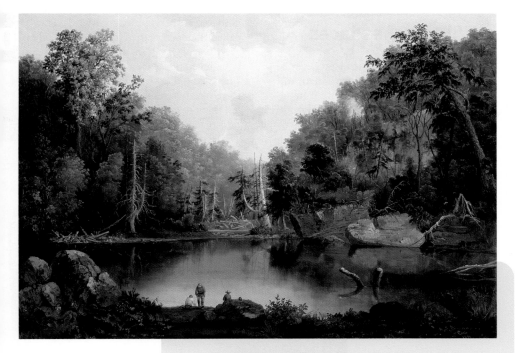

Fig. 4–11 **Midwestern landscapes, such as this one, encouraged people to visit or move to places west of the Appalachian Mountains. How does this painting call attention to the grandeur and majesty of the landscape?** Robert Scott Duncanson (1821–72), *Blue Hole, Little Miami River*, 1851.
Oil on canvas, 28 1/2" x 41 1/2" (72.4 x 105.4 cm). Cincinnati Art Museum, Gift of Norbert Heerman and Arthur Helbig 1926.18

Fig. 4–12 **What details suggest that this was a relatively new homestead at the time this painting was created? Why might viewers of the time have been interested in this painting?** Sally Cover, *Homestead of Ellsworth L. Ball*, ca. 1880–90.
Oil on canvas, 19 1/2" x 23" (49.5 x 58.4 cm.) Museum of Nebraska History Collections.

Connecting to Place

155

## Teach

### Engage
**Ask:** What postcards have you received? Show students tourist postcards. **Ask:** How did photographers make these places seem better than they might really be? *(dramatic lighting, fine weather, enhanced color)* Note how these cards show only the best view of the attraction, and explain that many nineteenth-century American artists did something similar: they painted idealized western landscapes for East Coast viewers.

### Using the Text
**Art History** Have students read the text to learn what invention and art styles influenced nineteenth-century American artists. Discuss subjects and painting styles of Romanticism and Realism.

### Using the Art
**Art Criticism** Discuss students' answers to the caption question for Fig. 4–11. **Ask:** Why might this painting have made someone want to visit this place? How did Duncanson emphasize the center of interest? Note the variety of colors and textures. How do they contribute to the message?

## More About...

**Robert Duncanson** (1823–72), one of the first African-American artists to achieve international prominence, is considered a classic painter of the Hudson River School style. Duncanson had a deep love of nature and the American landscape, and he traveled extensively. Many of his paintings show the intrusion of civilization into unspoiled nature, a frequent theme of the Hudson River School.

## More About...

**Romanticism** is an approach to art that emphasizes the personal, emotional, dramatic, and idealized, expressed through the use of exotic, literary, or historically remote subject matter. Nineteenth-century Romanticism arose as a reaction to Neoclassicism.

**Realism** is an art movement that countered the idealized subject matter of Romantic and Neoclassical artworks with a frank or even harsh picture of everyday life. The term also refers to the representational depiction of things as they appear in nature or real life, without distortion or stylization.

# The Majesty of Place

## Using the Text

**Art History** Explain that the Hudson River School is not a school, and have students read the text to discover what it is. Discuss Hudson River School subjects. **Ask:** How and why did these artists romanticize their landscapes?

## Using the Art

**Art Criticism** Develop a class list of students' descriptors for Durand's *Kindred Spirits*. **Ask:** How did the artist create a sense of majesty or awe? What does the scale of the figures to the landscape features tell you? How did Durand create depth? *(darker foreground objects against cooler, lighter background; more details in foreground)*

**Art Criticism Ask:** How did Bierstadt romanticize *The Wolf River*? *(use of light)* What ideas are most important?

## Studio Connection

Assemble these materials: heavy paper (manila, drawing, or watercolor), acrylic or tempera paints, brushes, palettes, water in containers, pencils, erasers, viewfinders. Either assign students to sketch a favorite place beforehand, or have them sketch a place on the school grounds. Emphasize that close attention to details in their sketch will make their painting more interesting. Students may use viewfinders to discover a composition.

Demonstrate mixing and blending of paint colors, and explain that colors can create moods. Ask students how they want viewers to feel about their scene. Guide students to begin by painting large background areas, with wide brushes, and then gradually to add finer details and textures, with smaller brushes.

**Assess** See Teacher's Resource Binder: Check Your Work 4.1.

---

## Wilderness Places

Do you know where the Hudson River is? Find the state of New York on a map, and you'll see the river moving south from Canada to New York City. The Hudson River Valley is rich in natural beauty and history. It is the area in which fables and folklore, such as Washington Irving's *The Legend of Sleepy Hollow*, take place.

Perhaps you have seen paintings such as those in Figs. 4–13 and 4–14. A group of nineteenth-century artists painted scenes of the Hudson River Valley and Catskill Mountains. These paintings show us the artists' view of the scenery there. The Hudson River Valley area was easy to get to from New York City, where the group frequently gathered and exhibited their work. They called themselves the Hudson River School.

Artists of the Hudson River School strongly believed in the ideals of their country. They wanted to show everyone the beauty of the United States. This nationalistic spirit led them to explore and document wilderness places throughout North America. Their romantic paintings were inspired by nature. They provided national images of majestic landscapes and community centers that most people in the nation recognize.

In what parts of the country were the paintings shown here painted? How can you tell? Do they make you feel proud to be a citizen of this country? Why?

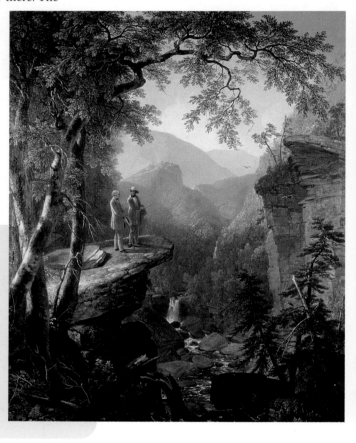

Fig. 4–13 The poet William Cullen Bryant and the painter Thomas Cole are seen here enjoying a breathtaking scene. If you were standing where they are, how would you feel? Does this painting have that kind of feeling? Why do you think so? Asher Brown Durand (1796–1886), *Kindred Spirits*, 1849. Oil on canvas, 3' 8" x 3' (112 x 91 cm). Collection of The New York Public Library, Astor, Lenox and Tilden Foundations.

---

## Teaching Options

### Meeting Individual Needs

**Gifted and Talented** Pair students to research archival images of their city, town, or neighborhood including photographs, newspaper articles, advertisements, architectural plans, and the like. Ask students to then develop a visual time line of the community. Discuss what surprised students most about the transition of the area from earlier times to the present.

### Teaching Through Inquiry

**Art History** Ask students to imagine that they are artists living at the time of the westward expansion in the United States, and have been on several expeditions to **document wilderness places**. Have them write a letter to a friend, in which they explain what they think their artworks will contribute to the move west.

## Studio Connection

Create a realistic painting of a place you know very well. Try to capture what you think is beautiful about this place. Look carefully at it and note details that others might miss at first glance. Sketch your composition. When you are ready to paint, use light and dull colors to create the largest background areas first. As you work toward the foreground, brighten your colors and add more details.

### 4.1 Art History

#### Check Your Understanding

**1.** What art styles influenced the way American artists interpreted place in the early nineteenth century?
**2.** What impact did early photography have on the way artists documented place?
**3.** How did art affect the geographical expansion of North American communities?
**4.** What kinds of places did the Hudson River School explore for sources of subject matter?

## Extend

Challenge students to paint another, similar scene, but to use different colors so as to discover how color can alter mood and depth.

## Assess

### Check Your Understanding: Answers

**1.** Romanticism and Realism

**2.** Photography changed the way painters thought about Realism. Because photographs could document places realistically, painters created works that were more interpretive.

**3.** Artists painted the beauty of the western landscape, which encouraged people in the eastern states to visit or move there.

**4.** wilderness, majestic landscapes, imagined places based on myths and legends, new settlements

## Close

Lead a class discussion based on students' answers to Check Your Understanding. Reteach areas of misconception. **Ask:** How might you change your work if you painted a similar scene again?

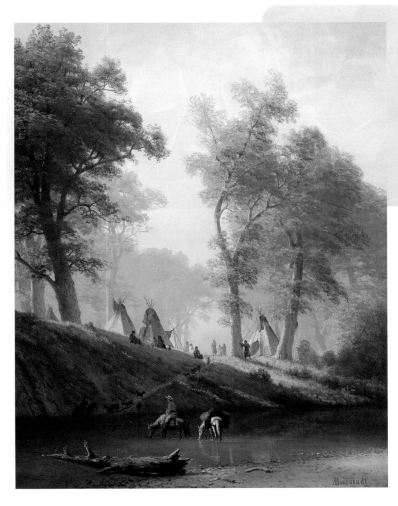

Fig. 4–14 Albert Bierstadt painted romantic pictures of the West. His paintings tempted many people to move from New York City to the western wilderness. Do you think this painting is romantic? Why? Albert Bierstadt, *The Wolf River, Kansas*, ca.1859. Oil on canvas, 48 1/4" x 38 1/4" (122.6 x 97.2 cm.) Founders Society Purchase, Dexter M. Ferry, Jr. Fund. Photograph © 1987 The Detroit Institute of Arts.

Connecting to Place

157

## More About...

The **Hudson River School** of nineteenth-century romantic painters included Thomas Cole, Asher B. Durand, Thomas Doughty, Frederick Edwin Church, John Kensett, and Albert Bierstadt.

## Assessment Options

**Teacher** On the chalkboard, write: *exotic places, actual scenes, mythical places, daily-life scenes, legend, documentary.* Ask students to categorize, in writing, the topics under the headings Romanticism and Realism.

**Self** Without referring to the book, have students outline the key points they would include in a presentation for social studies about how art contributed to the geographical expansion of North American communities. Ask them to check the accuracy of their notes by referring to the text, adjusting their outlines accordingly.

## Using the Overhead

**Think It Through**

**Ideas** What place in history is celebrated in this artwork?

**Materials** What materials did the artist use?

**Techniques** How did the artist use the materials to give the work its special appearance?

**Audience** What community might benefit from seeing the place depicted in the artwork?

8

## Prepare

### Pacing

Three 45-minute periods: one to consider art and text; two to make art

### Objectives

- Identify similarities and differences in the styles of Japanese printmakers Hiroshige and Hokusai.
- Explain how the subject matter of ukiyo-e printmakers changed over the centuries.
- Create relief prints that show moods and feelings in two different views of a special place in the community.

### Vocabulary

**ukiyo-e** Japanese pictures of the "floating world" district of Edo. These were first made in paint, but were more commonly produced in editions of woodcuts of many colors. They are the unique creation of the Edo period (1603–1868).

### Using the Map

Ask students to note Japan's length and number of islands. **Ask:** What countries are closest to Japan? How might their proximity have influenced Japan's art?

# Japanese Places in Art

## Global Glance

Japan is an island country in the Pacific Ocean. The four large islands and many smaller ones that make up Japan are spread out over 1300 miles of ocean. The islands lie along the northeastern coast of Asia and face Russia, Korea, and China. Because of the country's location along major trade routes, Japan's culture has been influenced by Korea, China, the South Pacific, Europe, and the Americas. The Japanese have adapted these influences into a unique artistic style that reflects Japanese culture.

Japan

## A Place in the Sun

Japan is called the "Land of the Rising Sun." The country's flag is a red sun on a white field. Images of the sun, sea, sky, and mountains have always appeared in Japanese art. Japanese artists have a deep respect for nature. They are especially aware of the beauty of places and spaces around them. The places in their art may be the sites of historical events, beautiful views, or places written about in poetry.

The Japanese are well known for their painted scrolls and folding screens, and for their woodblock prints. The pair of six-panel screens in Fig. 4–17 show the four seasons. Screens such as these provide people with a way to bring nature into the home.

Fig. 4–17 Can you see where one season fades into the next? Sesson Suikei, *Landscape of Four Seasons*, Muromachi period, 16th century.
Ink and light colors on paper (one of pair of six-panel screens), 61 3/8" x 133 1/4" (155.9 x 338.4 cm). Gift of the Joseph and Helen Regenstein Foundation, right side of pair - 1958.167, left side of pair -1958.168. Photograph courtesy The Art Institute of Chicago.

### National Standards 4.3 Global View Lesson

**1b** Use media/techniques/processes to communicate experiences, ideas.

**2c** Select, use structures, functions.

**4a** Compare artworks of various eras, cultures.

**Teaching Options**

## Resources

Teacher's Resource Binder
- A Closer Look: 4.3
- Map: 4.3
- Find Out More: 4.3
- Check Your Work: 4.3
- Assessment Master: 4.3

Large Reproduction 8

Slides 4e

## Teaching Through Inquiry

**Aesthetics** Throughout the ages, many artists have drawn inspiration from one another's works. Have students, in small groups, discuss the following questions: Is the **copying of another's art** ever acceptable or appropriate? Can copies of artworks be considered artworks themselves? How might such terms as *appropriation, homage, in the style of,* and *in tribute to* affect the way you think about the copying of an image?

Fig. 4–18 **What qualities of a Japanese landscape do you see in this print? Where do you see patterns?** Sakino Hokusai IITSU, *Fukagawa Mannembashi*, from 36 Views of Mt. Fuji, 1830. Multiple block wood blockprint, 10 1/4" x 15" (26 x 38 cm). Courtesy The Japan Ukiyo-e Museum.

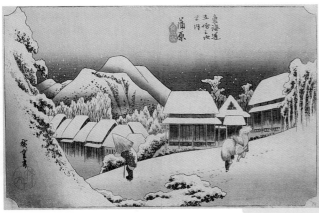

Fig. 4–19 **What details suggest that the village shown in this print is rural? What mood is expressed by the composition? Why do you think so?** Utagawa Hiroshige, *Night Snow at Kambara* (from the series Fifty-Three Stations on the Tokaido), ca. 1833. Woodblock print, 9 1/2" x 14 1/2" (24.1 x 36.8 cm). Clarence Buchingham Collection, 1925.3517. Photograph courtesy The Art Institute of Chicago.

## Prints of Places

The Japanese made woodblock prints as early as the eighth century. Color prints from woodblocks appeared in the seventeenth century. In the nineteenth century, Japanese landscape and nature prints influenced many artists in Europe and the United States. Western artists were interested in the lines, flat spaces, asymmetry, and close-up views shown in the images.

Two Japanese printmakers of the mid-nineteenth century became masters of the style of woodcut known as **ukiyo-e** (oo-key-OH-eh). They created *folios*, or series, of art-

works showing famous places in Japan. Many of Katsushika (Sakino) Hokusai's works show landscapes with clear patterns (Fig. 4–18). Ando (Utagawa) Hiroshige usually looked for rural places where men and women were at work (Fig. 4–19). Both artists tried to capture the moods of the scenic Japanese countryside. Ukiyo-e means "pictures of the floating world." The term refers to woodblock prints that show life in nineteenth-century Japan.

Connecting to Place

161

## Teach

### Engage

Tell students that the depiction of places, natural and humanmade, is an important part of Japanese art. **Ask:** Given the size and location of their country, why do you think the depiction of place would be important to the Japanese?

### Using the Text

**Art History** Have students read the text to learn of traditional Japanese art forms. **Ask:** What features of the prints shown in Figs. 4–18 and 4–19 interested nineteenth-century European artists? *(lines, flat spaces, asymmetry, close-up views)*

### Using the Art

**Art History** Have students list all the objects they can see in Hokusai's print (Fig. 4–18). **Ask:** Where is the viewer?

**Art Criticism Ask:** How did Hiroshige create a sense of depth in *Night Snow at Kambara*? *(overlapping, page placement)*

---

### More About...

**Sakino Hokusai** (1760–1849), an active artist by the age of six, became a master of both woodblock prints and painting. In Japan, during his lifetime, he was regarded as one of many good artists, whereas Western artists considered him to be a great master. His work led the transition from the traditional eighteenth-century to the nineteenth-century style in Japanese art. Hokusai was an experimental artist who introduced direct observation of places and nature.

### More About...

**Ando Hiroshige** (1797–1858) was one of Japan's great artists of landscape. Although he was influenced by Hokusai's style, Hiroshige's sympathetic observation of the common people going about their daily business was perhaps more lyrical than Hokusai's.

### Using the Large Reproduction

**Consider Context**

**Describe** What details are important here?

**Attribute** What clues suggest that this is the work of a Japanese artist?

**Understand** What is this artwork about?

**Explain** Would other works by this artist help you to better understand and explain what he was trying to do?

8

## Japanese Places in Art

### Using the Text

**Art History** Have students read the text. **Ask:** In your own words, what does *ukiyo-e* mean? How did ukiyo-e art come to reflect Japanese life?

### Using the Art

**Art Criticism Ask:** What is happening in each scene? *(people shopping; theater performance)* How did each artist create a sense of depth? *(overlapping, page placement, linear perspective)* Encourage students to describe patterns of lines and shapes in these prints.

### Studio Connection

Provide the following: Styrofoam blocks or 9" x 12" sheets (two per student), sharp pencils, erasers, 9" x 12" sketch paper (two sheets per student), ballpoint pens, brayers, inking plates, newspaper, water-soluble printing ink.

As students sketch, discuss the ways that lines can create mood. Have them darken the lines of their sketches with a soft pencil. They should place a sketch facedown on a Styrofoam block and trace over it. When they lift the paper, they will see the sketch on the block. Guide students to create indents deep enough so they will not take ink. Show them how to use a brayer and to rub the back of the printing paper. Encourage students to experiment with various colors of ink and colored papers.

Have students sign their name, in pencil, beneath the lower-right corner of their prints; and ask them to title their prints to describe the difference in mood or time.

**Assess** See Teacher's Resource Binder: Check Your Work 4.3.

## Ukiyo-e: Pictures of the Floating World

Artists Hokusai and Hiroshige brought ukiyo-e to the world's attention in the mid-nineteenth century. But the history of ukiyo-e began long before these two artists lived. In the seventeenth century, when Japan was ruled by a strict military government, merchants and artists had no power in society. The merchant class grew wealthy, but could not buy positions of power in Japan. Instead, they built their own communities centered around the pleasures of money, theater, and worldly possessions. The word *ukiyo*, meaning temporary or floating, was used to describe these communities. This way of life was frowned on by the ruling class.

Many ukiyo-e woodblock prints show life in the ukiyo-e communities. Japanese Kabuki theater was an important part of life there. The theaters needed prints to advertise their plays and actors. The popular themes and elaborate costuming of Kabuki drama made it a rich source of images for ukiyo-e artists.

Throughout the next two centuries, ukiyo-e became more and more accepted. Its subject matter began to include Japanese history, landscapes, and other natural images. Printing techniques also became more complex to allow the use of multiple colors. By the mid-nineteenth century, the woodcuts of ukiyo-e artists presented the world with a view of Japanese life.

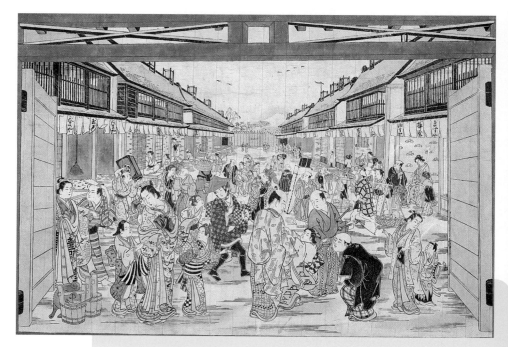

Fig. 4–20 **How would you describe the glimpse of Japanese life that you see in this print? How has the artist created mood?** Torii Kiyotada, *Naka-no-cho Street of the Yoshiwara*, Edo period, ca. 1735. Handcolored woodblock print, 17" x 35 1/4" (43.2 x 89.5 cm). Clarence Buchingham Collection, 1939.2152. Photograph courtesy The Art Institute of Chicago.

## Teaching Options

### Meeting Individual Needs

**Multiple Intelligences/Bodily-Kinesthetic, Spatial, and Linguistic** Encourage students to imagine walking through each image (Figs. 4–20 and 4–21). Ask students to write poetry or prose about what the artists might have felt as they walked through these places. **Ask:** Are these sensations different from or similar to those you have experienced in various places?

### Teaching Through Inquiry

**Art Production** Have students work together in small groups to create a hand-printed, three-panel **folding screen with the theme of nature**, perhaps each using a leaf shape for the design of a Styrofoam print. Guide students to plan the arrangement of the individual prints on the screen and then print directly on large paper.

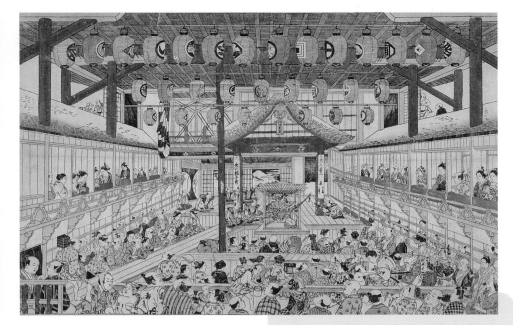

Connecting to Place

163

Fig. 4–21 This print shows the inside of a theater. How has the artist used line and pattern to create the feeling of busyness in this scene? Okumura Masanobu, *Interior View of the Nakamura-za Theatre in Edo*, 1740. Handcolored woodblock print, 18 ¼" x 26 ¾" (46.3 x 67.9 cm). Clarence Buchingham Collection, 1925.2285. Photograph courtesy The Art Institute of Chicago.

## Studio Connection

Create two relief prints that show different views of a special place in your community. You might choose to show the place in two different seasons, in different weather, or at different times of day.

Sketch your scenes on paper first, then transfer them to Styrofoam™ blocks. On the block, trace over the lines with a ballpoint pen, "carving away" areas that you do not want to print. Spread ink or paint onto the raised areas of the block. Carefully place a piece of paper over the inked block. Rub the back of the paper evenly. Carefully lift the print from the block. The raised areas of the block will have printed, and the carved-away areas will have remained the color of the paper. Repeat the process on the second block.

### 4.3 Global View

#### Check Your Understanding

1. How does the art of Japan show connections to place?
2. Who were two famous Japanese printmakers of the nineteenth century?
3. How did Japanese woodblock prints influence artists in the United States and Europe?
4. What can we learn about Japan from its ukiyo-e woodcuts?

## Extend

• Have students use large paper (at least 18" x 24") to create repeat patterns.
• Call students' attention to the chop marks, and explain that these indicate the artist, printer, and, sometimes, the owner. Have students design their own chop marks by: drawing a 1"-square design; transferring it to a 1"-square gum eraser by placing the design facedown on the eraser and rubbing; carving; and inking and stamping.

## Assess

### Check Your Understanding: Answers

1. The art, because of the artists' deep respect for nature, regularly includes many elements of the natural environment.

2. Hokusai and Hiroshige

3. The woodblock prints' lines, flat spaces, asymmetry, and close-up views intrigued Western artists.

4. some of its history, landscape, famous places, community centers, and worldly pleasures

## Close

Have students mat or mount their prints and display them. Ask students to describe how their scenes are different and how they achieved the different effects.

## Assessment Options

**Peer** For responses, have each student number a sheet of paper from 1 to 5. Write the following identifiers on the board, and ask students to attribute each to Hiroshige, to Hokusai, or to both. Have students exchange papers and use the textbook to check responses. (1) Created folios of artworks showing famous places. *(both)* (2) Most often showed landscapes with obvious patterns. *(Hokusai)* (3) Captured the moods of scenic Japan. *(both)* (4) For subject matter, sought out rural places where people were working. *(Hiroshige)* (5) Master of ukiyo-e. *(both)*

**Teacher** On the board, write: money, history, theater, landscapes, possessions, famous places, famous actors, nature. Ask students to sort the words into two groups: early ukiyo-e subject matter or later ukiyo-e subject matter.

## Prepare

### Pacing

Three 45-minute periods: one to consider art and text, and to learn two-point perspective; two to draw

### Objectives

• Understand the historical significance of postcards as documents of place.

• Explain various ways to create the illusion of space and distance on a two-dimensional surface.

• Create the illusion of space and distance by using two-point perspective in a pastel drawing of a special place.

### Vocabulary

**two-point perspective** A method of creating the illusion of deep space on a flat surface. In two-point perspective there are two vanishing points on the horizon line.

### Supplies

• shoe box
• sketch paper
• pastel paper, 18" x 24"
• pencils
• pastels
• rulers
• erasers
• paper towels
• fixative (optional)

### National Standards 4.4 Studio Lesson

**1b** Use media/techniques/processes to communicate experiences, ideas.

**2b** Employ/analyze effectiveness of organizational structures.

**3b** Use subjects, themes, symbols that communicate meaning.

---

Drawing in the Studio

# Perspective in Pastels

## A Postcard Scene

### Studio Introduction

If you were asked to design a postcard that shows a special place, what place would you choose? What details and qualities of this place would you want to capture? Which method of creating space would you use? You might decide to combine any of the perspective techniques that are described in the next few pages. **In this studio lesson, you will draw a scene in linear perspective.** Pages 166 and 167 will show you how to do it. **Two-point perspective** is a method of creating the illusion of deep space on a flat surface. Artists who use two-point perspective start with a horizon line.

## Studio Background

**Postcard Tales**

Why do you send postcards to your friends? Postcards let you show your friends a picture of where you are. The pictures on postcards are usually drawings, paintings, or photographs. They often show a popular scene or historical sight from a particular region. Sometimes, they document important events and inventions, such as world's fairs and first airplane flights.

Postcards first became popular at the beginning of the twentieth century. They allowed people to send short messages to family and friends without great expense. Many people collect old postcards, because they like their beautiful colors, special details, and historic value. Public libraries often have collections of postcards that show what local buildings, streets, and neighborhoods looked like in the past. These postcards (Figs. 4–24 and 4–25) are from Kansas City, Missouri. They show views of the same area twenty-five years apart. Perhaps your local library or historical society has old postcards or photographs of your town that you can examine.

Fig. 4–22 **This artist created a drawing to help her remember a visit to Paris. Would this be a good image for a postcard? Why or why not?** Linnea Pergola, *Le Consulat*, Fall 1998. Pastel, 16" x 20" (40.6 x 50.8 cm). Courtesy of the artist.

---

## Teaching Options

### Resources

Teacher's Resource Binder
  Studio Master: 4.4
  Studio Reflection: 4.4
  A Closer Look: 4.4
  Find Out More: 4.4
Overhead Transparency 8
Slides 4f

### Meeting Individual Needs

**Focusing Ideas** Have students concentrate on only two of the perspective techniques, or have them focus on one technique at a time. Provide postcards to help students formulate ideas.

**Assistive Technology** Provide rulers with handles or cork backing so that students can control the lines.

They place two vanishing points on the horizon line. If the lines that mark certain edges of objects are extended, those that seem to recede into the distance would meet at one of the vanishing points. Other receding lines would meet at the other vanishing point.

Fig. 4–23 "This home is part of the Ringling Museum estate on Sarasota Bay. It is very beautiful, large, and elegant. The difficult thing about drawing this picture was all of the detail and perspective. It took a long time. I tried to show shading through lines." Harrison Henke, *Ca'd'Zan*, 1999.
Pen, ink, 12" x 18" (30.5 x 46 cm). Laurel Nokomis School, Nokomis, Florida.

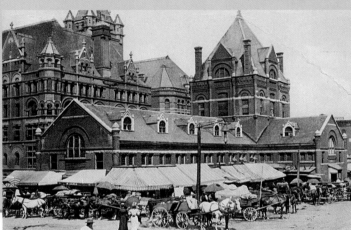

Fig. 4–24 Compare this postcard to the one shown in Fig. 4–25. What similarities do you see? What differences do you see? Why might these two postcards be valuable for recording the history of Kansas City? *Old City Hall and Police Station 4th and Main, Kansas City, MO*, 19th century.
Postcard. Special Collections, Kansas City Public Library, Kansas City, Missouri.

Fig. 4–25 If you were visiting Kansas City, Missouri, in 1913, why might you have chosen this postcard to send to friends? *The City Market, Kansas City, MO*, 1913.
Postcard. Special Collections, Kansas City Public Library, Kansas City, Missouri.

Connecting to Place

165

Supplies for Engage
• slides or photographs of your school or other local buildings

## Teach

### Engage
On the slides or photographs, point out lines that indicate linear perspective. Either tape one photograph to a large paper or project a slide onto paper. Use a marker to extend converging lines to their vanishing point. Challenge students to identify examples of linear perspective in the classroom walls, ceiling, floor, and furnishings.

### Using the Text
**Art Production** Have students read the text to discover ways of indicating depth. Challenge them to identify an example of each in images in the book.

### Using the Art
**Perception** Suggest to students that they use a ruler and their fingers to extend the parallel lines in the postcards (Figs. 4–24 and 4–25) to vanishing points. **Ask:** In addition to linear perspective, what other means help you "read" depth in these postcards?

**Art Criticism Ask:** What does each postcard say about the community? Why would these particular photographs be chosen to make into postcards?

### Teaching Through Inquiry
**Art Production** Project an artwork or display a photograph that is a good example of **two-point perspective**. Invite students to use markers to trace the receding parallel lines in one color, the horizontal lines in another, and the vertical lines in yet another. Have students do this with several artworks.

### More About...
Two-point perspective, also known as **angular perspective**, is a form of linear perspective. Artists use it when they depict a rectangular solid oriented so that only the set of lines defining one dimension is parallel to the vertical axis of the picture plane. Only two faces of the object show, and neither is parallel to the picture plane. Both of the visible surfaces recede at angles from the picture plane. The defining lines of the object's three dimensions converge on the horizon line, and have separate vanishing points.

### Using the Overhead
**Think It Through**

**Ideas** What does this image have to do with the theme of place? Where did the artist get his idea?

8

**Techniques** What perspective techniques did the artist use? How did he create an illusion of depth?

## 4.4 Studio Lesson
## Perspective in Pastels

## Studio Experience

1. To teach students to draw two-point perspective, hold up a shoe box and call attention to how it looks from above, from below, and at eye level.

2. Distribute pencils, rulers, and sketch paper. Guide students to draw a diagram similar to that on page 166: draw a horizon line; locate two vanishing points on the line; draw a vertical line for the front corner of the box; draw lines for the top and bottom of each side (continuing as dotted lines to the vanishing points); add the back edges.

3. Help students draw two more boxes, one from above and one from below the horizon line.

4. Distribute pastels and drawing paper. Discuss where students might locate the horizon line in their drawing. After they have sketched their scene, encourage them to double-check the perspective.

5. Students may preserve their drawing by spraying with fixative in a well-ventilated area or outdoors.

## Idea Generators

**Ask:** If you could send a picture of a special place to a friend, what view would you choose? How would you make the place look special? How would you show distance in the scene?

### Sketchbook Tip
Suggest to students that they find (in old magazines) pictures that are good examples of two-point perspective. Encourage students to paste them in their sketchbooks for future reference.

---

## Creating Your Postcard

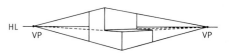

### You Will Need

- pencil
- ruler
- erasers
- large white drawing paper
- pastels

### Try This

1. Choose a special place that you would like to show on a postcard. The scene you choose should have objects in it that are up close and far away.

2. Decide whether you will draw the scene at eye level, or from above or below. Then figure out where you will place the horizon line (HL). Using a ruler, lightly draw the horizon line. Mark two vanishing points (VP) on it.

3. Sketch the shapes in your scene. The horizontal lines that recede into space should meet at a vanishing point. Fill the page with your drawing. What other methods of perspective can you use to create the illusion of space?

4. Add color to your drawing with pastels. Use bright bold colors for things that are up close. Use light dull colors to show things that are far away. Build up colors gradually and blend them with a tissue or cotton swab.

Fig. 4–26 "I was looking through pictures of historical buildings, and the Carnegie Library seemed to stand out, so I chose to draw it. It was easy to do a basic sketch or outline of the library. The difficult part was painting the palm leaves." Kara Nickell, *Carnegie Library*, 1999. Marker, 12" x 18" (30.5 x 46 cm). Laurel Nokomis School, Nokomis, Florida.

---

## Teaching Options

### Teaching Through Inquiry

**Art Production** Have students work together to organize a **postcard art exchange**—on the theme of "The Place Where I Live"—with another school, perhaps one in a foreign country.

## Check Your Work

What special qualities of your place did you show? How did you use two-point perspective to show space? What other perspective techniques did you use?

### Sketchbook Connection

Choose a simple object to draw. Use the object to create an example of each of the perspective techniques described in this lesson. Practice drawing some boxlike forms in linear perspective. Combine them with other forms such as cylinders.

### Computer Option

Use a drawing program to create the skeleton of a landscape in one- or two-point perspective. Use lines and shapes to create a framework of buildings, roads, and so on. Group and copy all the elements. Copy and paste the group in a paint program. Paint over the outlines and fill in shapes with color. Consider the use of color and other elements to enhance depth. Think of ways to make your image look like a painting.

## Perspective Techniques

**Overlap:** Draw near objects on top of or partly covering distant objects.

**Placement:** Place distant objects near the top of the picture. Place near objects at the bottom of the picture.

**Linear perspective:** Use the rules of linear perspective to draw objects that seem to disappear into the distance.

**Focus:** Draw sharper edges and more details on close objects. Draw distant objects with few details.

**Size:** Draw objects that are closer to the viewer larger than those that are farther away.

**Color and value:** Use light shades and dull colors to suggest distant features. Use bright colors in the foreground.

**Foreshortening:** Draw the nearest part of a form larger than the more distant parts.

## Extend

Assign students to draw a postcard scene, using only methods of creating depth that they did *not* use in their first drawing.

### Computer Option

Students may use the drawing programs ClarisDraw, AppleWorks, or Microsoft Works. Guide students in creating shadows and using color appropriately to enhance the feeling of depth in the painting. Students may paste the framework group in Apple-Works paint mode, and they may also use paint programs—Painter (MetaCreations), Photoshop (Adobe), PhotoDeluxe (Adobe), Paint Shop Pro (Windows only), Bryce 3D (MetaCreations)—that have layers to separate the elements.

## Assess

### Check Your Work

Create a display of students' work. Encourage students to explain techniques they used to indicate space.

## Close

Discuss reasons why artists might decide to create a sense of depth when showing a place in their work. **Ask:** Would an artist drawing a place to be printed as a postcard care more, or less, about showing depth than an artist who was drawing a picture of a place to display locally?

## More About...

**Pastels** are colored crayons made of pigment mixed with just enough binder, such as tragacanth, to hold it together.

Artists use soft pastels for drawing, and apply the color directly to the paper by hand. An artist may sometimes blend colors by rubbing them with fingers or a paper stump. Harder pastels, which can be sharpened to a point, are used for drawing fine details.

Since prehistoric times, artists have used dry lumps of colored materials for drawing, but pastel drawing as we know it was first made popular in the eighteenth century by the Italian artist Rosalba Carriera. Other artists who are well known for their work in pastels are Maurice Quentin de la Tour, Jean-Baptiste-Simeon Chardin, and Edgar Degas.

## Assessment Options

**Teacher** Have students do research on the history of postcards and then create a booklet for children on the history of postcards. For a title, suggest *Wish You Were Here*.

**Teacher** Have students create a poster of various ways to create the illusion of space and distance in a drawing.

**Self** Ask students to use the questions in Check Your Work as a basis for developing criteria for their work. Have each student use the criteria to judge his or her own work.

## Careers

Show and discuss pictures of landscaping and gardens. Describe the work of landscape architects: design of outdoor spaces, preparation of site plans and models, selection of plantings, and supervision and implementation for many kinds of clients. Have students work in small groups to evaluate the landscaping of the school grounds and then to develop a design for new landscaping. Have each group create both a site plan and an elevation (a straight-on view of the school and grounds showing no sides or perspective) drawn to scale. Have groups present their finished proposals to the principal.

## Social Studies

Have students conduct research to discover the part played in westward expansion by the Fred Harvey Company and artists Thomas Moran, Albert Bierstadt, Oscar E. Berninghaus, Bert Geer Phillips, and Ernest L. Blumenschein.

## Language Arts

Prepare a Venn diagram for use as an overhead transparency (two overlapping circles that fill an 8½" x 11" paper). Have students locate two landscapes. Display the Venn diagram on an overhead projector, and explain that each circle represents one of the artworks. Tell students that similarities between the two will

# Connect to...

## Careers

What buildings in your community have beautiful grounds or gardens? Do you ever notice people working in these landscapes? Though many people like to do their own gardening at home, large institutions—such as office and apartment complexes, public and governmental agencies, banks, schools, and malls—employ **landscape architects** to design the surrounding outdoor space. Landscape architects prepare site plans and models, select plantings, and supervise implementation for such clients as building contractors, architectural firms, developers, and homeowners. These architects must be knowledgeable about art and design, botany and ecology, climate and weather, and architecture and building codes. What evidence can you find in your community of a landscape architect's work?

Fig. 4–27 **Designers, decorators, and artists often look in books for ideas, information, and inspiration. This nineteenth-century book gave designers ideas about landscape architecture, a popular art form at the time.** *An illustrated page from the* Fragments on the Theory and Practice of Landscape Gardening, *1816.*
Photo by Philip de Bay. ©Historical Picture Archive/CORBIS.

## Daily Life

Is there a particular place that your family thinks of as home? It might be your grandparents' apartment or a piece of land that has been in your family for generations. In simpler times, families stayed closer together and shared a sense of place—**a sense of home**. In our increasingly mobile society, family members are now more likely to be separated by distance and may not be able to see one another often. Is there a place to which you feel strongly connected? A place that feels like home? If so, why are you drawn to it?

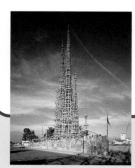

Fig. 4–28 **Sometimes an artwork inspires a sense of community. This group of outdoor sculptures has come to symbolize the Los Angeles neighborhood of Watts where it was built. When the structures were in danger of being torn down, the community worked to stop the demolition.** Simon Rodia, *Watts Towers*, 1921–54.
Photograph ©Marvin Rand.

**Internet Connection**
For more activities related to this chapter, go to the Davis website at **www.davis-art.com**.

## Teaching Options

### Resources

Teacher's Resource Binder
Using the Web
Interview with an Artist
Teacher Letter

### Video Connection

Show the Davis art careers video to give students a real-life look at the career highlighted above.

# Other Subjects

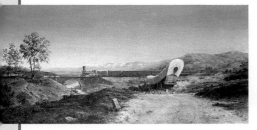

## Social Studies

Do you know what **Manifest Destiny** was? Manifest Destiny was a nineteenth-century political doctrine that promoted the belief that it was America's national destiny to spread over the entire continent, to control and populate the country while pushing aside the Native Americans and anyone else who got in the way. A number of artists played a role in westward expansion, by painting stereotypical images of Native Americans and other western subjects at the request of the railroads. The paintings were printed as posters and used back East to promote tourism—and, thereby, the use of trains. What ideas about Native Americans do you think these images promoted?

Fig. 4–29 This artwork, painted in 1860, calls attention to the new technology of the railroad. How has the artist contrasted the uncomfortable, dusty ride of the covered wagon with the smooth travel of the train? Thomas Otter, *On the Road*, 1860.
Oil on canvas, 22" x 45 ³/₈" (55.8 x 115.3 cm). The Nelson-Atkins Museum of Art, Kansas City, Missouri (Purchase: Nelson Trust).

## Language Arts

Why, do you think, are **landscapes** so popular? Are you drawn to these art forms? Look through this book to find landscapes that come from different times and cultures. Take a class vote for two of the landscapes. What similarities and differences can you identify? Are the two works more alike than they are different? Or vice versa? Which do you prefer? Why? How could you persuade someone else to agree with you?

## Science

You may recall from science class that **biomes** are major ecological communities of plants and animals. The average rainfall and temperature determine the different biomes. There are eight terrestrial biomes: tundra, taiga/evergreen coniferous forest, temperate deciduous forest, temperate grasslands/prairie, desert, dry scrubland/chapparal, tropical grassland/savanna, and rain forest. Can you identify the biome for where you live?

# Other Arts

## Music

The identity of a culture is expressed through its music—its rhythms, melodies, and vocal styles. Certain instruments identify regions: Caribbean steel drums, Scottish and Irish bagpipes, Japanese bamboo flutes.

Beginning in the nineteenth century, many composers were inspired by nationalism, a sense of national identity, to write music that reflected their particular culture. Aaron Copland (1900–90) composed distinctively "American" music. Heitor Villa-Lobos

Fig. 4–30 Aaron Copland was one of the great American composers. He was also wrote several books on music and music appreciation. Conductor Aaron Copland.
©Bettmann/CORBIS.

(1887–1959) wrote music infused with the folk and popular music of his native Brazil.

be written in the area where the circles overlap; the differences between the two will be written in the area of each circle that is not overlapping the other. Ask students to suggest similarities, and write their comments, if justifiable, in the center section. Move to the differences between the two works, encouraging elaboration of vocabulary as the discussion proceeds. As an extension, ask students to use the vocabulary developed in the diagram as the basis for a comparison-and-contrast essay.

## Science

Have students determine the biomes depicted in the this book's landscape paintings. Then ask students each to chose a biome as the subject of a landscape painting.

## Other Arts

Have students listen to Aaron Copland's "Hoedown," from *Rodeo*. **Ask:** How does the music create a sense of the energy and excitement that represents many people's ideal view of the West?

Play Villa-Lobos's "The Little Train of the Caipira" (also called "Toccata"), the fourth movement of his orchestral suite *Bachianas brasileiras,* no. 2. Note the use of Brazilian percussion instruments, the dance rhythms, and folk-like melody that convey images of farmworkers (caipira) traveling by train to the next harvest.

Connecting to Place

169

# Internet Resources

### Getty Museum
http://www.getty.edu/museum/
This site offers the museum's collections and history, an architecture tour of the Getty Center, and more.

### Japan Ukiyo-e Museum
http://www.cjn.or.jp/ukiyo-e/index.html
This museum site lets you view works not only by Hokusai and Hiroshige, but also by other ukiyo-e artists.

### Sydney Opera House
http://www.soh.nsw.gov.au/
This address lets you view the Australian international cultural landmark designed for its harbor setting. Use *The Past* to explore the planning and construction details.

# Community Involvement

Invite a member of the area's historical society to talk about the community's history and to work with students to design small-scale three-dimensional models of old buildings as they might have looked when they were new. Display the models in a public place.

# Interdisciplinary Planning

Have students use a graphic organizer, such as the Analogy Map in the Teacher's Resource Binder, for charting similarities and differences between familiar and new concepts that cross disciplines.

## Talking About Student Art

Identify a student artwork to discuss. **Ask:** Who has an interpretation statement that fits the artwork? Remind students to give reasons and note that there can be more than one plausible interpretation for a particular artwork.

## Portfolio Tip

When photographing student art for their portfolio, use a single-lens reflex camera whenever possible. Set the work against a plain background. If photographing outdoors, use 64 or 100-ASA film. For indoor shots, use 400-ASA film without a flash.

## Sketchbook Tips

• Encourage students to think of gateways in unique ways and to label their drawing with a word such as *opportunity, freedom, inspiration, success,* and *happiness.*

• Make a series of sketches for the design of an aquarium space, including fish and the placement of rocks, plants, and other features.

# Portfolio

"My great-aunt lives in Denver, Colorado, and we got to visit there. I always think of the mountains and how pretty they are."
**Jenna Skophammer**

Fig. 4–31 **How has this artist used color and texture to create a mood?** Jenna Skophammer, *Denver, Colorado, View,* 1999. Oil pastel, 12" x 18" (30.5 x 46 cm). Manson Northwest Webster, Barnum, Iowa.

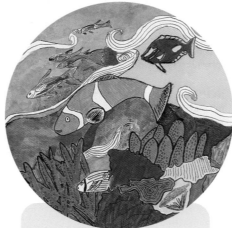

Fig. 4–32 Keith Bush, *Deep Blue Sea,* 2000. Markers, 16" diam. (40.5 cm). Sarasota Middle School, Sarasota, Florida.

"I was thinking about tropical fish. I thought of a clown fish—it's bright and looks cool. What I like most about my art is it is colorful and almost real." **Keith Bush**

"My teacher said that this would be a tough picture to do, but I knew that I could make it. The shading is the best part because it makes the house look realistic." **Marti Corn**

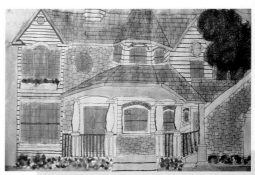

Fig. 4–33 **By observing detail, an artist becomes familiar with a place.** Marti Corn, *Architectural Creativity,* 1999. Watercolor, marker, 18" x 24" (46 x 61 cm). Laurel Nokomis School, Nokomis, Florida.

**CD-ROM Connection**
To see more student art, check out the Community Connection Student Gallery.

### Resources

Teacher's Resource Binder
Chapter Review 4
Portfolio Tips
Write About Art
Understanding Your Artistic Process
Analyzing Your Studio Work

### Advocacy

Put together an attractive booklet of students' writings about art. Make copies to distribute to all school-board members and school administrators.

# Chapter 4 Review

### Recall

Identify two artists whose artworks show the special features of community places.

### Understand

How can a photograph that documents the way a place looks also send a message about its special features? *(See example below.)*

### Apply

State at least one reason you could offer to try to convince community members to preserve the old buildings in your town center.

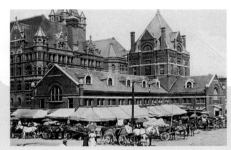

Page 165

### Analyze

Select an artwork from this chapter and tell how art elements are used to tell about the special characteristics of a place. You might mention the use of color, line, shape, value, texture, form, and/or space.

### Synthesize

Imagine that you are a member of the community group asked to select from proposals for a gateway to your town center. What criteria would you use to select the gateway design?

### Evaluate

Select an artwork from this chapter and offer at least three reasons why you believe it is successful in conveying the special features of a place. Be sure to state reasons that are based on your careful use of your skills in describing, analyzing, and interpreting art.

### For Your Portfolio

Select an artwork in this book that sends a clear message about place. Select one element from that artwork and incorporate it into your own artwork of a special place. Place this work in your portfolio. Include a photocopy of the artwork that inspired you and attach a short statement about why this detail appealed to you and how in contributed to your own artwork.

### For Your Sketchbook

Fill a page with thumbnail sketches of gateways to special places and actual scenes that can be associated with human aspirations, such as opportunity, success, freedom, and the like.

### Family Involvement

Invite family members to assist you in collecting criticism and reviews of local exhibits, interviews with artists, articles about artists, and articles related to art history, architectural restorations, and so on.

Connecting to Place

171

---

## Chapter 4 Review Answers

### Recall

Answers will vary.

### Understand

Much depends on the choice of subject matter and the way it is shown. For example, the photographer can choose a close-up or faraway view, or a particular angle, to highlight certain features.

### Apply

Answers will vary. Students might say that older buildings can tell about a community's past or that the town center is what people think about when they remember a place.

### Analyze

Answers will vary. Look for appropriate discussion of the use of art elements to tell about the special features of the place.

### Synthesize

Answers will vary. Students might mention that a gateway should tell something about a community's past or what the community is known for; or that it should be something that all community members will find educational, exciting, or fun.

### Evaluate

Answers will vary. Make sure that students state reasons based on a description, analysis, and interpretation of the artwork.

### Reteach

Have students design postcards of special places in the community. Encourage students to present the designs to community leaders or to the chamber of commerce, and to propose ways the designs could be reproduced and sold for community fundraising.

Summarize that art is an important way to commemorate and to call attention to special community places.

# Chapter Organizer

## Chapter Focus

**Chapter 5
Responding
to Nature**
Chapter 5 Overview
pages 172–173

- **Core** Artists serve communities by pointing to nature's power and beauty, through their investigations.
- **5.1** Responding to Beauty: 1860–1900
- **5.2** Graphic Design
- **5.3** Finding Beauty in Northern Light: Scandinavian Art
- **5.4** A Relief Sculpture

## Chapter National Standards

1 Understand media, techniques, and processes.
2 Use knowledge of structures and functions.
3 Choose and evaluate subject matter, symbols, and ideas.
4 Understand arts in relation to history and cultures.
5 Assess own and others' work.

---

| 9 weeks | 18 weeks | 36 weeks | | Objectives | National Standards |
|---|---|---|---|---|---|
| 4 | 4 | 4 | **Core Lesson Natural Wonders** page 174 Pacing: Four 45-minute periods | • Identify at least two general kinds of messages that artworks send about nature. <br> • Use examples to explain how artists investigate nature. | **4c** Analyze, demonstrate how time and place influence visual characteristics. <br> **5a** Compare multiple purposes for creating art. <br> **6b** Describe ways other disciplines are interrelated to art. |
| | | | **Core Studio Stamps Inspired by Nature** page 178 | • Design a set of postage stamps about nature. | **3a** Integrate visual, spatial, temporal concepts with content. <br> **3b** Use subjects, themes, symbols that communicate meaning. |

### Objectives / National Standards

| | | 3 | **Art History Lesson 5.1 Responding to Beauty** page 180 Pacing: Three to four 45-minute class periods | • Explain people's interest in paintings of the natural environment. <br> • Describe features and characteristics of the Art Nouveau style. <br> • Select and combine media to capture the beauty of the natural world. | **2c** Select, use structures, functions. <br> **4c** Analyze, demonstrate how time and place influence visual characteristics. |
|---|---|---|---|---|---|
| | | | **Studio Connection** page 182 | • Create a genre scene by using drawing, painting, and collage. | **1b** Use media/techniques/processes to communicate experiences, ideas. <br> **3a** Integrate visual, spatial, temporal concepts with content. |

### Objectives / National Standards

| | | 2 | **Forms and Media Lesson 5.2 Graphic Design** page 184 Pacing: Two 45-minute periods | • Explain why images, colors, and lettering are important to graphic design. | **2c** Select, use structures, functions. |
|---|---|---|---|---|---|
| | | | **Studio Connection** page 185 | • Create an illustrated version of a word that represents something in nature. | **3b** Use subjects, themes, symbols that communicate meaning. |

## Featured Artists

Kenojuak Ashevak
Grafton Tyler Brown
Agnes Denes
Maria Oakey Dewing
Jim Frazier
Martin Johnson Heade
Sven Hornell
Margareta Jacobson
Fitz Hugh Lane

Edvard Munch
Louis Sullivan
Louis Comfort Tiffany
Gunnar Gunnarson
    Vennerberg
Joe Walters
Anders Zorn

## Chapter Vocabulary

Art Nouveau
graphic design
graphic designer
Impressionist

relief sculpture
scientific record

## Teaching Options

Teaching Through Inquiry
More About…Martin Johnson Heade
Using the Large Reproduction
Using the Overhead
Meeting Individual Needs
More About…*Tree Mountain*

## Technology

CD-ROM Connection
  e-Gallery

## Resources

Teacher's Resource Binder
  Thoughts About Art:
    5 Core
  A Closer Look: 5 Core
  Find Out More: 5 Core
  Studio Master: 5 Core
  Assessment Master:
    5 Core

Large Reproduction 9
Overhead Transparency 10
Slides 5a, 5b, 5c

---

Meeting Individual Needs
Teaching Through Inquiry
More About…Postage stamps
Assessment Options

CD-ROM Connection
  Student Gallery

Teacher's Resource Binder
  Studio Reflection: 5 Core

## Teaching Options

Meeting Individual Needs
Teaching Through Inquiry
More About…Louis Sullivan
Using the Overhead

## Technology

CD-ROM Connection
  e-Gallery

## Resources

Teacher's Resource Binder
  Names to Know: 5.1
  A Closer Look: 5.1
  Map: 5.1
  Find Out More: 5.1
  Assessment Master: 5.1

Overhead Transparency 9
Slides 5d

---

Teaching Through Inquiry
More About…Louis Comfort Tiffany
More About…Art Nouveau
Assessment Options

CD-ROM Connection
  Student Gallery

Teacher's Resource Binder
  Check Your Work: 5.1

## Teaching Options

Teaching Through Inquiry
Using the Overhead
Assessment Options

## Technology

CD-ROM Connection
  e-Gallery

## Resources

Teacher's Resource Binder
  Finder Cards: 5.2
  A Closer Look: 5.2
  Find Out More: 5.2
  Assessment Master: 5.2

Overhead Transparency 9

---

CD-ROM Connection
  Student Gallery

Teacher's Resource Binder
  Check Your Work: 5.2

# Chapter Organizer continued

| 9 weeks | 18 weeks | 36 weeks | | | |
|---|---|---|---|---|---|
| | | 3 | **Global View Lesson 5.3 Scandinavian Art** page 186 Pacing: Three 45-minute class periods | **Objectives** <br> • Describe qualities and characteristics of Scandinavian art. <br> • Explain the importance of the Arts and Crafts Movement in Scandinavia. | **National Standards** <br> **4a** Compare artworks of various eras, cultures. <br> **4c** Analyze, demonstrate how time and place influence visual characteristics. |
| | | | **Studio Connection** page 188 | • Use impressions of natural forms to create a multicolor monoprint. | **1b** Use media/techniques/processes to communicate experiences, ideas. |
| | 2 | 2 | **Studio Lesson 5.4 A Relief Sculpture** page 190 Pacing: Two 45-minute class periods | **Objectives** <br> • Explain the function and history of ceramic tiles in America. <br> • Understand the process of creating a ceramic tile. <br> • Use a variety of textures to create a relief sculpture describing a natural environment. | **National Standards** <br> **1b** Use media/techniques/processes to communicate experiences, ideas. <br> **2a** Generalize about structures, functions. <br> **3a** Integrate visual, spatial, temporal concepts with content. <br> **4c** Analyze, demonstrate how time and place influence visual characteristics. |
| • | • | • | **Connect to...** page 194 | **Objectives** <br> • Identify and understand ways other disciplines are connected to and informed by the visual arts. <br> • Understand a visual arts career and how it relates to chapter content. | **National Standards** <br> **6** Make connections between disciplines. |
| • | • | • | **Portfolio/Review** page 196 | **Objectives** <br> • Learn to look at and comment respectfully on artworks by peers. <br> • Demonstrate understanding of chapter content. | **National Standards** <br> **5** Assess own and others' work. |

2 Lesson of your choice

## Teaching Options

Meeting Individual Needs
Teaching Through Inquiry
More About...Edvard Munch
Using the Large Reproduction

## Technology

CD-ROM Connection
  e-Gallery

## Resources

Teacher's Resource Binder
  A Closer Look: 5.3
  Map: 5.3
  Find Out More: 5.3
  Assessment Master: 5.3

Large Reproduction 10
Slides 5e

---

Teaching Through Inquiry
More About...Arts and Crafts Movement
More About...Stylized plant motifs
Assessment Options

CD-ROM Connection
  Student Gallery

Teacher's Resource Binder
  Check Your Work: 5.3

## Teaching Options

Meeting Individual Needs
Teaching Through Inquiry
More About...American Encaustic Tiling Co.
Using the Overhead
More About...Ceramic tile companies
Assessment Options

## Technology

CD-ROM Connection
  Student Gallery
Computer Option

## Resources

Teacher's Resource Binder
  Studio Master: 5.4
  Studio Reflection: 5.4
  A Closer Look: 5.4
  Find Out More: 5.4

Large Reproduction 9
Overhead Transparency 10
Slides 5f

## Teaching Options

Community Involvement
Interdisciplinary Tip

## Technology

Internet Resources
Video Connection
CD-ROM Connection
  e-Gallery

## Resources

Teacher's Resource Binder
  Using the Web
  Interview with an Artist
  Teacher Letter

## Teaching Options

Advocacy
Family Involvement

## Technology

CD-ROM Connection
  Student Gallery

## Resources

Teacher's Resource Binder
  Chapter Review 5
  Portfolio tips
  Write About Art
  Understanding Your Artistic Process
  Analyzing Your Studio Work

## Chapter Overview

### Theme

People in communities are an inseparable part of nature. Art can show communities how they are connected to nature's beauty and power.

### Featured Artists

Kenojuak Ashevak
Grafton Tyler Brown
Agnes Denes
Maria Oakey Dewing
Jim Frazier
Martin Johnson Heade
Sven Hornell
Margareta Jacobson
Fitz Hugh Lane
Edvard Munch
Louis Sullivan
Louis Comfort Tiffany
Gunnar Gunnarson Vennerberg
Joe Walters
Anders Zorn

### Chapter Focus

This chapter features ways that artists serve communities by pointing to nature's power and beauty through their scientific and fanciful investigations. Students see how artists of the late-nineteenth century investigated nature and how those in the Tiffany studio incorporated natural motifs in their designs. The role of graphic design within communities is explored, and a look at Scandinavian art reveals its many references to nature. Students use what they have learned to create a relief sculpture that shows a natural environment.

# 5 Responding to Nature

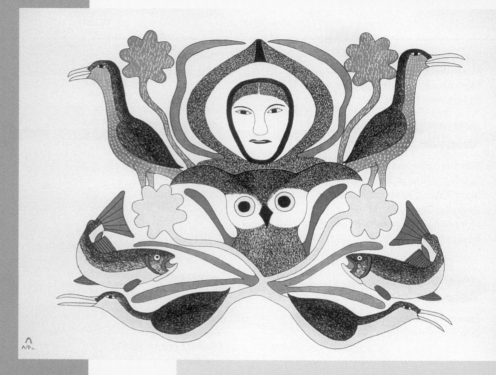

Fig. 5–1 Like other Inuit people, Kenojuak has seen many changes in her community because of the expanding modern world. As in other parts of the world, the environment in the northern arctic is in danger. What message about nature does her artwork convey? Kenojuak Ashevak, *The World Around Me*, 1980. Lithograph, 22 1/4" x 31 1/8" (56.5 x 79 cm). © By permission of the West Baffin Eskimo Cooperative Lmtd, Cape Dorset, Numavut, Dorset Fine Arts, Indian and Northern Affairs Canada.

172

## National Standards Chapter 5 Content Standards

1. Understand media, techniques, and processes.
2. Use knowledge of structures and functions.
3. Choose and evaluate subject matter, symbols, and ideas.
4. Understand arts in relation to history and cultures.
5. Assess own and others' work.

**Teaching Options**

### Teaching Through Inquiry

**Art Criticism** Have students work in groups to consider Fig. 5–1 and **select a site** in the school or local community where they would like to see the artwork displayed. Have each group write a proposal that describes the artwork and explains why its message is appropriate for the site. Ask groups to share the proposals with the entire class, and to comment on the persuasiveness of each proposal.

### More About...

**Kenojuak Ashevak** (b. 1937) follows the Inuit tradition of depicting the spirits of the earth's resources rather than describing recognizable scenes. Inspired by nature, she uses her imagination to embellish her images of birds, fish, and other natural subjects. Kenojuak knows nature well: as a teenager, she drove dog teams; and throughout her life she has enjoyed fishing.

- How are communities affected by nature and its beauty?
- How does art call attention to natural beauty in the world?

Think about the ways nature affects your life. How does the weather influence your activities, the clothes you wear, and the food you eat? How do you relate to wild animals that live in your area? If you think about it, you'll realize that we are connected to nature in many ways. Throughout history, people around the world have made art to show their connection to nature. In artworks dating from the earliest times, nature is seen as powerful and, at times, even ruthless. Artists have also created artworks that show nature as a gentle and nurturing force. They have long used plants and animals as the main subjects of their work and as inspiration for decoration and design.

In *The World Around Me* (Fig. 5–1), Kenojuak Ashevak, an Inuit woman living in Cape Dorset in the Canadian arctic, shows an Inuit person surrounded by birds, fish, and trees. They symbolize this culture's closeness to nature. The Inuit people live in a harsh, frozen land. Animals are very important for their survival. People who live in places like Cape Dorset understand how much people depend on nature.

Today, people all over the world still witness nature's power and beauty in events such as earthquakes, hurricanes, and blizzards. Artworks send messages about nature's power and beauty. They tell us how nature affects our lives.

### What's Ahead
- **Core Lesson** Learn how art helps people understand the power and beauty of nature.
- **5.1 Art History Lesson** Discover how nature inspired artists of the late nineteenth century.
- **5.2 Forms and Media Lesson** Explore ways that the work of graphic designers can send messages about nature.
- **5.3 Global View Lesson** Learn how Scandinavian art reflects these communities' connection with nature.
- **5.4 Studio Lesson** Make a relief sculpture that describes a natural environment.

### Words to Know
| | |
|---|---|
| scientific record | Art Nouveau |
| graphic designer | graphic design |
| Impressionist | relief sculpture |

Responding to Nature

173

## Chapter Warm-up
**Ask:** How is our community connected to nature? What do you see each day that is natural, not human-made? *(ocean, sky, birds, plants, animals, rocks, shells)* Lead students in imagining ways to draw the community's attention to local natural beauty.

## Using the Text
Have students read the text to learn how an Inuit artist drew her world. **Ask:** Why would communities such as those on Cape Dorset be especially sensitive to their natural environment? *(People are dependent on nature for their survival, but the climate is harsh and the area is sparsely populated.)*

## Using the Art
**Perception Ask:** What nature objects are in *The World Around Me*? *(birds, fish, owl)* What textures are in this art? Is it exactly symmetrical? Explain that Kenojuak Ashevak drew this with pencil, and then traced over the lines with marker. Challenge students to find slight discrepancies between the two sides.

## Extend
Encourage students to research other examples of Inuit and Pacific Northwest Native American art that features animals. Guide them in drawing a design of stylized plants and animals from their own community.

---

### Graphic Organizer
### Chapter 5

**5.1 Art History Lesson**
Responding to Beauty: 1860–1900
page 180

**5.2 Forms and Media Lesson**
Graphic Design
page 184

**Core Lesson**
Natural Wonders

**Core Studio**
Stamps Inspired by Nature
page 178

**5.3 Global View Lesson**
Finding Beauty in Northern Light: Scandinavian Art
page 186

**5.4 Studio Lesson**
A Relief Sculpture
page 190

### CD-ROM Connection

For more images relating to this theme, see the Community Connection CD-ROM.

# Natural Wonders

## Prepare

### Pacing

Four 45-minute periods: one to consider art and text; one to draw; two to paint

### Objectives

- Identify at least two general kinds of messages that artworks send about nature.
- Use examples to explain how artists investigate nature.
- Design a set of postage stamps about nature.

### Vocabulary

**scientific record** Accurate and highly detailed artworks or written works, used to help document or classify species.

**graphic designer** An artist who designs such things as packages, wrapping papers, books, posters, and greeting cards.

## Teach

### Engage

Ask volunteers to describe times that they were frightened by nature. Lead a class discussion about major storms, earthquakes, floods, or droughts. Remind students that people in ancient times associated these natural events with divine forces.

## Nature's Power

Does nature sometimes frighten you? Even though we understand much about how nature works, nature's fury can still frighten people or spark their curiosity. Some people brave wind and rain to watch oceans launch huge waves over sea walls. Others tremble under the covers at night during thunderstorms.

Artworks from the past show the awesome power of nature. Ancient communities tried to understand tornadoes, volcanoes, and tidal waves through stories about gods and goddesses. Gods and goddesses often appear in artworks with the sun, moon, and other natural elements. Many artworks show animals with magical powers. For example, the Celtic Cernunnos (Fig. 5–2) is a mythical animal who could change its form. Why do you think this figure is called the stag god?

## Investigating Nature

Have you ever watched a line of ants and wondered where they were going? Or have you ever wondered why moths fly around a bright light at night? Can you name the different kinds of clouds you see or the different kinds of trees and flowers in your yard or neighborhood? To learn about nature, you must look carefully and observe its characteristics and habits. Because people tend to be curious, they have looked carefully at natural things and tried to understand how nature works.

Artists help people investigate nature in different ways. People often ask artists to look closely at nature and make accurate **scientific records** of the plants and animals in their community. Other artists observe nature, then express their own ideas and feelings about it in their artworks. Which of the artworks in Figs. 5–3 and 5–4 is an example of scientific investigation? Which expresses more creative ideas?

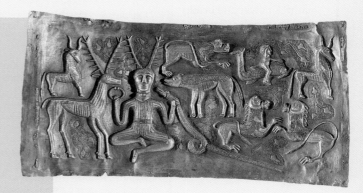

Fig. 5–2 Cernunnos, or The Horned One, was an ancient god of the Celtic people. He had ears and antlers of a stag and was thought to be lord of the beasts. He also could change into the form of a snake, wolf, or stag. Celtic, Gundestrup cauldron, inner plate: *Cerrunnos holding a snake and a torque, surrounded by animals*, 1st century BC. Embossed silver, gilded. National Museum, Copenhagen, Denmark. Erich Lessing / Art Resource, NY.

174

## Teaching Options

### Resources

Teacher's Resource Binder
- Thoughts About Art: 5 Core
- A Closer Look: 5 Core
- Find Out More: 5 Core
- Studio Master: 5 Core
- Studio Reflection: 5 Core
- Assessment Master: 5 Core

Large Reproduction 9

Overhead Transparency 10

Slides 5a, 5b, 5c

### Teaching Through Inquiry

**Aesthetics** Provide students with information about Martin Johnson Heade, and ask them to consider it as they address this question: Should **Heade's paintings** be used in a textbook on hummingbirds and orchids? Have students work in groups to complete a two-column chart: in one column, writing reasons for using the paintings; in the other, reasons for not using them. Have groups compare their responses.

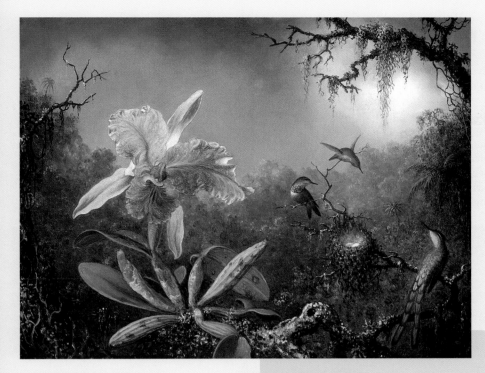

Fig. 5–3 Why might some people compare the quality of this painting to that of a photograph? How is the painting different from a photograph? Martin Johnson Heade, *Cattleya Orchid and Three Brazilian Hummingbirds*, 1871. Oil on wood, 13 3/4" x 18" (34.8 x 45.6 cm). Gift of The Morris and Gwendolyn Cafritz Foundation, © 1999 Board of Trustees, National Gallery of Art, Washington, DC.

Fig. 5–4 Would you consider this artwork to be an example of a scientific record or an artistic expression of nature? Why? Joe Walters, *Vignette #6* (butterfly, songbird), 1999. Aluminum, mesh, polymer clay, resin, glue, sand, paint, 32" x 32" x 10" (81.3 x 81.3 x 25.4 cm). Courtesy Bernice Steinbaum Gallery, Miami, FL.

Responding to Nature

175

## Using the Text

**Art History** Have students read Nature's Power to understand how ancient cultures represented nature in art. **Ask:** What human traits are often represented by particular animals or objects in nature? *(bravery = lion; love = rose)*

**Aesthetics** Have students read Investigating Nature to learn of an important link between art and science. Discuss students' answers to the questions at the end of the section.

## Using the Art

**Perception** Have students describe the habitat and weather in Heade's painting. **Ask:** How did Heade emphasize the foreground? *(by enlarging the orchid, using warm colors against a cool background)*

**Art Criticism** Have students list the animals in Walters's sculpture. **Ask:** How did Walters join forms to create a unified design?

## Critical Thinking

Have students research the sketchbooks of Leonardo da Vinci to learn why he is considered a scientist. Have students present a page from his sketchbooks to the rest of the class, explaining how its contents combine science and art. **Ask:** What skills must both scientists and artists possess?

## Journal Connection

Instruct students to keep a diary, over the course of a week, of what they observe as links between science and art. Ask students to write about the ways that art can make science more meaningful, and vice versa.

---

## More About...

**Martin Johnson Heade** (1819–1904) is known for his careful observations of nature, especially in his paintings of hummingbirds and orchids. To learn about the different species of these birds and flowers, Heade visited Latin America. He brought back hummingbird skins so that he could observe and then accurately depict the range of intense colors. Despite this attention to detail, Heade sometimes depicted, in one painting, pairs of birds that didn't share the same habitat.

## Using the Large Reproduction

### Talk It Over

**Describe** What materials were used in these gates?

**Analyze** How are the forms arranged?

**Interpret** In what ways do these gates suggest forms found in nature?

**Judge** Why might some people say that this is a beautiful gate? What do you think?

## Using the Overhead

### Think It Through

**Ideas** From where, do you think, did the artist get ideas for this mask?

**Materials** What materials did he use?

**Techniques** How did he put these materials together?

**Audience** How might this mask have been used?

10

## Using the Text

**Art History** Direct students to read Natural Beauty to begin thinking about how artists are inspired by nature. **Ask:** How did Fitz Hugh Lane emphasize the beauty of nature in *Brace's Rock*?

**Art Criticism** After students have read A Message to Care, challenge them to explain how artists can help preserve the environment. *(They direct people's attention to the balance of nature.)* Discuss how Agnes Denes's *Tree Mountain* focuses attention on natural preservation.

## Using the Art

**Art Criticism Ask:** Where is the focal point in Lane's painting? How did he emphasize this center of interest? What is the message? What is the mood of this location? How did Denes create rhythm and pattern? *(by an even repetition of the trees)*

## Critical Thinking

**Ask:** Is Denes's *Tree Mountain* art? Have students debate the work's aesthetics. Encourage them to explain what they believe constitutes a work of art.

## Natural Beauty

Even though people have feared the power of nature, they have also enjoyed the natural world for its beauty. They have looked for places in nature for quiet thought. Delicate flowers, brightly colored birds, and magnificent scenery have given people great pleasure for thousands of years. People have been inspired by the beauty of nature to write poetry and to capture views in paintings and other artworks.

Many artists find beauty in the natural environment near their homes. The seascape in Fig. 5–5 is by artist Fitz Hugh Lane. It shows a view of nature from a seaside community on Cape Ann in Massachusetts. In *Brace's Rock, Brace's Cove*, Lane captured the peaceful beauty of the rugged New England coastline where he lived.

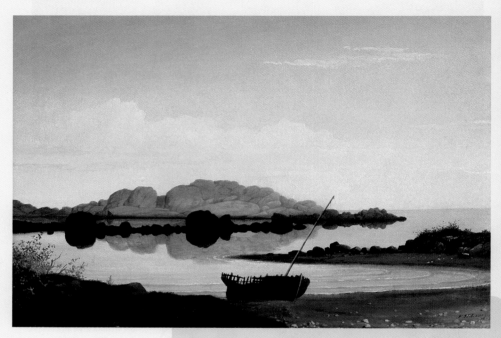

Fig. 5–5 Many people go to places like the one shown here to sit quietly and enjoy the beauty of nature. Where would you go to enjoy nature? How would you show that place in a painting? Fitz Hugh Lane, *Brace's Rock, Brace's Cove*, 1864. Oil on canvas, 10 1/4" x 15 1/4" (26 x 38.7 cm). Terra Foundation for the Arts, Daniel J. Terra Collection, 1999.83, Photograph courtesy Terra Museum of American Art, Chicago.

## Teaching Options

### Meeting Individual Needs

**Multiple Intelligences/Intrapersonal** Ask students to select an element in nature—such as wind, sunshine, tornadoes, or lightning—and translate it into a figurative form. Discuss ways that their work could communicate how they feel about aspects of the element, such as its power or essence. After students have created their figures, have them read myths or legends from other cultures about natural phenomena. Ask students to explain the similarities and differences between their representation of the element and the ways that other cultures have conceived of it.

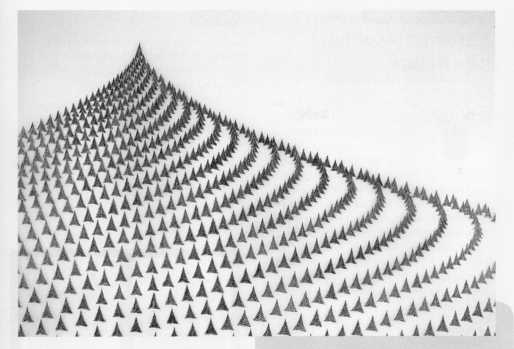

## A Message to Care

Today, many artists reflect our concerns about the environment in their artworks. Environmental groups work hard to protect endangered species of animals and plants. They think about how the extinction of these plants and animals will upset the balance of nature. Many areas of natural beauty in our world could disappear.

Much contemporary art calls our attention to this delicate balance in nature. Artists who create these artworks often use nontraditional art materials and sites. Some of them use plants and other natural materials or place their artworks outdoors. The drawing of Agnes Denes' *Tree Mountain* (Fig. 5–6) shows the artist's plan for creating a living artwork. For *Tree Mountain*, 11,000 trees were planted by 11,000 people from all over the world. The trees were planted in a spiral pattern on a human-made mountain. They will live for 400 years. During that time, the people who planted the trees and the generations of family that follow them are expected to care for the trees. The artist thought of this artwork as a growing "time capsule" representing 400 years of life. The trees were planted in Finland between 1992 and 1996.

Responding to Nature

## Supplies for Using the Text

• commemorative stamp

## Supplies

• sketchbooks
• pencils
• drawing paper, 12" x 18"; or illustration board, 15" x 20"
• colored pencils, markers, paint, or construction paper

## Using the Text

**Art Production** Have students read pages 178 and 179. Challenge them to cite examples of graphic design in the classroom. Show students the commemorative stamps, and discuss their subject and design.

Discuss possible ideas for nature stamps. **Ask:** What features about the local landscape, weather, animals, or plants could you emphasize? Are any of the animals endangered? Encourage students to experiment with several ideas in their sketchbook before drawing their design in pencil on large paper. Emphasize that their four designs should have a common theme. After students have completed drawing all four stamps, they may add color to them.

## Using the Art

**Art Criticism Ask:** How are the four stamps alike? How are they different? What is their theme? *(flowers)* What is the artist's message?

---

**Design in the Studio**

# Stamps Inspired by Nature

So far in this chapter, we have explored how artists express ideas about nature's powerful forces. Sometimes, artists stand back and view nature from a distance. Other times, they show natural objects close up. **In this studio experience, you will design a set of four postage stamps that sends a message about your natural surroundings.** You may wish to say, "Look closely at the textures and lines in plants." Or "See a tree in every season." Or "Stand back and admire the power of wind." How might you express your own ideas about nature?

**You Will Need**

• sketch paper
• pencil and eraser
• drawing paper
• colored pencils, markers, or paint

## Studio Background

**The Nature of Design**
If you look around, you will see objects that have designs inspired by nature. **Graphic designers** are artists who design such things as packages, wrapping papers, book jackets, posters, and greeting cards. Some graphic designers simplify the features of natural objects in the designs they create.

Designers also create the postage stamps used in communities around the world. By examining stamps, you can discover what a community cares about. Compare today's postage stamps with those from the past. You can see how graphic design styles have changed. Subject matter for stamps has

**Try This**

**1.** Choose a subject or theme for your stamps that sends a message about your natural surroundings. Will you choose birds or flowers? The seasons or weather?

**2.** Decide what shape you want your stamps to be. Choose the shape that best expresses your ideas about nature. Will they be round or oval? Square or triangular?

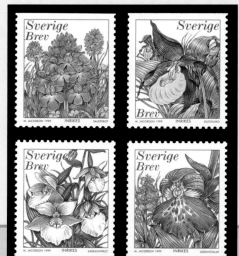

Fig. 5–7 Artists and designers in Sweden often look to nature for subject matter. Here we see one designer's representation of flowers found in Sweden. In what other ways do these stamps look like they belong together in a set? Margareta Jacobson, *Swedish Orchids Stamps*, May 20, 1999. © Sweden Post Stamps.

changed over time, too. Some stamps now focus on community heroes or special events. Others, such as those shown in Figs. 5–7 and 5–9, feature the beauty of nature.

---

## Meeting Individual Needs

**Alternative Assignment** Have students design only one stamp.

**Focusing Ideas** Provide stamps or photos to help generate ideas. If appropriate, brainstorm ideas with students.

## Teaching Through Inquiry

**Art History** Have students work alone or in groups to collect and display **items whose graphic design has changed** over time, such as postage stamps, product labels, baseball cards, book covers, or advertisements. Have students work in pairs to formulate generalizations about the design changes, and to suggest why such changes were made. Emphasize that an important outcome of their investigation is the questions they still have after considering the changes.

**3.** Sketch your ideas. Remember that the stamps belong in a set and should look good together. Think about the colors you want to use.

**4.** When you are happy with your sketches, create your finished drawings on drawing paper.

### Check Your Work

Share your completed set of stamps with a group of classmates. Try to determine the message sent by each stamp and by the set as a whole. Do the four stamps work together as a set? To answer this, think about both the message and the design.

### Core Lesson 5

**Check Your Understanding**
1. What are two general kinds of messages that artworks send about nature?
2. Use examples to explain how artists investigate nature.
3. Describe an artwork that a graphic designer might make that refers to nature in some way.
4. Suggest an idea for making an artwork that would include a message to care about the natural world.

### Sketchbook Connection

Take your sketchbook outdoors and choose a natural object that you think is beautiful. Draw it from a distance and then close up. Focus on drawing the overall form of the object in the far-away view. Focus on details in the close-up view. Think of the messages about nature that each view might help you express.

Fig. 5–8 "My message is: 'every difference is the same'—all of the stamps are different, but they are all bad weather." Ted LoDuca, *My Brother's Attitude*, 1999. Colored pencil, each stamp design is 7 1/2" x 5 5/8" (19 x 14 cm). Pocono Mountain Intermediate School South, Swiftwater, Pennsylvania.

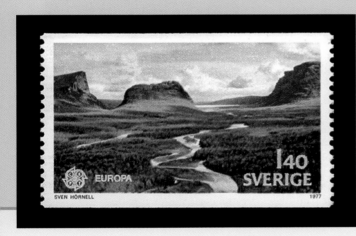

Fig. 5–9 This stamp is older than those in Fig. 5–7. Imagine receiving a letter from Sweden with this stamp on it. What does the stamp tell you about the Swedish landscape? Would you want to go there? Why or why not? Sven Hornell, *Rapa Valley Stamps*, May 2, 1977. © Sweden Post Stamps.

Responding to Nature

179

### Sketchbook Tip

Call attention to how details change when looking at a nature object far away and then up close. **Ask:** How do the leaves on a tree look up close? From a distance? How close must you be to a tree to make out individual leaves?

## Assess

### Check Your Work

Guide groups of students to critique each other's works for clarity of their messages, unity of theme, and use of color and shape.

### Check Your Understanding: Answers

**1.** Artists send messages about the beauty and power of nature, especially how these aspects affect communities.

**2.** Artists investigate nature by making scientific records of plants and animals. They also participate in more fanciful investigations of nature, emphasizing ideas and feelings.

**3.** Answers will vary. Possible responses: book covers, advertisements, billboards, magazine pages, place mats, posters, greeting cards, wrapping papers.

**4.** Answers will vary. The suggested artworks might be small or large, done by individuals or collaborative groups, and of any media.

### More About...

The Bureau of Engraving and Printing officially took over production of **postage stamps** in 1894, printing more than 2.1 billion stamps by the end of the first year, compared to today's annual 20 billion. Bureau designers currently create models by hand or computer, based on orders from the United States Postal Service. The design, lettering, and denominations are then manually engraved on a steel master die and mass-produced.

### Assessment Options

**Teacher** Have students create a graphic organizer, such as a concept map, to show how art, nature, and communities are related. Explain that the map must include the ways artists investigate nature and the kinds of messages about nature that are sent to communities. Have students include the titles of artworks on pages 172–179 (and any others) as examples. Look for evidence that students know that artworks send messages about nature's beauty and power; how these aspects of nature affect communities; and that artists make scientific records of nature and then convey feelings and ideas in more fanciful investigations.

## Close

Display the stamp designs, and have students identify messages about nature in one another's stamps. **Ask:** How do the four stamps work together as a set? What is their common theme? After students answer the questions in Check Your Understanding, review their responses and reteach any concepts that are unclear.

## Prepare

### Pacing

Three to four 45-minute periods: one to consider art and text; three to make art

### Objectives

- Explain people's interest in paintings of the natural environment.
- Describe features and characteristics of the Art Nouveau style.
- Select and combine media to capture the beauty of the natural world.

### Vocabulary

**Impressionist** A group of artists who worked outside and painted directly from nature. Impressionist artists used rapid brushstrokes to capture an impression of light and color.

**Art Nouveau** A French phrase that means "New Art." A design style that explored the flowing lines, curves, and shapes of nature.

### National Standards 5.1 Art History Lesson

**1b** Use media/techniques/processes to communicate experiences, ideas.

**2c** Select, use structures, functions.

**3a** Integrate visual, spatial, temporal concepts with content.

**4c** Analyze, demonstrate how time and place influence visual characteristics.

---

5.1 ART HISTORY LESSON

# Responding to Beauty: 1860–1900

1895
Dewing, *Garden in May*

ca. 1900
Tiffany, *Dragonfly Lamp*

1914–15
Tiffany, *Necklace with grape and vine motifs*

Realism and Romanticism
page 154

**Late 19th Century America**

Industrial Amer
page 206

1891
Brown, *Grand Canyon of the Yellowstone from Hayden Point*

1908
Tiffany, *View of Oyster Bay*

1915
Sullivan, *J. D. Van Allen Building*

### History in a Nutshell

Between 1860 and 1900, the developing nations of North America saw times of peace and turmoil. In 1867, Canada became the independent nation it is today. Politics in Mexico were stable and the country's economy was growing. The United States, however, was fighting the Civil War from 1861 to 1865. Following the Civil War, cities grew rapidly as the age of industrialism began.

## The Appeal of Nature

In the last decades of the nineteenth century, there was a great demand for paintings of the natural environment. People wanted to see the natural beauty of the North American wilderness they had heard about. In the years following the Civil War, there was a need in the United States to find new national symbols. People's interest in nature became something all communities could share. The first national parks in the United States were created at this time.

In response to the people's desire to see the wilderness, artists journeyed into unexplored regions of the United States. They took photographs and made sketches of the plants and features of the land. Back in their studios, they painted landscapes from these photos and sketches. Landscape paintings, such as the one by Grafton Brown (Fig. 5–10), allowed communities to see the natural beauty of their nation.

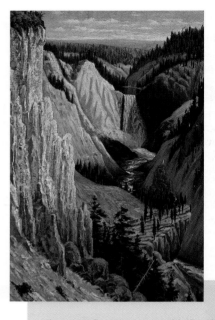

Fig. 5–10 Grafton Brown was one of the first African-American artists to paint mountain scenes in California. Why would people living in late-nineteenth-century America find this image exciting? Grafton Tyler Brown, *Grand Canyon of the Yellowstone from Hayden Point*, 1891.
Oil on canvas, 24" x 16 " (61 x 40.6 cm). Oakland Museum of California Founders Fund.

## Teaching Options

### Resources

Teacher's Resource Binder
- Names to Know: 5.1
- A Closer Look: 5.1
- Map: 5.1
- Find Out More: 5.1
- Check Your Work: 5.1
- Assessment Master: 5.1
- Overhead Transparency 9
- Slides 5d

### Meeting Individual Needs

**Multiple Intelligences/Musical** Play examples of indigenous Japanese, Native American, and Indian music in which instruments evoke the sounds of nature. Have students discuss the natural elements they hear—such as rustling grass, whistling wind, and falling rain—and then create their own musical composition inspired by one of the nature-related images in this chapter. Finally, ask students to describe the differences and similarities between visual and musical works relating to nature.

## Natural Impressions

**Impressionist** artists painted the seasonal changes and weather in their local regions. They worked outside and painted directly from nature. With rapid brushstrokes, they captured an impression of light and color. They painted what the eye sees at one particular moment. The American Impressionist artists saw this approach as a way to explore color in art. The close-up view of flowers in *Garden in May* by Maria Oakey Dewing (Fig. 5–11) shows the artist's impressionist style.

The theme of nature can also be seen in architecture of this period. Notice the details used by architect Louis Sullivan (Fig. 5–12).

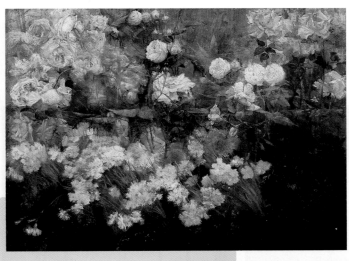

Fig. 5–11 Maria Oakey Dewing was probably the most important flower specialist of this period. Where do you see impressionistic brush-strokes? Maria Oakey Dewing, *Garden in May*, 1895.
Oil on canvas. 23 ⅝" x 32 ½" (60.1 x 82.5 cm). National Museum of American Art, Smithsonian Institution, Washington, DC./Art Resource, NY.

Fig. 5–12 The decorative elements that you see here add beauty to what could have been an ordinary-looking building. How many different plant forms can you find? Louis Sullivan, *J. D. Van Allen Building*, 1915.
Detail of terra cotta leaf bursts on the 4th story attic. @ artonfile.com.

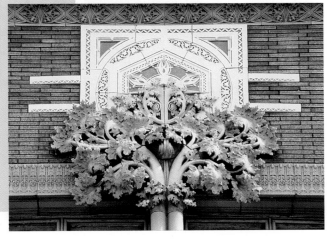

Responding to Nature

181

### Using the Time Line

Have students study the time line. Encourage them to place artworks within the context of the times. **Ask:** What were some of the struggles in United States history in the late nineteenth and early twentieth centuries? Where were your ancestors during this time? What were the principal means of travel?

### Teach

### Engage

If any students have visited a national park, ask volunteers to describe their experience. **Ask:** Why, do you think, were national parks established?

### Using the Text

- Have students read The Appeal of Nature. **Ask:** How did artists respond to the public's passion for the wilderness? *(traveled there, photographed and sketched it)*
- Have students read Natural Impressions. **Ask:** Where did the Impressionists usually paint? What were they trying to capture in their paintings?

### Using the Art

**Art Criticism** Lead students in comparing Brown's and Dewing's viewpoints. **Ask:** Where is the viewer located in each painting? What was each artist saying about nature?

---

### Teaching Through Inquiry

**Art History** Have students, individually or in small groups, research the **history of national parks** and identify those that were established in the last half of the nineteenth century. Instruct students to find **artworks and photographs** related to these parks, and to create a display entitled "Gifts to a Nation" or "Symbols of a Great Nation."

### More About…

**Louis Sullivan** (1856–1924) developed his love of nature, and an influence on his later style, from a childhood of summers on his grandparents' farm in Massachusetts. Sullivan bowed to nature when creating architecture that sought "expression in ornament based on natural growth."

### Using the Overhead

**Talk It Over**

**Describe** Observe the shapes and spacing in the letter forms. What other visual details catch your eye?

**Attribute** What visual clues would help you to date this graphic design?

THE LARK

**Interpret** How do you think this cover illustration was created?

**Explain** How is this similar to and different from cover illustrations today? Why is this the case?

9

## Responding to Beauty

## Using the Text

**Art History** Assign students to read Design Inspired by Nature to learn what subjects were often featured in Art Nouveau. *(animals, plants, flames, waves)* **Ask:** What forms of art did Tiffany design? *(stained glass, jewelry)*

## Using the Art

**Perception** Lead students in discussing the similarities among the Tiffany pieces. **Ask:** How did Tiffany create unity within the lampshade and the necklace? *(repetition of shapes and colors)* What is the focal point in the stained-glass window? How is this emphasized?

## Studio Connection

Assemble these supplies: crayons, oil pastels, or other dry media; watercolors or other wet media; heavy paper (such as watercolor or manila); brushes; water in containers; pencils; palettes.

Guide students in developing a list of natural objects and features that they think are beautiful. Have students sketch these outdoors, or bring in examples of local natural objects. Encourage students to observe details as they fill their paper with a close-up view. Demonstrate crayon resist or combinations of wet and dry media. Suggest to students that they try using a variety of colors. Discuss how to indicate light and shadows.

**Assess** See Teacher's Resource Binder: Check Your Work 5.1.

### Sketchbook Tip

Ask students to explore the design possibilities of natural elements such as plant and insect forms.

# Design Inspired by Nature

Painters, sculptors, and architects were not the only artists who were inspired by nature. Artists such as Louis Comfort Tiffany, who designed decorative items, also turned to nature for ideas. Patterns created from plant and animal forms, flames, smoke, waves, and other natural elements can be seen in jewelry, stained-glass windows, and home furnishings. Tiffany is known as the American pioneer of the **Art Nouveau** movement (ca. 1890–1918). This design style explores the flowing lines, curves, and shapes of nature.

Tiffany is best known for his designs of stained-glass items, such as windows and lamps, and jewelry. Tiffany hired a great number of craftspeople to produce jewelry and blown-glass designs. He encouraged these craftspeople to be creative in their work. He wanted every piece produced in Tiffany Studios to reflect his unique sense of design. Each piece had to be crafted in the nature-inspired Art Nouveau style. Tiffany also designed and built a home for his family. It was known as the finest example of Art Nouveau architecture in the United States. A stained-glass window from his home is shown in Fig. 5–14.

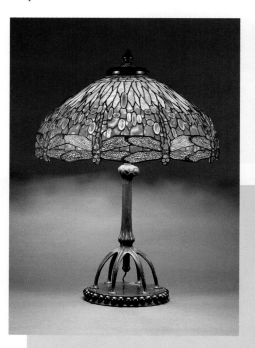

Fig. 5–13 Notice how Tiffany created a pattern of dragonflies in this stained-glass lampshade. What other elements from nature do you see on the lamp? Louis Comfort Tiffany, *Dragonfly Lamp*, ca. 1900. Bronze base with color favrile glass, 28" x 22" (71.2 x 55.9 cm). Collection of the New York Historical Society (N84.113).

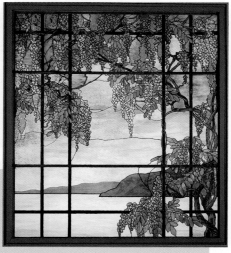

Fig. 5–14 Why might people recognize this stained-glass window as a work of Tiffany? Louis Comfort Tiffany, *View of Oyster Bay*, Window from the William C. Skinner House, New York City, ca. 1908. Leaded favrile glass, 72 ¾" x 66 ½" (184.8 x 168.9 cm). The Metropolitan Museum of Art, Lent by the Charles Hosmer Morse Museum of American Art, Winter Park, Florida, in memory of Charles Hosmer Morse. (L.1978.19) Photograph © 1993 The Metropolitan Museum of Art.

## Teaching Options

### Teaching Through Inquiry

**Art History** Have students, working individually or in groups, do more research on **Art Nouveau**. Help them find sources of images, both historical and contemporary, to create a classroom display on nature-inspired design.

### More About...

**Louis Comfort Tiffany** (1848–1933) originally painted scenes from his travels in Europe and North Africa, but the medieval and Roman glass he saw on these journeys changed his career. Tiffany made stained-glass windows with images from nature and, by the mid-1880s, created stained-glass lamps that relied on artificial rather than natural light.

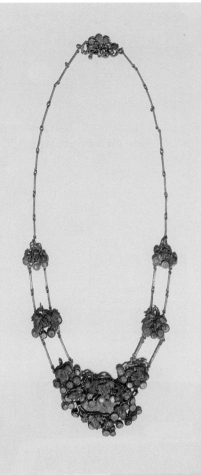

Responding to Nature

183

**Studio Connection**

How can you capture the beauty of the natural world around you? Scenes of nature can be close-up views or far-away vistas. For a close-up view, create a still-life arrangement of natural forms from your area. Let one or more main shapes fill your paper. Focus on the shapes, lines, and subtle changes in color, light, and shadow that you see. Make a sketch first. As you plan your composition, think carefully about your choice of media. Try creating a resist by combining crayon or oil pastel with water-color. Notice how you can achieve rich textural effects using this technique.

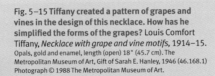

**5.1 Art History**

**Check Your Understanding**

1. Give examples of how artists in the last forty years of the nineteenth century helped North American communities connect with the beauty of nature.
2. How did American Impressionist painters create landscapes? Describe their style of painting.
3. What natural elements appear in decorative items of the Art Nouveau style?
4. What designer is particularly known for his Art Nouveau designs?

Fig. 5–15 Tiffany created a pattern of grapes and vines in the design of this necklace. How has he simplified the forms of the grapes? Louis Comfort Tiffany, *Necklace with grape and vine motifs*, 1914–15. Opals, gold and enamel, length (open) 18" (45.7 cm). The Metropolitan Museum of Art, Gift of Sarah E. Hanley, 1946 (46.168.1) Photograph © 1988 The Metropolitan Museum of Art.

Fig. 5–16 All of the men in this photograph are crafting Tiffany lampshades. How might this studio have been different from a present-day lampshade factory? Tiffany Studio, Madison Avenue and 45th Street, ca. 1902. J. and F. Van Brink collection.

## Extend

Invite students to research the art of American Impressionists (such as Hassam, Sargent, and Chase), and then to paint their own impression of a landscape they see daily.

## Assess

**Check Your Understanding: Answers**

1. Artists responded to people's desire for images of the natural beauty of the North American wilderness by traveling into un-developed regions and taking photographs and making sketches of the local plants and other natural features.

2. They painted directly from nature, working with rapid brushstrokes to capture an im-pression of light and color, and to depict what the eye sees at one particular moment.

3. flowing lines, curves, and shapes of nature; plant life, as well as motifs inspired by flames, smoke, and waves; ani-mal forms, such as snakes, butterflies, and peacocks

4. Louis Comfort Tiffany

## Close

Assign students to write a description of the natural beauty they depicted. **Ask:** How successful do you think you were in showing this beauty? If you were to repeat this project, how would you paint a similar subject?

## More About...

Artists of the **Art Nouveau** (French for "new art") rejected the fancy Victorian style. In their designs, they instead used simplified, abstract ele-ments based on nature. Followers created decorative furniture, jewelry, windows, lamps, and other items to develop a unified environment, in the hope of eliminating the division be-tween the major and minor arts.

## Assessment Options

**Teacher** Have students use col-ored pencils to draw a series of Art Nouveau-style pendants or pins. Then have them write an ad for their line of jewelry so as to appeal to people in the late 1800s who were interested in the natural environment.

## Prepare

### Pacing

Two 45-minute periods: one to consider art and text, and to begin sketching; one to ink

### Objectives

- Explain why images, colors, and lettering are important to graphic design.
- Create an illustrated version of a word that represents something in nature.

### Vocabulary

**graphic design** A general term for artwork in which letter forms (writing, typography) are an important part of the artwork.

## Teach

### Engage

Present these descriptions: an overnight-express delivery van is decorated with an image of a tortoise; the label for a shampoo guaranteed to make your hair "soft and manageable" is in the form of jagged rocks. **Ask:** What's wrong with these images? What images from nature would be better representations?

### Using the Text

**Art Production** Have students read the text. Exhibit several cold-drink cans, and lead students in discussing the artist's message, the audience, and the design's effectiveness.

### National Standards 5.2 Forms and Media Lesson

**2c** Select, use structures, functions.

**3b** Use subjects, themes, symbols that communicate meaning.

# Graphic Design

## What Is It?

In **graphic design**, designers create packages, labels, and logos for products and businesses. The messages expressed in graphic designs can help people decide whether to buy a product or service. Graphic designs can provide information. They can persuade people to support other people, groups, and ideas. And they can identify places and services in the community. These messages are conveyed on posters, billboards, and in newspaper and magazine advertisements. Other examples of graphic design include wallpaper, fabrics, greeting cards, and books.

Fig. 5–18 What ideas does this image convey? How does color contribute to the message? What might be a good commercial use for an image like this? Jim Frazier, *Hands Wrapped Around Globe*, 1995. Mixed media, paint and paper, 8" x 8" (20.3 x 20.3 cm). Courtesy Stock Illustration Source, Inc.

Fig. 5–17 Why can the side of this bus be considered an example of graphic design? What form of graphic design is it similar to? American Museum of Natural History, *Mobile Museum*, 2000. Courtesy American Museum of Natural History.

## Teaching Options

### Resources

Teacher's Resource Binder
- Finder Cards: 5.2
- A Closer Look: 5.2
- Find Out More: 5.2
- Check Your Work: 5.2
- Assessment Master: 5.2
- Overhead Transparency 9

### Teaching Through Inquiry

**Art Criticism** Have students work in small groups. Provide each group with a collection of items that include **examples of graphic design**. Have students sort the items in three ways: by the kinds of messages the items send, by the intended audience, and by the way the design is organized to send the message. Encourage students to create their own categories with each sorting activity. Discuss their findings.

# Effective Graphic Design

For a graphic design to work, the designer must consider the following questions:
1. What is the message?
2. Who is the audience?
3. What is the best way to get the message to the audience?

Fig. 5–19 Why might the image of a fish have been a good choice for the cover of an art education magazine? What ideas about art does it suggest? *School Arts* cover, October 1999. Courtesy *School Arts*.

Messages are most easily expressed by combining images and words. The next time you're at a supermarket, take a look at several different brands of bottled spring water. How does each label suggest the idea that spring water is natural, clean, clear, and good for your health? Look carefully at the images, colors, and lettering. The images might show clear, fresh water. The colors can suggest healthful moods and feelings. The choice of lettering might suggest how clean and natural the water is. All of these elements work together to send the message.

### Studio Connection

Sometimes, the shapes of letters used in a word can help illustrate the meaning of the word. For example, the word ice might have letters that look like chunks of carved ice. The word flower could have letters that resemble flowers. Choose a word that represents something in nature. Create an illustrated version of your word. Plan the shape of each letter and the spacing between them. What colors can you use? Make several sketches. Choose your best design and create a finished drawing.

### 5.2 Forms and Media

**Check Your Understanding**
1. What can graphic designs provide to people in communities?
2. Why are images, colors, and lettering important to graphic design?

Responding to Nature

185

## Using the Art

**Art Criticism Ask:** What is the message of the poster shown in Fig. 5–18? What is its symbolism? How do the colors affect the message? How did the artist organize the work? What is its most important art element?

## Studio Connection

Distribute pencils, sketch paper, 9" x 12" drawing paper, markers or pens and ink, and rulers. Brainstorm nature words. Have students sketch ideas before drawing their final word on 9" x 12" paper. Demonstrate how to draw pencil guidelines and to center the lettering. Have students ink over their pencil lines.

**Assess** See Teacher's Resource Binder: Check Your Work 5.2.

## Assess

**Check Your Understanding: Answers**

1. Graphic designs can provide information, persuade people to support a political candidate or social cause, and identify places and services in a community.

2. Images can convey ideas; colors can convey moods and feelings; and letters can convey messages.

## Close

Have students look around the artroom and in books for what they think are particularly effective corporate logos. Point out how designers used negative shapes. Have students write an explanation of why one of the logos is effective.

## Using the Overhead

**Write About It**

**Describe** Write a few sentences to describe the subject matter and message in this cover design.

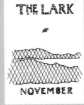 THE LARK **Analyze** Use the overlay, and have students write about the way Lundborg used shapes to create the design.

9

## Assessment Options

**Teacher** For their future reference, have students each create a booklet about graphic design, which includes ways to identify graphic design from other art forms; ways that people in communities use graphic design; and reasons why images, colors, and lettering are important in graphic design.

185

## Prepare

### Pacing

Three 45-minute periods: one to consider art and text; two to make art

### Objectives

• Describe qualities and characteristics of Scandinavian art.

• Explain the importance of the Arts and Crafts Movement in Scandinavia.

• Use impressions of natural forms to create a multicolor monoprint.

### Using the Map

Have students locate Norway, Sweden, Denmark, Finland, and Iceland on the world map (page 306), and have them compare the latitude of these countries to that of the United States. *(They are much farther north.)* **Ask:** How does this northern latitude affect the length of days? *(long summer days, long winter nights)*

# Finding Beauty in Northern Light: Scandinavian Art

**Scandinavia**

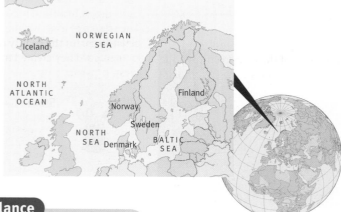

## Global Glance

Scandinavia includes the countries of Norway, Sweden, and Denmark, although many experts also include Finland and Iceland in the list. Norway and Sweden make up the Scandinavian peninsula.

The Scandinavian countries share the seafaring Viking culture. Germany had some influence in the area during the Middle Ages. France influenced Scandinavia in the centuries that followed. However, there has always been a strong feeling of individualism in Scandinavia. "Every person's right" is an expression of freedom in Norway, Sweden, and Finland.

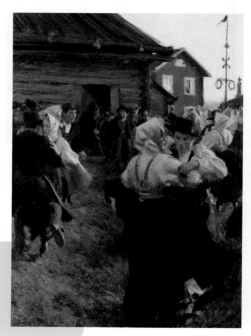

Fig. 5–20 Can you tell what time of night is shown in this painting? Notice the wispy, impressionistic quality of the brushstrokes. How would you describe the artist's use of light in this picture? Anders Zorn, *A Midsummerdance*, 1897. Oil on canvas, 55 1/8" x 38 5/8" (140 x 98 cm). Courtesy Nationalmuseum, Sweden.

186

### National Standards 5.3 Global View Lesson

**1b** Use media/techniques/processes to communicate experiences, ideas.

**4a** Compare artworks of various eras, cultures.

**4c** Analyze, demonstrate how time and place influence visual characteristics.

## Teaching Options

### Resources

Teacher's Resource Binder
  A Closer Look: 5.3
  Map: 5.3
  Find Out More: 5.3
  Check Your Work: 5.3
  Assessment Master: 5.3
Large Reproduction 10
Slides 5e

### Meeting Individual Needs

**English as a Second Language** Ask students not to read the credit for Fig. 5–21, but to write a title for the work in English. Then have students use English to describe the painting's expression of nature. Write their words on the chalkboard, and then have students draw their own scene with a similar expression of nature.

## Nature in Isolation

If you look at a map of Europe, you can see how the countries on the Scandinavian peninsula are somewhat isolated. The people who live there understand the forces of nature and how those forces can affect their communities. Probably for this reason, they developed a style of art that is deeply rooted in nature and community life.

This relationship between people and nature is the focus of the art and cultural life of Scandinavia. Annual festivals and traditions follow the cycles of nature. Myths and folk tales take place in deep, dense forests full of elves, trolls, or nymphs.

Scandinavia has vast amounts of unspoiled land. Although winters are long and dark, in midsummer nights the sun does not set. Scandinavian artists in the late nineteenth century focused their art on nature and its cycles. *A Midsummerdance* by artist Anders Zorn (Fig. 5–20) shows us a Scandinavian celebration of the unique northern midsummer night.

While studying in Paris, many Scandinavian artists discovered the decorative and expressive possibilities of their own country's light and landscape. French *plein-air* painting, or painting in the open air, inspired the artists to paint the beauty of their own homeland. They created images of the countryside, particularly at dawn and dusk. In their artwork, they captured the many changing moods of nature. Artist Edvard Munch was a master at showing the light of the northern summer night in landscapes. In *White Night* (Fig. 5–21), he uses soft light to create a calm mood.

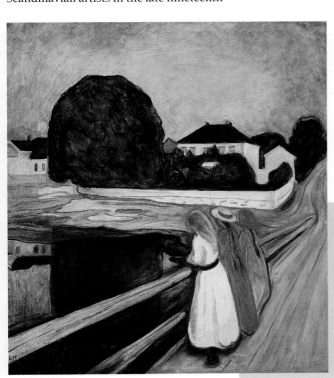

Fig. 5–21 Munch's flowing brushstrokes add a dream-like, fluid quality to this image. How do his brushstrokes also suggest the closeness of the girls to their surroundings? Edvard Munch, *White Night*, 1904–07.
Oil on canvas, 31 1/2" x 27 1/4" (80 x 69 cm). Pushkin Museum of Fine Arts, Moscow, Russia. Scala/Art Resource, NY © 2000 The Munch Museum / The Munch-Ellingsen Group / Artist Rights Society (ARS), New York.

Responding to Nature

187

## Teach

### Engage
Ask students to imagine how their lives might be different if they lived in a place where in midsummer, the sun never set and in midwinter, the sun never rose. Discuss ways this setting might affect their own art-making.

### Using the Text
**Art History** Have students read the text to learn how the geography of Scandinavia has influenced its art. **Ask:** Why is nature so important in this region's art?

### Using the Art
**Art Criticism Ask:** How is the celebration in Zorn's *A Midsummerdance* related to natural cycles? *(The dance is outdoors in one of the long summer evenings of the northern latitudes.)* How are Munch's and Zorn's paintings alike? What is the greatest difference between them? How did each artist create a sense of depth? Which work seems to have greater depth?

---

### Teaching Through Inquiry

**Art Criticism** Have students use both the Descriptive Word Cards and the Expressive Word Cards in the Teacher's Resource Binder to **write interpretative captions** for each artwork on pages 186 and 187. After students work individually on a rough draft, have them work in pairs to discuss each other's writing before refining and completing the final draft.

### More About...

When **Edvard Munch** (1863–1944) was a child, his mother and sister died. The effects of these tragedies coupled with his own unsteady health are evident in his haunting scenes. However, not just Munch but also many other painters at the time were interested in depicting an interior, emotional world.

### Using the Large Reproduction

**Consider Context**

**Describe** How is this composition organized?

**Attribute** What clues might help you to identify the culture of the artist that produced this painting?

**Understand** How does this work show a respect for nature?

**Explain** How does this painting reflect the place where it was made?

**10**

## Using the Text

**Art History** Assign students to read pages 188 and 189. **Ask:** Where were most Scandinavian textiles, furniture, and household objects produced during the late nineteenth century? What style greatly influenced Scandinavian art during the late nineteenth century? *(Arts and Crafts)* What were the goals of this movement? *(to make practical, beautiful, affordable household goods)*

## Using the Art

**Art Criticism Ask:** How is the design of the embroidered door curtain like that of the cabinet doors? *(both based on plant shapes)* Encourage students to describe the lines and shapes in these. **Ask:** How are the villa and the cabinet alike? *(examples of fine woodworking)* How are the villa and homes in our area alike? How are they different?

## Studio Connection

Supplement students' collection of natural flat shapes with leaves, grass, pressed flowers, and feathers. Provide drawing or construction paper, printing ink or paint, brayers, flat natural objects, and newspaper.

Demonstrate inking a smooth plate, arranging the nature shapes, and pressing paper over this to create a monoprint. Encourage students to experiment with ink colors and shape arrangements. Discuss ways to arrange objects into a unified design with a focal point.

**Assess** See Teacher's Resource Binder: Check Your Work 5.3.

## A Sense of Community

Scandinavian art and design reflect the Scandinavian sense of community. In the late nineteenth century, most people in Scandinavia lived in the countryside. Handcrafted textiles, furniture, and other household items were made at home or in small community groups. Scandinavians believed that decoration in community design and home furnishings was important. Each villa, or house, within a community shared common design elements. Notice the decorative details on the villa in Fig. 5–22. Imagine a community in which all the houses are decorated in a similar way.

Nature was the great source of ideas for the artists and designers of the period. Painted furniture, such as the cabinet in Fig. 5–23, was decorated with *stylized,* or simplified, flower motifs. For many designers, images of flowers were a way of expressing national identity. For others, beauty was found in the natural grain of unpainted wood furniture.

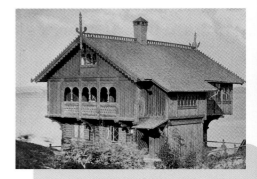

Fig. 5–22 In the late nineteenth century, people in Scandinavia were interested in creating a national style in architecture and household goods. The style of this villa was inspired by the storehouses on Norwegian farms. How would you describe the decorations on this villa? *Professor Carl Curman's Villa in Lysekil,* 1875 and replaced due to fire in 1878. Photograph by M. Jacobson, date unknown. Nordiska Museum, Stockholm, Sweden. (8169)

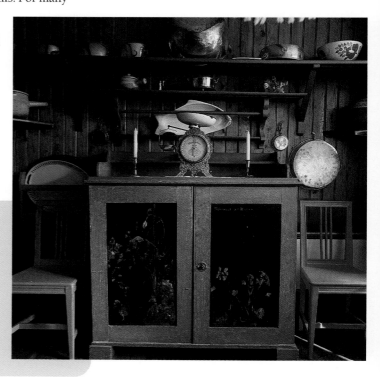

Fig. 5–23 Many of the flower forms in Scandinavian art are stylized. Would you consider these flowers to be stylized? Why or why not? *Cabinet in Carl and Karin Larson's home,* Sondborn, Sweden, early 20th century. Photograph courtesy Nisse Peterson.

## Teaching Options

### Teaching Through Inquiry

**Art Production** Have students, working in small groups, research Scandinavian design in furniture, housewares, and textiles in traditional and contemporary styles. Then ask groups to work together to create a display of the **relationship of design to nature**.

### More About...

The **Arts and Crafts Movement** began in England as a reaction to the mass-produced, machine-made objects of the Industrial Revolution. The artists of the movement hoped to restore to craftspeople, who made items by hand, an honor similar to what they had before industrialization. Followers in Europe and the United States created pieces that were both useful and beautiful.

## A Scandinavian Style

In the late nineteenth century, the artworks made in Sweden, Denmark, Norway, Iceland, and Finland shared certain similarities. The *Arts and Crafts Movement*, which reacted against the industrialization of crafts design, influenced Scandinavian artists. People involved in the movement were interested in the individuality of handmade items. In Scandinavia, people wanted to make affordable household goods that were both practical and beautiful.

Various community arts and crafts groups and home-industry organizations were committed to preserving the Scandinavian

design style. There was a blending of old and new ideas, and of painted and natural wood. Designs included simple plant motifs and clean, sharp lines. Handcrafted products were known for their beauty and simplicity. These ideals in Scandinavian design are still seen today.

### Studio Connection

Make a monoprint of objects from nature. A monoprint starts as an image that is created with paint or ink. Then, while the image is still wet, it's transferred to another surface. Collect leaves, blades of grass, feathers, flower petals, and other flat objects from your yard or neighborhood. Paint or ink the surface of a square of smooth plastic or glass. Lay your objects on the ink or paint and then place a sheet of paper on top. Rub evenly, but gently, over the entire paper. When you remove the paper, the shapes of your objects will be white. Using a different color, paint or ink another surface. Position the objects differently, and lay the same sheet down to make a second impression. What happens when the colors overlap?

### 5.3 Global View

#### Check Your Understanding

1. What role did nature play in the art of Scandinavian countries?
2. What characteristic of midsummer is unique to the Scandinavian region?
3. What is a common characteristic of the art of Scandinavian countries?
4. What was the basic idea behind the Arts and Crafts Movement in Scandinavian countries?

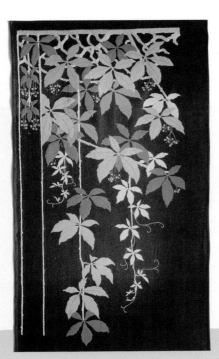

Fig. 5–24 Notice the delicate design of this embroidered door curtain. How does this plant motif compare to the one on the cabinet doors in Fig. 5–23? Gunnar Gunnarson Vennerberg, *Embroidered Door Curtain*, 1899. Made by The Association of Friends of Textile Art (Handarbetets Vanner). Photography Nordiska Museum. Nordiska Museum, Stockholm, Sweden.

Responding to Nature

### Extend

Teach students to make translucent nature collages: arrange flat nature objects on a sheet of freezer wrap; glue them to the wrap; separate the layers of double-layered facial tissues, and cover the objects with a single layer of tissue; paint diluted white glue over the tissue; after the glue has dried, iron the collage.

## Assess

### Check Your Understanding: Answers

1. Artists focused on nature because life in Scandinavia is dependent on understanding nature's forces and cycles.

2. the lack of darkness at night

3. a beauty and simplicity that blends old and new in quality, handcrafted products

4. to make practical and beautiful household goods that were affordable to everyone

## Close

Have students select their favorite print to mat or mount. Create a display of their art, and encourage them to describe the colors, lines, and shapes. **Ask:** How did you create unity and a focal point? Have students answer Check Your Understanding questions in small groups, and then review their responses with the whole class.

### More About...

Founded in 1874, the Association of Friends of Textile Art was famous in the 1890s for its modern textiles and embroidery for which skilled designers created **stylized plant motifs** for interior decoration.

### Assessment Options

**Peer** Ask students to work in groups to design a travel poster that would inspire people to visit Scandinavia to see traditional art. Instruct students first to research the characteristics of Scandinavian art, and then to present them visually in the poster. Have students decide on evaluation criteria to be used by their peers.

**Teacher** Ask students to write two paragraphs to demonstrate what they know about the goals of the Arts and Crafts Movement in England and elsewhere, and why the movement caught on and lasted so long in Scandinavia.

## Prepare

### Pacing
Two 45-minute periods

### Objectives
- Explain the function and history of ceramic tiles in America.
- Understand the process of creating a ceramic tile.
- Use a variety of textures to create a relief sculpture describing a natural environment.

### Vocabulary
**relief sculpture** A sculpture with parts that are raised from a background.

### Supplies
- balls of clay, wedged, 1 lb/student
- flat sticks, about 3/8" thick
- rolling pins or dowels
- pieces of cloth or plastic
- flat boards
- plastic knives and other clay-modeling tools
- sponges
- water containers
- plastic bags that seal, or plastic wrap

### National Standards
### 5.4 Studio Lesson

**1b** Use media/techniques/processes to communicate experiences, ideas.

**2a** Generalize about structures, functions.

**3a** Integrate visual, spatial, temporal concepts with content.

**4c** Analyze, demonstrate how time and place influence visual characteristics.

---

## STUDIO LESSON

### 5.4

**Teaching Options**

Sculpture in the Studio
# A Relief Sculpture

## The Nature of Clay

### Studio Introduction
Did you know that clay is a fine-grained material that comes from the earth? When some people see clay, they think of mud. But some artists look at clay and imagine making a beautiful pot or vase with it. They know that moistened clay can keep its form when it's shaped by hand. And they know that *firing* clay, or baking it at a high temperature, can change it to a rocklike material.

Some artists use clay to create a **relief** sculpture—a sculpture with parts that are raised from a background. **In this studio experience, you will create a relief sculpture that shows a natural environment.** Pages 192 and 193 will tell you how to do it. What natural environment is in your area? A forest, an ocean, or a prairie? A mountain or a desert? A river, a flat plain, gentle hills? Think about the plants and animals that live there. How can you show a natural environment in a relief sculpture?

## Studio Background

### Ceramic Tiles
Ceramic, or clay, tiles have been used as flooring in homes for centuries. Your kitchen or bathroom may have ceramic tile on the walls, floors, or countertops. During the Arts and Crafts Movement of the late nineteenth century, decorative ceramic tiles for homes became popular. Tiles from this period show scenes from nature and other designs impressed into their surfaces. They were used on floors and fireplaces, and served as decorative elements in kitchens and bathrooms.

Craftspeople create art tiles by pressing layers of clay into a mold. The mold usually has a relief design in the bottom. This design forms an impression in the clay. After the tile dries, colored slip is poured into the impression and allowed to dry slowly. Then the tile is fired.

Fig. 5–25 This tile comes from a series of tiles that shows woodland scenes. It was made by an American company in the late 1800s. How would you describe the lines and shapes in this scene? Grueby Faience Co., *Woodland Scene*, ca. 1895. Tile, 13" (33 cm). Courtesy National Museum of American History, Smithsonian Institution, Washington, DC.

190

### Resources

Teacher's Resource Binder
Studio Master: 5.4
Studio Reflection: 5.4
A Closer Look: 5.4
Find Out More: 5.4
Overhead Transparency 10
Slides 5f

### Meeting Individual Needs

**Adaptive Materials** Have students use an alternative material, such as balsa foam or modeling compound.

Fig. 5–27 "I got the idea from a photograph in *National Geographic*. I thought about where my colors would go and where each of my leaves were to be placed." Jacqueline Driscoll, *Volcano View*, 2000. Clay with glaze, 6 1/2" x 6 1/2" (16.5 x 16.5 cm). Wescott Junior High School, Westbrook, Maine.

Fig. 5–28 "I wanted to glorify the beauty of the land through texture, color, and shape. Painting and choosing colors was easy and the most fun. Forming the detailed trees into shapes was the most difficult. I like the finished product, where all of my ideas came together." Madison Echols, *Majestic Mountainside*, 2000. Clay with glaze, 6 1/2" x 6 1/2" (16.5 x 16.5 cm). Wescott Junior High School, Westbrook, Maine.

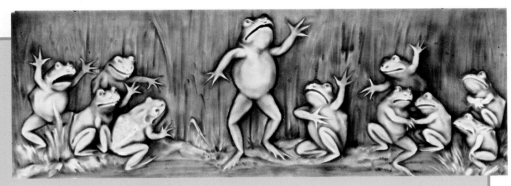

Fig. 5–26 As you can see in this example, not all tiles are square. They are made in many different shapes and sizes. What kind of natural environment does this tile show? How has the artist added humor to the image? American Encaustic Tiling Co., Ltd., Zanesville, OH, *Frog Plaque*, prob. 19th century. Ceramic, 6" x 18 1/6" (15.4 x 45.9 cm). Cincinnati Art Museum, Gift of Theodore A. Langstroth, 1970.515

Responding to Nature

191

## Supplies for Engage
• relief tile (either made before class or obtained from a tile supplier)

## Teach

### Engage
Call attention to different depths of relief in the tile, and allow students to feel its texture. Lead the class in developing a list of natural communities that they have studied in science.

### Using the Text
**Art Production** Have students read The Nature of Clay. **Ask:** How is clay different from mud?

**Art History** Direct students to read the Studio Background to learn about the production of ceramic tiles in the late 1800s. **Ask:** Where are tiles often used in homes? *(floors, fireplaces, kitchens, bathrooms)*

### Using the Art
**Art Criticism Ask:** Which of these tiles is a relief? *(Frog Plaque)* How did each artist indicate depth? *(overlapping in both; in* Frog Plaque, *nearest frogs protrude more)* What is the background in each? How did each artist create rhythm?

## Teaching Through Inquiry

**Art Production** Ask students to consider the images of tiles and try to imagine how each motif would look as part of a **repeated border or wall covering**. Then have students, working individually or in small groups, create a **cut-paper design** that can be repeated on twelve or more 4" squares. Encourage students to experiment with ways to incorporate the decorated squares into a larger pattern.

## More About...

The town of Zanesville, Ohio became the largest center for pottery and tile-making in the world during the last quarter of the nineteenth century. **The American Encaustic Tiling Company** (1876) was one of the first, and most successful, tile manufacturers in Zanesville. Fig. 5–26 is an example of the many different shapes and sizes of tile that were available in various designs.

## Using the Overhead

**Think It Through**

**Ideas** Where did this artist get his ideas? How closely did the artist observe details?

10

**Techniques** How might the way the artist represented nature in this painting help you to think about ways to represent natural forms when working with clay?

## A Relief Sculpture

### Studio Experience

1. Demonstrate creating a relief tile by rolling clay flat on a cloth-covered board between two sticks. Demonstrate indenting and building up the clay to create a relief. Emphasize creating a background, middleground, and foreground.

2. Before students begin their relief, suggest that they experiment by creating clay texture samplers. As students complete their large forms, remind them to add texture to their design.

3. Allow the completed tiles to dry slowly. When they are completely dry, they may be fired.

### Idea Generators

Ask students to research some of the plants, animals, and landforms of the natural communities they listed in Engage, and then to make sketches of them.

**Safety Note**
Students with allergies should wear protective masks.

### Studio Tip

Use self-hardening clay if you do not have access to a kiln. Students can paint the tile surface, but it will not be waterproof. Regular ceramic clay, once glazed and fired, will be waterproof.

**Computer Option**
Suggest to students that they use the key words *encaustic art tiles*, *American Encaustic Tile*, *Grueby Faience,* or *Motawi.* Guide students to the World Wide Arts Resources site, at: http://wwar.com/; to a directory of various pottery and clay companies that create fine tiles, at: http://www.csn.net/ragtime/M/HGP.html; and to a description and illustration of the Motawi tiles, at: http://www.themission-shop.com/motawi_tiles.htm. Students may use bas-relief filters in Painter (MetaCreations) or Photoshop (Adobe).

**Sculpture in the Studio**

# Creating Your Relief Sculpture

### You Will Need

- sketch paper
- pencil and eraser
- clay
- two flat sticks
- rolling pin
- plastic knife
- dowel
- clay modeling tools
- sheet of plastic

### Try This

1. Choose a natural environment to show in your relief sculpture. What features of the land can you show? What plant and animal forms can you include? Sketch your ideas.

2. Place a ball of clay between two flat sticks. Roll out a slab of clay with a rolling pin. Place the slab on a moveable surface, such as a piece of cardboard covered with plastic. Cut the slab into the shape that will best represent your environment. Will it be an oval? A rectangle? A square? Another shape?

3. With a pencil, lightly draw the important features of your environment into the clay surface. Create a foreground, middle ground, and background. Use the pencil eraser or a dowel to carve along the guidelines. Foreground areas should be raised higher than the middle ground and background areas.

4. Add textures to your sculpture. Press objects into the clay to make patterns. Draw textures into the clay with a pencil or dowel. Shape the clay with your fingers or press small shapes of clay, such as tiny balls or coils, onto the surface.

5. When you are finished, cover your sculpture with plastic and allow it to dry slowly.

**Check Your Work**

Did you create a variety of textures? Is there a clear distinction between foreground, middle ground, and background areas? Do the features of your sculpture show a particular natural environment?

**Sketchbook Connection**
Find a small natural form with an interesting texture. Draw it so the textural qualities stand out. You might create a series of drawings showing different combinations of overlapping shapes and textures. What patterns do you see? Think about a decorative design you might create based on this form from nature.

## Teaching Options

### Teaching Through Inquiry

**Art Production** Have students collaborate on a **ceramic-tile mural** based on impressions of nature. Have the class collect natural forms, make square tiles, and use the objects to make impressions in clay tiles. Guide students to glaze and fire the tiles and then glue them to plywood for a permanent mural in the school.

### More About...

Between 1876 and 1894, several **ceramic tile companies** were founded in the United States. The location of these potteries was dependent on the availability of clay and feldspar (a mineral used in glazes). The cost of shipping tiles restricted sales to local areas, so the success of a tile company also depended on the community in which it operated.

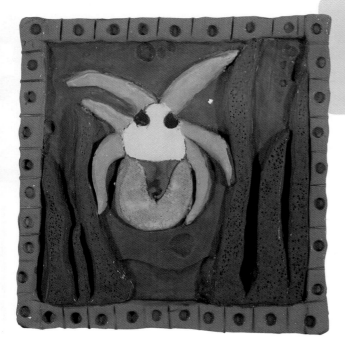

Fig. 5–30 The student who made this artwork was thinking about swimming. What do you think is most effective about the colors he chose? Alexander Cuddy, *Ocean Life*, 2000. Clay with glaze, 6 ½" x 6 ½" (16.5 x 16.5 cm). Wescott Junior High School, Westbrook, Maine.

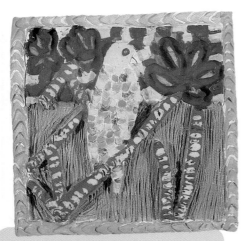

Fig. 5–29 Having made this tile during January in Maine, the artist comments, "I like the bright colors and the jungle-like bird. I think winter can be drab, so I like to brighten things up." Jenna Frank, *Jungle*, 2000. Clay with glaze, 6 ½" x 6 ½" (16.5 x 16.5 cm). Wescott Junior High School, Westbrook, Maine.

## Studio Collaboration

Work with classmates to create a ceramic tile mural based on impressions of nature. As a class, collect interesting leaves, shells, flowers, seedpods, nuts, twigs, and other natural forms. Make one size of square tiles, about ⅜" thick. Press the objects into the clay. Score the back of the tiles to prevent warping. Glaze and fire the tiles, then glue them to a large piece of plywood. Display the mural in your school.

## Computer Option

Use a paint program to create a simple graphic design based on nature imagery in the style of the tiles in Figs. 5–25 and 5–26. Search the Web for sites that show examples of tiles. Apply a bas-relief effect to the design.

Responding to Nature

193

## Sketchbook Tip
Suggest to students that they use their sketchbook as a place to keep pressed flowers, leaves, and grasses.

## Extend

- Students may glaze or paint their ceramic tiles. *To glaze:* Paint tiles with underglazes. Cover with transparent glaze or with colored glazes. To leave color only in the indents, coat the tile surface with a dark glaze or underglaze, and wipe off most of it. Fire dry glazeware in a ceramic kiln. *To paint:* Paint tiles with acrylic paints.

- Encourage students to make nature reliefs: Press natural objects (shells, leaves, pinecones) into clay slabs to create indents. Join four slabs on a base to create a box.

## Assess

### Check Your Work

Have students work in pairs to describe and compare textures, foreground, middleground, background, plants, animals, and landforms in their tiles.

## Close

Review the function and history of ceramic tiles in America. Share with students the information in the More Abouts. Suggest that they research the current status of tile-making in North America, or the history of ceramic arts in other parts of the world.

## Assessment Options

**Self** Have students use the Production Analysis worksheet in the Teacher's Resource Binder to write about the artwork they created in this lesson.

**Peer** Have students plan and present to a peer group, a five-minute demonstration for making a clay tile. Have peers use class-developed criteria to evaluate their understanding of the process of creating a ceramic tile.

## Social Studies

To illustrate how the seasons are reflected in the tea ceremony, display and discuss both winter and summer Japanese tea bowls, if available. Winter bowls have thick, narrow sides to keep the heat of the tea from escaping; summer bowls have wide, flared sides to allow the heat to escape. Have students use clay to make handmade tea bowls befitting a particular season, with designs based on local flora and fauna.

## Language Arts

Instruct students to write the title of their chosen artwork in a vertical column on the left side of a paper, and then to write a poem in which each line forms a row next to each letter. Instruct students that each horizontal phrase should say something about the artwork. Display the completed poems next to the artworks that inspired them.

# Connect to...

## Other Subjects

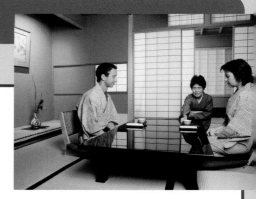

Fig. 5–31 **The Japanese word for tea is** *cha* **and the tea ceremony is called** *Chaji.* **Along with tea, guests are usually served a small meal.** *Tea Room in a Japanese Inn,* 1989. ©Bob Krist/CORBIS.

### Social Studies

Have you ever witnessed a **Japanese tea ceremony**? The tea ceremony, which developed under the influence of Zen Buddhism, symbolizes simplicity and the basic Zen principles of harmony, respect, purity, and tranquility. The ceremony varies with the seasons: appropriate tea bowls, types of tea, flowers, and scrolls are chosen for each time of year. Participants follow certain rules and procedures that communicate the highest ideals of the tea ceremony. Are there any similar ceremonies in other cultures? How could you find out?

### Language Arts

Why, do you think, have so many people from different times and cultures written poetry about the **beauty in nature**? Why are we so attracted to the natural world? Choose one artwork from this text that you believe is the best depiction of natural beauty. What are the reasons for your choice? How would you persuade another person to agree with you?

### Mathematics

In 1202, the Italian mathematician Fibonacci (Leonardo of Pisa) developed a sequence of numbers in which each term after the first two terms, which are both 1, is the sum of the two preceding terms. Do you see this pattern in 1, 1, 2, 3, 5, 8, . . .? What, do you think, is the next number in the sequence? Fibonacci made this and other significant contributions to the history of mathematics. The **Fibonacci sequence** appears in growth patterns in natural objects such as shells and has fascinated mathematicians and artists for centuries.

### Science

You may recall the story of an apple falling on Sir Isaac Newton's head, but do you remember the reason this event was so important? In 1687, Newton— possibly inspired by seeing an apple fall from a tree—proposed the **law of universal gravitation**. With this law he could account for the motion of the falling apple, the motion of the moon around the earth, the motion of the planets around the sun, and the paths of comets. Today, many of us take his theories for granted; but, in Newton's day, they dramatically transformed people's ideas about the natural world. How, do you think, does Newton's law of universal gravitation represent ideas of beauty in the organization of the universe?

**Internet Connection**
For more activities related to this chapter, go to the Davis website at **www.davis-art.com.**

## Teaching Options

### Resources

Teacher's Resource Binder
　Using the Web
　Interview with an Artist
　Teacher Letter

### Video Connection

Show the Davis art careers video to give students a real-life look at the career highlighted above.

### Interdisciplinary Tip

Work with social-studies teachers to help students understand the geography and history of Scandinavia, including the explorations of the Vikings.

## Careers

What kind of artist would be most likely to use natural materials for media? What do you think were the very first art materials? Since prehistoric times, **ceramists** (also called potters or clayworkers) worldwide have produced objects from clay. At first, pottery was made for practical purposes—for cooking food, storing grains, or use in ceremonies. Today's ceramists still produce functional items, but they also create work that is more aesthetic than practical. These artists may be production potters, who make large quantities of standardized pieces; or they may be fine artists, who create original, individual pieces. To work with clays and glazes, potters need some knowledge of chemistry. No matter how they practice their art— building pieces by hand or "throwing" them on a potter's wheel—ceramists are drawn to the hands-on pleasures of working with the physical and natural qualities of clay.

## Daily Life

Are you always in a hurry, or do you take the time to notice what happens around you in the natural world? In our fast-paced society, we often forget to slow down and really see the **world around us**. How can we develop a greater aesthetic awareness of the world's natural beauty? How can we learn to look more closely and appreciate the simplicity of a flower, the curve of a seashell, or a reflection in a raindrop?

Fig. 5–32 Nature is full of interesting shapes, colors, and designs. What color scheme does this leaf have? What type of balance do you see?
Photo © Karen Durlach.

## Mathematics

Have students research artists such as Leonardo da Vinci and Albrecht Dürer to discover where the Fibonacci sequence was illustrated in their artworks.

## Other Arts

Play selections from Paul Winter's *Canyon* album and from Ferde Grofé's *Grand Canyon Suite*. **Ask:** Which music is more expressive of the Grand Canyon? Why do you think so?

## Other Arts

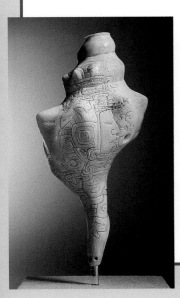

### Music

Musicians, like artists, have often been **inspired by nature**. For instance, Navajo musician R. Carlos Nakai plays a Native-American flute, an instrument made from natural materials, and he produces music that seeks to represent the connection that the Navajo feel with nature. Vivaldi also was inspired by the natural world: he produced the piece of classical music known as *The Four Seasons*. Paul Winter, a contemporary musician, took his interest in nature a step further: he performed and recorded his album *Canyon* in the Grand Canyon. The sounds of the natural environment and the acoustical characteristics of that huge outdoor space have given Winter's music a uniquely appealing sound.

Fig. 5–33 **This Mesoamerican artist combined art, music, and nature by transforming a shell into a decorated trumpet. Why do you think people have used natural objects as musical instruments?** Pre-Columbian, Maya (Guatemala), *Incised Conch Shell*, 250–400 AD.
Shell with cinnabar tracings, height: 11 9/16" (28.6 cm). Courtesy Kimbell Art Museum, Fort Worth, Texas.

Responding to Nature

195

## Internet Resources

### Canadian Museum of Civilization
http://www.civilization.ca/cmc/cmceng/welcmeng.html

Take a virtual tour of the halls, and investigate diverse artworks—from Japanese kimonos to African ritual figurines.

### Oakland Museum of Art
http://www.museumca.org/

Check out past, present, and upcoming exhibitions.

## Community Involvement

• Ask students to identify any buildings in the community that are decorated with ceramic tiles. If your area has a ceramic-tile store, invite the owner to bring in a selection of decorative tiles for display in your school.

• Ask a local lumber yard to donate samples of types of wood—such as oak, pine, walnut, and ash—that show a variety of natural grains. Assist students in arranging an exhibit on the beauty of natural wood.

• Invite an area stained-glass artist to bring in examples of his or her work and explain the process of creating them.

• Plan an architectural treasure hunt in your community. Have students identify buildings that have decorative or ornamental details based on forms in nature. Encourage students to find out which buildings in the community were constructed in the late nineteenth and early twentieth centuries.

## Talking About Student Art

When you have students talk about a student artwork, ask the student artist to listen to what others have to say. After the class has discussed the work, ask the student artist to respond to the comments and talk about his or her artistic intentions.

## Portfolio Tips

• Suggest to students that they use descriptive and expressive words to assist in the writing of peer reviews.

• Have students place a protective sheet of paper between all artworks in their portfolio.

## Sketchbook Tips

• Assign students to study an animal and make sketches showing anatomical details. Encourage students to write about what they see, and the ways that art and science are connected.

• Encourage students to take their sketchbook and spend quiet time in a favorite outdoor place where they like to be alone. They can make a series of simple drawings to describe their place. Challenge them to capture the essence of rocks, plants, or clouds with just a few simple strokes.

# Portfolio

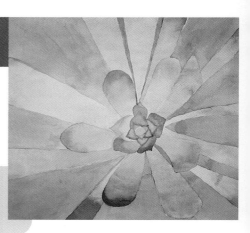

"I got the idea of painting it when we were working on Georgia O'Keeffe paintings. My favorite part is when the colors run." **Michael Santa Maria**

Fig. 5–34 Michael Santa Maria, *Watercolor Flower*, 1999. Watercolor, 18" x 24" (46 x 61 cm). Desert Sands School, Phoenix, Arizona.

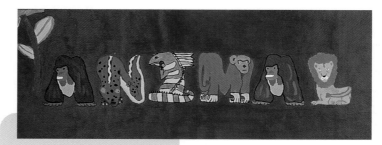

Fig. 5–35 Heidi McEvoy, *Animal*, 1999. Acrylic paint, 8 ½" x 23 ½" (21.5 x 59.5 cm). Fairhaven Middle School, Bellingham, Washington.

"I have always loved animals, so this seemed like a perfect project for me. My ideas just seemed to spring onto my paper as I began to think of what animal shapes to draw." **Heidi McEvoy**

"The moon and sky are inspiring to me. I wanted my monoprint to be bright with the colors of nature and the sunset." **Vicki Rokhlin**

**CD-ROM Connection**
To see more student art, check out the Community Connection Student Gallery.

Fig. 5–36 Vicki Rokhlin, *Funky Universe*, 1999. Monoprint, 14" x 17" (35.5 x 43 cm). Atlanta International School, Atlanta, Georgia.

196

## Teaching Options

# Chapter 5 Review

## Recall

How do artworks from the past show the awesome power of nature?

## Understand

Explain how artists help people investigate nature.

## Apply

Find examples of artworks in your home, school, or community that show our admiration for the beauty of nature.

## Analyze

Select an artwork from this chapter and tell how the artist used the principles of design to show the power and beauty of nature. Make sure to explain how the artist used design principles to attract and hold the attention of a viewer.

**For Your Portfolio**
Develop an artwork for your portfolio based on the theme of nature. Exchange your artwork with a peer and write a critique of each other's work. Describe important details and make connections between what you see and the artwork's message about nature. Comment on strengths and offer suggestions for improvement. Respond to the peer review. Include all of this in your portfolio.

**For Your Sketchbook**
Select one thing from nature and draw it in many different ways, from different points of view. Use different color combinations and explore different media and technical effects.

## Synthesize

Create an exhibition of items designed by graphic designers who were inspired by natural forms. Organize the exhibition according to categories. Your categories might indicate, for example, how graphic designers show the awesome power of nature, the beauty of nature, and the need to care for our natural environment.

## Evaluate

Imagine that you are a member of a group of people who will select a winning design for a set of postage stamps about nature (*see example below*). Write a brief statement of the rules for entering the contest, indicating the kinds of subject matter that might be submitted, and the standards that will be used to select the winning design.

Page 178

## Advocacy

Have students create posters, for display at area businesses, that focus attention on seeing beauty in nature. Ask students to use the theme "Art in the World Around Us" to show relationships between art objects and natural forms.

## Family Involvement

Invite family members to assist you in collecting natural forms (such as potted plants, seed pods, dried plants and flowers, and even artificial plant forms) for use in still lifes.

---

## Chapter 5
## Review Answers
### Recall

Ancient communities believed that gods and goddesses were the powerful forces of nature, and artists depicted these beings. Artworks also showed animals with magical powers, and animals and plants that represented human characteristics that people valued.

### Understand

Artists make scientific records of plants and animals. They also create fanciful artworks that not only depict plants and animals, but also convey ideas and feelings.

### Apply

Examples will vary. Possible examples: flower-patterned drapery fabric; paintings or prints of animals or plants; calendars, note cards, and wrapping paper that depict plants or animals.

### Analyze

Answers will vary. Check that students explain how the artist created a focal point or contrast to attract a viewer's attention, and how the artwork is unified to hold attention through balance, repetition, rhythm, and so on.

### Synthesize

Collections and categories will vary. Check for awareness of the range of items designed by graphic designers, and of the various messages that the items convey.

### Evaluate

Answers will vary. Check that students demonstrate knowledge of the range of subjects about nature, as well as the limits and potential of a postage stamp to convey a message.

### Reteach

Have students prepare a set of posters for the science classes, in which they illustrate the ways in which nature has been the subject of artworks. Have students decide on the focus of each poster, such as artworks that show nature as powerful, beautiful, and nurturing.

Summarize by indicating that art helps people in communities understand the power and beauty of nature.

# Chapter Organizer

## Chapter 6 Changing
Chapter 6 Overview
pages 198–199

### Chapter Focus
- **Core** Art reflects and inspires changes in technology, ideas, and ways of living in communities.
- **6.1** Confidence and Change: 1900–1920
- **6.2** Painting
- **6.3** Changing Perspectives in Russian Art
- **6.4** Exploring Styles

### Chapter National Standards
1. Understand media, techniques, and processes.
2. Use knowledge of structures and functions.
3. Choose and evaluate subject matter, symbols, and ideas.
4. Understand arts in relation to history and cultures.
5. Assess own and others' work.

---

**4 | 4 | 3**

**Core Lesson
Art and Change**
page 200
Pacing: Three to four
45-minute periods

### Objectives
- Identify ways that art reflects changes in community life.
- Use examples to explain how art inspires change in community life.

### National Standards
**4c** Analyze, demonstrate how time and place influence visual characteristics.
**5b** Analyze contemporary, historical meaning through inquiry.

---

**Core Studio
Making a Skyscraper**
page 204

- Use Post-Modern ideas about architecture to create an architectural model of a skyscraper.

**2b** Employ/analyze effectiveness of organizational structures.

---

**3**

**Art History Lesson 6.1
Confidence and Change**
page 206
Pacing: Three to four
45-minute periods

### Objectives
- Explain how early twentieth-century art reflected changes in both art and community life.
- Explain the significance of the Armory Show to North American art.

### National Standards
**1a** Select/analyze media, techniques, processes, reflect.
**4c** Analyze, demonstrate how time and place influence visual characteristics.
**5a** Compare multiple purposes for creating art.

---

**Studio Connection**
page 208

- Select subject matter and appropriate media to make a statement, in an artwork, about community life.

**1a** Select/analyze media, techniques, processes, reflect.

---

**2**

**Forms and Media
Lesson 6.2
Painting**
page 210
Pacing: Two or three
45-minute periods

### Objectives
- Identify the kinds of decisions painters must make about their work.

### National Standards
**1a** Select/analyze media, techniques, processes, reflect.
**4a** Compare artworks of various eras, cultures.

---

**Studio Connection**
page 211

- Make a painting to convey an idea about the theme of change.

**1b** Use media/techniques/processes to communicate experiences, ideas.
**3b** Use subjects, themes, symbols that communicate meaning.

## Featured Artists

Alexander Apsit
George Bellows
John Burgee
    Architects/ Philip
    Johnson
Jules Gherin
Cass Gilbert
Natalia Goncharova
Robert Henri

Lewis Hine
Kasimir Malevich
Joan Mitchell
Vera Mukhina
Georgia O'Keeffe
Nam June Paik
Jaune Quick-to-See-
    Smith
Jacob Riis

Aleksander Rodchenko
Ludwig Mies van der
    Rohe
John Sloan
Mark Tansey
Vladimir Tatlin
Alma Woodsey Thomas
John Henry Twachtman

## Chapter Vocabulary

abstract
avant-garde
cityscape
kinetic sculpture
pigments

pointillism
Post-Modern
technology

## Teaching Options

Teaching Through Inquiry
More About…Scientific advances
Using the Large Reproduction
More About…Lewis Hine

## Technology

CD-ROM Connection
    e-Gallery

## Resources

Teacher's Resource Binder
    Thoughts About Art:
    6 Core
    A Closer Look: 6 Core
    Find Out More: 6 Core
    Studio Master: 6 Core
    Assessment Master:
    6 Core

Large Reproduction 11
Overhead Transparency 11
Slides 6a, 6b, 6c

Meeting Individual Needs
Teaching Through Inquiry
Using the Overhead
Assessment Options

CD-ROM Connection
    Student Gallery

Teacher's Resource Binder
    Studio Reflection: 6 Core

## Teaching Options

Meeting Individual Needs
Teaching Through Inquiry
More About…The Armory Show
Using the Overhead

## Technology

CD-ROM Connection
    e-Gallery

## Resources

Teacher's Resource Binder
    Names to Know: 6.1
    A Closer Look: 6.1
    Map: 6.1
    Find Out More: 6.1
    Assessment Master: 6.1

Overhead Transparency 12
Slides 6d

Teaching Through Inquiry
More About…The Ash Can School
Assessment Options

CD-ROM Connection
    Student Gallery

Teacher's Resource Binder
    Check Your Work: 6.1

## Teaching Options

Teaching Through Inquiry
More About…Joan Mitchell
Using the Overhead
Assessment Options

## Technology

CD-ROM Connection
    e-Gallery

## Resources

Teacher's Resource Binder
    Finder Cards: 6.2
    A Closer Look: 6.2
    Find Out More: 6.2
    Assessment Master: 6.2

Overhead Transparency 11

CD-ROM Connection
    Student Gallery

Teacher's Resource Binder
    Check Your Work: 6.2

**9 weeks**

**18 weeks**

**36 weeks**

Lesson of your choice

| | | |
|---|---|---|
| | | **3** |

**Global View Lesson 6.3
Russian Art**
page 212
Pacing: Three 45-minute
periods

## Objectives

- Define how the term avant-garde applies to art.
- Explain changes in the direction of art in Russia in the early twentieth century.

## National Standards

**1a** Select/analyze media, techniques, processes, refle
**2b** Employ/analyze effectiveness of organizational structures.
**4a** Compare artworks of various eras, cultures.
**4c** Analyze, demonstrate how time and place influenc visual characteristics.

---

**Studio Connection**
page 214

- Select materials and create a kinetic sculpture based on the theme of change.

**1b** Use media/techniques/processes to communicate experiences, ideas.
**3b** Use subjects, themes, symbols that communicate meaning.

---

## Objectives

| | | |
|---|---|---|
| | **3** | **3** |

**Studio Lesson 6.4
Exploring Styles**
page 216
Pacing: Three or four
45-minute periods

- Understand the role of experimentation with media in the expression of ideas.
- Experiment with painting media, techniques, and styles, for the purpose of finding unique ways to describe subjects and themes.
- Work to develop a painting on the theme of change in your community.

## National Standards

**1a** Select/analyze media, techniques, processes, refle
**1b** Use media/techniques/processes to communicate experiences, ideas.
**3b** Use subjects, themes, symbols that communicate meaning.
**4a** Compare artworks of various eras, cultures.

---

## Objectives

**Connect to...**
page 220

- Identify and understand ways other disciplines are connected to and informed by the visual arts.
- Understand a visual arts career and how it relates to chapter content.

## National Standards

**6** Make connections between disciplines.

---

## Objectives

**Portfolio/Review**
page 222

- Learn to look at and comment respectfully on artworks by peers.
- Demonstrate understanding of chapter content.

## National Standards

**5** Assess own and others' work.

**2**

## Teaching Options

Meeting Individual Needs
Teaching Through Inquiry
More About…Natalia Goncharova
Using the Large Reproduction

## Technology

CD-ROM Connection
e-Gallery

## Resources

Teacher's Resource Binder
 A Closer Look: 6.3
 Map: 6.3
 Find Out More: 6.3
 Assessment Master: 6.3

Large Reproduction 12
Slides 6e

---

Teaching Through Inquiry
Assessment Options

CD-ROM Connection
 Student Gallery

Teacher's Resource Binder
 Check Your Work: 6.3

---

## Teaching Options

Meeting Individual Needs
Teaching Through Inquiry
More About…Alma Thomas
Using the Overhead
Assessment Options

## Technology

CD-ROM Connection
 Student Gallery
Computer Option

## Resources

Teacher's Resource Binder
 Studio Master: 6.4
 Studio Reflection: 6.4
 A Closer Look: 6.4
 Find Out More: 6.4

Overhead Transparency 11
Slides 6f

---

## Teaching Options

Curriculum Connection
Community Involvement
Interdisciplinary Tip

## Technology

Internet Resources
Video Connection
CD-ROM Connection
 e-Gallery

## Resources

Teacher's Resource Binder
 Using the Web
 Interview with an Artist
 Teacher Letter

---

## Teaching Options

Family Involvement
Advocacy

## Technology

CD-ROM Connection
 Student Gallery

## Resources

Teacher's Resource Binder
 Chapter Review 6
 Portfolio Tips
 Write About Art
 Understanding Your Artistic Process
 Analyzing Your Studio Work

## Chapter Overview

### Theme

People living in communities experience changes in technology, ideas, and ways of life. Art reflects and inspires changes in communities.

### Featured Artists

Alexander Aspit
George Bellows
John Burgee Architects/Philip Johnson
Jules Gherin
Cass Gilbert
Natalia Goncharova
Robert Henri
Lewis Hine
Kasimir Malevich
Ludwig Mies van der Rohe
Joan Mitchell
Vera Mukhina
Georgia O'Keeffe
Nam June Paik
Jaune Quick-to-See-Smith
Jacob Riis
Aleksander Rodchenko
John Sloan
Mark Tansey
Vladimir Tatlin
Alma Woodsey Thomas
John Henry Twachtman

### Chapter Focus

This chapter focuses on the way art reflects and inspires changes in technology, ideas, and ways of living in communities. Students learn how the early part of the twentieth century was a time of rapid change in community life and art. They explore how art traditions reflect such community changes, and how Russian artists also changed with the times. Students learn that, in times of

### 6 Changing

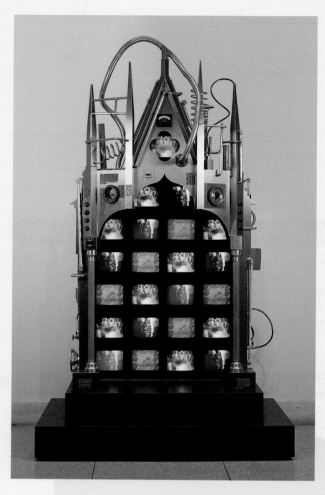

Fig. 6–1 **What message does this artwork send about television? What do you think it says about technology? Why do you think so?**
Nam June Paik, *Technology*, 1991.
25 video monitors, 3 laser disc players with unique 3 discs in cabinet. National Museum of American Art, Smithsonian Institution, Washington, DC./Art Resource, NY.

198

## National Standards
## Chapter 6
## Content Standards

1. Understand media, techniques, and processes.

2. Use knowledge of structures and functions.

3. Choose and evaluate subject matter, symbols, and ideas.

4. Understand arts in relation to history and cultures.

5. Assess own and others' work.

**Teaching Options**

### Teaching Through Inquiry

**Aesthetics** Have students address the question "Should all artists purposefully incorporate the latest technological developments in their artworks?" Have students work in groups to develop a two-column chart. Ask them to list, in one column, reasons *for* having all artists incorporate recent technology; and in the other column, reasons *against*. For each position, encourage students to consider the benefits for communities, artists, and the history of art. As a class, discuss each group's views.

### More About...

Since 1963, **Nam June Paik** (b. 1932) has used televisions as media. He typically creates three-dimensional forms with numerous sets, each of which transmits live or taped shots. Paik not only manipulates the placement of the televisions, but also their inner circuitry. He sometimes further disrupts our expectations by projecting viewers themselves as they watch the screens.

## Focus

- How do we adapt to changes in our lives?
- How does art reflect and inspire change?

**As you've grown up, what kinds of changes have taken place that make your daily life easier or more pleasant? Perhaps your school library has become computerized.** Or perhaps your family's newest car has a CD player in it.

Changes sometimes happen because of a new technology. **Technology** can help make life easier or more enjoyable. It can offer ways for people to meet their needs more quickly than they could before. New technology has also changed people's ability to communicate with each other. Can you remember when people didn't have cell phones, pagers, fax machines, or the Internet?

As technology changes, so do the materials and tools used to create art. New technology and its influence on communities often inspire artists to create art that reflects these changes. For example, the invention of the television in the early twentieth century changed the way people spent their free time. Now, the television is sometimes used as an art material. In the early 1960s, Nam June Paik began to experiment with television sets in his art (Fig. 6–1). He continues to use television sets as a sculptural medium. The television image is also important in Paik's artworks. He alters the shape, color, motion, and sound of each image to give the viewer a constantly changing experience.

### What's Ahead

- **Core Lesson** Discover how art reflects and inspires changes.
- **6.1 Art History Lesson** Learn how art in the early twentieth century reflected changes in art and community life.
- **6.2 Forms and Media Lesson** Learn how change influences painting traditions.
- **6.3 Global View Lesson** Explore how Russian artists changed the direction of art in Eastern Europe in the early twentieth century.
- **6.4 Studio Lesson** Create a painting that celebrates or promotes change in your community.

### Words to Know

| | |
|---|---|
| technology | avant-garde |
| Post-Modern | kinetic sculpture |
| cityscape | pointillism |
| pigments | Abstract |

Changing

199

change, painters often experiment with media and techniques. Students create a painting on the theme of change in their community.

## Chapter Warm-up

Lead students in discussing changes in their lifetime. Develop a list of inventions and objects (including popular games, toys, and technology) that have appeared in the last ten years, and then discuss their effects on us.

## Using the Text

**Art History** Ask students to read the text to get ideas about changes that affect everyday life. **Ask:** How have technological changes affected artists? *(Some artists now create art with computers. Artists such as Nam June Paik incorporate technology into their art.)*

## Using the Art

**Art Criticism Ask:** How did Paik include shape, color, motion, and sound in *Technology?* What does the overall shape of this sculpture remind you of? Are you reminded of a Gothic church or window? By enclosing TVs in this shape, what message might Paik be sending about technology and how we view it in our culture?

## Extend

Have students create art about a change in their life. Lead them in discussing significant changes, such as a move, a change in schools, or something new in their home. Suggest that they draw this with pencil and add color with markers, pencils, or paint.

---

## Graphic Organizer
## Chapter 6

**6.1 Art History Lesson**
Confidence and Change:
1900–1920
page 206

**Core Lesson**
Art and Change

**Core Studio**
Making a Skyscraper
page 204

**6.2 Forms & Media Lesson**
Painting
page 210

**6.3 Global View Lesson**
Changing Perspectives
in Russian Art
page 212

**6.4 Studio Lesson**
Exploring Styles
page 216

### CD-ROM Connection

For more images relating to this theme, see the Community Connection CD-ROM.

## Prepare

### Pacing

Three to four 45-minute periods: one to consider art and text; one to construct model; two to paint model

### Objectives

- Identify ways that art reflects changes in community life.
- Use examples to explain how art inspires change in community life.
- Use Post-Modern ideas about architecture to create an architectural model of a skyscraper.

### Vocabulary

**technology** The application of science to practical purposes.
**Post-Modern** Architectural style that combines some characteristics from past styles with increased use of decoration, line, and color.

## Teach

### Engage

Tell students when their school was built. **Ask:** What technology, materials, and methods were used in its construction? Were these typical of construction techniques at the time?

### Using the Text

**Art History** Have students read pages 200–201. **Ask:** What architectural innovations throughout history used the latest technology of their time? *(Roman arches, vaults, and*

### National Standards Core Lesson

**2b** Employ/analyze effectiveness of organizational structures.

**4c** Analyze, demonstrate how time and place influence visual characteristics.

**5b** Analyze contemporary, historical meaning through inquiry

---

6 CORE LESSON

# Art and Change

## Changes in Technology

Look at the buildings around you. What materials were used to build them? You might see materials from nature, such as stone and wood. Or you might see human-made materials, such as glass, steel, and concrete.

From the earliest of times, artists have used technology to create art and architecture. In ancient Rome, the invention of the arch,

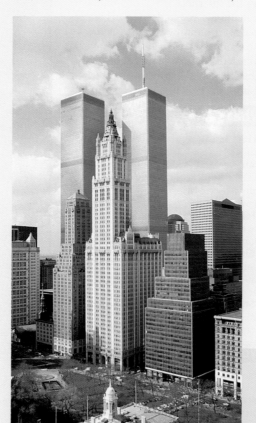

Fig. 6–2 **As more and more people moved into the city, skyscrapers became a necessity. The Woolworth Building is nestled in the center of this group of skyscrapers. Notice its decorative elements. How does it compare to the surrounding buildings?** Cass Gilbert, *Woolworth Building, New York, NY,* 1911–13.
© Peter Mauss/Esto. All rights reserved.

200

vault, and dome led architects to design huge buildings with no visible supports. Centuries later, architects designed suspension bridges, factories, and warehouses.

As cities grew, more and more people needed places to live and work. So, architects created high-rise buildings called *skyscrapers*. Before skyscrapers, most city buildings were low and spread out. Skyscrapers, such as the Woolworth Building in New York City (Fig. 6–2), provided space in a new and inventive way: from the basement to the "sky." See Studio Background (pages 204 and 205) to learn more about skyscrapers.

## Changes in People's Lives

In the late 1800s and early 1900s, many factories were built in North American cities. People from other countries and farm communities moved to the cities to find jobs. Workers and their families crowded into apartments. They had to adapt to many changes as they began their new life in the city.

During this time, artists made artworks to show both the good and the bad parts of living in urban areas. George Bellows was one of several American painters who tried

---

**Teaching Options**

### Resources

Teacher's Resouce Binder
Thoughts About Art: 6 Core
A Closer Look: 6 Core
Find Out More: 6 Core
Studio Master: 6 Core
Studio Reflection: 6 Core
Assessment Master: 6 Core
Large Reproduction 11
Overhead Transparency 11
Slides 6a, 6b, 6c

### Teaching Through Inquiry

**Art Production** Have students work in pairs to plan three artworks: one that reflects changes in ideas, one that reflects changes in technology, and one that reflects changes in ways of living. As they plan their artworks, encourage students to make notes and sketches in their sketchbook. As a class, discuss their plans.

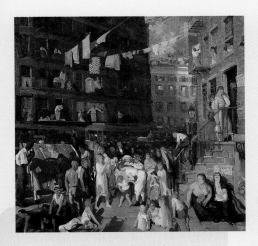

Fig. 6–3 The term "cliff dwellers" was used to describe groups of people who built their homes in cliff walls or rocky ledges. Why might this artist have used the same term as a title for this painting? George Bellows, *Cliff Dwellers*, 1913.
Oil on canvas, 40 ³/₁₆" x 42 ¹/₁₆" (104.6 x 106.8 cm). Los Angeles County Museum of Art, Los Angeles County Fund © 1998 Museum Associates, Los Angeles County Museum of Art. All Rights Reserved.

to capture the changes that were taking place in urban life. What does his painting titled *Cliff Dwellers* (Fig. 6–3) say about city life during this time?

## Changes in Ideas

At the beginning of the twentieth century, people all over the world were adapting to changes. After many years of hardship in Russia, a new form of government began there. The form of government was called *communism*. The main idea of communism was to create communities in which people worked together. They shared food and other necessary goods and services equally. Russian artists created artworks that pro-

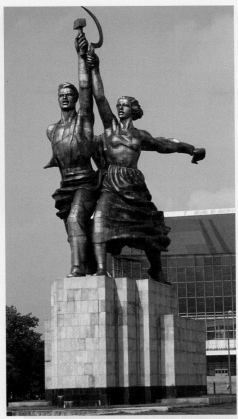

Fig. 6–4 How do the poses of the figures in this sculpture help express the idea of equality? Vera Mukhina, *Industrial Worker and Collective Farm Girl*, 1937.
Stainless steel, h. 79' (24 m), weight 75 tons, base h. 131 ¹/₂" (334 cm). Courtesy SovFoto/EastFoto. © Estate of Vera Mukhina/ Licensed by VAGA, New York, NY.

moted this change in people's daily lives. The sculpture by Russian artist Vera Mukhina (Fig. 6–4) shows a factory worker and a farm worker posed together and striving toward a common goal.

*domes; twentieth-century skyscrapers)* Imagine living in the early twentieth century and moving to the city. How might you feel about the newly-built skyscrapers?

**Art History** What is the communist message in Fig. 6–4?

## Using the Art

**Art Criticism Ask:** What are the main lines of the *Woolworth Building*? *(vertical)* Why would an architect create such a strong vertical design? How do you think the designer tried to make this building look? *(tall)* Point out to students that the building is narrower at the top, which allows sunlight to reach the streets.

**Art Criticism Ask:** What activities are shown in *Cliff Dwellers*? What is Bellows's message about the city?

## Critical Thinking

Lead a discussion about why a corporation would want to build and occupy a skyscraper. Compile a class list of possible reasons. Guide students to consider practical reasons of space for many workers who need ready access to one another, and also reasons of corporate identity and power.

## Journal Connection

Encourage students to describe several buildings in their community, telling how they reflect the technology of when they were built. Ask students also to write how they feel about these buildings—whether, for instance, they seem warm and inviting, cold and businesslike, or exciting and energetic.

Changing

201

## More About...

In 1543, Copernicus, a Polish astronomer, proposed that the sun, not the earth, is the center of the universe. His theory and subsequent work by Galileo dramatically changed the way people thought about the world, and they began to trust the process of scientific investigation as a way of learning more about the world and their relationship to it. Eventually, **artworks reflected scientific advances:** Among other things, artists developed systems of perspective and composition and investigated human anatomy and proportion.

Centuries later, ideas about the earth dramatically changed again, when the first images of earth were taken from outer space. Seen from afar, the earth seemed small and even fragile. Many artists echoed the environmental concerns of their communities by creating artworks that send messages about clean air, water, and similar issues.

## Using the Large Reproduction

**Talk It Over**

**Describe** Identify all recognizable objects in the painting.

**Analyze** How did the artist organize shape, line, color, and pattern?

**Interpret** How did the artist show changes in society?

**Judge** How well did the artist reflect community changes?

11

## Using the Text

**Art History** Have students read The Art of Persuasion. **Ask:** How did artists use photography to effect changes in child labor laws?

**Aesthetics** Ask students to recall the ways that they receive messages. *(television, books, billboards, Internet, newspapers, radio, package design, signs)* **Ask:** Which of these did an artist create?

## Using the Art

**Art Criticism Ask:** What, do you think, was each of these three artists protesting or advocating? How did each artist emphasize his or her message?

## The Art of Persuasion

What are some ways in which you receive messages? Your answer might include letters, phone calls, newspapers, magazines, books, or conversations. You can also receive messages from art.

From the time of the earliest cave paintings, art has influenced, and even changed, people's views and opinions. For example, political posters have persuaded people to change the way they think about issues such as equality and democracy. Artworks can call attention to environmental concerns, such as erosion, endangered species, or poverty. Through their art, artists can inspire changes within their own communities.

With the invention of photography, artists were quick to use the new medium. First, they used it to make photographs that looked like paintings. They could also document what was happening in the world. Now viewers could see real people and real-life situations. When artists realized the possibilities, they explored photography as its own art form.

## Artworks that Change Minds

The three artworks shown here try to influence people's views in different ways. Jaune Quick-to-See Smith's painting, *The Spotted Owl* (Fig. 6–5), makes a strong statement against the timber industry. The artist hoped that this artwork would encourage people to think about our endangered environment. In *Little Girl in Carolina Cotton Mill* (Fig. 6–6), Lewis Hine tried to draw attention to a need for change in a community. When this photograph was taken in 1908, children were sent to work long hours in dirty, dangerous factories. Since then, child labor laws have stopped this practice in the United States. The poster from Russia (Fig. 6–7) is another example of art for political change. In 1705, Peter the Great passed a law that angered the people. Part of the law stated that all but certain groups of men had to shave off their beards. The act went against ancient custom and the rules of the church. In this image, the bearded gentleman shows his resistance.

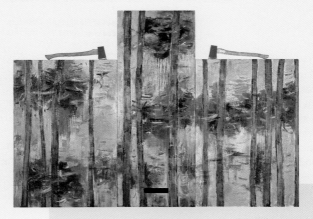

Fig. 6–5 **In this artwork, the artist reminds viewers about the need to care for the delicate balance of nature. The timber industry is endangering the spotted owl by cutting old growth forest in the Northwest. What elements of the artwork symbolize the danger?** Jaune Quick-to-See-Smith, *The Spotted Owl*, 1990. Oil, beeswax on canvas, 2 axes, wood panel, 80" x 116" (203.2 x 294.6 cm) triptych. Courtesy Bernice Steinbaum Gallery, Miami.

## Teaching Options

### Meeting Individual Needs

**Multiple Intelligences/Naturalistic and Linguistic** Have students study all the images on pages 198–205, and ask them to help you make two lists. One list should be of artworks that show a positive attitude toward changes in technology. The other should list artworks that show a more negative or questioning attitude. Have students select one image from each list, and write an imaginary debate between the two artists, about the pros and cons of technology.

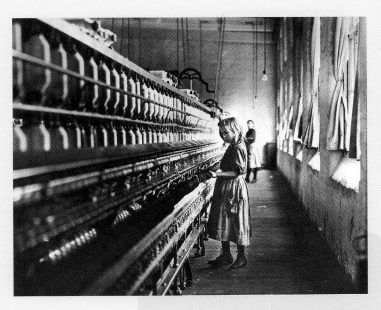

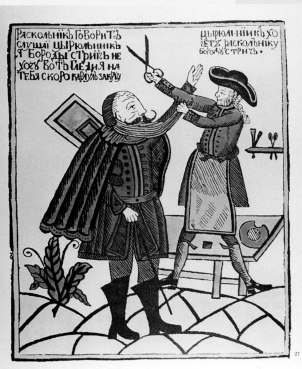

## Critical Thinking

Guide students to research other examples of photojournalism to discover how photography changed public perception and brought about change. For example, Jacob Riis's 1880s images of New York slums led to major changes in building codes and labor laws; photographs of scenes from the Vietnam conflict and Dorothea Lange's studies of the 1930s dust bowl heightened public awareness of suffering. Have students locate photographs that caused a change in viewers' attitudes.

## Journal Connection

Ask students to jot down ideas about photography, signs, and videos that they see in their everyday life, that influence their thinking. Encourage students to reflect on why they notice these visuals and how they respond to them.

Fig. 6–6 Imagine having to work in a factory instead of going to school or playing on the soccer team. If you were to see a photograph like this in the newspaper, how would it make you feel about your own life? Lewis Hine, *Little Girl in Carolina Cotton Mill*, 1908. Silver gelatin print. ©Corbis-Bettmann.

Fig. 6–7 While most of us can't read the Russian words on this poster, we can guess that they might show the dialogue between the two men. How does poster art influence people to think about artists' messages? Russia, *The Barber Wants to Cut the Old Believer's Whiskers*, ca. 1770. Woodcut, 38" x 30" (96.5 x 76.1 cm). Courtesy Scott Archive.

Changing

203

### Teaching Through Inquiry

**Art Criticism** Remind students that the three artworks were made to inspire changes in the way people think and behave. Have students work in small groups, assign each group one of the artworks, and have each student assume the role of one part of the assigned artwork. For instance, one student might be a tree in Smith's painting, or the child in Hine's photograph. Ask students to prepare a monologue in which they explain their role in the artwork, and how they work with the other parts of the artwork to effect change in how viewers think and behave. Have one student from each group perform his or her monologue for the rest of the class.

### More About...

**Lewis Hine** (1874–1940) used his artworks, which he called "photo-interpretations," to draw attention to the lives of the poor, children, and immigrants struggling in harsh conditions. He also celebrated positive human undertakings in his pictures of the American Red Cross relief in Europe and of American workers, such as those who built the Empire State Building.

## Supplies

- cardboard or foam core
- scissors
- glue or tape
- X-acto knives (optional)
- tempera or acrylic paints, colored pencils or markers (optional)
- foil, cellophane, acetate, wood scraps or dowels (optional)

## Using the Text

**Art History** Have students read The Rise of Skyscrapers. Encourage students to explain the Modern credo "Less is more" and the Post-Modern "Less is a bore."

**Art Production** Review characteristics of Post-Modern architecture, and encourage students to sketch ideas for a skyscraper and to consider a particular site for it. Guide students in considering how the location and purpose of their building should be reflected in its design.

Demonstrate cutting shapes from cardboard or foam core and joining them with glue or tape. Suggest that students might "construct textures" for their buildings by using cellophane or acetate as glass, foil as metal, and wood.

## Using the Art

**Art Criticism** Challenge students to compare the design of the Woolworth Building (Fig. 6–2) to that of the Seagram Building (Fig. 6–10). **Ask:** How is each building decorated? Why is the Pittsburgh Paper and Glass Building (Fig. 6–8) an appropriate symbol for the firm that built it? *(The firm produces glass.)*

### Sketchbook Tip

Suggest that students draw buildings in their community, especially those with patterns formed by repeated windows and textures. Have students design a building to fit their community. Ask: What would be its purpose? What materials would be used?

---

### Sculpture in the Studio

# Making a Skyscraper

The next time you're in a city, look closely at the buildings around you. You will probably see vast differences in their forms, decorations, and colors. You will probably also recognize the different materials, such as stone, glass, or steel that were used to build them.

The buildings in most cities were designed at different times over many decades. Clearly, the styles of buildings have changed over time. Skyscrapers reflect some of the biggest changes in architecture of the twentieth century. **In this studio experience, you will build a model of a Post-Modern skyscraper.** To learn more about Post-Modern architecture, read the Studio Background.

### You Will Need

- sketch paper
- pencil and eraser
- cardboard or foam board
- scissors
- glue or tape
- tempera or acrylic paint
- colored pencils or markers

### Try This

**1.** Sketch your ideas for a skyscraper. Determine the main shapes of your building. What materials might be used to build it? How big will it be?

**2.** Cut the main shapes from cardboard or foam board. Glue or tape them together to construct a model of your design.

**3.** Add windows and doors to your model with drawing materials or cut paper.

## Studio Background

### The Rise of Skyscrapers

At the turn of the century, two changes in technology allowed architects to develop the skyscraper. The first change was the use of steel as a building material. With steel, architects could create building frames that were taller and stronger than the frames of buildings from the past. The second change was the invention of elevators. As elevators were designed to

Fig. 6–8 This Post-Modern skyscraper borrows elements from Gothic architecture seen in Europe. What similarities and differences do you see between this skyscraper and the Seagram Building (Fig. 6–10)? John Burgee Architects with Philip Johnson, *PPG Place*, 1984. Pittsburgh. Courtesy Richard Payne.

---

## Teaching Options

### Meeting Individual Needs

**Adaptive Materials** Precut material for students to decorate; or have students design the building, and cut out the design for them.

**Focusing Ideas** Instead of having students create a new design, give them several building designs from which to choose, and then have them decorate the skyscraper to make it original. Eric Nash's *Manhattan Skyscrapers* (Princeton Architectural Press, 1999) is a helpful reference book, with photos.

### Teaching Through Inquiry

**Art History** Invite students to consider some of the local architecture they use, such as restaurants, stores, movie theaters, or a house. Allow students to work alone or in pairs to select one of these and speculate how the design of such structures has changed over the years. Students might wish to draw or write their thoughts. Encourage students to investigate the architectural history of their chosen building type, and then to present to the class an oral report or a visual display.

**4.** Use paint or drawing materials to create colors and surface textures. Add other details as desired.

**Check Your Work**

Display your completed model and statement with those of your classmates. What features of Post-Modern architecture do you see in each model?

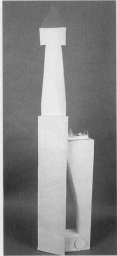

Fig. 6–9 **This student pictures his skyscraper in Chicago. He imagines it as an office building and a place for people to come sightseeing.** Dan Quinn, *Quinn Towers*, 2000. Cardboard, glue, paint, 62 ½" x 14" x 8" (159 x 35.5 x 20 cm). Thomas Prince School, Princeton, Massachusetts.

**Sketchbook Connection**
Walk through your town or city and notice the different materials that were used to create its buildings. What colors and textures do you see? Sketch a variety of the buildings' textures and note their colors. Refer to your sketches when you build your model.

**Core Lesson 6**

### Check Your Understanding

**1.** What are some ways that art reflects change in community life?
**2.** Cite examples from this chapter that show how art inspires change in communities.
**3.** What do changes in architecture say about communities?
**4.** The invention of elevators allowed for the development of skyscrapers. How might the use of moving sidewalks influence architectural design in years to come?

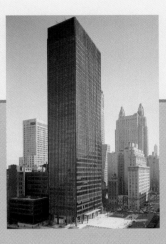

rise faster and farther, buildings could be made taller. These early skyscrapers had clean, simple lines. They clearly showed the structure of the buildings and the materials used to create them.

In the 1960s and 1970s, architects felt that the simple lines of this *Modern* style of architecture were too rigid and tiresome. They began looking to buildings from the past for ideas. Soon they were adding decorative forms and details to the simple lines that characterized Modern architecture. This new **Post-Modern** style of architecture combined line, color, and decoration. Post-Modern architects used new materials to build their skyscrapers, and combined the materials in unexpected ways.

Fig. 6–10 **This Modern-style skyscraper is made of amber glass and bronze. Notice the simple lines of its design. Almost every city has an imitation of this building. Why might cities find this skyscraper design so appealing?** Ludwig Mies van der Rohe, *Seagram Building, New York, NY*. Photograph by Ezra Stoller © Esto. All rights reserved.

Changing

205

### Assess

#### Check Your Work

Help students arrange their skyscraper models. Lead a discussion of the ways various models show architectural features from particular style movements.

**Check Your Understanding: Answers**

**1.** Art reflects changes in technology, people's lives, and community ideas.

**2.** Answers will vary. Sample response: Smith's art inspires people to stop old-growth logging; Hine's art calls attention to child labor; the Russian poster motivates political change.

**3.** Changes in architecture reflect a community's adapting to changes in technology, needs, and ideas about art.

**4.** Answers will vary but might include the idea that airports, shopping malls, or hotels can be developed over larger areas.

### Close

Ask students to consider some changes in their world during their lifetime. Brainstorm with students and list on the chalkboard. **Ask:** Which of these might art have helped bring about? Which of these is shown in artworks you have seen?

---

**Using the Overhead**

**Ideas** What might have been the artist's source of ideas for this artwork?

**Materials** What materials did she use?

**Techniques** How did she work with these materials to achieve the effects?

**Audience** For whom do you think the artist created this work?

**11**

**Assessment Options**

**Self** Ask students each to write a letter to a family member or friend, telling what they used to think; what they have learned; and what they still wish to know about the ways that art reflects and inspires change. Encourage students to cite artworks from the book to help make their points clear to their reader.

## Prepare

### Pacing
Three to four 45-minute periods: one to consider art and text: three to make art

### Objectives
- Explain how early twentieth-century art reflected changes in both art and community life.
- Explain the significance of the Armory Show to North American art.
- Select subject matter and appropriate media to make a statement, in an artwork, about community life.

### Vocabulary
**cityscape** An artwork that shows a view of a city as subject matter.

### Supplies for Engage
- photographs and information about your community during the early 1900s (from the historical society, library, books, or long-time residents)

### Using the Time Line
**Ask:** How did American cities change during the first two decades of the twentieth century? What major conflict happened during this time? What amendment was passed?

### National Standards
### 6.1 Art History Lesson

**1a** Select/analyze media, techniques, processes, reflect.

**4c** Analyze, demonstrate how time and place influence visual characteristics.

**5a** Compare multiple purposes for creating art.

# Confidence and Change: 1900–1920

| | | | |
|---|---|---|---|
| **ca. 1898** Riis, *Class in Condemned School* | **1907** *Plan of Chicago* | **1917** Sloan, *Gloucester Trolley* | |

Late 19th Century page 180

**Industrial America**

American Regionalism page 232

**1902** Henri, *Street Scene*

**1927** O'Keeffe, *Radiator Building*

### History in a Nutshell
During the first decade of the twentieth century and the years before World War I, industry grew rapidly in the United States. The thousands of immigrants who arrived on American soil added to the growth of cities. For the nation's communities, this was a period of expansion and hope for the future.

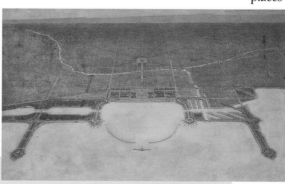

Fig. 6–11 As cities developed, there was a need to design parks and places where people could gather. This plan of Chicago was created in 1907. It shows a proposed civic center, a park, and the waterfront. Why might newcomers at the time have found this plan exciting? Jules Gherin, (Daniel H. Burnham and Edward H. Bennett, Chicago, Illinois partnership 1903–12), *Chicago: View Looking West over the City Showing the Proposed Civic Center, the Grand Access, Grant Park and the Harbor; Plan of Chicago, 1909*, plate 87, 1907.
Watercolor and graphite on paper, 57 1/8" x 91 3/4" (145.5 x 233 cm). Gift of Patrick Shaw, 1991.1381. Photograph courtesy The Art Institute of Chicago.

### Art for Change, Changes for Art

During these years of industrial and economic strength in the United States, American artists turned their attention to cities. The subjects of their artwork were places where people gathered: streets, parks, beaches, restaurants, theaters, and nightclubs. Look at the **cityscapes** —artworks that show a view of a city—of New York and Chicago. *Radiator Building–Night, New York* (Fig. 6–13) by Georgia O'Keeffe shows an inviting nighttime scene. It reflects people's feelings at this time about cities as good places to live. The view of Chicago (Fig. 6–11) is shown from above, as though the artist were looking down on it from an airplane.

At first, artists of this time were mainly interested in how the change in cities gave them new subject matter for their art. They could shift the focus of their art from landscapes to cityscapes. After a while, however, artists and photographers wanted to use their art to influence new changes in communities. Their artworks called attention to social and economic problems, such as injus-

206

## Teaching Options

### Resources
Teacher's Resource Binder
  Names to Know: 6.1
  A Closer Look: 6.1
  Map: 6.1
  Find Out More: 6.1
  Check Your Work: 6.1
  Assessment Master: 6.1
Overhead Transparency 12
Slides 6d

### Meeting Individual Needs
**Gifted and Talented** Have students look at images in this chapter and identify which ones show the reality of city life. Ask students to select a current problem in urban America and create their own art that will urge people to correct the situation. Discuss ways that students can best use realistic or abstract images to influence viewers. When the artworks are complete, have each student describe how his or her own view of the cause might have changed as a result of this activity.

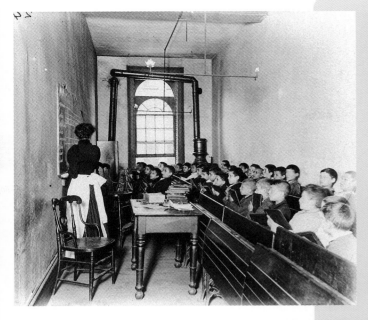

Fig. 6–12 **How is this classroom like yours? What do you think the artist was saying about the condition of schools at the turn of the century?** Jacob Riis, *A Class in the Condemned Essex Market School with Gas Burning by Day,* ca. 1898.
Silver gelatin print. Museum of the City of New York, The Jacob A. Riis Collection.

Fig. 6–13 **How does this painting make you feel? If you saw it in a travel brochure about New York, would it make you want to go there?** Georgia O'Keeffe, *Radiator Building—Night, New York,* 1927.
Oil on canvas, 48" x 30" (121.9 x 76.1 cm). The Carl Van Vechten Gallery of Fine Arts, Fisk University Galleries, Nashville, Tennessee. © 2000 The Georgia O'Keeffe Foundation/Artist Rights Society (ARS), New York.

tice, poverty, and overcrowding in American cities. Artists began to express their feelings about these problems. The photograph by artist Jacob Riis (Fig. 6–12) shows students in a city classroom. Look closely at the photograph. Imagine what city schools were like in the early twentieth century.

In 1913, a major art exhibition in New York City greatly influenced change in the art of the United States. The show was called the "International Exhibition of Modern Art" (later called "the Armory Show"). After viewing this exhibition, people in the United States thought that American art was behind the times compared to the new art by European artists. In the years following the Armory Show, artists shifted their attention away from the public community. Instead, they began using their art as a way to express their personal feelings.

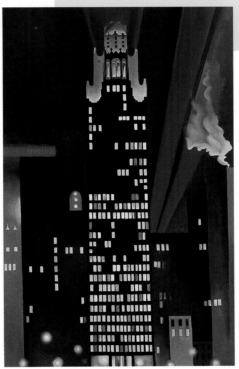

Changing

207

## Teach

### Engage

Share the information about your community. **Ask:** In 1920, what buildings were standing? Was this school? Were there any main industries? Have these changed? If you were to create an artwork about this period in the community, what would you show?

### Using the Text

**Art History** Have students read pages 206–207. **Ask:** Why did artists change their focus to social and economic problems? Discuss students' answers to the caption questions for Fig. 6–12. Point out the title as an aid to understand the setting. Explain that by calling attention in newspapers and books to dangerous and unhealthful conditions in New York slums, Riis's photographs led to changes in the city's labor laws and housing codes.

### Using the Art

**Art Criticism Ask:** How did O'Keeffe create a sense of grandeur in *Radiator Building?* Where are the light sources in this painting? What are the shapes? Which are geometric? Which are organic? How do they contribute to the feeling, or mood, of this painting?

## Teaching Through Inquiry

**Art Production** Challenge students to collect—from newspapers and magazines—pictures and articles that report on social conditions, unfair practices, injustices, health issues, and so on. Have students use their collection, along with images in this book, to generate ideas for an artwork that, through imagery but no words, calls for change.

## More About...

The 1913 **Armory Show** introduced Americans to the most advanced European art of the day, largely characterized by bold abstraction and unrealistic color. While some American artists and viewers were greatly impressed by the new European art, others disliked the cutting-edge styles.

## Using the Overhead

**Investigate the Past**

**Describe** What subject matter and details are noticeable?

**Attribute** What clues do you have as to when and where this was painted? What is the style?

**Interpret** What do you think this work meant to people at the time it was created?

**Explain** What situations or conditions might have influenced the artist?

**12**

207

## Confidence and Change

### Using the Text

**Art History/Criticism** Have students read Art in the City. **Ask:** Who were the artists known as "The Eight"? Why, do you think, were they called the Ash Can School? Why did they paint this subject matter?

### Using the Art

**Art Criticism Ask:** In what ways are these street scenes similar? How did each artist indicate distance? (one-point perspective) What was each artist's message? What is the mood of each work? How did each artist achieve this?

### Studio Connection

Gather these supplies: heavy paper (watercolor, manila, or drawing), paints, brushes, drawing media (markers, pencils), collage materials, scissors, and glue (optional).

Discuss what messages students might want to send about life in their community. Have students sketch ideas before drawing their scene on heavy paper, and allow them a choice of drawing media, paints, and collage materials. Encourage students to fill in larger areas first and then add details, and to look at their work from a distance when they near completion.

**Assess** See Teacher's Resource Binder: Check Your Work 6.1.

### Extend

Assign students to research an Ash Can School artist and his work, and then to create posters that describe important events in his life and that include several photocopied examples of his art. Direct students to describe the artist's typical subjects and techniques.

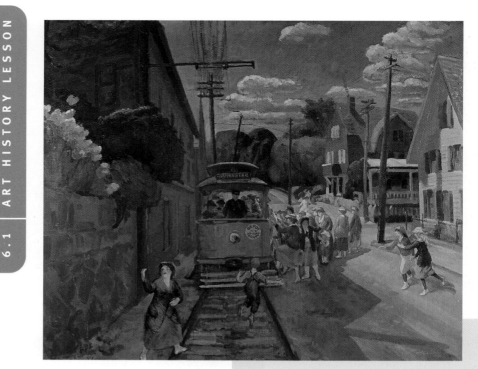

Fig. 6–14 **What colors help make this painting cheerful? How do they compare to the colors in** *Street Scene with Snow* **(Fig. 6–15)?** John Sloan, *Gloucester Trolley*, 1917.
Oil on canvas, 25" x 30 ½" (63.5 x 76.8 cm). Courtesy Canajoharie Library and Art Gallery.

## Art in the City

One group of artists from the early twentieth century became known as "The Eight." Artists Robert Henri and John Sloan led the group, which included George Luks, William Glackens, Everett Shinn, Maurice Prendergast, Arthur B. Davies, and Ernest Lawson. These eight artists also were called the *Ash Can School* because they liked to show real scenes of city life in their artworks. They painted images from both the upper class and poorer neighborhoods of New York City. They did not create their artworks to express feelings about the differences between these neighborhoods. These artists thought this subject matter made

their art interesting and lively. They showed the streets and people of city communities as they really looked. Some people didn't like this realistic look at city life.

Artists of the Ash Can School dared to show the dirt and grime of real life. Their artwork reflected how the changes of the twentieth century affected people's daily lives. John Sloan's *Gloucester Trolley* (Fig. 6–14) shows neighborhood people rushing to catch the trolley. While the neighborhood might be poor, Sloan creates a cheerful feeling in his painting. Robert Henri captures a more somber mood in *Street Scene with Snow* (Fig. 6–15).

208

### Teaching Through Inquiry

**Aesthetics** Have students work in small groups to choose a place in the community for a **public sculpture**. Ask groups to decide what kind of art would fit in the place and to explain why, and then to consider how to present their proposal, anticipating possible opposition based on various beliefs about art. Have students use the Role Playing cards and the Beliefs About Art Cards in the Teacher's Resource Binder to better understand the possible viewpoints about their proposal.

**Studio Connection**

Create a cityscape. How can you show a real life scene from your community or a community you know? What statement can you make about life there? Think about the media you might use. Be imaginative about your subject matter. Will you include a waterfront or an industrial area? An old factory or building that stands empty? Is there a beautiful view that you like? Think about the colors of shop displays, houses, and buildings. What do the people on the street look like? Try to capture something about the community that could not be seen anywhere else.

**6.1 Art History**

**Check Your Understanding**

1. Why did artists turn their attention to cities as a source of subject matter?
2. How did art in the first decades of the twentieth century reflect changes in art and community life?
3. What major art exhibition in New York influenced the future of art in the United States?
4. What was the main subject matter of Ash Can School artists?

**Assess**

**Check Your Understanding: Answers**

1. They saw cities as representative of economic and industrial strength, as well as the resulting social problems and injustices.

2. The subject matter of art shifted from landscapes to cityscapes. Also, many artists began to use art to express their feelings about social problems such as poverty, overcrowding, and injustice.

3. the International Exhibition of Modern Art (the Armory Show)

4. real-life scenes of the city

**Close**

Have students title their cityscape to clarify what they tried to show about their community. Display their titled artworks, and discuss the messages that students see in one another's work. After students answer the questions in Check Your Understanding, call on students to share their answers with the class. Reteach areas of misunderstanding.

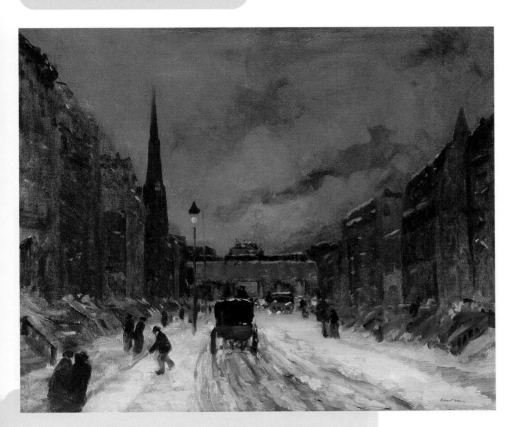

Fig. 6–15 **Do you think that the city street shown here actually looked like this? Why or why not? How did the artist create the mood of a city neighborhood in this painting?** Robert Henri, *Street Scene with Snow, East 57th Street, New York*, 1902. Oil on canvas, 26" x 32" (66 x 81.3 cm). Yale University Art Gallery, Mable Brady Garvan Collection.

Changing

**More About...**

Many of the American Realist artists of the **Ash Can School** began their careers working for magazines or newspapers, recording the life of average people. They later brought these views to their artwork. They recorded crowded streets, back yards, early morning views of the city, snow-filled avenues, and other glimpses of urban life. The artists were unfavorably called the Ash Can school after their first show, in 1908, because their subject matter focused on the dull aspects of ordinary, urban living.

**Assessment Options**

**Teacher** Ask students to research, and write an essay on, the significance of the Armory Show in the history of North American art. Instruct students to identify at least three artists whose work was influential to the show, and three artists whose work was affected by it.

**Peer** Ask students to select one work in this lesson as a good example of how early-twentieth-century art reflected a major change, and another as a good example of art that brought about changes in community life. Have students write a caption for each work so as to explain how the two artworks reflect changes both in art and in community life. Have students pair up, check each other's response, and discuss differences in selections.

## Prepare

### Pacing
Two or three 45-minute periods

### Objectives
- Identify the kinds of decisions painters must make about their work.
- Make a painting to convey an idea about the theme of change.

### Vocabulary
**pigments** Coloring materials made from earth, crushed minerals, plants, or chemicals. Pigments are mixed with a liquid or binder (such as glue, egg, wax, or oil) to make paint, ink, dyes, or crayons.

## Teach

### Engage
Ask students to describe a favorite painting that they have seen.

### Using the Text
**Art Production** Assign students to read the text. **Ask:** What is pigment? What are some other ways that artists apply paints, besides using brushes or palette knives?

### Using the Art
**Art Criticism Ask:** How, do you think, did Mitchell move about the canvas as she painted *Mountain*? How did she move her brush? Why is *action painting* an appropriate term for *Mountain*?

# Painting

Painting is one of the oldest and most colorful forms of art. Paintings hang in people's homes and offices and in libraries, hospitals, and museums. How many different styles of painting, such as realistic, abstract, or fantasy, have you seen? Subjects, themes, and styles of painting can reflect the culture, artistic traditions, and time period in which the artist lives. As communities change, so do painting traditions. Since the Renaissance period, most artists in Western culture have tried to develop their own individual styles and methods of painting.

Painters must make decisions about subject matter, materials, and techniques. Local traditions and changes in communities can influence these decisions. Painters' choices of subjects or themes may reflect the history and traditions found in the places where they live. An artist's decisions about tools and materials may depend on what is available at the time.

Most paints are made from powdered **pigments**—coloring materials made from earth, crushed minerals, plants, or chemicals. Pigments are held together with glue, egg, wax, or oil. Paint is applied to a surface such as paper, canvas, wood, or plaster. It is usually applied with a paintbrush. Paintbrushes come in all sizes and shapes. A painter might also use a palette knife—a dull-edged tool for spreading and mixing paint.

Artists experiment with paints and painting techniques. Some recent artists have used house paints and paints mixed with sand or other materials. They have applied paint with rollers, sponges, and their hands. Some pour, drip, or spray paint onto a surface, or squeeze it directly from the tube.

Compare the paintings in this lesson. In what ways are their styles different? What techniques did the artists use to create their images?

Fig. 6–16 **When artists plan a painting, they choose a color scheme that will help express their ideas. This artist has created a *monochromatic*—one color—color scheme with shades of blue-green. What kind of mood does his color create?** Mark Tansey, *Action Painting no. 2,* 1984. Diachrome, 76" x 100" (193 x 254 cm). Collection du Musée des beaux-arts de Montreal/The Montreal Museum of Fine Arts' Collection. Photograph: Brian Merrett, MMFA.

210

### National Standards
### 6.2 Forms and Media Lesson

**1a** Select/analyze media, techniques, processes, reflect.

**1b** Use media/techniques/processes to communicate experiences, ideas.

**3b** Use subjects, themes, symbols that communicate meaning.

**4a** Compare artworks of various eras, cultures.

## Teaching Options

### Resources
Teacher's Resource Binder

Finder Cards: 6.2

A Closer Look: 6.2

Find Out More: 6.2

Check Your Work: 6.2

Assessment Master: 6.2

Overhead Transparency 11

### Teaching Through Inquiry

**Art Production** Provide students with an assortment of paint and tools for applying paint, and ask them to explore painting materials and techniques. Have students write specific notes about the appropriateness of each material and technique for expressing certain ideas or depicting certain subject matter. Ask students to share and discuss the results of their investigations.

Fig. 6–17 **This style of painting is called Action Painting or Abstract Expressionism. Notice how the brushstrokes look like they were placed anywhere and everywhere. Do you feel a sense of energy when you look at this artwork?** Joan Mitchell, *Mountain*, 1989. Oil on canvas, 110 1/4" x 157 1/2" (280 x 400 cm). Photograph courtesy Robert Miller Gallery, New York (RGM# MITC-0228) © The Estate of Joan Mitchell.

## Critical Thinking

**Ask:** Why is Tansey's painting humorous? How did Tansey make this art *about* art? *(pokes fun at the idea that paintings accurately depict events)*

## Studio Connection

 Discuss ideas for a painting about change—perhaps one that shows stages of a metamorphosis, or a view in different seasons. Instruct students to sketch their ideas.

Provide students with paint and surfaces (watercolor paper, cardboard, canvas board, Masonite coated with gesso). Inform students of the advantages of each. Discuss which colors students might use.

**Assess** See Teacher's Resource Binder: Check Your Work 6.2.

## Assess

### Check Your Understanding: Answers

**1.** decisions about subject matter, materials, and techniques

**2.** History and traditions may be reflected in choices of subject; what is available locally may be reflected in choices of materials and techniques.

## Studio Connection

Make a painting to convey an idea about the theme of "change." What kinds of change do you see around you? How could you use paint to express an idea about such changes?

Make decisions about the idea you wish to express and the kind of materials you will need to express the idea. How big will your completed work be? What painting techniques will best convey your idea? Look at many examples of painting in your book and elsewhere to help plan your work.

### 6.2 Forms and Media

**Check Your Understanding**
**1.** What decisions must painters make about their work?
**2.** How do changes in communities influence painters' decisions?

## Close

Display students' paintings, and have partners explain their work to each other.

---

## More About...

**Joan Mitchell** (b. 1926) was a leading member of the second generation of Abstract Expressionists. Although her artwork is abstract, it does refer to the visible world. She states: "My paintings are about a feeling that comes to me from the outside, from landscape." Mitchell's lines skim across her work, recalling her childhood years as a champion ice skater.

## Using the Overhead

**Write About It**

**Describe** Write two sentences to describe the subject matter.

**Analyze** Have students write about how the artist organized the art elements to create emphasis and a center of interest.

## Assessment Options

**Peer** Have students create a booklet on painting, for their own use, in which they focus on the potential of painting for expressing ideas and feelings. Emphasize to students that they include ways to identify an artwork as a painting, an explanation of the materials commonly used in painting, and a description of techniques commonly used to make paintings. Ask students to develop additional criteria for assessing their booklets, and have partners use the established criteria to assess each other's booklet.

## Prepare

### Pacing

Three 45-minute periods: one to consider art and text; two to make art

### Objectives

- Define how the term *avant-garde* applies to art.
- Explain changes in the direction of art in Russia in the early twentieth century.
- Select materials and create a kinetic sculpture based on the theme of change.

### Vocabulary

**avant-garde** Art that is original and different from traditional styles of art. Avant-garde artists often experiment with new materials and ways of expressing ideas.

**kinetic sculpture** A sculpture that moves or has moving parts. The motion may be caused by different forces, including air, gravity, and electricity.

### Using the Map

Ask students to locate Russia on a world map (see page 306) and to compare its size and latitude to those of the United States. *(Russia is almost twice the land area of the United States and extends farther north.)* **Ask:** Which continent is it on? *(both Europe and Asia)*

# Changing Perspectives in Russian Art

## Global Glance

For many centuries, Russia looked west of its borders for cultural inspiration. One of Russia's best-known traditional art forms is religious icons. These are based on the Byzantine traditions. During the nineteenth century, Russian artists continued to rely on western European styles such as Realism, Impressionism, and Art Nouveau for ideas. In the early twentieth century, however, Russian communities and their art changed. Revolutionary movements in Russia now interested western European artists. They began looking to Moscow for new and revolutionary ideas.

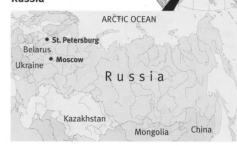

**Russia**

## The First Avant-Gardes

The first two decades of the twentieth century were marked by a rapid series of new artistic styles in Russia. Russian artists wanted to do things differently than they had in the past. Those artists who took the lead in these changes became known as **avant-garde.**

In the military, the term *avant-garde* means an advance force. In the world of art, it refers to a group or style that is at the front of artistic change. It generally describes art that is very different or experimental. Russian avant-garde artists wanted to modernize Russian art. Early avant-garde artists, such as Natalia Goncharova, drew ideas

**Fig. 6–18 Look carefully at this painting. What qualities of abstract art do you see? Can you find the lady that's referred to in the title?** Natalia Goncharova, *Lady with Hat*, 1913.
Oil on canvas, 35 1/2" x 26" (90 x 66 cm). Musee National d'Art Moderne, Paris. Photo Philippe Migeat © Centre Georges Pompidou. © 2000 Artist Rights Society (ARS), New York/ADAGP, Paris.

212

## Teaching Options

### Resources

Teacher's Resource Binder
- A Closer Look: 6.3
- Map: 6.3
- Find Out More: 6.3
- Check Your Work: 6.3
- Assessment Master: 6.3

Large Reproduction 12

Slides 6e

### Meeting Individual Needs

**Multiple Intelligences/Bodily-Kinesthetic**
Explain that avant-garde Russian artists created costumes and sets for dance performances in the early twentieth century. Have students develop movement that conveys an energy inspired by the artworks on pages 212–213. Ask students to describe how costumes and sets in an abstract style, similar to this art, might enhance their own movement.

from medieval icon painting and the Russian folk art traditions (Fig. 6–18). They experimented with color and line, and created art that was not realistic in style.

## New Ways of Seeing

Avant-garde artists wanted people to abandon their usual way of seeing things. The group continued to investigate new ideas, particularly the use of abstraction. (See page 12 of Foundation 1 to learn more about Abstract art.) Some artists based their ideas on scientific theories of light. Others, such as Kasimir Malevich, based their work on geometric shapes and forms (Fig. 6–20).

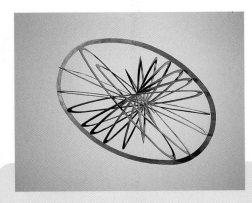

Fig. 6–19 **Take a close look at the shape and form of this kinetic sculpture. What might the physical movement of it be?** Alexander Rodchenko, *Oval Hanging Construction Number 12*, ca. 1920.
Plywood, open construction partially painted with aluminum paint, and wire, 24" x 33" x 18 1/2" (61 x 83.8 x 47 cm). The Museum of Modern Art, New York. Acquisition made possible through the extraordinary efforts of George and Zinaida Costakis, and through the Nate B. and Frances Spingold, Matthew H. and Erna Futter and Enid A. Haupt Funds. Photograph © 2000 The Museum of Modern Art, New York. © Estate of Alexander Rodchenko/Licensed by VAGA, New York, NY.

The artists of these movements did not think art should have any practical purpose. They thought art should exist only to be looked at as beautiful forms. Some artists used a variety of materials to construct abstract, freestanding, or suspended sculptural works. Others created **kinetic sculptures**, which have moving parts (Fig. 6–19). Where have you seen mobiles and other sculptures that move?

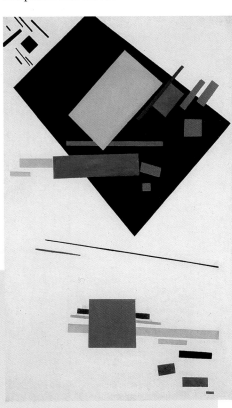

Fig. 6–20 **In 1913, Kasimir Malevich started the suprematist movement in art. He and other suprematists were interested in arranging simple geometric shapes to show pure colors and nonobjective forms. Do you think this painting is beautiful? Why or why not?** Kasimir Malevich, *Suprematist Painting*, 1915.
Oil on canvas, 40" x 24 1/2" (101.5 x 62 cm). Stedelijk Museum, Amsterdam.

Changing

213

# Teach

## Engage
Ask students if anyone has heard the term *avant-garde* before. What do they think this term might mean?

## Using the Text
**Art History** Assign students to read The First Avant-Gardes. **Ask:** What was the goal of Russian avant-garde artists? Inform students that some ways artists introduce new ideas are by breaking traditions, borrowing from traditions, and building on traditions. **Ask:** Which approach did the Russian avant-garde artists take? *(breaking and borrowing from traditions)*

Have students read New Ways of Seeing. **Ask:** Why did avant-garde artists produce art? What did they think the purpose of art objects should be?

## Using the Art
**Art Criticism Ask:** What do all three artworks on pages 212–213 have in common? *(abstract, have geometric shapes)* Which ones have no recognizable subject matter? *(both on page 213)* What do these artists emphasize? *(design, shapes)*

## Teaching Through Inquiry
**Art Criticism** Provide students with the Descriptive Word Cards, the Expressive Word Cards, and the Interpretation Statements from the Teacher's Resource Binder. Have them work in small groups to imagine that they are critics writing about the Russian art in this lesson for their local paper. Suggest to students that they use the cards as a starting point for writing about each work in the "exhibition," and remind them to support statements with visual evidence. Have groups share reports and discuss.

## More About...
**Natalia Goncharova** was especially influential during the period from 1908 to 1914 when she helped lead Russian art into the Modern period. In 1915 she left Russia and eventually settled in Paris where she achieved great success as a set designer for the Ballet Russe.

## Using the Large Reproduction
**Consider Context**
**Describe** What is represented in this artwork?
**Attribute** What clues do you have as to where it was made?
**Understand** Do you think this work is part of a long tradition of similar works?

**Explain** Knowing more about Russian folk-art traditions might help you to explain the cultural importance of this work.

12

213

## Using the Text

**Art History/Aesthetics** Have students read Revolutionary Ideas. **Ask:** What did Productivists consider the purpose of art to be? How does Fig. 6–22 fit into this theory of purposeful art?

## Using the Art

**Art Criticism** Have students study Fig. 6–21. **Ask:** Why was this created? *(to inspire Russians to support the revolution)* How is its purpose different from the avant-garde art on the preceding page? What do you see in this poster? *(A worker and peasant stand beside a vision of a communist nation of smokestacks, rising sun, and flag-waving patriots. Symbols of the tsars are beneath their feet.)*

**Art Criticism** Call students' attention to the design of Fig. 6–22. Have students trace the circular movement from the bottom to the top. **Ask:** What kind of rhythm is created by the vertical supports?

## Studio Connection

Gather these supplies: wire hangers, wooden dowels or sticks, wire cutters, nylon fishing cord or thin wire, cardboard or tag board, colored paper, glue, scissors, acrylic paint and brushes (optional), recycled objects (optional), magazine photographs (optional).

Refer students to Fig. 6–19, and then brainstorm ways to indicate change in a kinetic sculpture (such as geometric shapes that gradually change into other shapes or animals; a progression of colors; the evolution of beings). Demonstrate creating a mobile by tying shapes to wire or wood supports with cord or wire. Guide students to begin at the bottom and work upward, and to suspend the mobile periodically to check for balance.

**Assess** See Teacher's Resource Binder: Check Your Work 6.3.

## Revolutionary Ideas

Another avant-garde community of artists were called *Productivists*. These artists wanted to be actively involved in reshaping society. They felt that the combined forces of art, craftsmanship, and industry could help build a better world. This group believed that art is useful to society. Artists played important roles in cultural activity and teaching. They were expected to concentrate on architecture, the design of household objects, and printing. Artists rejected any creativity that did not have a purpose. *Monument to the Third International* (Fig. 6–22) is a model for a building that was never built. The artist who designed the model was trying to create a structure unlike any other. Have you ever seen a building that looks like this monument?

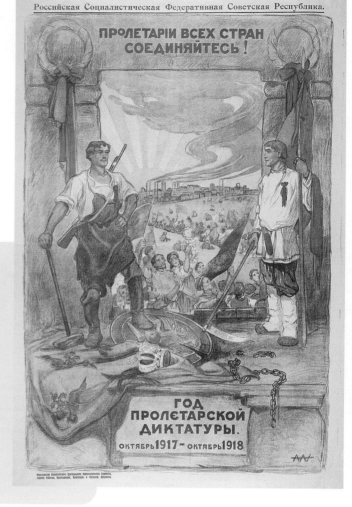

Fig. 6–21 This poster illustrates the change from tsarist Russia to communist Russia. The image through the window represents the future. The details inside the room represent the past. How might the meaning of the worker and peasant, standing on each side of the window, be similar to that of the figures in *Industrial Worker and Collective Farm Girl* (Fig. 6–4, page 201)? Alexander Apsit, *A Year of the Proletarian Dictatorship*, October 1917–1918, 1918. Poster. Courtesy David King Collection.

## Teaching Through Inquiry

**Art Production** Remind students of the Productivist notion that art and craftsmanship could help build a better world, and then have them work in groups to use art and good craftsmanship to **construct a tabletop model** (on a large cardboard or plywood base) **of an ideal community**. While they create their "better world," encourage students to consider these questions: How can you make a community that is both ideal and able to meet the basic needs of food, water, air, and shelter? How can you make it an inviting place to live and work? How can you organize and manage your community? What does it mean to be a citizen in your community? What role will technology and science play? What arts and cultural institutions will you feature?

In these and other ways, the success of the Russian Revolution in 1917 brought many Russian artists together. This group shared an interest in promoting the revolution's ideals of change. Alexander Aspit's poster (Fig. 6–21) uses strong images to teach people about political change. Later, some Russian artists who took part in these changes moved to Paris. They became part of western European movements.

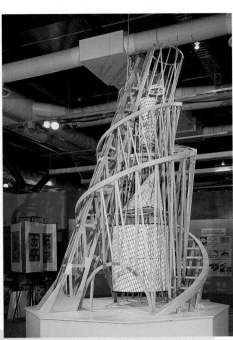

Fig. 6–22 **This artist believed that art should be composed of simple shapes and forms. Inside this tower are four forms that seem to float in space. What do you think the artist wanted this building to say about art and Russia?** Vladimir Tatlin, *Monument to the Third International,* 1919 (reconstructed in 1979). Sculpture, wood and metal, h. 16 ¼" (500 cm), diam. 9' 8" (300 cm). Musee National d'Art Moderne, Paris. © Centre Georges Pompidou. © Estate of Vladimir Tatlin/Licensed by VAGA, New York, NY.

### Studio Connection

A kinetic sculpture has moving, changing parts. Today, there are many different types of kinetic sculpture. A *mobile* hangs from a supporting structure so that air currents can move it freely in space. Some kinetic sculptures have motor-driven parts. Others use solar power or the energy of moving water. Electricity and computers can also be used in kinetic sculptures. How can you create a kinetic sculpture around the theme of change? You can show change by planning the relationships between sizes, colors, and other visual elements in your sculpture. Will you use only flat shapes or three-dimensional forms? Will your shapes and forms be geometric or organic? You can suspend or connect moving parts with string, wire, or wooden dowels.

### 6.3 Global View

#### Check Your Understanding
1. What is one of Russia's best-known traditional art forms?
2. What is meant by avant-garde art?
3. How did Productivist thinking change the direction of art in Russia?
4. Many Russian artists developed new styles simply because they wanted to do things differently. Is this a good reason to change something? Why or why not? When might change not be appropriate or good? Why?

## Assess

### Check Your Understanding: Answers

**1.** religious icons

**2.** a different, new, sometimes experimental style that leads to artistic change

**3.** It declared that the combined forces of art, craftsmanship, and industry could reshape society and help build a better world. Productivists promoted revolutionary ideals of change, and they played important roles in cultural activity and teaching.

**4.** Answers will vary. Look for reasons to support positions.

## Close

Create a display of the kinetic sculptures. **Ask:** What is the concept of change in each sculpture? What was most challenging about creating this art? Are you pleased with your sculpture? Does it move? Is it balanced?

Changing

215

### Assessment Options

**Teacher** Have students write an essay on avant-garde art in early-twentieth-century Russia. Instruct students to do research beyond the text and identify at least three ways that the direction of art changed.

## Prepare

### Pacing

Three or four 45-minute periods: one to consider art and text, and to experiment; two or three to paint

### Objectives

- Understand the role of experimentation with media in the expression of ideas.
- Experiment with painting media, techniques, and styles, for the purpose of finding unique ways to describe subjects and themes.
- Work to develop a painting on the theme of change in your community.

### Vocabulary

**pointillism** A style of painting in which small dots of color are placed side by side. When viewed from a distance, the eye tends to see the colors as mixed.

**abstract** Art that is based on a recognizable subject, but with simplification, omission, or rearrangement of some elements so that you may not recognize them.

### Supplies

- drawing or watercolor paper
- paint (watercolor or acrylic)
- brushes, several sizes
- water in containers
- paper towels
- palettes
- pastels (optional)

### National Standards 6.4 Studio Lesson

**1a** Select/analyze media, techniques, processes, reflect.

**1b** Use media/techniques/processes to communicate experiences, ideas.

**3b** Use subjects, themes, symbols that communicate meaning.

**4a** Compare artworks of various eras, cultures.

---

# Exploring Styles

## Paintings for Change

### Studio Introduction

As you have grown up, what changes have taken place in your town or city? Perhaps your community has built a new school or begun a strong recycling program. Perhaps it has improved its recreation facilities or opened a health food store. You might have your own ideas about changes you'd like to see in your community. Is there an unused lot where you'd like to see a park or a playground? Is there a leash law or other pet restriction that you'd like to see changed? Maybe you'd like new school lockers or more time between classes.

**In this studio experience, you will create a painting that celebrates or promotes change in your community.** Page 218 will tell you how to do it. As you know, many artists create paintings that celebrate or promote change in their community. They choose the style of painting that will best express their ideas. These styles might include abstract, realistic, impressionist, expressionist, or the artists' personal style. (To learn more about art styles, see Studio Background and Foundation 1, pages 10–13.) Create your painting in the style of your choice. When you are finished with the painting, write a short paragraph expressing your feelings or ideas about the change you show.

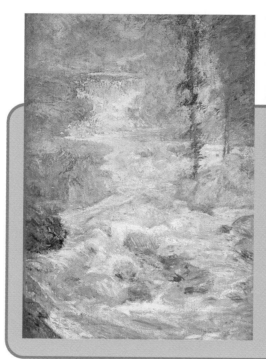

## Studio Background

### New Ways of Looking

During times of change, painters and other artists often experiment with the media and techniques they use to create art. The Impressionist artists of the late nineteenth century wanted to capture the change of color and light at exact moments in time. They used feathery brushstrokes and painted quickly. Other artists of the time used a technique called **pointillism**. They created tiny dots of color with the tip of their paintbrush. They placed the

Fig. 6–23 John Henry Twachtman was an American Impressionist painter. Look carefully at this painting. How would you describe the brushstrokes? John Henry Twachtman, *The Rainbow's Source*, ca. 1890–1900.
Oil on canvas, 34 1/8" x 24 1/2" (86.7 x 62.2 cm). The St. Louis Art Museum (Modern Art), Purchase 124:1921. [ISN 3470]

216

---

## Teaching Options

### Resources

Teacher's Resource Binder
  Studio Master: 6.4
  Studio Reflection: 6.4
  A Closer Look: 6.4
  Find Out More: 6.4
Overhead Transparency 11
Slides 6f

### Meeting Individual Needs

**Alternative Assignment** Have students use newspaper or magazine pictures to make a collage that represents change in their community.

Fig. 6–24 "My picture has to do with my feelings about homeless people. My teddy bear represents love and warmth for people. If I could change one thing in the world, I would make sure that homeless people had homes and there would be no more violence and crime." Tammy M. Dagen, *A Bear and His Bike*, 2000. Tempera paint, 18" x 12" (48 x 30.5 cm). Plymouth Middle School, Minnesota.

dots next to each other. When viewers stand back from pointillist paintings, their eyes blend the dots together and see shapes.

**Abstract** artists found yet another way to look at subject matter. They discovered that by drawing and painting simple shapes, they could suggest a realistic subject without details. Sometimes their artworks have no recognizeable subject at all. Abstract artists use color and shape to express their ideas.

Fig. 6–25 Alma Thomas was an abstract artist who often chose nature as her subject matter. Crepe myrtle has very colorful masses of flowers that hang down and blow in the wind. A concerto is a musical composition for one or more solo instruments and orchestra. Why do you think Thomas titled this painting as she did? Alma Woodsey Thomas, *Wind and Crepe Myrtle Concerto*, 1973. Acrylic on canvas, 35" x 52" (88.9 x 132.1 cm). National Museum of American Art, Smithsonian Institution, Washington, DC /Art Resource, NY

Changing

217

## Supplies for Engage
- historical photographs of your community

## Teach

### Engage
Show students the photographs, and discuss how the community has changed since the photos were created. **Ask:** What are some recent changes? Are there new buildings, billboards, communication towers, roads, or parks?

### Using the Text
**Art Production** Have students read Paintings for Change and begin thinking about what they might paint.

**Art History** Have students read Studio Background to learn about twentieth-century painting styles. **Ask:** What is pointillism? Which painting shown here is abstract? (*Thomas's* Wind and Crepe Myrtle Concerto)

### Using the Art
**Perception** As students study Fig. 6–23, ask them to describe the brushstrokes. **Ask:** What colors are in the water? Have students trace the compositional movement through the painting. Ask students to compare the viewpoint of Figs. 6–23 and 6–25. **Ask:** In which painting is the viewer closer to the subject? (*Fig. 6–25*) Have students describe the movement and rhythm in this painting.

## Teaching Through Inquiry

**Art Criticism** Provide students with the Art Criticism Inquiry Cards, the Descriptive Word Cards, and the Expressive Word Cards in the Teacher's Resource Binder. Have students work in small groups to **write descriptive labels** for the artworks by Twachtman and Thomas, by focusing on technical and expressive qualities.

## More About...

**Alma Thomas** (1892–1978) was one of the artists who, starting in the 1960s, began exploring abstraction through the use of simplified shape and color. Thomas, however, typically painted images related to the natural world. She developed a style of short, almost mosaic-like strokes to create a sense of nature's underlying energy.

## Using the Overhead

**Think It Through**

**Ideas** What seem to be Emily Carr's interests and concerns? What decisions and choices might she have made in developing her ideas?

**Techniques** What materials and techniques did Carr use? What do you think she painted first? Last?

11

# Exploring Styles

## Studio Experience

1. Guide students in experimenting with several painting styles such as pointillism, abstraction, or others.

2. Place students in groups according to the style they have chosen, and encourage group members to work together to decide on a common theme for their paintings.

3. As students paint, remind them of the various aspects of their chosen art style, and help them with their technique.

4. Ask groups to title their series according to the unifying theme and the attitude toward change in each painting.

5. Allow each group to create a display of their completed artworks.

## Idea Generators

Lead students in brainstorming a list of changes in their life or community that they might paint. Suggest that they try to show how they feel about these changes.

### Computer Option
Students may use HyperStudio for painting a scene as a background, and for creating other objects separately and saving them as objects that can be moved along a path, which, in effect, animates them. Ray Dream 3D allows for the creation and animation of models. For examples of computer graphics, including 3-D modeling and animation, go to the SIGGRAPH gallery, at: http://www.siggraph.org/artdesign/gallery/gallery.html.

### Painting in the Studio
## Creating Your Painting

**You Will Need**

- drawing paper
- paintbrushes
- paint
- water
- paper towels
- pastels (optional)

**Try This**

1. As a class, discuss changes that have taken place in your community as you have grown up. Then discuss changes that you would like see happen in your community.

2. Decide which change you would like to show in a painting. Will you choose a change that has already taken place or one that you would promote? How can you show the change, as it's happening, in a painting? For example, if you want to show your new school, you might show how the school looked when it was under construction. If you want to promote the idea of a new park, you might show it being constructed in the location where you imagine one.

3. Experiment with different styles of painting. Try creating lines and shapes in different styles. For example, how might the lines and shapes in an abstract painting look different from the lines and shapes in a realistic painting? How might the colors be different?

4. When you have chosen a subject and the style in which you will create your painting, sketch your composition. Are there any changes you would like to make?

 5. Create your finished painting.

**Check Your Work**

Display your artwork with those of your classmates. Discuss the different art styles and subject matter that you see. Why do you feel the style of art you chose suits the community change you show? How did you use line, shape, and color to express your feelings about the change?

### Computer Connection
With a paint or multimedia program, create a background scene that includes buildings or other structures. Create cars and other objects to place in the scene, or use software that allows for the creation of 3-D models. Use animation to move the objects or models through the scene.

## Teaching Options

### Teaching Through Inquiry

**Art History** Provide students with a copy of the handout **Biography of an Artist**, from the Teacher's Resource Binder. Have each student select one of the artists introduced in this lesson—or an artist who had an influence *on* that artist, or an artist who was influenced *by* that artist. Have students use the handout to prepare and present an oral report on their artist. Encourage students to show examples of the artist's work.

**Art Production** When students use **watercolor paints**, have them experiment with the amount of water they place on their brush before dipping it into the paint. Also have them lightly layer a wash of water over an area they have already painted. Encourage students to improvise results by washing part of their paper with water and then dipping the point of the brush with pigment into the area and letting it spread.

## Sketchbook Connection

Make quick sketches of the changes you see happening in your community. You might see a building under construction, a new billboard, or a road being built. Some changes are not as obvious, such as feelings or opinions about things that are happening in your community. Try sketching these kinds of changes, too. Use lines, shapes, and colors to suggest mood and emphasis.

## Studio Collaboration

Join with other students in your class who have chosen to work in the same style as you. Discuss the painting techniques used in this style. Talk about how you can work together to create a series of paintings about change in your community. Give your group a name. Working in the same style, you might each paint different subject matter. All of your paintings together should reflect changes you see in your community.

## Sketchbook Tip

Encourage students to use sketching and photography to document change. Remind students that views that seem as though they will remain forever, will eventually change. Have students sketch or photograph their favorite buildings, trees, and scenes. Suggest that they watch these views over the course of a year, sketching or photographing any changes they detect.

## Extend

Challenge students to imagine how their community will change in the next thousand years. **Ask:** Will the community grow or shrink? How will people move from place to place? What will they do for entertainment? How will homes and schools change? Encourage students to draw or paint their vision of their community's future.

## Assess

### Check Your Work

As students near completion of their art, remind them to determine, by asking the other members of their group, if their message about change is understandable.

## Close

Permit each group to describe the common theme in their series of paintings. Discuss the changes depicted in the paintings, and challenge students to identify the artists' feelings towards these changes.

Fig. 6–26 "We brought in objects that reflect how we live today compared to when baby boomers were kids. Although they had a lot of bikes back then, kids today are getting more into extreme sports like bike jumping. The hardest part was mixing colors to the right shade using only black, white, red, blue, and yellow paints." Joanas Wuollet, *Rocket Sprocket*, 2000. Tempera paint, 18" x 12" (46 x 30 cm). Plymouth Middle School, Plymouth, Minnesota.

Changing

219

## Careers

Bring several board games to class, and discuss them with students, focusing on the kinds of choices designers make in creating new toys and games. Have students work in small groups to design and create a prototype for a new board game. Ask students to display, discuss, and play the completed games.

## Social Studies

Hung Liu is a contemporary artist born in China and now residing in the United States. For her art, she appropriates historical photographs such as stereographs to create paintings and mixed-media installations that express her concern with social issues related to immigration. Direct students to conduct research on the Web to find her work and learn more about this artist.

# Connect to...

## Careers

Have you ever played with Lego blocks? The Lego block was named "Toy of the Decade" by a business magazine in 1999, evidence that the simplest toys remain some of the best. (The Lego company began in 1932.) Despite the continuing success of classic toys that require no batteries or microchips, **toy designers** now incorporate advances in technology in all kinds of toys. However, these designers not only research and design new toys, but they also consider factors such as safety, child psychology, manufacturing procedures, packaging, and promotion. They may specialize in designing hard toys, soft toys (such as stuffed animals and dolls), or board or electronic games. What were your favorite toys

Fig. 6–27 **Toy designer Sean Lee enjoys every aspect of his job: from working with other designers on new toy ideas to meeting with engineers to decide on how a toy will actually work.** Photo reproduced with permission of Sean Lee.

when you were young? How are they different from the toys that your siblings or young relatives play with now? If you could design a new toy, what would it be?

## Other Arts

### Theater

Technological changes have affected not only the visual arts, but also the art of theater. The most profound impact on theater was the **invention of the motion picture**, in the early twentieth century.

Theater had been a popular form of entertainment for people of all classes. However, with the first public showing of movies, theaters began to lose their audiences. Movies could be duplicated cheaply and played in many locations simultaneously, so more people could view a film than any particular theater production, and they could do so less expensively. Also, films realistically depicted places unfamiliar to viewers, documented real events,

and used fascinating special effects. To compete with all this, theater artists had to identify and promote the unique characteristics of theater: that theater is a live event is perhaps the most important.

What are the similarities and differences between attending a live event, such as theater, and a recorded event, such as film? Which type of event do you prefer? Why? What is the effect of the audience on actors in theater? On actors in a film? How would you use film to tell the story of Jack and the beanstalk? How would you use theater? How would you show the beanstalk growing? How would you show the difference in size between the giant and Jack?

**Internet Connection**
For more activities related to this chapter, go to the Davis website at **www.davis-art.com.**

## Teaching Options

### Resources

Teacher's Resource Binder
  Using the Web
  Interview with an Artist
  Teacher Letter

### Video Connection

Show the Davis art careers video to give students a real-life look at the career highlighted above.

### Internet Resources

**Nam June Paik**
http://www.reynoldahouse.org/ leonardo.htm
Further investigate the work of Nam June Paik.

## Other Subjects

Fig. 6–28 **Angel Island has a long history. It was once a favorite hunting and fishing place of the Native-American tribe the Miwok. Today it is a California state park with many trails and paths.** *Angel Island, Ayalla Cove.* Courtesy California State Parks, 2000.

### Social Studies

What do you know about Ellis Island? Have you ever heard of its counterpart, Angel Island? **Angel Island**, near San Francisco, was the western point of entry, mostly for Chinese immigrants, to the United States in the early 1900s. At Angel Island, prospective immigrants were met by harsh procedures for processing. Subjected to humiliating medical exams and lengthy interrogations, many Chinese were held on the island for up to twenty-four months in intolerable conditions. Where could you look to compare immigration processing today with that at Ellis and Angel islands?

Fig. 6–29 **A caterpillar hatches from an egg and is the larva stage of a butterfly or moth. Is this an example of simple or complete metamorphosis?** Photo ©Karen Durlach.

### Language Arts

When have you tried to change a friend's opinion? How did you go about it? Verbally? In writing? Many writers—especially critics—use **persuasive writing**, in which they present and discuss arguments or reasons to change or influence the reader's opinion. Most articles written by art critics are persuasive pieces. Try to find real-life examples of persuasive writing in the arts section of your local Sunday paper. Which articles represent persuasive writing? Are any of these articles about art? Where else could you look for examples of persuasive writing about art?

### Science

What represents change in the area of natural science? Consider **metamorphosis**—a change, or transformation, through distinct stages in the life cycle. For instance, an insect hatches from an egg; as it grows, it molts (sheds) its exoskeleton (skin). Changes in form may occur with each molt. In simple metamorphosis, an insect develops from egg to larva to adult, but the larva resembles the adult. In complete metamorphosis, development moves from egg to larva to pupa to adult. How could you depict in a drawing or painting each stage of the complete metamorphosis of a toad or another creature?

### Language Arts

Have each student write a persuasive letter about art for the editorial page of an imaginary newspaper.

### Other Arts

If possible, conduct the discussion after students have attended, or viewed a videotape of, a local theatre production and then viewed the same story on film. Holiday productions, such as *A Christmas Carol,* and fairy tales are widely produced by community theatres and are available on videotape.

## Daily Life

By what ways do you communicate with your friends? Have these ways changed since you were a child? Since your parents were teenagers? Especially rapid changes in **personal communications** have resulted from recent technological advances. E-mail, cell phones, and pagers allow nearly instant contact, but their use may affect other, more traditional avenues for interpersonal communication. For instance, when did you last write and mail a personal letter? Do you think e-mail will replace regular, or "snail," mail? Will handwriting a letter become a lost art? What might be the consequences of such a loss?

Changing

221

### Internet Resources

**The Photography of Lewis Hine**

http://www.ibiscom.com/hnintro.htm

See photos of miners, mill workers, and newsboys taken by Lewis Hine while investigating child labor practices, plus some of Hine's field notes.

**Statue of Liberty and Ellis Island Monument**

http://www.nps.gov/stli/mainmenu.htm

Tour the two national monuments to learn more about American immigration.

### Curriculum Connection

**Social Studies** Have students investigate the role of photographers such as Jacob Riis and Edward Hine in calling attention to child labor and other social conditions in the early twentieth century.

### Community Involvement

Have students design a time line, illustrated with photographs and small drawings, to show the architectural history of their community.

### Interdisciplinary Tip

Work with language-arts and social-studies teachers to explore ways to enrich the study of art and other subjects through use of narratives, journals, stories, biographies, and autobiographies.

## Talking About Student Art

After discussion about the meaning of a student artwork, summarize the different interpretations that students proposed. Create a continuum with the most plausible interpretation at one end, and the least plausible at the other. Invite students to place interpretations along the continuum, providing reasons for their decisions.

## Portfolio Tip

 Remind students that clear writing for the portfolio would have an introduction that draws the reader in while setting up what is to follow: elaborate ideas, rich with vivid details; and an engaging, expressive voice. Students can use these criteria to reflect on and set goals for the written reports they include in their portfolio.

## Sketchbook Tip

 Remind students that sketchbooks are places for brainstorming—for generating ideas and working toward solving problems creatively.

# Portfolio

"I liked this scene because of the peaceful mood of the pond in contrast to the rowdy soccer players. I like how this scene looks out into the forest. You can see a picture of the playground against the forest. Boys at my school like to play soccer." **Marysa Leya**

Fig. 6–30 Marysa Leya, *Autumn at Avery Coonley*, 1999.
Colored pencil and marker, 9" x 12" (23 x 30.5 cm). Avery Coonley School, Downers Grove, Illinois.

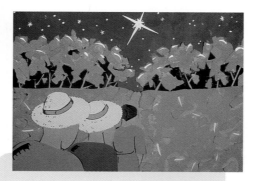

Fig. 6–31 Meg Weeks, *Twilight Trek to Freedom*, 1999.
Construction paper collage, 18" x 24" (46 x 61 cm). Winsor School, Boston, Massachusetts.

This collage was inspired by stories of the Underground Railroad for runaway slaves during the Civil War, a time of great change in our country. The artist says, "Despite the fact that this piece is set at night, the colors of the people and their surroundings are not bleak, thus the piece still has some light and cheer—to express the hopeful emotions of the people." **Meg Weeks**

"I made a dolphin diving into water, but as it dives it eventually turns into a drop of water. I did this piece because I love animals and the sea." **Cami Rosboschil**

Fig. 6–32 Cami Rosboschil, *Dolphin Mobile*, 1999.
Foam, acrylic, 23" high (58.5 cm). Hayfield Secondary School, Alexandria, Virginia.

 **CD-ROM Connection**
To see more student art, check out the Community Connection Student Gallery.

**Teaching Options**

**Resources**

Teacher's Resource Binder

Chapter Review 6

Portfolio Tips

Write About Art

Understanding Your Artistic Process

Analyzing Your Studio Work

 **CD-ROM Connection**

For students' inspiration, for comparison, or for criticism exercises, use the additional student works related to studio activities in this chapter.

# Chapter 6 Review

**Recall**

How does the art of Nam June Paik (*see below*) refer to changes in technology?

**Understand**

Use examples to explain how art reflects and inspires changes in communities.

**Apply**

Styles in music have undergone many changes over the years. What might account for changes in music over time?

**Analyze**

Select an artwork in this chapter and tell how the art elements are arranged to reflect or inspire change.

**Synthesize**

Speculate about how art might look in twenty years. Give reasons for your predictions.

**Evaluate**

Select an artwork from this chapter that you believe is a good example of how artworks can inspire change in communities. Give reasons for your judgment.

Page 198

**For Your Portfolio**

Look at the global view lessons for each of the chapters in this book to see art from another place in the world. Select one work that interests you. Find out as much as you can about the place where this artwork was made. Prepare a written report including a map, a description of geography, climate, natural resources, beliefs of the people, etc. Speculate about how the characteristics of the place are reflected in the artwork you have selected.

**For Your Sketchbook**

Look through the pages in your sketchbook and make a list of the characteristics or qualities that are consistent throughout your sketchbook. Do you see color preferences, for example? Also identify ways that your entries have changed. Summarize your findings on continuity and change on a blank page in your sketchbook.

**Advocacy**

Set up an exhibition of student artwork in the school-board meeting room. Be sure to include statements of learning goals and objectives.

**Family Involvement**

If field trips are not possible, involve family members in helping students "visit" a place. Family members might collect materials from travel agents and embassies, or they might assist students in researching various aspects of the place.

## Chapter 6
## Review Answers
### Recall

Nam June Paik uses televisions, combining them to create sculpture and images on the screens.

### Understand

Answers will vary. Students might mention *Cliff Dwellers,* which reflects changes in urban life; and *The Spotted Owl* or *Little Girl in Carolina Cotton Mill,* which were meant to inspire changes in society.

### Apply

Answers will vary, but students should apply their understanding of how changes in technology, ideas, and culture affect the development of music.

### Analyze

Answers will vary, but students should demonstrate that they understand how art elements are organized to convey messages.

### Synthesize

Answers will vary, but students should demonstrate that they understand how changes in community needs, technology, and ideas about art affect developments in the art produced in a culture.

### Evaluate

Answers will vary, but students should provide reasons regarding the meaning conveyed by, or the materials and techniques used in, the artworks.

### Reteach

Have students create a time line that demonstrates how art changes over time. Ask students to select two artworks from two different periods, and to indicate on their time line any conditions or events during these two different periods, that would help explain the differences between the artworks.

Summarize by pointing out how art reflects and inspires change in communities.

# Chapter Organizer

| 9 weeks | 18 weeks | 36 weeks | | | |
|---------|----------|----------|---|---|---|

## Chapter Focus

**Chapter 7 Celebrating**
Chapter 7 Overview
pages 224–225

- **Core** Art is used in the celebration of community heritage and pride. Art in America between the two world wars celebrated national and regional spirit.
- **7.1** Art and Pride: 1920–1950
- **7.2** Photography
- **7.3** Caribbean Art
- **7.4** 3-D Montage

## Chapter National Standards

1 Understand media, techniques, and processes.
2 Use knowledge of structures and functions.
3 Choose and evaluate subject matter, symbols, and ideas.
4 Understand arts in relation to history and cultures.
5 Assess own and others' work.

---

| 9 weeks | 18 weeks | 36 weeks |
|---------|----------|----------|
| 3 | 3 | 3 |

### Objectives

**Core Lesson
Pride in Community**
page 226
Pacing: Three 45-minute periods

- Explain how artists help communities remember and celebrate their local heroes, celebrities, and historical events.
- Identify ways that art is used in traditional community celebrations.

### National Standards

**1b** Use media/techniques/processes to communicate experiences, ideas.
**4b** Place objects in historical, cultural contexts.
**5b** Analyze contemporary, historical meaning through inquiry.

---

### Objectives

**Core Studio
A Festival in Pastel**
page 230

- Create a pastel drawing of a community celebration.

### National Standards

**2b** Employ/analyze effectiveness of organizational structures.
**3b** Use subjects, themes, symbols that communicate meaning.

---

| 36 weeks |
|----------|
| 3 |

### Objectives

**Art History Lesson 7.1
Art and Pride:
1920–1950**
page 232
Pacing: Three to four 45-minute periods

- Give examples of how artists in the first half of the twentieth century documented community spirit.
- Explain what was important about the Harlem Renaissance.

### National Standards

**1a** Select/analyze media, techniques, processes, refle
**2b** Employ/analyze effectiveness of organizational structures.
**4a** Compare artworks of various eras, cultures.
**4c** Analyze, demonstrate how time and place influenc visual characteristics.

---

### Objectives

**Studio Connection**
page 234

- Combine media to capture the spirit of community life.

### National Standards

**1b** Use media/techniques/processes to communicate experiences, ideas.
**3b** Use subjects, themes, symbols that communicate meaning.

---

| 36 weeks |
|----------|
| 1 |

### Objectives

**Forms and Media
Lesson 7.2
Photography**
page 236
Pacing: One or two 45-minute class period

- Identify ways that photography is used for artistic expression, and explain how it requires artistic and scientific knowledge.

### National Standards

**1b** Use media/techniques/processes to communicate experiences, ideas.
**2b** Employ/analyze effectiveness of organizational structures.
**3a** Integrate visual, spatial, temporal concepts with content.

---

### Objectives

**Studio Connection**
page 237

- Make a flip book about a community celebration.

### National Standards

**1b** Use media/techniques/processes to communicate experiences, ideas.

## Featured Artists

Thomas Hart Benton
Wayne Berkeley
Herrod Blank
Colleen Browning
Philip Latimer Dike
Meta Warrick Fuller
Red Grooms
Stan Herd

Lois Mailou Jones
Jacob Lawrence
Russell Lee
Ethel Magafan
Edna Manley
Peter Minshall
Paul Nagano
Andre Normil

Barbara Jo Revelle
Simon Rodia
James VanDerZee

## Chapter Vocabulary

celebrate
Dada
Harlem Renaissance
montage

Regionalist
Surrealist
traditions

---

## Teaching Options

Teaching Through Inquiry
More About...Stan Herd
More About...Puppetry
Using the Large Reproduction
Using the Overhead

## Technology

CD-ROM Connection
e-Gallery

## Resources

Teacher's Resource Binder
  Thoughts About Art:
    7 Core
  A Closer Look: 7 Core
  Find Out More: 7 Core
  Studio Master: 7 Core
  Assessment Master:
    7 Core

Large Reproduction 13
Overhead Transparency 14
Slides 7a, 7b, 7c

---

Meeting Individual Needs
Teaching Through Inquiry
More About...Jacob Lawrence
Assessment Options

CD-ROM Connection
Student Gallery

Teacher's Resource Binder
  Studio Reflection: 7 Core

---

## Teaching Options

Meeting Individual Needs
Teaching Through Inquiry
More About...American Regionalists
Using the Overhead

## Technology

CD-ROM Connection
e-Gallery

## Resources

Teacher's Resource Binder
  Names to Know: 7.1
  A Closer Look: 7.1
  Map: 7.1
  Find Out More: 7.1
  Assessment Master: 7.1

Overhead Transparency 13
Slides 7d

---

Teaching Through Inquiry
More About...Works Progress Administration
More About...Lois Mailou Jones
Assessment Options

CD-ROM Connection
Student Gallery

Teacher's Resource Binder
  Check Your Work: 7.1

---

## Teaching Options

Teaching Through Inquiry
More About...Daguerrotype
Using the Overhead
Assessment Options

## Technology

CD-ROM Connection
e-Gallery

## Resources

Teacher's Resource Binder
  Finder Cards: 7.2
  A Closer Look: 7.2
  Find Out More: 7.2
  Assessment Master: 7.2

Overhead Transparency 13

---

CD-ROM Connection
Student Gallery

Teacher's Resource Binder
  Check Your Work: 7.2

**9 weeks**

**18 weeks**

**36 weeks**

| | | | | Objectives | National Standards |
|---|---|---|---|---|---|

| | | 3 | **Global View Lesson 7.3 Caribbean Art** <br> page 238 <br> Pacing: Three 45-minute class periods | • Identify traditions and influences in Caribbean art. <br> • Consider artistic elements of carnival festivities. | **1a** Select/analyze media, techniques, processes, reflect. <br> **4a** Compare artworks of various eras, cultures. <br> **4c** Analyze, demonstrate how time and place influence visual characteristics. <br> **5b** Analyze contemporary, historical meaning through inquiry. |
| | | | **Studio Connection** <br> page 240 | • Explore the techniques of assemblage to create a sculpture expressing the theme of celebration. | **2b** Employ/analyze effectiveness of organizational structures. |

| | | | | Objectives | National Standards |
|---|---|---|---|---|---|

| | 3 | 3 | **Studio Lesson 7.4 3-D Montage** <br> page 242 <br> Pacing: Three 45-minute periods | • Recognize that combining photographic images can communicate important ideas about a community. <br> • Construct a three-dimensional montage to celebrate community spirit. | **1b** Use media/techniques/processes to communicate experiences, ideas. <br> **2b** Employ/analyze effectiveness of organizational structures. <br> **3b** Use subjects, themes, symbols that communicate meaning. <br> **4a** Compare artworks of various eras, cultures. |

| | | | | Objectives | National Standards |
|---|---|---|---|---|---|

| • | • | • | **Connect to...** <br> page 246 | • Identify and understand ways other disciplines are connected to and informed by the visual arts. <br> • Understand a visual arts career and how it relates to chapter content. | **6** Make connections between disciplines. |

| | | | | Objectives | National Standards |
|---|---|---|---|---|---|

| • | • | • | **Portfolio/Review** <br> page 248 | • Learn to look at and comment respectfully on artworks by peers. <br> • Demonstrate understanding of chapter content. | **5** Assess own and others' work. |

**2** Lesson of your choice

## Teaching Options

Teaching Through Inquiry
More About...Caribbean islands
Using the Large Reproduction

## Technology

CD-ROM Connection
e-Gallery

## Resources

Teacher's Resource Binder
  A Closer Look: 7.3
  Map: 7.3
  Find Out More: 7.3
  Assessment Master: 7.3

Large Reproduction 14
Slides 7e

---

Meeting Individual Needs
Teaching Through Inquiry
More About...Carnival
Assessment Options

CD-ROM Connection
Student Gallery

Teacher's Resource Binder
  Check Your Work: 7.3

## Teaching Options

Teaching Through Inquiry
More About...Photomontages
More About...Colorado Panorama
Using the Overhead
Meeting Individual Needs
More About...Surrealism
Assessment Options

## Technology

CD-ROM Connection
  Student Gallery
Computer Option

## Resources

Teacher's Resource Binder
  Studio Master: 7.4
  Studio Reflection: 7.4
  A Closer Look: 7.4
  Find Out More: 7.4

Large Reproduction 14
Slides 7f

## Teaching Options

Curriculum Connections
Community Involvement
Museum Connection

## Technology

Internet Resources
Video Connection
CD-ROM Connection
  e-Gallery

## Resources

Teacher's Resource Binder
  Using the Web
  Interview with an Artist
  Teacher Letter

## Teaching Options

Family Involvement

## Technology

CD-ROM Connection
  Student Gallery

## Resources

Teacher's Resource Binder
  Chapter Review 7
  Portfolio Tips
  Write About Art
  Understanding Your Artistic Process
  Analyzing Your Studio Work

## Chapter Overview

### Theme

People in communities find ways to celebrate their past, their heroes, and their community spirit. Art helps people celebrate and express pride in their communities.

### Featured Artists

Thomas Hart Benton
Wayne Berkeley
Herrod Blank
Colleen Browning
Philip Latimer Dike
Meta Warrick Fuller
Red Grooms
Stan Herd
Lois Mailou Jones
Jacob Lawrence
Russell Lee
Ethel Magafan
Edna Manley
Peter Minshall
Paul Nagano
Andre Normil
Barbara Jo Revelle
Simon Rodia
James VanDerZee

### Chapter Focus

This chapter features the ways that art is used in the celebration of community heritage and pride, and how art in America between the two world wars celebrated national and regional spirit. Students learn how the medium of photography is uniquely suited to capture the celebration of community spirit. Students focus on ways that Caribbean communities use art for the purpose of celebrating local pride, and

**Teaching Options**

# 7 Celebrating

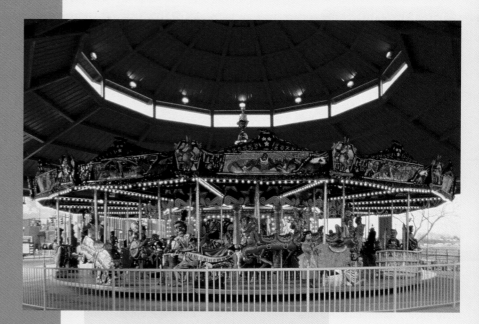

Above: Fig. 7–1 **This full-size operating carousel celebrates Tennessee history and culture. If you were to create a carousel to celebrate the heritage of your own community, what people or events would you include?** Red Grooms, *Tennessee Fox Trot Carousel*, Riverfront Park, Nashville, TN.
Fiberglass over an aluminum frame, 35' x diam. 46' (88.9 x 116.8 cm). Illustrations © 1998 Red Grooms. Photo courtesy of Tennessee Fox Trot Carousel Operating Company. © 2000 Red Grooms / Artist Rights Society (ARS), New York.

Right: **Adelicia Acklen is one of many Nashville figures featured on this carousel. Why might an artist create an artwork that celebrates a specific person or group of people?** Red Grooms, *Tennessee Fox Trot Carousel* (detail).

### National Standards Chapter 7 Content Standards

1. Understand media, techniques, and processes.
2. Use knowledge of structures and functions.
3. Choose and evaluate subject matter, symbols, and ideas.
4. Understand arts in relation to history and cultures.
5. Assess own and others' work.

### Meeting Individual Needs

**Multiple Intelligences/Interpersonal and Linguistic** Ask students to locate art in the area that relates to community pride or spirit, and to research who commissioned the piece, what it represents, who its intended audience is, and reasons why the artist portrayed the subject in this particular manner. Next, have students write a conversation about the work among three different people: the artist, a shop owner who wants the art moved away from her/his property, and a citizen who enjoys seeing the piece every day.

### Teaching Through Inquiry

**Art Production** Have students work in groups to design an amusement park ride for celebrating the heritage of their school or local community. Encourage students to consider special events and people who have contributed to the school or the locale's identity, make a list of what the ride will celebrate, and brainstorm types of rides to use in the design. Have each group write and attach a statement that tells how the rider will learn about the special people and events. Have groups share their designs.

## Focus

- What do people celebrate?
- How is art a part of celebrations?

Does your town or city celebrate, or honor, things that have special meaning to the community? Some cities and towns have annual festivals, such as a dogwood festival or a potato festival, to celebrate a plant or food that is an important part of their environment. Other places **celebrate** the anniversary of the founding of their town or city. This kind of celebration might happen only once or twice in the life of the community and honors its history.

There are countless kinds of community celebrations and countless ways to show these celebrations in artworks. Sometimes an artwork can be a kind of celebration in itself. For example, imagine learning about the history of your hometown by riding a colorful carousel such as this one in Nashville, Tennessee (Fig. 7–1). The carousel is a way for Nashville to celebrate its heritage and community spirit. It focuses on the history of the city, the people who live there, and what they have accomplished.

Many artists have helped communities celebrate their heritage by creating artworks about the local people and their way of life. Often, artworks that reflect community spirit are made to be seen and used in public. What kinds of public art have you seen that honors a community or its heritage? Are there any such artworks in your town or city?

### What's Ahead

- **Core Lesson** Discover ways that art helps people celebrate and express pride in their communities.
- **7.1 Art History Lesson** Explore how American artists celebrated regional and national spirits in their art from the 1920s through the 1950s.
- **7.2 Forms and Media Lesson** Learn how artists capture celebrations in photographs.
- **7.3 Global View Lesson** Investigate the art and celebrations of communities in the Caribbean.
- **7.4 Studio Lesson** Create a three-dimensional photomontage that celebrates community spirit.

### Words to Know

| | |
|---|---|
| celebrate | montage |
| traditions | Dada |
| Regionalist | Surrealist |
| Harlem Renaissance | |

they create a three-dimensional montage to celebrate a community of their choice.

## Chapter Warm-up

Lead students in understanding how communities celebrate their spirit and uniqueness. **Ask:** How does this school celebrate its spirit, people, and traditions? *(pep rallies, spirit days, awards ceremonies)* Inform students that they will consider the role that art plays in community celebrations.

## Using the Text

**Aesthetics** Have students read the text to learn how communities celebrate their heritage with art. Inform students that for the *Tennessee Fox Trot* carousel, Grooms created thirty-six figures and twenty-eight panels. Each figure represents a famous person from Tennessee who helped shape the city of Nashville. Figures include frontiersman Davy Crockett, President Andrew Jackson, Olympic gold medalist Wilma Rudolph, and local sculptor William Edmundson. The panels depict scenes from the city's past. To ride the carousel, visitors choose a horse or a vehicle that is connected to one of the figures. (Country signer Kitty Wells's tour bus is one option.) **Ask:** How does Nashville celebrate its heroes and history with art? How would a ride on this carousel compare to a ride on other, more typical carousels?

## Using the Art

**Perception** Have each student point out a different feature of the carousel. **Ask:** How is it serious? How is it playful?

## More About...

**Red Grooms** (b.1937) turns to the everyday world as the basis for his work, but transforms the essence of a place or event into a humorous fantasy. Typically, Grooms creates bold, colorful, papier-mâché environments full of visual puns, cartoonlike figures, and exaggerated perspective.

## Graphic Organizer
### Chapter 7

**7.1 Art History Lesson**
Art and Pride: 1920–1950
page 232

**Core Lesson**
Pride in Community

**Core Studio**
A Festival in Pastel
page 230

**7.3 Global View Lesson**
Caribbean Art
page 238

**7.2 Forms and Media Lesson**
Photography
page 236

**7.4 Studio Lesson**
3-D Montage
page 242

## Prepare

### Pacing

Three 45-minute periods: one to consider art and text; two to draw with pastels

### Objectives

* Explain how artists help communities remember and celebrate their local heroes, celebrities, and historical events.

* Identify ways that art is used in traditional community celebrations.

* Create a pastel drawing of a community celebration.

### Vocabulary

**celebrate** To honor or observe an event or local tradition with other members of a community.

**traditions** Customs, actions, thoughts, or beliefs that are passed on or handed down from generation to generation, either by word of mouth or by example.

## Teach

### Engage

**Ask:** What celebrations and artworks honor the heroes and heritage of our region? Do any groups hold parades or fairs to celebrate something in the community? Are there special foods at these celebrations? Are fireworks set off?

### National Standards Core Lesson

**1b** Use media/techniques/processes to communicate experiences, ideas.

**2b** Employ/analyze effectiveness of organizational structures.

**3b** Use subjects, themes, symbols that communicate meaning.

**4b** Place objects in historical, cultural contexts.

**5a** Analyze contemporary, historical meaning through inquiry.

# Pride in Community

## Local Customs

When we meet people from other places, we are sometimes surprised to learn their different words for the simple things we use and do every day. For instance, people refer to soft drinks as "soda" or "tonic" or "pop," depending on where they live or grew up. The words people use are just a small part of what makes the spirit of a community special. A community's spirit comes from the pride its members have in their heritage. Language, clothing, mannerisms, and local customs can all add to the spirit of a community.

To celebrate the spirit of a community is to celebrate its people and their way of life. Stories about other times are passed down through generations. Local customs can also be traced back in time. It can be fun to learn about the differences in the way people live in other regions. Artists can help us learn by creating artworks that show people going about their lives in local ways.

## Local Heroes

Another source of community spirit is the pride people have in the accomplishments of local heroes and celebrities. The *Watts Tower* (Fig. 7–3) is an example of such pride. Artist Simon Rodia built this tower with millions of found objects: broken jewelry, toys, pieces of plastic and glass, and so on. When local officials tried to tear it down, people in the community fought to keep it. It is now a symbol of pride and spirit in the Watts district of south-central Los Angeles. Even though the artist left the area after working on it for thirty-four years, he is still considered a local hero.

Fig. 7–2 **Most communities in the United States celebrate the Fourth of July. Here, a little boy dresses like Uncle Sam. How does your town or city celebrate the Fourth?** Russell Lee, *Boy on Float in Fourth of July Parade*, 1941.
Silver gelatin print. Courtesy of the Library of Congress (LC-USF33-013103-M1)

226

## Teaching Options

### Resources

Teacher's Resource Binder
   Thoughts About Art: 7 Core
   A Closer Look: 7 Core
   Find Out More: 7 Core
   Studio Master: 7 Core
   Studio Reflection: 7 Core
   Assessment Master: 7 Core
Large Reproduction 13
Overhead Transparency 14
Slides 7a, 7b, 7c

### Teaching Through Inquiry

**Art Criticism** Have students write a letter in which they describe—to the people of Atchison—*Portrait of Amelia Earhart*, tell the message that the image conveys, and give reasons why the portrait is a good way to celebrate the aviator's 100th birthday.

As you travel into cities and towns, you may see welcome signs that tell you about the famous people who were born or lived there. Motels, restaurants, and parks are often named after favorite citizens. Communities sometimes ask artists to help them create artworks that show the accomplishments of their citizens. For example, many cities and towns have a mural that an artist might have made with the help of local volunteers. The people of Atchison, Kansas—hometown of aviator Amelia Earhart—asked Kansas artist Stan Herd to help them commemorate Earhart's 100th birthday. Many townspeople volunteered to help the artist create her portrait (Fig. 7–4) using native stone, grasses, and other ground covers. Like most of Herd's artworks, the portrait of Amelia Earhart is best seen from the air!

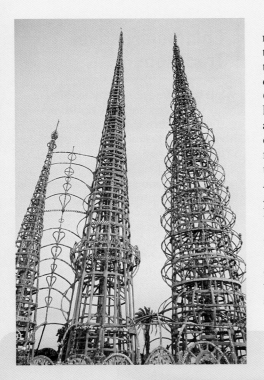

Fig. 7–3 This tower is made of thousands of found materials put together by one man. Why might he still be considered a local hero after leaving the area? Simon Rodia, *Watts Tower*, Los Angeles, California, 1921–55.
© Rene Burri / Magnum Photos.

Fig. 7–4 Stan Herd is known for his "crop art." He uses plants to make images. Is there an artwork in your area that people worked on together? Stan Herd, *Portrait of Amelia Earhart*, Atchison, Kansas, 1997.
Native stone with perennial grasses and other ground covers. Photograph © by Jon Blumb, 1997.

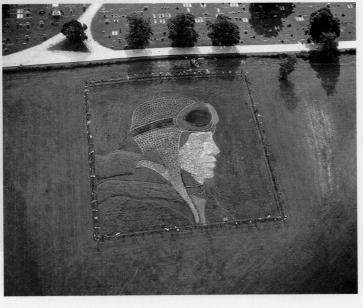

Celebrating

227

## Using the Text

**Art History** Ask students to read pages 226–227. If any students have moved into the area recently, ask them what customs and words are different from those used in their former community. **Ask:** How has Watts Tower become a symbol for its community? *(The community fought to preserve it.)*

## Using the Art

**Art Criticism Ask:** From where were *Watts Tower* and Herd's *Amelia Earhart* designed to be viewed? (Watts Tower: *on ground level, looking up;* Amelia Earhart: *in the air, looking down*) Lead students in comparing what prompted the creation of each of these artworks. (Amelia Earhart *was a community endeavor of volunteers led by an artist,* whereas Watts Tower *was created by the passion of one man.*)

## Critical Thinking

**Ask:** What must a person have accomplished, or what characteristics must he or she have, in order to be considered a local hero? Can a local hero be someone who has committed a crime?

## Journal Connection

Encourage students to write descriptions of sights, sounds, smells, and emotions that they can recall about any community or school celebrations they have attended. **Ask:** How could you convey the sensations of this event in a poem or artwork?

### More About...

**Stan Herd** (b. 1950) studied art in college and went on to develop his own style of "crop art"—art that is best seen from an aerial viewpoint. Some of the challenges he faces as an earth artist are: the works are difficult for the public to view, plants used to create certain colors may only bloom particular times of the year, and the sizes and locations of his work demand special considerations.

### Using the Large Reproduction

**Talk It Over**

**Describe** Name all the objects you see in this painting.

**Analyze** Use carefully chosen words to describe the use of color, line, shape, and pattern.

**Interpret** What does this painting say about Independence Day?

**Judge** Is this painting a good way to communicate ideas about community celebrations? Why?

13

### CD-ROM Connection

 For more images relating to this theme, see the Community Connection CD-ROM.

## Using the Text

Have students read about community festivals. Ask students to name several community celebrations. *(to honor regional foods or celebrities, religious figures and events, seasonal customs, common interests such as the art car festival)* Encourage students to describe their experiences at these or similar events.

## Using the Art

**Perception** As students study the Indonesian shadow puppet, explain that the audience sees only the puppet's shadow cast on a white curtain. The puppets are flat shapes cut from leather. Note how important the negative space within this shape becomes. **Ask:** What kinds of lines are in this puppet?

**Art Production** Ask students to consider how the media of the snow sculpture and *Camera Van* affected the design of each work.

## Community Festivals

When you look at a tour book for any region in North America, you can usually find a list of many local festivals. These celebrations provide an opportunity for people in a city or town to take part in local cultural events, seasonal customs, religious beliefs, and community traditions. Seasonal festivals highlight special activities associated with each time of the year. Snow sculptures are common activities at winter festivals in colder regions (Fig. 7–5). Festivals are also held to honor religious figures and events. Regional festivals often celebrate local foods—such as chili, bratwurst, tomatoes, or pumpkins—or local crafts and music. Some communities hold festivals to honor local celebrities, such as astronauts, war heroes, or poets.

## Common Festival Traditions

While community celebrations differ in many ways, there are some **traditions**—customs or beliefs that are passed down from earlier generations—that festivals have in common. Parades and fireworks, for instance, have long been part of community celebrations. Banners, flags, costumes, and music are often part of parades. Some communities parade their animals and vehicles, too. In some places, parades are even held on water with decorated boats. Public dance, theater, and concert performances add to the festivities. Many communities celebrate with puppet shows that tell religious or other familiar stories. In Indonesia, puppeteers perform all-night shows with shadow puppets (Fig. 7–7).

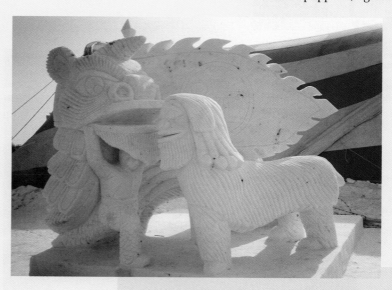

Fig. 7–5 **The largest winter festival in Canada, called the Festival du Voyageur, is a celebration of Manitoba's French-Canadian history. It is internationally famous for its snow sculpture competition. Would you guess that this snow sculpture was designed by an artist from China? Why or why not?** Hong Kong's entry in the International Snow Sculpture Symposium, 1993. Courtesy Festival du Voyageur.

**Teaching Options**

### Teaching Through Inquiry

**Aesthetics** Ask students to create a list of characteristics that a car must have in order to be considered an "art car," and to indicate under what conditions an ordinary car becomes art. Have students create another list of characteristics that a form made out of snow must have in order to be considered "snow sculpture." **Ask:** Is an ordinary snowperson a "snow sculpture"? Have students work alone or in groups and then share their position with the rest of the class.

### More About...

**Other puppetry** In Bunraku, a classic form of puppet theater in Japan, three to five performers manipulate three-foot-tall puppets. Dressed in black and wearing hoods, the puppeteers remain onstage while the story is recited from off-stage. The puppets have heads, hands, and feet of wood attached to a bodiless cloth costume. Before being allowed to work the hands of these puppets, a performer must apprentice for eight years to learn how to manipulate the feet.

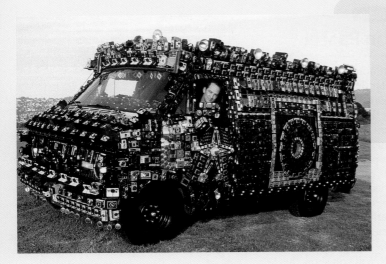

Fig. 7–6 Have you ever seen a car made into a sculpture? Imagine seeing a whole group of cars and vans that have been transformed into works of art! What does this work tell you about the artist who created it? Herrod Blank, *Camera Van*, 1995. 1972 Dodge van with 2000 cameras. Courtesy of the artist, cameravan.com.

## Critical Thinking

Challenge students to imagine the personality of the Indonesian shadow puppet, and to describe the facial features and dress. Encourage students to look at other types of Indonesian art to understand traditional design influences in the shapes and lines of this puppet.

## Journal Connection

Encourage students to look for local newspaper and other announcements of community, club, school, religious, and other group celebrations, to consider how and why these may have begun, and to describe traditions associated with them.

## Extend

Assign students each to design a poster announcing a school or community celebration. Discuss symbols and art styles traditionally associated with the event. Suggest to students that they use colors, lettering, and illustrations on their poster so as to reflect the meaning or heritage of the celebration. Instruct students to draw these in pencil on poster board and to add color with markers or tempera paint.

People with a common interest sometimes come from all over the world to attend festivals. For several years, Houston, Texas, has been the destination for people interested in art cars—vehicles transformed into spectacular moving sculptures (Fig. 7–6). Although people bring their art cars from many different places, the community of Houston has adopted the festival as its own.

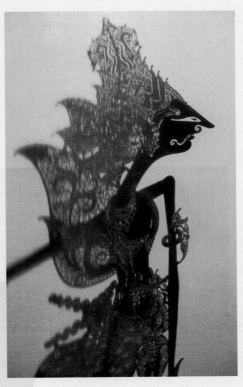

Fig. 7–7 Shadow puppet shows are featured in festivals throughout Indonesia. Traditionally, they tell stories from Hindu mythology. The shows start late and last all night. Have you seen puppet shows at festivals? How were they related to the festival's theme? Indonesia, Central Java, *Shadow Puppets*.
© Luca Tettoni / Viesti Associates Inc.

Celebrating

229

### Using the Overhead

**Think It Through**

**Ideas** What might have inspired the artist to include the various items depicted?

**Materials** What materials did she use?

**Techniques** How, do you think, did she use materials and tools to create the artwork's special look?

**Audience** Can you think of an audience who would *not* understand the meaning of this artwork?

14

## Supplies

- pastels
- pastel paper, 18" x 24"
- scrap paper
- facial tissues
- cotton swabs
- water
- paper towels
- fixative

### Safety Note

Use only pastels that have been certified as nontoxic. Dust from pastels can irritate breathing passages. Provide paper masks for students who wish to cover their nose and mouth. Have students use fixative only in well-ventilated areas.

## Using the Text

**Art Production** Discuss fairs, festivals, parades, picnics, and community events that students might draw. **Ask:** What colors will go with your celebration? Will you focus on details, or take a distant view of the whole festival? How will you emphasize your message?

Teach students to blend pastels, and encourage them to experiment with applying pastels to damp paper. After students have practiced making a variety of textures and values, have them make their final drawing. Suggest that they repeat shapes and colors to create unity.

## Using the Art

**Art Criticism Ask:** What is the center of attention in Fig. 7–8? How did the artist emphasize this? How did she create unity? Describe this painting in one or two words. Now focus on Fig. 7–10. **Ask:** What is Lawrence's message about this parade? How did he use elements of design to create a mood?

**7 CORE STUDIO**

### Drawing in the Studio
## A Festival in Pastel

Community celebration is a popular theme for drawings and paintings. Artists who create these works make choices about subject matter, media, and techniques. Some choose to draw festivals from up close; others work from far away. Artists can create the excitement of festivals by using bright colors and lively lines and shapes in their artworks.

**In this studio experience, you will create a pastel drawing of a community celebration.** Will the point of view of your scene be from up close or far away? Will you show the event or the people? How will you use color, line, and shape to create a particular mood or feeling?

### You Will Need

- sketch paper
- pencil
- pastels
- scrap paper
- facial tissues
- cotton swabs
- drawing paper

### Try This

**1.** Choose a community celebration to show. Then choose a format and point of view for your drawing. Will it be horizontal or vertical? Will you show a daytime or nighttime scene? Sketch your ideas.

**2.** Experiment with pastels on scrap paper. Try making different kinds of marks. Blend colors with a tissue or cotton swab. Decide which colors and pastel techniques will best express your ideas.

**3.** Create your final drawing. Draw large shapes first. Then fill in colors and details.

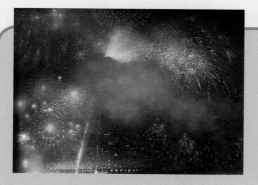

Fig. 7–8 This artist created a series of paintings that capture the 100th birthday celebration of the Brooklyn Bridge, in New York. Do you think her painting shows what it's like to watch a fireworks display? Colleen Browning, *Fireworks III*, 1983–84. Oil on canvas, 19" x 27" (48.3 x 68.6 cm). Courtesy Hamon-Meek Gallery, Naples, Florida.

## Studio Background

**Festive Crowd Pleasers**

Parades and fireworks displays are by far the most popular expressions of celebration. Most people love parades for their music, floats, clowns, balloons, confetti, and general excitement. People often work together to create different kinds of art for parades, such as banners, sculptures for floats, and costumes. Many artists then go on to record these events in paintings and drawings.

Fireworks are more mysterious than parades. People are entranced by their delicate and instantaneous beauty. Artists have been actively

## Teaching Options

### Meeting Individual Needs

**Focusing Ideas** Have students use an outline or graphic organizer to answer questions in the second paragraph of A Festival in Pastel before they begin to focus their ideas.

**Adaptive Materials** For students who find pastels difficult to use, provide crayons or paint.

### Teaching Through Inquiry

**Art History** Have students work together to create a list of questions to investigate a festival in a place and time of their choice. Encourage students to identify any art form typically used in the festival. Have students create a bulletin-board display of their findings.

## Check Your Work

Display your completed artwork with your classmates' artworks. Separate them according to subject matter and point of view. Use descriptive words to indicate the moods or feelings of the artworks. Determine how the use of color, line, and shape contributes to the moods and feelings conveyed.

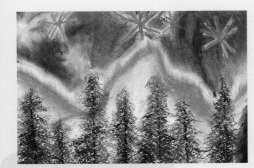

Fig. 7–9 "I used chalk pastels to make a drawing of northern lights and a fireworks show. It takes place on New Year's eve." Cathy Mae Searles, *An Alaskan Light Show*, 2000. Pastel, 12" x 18" (30.5 x 46 cm). Colony Middle School, Palmer, Alaska.

involved in the design of fireworks displays. Famous artists Michelangelo, Leonardo da Vinci, Rubens, and Bernini all helped design fireworks displays. People rely on artists to create images that will help them remember the momentary fireworks experience.

### Core Lesson 7

#### Check Your Understanding
1. Use examples to explain how artists help communities remember and celebrate their local heroes and celebrities.
2. How might an artist show the spirit of a community?
3. Identify two traditions that community festivals have in common.
4. Why, do you think, do people use fireworks in community celebrations?

**Sketchbook Connection**
Take your sketchbook to a festive event. Focus on just one kind of object or action—people's faces, the movements of people's bodies, food, banners, or toys, for example. Keep sketching until you feel comfortable with your subject matter.

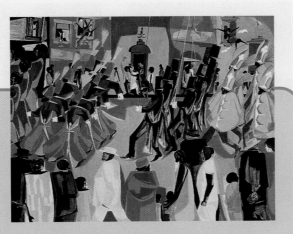

Fig. 7–10 Jacob Lawrence used bright colors and simple shapes to draw viewers into this scene. The close-up view helps viewers feel like part of the celebration. How did Lawrence use color and shape to create the rhythm and excitement of a parade? Jacob Lawrence, *Parade*, 1960. Tempera with pencil underdrawing on fiberboard, 23 7/8" x 30 1/8" (60.6 x 76.5 cm). Hirshhorn Museum and Sculpture Garden, Smithsonian Institution, Gift of Joseph H. Hirshhorn, 1966. Photographed by Lee Stalsworth.

Celebrating

231

**Sketchbook Tip**
Encourage students to sketch objects and symbols associated with festivals.

## Assess

### Check Your Work
Allow students to group their drawings by subject and arrange a display. Ask student pairs to write a one- or two-word description of the mood or feeling in their partner's artwork, and to discuss whether the artist agrees with the assessment.

#### Check Your Understanding: Answers
**1.** Students might mention Red Grooms, Stan Herd, and Jacob Lawrence, all of whom have created artworks that feature local heroes and celebrities.

**2.** Answers will vary, but students might mention that artists have recorded parades, fireworks, and festivals.

**3.** Answers will vary. Possible answers: parades, fireworks, banners, flags, costumes, music, performances.

**4.** Answers will vary.

## Close

Ask students to summarize the role that art played in the festival that they drew.

### More About...

When **Jacob Lawrence** (b. 1917) lived in Harlem, the area was a renowned center for African-American writers, artists, and jazz musicians. Lawrence was inspired by African-American culture and history, and that inspiration gave rise to the many series of paintings that have made him famous. His first series, *Toussaint L'Overture*, consists of forty-one scenes that feature the Haitian hero. Later series featured Frederick Douglass, Harriet Tubman, and John Brown. Among his most famous works is *Migration Series*, which depicts the migration of southern African Americans to northern cities. His unique style, sometimes called *collage cubism*, consists of bold shapes in strong colors.

### Assessment Options

**Teacher** Have students create a concept map showing how art helps communities celebrate their heritage. Instruct students to include reference to art that shows community members going about their lives and to objects that people use in their local celebrations. Suggest to students that they find examples on pages 224–231 or from their own community. Look for evidence that students understand that artists help communities remember and celebrate their local heroes, celebrities, and historical events.

# Prepare

## Pacing

Three to four 45-minute periods: one to consider art and text; three to make art

## Objectives

- Give examples of how artists in the first half of the twentieth century documented community spirit.
- Explain what was important about the Harlem Renaissance.
- Combine media to capture the spirit of community life.

## Vocabulary

**Regionalist** An artist whose artworks focus on a specific region or section of the country.

**Harlem Renaissance** A name of a period and a group of artists who lived and worked in Harlem, New York City. They used a variety of art forms to express their lives as African Americans.

## Using the Time Line

**Ask:** Have you heard stories of how your family or community was affected by the Great Depression? By wars during this period? How did transportation change from 1920–1950?

---

# Art and Pride: 1920–1950

**1930**
Benton, *Changing West*

**1936**
Dike, *Copper*

Industrial America
page 206

**American Regionalism**

American Social Causes
page 258

**1932**
Jones, *The Ascent of Ethiopia*

**1937**
Magafan, *Wheat Threshing*

## History in a Nutshell

Major international wars took place between the 1910s and the 1950s. In 1918, the United States was emerging from World War I, which was fought in Europe. Americans were tired of European political and economic affairs. They wanted to focus on the quality of life in the United States. Then, in 1929, the American stock market crashed, triggering the Great Depression of the 1930s. During this time many people in the United States lost everything they owned as well as their means of earning a living. Economic recovery programs, such as the Works Progress Administration (WPA), helped the United States recover from these losses. So did World War II. World War II dominated the first half of the 1940s, and was followed by the Korean War, in the early 1950s.

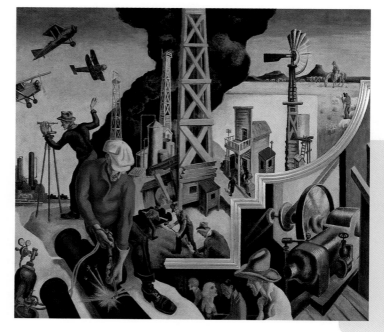

Fig. 7–11 **In this painting, the artist created a variety of snapshots of the American West. Why might people consider this artwork an expression of the national spirit of the time?** Thomas Hart Benton, *The Changing West* from *America Today*, 1930.
Distemper and egg tempera on gessoed linen with oil glaze, 92" x 117" (233.7 x 297.2 cm). Collection, AXA Financial. © AXA Financial. © T.H. Benton and R.P. Benton Testamentary Trusts / Licensed by VAGA, New York, NY.

---

## National Standards
## 7.1 Art History Lesson

**1a** Select/analyze media, techniques, processes, reflect.

**1b** Use media/techniques/processes to communicate experiences, ideas.

**2b** Employ/analyze effectiveness of organizational structures.

**3b** Use subjects, themes, symbols that communicate meaning.

**4a** Compare artworks of various eras, cultures.

**4c** Analyze, demonstrate how time and place influence visual characteristics.

# Teaching Options

## Resources

Teacher's Resource Binder
- Names to Know: 7.1
- A Closer Look: 7.1
- Map: 7.1
- Find Out More: 7.1
- Check Your Work: 7.1
- Assessment Master: 7.1
- Overhead Transparency 13
- Slides 7d

## Meeting Individual Needs

**English as a Second Language** Ask students to identify, in English, elements that Benton (Fig. 7–11) painted. List responses on the chalkboard. **Ask:** Do you see these items (such as planes, towers, or windmills) in cities today? Have students draw a composition of their community and label, in English, the items they include.

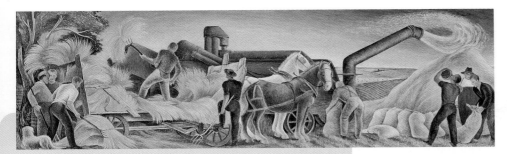

Fig. 7–12 Communities receiving government-funded murals had to approve the artworks first. The murals often showed the things in which a community took pride. What do you think the people in this community valued? Ethel Magafan, *Wheat Threshing*, 1937.
Egg tempera on gessoed masonite panel, 17 1/2" x 34 1/8" (44.5 x 88.6 cm). Museum Purchase, Art Purchase Fund, Friends of the Wichita Art Museum, Wichita Art Museum, Wichita, Kansas. (1981.19)

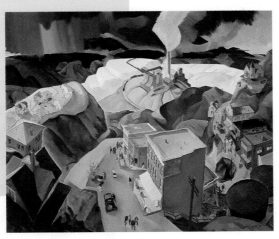

Fig. 7–13 Would you consider this painting the work of an Urban Regionalist or a Rural Regionalist? Why? Philip Latimer Dike, *Copper*, 1936.
Oil on canvas, 38 3/16" x 46 1/4" (96.5 x 117.5 cm). Phoenix Art Museum, Museum purchase with funds provided by Western Art Associates. (78.10)

## Community and National Spirit

In the years following World War I, many artists focused their attention on specific regions or sections of the country. They became known as **Regionalists.** Some of these artists used the city as subject matter for their art. *Urban Regionalists*, as they came to be called, celebrated the spirit of the community. Their artworks showed scenes crowded with people, new architecture, and changing styles of clothing. People began to think about where their ancestors came from. Groups of people gathered together to celebrate their common heritages.

Outside of cities, artists searched for ways to celebrate a national spirit. Artists such as Grant Wood and Thomas Hart Benton

became known as the *Rural Regionalists*. Their works captured American pride, traditions, and morals. They recorded the roots of America, often looking back to American folk art for inspiration. Figures 7–11 and 7–13 celebrate the spirit of the American West.

During the Great Depression, the United States started one of the most extraordinary programs of support for the arts ever imagined. Inspired by the Mexican mural movement, the government paid artists minimum wages to create public works of art. These works included murals that focused on regional and community spirit. Many of these murals are landmarks in North American art history. How does the mural by Ethel Magafan (Fig. 7–12) show community spirit?

<div style="text-align: right">Celebrating</div>

233

## Teach

### Engage

**Ask:** If you were asked to create a painting to glorify the spirit and traditional American values of your community, what would you paint? Tell students that they will learn of artists who were given just such an assignment.

### Using the Text

**Art History** Have students read History in a Nutshell to learn the major events of the first half of the twentieth century. Encourage students, as they read Community and National Spirit, to look for ways that artists expressed their national and community pride. **Ask:** Why were many public murals painted during the Great Depression? *(The government provided artists with work by commissioning them to paint murals as part of economic recovery programs such as the W.P.A.)*

### Using the Art

**Art Criticism Ask:** How are these three paintings alike? What do the artists tell us about the workers? Challenge students to compare the painting styles. **Ask:** Are these paintings realistic? Note how the artists simplified forms and shapes and altered colors. **Ask:** Which artwork is the most dramatic? How did the artists create a sense of drama? *(dark clouds, billowing smoke, rays of sunlight, flying wheat, unusual viewpoints)*

### Teaching Through Inquiry

**Art History** Have students work in small groups to identify **artists supported by the W.P.A.** art programs during the Great Depression. Have groups pool information and make assignments for preparing a class booklet of artist biographies, in which they list artists' best-known works.

**Aesthetics** Have students find out about programs supported by the National Endowment for the Arts. Challenge students to research and then debate political controversies surrounding government support for the arts, especially with regard to censorship.

### More About...

The **American Regionalists** were interested in depicting scenes that reflected areas, or regions, of the United States. Grant Wood became famous for his rural paintings of middle America, as did Thomas Hart Benton, who wished to create an American art style that had little to do with either modern or past European traditions.

### Using the Overhead

**Describe** What details might go unnoticed to the casual observer?

**Attribute** Would any of these details help you identify when the photograph was taken?

**13**

**Interpret** From this photograph, what can we learn about life in the early twentieth century?

**Explain** How is this photograph different from photographs taken earlier and those that might be taken today?

## Art and Pride: 1920–1950

### Using the Text

**Art History** Assign students to read Harlem Renaissance. **Ask:** When and where did this Renaissance take place? Why is *renaissance* an appropriate term for this movement?

### Using the Art

**Art Criticism** Have students list all the objects that they can see in Fig. 7–14. Challenge them to decode the symbolism in this painting, reminding them that the work describes African-American history. **Ask:** How did Jones create a sense of depth? Why, do you think, did both Fuller and Jones use a symbol of Egypt in their art?

### Studio Connection

Assemble these materials: 12" x 18" heavy drawing paper, magazines, glue, scissors, paint (tempera or watercolors), brushes, water in containers, wax crayons or oil pastels, envelopes.

Suggest to students that they look at Figs. 7–11 and 7–12, images that feature workers. Have students paint the background and then experiment with arrangements of their cutout figures before gluing them on the background. Discuss how to create a sense of distance by overlapping figures and placing the larger ones lower on the page. Encourage students to experiment with crayon or oil pastels (by drawing some figures in these media) and then painting over, and to indicate highlights and shadows with light and dark colors.

**Assess** See Teacher's Resource Binder: Check Your Work 7.1.

### Extend

Assign students to research American Regional artists Grant Wood, Thomas Hart Benton, or John Steuart Curry. Instruct students to create a poster with reproductions of the artist's famous works and significant facts of his life. Then have students paint and include a parody of one of the artist's works (similar to the many variations of Grant Wood's *American Gothic*). **Ask:** How can you change the subject matter to make a statement about your community?

## Harlem Renaissance

In the 1920s, a group of artists, writers, photographers, and entertainers gathered in Harlem, a section of New York City, to express their heritage as African Americans. Their celebration is known as the **Harlem Renaissance.** *Renaissance* means a rebirth of culture. In Harlem, artists helped the African-American community explore its background and express pride in its culture. Some artists, such as photographer James VanDerZee, captured scenes of important figures and events of the Harlem Renaissance in their artwork (Fig. 7–15). Others, such as

Meta Warrick Fuller, used their art to teach and remind people of African-American history (Fig. 7–16).

The Harlem Renaissance ended with the stock market crash in 1929. Artists such as Lois Mailou Jones (Fig. 7–14) continued to create important works in the decades that followed. These artists spread cultural pride to other African-American communities throughout the country. Although less publicized, creative activities were taking place in African-American communities in many other cities, such as Philadelphia, Chicago, Boston, Baltimore, and San Francisco.

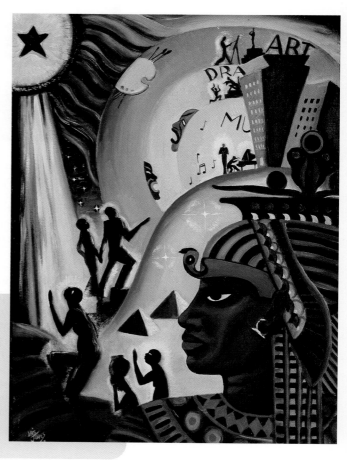

Fig. 7–14 **How does this painting celebrate the heritage of African-American people?** Lois Mailou Jones, *The Ascent of Ethiopia*, 1932.
Oil on canvas, 23 1/2" x 17 1/2" (59.7 x 43.8 cm). Milwaukee Art Museum, Purchase, African-American Acquisition Fund, matching funds from Suzanne and Richard Pieper, with additional support from Arthur and Dorothy Nelle Sanders. Photo credit: Larry Sanders.

## Teaching Options

### Teaching Through Inquiry

**Art Production** Remind students that Harlem Renaissance artists were inspired by their African-American heritage. Ask students to examine their community, state, or region's ethnic roots and to create an artwork that celebrates its cultural pride.

**Art Criticism** Have students use the Descriptive and Expressive Word Cards, as well as the Interpretation Statements, in the Teacher's Resource Binder in small-group discussions of the artworks in this lesson. Have each group select one artwork and write about it in the form of a letter to someone who has never seen the artwork and who also wants to know about life in the United States between the world wars.

### More About...

The **Works Progress Administration** (1939–43) oversaw the Federal Arts Project, part of the United State Government's efforts to give work to approximately 10,000 unemployed artists. In the first test program, beginning in 1933, 3700 artists participated, creating some 15,600 artworks.

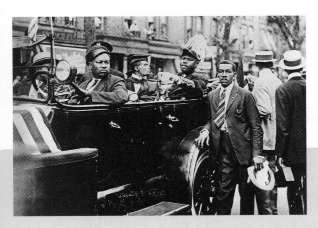

Fig. 7–15 James VanDerZee was the most successful of Harlem's commercial photographers during the Harlem Renaissance. He used his camera to record the life and glamour of urban Black America. This photograph shows Marcus Garvey, an important community leader of the time. James VanDerZee, *Marcus Garvey in Regalia*, 1924. Silver gelatin print, 5 5/16" x 10" (15.2 x 25.6 cm). © Donna Mussenden VanDerZee

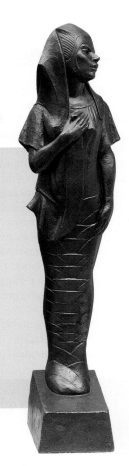

Fig. 7–16 Meta Warrick Fuller created this sculpture before the Harlem Renaissance. Notice the Egyptian headdress and bandages of mummification, which the woman is unwrapping. These are believed to represent the greatness of the African people. Why might African Americans be interested in this sculpture? Meta Warrick Fuller, *Ethiopia Awakening*, ca. 1907–10. Plaster (bronze cast), 67" x 16" x 20" (170 x 40.6 x 50.8 cm). Art and Artifacts Division, Schomburg Center for Research in Black Culture, The New York Public Library, Astor, Lenox and Tilden Foundations. Photo by Namu Sassoonian.

### 7.1 Art History

#### Check Your Understanding
1. Explain the basic differences between the art of the Urban Regionalists and the Rural Regionalists.
2. How did the Mexican mural movement have an impact on the United States during the Great Depression?
3. What is meant by the term *Harlem Renaissance*?
4. What role did artists have in the Harlem Renaissance?

**Studio Connection**
Crowds of people are among the many subjects artists painted to capture the spirit of community life in the twentieth century. You can create a mixed-media painting of people. Experiment with ways to combine different media, such as collage techniques with painting. Use magazine or newspaper cutouts of figures for your crowd scene. Then combine these with your own drawings and a painted background. Use a variety of thick and thin lines. Use light colors for highlights and dark colors for shadows.

Celebrating

## Assess

### Check Your Understanding: Answers

1. Urban Regionalists showed scenes crowded with people, new architecture, and changing styles of clothing. Rural Regionalists, looking to traditional roots and American folk art for inspiration, tried to capture American pride, traditions, and morals.

2. The government, inspired by the Mexican murals, paid artists to create public artworks.

3. the rebirth or celebration of cultural activities in the African-American community of Harlem

4. Artists explored the heritage of African Americans and expressed pride in their culture.

## Close

As students review a display of their works, encourage volunteers to describe their composition.

## More About...

**Lois Mailou Jones** (b. 1905) originally painted in an Impressionistic style, much of which she learned while studying in Paris. In the early 1940s, Jones began focusing on scenes of her experience as an African-American artist. In her work—which includes paintings, prints, and textiles—she makes references to Haitian and African art.

## Assessment Options

**Peer** Have students work in pairs and interview each other to identify three artworks in this chapter that each student thinks clearly document community spirit. Instruct students to support their selections with reasons.

**Teacher** Have students work in groups to write a short script for a TV program in which they highlight the importance of the Harlem Renaissance. They should focus on the work of visual artists. Look for evidence that students know that African Americans explored their heritage and expressed pride in their culture.

## Prepare

### Pacing
One or two 45-minute periods

### Objectives
- Identify ways that photography is used for artistic expression, and explain how it requires artistic and scientific knowledge.
- Make a flip book about a community celebration.

**Prepare for Studio Connection:** Make or obtain a sample flip book.

## Teach

### Engage
**Ask:** What photographic images have you seen today? Remind students that most advertising contains photographs.

### Using the Text
**Art History** Have students read Photography. **Ask:** How have some painters used photographs? *(as guides for paintings)* How do technology and art join in photography?

### Using the Art
**Art Criticism** Call attention to how the photographer of Fig. 7–18 filled the picture with faces. **Ask:** Where is the light source? Where are the lightest and the darkest values? How can you tell what these people are celebrating? Where is the camera? By taking this viewpoint, what did the artist emphasize?

### National Standards 7.2 Forms and Media Lesson

**1b** Use media/techniques/processes to communicate experiences, ideas.

**2b** Employ/analyze effectiveness of organizational structures.

**3a** Integrate visual, spatial, temporal concepts with content.

# Photography

You probably have at least one photograph of yourself with your family or friends during a holiday celebration. When cameras became relatively inexpensive, people all over the world began using them to record memorable times. After photography was invented, in 1826, artists slowly began to realize the possibilities for creative expression. Using a camera, they could look around and "frame" pictures. Some artists have taken photographs as guides for later paintings. Others value photographs for their unique characteristics. For over 175 years, artists have been using photography to explore their world and create unforgettable images.

Some of these unforgettable images document important celebrations in our communities, such as a bicentennial parade or a

moment during the Olympics. Many photographers focus on people in the artworks they create. Photographs like these remind us that we all share basic human emotions and do very similar kinds of activities. Some photographers are not interested in showing the world as it actually exists. They create images by posing actors or objects and then photographing them. They often create eerie scenes for us to contemplate.

## Photography as Art and Science

The art of photography starts with the person who uses the camera. A professional photographer needs to know the elements and principles of design when preparing to take a picture. (See Foundation 3 to learn more about the elements and principles of design.) Good photography also comes from a scientific knowledge of camera tech-

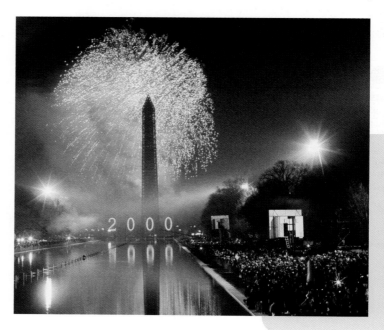

Fig. 7–17 This photograph represents one city's perspective of a once-in-a-lifetime world celebration: the ringing in of the new millenium. Notice how the photographer has used the design principles of balance and emphasis to create his image. Besides the blazing 2000, what other element in this photograph will never be seen again? Fireworks in Washington, New Year's, 2000, Celebration. © Reuters Newmedia Inc. / CORBIS

236

## Teaching Options

**Teaching Through Inquiry**

**Art Criticism** Have students work in groups to collect photographs—from family, newspapers, magazines, the Internet, and other sources—and then categorize them by the ways photography can help communities **celebrate** their heritage and pride (such as by their power to document community events, show that people have similar emotions, and teach about our heroes and celebrities). Have groups share their findings.

niques, films, light sources, and printing processes. In the darkroom, an artist can change images to hide or reveal details caught on film. Photographic technology has changed over the years. Today, many photographers are experimenting with computer technology and digital cameras to create and manipulate pictures.

### 7.2 Forms and Media

**Check Your Understanding**
1. What do photographers do?
2. What does a photographer need to know to create a good picture?

**Studio Connection**
*Cinematography* is the art of making moving, or motion, pictures. The illusion of motion is created by rapidly showing a series of photographs called frames. The picture in each frame is slightly different from the preceding one. Flip books are a way to create motion pictures without using a camera. Try making a flip book that shows something from a community celebration, such as fireworks or a festival dance. Make a series of drawings by hand or on a computer. Each drawing should be slightly different from the one before it. Staple the drawings together at one end. When you are finished, rapidly flip the pages to show the action.

### Studio Connection

Gather these supplies: 3 1/2" x 3 1/3" drawing or copy paper, staples and staplers, pencils, markers.

Demonstrate your flip book, and discuss possible subjects for students to animate. Suggest to students that they draw the first, last, and middle images and then draw the rest. Instruct students to sketch in pencil before drawing over with markers. When sketching nears completion, encourage students to check by flipping the pages, deciding whether to add or subtract images.

**Assess** See Teacher's Resource Binder: Check Your Work 7.2.

## Assess

### Check Your Understanding: Answers

**1.** take photographs as guides for later paintings; document important events in communities; focus on people; and create images by posing actors or objects.

**2.** A photographer must understand design elements and principles, techniques for using cameras, film, light sources, and printing procedures.

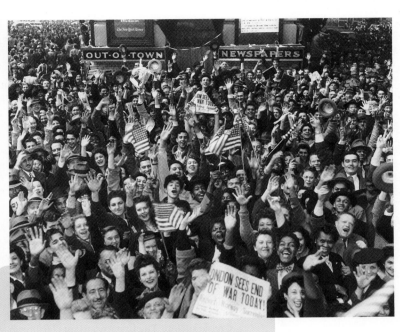
Fig. 7–18 This photograph shows a different kind of celebration. Communities in many parts of the world celebrated the surrender of German forces at the end of World War II. Here we see a neighborhood in New York City. What makes this a powerful photograph? Large group of people celebrating V-E Day.
Silver gelatin print. © Corbis / Bettmann-UPI

Celebrating

237

## Close

Encourage students to write a few words to describe the motion in one another's books.

### More About...

Frenchman Louis Jacques Mandé Daguerre (1789–1851) invented one of the earliest photographic processes. His images on highly polished sheets of silver-plated copper had a clarity and brilliance previously unknown. Using the new **daguerrotype** technique, after 1839 numerous portrait studios opened in North America.

### Using the Overhead

**Write About It**

**Describe** Describe the areas that show paths of movement.

**Analyze** Use the overlay, and have students write two or three sentences about how the artist repeated elements to create rhythm and movement.

13

### Assessment Options

**Teacher** Have students imagine that the board of directors of a local museum has complained about an upcoming photography exhibit, claiming that such an exhibition is not a good use of the museum. They say that anyone can take a photograph, and that the museum must be reserved for "real" art—art that requires knowledge to make and that can send important messages to community members. Ask students to use what they have learned about photography to write a letter to the board, defending the exhibition.

## Prepare

### Pacing

Three 45-minute periods: one to consider art and text; two to make art

### Objectives

- Identify traditions and influences in Caribbean art.
- Consider artistic elements of carnival festivities.
- Explore the techniques of assemblage to create a sculpture expressing the theme of celebration.

### Using the Map

Have students locate the Caribbean Sea, the Bahamas, and Trinidad on the map. **Ask:** Which Caribbean island is largest? *(Cuba)* Note the proximity to the Florida Keys.

# Caribbean Art

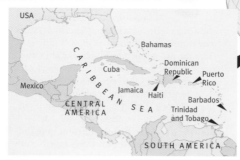

**Caribbean**

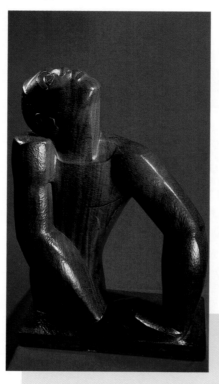

Fig. 7–19 In the Caribbean, small woodcarvings such as this are used for religious rituals performed in the home. Most are sculptures of saints. Anonymous, Caban family member, *La Mano Poderosa*, Camuy area, Puerto Rico, 19th century.
Wood, 10" (25.5 cm). Private Collection, San Juan, Puerto Rico.
Courtesy Galeria Botello, Hato Rey, P.R.

238

## Global Glance

The Caribbean is a chain of many large and small islands from Cuba and the Bahamas in the north to Trinidad and Barbados in the south. The communities of these islands do not all share the same culture and language. The four main language groups of the Caribbean are Spanish, French, English, and Dutch. West African and Asian languages are also spoken on the islands. All the island communities of the Caribbean, however, have two things in common: religious icons and carnival or festival traditions. These traditions are important to the art of the Caribbean.

## A New Beginning

Before the seventeenth century, the Caribbean was not known for its artwork. No large-scale monuments or stone architecture stopped explorers on their way through the region, and most early Caribbean art has been lost or destroyed. The artworks of this early period that remain, such as funerary figures and pottery, are religious, utilitarian, or related to ritual.

By the end of the seventeenth century, the Caribbean was a mixture of European cultures, African slave groups, and an emerging Creole society. The first important Caribbean-born artists became known in the second half of the eighteenth century. The European influence on their artworks is easy to see. During this time, religious artworks and portraits were in great demand by the upper classes. Religious and ritual art remained popular through the nineteenth century.

## National Standards 7.3 Global View Lesson

**1b** Select/analyze media, techniques, processes, reflect.

**2b** Employ/analyze effectiveness of organizational structures.

**4a** Compare artworks of various eras, cultures.

**4c** Analyze, demonstrate how time and place influence visual characteristics.

**5b** Analyze contemporary, historical meaning through inquiry.

## Teaching Options

### Resources

Teacher's Resource Binder
  A Closer Look: 7.3
  Map: 7.3
  Find Out More: 7.3
  Check Your Work: 7.3
  Assessment Master: 7.3
Large Reproduction 14
Slides 7e

### Teaching Through Inquiry

**Art History** For each Caribbean island, assign individual groups of students to create a teaching board, which includes a time line of the island's settlement and history; photographs of the scenery; a description of the climate; identification of popular art forms, including carnival traditions; and identification of local artists. Have each group share their board with the rest of the class.

## A Celebration of Culture

In the early twentieth century, Caribbean artists turned their attention to cultural symbols, the daily work of islanders, and the gaiety of life and leisure. Their artworks were filled with the bright colors and excitement of festivals, such as carnival.

Even as Caribbean art celebrated its island cultures, artists looked to communities around the world for inspiration. Caribbean artists of Spanish descent began to create images of local island conditions, such as poverty, in much the same way as the Mexican muralists of the time. The connection between African-American communities and the Caribbean became strong. Several Caribbean artists were key figures in the Harlem Renaissance.

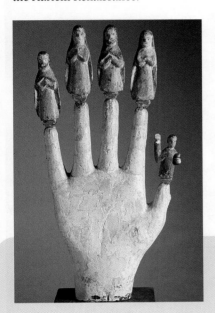

Fig. 7–20 Edna Manley created some of her works at the time of the Harlem Renaissance. Notice the upturned face and the strong arms of this sculpture. How might these features suggest the Renaissance idea of rebirth or reawakening? Edna Manley, *Negro Aroused*, 1935.
Mahogany, height: 51" (129.5 cm). National Gallery of Jamaica, Kingston. Photograph © 2000, Denis Valentine.

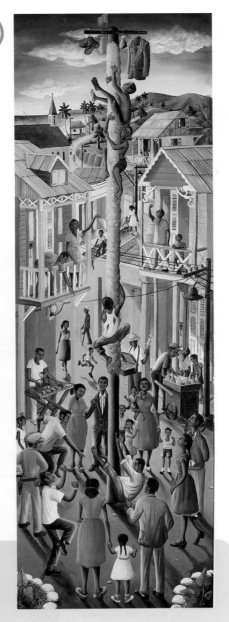

Fig. 7–21 Notice the tall and narrow format of this painting. Why might the artist have chosen this format for this festive scene? Andre Normil, *The Greased Pole*, 1966.
Oil on masonite, 49 1/2" x 17 1/2" (125.7 x 44.5 cm). Milwaukee Art Museum, Gift of Richard and Erna Flagg. Photo by Larry Sanders (M1991.136)

Celebrating

239

## Teach

### Engage

**Ask:** For what celebrations have you dressed in costume? Tell students that they will study Caribbean celebrations.

### Using the Text

Have students read A New Beginning and A Celebration of Culture. **Ask:** What was the "new beginning"? In what ways did Caribbean artists in the early twentieth century draw attention to the cultural life of their communities?

### Using the Art

**Art Criticism Ask:** How does Andre Normil use color to direct your eye in Fig. 7–21, *The Greased Pole?*

**Art Criticism** Note to students that Edna Manley depicted an awakening of cultural pride in Fig. 7–20. **Ask:** Where is the negative space in this sculpture? *(between the torso and arm)* How does that space strengthen the impact of the figure's message?

The many now-independent **islands of the Caribbean** host an array of cultures. Over the centuries, the languages and traditions of the original inhabitants mixed with the those of Spanish, Portuguese, French, Dutch, and British colonizers, as well as enslaved Africans who had worked the plantations.

## Using the Large Reproduction

**Consider Context**

**Describe** What is this? How was it made? What materials were used?

**Attribute** What tradition is this artwork a part of? What parts of the world follow this art-making tradition? What clues might help someone who is familiar with these traditions identify where it was made?

**Understand** How might this have been used?

**Explain** How does this artwork reflect where it was made?

14

## Using the Text

**Ask:** What are some ways Caribbean artists contribute to the festivals that celebrate life? How do these compare to the traditions of other cultures?

## Using the Art

**Perception** As students consider *The Merry Monarch* and *Diana Goddess of the Hunt*, lead them in explaining how these move. **Ask:** How might these look at night in parades, accompanied by music and crowds? What are the colors in these artworks?

## Studio Connection

Assemble these supplies: shallow boxes; found objects; clay, wood, paper, cardboard, and/or wire; glue; scissors; acrylic paint; brushes; water in containers.

Discuss what students might create, and tell them that they may include previously-made clay objects. Encourage creating layers of colors, textures, shapes, and forms to create a sense of rhythm or movement. Students may choose to paint all or parts of their assemblage.

**Assess** See Teacher's Resource Binder: Check Your Work 7.3.

## Carnival as Art

At carnival, there are no rules except one: to have fun. People wear bright and funny costumes, parade through the streets, throw candy and trinkets to the crowds, eat and drink traditional fare, dance and sing all in a colorful jumble of noise, movement, and music. It's a party on a massive scale. It's a celebration of what it means to live in a community where carnival is one of the most important festivals of the year.

Carnival celebrates life. Latin communities around the world hold this traditional festival in the spring of each year. Traditionally, carnival comes from ancient celebrations of many civilizations: European, African, Asian, and Middle Eastern. European traditions seek new and creative ideas for ways to celebrate. From Africa, traditions of masquerade combine music, dance, costume,

sculpture, and drama in a single performance. The influence of East Indian Islamic cultures contributes abstract, geometric, colorful patterns to costumes, parade floats, and other artworks.

Some might say that a Caribbean carnival is performance art at its best. As an art of celebration, carnival is an opportunity to be part of the energy and spirit of a community of people. It allows individuals to be a part of something larger than themselves. For some individuals, it satisfies a need to stand out in a crowd. For others, it provides a means of expressing community pride.

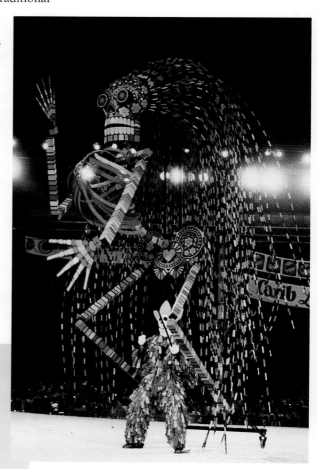

Fig. 7–22 The artist created this elaborate costume from strips of cloth. Would you believe that the theme of the costume is life and death? Which features represent life? Which features represent death? Peter Minshall, *The Merry Monarch*, Caribbean Festival of Arts, 1987.
Courtesy John W. Nunley.

240

## Teaching Options

### Meeting Individual Needs

**Multiple Intelligences/Bodily-Kinesthetic** If possible, play Caribbean carnival music as students think about this experience. Ask students to take the pose of the dancer/puppeteer in Fig. 7–22. **Ask:** What might it feel like to manipulate this enormous work? How would you feel to be part of a festival with dancing figures, boisterous music, fireworks, and good food?

### Teaching Through Inquiry

**Art Production** Ask students to do further research to identify the various cultural influences on Caribbean festival traditions. Encourage individual students to select one influential culture and find examples of its maskmaking traditions. Then have students design a two-dimensional paper mask with stylistic features of that culture. If time permits, have students create a three-dimensional version of the same mask in clay or papier-mâché.

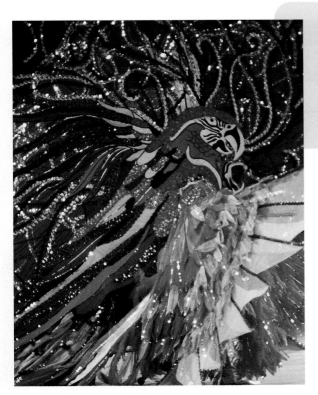

## Assess

### Check Your Understanding: Answers

**1.** the focus on religious icons and festival traditions

**2.** carnival celebrations, the work of the Mexican muralists, the daily life of islanders, local island conditions, and even the Harlem Renaissance

**3.** Carnival is a form of performance art. As an art form, it is a means of expressing community pride.

**4.** masquerade, costumes, floats, parades, dancing, music, performances

## Close

Ask students to identify influences in Caribbean art. Assign them to work in small groups to answer the questions in Check Your Understanding. Discuss their answers as a class.

### 7.3 Global View

**Check Your Understanding**
1. What are the basic similarities among the art of Caribbean cultures?
2. Name some influences on Caribbean art.
3. How might Caribbean festivals or carnivals be considered an art form?
4. What traditions are associated with carnival?

**Studio Connection**
Festival or carnival art includes sculptural forms that are made from assembled parts. An *assemblage* is a sculpture made by combining discarded objects such as boxes, pieces of wood, parts of old toys, and so on. To explore assemblage, create a relief sculpture in a shallow box. Try creating a freestanding sculpture of a festive figure or a small environment. Collect some discarded objects or fabricate some interesting shapes and forms from clay, wood, paper, or wire. From your collection, choose things that express the theme of celebration. Think about the symbolism of the materials—what they mean to you or to other people. Consider the principles of design in arranging the items. Work with layers of texture, color, and collage-like forms.

Celebrating

241

### Studio Collaboration

Have students work together to plan and prepare models of richly decorated floats for a local parade on the theme of "Pride and Progress."

### More About...

**Carnival** is celebrated throughout January and February in Trinidad, a small island off the northern coast of Venezuela. The height of festivities is what Trinidadians call "playing mas," short for "masquerade," which they do on the two days before Ash Wednesday. People can *play mas* alone or in a group as large as 3000, but they all typically focus on a central theme, perhaps from nature, history, or the imagination.

### Assessment Options

**Peer** Instruct students to write three questions that they think are important for students to be able to answer as a demonstration of their understanding of this lesson. Have students exchange papers, answer each other's questions, and discuss responses.

## Prepare

### Pacing

Three 45-minute periods: one to consider art and text, and to cut photographs; two to assemble montage

### Objectives

- Recognize that combining photographic images can communicate important ideas about a community.
- Construct a three-dimensional montage to celebrate community spirit.

### Vocabulary

**montage** An artwork created by combining photographic and other images.

**Dada** An art movement that was known for rejecting traditional art styles and materials. Dada artists created artworks based on chance, and often used found objects to create new art forms.

**Surrealist** Artists who work in a style in which dreams, fantasy, and the human mind are the source of ideas.

### Supplies

- magazines, newspapers to cut
- cardboard
- ruler
- sturdy tape
- white glue
- scissors
- X-acto knife

### National Standards 7.4 Studio Lesson

**1b** Use media/techniques/processes to communicate experiences, ideas.

**2b** Employ/analyze effectiveness of organizational structures.

**3b** Use subjects, themes, symbols that communicate meaning.

**4a** Compare artworks of various eras, cultures.

---

Sculpture in the Studio

# 3-D Montage

## The Spirit of Celebration

### Studio Introduction

Have you ever been disappointed with a photograph you've taken to remember an event? You might have been disappointed because the photograph showed only one split second of the event, and not the whole story. Do you wonder how you can capture the whole story next time? Here's one way: You can create a **montage**—a collage that is created mainly from photographs.

In this studio experience, you will create a three-dimensional (3-D) montage that celebrates the spirit of your community. Page 244 will tell you how to do it. The community you celebrate might be your family, neighborhood, school, team, or the like. What kinds of photographs will help capture the spirit of your community? Focus on the people, places, or objects that will remind viewers of the community you choose.

## Studio Background

### The Story of Montage

Artists have been combining photographic images for almost as long as photography has been around. In the early twentieth century, a group of European artists created artworks by combining parts of photographs. These artists from the **Dada** movement—a movement that was known for rejecting traditional art styles and materials—named this process montage. They arranged photographic images in nonsensical ways. **Surrealists**—artists who created artworks based on dreams and fantasy—and other artists later found that the art of montage can convey new or unintended meaning.

Although a montage is made up mostly of photographic images, it might

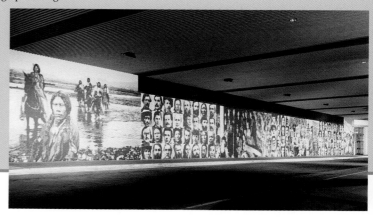

Fig. 7–24 To celebrate the history of Colorado, artist Barbara Jo Revelle created this ceramic tile mural. She used photographs of people who took part in shaping the character and spirit of the state. What other public artwork in this book could be considered photomontage? Barbara Jo Revelle, *Colorado Panorama: A People's History of Colorado.* Courtesy the artist.

---

## Teaching Options

### Resources

Teacher's Resource Binder
- Studio Master: 7.4
- Studio Reflection: 7.4
- A Closer Look: 7.4
- Find Out More: 7.4
- Overhead Transparency 9
- Slides 7f

### Teaching Through Inquiry

**Art Production** Have students work in groups to consider Fig. 7–24 or Fig. 7–26. Ask them to write a list of decisions, in order, that they think the artist had to make to create the artwork. Suggest to students that they think about subject matter, message, materials, and techniques. Have students share and discuss their lists.

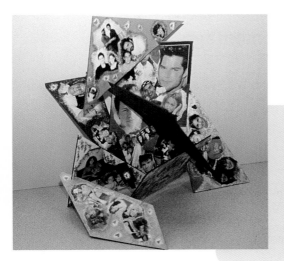

Fig. 7–25 "The only really difficult part of the project was getting the photos to rip exactly the way I wanted them to. Each area of my artwork has a special theme: family, friends, siblings, vacations, etc." Amanda Scafidi, *All About Me,* 1999.
Photographs, mat board, colored pencil, 9" x 5" x 6" (23 x 13 x 6 cm). Plum Grove Junior High School, Rolling Meadows, Illinois.

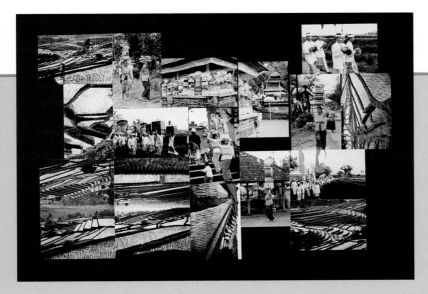

also include drawing or painting. Artists who create photomontages use parts of magazine and newspaper images, as well as snapshots and other single photographs. They use photographs in many ways to help them tell the complete story of their subject.

Fig. 7–26 Paul Nagano uses entire photographs to create his artworks, and he does not overlap them. He invented the word *photofusion* to describe his process of assembling photos into panoramic views. How is Nagano's "story" different from Revelle's (Fig. 7–24)? Paul Nagano, *Balinese Offerings,* 2000.
Photofusion, 22" x 32" (55.9 x 81.3 cm). Courtesy of the artist.

Celebrating

243

## Teach

### Engage
Display yearbooks or other photographs of student activities. **Ask:** Why does one photograph not tell the whole story of an event?

### Using the Text
**Art Criticism** Have students read 3-D Montage. **Ask:** What is a montage? Why might an artist choose a montage to show a story or idea?
**Art History** Have students read Studio Background. **Ask:** What is the difference between Dada and Surrealist montages?

### Using the Art
**Art Criticism Ask:** How did Revelle make the mural shown in Fig. 7–24? *(She printed computer images of photographs on ceramic tiles.)* Who are the people in the mural? How might this mural encourage state pride? How did Revelle create rhythm? *(repeated face shapes)* How did she add variety to this composition? *(by varying the size and viewpoint of some images)*
**Art Criticism** Ask students to look at Figs. 7–24 and 7–26. **Ask:** When might a single photograph be more useful than a montage to convey a message? When might a montage be more useful?

### Extend
Have students research David Hockney's work. Challenge students to photograph a gathering of friends or family and create a Hockney-style montage.

14

243

## 3-D Montage

## Studio Experience

1. Demonstrate how to begin building supports by opening out flaps and adding cardboard pieces to a cardboard box, cutting slots, inserting tabs, and gluing or taping these.

2. Suggest to students that, as they work, they will probably want to add more cardboard stand-ups and search for other pictures. Encourage students to create unity in their design by repeating colors, shapes, and textures.

## Idea Generators

Ask students what community celebration they might depict. Remind them that communities may be families, teams, clubs, or other groups.

## Studio Tip

Have students store their photographs in envelopes.

### Sketchbook Tip
For sketching images of their community, have students look at the actual buildings and objects, or refresh their memory by looking at photographs of them.

### Computer Option
Students may use paint programs such as Photoshop, Painter, and Color It to create composite photos. They can make a selection around an element—such as a chair, table, or person—and copy and paste it into the composite. In turn, they can change selections by scaling, rotating, and overlapping to create a surreal look.

---

### Sculpture in the Studio
# Making Your 3-D Photomontage

### You Will Need
- magazines
- newspapers
- stiff cardboard
- ruler
- scissors
- X-acto knife
- tape
- glue

### Safety Note
Use knives and other sharp tools with extreme care to avoid cuts and other accidents.

### Try This

**1.** Collect photographs from magazines, newspapers, or your own home. Which photographs will best show your community's spirit? Will you use photographs of people, objects, or places? Remember that you can use all or part of an image.

**2.** Create a cardboard form. (Your photos will be glued to the form.) Cut, score, and fold flat pieces of cardboard. Or use slotting techniques and tape to join cardboard pieces. How can the form you create help express your message?

**3.** Try arranging your images in different ways on your cardboard base. Which images work well together? What surprising combinations can you come up with? As you work, you may need to find additional photographs.

**4.** When you are satisfied with your arrangements, glue the photographs in place.

### Check Your Work

Share your artwork with a classmate. Talk about the decisions you made and how you think the photographic images show the spirit of your community. Write a short paragraph about your artwork that will help others better understand its meaning. Display the statement and your artwork with those of your classmates. Take time to look at the work and read the accompanying statements.

---

## Teaching Options

### Meeting Individual Needs

**Adaptive Materials** Provide bases for students to glue their pictures.

**Focusing Ideas** Before students cut out pictures, brainstorm ideas for their theme. Or help students decide on a theme based on the pictures they have cut out. Have students choose from two or three themes.

**Assistive Technology** Allow students to use a word-processing program to write their paragraph.

### Studio Collaboration

Students may work in pairs or small groups to complete the assignment. Collaborative groups will need to decide what community they will address and what ideas they want to communicate; and to divide the tasks of finding and combining images as well as constructing the three-dimensional form.

## Sketchbook Connection

Use your sketchbook to help plan your artwork. Sketch various shapes and forms that might help show the spirit of your community. Try drawing several recognizable forms, such as buildings or trees, related to your community. Then sketch some geometric or organic forms. Decide which shapes and forms might best convey your ideas about the community.

## Computer Option

Collect images around a theme by scanning photos or taking photos with a digital camera. Use a paint or digital-imaging program to arrange selections from the various photos. Make some selections appear to float (by adding cast shadows) and seem unrealistic or surrealist (by placing unrelated items next to each other).

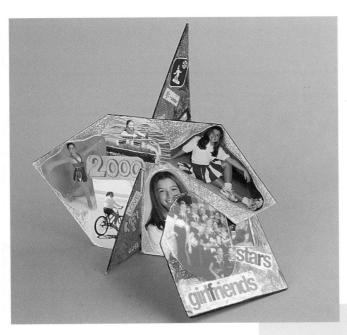

Fig. 7–27 "This photo project was a lot of fun! Using color in the background helped to make all the photos flow together." Stephanie Bacino, *I'm All About Life*, 1999.
Photographs, mat board, colored pencil, 6" x 8" x 5 ½" (15 x 20 x 14 cm). Plum Grove Junior High School, Rolling Meadows, Illinois.

Celebrating

245

## Assess

### Check Your Work

Allow students time to read the statements displayed with the artworks. **Ask:** How does knowing the artist's intentions help viewers appreciate a work? How did you create unity in your artwork?

## Close

Review reasons why artists create montages. Remind students that more than one viewpoint or time can be shown with a group of pictures. **Ask:** How does your artwork celebrate community spirit?

---

## Teaching Through Inquiry

**Aesthetics** Have students work in groups to create a set of standards for judging the quality of a three-dimensional montage. Remind students that they will need to consider the sculptural characteristics and the two-dimensional imagery—and whether these should be judged separately or together. Have students share and discuss their lists with the class.

## More About...

The artists of **Surrealism,** a movement that began in mid-1920s Paris, created fantastic imagery based on dreams, fears, and odd combinations of images. They sometimes tore up bits of old artwork and other images, and then tossed them into the air. They attached the pieces, however they landed, to canvas or paper, thereby creating the composition by chance.

## Assessment Options

**Peer** Have each student create a worksheet to help someone learn how to use combinations of photographs to convey important ideas. Instruct students to include step-by-step directions for generating ideas, finding and combining images, and completing the artwork. Have students exchange their worksheet with another student, review their classmate's worksheet, and make comments about particularly useful aspects. Students might also make suggestions for improvement.

## Social Studies

To help students understand that artists often illustrate traditional foods particular to individual cultures, show and discuss still lifes by Diego Rivera and Frida Kahlo, and the bizarre fruit and vegetable portrait paintings of Giuseppe Arcimboldo. Instruct students to create a still-life painting to celebrate the foods they love, or to use local produce in an Arcimboldo-style painting.

## Language Arts

A more specific parallel between biography and portrait is that between autobiography and self-portrait. To combine these two approaches, ask students each to create a self-portrait and a short autobiography to accompany it.

# Connect to...

## Careers

What were your favorite picture books when you were a child? Did you realize that artists created the images in the books? The artists who provide images for picture books, juvenile nonfiction and novels, and textbooks are **children's-book illustrators**. They may write and illustrate their own books or create illustrations to accompany another author's text. A children's-book illustrator, usually a freelance artist, may develop a distinctive style and technique by which he or she is known. One such artist is Carmen Lomas Garza, who illustrates and writes the text for captivating, bilingual storybooks that celebrate her childhood memories, especially those that involved her family and community. Through her books, she honors images that are recognized and appreciated by Mexican Americans, and that serve to inform those who are unfamiliar with the culture.

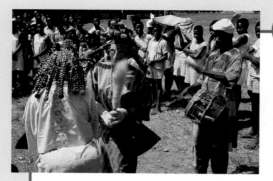

Fig. 7–28 **Some communities use music and dance to honor group members, either living or dead. The Yoruba of Nigeria hold egungun festivals in honor of their ancestors.** Nigeria, Africa, Yoruba peoples, *Egungun dancers*. Courtesy Davis Art Slides.

**Internet Connection**
For more activities related to this chapter, go to the Davis website at **www.davis-art.com.**

## Other Arts

### Music

**Musicians, like artists, celebrate their community**. Duke Ellington, a famous jazz composer and performer, wrote the symphony *Harlem* to celebrate this community. Ellington wrote: "We would like now to take you on a tour of this place called Harlem … It is Sunday morning. We are strolling from 110th Street up Seventh Avenue … Everybody is nicely dressed, and on their way to or from church. Everybody is in a friendly mood . . . You may hear a parade go by …"

In *Opelousas Hop*, Clifton Chenier celebrates his Louisiana home, where Cajun music developed from a blending of European and African-American traditions. Here, Chenier's "squeeze box" (accordion) sounds celebrate one French contribution to Cajun music. Listen to the two pieces of music. Can you hear ways that the composers celebrated their communities?

246

# Teaching Options

## Resources

Teacher's Resource Binder
Using the Web
Interview with an Artist
Teacher Letter

## Video Connection

Show the Davis art careers video to give students a real-life look at the career highlighted above.

## Internet Resources

**Georgia O'Keeffe Museum**

www.okeeffemuseum.org/
This Santa Fe museum's site offers images, a biography, and more.

**Sandy Skoglund**

www.artsednet.getty.edu/ArtsEd
Net/Images/Skoglund/gallery1.html
Images, activities, artist interviews, online discussion, analysis, and interpretive questions.

## Other Subjects

### Social Studies

Artists often depict **traditional foods** of individual cultures. In his work, Mexican artist Diego Rivera celebrates maize (corn), an important food plant in the Americas. Corn provides basic nutrition in the daily diet of many areas of North and Central America. The Maya and other Mesoamerican civilizations were founded on the cultivation of corn, the basis of their diet. Corn-based foods are still prepared for special celebrations: tamales, made from corn and cooked in cornhusks, are traditionally served in Latino families on Christmas Eve; cornbread dressing is an essential part of many Thanksgiving dinners. What particular foods does your family enjoy on special occasions?

### Language Arts

What sort of people are the subjects of biographies? Are they ordinary people, or accomplished individuals? **Biographies** usually tell about people celebrated for their achievements, discoveries, or heroism. Can you think of something in art that is like biography? A portrait is a visual image of a particular person, and it often provides insight into the subject's personality or accomplishments. Do you think portraits, like biographies, mostly depict celebrated people?

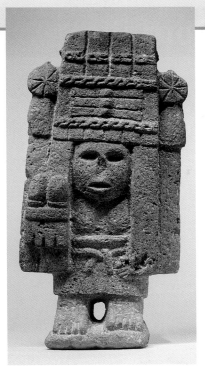

Fig. 7–30 **This sculpture shows the Aztec corn goddess, Chicomecoatl (*che-co-ME-co-ah-tul*). Are the features of the sculpture stylized or naturalistic?** Pre-Columbian, Aztec (Mexico), *Chicomecoatl (Corn Goddess)*, 15th–early 16th century.
Stone, height: 13 1/2" (34.3 cm). The Metropolitan Museum of Art, Purchase, 1900 (00.5.51). Photograph ©1981 The Metropolitan Museum of Art.

## Other Arts

Play *Harlem* for students. **Ask:** How are the events Ellington described portrayed musically in the symphony? How can you tell that people are in a "friendly mood"? What is the overall mood of the piece?

Play *Opelousas Hop*. **Ask:** Do you hear the accordion? What other instruments do you hear? What does this music suggest about the community and its people? How does this piece differ from Ellington's *Harlem*?

Ordering information: *Harlem* is found on *Still: Symphony No. 2* (Chandos #9226, 1994). *Opelousas Hop* is found on *Clifton Chenier: Bayou Blues* (Specialty Records, Inc., SPCD 2139, 1989).

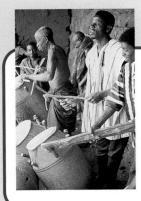

Fig. 7–29 **Festivals and other celebrations are common in communities throughout the world. Why do you think people enjoy getting together for such events?** Ghana, Africa, Bono peoples, *Festival*.
Courtesy Davis Art Slides.

### Daily Life

**Has your neighborhood ever celebrated** by holding a street fair, a block party, or a backyard barbecue? Do your neighbors ever gather just for fun? Have you ever experienced a community parade for a sports victory, a returning hero or celebrity, or a holiday, such as the Fourth of July? Such celebrations allow neighbors to meet and get to know one another. What other benefits might these celebrations have?

Celebrating

247

### Curriculum Connections

**Other Arts** Work with teachers in the other arts to plan ways for students to investigate the influence of the Caribbean arts on popular culture in the United States. Identify music, dances, literary works, and movies with Caribbean settings.

**Language Arts** Plan ways to involve students in identifying and writing about Harlem Renaissance artists, musicians, dancers, and writers. Display books, student reports, and artworks that pay tribute to these artists.

### Community Involvement

- Have students look at their own community, county, or state in terms of a "renaissance," by collecting information about arts events and creating a display titled "Celebrating the Arts in Our Community."

- Find out more about a community celebration, and invite a planning-committee member to speak with students. Ask the guest to explain how the committee organizes the event, makes decisions, recruits volunteers, etc.

### Museum Connection

Contact local museums to find out about works in the collection related to community celebrations—artworks that depict celebrations, or artifacts that were used in celebrations. For a class visit to the museum, the education department might be able to provide slides or other resource materials about these objects.

## Talking About Student Art

As you talk with students about their artworks, ask them each to tell the class how the artworks completed in this chapter fit in with other artworks they have made. Direct students to talk about how these artworks continue to explore some of their previous ideas or how they represent new directions.

## Portfolio Tip

Remind students to revise their writing assignments to improve them. Encourage students to date their written assignments and to keep them in chronological order in their portfolio.

## Sketchbook Tips

• Suggest to students that they keep a collection of canceled stamps in their sketchbook. Remind students that stamps are often a good source of design ideas and that the stamps themselves may be used in collages.

• Present the idea that students might sketch structures and objects associated with the industry or work of their community (such as boats, oil pumps, computers, trucks, windmills, grain elevators, and smokestacks).

# Portfolio

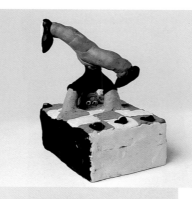

Fig. 7–31 **Turning cartwheels is a classic way for young people to celebrate the spirit of fun.** Stephen Torosian, *Caught in the Act*, 1997. Clay. Remington Middle School, Franklin, Massachusetts.

"I did this work to become more familiar with my hometown. What better way to come closer to something than to draw it? I think the Elissa Ship was the easiest because I practiced it many times before I drew it on the main paper."
**Dennis McClanahan**

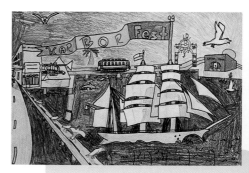

Fig. 7–32 **Every year Galveston has a celebration called Harborfest, the inspiration for this poster.** Dennis McClanahan, *Favorite Places*, 1999. Colored pencil, 12" x 18" (30 x 46 cm). Central Middle School, Galveston, Texas.

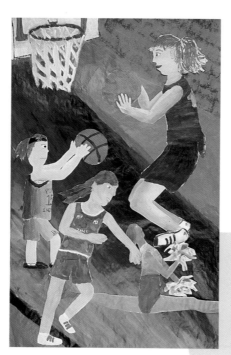

 **CD-ROM Connection**
To see more student art, check out the Community Connection Student Gallery.

Fig. 7–33 **Four students worked together to create a lively scene large enough to cover a classroom door.** One artist says, "I have basketball almost every night of the week and it's a big part of my life." Another says, "With every work of art I do, a part of me goes into it and I can become more and more expressive and skilled in creating." Jayme Kimball, Cecelia Ortega, Elissa Teasdale, Kay Thibealt, *Fastforward: Girls' Basketball*, 2000. Acrylic, 5' x 3' (1.5 x 1 m). Merrimack Valley Middle School, Penacook, New Hampshire.

248

## Teaching Options

### Resources

Teacher's Resource Binder
  Chapter Review 7
  Portfolio Tips
  Write About Art
  Understanding Your Artistic Process
  Analyzing Your Studio Work

### CD-ROM Connection

 For students' inspiration, for comparison, or for criticism exercises, use the additional student works related to studio activities in this chapter.

# Chapter 7 Review

### Recall

Identify an artist from this chapter whose artworks are best seen from the air. Identify an artist whose artworks are best considered up close.

### Understand

Use examples to explain how art plays a role in community festivals and celebrations.

### Apply

If you were asked to help your own family or group of friends celebrate their heritage and spirit, how might you suggest using art to do this?

Page 234

### Analyze

Select one artwork from this chapter (*see example below*) and discuss how the arrangement of art elements contributes to its message about community heritage and spirit.

### Synthesize

Imagine that a major manufacturer of cameras has asked you to suggest ways that photography might be used to celebrate a community's special heritage, traditions, and community spirit. What suggestions would you offer? Be as specific as possible.

### Evaluate

Select an artwork from the chapter that you believe is an excellent example of how art can play a significant role in celebrating community spirit. Give reasons for your selection, considering such things as subject matter, materials and techniques, moods, feelings and ideas, and the organization of art elements.

**For Your Portfolio**

Develop an artwork especially for your portfolio based on the theme of celebration. Exchange your artwork with a peer and write a critique of each other's work. Be sure to tell what you see in the work, describing details. Interpret the meaning, making connections between what you see and what the work is about. What is its message about celebration? Comment on how the artwork is successful. Offer suggestions for improvement, with reasons or questions. Make a written response to the peer review.

**For Your Sketchbook**

Design a series of four postage stamps to commemorate your community. Focus on the theme of celebration and feature your community in connection with four different holiday celebrations.

### Family Involvement

Invite parents or other family members to share their memories of community celebrations that they experienced when they were children or teens.

---

## Chapter 7 Review Answers

### Recall

Stan Herd. Answers may vary but might include Colleen Brown or Jacob Lawrence.

### Understand

Depending on local customs, festival and celebration art may be in the form of banners, parade floats, decorated cars, snow sculptures, puppet shows, and fireworks.

### Apply

Answers will vary. Look for evidence that students understand that artworks can be used in specific ways to celebrate heritage and spirit.

### Analyze

Answers will vary. Look for evidence that students understand how formal organization helps convey meaning about community heritage and spirit.

### Synthesize

Answers will vary. Look for evidence that students understand that photographs can depict special events, scenes, and people in a community; and that they can be used in both traditional and novel ways.

### Evaluate

Answers will vary. Look for sound reasons based on appropriate characteristics of the artwork.

### Reteach

Ask students to compare Red Grooms's carousel (Fig. 7–1) to Barbara Jo Revelle's mural (Fig. 7–24). **Ask:** What parallels can you find? How is each artwork well suited for use in the community? Which of the two would you prefer to see in person? Why? Which would you like to use as a model for an artwork to celebrate the spirit of your community? Why?

Summarize by reminding students that they have considered many different types of artworks that can help communities celebrate their heritage and spirit.

# Chapter Organizer

## Chapter 8 Making a Difference
Chapter 8 Overview
pages 250–251

### Chapter Focus

- **Core** Artists address social issues in their art and printmaking is useful for communicating social messages to many people.
- **8.1** Making a Difference: 1950–1980
- **8.2** Printmaking
- **8.3** African Art in a Modern World
- **8.4** Making Relief Prints

### Chapter National Standards

1. Understand media, techniques, and processes.
2. Use knowledge of structures and functions.
3. Choose and evaluate subject matter, symbols, and id
4. Understand arts in relation to history and cultures.
5. Assess own and others' work.
6. Make connections between disciplines.

---

**9 weeks:** 3  **18 weeks:** 3  **36 weeks:** 3

### Core Lesson
**Artists Can Make a Difference**
page 252
Pacing: Three 45-minute periods

#### Objectives

- Use examples to explain how artists use their art to address problems in communities.
- Describe the benefits of collaboration as a way of creating art to make a difference.

#### National Standards

- **1a** Select/analyze media, techniques, processes, reflect.
- **4c** Analyze, demonstrate how time and place influence visual characteristics.
- **5a** Compare multiple purposes for creating art.
- **5b** Analyze contemporary, historical meaning through inquiry.

---

### Core Studio
**Making a Collaborative Sculpture**
page 256

#### Objectives

- Create a collaborative sculpture that makes a difference in the way viewers think about a social issue.

#### National Standards

- **1a** Select/analyze media, techniques, processes, reflect.
- **3b** Use subjects, themes, symbols that communicate meaning.

---

**36 weeks:** 3

### Art History Lesson 8.1
**Making a Difference**
page 258
Pacing: Three to four 45-minute periods

#### Objectives

- Name some styles of art that emerged in the second half of the twentieth century.
- Explain ways that artists influenced change in twentieth-century art.

#### National Standards

- **1a** Select/analyze media, techniques, processes, refle
- **2b** Employ/analyze effectiveness of organizational structures.
- **4a** Compare artworks of various eras, cultures.
- **5b** Analyze contemporary, historical meaning through inquiry.

---

### Studio Connection
page 260

#### Objectives

- Create a monoprint to inspire people to make a difference in community life.

#### National Standards

- **1b** Use media/techniques/processes to communicate experiences, ideas.
- **3b** Use subjects, themes, symbols that communicate meaning.

---

**36 weeks:** 3

### Forms and Media 8.2
**Printmaking**
page 262
Pacing: Three to four 45-minute periods

#### Objectives

- Explain the basic steps of any printmaking process and identify ways that artists use printmaking techniques to express ideas.

#### National Standards

- **1a** Select/analyze media, techniques, processes, reflect.
- **3a** Integrate visual, spatial, temporal concepts with content.

---

### Studio Connection
page 263

#### Objectives

- Make a relief print aimed toward making a difference.

#### National Standards

- **1b** Use media/techniques/processes to communicate experiences, ideas.

## Featured Artists

Chicago Mural Group/Mitchell Caton
Mel Chinzz
Sue Coe
Marisol Escobar
Lamidi O. Fakeye
Ernst George Fischer
Antonio Frasconi

Keith Haring/Chantal Regnault
Lynne Hull
Cleve Jones
Bonnie Mackain
Tom Nakashima
Elimo Njau
Ouattara

Pablo Picasso
Elijah Pierce
Robert Rauschenberg
James Rosenquist
Miriam Schapiro
Krzysztof Wodiczko

## Chapter Vocabulary

cause
collaborate
intaglio print
linoleum cut
lithographic print
mural movement

relief print
trade art
traditional art

## Teaching Options

Teaching Through Inquiry
Using the Large Reproduction
Using the Overhead
Meeting Individual Needs
Teaching Through Inquiry
More About...*AIDS Memorial Quilt*

## Technology

CD-ROM Connection
e-Gallery

## Resources

Teacher's Resource Binder
Thoughts About Art:
8 Core
A Closer Look: 8 Core
Find Out More: 8 Core
Studio Master: 8 Core
Assessment Master:
8 Core

Large Reproduction 15
Overhead Transparency 16
Slides 8a, 8b, 8c

---

Meeting Individual Needs
Teaching Through Inquiry
More About...Lynne Hull
Assessment Options

CD-ROM Connection
Student Gallery

Teacher's Resource Binder
Studio Reflection: 8 Core

## Teaching Options

Meeting Individual Needs
Teaching Through Inquiry
More About...Pop Art
Using the Overhead

## Technology

CD-ROM Connection
e-Gallery

## Resources

Teacher's Resource Binder
Names to Know: 8.1
A Closer Look: 8.1
Map: 8.1
Find Out More: 8.1
Assessment Master: 8.1

Overhead Transparency 15
Slides 8d

---

Teaching Through Inquiry
More About...Earth artists
Assessment Options

CD-ROM Connection
Student Gallery

Teacher's Resource Binder
Check Your Work: 8.1

## Teaching Options

Teaching Through Inquiry
Using the Overhead
Assessment Options

## Technology

CD-ROM Connection
e-Gallery

## Resources

Teacher's Resource Binder
Finder Cards: 8.2
A Closer Look: 8.2
Find Out More: 8.2
Assessment Master: 8.2

Overhead Transparency 15

---

CD-ROM Connection
Student Gallery

Teacher's Resource Binder
Check Your Work: 8.2

**9 weeks**

**18 weeks**

**36 weeks**

| | | |
|---|---|---|
| | | **3** |

## Objectives

## National Standards

**Global View Lesson 8.3
African Art**
page 264
Pacing: Three 45-minute
periods

- Make distinctions among the different types of art traditions in Africa.
- Understand how new African art shows similarities to global modern art movements, yet remains distinctly African.

**2b** Employ/analyze effectiveness of organizational structures.
**4b** Place objects in historical, cultural contexts.
**4c** Analyze, demonstrate how time and place influence visual characteristics.

**Studio Connection**
page 266

- Create a sculpture to inspire others to think differently about conditions in the world.

**1b** Use media/techniques/processes to communicate experiences, ideas.
**3b** Use subjects, themes, symbols that communicate meaning.

## Objectives

## National Standards

**4** **4**

**Studio Lesson 8.4
Making Relief Prints**
page 268
Pacing: Three to four
45-minute periods

- Explain why photography can be an effective medium for the expression of ideas and feelings.
- Create a montage to convey ideas about continuity and change in a family or cultural tradition.
- Place the art of montage in historical time frame.

**1a** Select/analyze media, techniques, processes, reflect.
**2b** Employ/analyze effectiveness of organizational structures.
**3a** Integrate visual, spatial, temporal concepts with content.

## Objectives

## National Standards

**Connect to...**
page 272

- Identify and understand ways other disciplines are connected to and informed by the visual arts.
- Understand a visual arts career and how it relates to chapter content.

**6** Make connections between disciplines.

## Objectives

## National Standards

**Portfolio/Review**
page 274

- Learn to look at and comment respectfully on artworks by peers.
- Demonstrate understanding of chapter content.

**5** Assess own and others' work.

**2** Lesson of your choice

## Teaching Options

Teaching Through Inquiry
More About…Trade art
Using the Large Reproduction

## Technology

CD-ROM Connection
e-Gallery

## Resources

Teacher's Resource Binder
  A Closer Look: 8.3
  Map: 8.3
  Find Out More: 8.3
  Assessment Master: 8.3

Large Reproduction 16
Slides 8e

---

Meeting Individual Needs
Teaching Through Inquiry
Assessment Options

CD-ROM Connection
  Student Gallery

Teacher's Resource Binder
  Check Your Work: 8.3

## Teaching Options

Meeting Individual Needs
Teaching Through Inquiry
More About…Relief prints
Using the Large Reproduction
More About…Multicolored relief prints
Assessment Options

## Technology

CD-ROM Connection
  Student Gallery
  Computer Option

## Resources

Teacher's Resource Binder
  Studio Master: 8.4
  Studio Reflection: 8.4
  A Closer Look: 8.4
  Find Out More: 8.4

Large Reproduction 16
Slides 8f

## Teaching Options

Community Involvement
Interdisciplinary Planning
Museum Connection

## Technology

Internet Resources
Video Connection
CD-ROM Connection
  e-Gallery

## Resources

Teacher's Resource Binder
  Using the Web
  Interview with an Artist
  Teacher Letter

## Teaching Options

Advocacy
Family Involvement

## Technology

CD-ROM Connection
  Student Gallery

## Resources

Teacher's Resource Binder
  Chapter Review 8
  Portfolio Tips
  Write About Art
  Understanding Your Artistic Process
  Analyzing Your Studio Work

## Chapter Overview

### Theme

People in communities seek ways to have meaning and purpose in their lives, and try to make the world a better place. Art is a way for people to make a difference in the quality of life in communities.

### Featured Artists

Chicago Mural Group/Mitchell Caton
Mel Chin
Sue Coe
Marisol Escobar
Lamidi O. Fakeye
Ernst George Fischer
Antonio Frasconi
Keith Haring/Chantal Regnault
Lynne Hull
Cleve Jones
Bonnie Mackain
Tom Nakashima
Elimo Njau
Ouattara
Pablo Picasso
Elijah Pierce
Robert Rauschenberg
James Rosenquist
Miriam Schapiro
Krzysztof Wodiczko

### Chapter Focus

This chapter focuses on the ways that art is used to improve life in communities, and how individuals, working alone or in collaboration, have made artworks to draw attention to possibilities for change. Students learn how artists in the last part of the twentieth century addressed social issues in their art and how printmaking is particularly useful for communicating social mes-

**8**

# Making a Difference

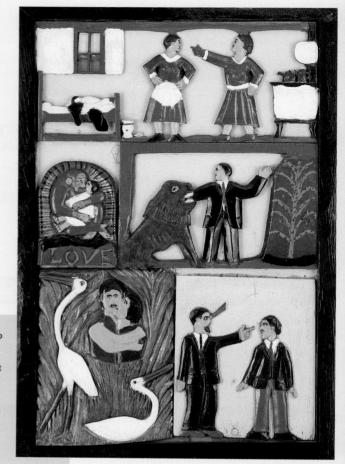

Fig. 8–1 Elijah Pierce's barbershop was a place where people could view his art and learn lessons about how to live a good life. What story could you tell in an artwork? How might it make a difference in someone's life? Elijah Pierce, *Monday Morning Gossip*, 1934. Carved and painted wood relief with glitter, mounted on painted panel, 33 1/2" x 24" (85.1 x 61.0 cm). Collection of Michael D. Hall. Courtesy the Columbus Museum of Art.

## National Standards Chapter 8 Content Standards

1. Understand media, techniques, and processes.

2. Use knowledge of structures and functions.

3. Choose and evaluate subject matter, symbols, and ideas.

4. Understand arts in relation to history and cultures.

5. Assess own and others' work.

6. Make connections between disciplines.

## Teaching Options

## Teaching Through Inquiry

**Aesthetics** Have students work in pairs or small groups to discuss possible answers to these questions: Can someone without formal training be considered an artist? Why or why not? What makes someone an artist? Does someone need to think of oneself as an artist in order to be an artist? What is "good" art? Must it have realistic details?

## More About...

The art of Elijah Pierce and other so-called "outsider" artists prompts questions about the importance of artistic training, realistic imagery, and refined craft for making art. Pierce, like many self-taught artists, did not think about his work as art-making. His purpose was to entertain and teach with his carvings. In many ways, his imagery is rough and fails to meet standards for realism that people often consider important characteristics of "good" art.

## Focus

- How do people work to improve their communities?
- How does art make a difference in community life?

**When friends or family members are sick or feeling sad, you try to cheer them up. You might tell a joke, give a gift, or simply be there to listen. Whatever you do, you try to make a difference in the way a person you care about feels.** Many groups and individuals want to help the people around them. For example, artists often use their talents to make a difference in their communities.

The artwork shown in Fig. 8–1 was made by Elijah Pierce. For most of his life, Pierce was a barber in Columbus, Ohio. While waiting for his customers, Pierce whittled wood. He sometimes carved small sculptures of animals and people. Most of the time, however, he made relief carvings that illustrated stories that teach lessons about life.

Pierce didn't think of himself as an artist. He was a very religious man who wanted to share his faith with others and help them lead good lives. He used his whittling talent as a way of making a difference. For a long time, he shared his artworks only with customers. After another local artist told others about the carvings, Pierce's artworks were exhibited for the city of Columbus.

It doesn't always take a lot of people to make a difference in the lives of those around them. Elijah Pierce, working alone, made a difference in the lives of his customers and, eventually, in the lives of people around the world.

### What's Ahead

- **Core Lesson** Learn how other artists have used their talents to make a difference in their communities.
- **8.1 Art History Lesson** Explore how artists in the second half of the twentieth century addressed social issues with their art.
- **8.2 Forms and Media Lesson** Learn about printmaking and how artists use it to send a message to many people.
- **8.3 Global View Lesson** Discover how twentieth-century African artists have made a difference in the way we think about African art.
- **8.4 Studio Lesson** Create a relief print that shows an endangered natural environment in a positive way.

### Words to Know

| | |
|---|---|
| collaborate | lithographic print |
| cause | serigraph |
| mural movement | traditional art |
| relief print | tourist art |
| intaglio print | linoleum cut |

*Making a Difference*

251

...sages to many people. Students learn about African art forms, and they create a relief print to draw attention to communities in the natural world.

## Chapter Warm-up

**Ask:** How can art make people feel better? What art have you given to people to cheer them up? Explain that art can make a difference in people's lives.

## Using the Text

**Aesthetics** Assign students to read the text to discover how Elijah Pierce enriched his community with his art. Ask students to indicate how he tried to make a difference in his local community.

## Using the Art

**Perception** As students study Pierce's *Monday Morning Gossip*, ask them to identify the subjects and stories in it. Explain that this is a relief sculpture, with forms that protrude from the background. Ask students to imagine and then describe running their fingers over this sculpture.

## Extend

Encourage students to make cards to give to people who need to be cheered up or thanked. Guide students first to sketch several ideas and, if students wish to mail the cards, to size the cards for the envelopes they will use. Have students draw their designs in pencil or marker and add color with watercolors, markers, or colored pencils. Remind students to write a message inside each card.

## Graphic Organizer
## Chapter 8

**8.1 Art History Lesson**
Making a Difference: 1950–1980
page 258

**Core Lesson**
Artists Can Make a Difference

**Core Studio**
Making a Collaborative Sculpture
page 256

**8.2 Forms and Media Lesson**
Printmaking
page 262

**8.3 Global View Lesson**
African Art in a Modern World
page 264

**8.4 Studio Lesson**
Making Relief Prints
page 268

### CD-ROM Connection

For more images relating to this theme, see the Community Connection CD-ROM.

# Prepare

## Pacing

Three 45-minute periods: one to consider art and text, and to plan project; one to create sculpture; one to present sculptures

## Objectives

- Use examples to explain how artists use their art to address problems in communities.

- Describe the benefits of collaboration as a way of creating art to make a difference.

- Create a collaborative sculpture that makes a difference in the way viewers think about a social issue.

## Vocabulary

**collaborate** To work together with others.

# Teach

## Engage

Ask students to find photographs of events or situations that call for positive change. Tell students that they will study *Guernica,* Picasso's response to a tragic bombing that he learned about from newspaper photographs and accounts.

---

# Artists Can Make a Difference

Throughout history, artists have used art-work to address the problems that communities face. Through their artworks, artists can express points of view about problems and try to influence the way people feel. For example, an artist might create a painting that shows how war or poverty can affect people. Some people who see the painting might then actively seek a way to help prevent war or diminish poverty. Other viewers might become more aware of the effects of war or poverty on all people. Through their work, artists can make a difference.

## Protesting War

You have probably heard of the great twentieth-century artist Pablo Picasso. Picasso is famous for his development of *Cubism,* an abstract style of art, and for other ways of making art. He made one of his most powerful artworks after a village in Spain was bombed. The terrible bombing killed hundreds of innocent people. Picasso hoped *Guernica* (Fig. 8–2), named for the village that was bombed, would show the anguish and confusion people felt. Although *Guernica* is about a single event, its message is about all wars. *Guernica* has been seen by millions of people. Picasso is one artist who used his talents to make a difference in our attitudes about the horrors of war.

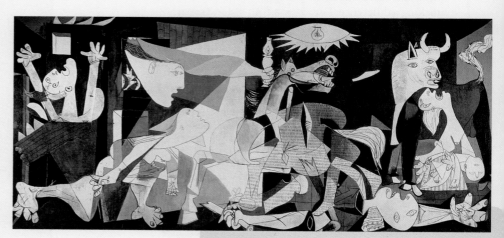

Fig. 8–2 In his own way, Picasso shows the horrors of war. What details are most expressive to you? How does this artwork make you feel about war?
Pablo Picasso, *Guernica,* 1937.
Oil on canvas, 137 ³/₄" x 307 ⁹/₁₀" (350 x 782 cm). Museo del Prado, Madrid, Spain. Giraudon/Art Resource, New York. © 2000 Estate of Pablo Picasso / Artist Rights Society (ARS), New York.

---

## National Standards Core Lesson

**1a** Select/analyze media, techniques, processes, reflect.

**3b** Use subjects, themes, symbols that communicate meaning.

**4c** Analyze, demonstrate how time and place influence visual characteristics.

**5a** Compare multiple purposes for creating art.

**5b** Analyze contemporary, historical meaning through inquiry.

## Teaching Options

### Resources

Teacher's Resource Binder
  Thoughts About Art: 8 Core
  A Closer Look: 8 Core
  Find Out More: 8 Core
  Studio Master: 8 Core
  Studio Reflection: 8 Core
  Assessment Master: 8 Core
Large Reproduction 15
Overhead Transparency 16
Slides 8a, 8b, 8c

### Teaching Through Inquiry

**Art Criticism** Have students work individually or in groups to consider the artworks on these pages and address these questions: What do viewers see when looking at each artwork? What did the artist do to try to change the way viewers think about an important issue? Of the three artworks, which has the greatest potential for making a difference in the way people think? Why? Hold a discussion in which students share their ideas.

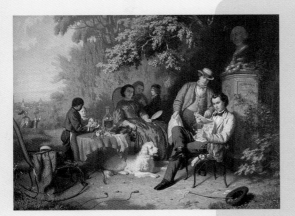

Fig. 8–3 When you look at this painting, you might first see the gentlemen reading the paper. How does the retitling of the work change the way you look at it? Ernst George Fischer, *Country Life*, ca. 1850. Oil on canvas. Courtesy Maryland Historical Society, Baltimore, Maryland.

Fig. 8–4 In many of her artworks, Miriam Schapiro focuses on the beautiful items that women have created over the years. What details in this artwork celebrate the creative work of women? Miriam Schapiro, *Wonderland*, 1983. Collage: acrylic, fabric and plastic beads on canvas, 35 1/2" x 56 3/4" (90 x 144 cm). National Museum of American Art, Washington, DC / Art Resource, NY.

## Celebrating Differences

The 1960s Civil Rights movement in the United States led to laws that prohibited discrimination. However, people in many communities continue to struggle against prejudice and stereotyping based on race, ethnic background, and gender. Many women artists, such as Miriam Schapiro (Fig. 8–4), create artworks with strong messages. They try to make a difference in the way people think about the contributions and abilities of women.

Through his art, African-American artist Fred Wilson challenges people to see history in a different way. Sometimes he makes objects, but often he creates new exhibits by changing existing gallery or museum displays. For example, he was invited to work with the collection of the Maryland Historical Society in Baltimore. He changed the title of a painting that showed a wealthy white family enjoying a picnic. By changing the title from *Country Life* to *Frederick Serving Fruit* (Fig. 8–3), he drew attention to the young male slave who was serving the family. The title change made a difference in the way viewers saw the subject matter of the painting.

Making a Difference

253

## Using the Text

**Art History** Have students read pages 252 and 253. **Ask:** How can artists change people's lives? *(by drawing attention to issues and presenting different viewpoints)* How did Picasso protest war? How can artists call attention to contributions of women and minorities?

## Using the Art

**Art History Ask:** What objects do you see in *Guernica*? What might be their symbolism? *(bull—Spain; flower in fist holding a sword —hope after war)* Explain that this is a Cubist-style painting, in which forms are simplified and different views of an object are shown. **Ask:** What multiple views do you see? Remind students that Picasso read newspaper articles about this bombing. **Ask:** What areas have a newspaper-like texture? *(horse's body)* How does color contribute to the message?

**Perception Ask:** What objects, patterns, and colors do you see in Schapiro's *Wonderland*? How do these contribute to the artist's message?

## Critical Thinking

*Guernica*'s title identifies a specific place and time. Challenge students to suggest alternative titles for the work so as to call attention to universal issues of war.

## Journal Connection

Encourage students to write their reaction to *Guernica*. **Ask:** What words can you use to describe the body language of the figures?

253

## Using the Large Reproduction

**Talk It Over**

**Describe** List the important features of this artwork.

**Analyze** How did the artist arrange the various parts for expressive purposes?

**Interpret** What does the artwork say about women? About aging?

**Judge** How well does this artwork convey ideas that can make a difference in the way people think about important social issues?

15

## Using the Overhead

**Think It Through**

**Ideas** What might have inspired the artist to make this sculpture?

**Materials** What materials did he use?

**Techniques** How was this made?

**Audience** Who will see this sculpture? How might this artwork make a difference in the lives of these people?

16

## Using the Text

**Aesthetics** Assign students to read pages 254 and 255. **Ask:** Why was the AIDS quilts made? How does *Revival Field* combine art and science to improve the health of the environment?

## Using the Art

**Art Criticism** Have students study *AIDS Memorial Quilt.* **Ask:** What about this art sends a powerful message? *(size, that hundreds of squares represent victims)* How did the designers create a unified artwork made by so many artists? *(repeated same-size squares; arranged into larger square motifs)*

**Art Criticism Ask:** What might be the pros and cons of walking in Chin's *Revival Field*? What materials did the artist use? What are the main shapes in the design?

# Collaborating to Make Art

Sometimes artists **collaborate**, or work together, with communities to create artworks. Collaborative artworks are made for many reasons. They can address the concerns of the community. Some of them celebrate the diversity of our nation's culture and people. Others express powerful feelings that we share as human beings.

Collaborations can involve any number of people—from two people to thousands. By working with communities to create artworks, artists try to help people see how their attitudes and behavior affect others.

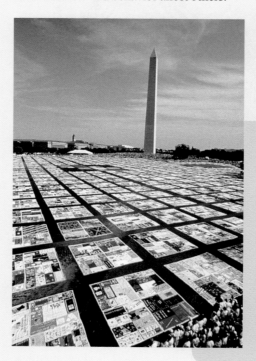

# Collaborating to Make a Difference

There are many examples of people working together to make a difference through art. One example is the *AIDS Memorial Quilt* (Fig. 8–6). As thousands of Americans faced the loss of loved ones to the AIDS disease, they were invited to create a quilt square in memory of those people. The AIDS quilt was displayed at a public space in Washington,

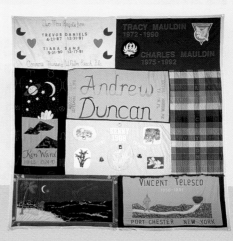

Fig. 8–5 Each panel on this quilt square is a personal expression of loss. This is a close-up of a single square from the quilt at left. In what ways do you think the quilt makes a difference? *AIDS Memorial Quilt* (detail) 1985–present.
Fabric and mixed media, each panel measures 36" x 72" (91.4 x 182.9 cm). Photo by Paul Margolies. Courtesy the NAMES Project Foundation.

Fig. 8–6 Caring for others sometimes means helping them accept the death of a loved one. Why might a collaboration like this be comforting for the people involved? How might the experience have been different if each person created his or her own artwork independently? Cleve Jones, Founder, *AIDS Memorial Quilt*, 1985–present.
Fabric and mixed media, each panel measures 36" x 72" (91.4 x 182.9 cm) (over 43,000 panels as of 1999). Photo by Mark Theissen. Courtesy the NAMES Project Foundation.

254

### Meeting Individual Needs

**Multiple Intelligences/Spatial** Have students study Figs. 8–5 and 8–6. Discuss what it might feel like to walk among the quilted artworks that honor loved ones who died from AIDS. Have the class select a social cause, and then have each student create a collage expressing her or his feelings on the issue. Display the works side by side on the floor, and have students walk around the room and view them. Lead a discussion about whether or not the gathered artworks have more impact than the individual works would have.

DC, and in other places around the country. This enormous quilt was a collaborative artistic effort. It provided a solemn comfort for those who contributed to it. It also brought public attention to the need for medical research to find a cure for AIDS.

*Revival Field* (Fig. 8–7) is another example of a collaboration. *Revival Field* is the name given to a series of "growing" sculptures. Artist Mel Chin thought of the project when he read an article about certain plants that absorb heavy metals from the soil in which they grow. He contacted scientist Rufus Chaney to see if he would help him create test plantings as an art project.

Chaney, a plant and soil expert, agreed enthusiastically. Between 1990 and 1993, Chin and others planted these special plants in a landfill in Saint Paul, Minnesota. The plants are meant to transform the ecology of a site from dead or dangerous to living. After three years and annual soil testing, scientists noted that the plan was working. The plants were "cleaning" the toxic soil in which they grew. Another *Revival Field* was established in Pennsylvania. The artist hopes that his work on these projects will make a difference in the future, as communities seek ways to restore the environment.

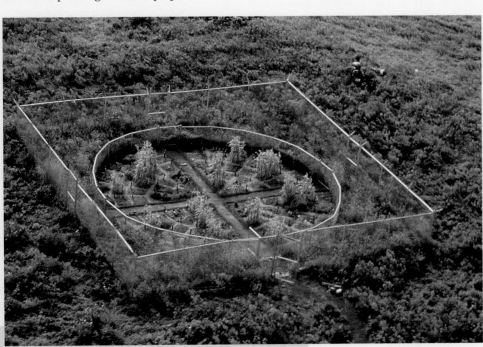

Fig. 8–7 The artist who worked on this collaboration was concerned about the environment. Does this work challenge your idea of what art is? How? Why do you think it is considered a sculpture? Mel Chin, *Revival Field*, 1990–93. Plants and industrial fencing on a hazardous-waste landfill, approximately 60' x 60'x 9' (18.3 x 18.3 x 2.7 m). Pig's Eye Landfill, Saint Paul. Photo: David Schneider, 1993.

Making a Difference

## Critical Thinking

Challenge students to compare *Revival Field* to Denes's *Tree Mountain*, (Fig. 5–6) on page 177. **Ask:** What do these outdoor sculptures have in common? How and why was each created? *(Denes's was a community effort to create a living time capsule; Chin's was done by two men to improve the environment.)*

## Journal Connection

Encourage students to compare the traditional uses of quilts to the uses of those in the AIDS project. Print the word *quilt* on the board, and have students write associated words that come to mind. Encourage students to write in their journal about why quilts might be appropriate symbols for the fight against AIDS.

## Teaching Through Inquiry

**Art History** Remind students that the AIDS quilt follows traditions of quilt-making, other forms of needlework, and collaborative art-making. Have students work in pairs or small groups to generate questions, for historical investigation, that focus on the AIDS quilt, needlework traditions, and collaborative art-making traditions. Display and discuss the art-historical questions, and then ask students to work in pairs or small groups to address one question of their choice. Guide students to create a plan for their investigation and to share their findings.

## More About...

In June 1987, a small group of strangers gathered to create a memorial for those who had died of AIDS. The meeting served as the foundation of the NAMES Project **AIDS Memorial Quilt**. Activist Cleve Jones conceived the idea for the quilt and made a tapestry panel in honor of a friend. As awareness of the quilt grew, so did participation. On October 11, 1987, the NAMES Project displayed the quilt for the first time, in Washington, DC; it returned there in 1988, 1989, 1992, and 1996. Parts of the quilt have toured the nation and have raised awareness about the seriousness of AIDS.

## Supplies

- various materials, according to student choice

### Safety Note

Remind students to make sure that their sculpture is stable, for viewing safely.

## Using the Text

**Aesthetics Ask:** With whom did Hull and Wodiczko work to create useful sculptures? *(Hull: wildlife experts; Wodiczko: homeless people, designers)*

**Art Production** Have students work in cooperative-learning groups of four. Brainstorm issues for sculptures, and remind students to use art elements and principles in their design so as to communicate their message effectively. Students may choose to build a maquette of their sculpture instead of making it full-size. Guide students to decide on a subject, sketch plans, and create a list of materials that they will need. They may bring in objects to include in their sculpture. After students have completed their art, have them write descriptions of their sculpture and how it may change people's thoughts.

## Using the Art

**Art Criticism Ask:** How, do you imagine, were these sculptures used? What materials were used? How do

**Sculpture in the Studio**

# Making a Collaborative Sculpture

When people work together on an artwork, they choose the subject matter, plan the artwork, and create it as a group. **In this studio experience, you will work with classmates to create a sculpture that will change the way people think about an issue or problem.** You and your group will choose the issue or problem together. Then you will sketch a plan for the sculpture and choose the materials that will best express your ideas.

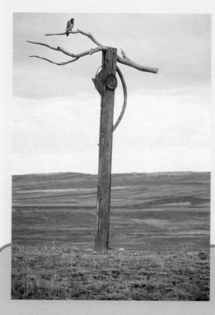

Fig. 8–8 Artist Lynne Hull was concerned that hawks and eagles were being electrocuted when they roosted on telephone poles. So, she created structures for them. In what ways is this sculpture different from others you have seen? Lynne Hull, *Raptor Roost L-1 with Swainson's Hawk: a safe roosting sculpture for hawks and eagles*, 1988. Wood, found metals, stone from site, height: 16' (4.9 m). Photo by Bertrand de Peyer. Courtesy of the artist.

256

- sketch paper
- pencil
- variety of sculptural materials
- related sculpture tools

**Try This**

**1.** Work with your group to create a plan for your sculpture. How can your sculpture

make a difference in the way people think about the issue or problem you chose as a theme? What materials will help send your message? Sketch your ideas.

**2.** Decide who will be responsible for each section or phase of the project. For example,

one person might collect the materials, another might arrange them, and another might assemble them into the sculpture.

**3.** As you work together, discuss any changes or ideas you might have. Offer helpful suggestions to classmates working on a particular phase of the project.

## Studio Background

### Sculptures That Make a Difference

Many late-twentieth-century artists have created artworks that force us to change our ideas about sculpture. Artists such as Lynne Hull (Fig. 8–8) and Krzysztof Wodiczko (Fig. 8–9) often choose a social or environmental problem as the theme of their artwork. They discuss their ideas with experts on the problem. They decide what art materials to use. Then, the artists create a sculpture they think can change the way people feel about the problem.

**Meeting Individual Needs**

**Focusing Ideas** Some students may need to be assigned specific tasks that they may do independently.

**Teaching Through Inquiry**

**Art Production** Remind students that art-making often requires research. Have students select an artwork from pages 250–257 and list what the artist might have had to learn before making the artwork.

## Check Your Work

Display your completed artwork with class-mates' artworks. Each group should present its work to the class. Identify the issue you have addressed, and explain how your art-work will make a difference in the way people think about the issue.

**Sketchbook Connection**
Use your sketchbook to plan your work. Take notes during discussions with your class-mates. Investigate the issue or problem you wish to address by reading about it and talking to others. Sketch ideas that come to mind during your research.

### Core Lesson 8

#### Check Your Understanding
1. How have artists used their art to address the problems that people face in communities?
2. Why might the painting *Guernica* help make a difference in the way people think about war?
3. Provide examples to explain how artists sometimes collaborate with others to make a difference with their art.
4. Do you think it is a good idea for artists to collaborate with others as they make their art? Why or why not?

Fig. 8–10 Working together, students created maquettes of hot air balloons. They also met with a local balloonist to learn more about the technology, materials, and safety issues involved in full-sized hot air balloons. How does a balloon make a difference? It's art for everyone to enjoy as it drifts across the sky. Students of Logan Fontenelle Middle School, *Transformation Transportation*, 1999. Tissue paper, white glue, wire. 8' x 6' (2.4 x 1.8 m). Bellevue, Nebraska.

To some viewers, the main purpose of the sculptures you see here might be the messages they send. Some people might not even consider these to be art-works, because they look very different from sculptures that most people are used to seeing. Yet, these sculptures *are* works of art. The artists came up with a plan. They thought about how to use color, line, shape, form, space, balance, and unity. And they expressed their ideas and feelings in the artwork. These artists, however, tried to make a difference.

Fig. 8–9 This artist worked with a team of homeless people and designers to create a vehicle for the home-less. The vehicle is made to carry belongings and to store recyclable trash. It has an insulated sleeping space, washing basin, toilet, and storage space. How do you think viewers respond to this artwork when they see it? Krzysztof Wodiczko, *Homeless Vehicle, Version 3*, 1988. Aluminum, lexan, plywood, plastic, fabric, steel, 72" x 92" x 40" (182.9 x 233.7 x 101.6 cm). Courtesy of the artist and Galerie Lelong, New York.

Making a Difference

257

the designs fit their environment? What are the major forms and shapes of each? What message does each send?

### Extend
Have students research birds and animals native to their region. Assign students to design a house, roost, or shelter to meet the needs of a partic-ular species. Allow them to construct it out of clay, wood, or other natural materials.

### Assess

#### Check Your Work
Display the art along with the de-scriptions. Allow each group to pres-ent their work to the whole class by explaining how the sculpture might make a difference in people's think-ing about the issue. **Ask:** What is the best part of your sculpture? If you were to create another, similar sculp-ture, what would you do differently?

#### Check Your Understanding: Answers
1. They have created works that may change people's ideas about a social or envi-ronmental problem.

2. *Guernica* expresses the hor-ror of war. Viewers might be moved to accept Picasso's po-sition on war.

3. Answers may vary. Students may cite Wodiczko and Hull and their works.

4. Answers will vary. Check that students have offered valid reasons in support of their position.

### Close
Review how the artists in this lesson created art that has made a differ-ence in people's lives. Discuss expe-riences that students had as they worked together to create their sculpture.

### More About...
**Lynne Hull** makes artworks that contribute to natural habitats of wildlife. She has made carvings, into desert rock formations, to hold water for wildlife; created safe resting places for birds; installed habitats to nurture reforestation; and created floating islands for waterfowl nesting. She has made sculptural forms to sustain the life of other wildlife, such as beavers, bats, otters, frogs, butterflies, and bees. She works in collaboration with experts: biologists, zoologists, and landscape designers.

### Assessment Options

**Peer** Have students independently write answers to these questions: What are the key ideas in pages 250–257? What artworks from these pages help explain the key ideas? What questions do you have about the ideas and artworks? What connections can you make with other subjects? How can you apply these ideas to your own life? Ask students to exchange their answers with a peer, who should write a review of the responses; indicate which re-sponses they agree with; offer alternative re-sponses, as appropriate; and ask for clarifi-cation, if needed. Ask students to discuss their responses and reviews.

# Prepare

## Pacing

Three to four 45-minute periods: one to consider art and text; three to make art

## Objectives

- Name some styles of art that emerged in the second half of the twentieth century.
- Explain ways that artists influenced change in twentieth-century art.
- Create a monoprint to inspire people to make a difference in community life.

## Vocabulary

**cause** A belief or issue that moves people to action.

**mural movement** Begun by American artists in the 1970s; focused on adding beauty to city neighborhoods through the creation of large, public paintings.

## Using the Time Line

**Ask:** What major world events occurred during this time? What inventions from this period have had the greatest effect on your life? Where were family members during this time? How did world events shape their lives?

**8.1 ART HISTORY LESSON**

# Making a Difference: 1950–1980

**1962**
Rosenquist, *A Lot to Like*

**1970**
Rauschenberg, *Signs*

**1974–75**
Chicago Mural Group, *History of Mexican American Worker*

American Regionalism page 232

**American Social Causes**

American Art Since 1980 page 284

**1962**
Marisol, *The Family*

**1973**
Chicago Mural Group, *Wall of Self-Awareness*

## History in a Nutshell

The second half of the twentieth century was a time of great unrest and turmoil. People lived with the threat of war and atomic weapons. Communities worldwide debated over different forms of government: capitalism versus communism, democracy versus fascism. Cities expanded into large suburbs. In America, some community groups formed in opposition to each other, expressing hatred that came from prejudice and fear. Groups struggled with a variety of social, environmental, and political issues.

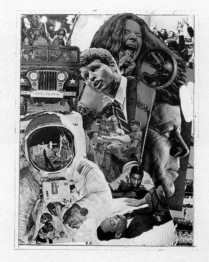

## Art and Social Causes

You've probably heard the expression "that's a good cause" or "that cause is worth supporting." A **cause**, or movement that focuses on an issue, happens when a group of people shares a belief that something needs changing. Following World War II, groups began to focus on social causes such as civil rights, women's issues, and the environment. This was also a time of antiwar protests. Many twentieth-century artists addressed these issues through artworks such as community murals. Robert Rauschenberg (Fig. 8–11) believed that art can make a difference in social and political causes.

Artists working in different styles shared the belief that art has a social and political purpose. The social commentaries of *Pop Art* were based on the products and images of popular culture. Other artists used the environment itself as the material for *Earth Art*. Earth Art draws people's attention to environmental issues. Some sculptures focused on social issues in all kinds of communities, from family groups to national and international concerns.

Fig. 8–11 Each image in this silkscreen print is a powerful expression of the political and social turmoil America faced in the late 1960s and early 1970s. Robert Rauschenberg, *Signs*, 1970. Silkscreen print, 43" x 43" (109 x 109 cm). Edition: 250. Published by Castelli Graphics. © Untitled Press, Inc. / Licensed by VAGA, New York, NY.

## National Standards 8.1 Art History Lesson

**1a** Select/analyze media, techniques, processes, reflect.

**1b** Use media/techniques/processes to communicate experiences, ideas.

**2b** Employ/analyze effectiveness of organizational structures.

**3b** Use subjects, themes, symbols that communicate meaning.

**4a** Compare artworks of various eras, cultures.

**5b** Analyze contemporary, historical meaning through inquiry.

**Teaching Options**

### Resources

Teacher's Resource Binder
- Names to Know: 8.1
- A Closer Look: 8.1
- Map: 8.1
- Find Out More: 8.1
- Check Your Work: 8.1
- Assessment Master: 8.1

Overhead Transparency 15

Slides 8d

### Meeting Individual Needs

**Gifted and Talented** Have students research some of the 1960s and '70s issues mentioned in History in a Nutshell. Then have each create a mural, collage, or poster that responds to a similar issue today.

## Art and Art Issues

Not all of the art during this period, however, was about social causes. Some artists chose not to use their art for making a difference in society. Their subject matter and images did not represent environmental conditions or social needs. For these artists, making a difference in the way art is made and viewed seemed most important. These artists explored the qualities and effects of lines, shapes, colors, and surfaces. Artists such as James Rosenquist (Fig. 8–12) invited other artists to create art in new ways.

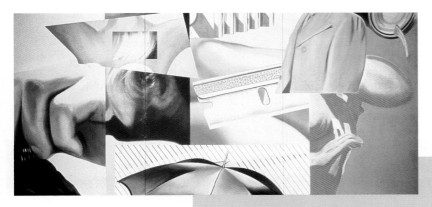

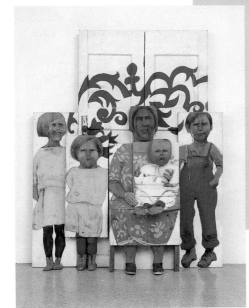

Fig. 8–12 **Does this painting remind you of a collage? How does it compare to** *Signs* **(Fig. 8–11)? What do you think this painting means?** James Rosenquist, *A Lot to Like*, 1962. Oil on canvas, 93" x 204" (236 x 518.2 cm) (triptych). The Museum of Contemporary Art, Los Angeles. The Panza Collection. © James Rosenquist / Licensed by VAGA, New York, NY.

Fig. 8–13 **When you look at this family portrait, you might wonder where the father is. What might this artist be saying about the American family in this artwork? How might she be trying to make a difference?** Marisol Escobar, *The Family*, 1962. Painted wood and other materials in three sections, overall, 6' 10 5/8" x 65 1/2" x 15 1/2" (209.8 x 166.3 x 39.3 cm). The Museum of Modern Art, New York. Advisory Committee Fund. Photograph © 2000 The Museum of Modern Art, New York. © Marisol / Licensed by VAGA, New York, NY.

Making a Difference

259

## Teach

### Engage

On the chalkboard, write: *civil rights, women's rights,* and *ecology.* Explain that these issues came into the spotlight from 1950 through the end of the century. Ask students to tell what they know about these issues and how attitudes about them have changed since 1950. *(Students might discuss desegregation, TV coverage of women's sports, recycling.)* Encourage students to think of other changes associated with these issues.

### Using the Text

**Art History** Have students read pages 258 and 259. **Ask:** What were some of the art styles of this time? *(Pop Art, Earth Art)* What did Pop and Earth artists consider to be most important in their art? *(how art is made and viewed; the qualities and effects of lines, shapes, colors, and surfaces)*

### Using the Art

**Art Criticism** Have students study the artworks on pages 258 and 259 and compare the message of each. **Ask:** How did each prompt an attitude or feeling toward the subject? How did each artist use color, shape, and texture to present the message?

---

### Teaching Through Inquiry

**Art Criticism** Provide the Descriptive and Expressive Word Cards and the Interpretation Statements in the Teacher's Resource Binder, and have students work in groups to write interpretations of the three artworks on these pages.

**Aesthetics** Provide the Beliefs About Art Cards and the Artists and Beliefs Cards in the Teacher's Resource Binder, and have students work in groups to discuss the extent to which the three artworks on these pages seem associated with a particular belief about art. Ask students to write a summary of the key points of their discussion.

### More About...

**Pop Art** reached its height in the 1960s. Artists created works that recalled everyday items, such as cartoons and mass-market products. However, when these artists isolated common objects from their typical environment and presented them as "art," they asked viewers to see them in a new light.

### Using the Overhead

**Investigate the Past**

**Describe** What exactly do you see in this print?

**Attribute** What clues might suggest that this is a twentieth-century work of art?

**Interpret** What was the artist trying to say?

15

**Explain** Seeing other works by this artist and reading about his work might help you to explain why his work looks the way it does.

259

## Using the Text

**Art History** Ask students to read Art and Community Involvement to learn how artists created murals in Chicago and other cities. **Ask:** Why did artists begin painting urban murals in the 1970s? *(to beautify cities, express community pride)*

## Using the Art

**Art Criticism** Call students' attention to Figs. 8–14 and 8–15. **Ask:** What do you see in each mural? What is the message of each one? How did the artists make their subjects exciting? How did they create unity in these works? *(overlapping shapes, repeating colors)*

## Studio Connection

Assemble these materials: water-soluble block-printing ink; brayers; inking plates; assorted 9" x 12" paper (color, white drawing, newsprint), several sheets per student; pencils; cotton swabs; cotton balls; rags; scrap paper; scissors (optional); newspaper; glue.

Discuss images and symbols that students might use. Demonstrate some monoprint techniques:

- Roll a very small amount of ink on the inking plate to form a thin layer. Lay a sheet of paper on the ink, and draw on it with a pencil, being careful not to press your hand on the paper as you work. Remove the paper; the inked image is on the reverse side of the pencil drawing.

# Art and Community Involvement

Does your community have a mural? Do you know how or when it was made? What message does it send? In the early 1970s, artists began a **mural movement** in many cities throughout the United States. The mural movement helped add beauty to city neighborhoods and gave people an opportunity to express pride in where they live.

The first murals appeared in Chicago. The Chicago Mural Group included about a dozen artists, both men and women, of different races and backgrounds. The group has created more than fifty outdoor murals and twenty-four indoor murals (Figs. 8–14 and 8–15). Money to pay for supplies and artists' time comes from national nonprofit sources, such as the National Endowment for the Arts (NEA), and from local support.

The success of the Chicago Mural Group inspired artists to create murals on walls in neighborhoods from Boston to Los Angeles. Often, the residents of the neighborhoods helped. Through these murals, artists have helped people in communities make a difference in their lives.

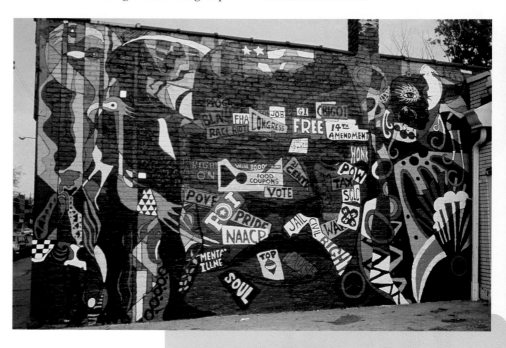

Fig. 8–14 Look carefully at this mural. What issues does the artist address? Why might the people who live in the neighborhood where the mural is located be proud of the work? Chicago Mural Group, Chicago, *Wall of Self-Awareness*, 1973, by Mitchell Caton (1249 East 63rd Street).
Courtesy Chicago Public Art Group.

## Teaching Through Inquiry

**Art History** Have students work in small groups to identify locations of **outdoor murals** in major U.S. or Canadian cities. Each group can choose a city and find information about the artists, the stories behind the murals, and when the murals were created. As students share information, have the class create a time line of the mural movement in the United States.

**Art Production** Ask students to focus on the theme of community pride and use mixed media and collage techniques to **create a plan for a mural** in the community.

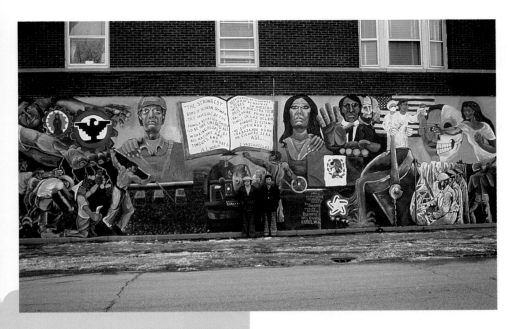

Fig. 8–15 City neighborhoods can be very different from one another in terms of the people who live there and the issues they're concerned about. How are the ideas expressed in this mural different from those in Fig. 8–14? Chicago Mural Group, Chicago, *History of Mexican American Worker* (detail), 1974–75. (13337 South Western). Courtesy Chicago Public Art Group.

### 8.1 Art History

#### Check Your Understanding
1. For what purposes did artists use artwork in the period following World War II?
2. Name some of the different styles of art in the second half of the twentieth century.
3. How did artists make a difference in the second half of the twentieth century?
4. What was the mural movement and how did it affect community life?

### Studio Connection

Create a *monoprint* based on the theme of making a difference. A monoprint is made by transferring one image from a painted or inked surface onto a sheet of paper. Cover a piece of glass or other smooth, nonabsorbent surface with printing ink. Draw into the ink with cotton swabs, a comb, a brush, or the eraser end of a pencil. Try laying paper shapes on the ink. When you are satisfied with your image, place a sheet of drawing paper over the prepared surface. Rub the paper carefully until you see a faint image of your work through the back of the paper. Carefully lift the print. The drawn lines and shapes will remain white on the paper. Note that you must work quickly. Try not to let the ink dry before you finish the print.

Making a Difference

261

- Roll out several colors of ink on the inking plate, lay cut paper shapes on the ink, and press paper over the plate. This is similar to a stencil process.
- Roll the ink into shapes or areas on the inking plate, and then draw. Wipe away ink with cotton, rags, a brush, or a pencil eraser. Press the paper over the drawing, and then carefully remove the paper.

**Assess** See Teacher's Resource Binder: Check Your Work 8.1.

## Assess

### Check Your Understanding: Answers

1. to make a difference in social, political, and environmental causes by focusing on concerns such as civil rights, women's issues, and ecology

2. Pop Art, Earth Art

3. Artists worked in new ways and with different materials; they challenged viewers to see art in different forms and settings; they explored the effects of design elements.

4. The mural movement, in which urban artists expressed pride in their community by adding beauty to city neighborhoods, affected community life by creating opportunities for people to work together.

## Close

Encourage students to explain the meaning of their prints and to describe the printing materials that they used.

### More About...

The ecology movement and a desire to break away from the art-gallery world prompted some artists in the 1970s to move into the landscape itself. **Earth artists** no longer painted scenes of the land but actually sculpted, carved, and moved pieces of the earth, using nature as their medium. Viewers usually could walk in and around the earth art, unlike the traditional approach to viewing sculpture.

### Assessment Options

**Self** Ask students to review this lesson and then use the names of styles and artists covered to construct a simple crossword puzzle. Have student pairs exchange and solve puzzles.

**Peer** Ask students to interview a partner about the ways that late-twentieth-century artists effected change in communities. Have students provide examples from the text.

## Prepare

### Pacing

Three to four 45-minute periods

### Objectives

- Explain the basic steps of any print-making process and identify ways that artists use printmaking techniques to express ideas.

- Make a relief print aimed toward making a difference.

### Vocabulary

See the glossary, page 312, for definitions.

**relief print**

**intaglio print**

**lithographic print**

**serigraph**

## Teach

### Using the Text

**Art Production** Have students read the text and describe each printmaking process. If possible, show examples or demonstrate each.

### Using the Art

**Perception Ask:** What are the textures in Nakashima's *Turtle*? Where are the negative spaces? How did the artist emphasize the turtle? *(placed it near the center and against dark, contrasting values)*

# Printmaking

In the simplest terms, printmaking is a process of transferring an image or words from one surface to another. For instance, when you use a rubber stamp, you make a print of the image or words that are on the stamp. When you create a poster using letter stencils, you make a print of those letters. Artists use printmaking techniques to tell stories, express ideas, and create beautiful designs. As with other art forms, ideas for printmaking can come from observation, imagination, or personal feelings.

Printmaking allows artists to make multiple copies of an image. This makes it an especially good way to send a message to many people.

## Types of Prints

There are three basic steps for making any print. Create an image on a printing plate. Ink the plate. Transfer the image by pressing the inked plate against paper or cloth. By varying the three basic steps, artists make different kinds of prints.

**Relief Prints** To make a relief print, artists carve into a wood or linoleum block with a sharp tool. When the block is inked and pressed on paper, the raised part of the block prints. The carved out areas remain the color of the paper.

**Intaglio Prints** In this process, artists scratch lines into a smooth metal plate. After the plate is inked, they use a printing press to apply even pressure between the plate and the paper. Most intaglio prints have very fine, thin lines or soft, velvety shadows. Their look is usually more delicate than relief prints.

**Lithographic Prints** To make a lithographic print, artists draw an image on a flat slab of stone (or a special

Fig. 8–16 The lines and shapes in this intaglio print are bolder than you might expect to see in an intaglio print. How might the artist's message be different if she had used fine lines and soft shadows to create the image? Sue Coe, *The New World Order*, 1991.
Photo-etching, 13 3/8" x 10 5/8" (34 x 27 cm). Copyright © 1991 Sue Coe. Courtesy Galerie St. Etienne, New York.

262

## Teaching Options

### National Standards 8.2 Forms and Media Lesson

**1a** Select/analyze media, techniques, processes, reflect.

**1b** Use media/techniques/processes to communicate experiences, ideas.

**3a** Integrate visual, spatial, temporal concepts with content.

### Resources

Teacher's Resource Binder

Finder Cards: 8.2

A Closer Look: 8.2

Find Out More: 8.2

Check Your Work: 8.2

Assessment Master: 8.2

Overhead Transparency 15

### Teaching Through Inquiry

**Art Criticism** Have students work in groups to compare *The New World Order* with Picasso's *Guernica,* on page 252. Ask them to describe the items depicted in each work; to analyze how each artist arranged the components to attract and hold the viewer's attention; and to write one or two sentences that tell the message of each artwork. Then ask students to imagine that they have the responsibility of selecting one of these images for a poster to persuade people to avoid war. **Ask:** Which of the two would you select? Why? Have students discuss group ideas with the entire class.

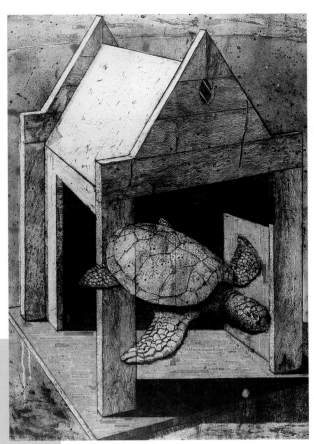

metal plate) with a greasy crayon. Then they coat the blank areas of the stone with a special chemical. The ink sticks to the drawn areas, but will not stick to the chemical. The print is made using a printing press.

**Serigraphs or Silkscreen Prints** In the serigraph printing process, artists use stencils to overlap colors. First they place a stenciled image on a fine screen mounted on a frame. Then they place paper under the screen. When they pull ink across the screen with a squeegee, the image is transferred to the paper. They can use several stencils to apply different colors through the same screen.

Fig. 8–17 **This artist combined lithography with collage techniques to express his personal concern for the environment. What message does this image send?** Tom Nakashima, *Turtle*, 1994. Lithograph on paper, hand-colored newsprint collage, 51 ¾" x 38 ⅝" (131.5 x 98.2 cm). Photo by Noel Allum, NY, Courtesy Bernice Steinbaum Gallery, Miami.

**8.2 Forms and Media**

**Check Your Understanding**
1. For what reasons do artists use printmaking techniques?
2. What are the three basic steps of printmaking?

**Studio Connection**
Create a relief print that will make a difference in the way people think or feel about your school community. You can create the print from almost any raised surface that can be inked. You might try using shells, leaves, bottle caps, or wood scraps. Or try cutting designs into the flat surfaces of a potato. Create an image with glue or string. Allow it to dry before inking and printing. Tear or cut cardboard, foam, or other flat materials. Glue the pieces down and, when dry, ink and print. Plan your design. Use what you know about the principles of design to create a unified composition.

Making a Difference

## Studio Connection

The day before students are to begin, draw one raised design with a line of white glue on cardboard; and another, by gluing yarn to cardboard. Also, assemble these supplies: various types of cardboard; flat or slightly textured objects; potatoes, carrots, or turnips; glue; yarn; scissors; knives; printing ink; assorted paper; brayers; inking plates.

Demonstrate rolling ink on your glue and yarn designs, and printing; also, gluing textures and shapes to heavy cardboard and printing. Show how to carve vegetables and use them like rubber stamps. Discuss designs that students might create, and encourage them to experiment with techniques.

**Assess** See Teacher's Resource Binder: Check Your Work 8.2.

## Assess

**Check Your Understanding: Answers**

**1.** to tell stories, express ideas, and create designs

**2.** Make an image on a printing plate; ink the plate; transfer the image.

## Close

Guide students in matting or mounting a print that best conveys their message.

## Using the Overhead

**Write About It**

**Describe** Write a description of Lewis's composition. Focus especially on the artist's use of line.

**Analyze** Write two sentences that tell how Lewis created pattern.

**15**

## Assessment Options

**Teacher** Have students write a proposal to a local organization that is devoted to improving conditions in the community (such as one devoted to conserving wildlife habitat, reducing drunk driving, or assisting the homeless). Instruct students to propose using printmaking as a way to communicate, to community members, the important ideas for which the organization stands; give reasons why printmaking is an appropriate art form; describe the steps for making the print; and explain options for the kind of print to use. Look for evidence that students understand the potential of printmaking for communicating to large numbers of viewers, the basic printmaking steps, and the advantages of various types of printmaking processes.

## Prepare

### Pacing

Three 45-minute periods: one to consider art and text; two to make art

### Objectives

- Make distinctions among the different types of art traditions in Africa.
- Understand how new African art shows similarities to global modern art movements, yet remains distinctly African.
- Create a sculpture to inspire others to think differently about conditions in the world.

### Vocabulary

**traditional art** Artwork created in almost the same way year after year because it is part of a culture, custom, or belief.

**trade art** Art that is created primarily for sale to tourists or for export to foreign markets.

### Using the Map

Point out to students that the countries and peoples indicated on the map are those of the artists whose works are featured on these pages. Challenge students to hypothesize about trade routes to and from Africa. Ask volunteers to describe how the proximity of Europe to northern Africa might have affected African art over time. **Ask:** What European country is closest to Africa? *(Spain)*

---

# African Art in a Modern World

### Global Glance

During the last half of the twentieth century, communities in Africa have experienced great changes in their political, economic, social, and religious ideas. These community changes have caused changes in art as well. From these modern African communities, four types of art have made a difference in the way we think about African art today: traditional art, Christian art, tourist art, and new African art.

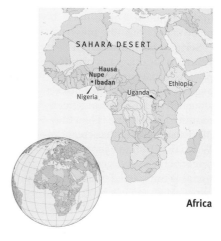

**Africa**

## Traditional Art

Africa is a vast continent with two major regions of culture and geography. In the north, around the Mediterranean Sea, there are many records of the artwork of ancient Egypt, near the Nile River. This art influenced the Greek and Roman civilizations and the development of Western art throughout Europe and much of Russia. In the region south of the Sahara, African kingdoms also have a long artistic heritage. People of this region created **traditional art** such as textiles, masks, ritual power figures, sculptured heads, wall decorations, and ceremonial and everyday objects. The painted house in Fig. 8–18 is an example of traditional African art.

In all parts of Africa, traditional art is similar in one way. Most

African traditional art forms have been created as expressions of religious or social needs in the community. The traditional art forms, styles, and processes of working with wood, fibers, metal, and clay have survived throughout Africa's history. Changes in Africa's politics created changes in the communities that make African art.

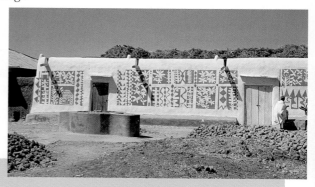

Fig. 8–18 The technique of house painting is similar to that of fresco painting. The paint or pigments are applied to a wall when the plaster is fresh. The designs usually have some symbolic meaning. Where do you see geometric designs? Where do you see organic designs? Africa, Nigeria, Giwa, Hausa People, *Painted house*, 20th century. Facade, left side. © Maude Wahlman.

264

---

### National Standards 8.3 Global View Lesson

**1b** Use media/techniques/processes to communicate experiences, ideas.

**2b** Employ/analyze effectiveness of organizational structures.

**3b** Use subjects, themes, symbols that communicate meaning.

**4b** Place objects in historical, cultural contexts.

**4c** Analyze, demonstrate how time and place influence visual characteristics.

## Teaching Options

### Resources

Teacher's Resource Binder
- A Closer Look: 8.3
- Map: 8.3
- Find Out More: 8.3
- Check Your Work: 8.3
- Assessment Master: 8.3

Large Reproduction 16

Slides 8e

### Teaching Through Inquiry

**Art Production** Have students work in small groups to generate ideas for souvenirs of their community. **Ask:** What mementos of your community would be most appealing to visitors? What are the features of your region that you want people to remember? What kinds of things do people collect as souvenirs? Have each student create a design prototype for a souvenir.

## Other Traditions in Art

Traditional art fills the everyday and cere-monial needs of the African people. Other kinds of art serve different purposes. *Christian art* began in the fifteenth century and continues today. Sculptures and paint-ings decorate the walls, altars, and doorways of mission churches such as the one in Fig. 8–19. The artworks are made by craftspeo-ple or Christian artists.

Probably the most widely recognized form of African art is souvenir, or **tourist, art.** Travelers buy tourist art to help them remember places they visited in Africa. It is also popular with people not able to visit Africa. Much tourist art realistically depicts the animals of Africa or shows scenes of village life. It is sold in art stalls at African markets such as the one in Fig. 8–20. As a business, it has been very successful and a source of income to the African economy.

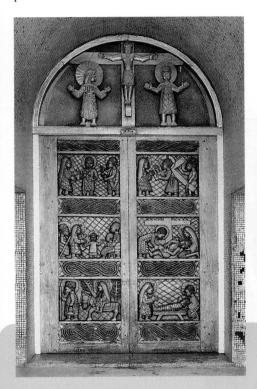

Fig. 8–19 You might be familiar with the scenes shown on these doors. What lessons do you think the images teach? Lamidi O. Fakeye, *Doors for St. Mary's Roman Catholic Church,* Oke-Padi, Ibadan, 1956. Iroko wood. Photographed by David H. Curl.

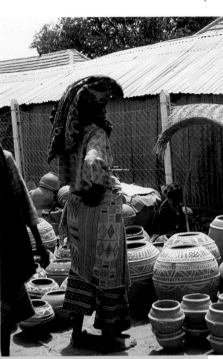

Fig. 8–20 In a traditional market, like the one you see here, all kinds of objects are bought and sold. Notice the examples of traditional art, such as the decorated pots and the patterned fabrics of the women's clothing. Africa, Nigeria, Nupe People, *Market Scene: Selling Bide-Pottery,* 1974. © Maude Wahlman

Making a Difference

265

### Teach

#### Engage
Show students examples of African art, such as figural carvings and masks. Tell students that they will study African art and create a statue to influence people's thoughts on a world issue.

#### Using the Text
**Art History** Have students read Tradi-tional Art and Other Traditions in Art. **Ask:** Which area of Africa influenced Western art? *(the north)* Which re-gion of Africa is associated with tra-ditional African art? *(south of the Sahara)* What subjects does trade art depict? *(African animals or scenes of village life)*

#### Using the Art
**Art Criticism Ask:** What Christian symbols and stories can you identify in the frames of the African church door? What features in this design suggest that it is African? *(African faces and the geometric designs on the clothes and in the background)*

### More About...
Artists in many cultures some-times incorporate traditional techniques, materials, subjects, or styles into **trade art**—pieces produced specifically for the marketplace. Some critics feel that trade art is unimportant be-cause it is made to please cus-tomers rather than for use within the community. Others support people's adaptation of traditional expressions to purposes that create much-needed income.

### Using the Large Reproduction
**Consider Context**

**Describe** What details would you want people to notice in this artwork?

**Attribute** How can you tell that this print might have been made by an African artist?

**Understand** What seems to have been impor-tant to this artist?

**Explain** What traditions in African art are evident in this print?

16

265

## Using the Text

**Art History** Have students read New African Art to learn about late twentieth-century African art. **Ask:** How is this art distinctly African? *(It deals with African subjects, settings, and political and social issues.)*

## Using the Art

**Art Criticism Ask:** What is the subject matter in each composition? How is it distinctly African? How did the artist emphasize the subject and message? How would you describe the main shapes, forms, and lines?

## Studio Connection

Gather these supplies: sculpture wire (14-gauge aluminum sculpture wire is easily bent), about 6' per student; wire cutters; wood scrap for base; staple gun and staples; papier-mâché, foil, or plaster gauze; scissors; hammer; acrylic paints; brushes; water in containers.

Discuss what students might create to influence how people think about the world (such as a statue of a community leader holding symbols of change, or an animal in an environment).

Demonstrate ways of creating a figure. After students have created their armature, staple each work to a piece of wood. Suggest to students that they turn their sculpture to consider how the form and space in and around it look from different views, and to find compositional movement lines. Teach students how to fill out their form by wrapping or draping the wire with papier-mâché, foil, or plaster gauze. Students may wish to paint their sculptures and bases.

**Assess** See Teacher's Resource Binder: Check Your Work 8.3.

## New African Art

Since the mid-twentieth century, a new African art has caught the attention of art museums and collectors around the world. The majority of these artists have been trained in art schools such as Makerere School of Fine Arts in Uganda. These artists are aware of both historic and modern art traditions in Africa and other parts of the world. They are aware of political and social events occurring in modern Africa. They use their art to comment on these events.

The style of new African art is similar to modern art movements around the world, but the subject matter and themes are distinctly African. These artworks show African subjects in African settings, and deal with African political and social issues. The new African art shows the artists' views of scenes from their world (Figs. 8–21 and 8–22). In the last half of the twentieth century, African artists have continued to make a difference as they use their talent, training, and ideas to describe the exciting and unique experience of life in African communities.

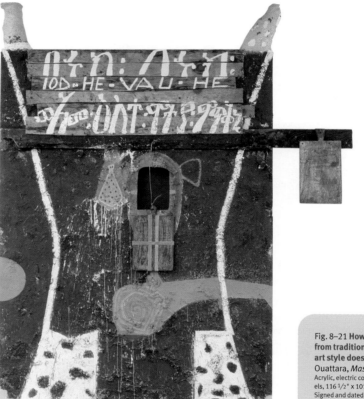

Fig. 8–21 How is this artwork different from traditional African art? What modern art style does it make you think of? Ouattara, *Masada*, 1993.
Acrylic, electric cord, and mixed media on 2 wood panels, 116 1/2" x 101 1/2" x 7 1/2" (296 x 257.8 x 19 cm). Signed and dated on the reverse. Courtesy Cavaliero Fine Arts, New York.

## Teaching Options

### Meeting Individual Needs

**Multiple Intelligences/Spatial** Ask students to categorize images on pages 264–267 as traditional, Christian, trade, or "new" African art. **Ask:** Although the works are different from one another, what do they have in common? What makes them appear distinctly African? Encourage students to consider style (many have abstracted qualities), subjects (most relate to African life), color schemes, and what the artists might have wanted viewers to understand.

Fig. 8–22 What qualities of Expressionist art does this painting show? (See page 10 to learn about Expressionist art.) How is this artwork different from the traditional artworks on pages 264 and 265? Elimo Njau, *Milking*, undated.
Oil on canvas, 20 1/8" x 15 3/4" (51 x 40 cm). Museum fuer Volkerkunde, Frankfurt am Main. Photo: Maria Obermaier.

Fig. 8–23 This is a picture of Ethiopian artist Afework Tekle's studio. Notice the unfinished portrait of a West African leader. What do you see in the studio that suggests the artist's African heritage?
Photo courtesy Eldon Katter

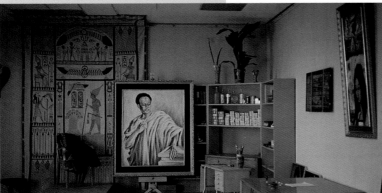

### Studio Connection

Create a sculpture of a person or animal using wire or papier-mâché. Many sculptures are made over a wire *armature*. An armature is like a skeleton. For small sculptures, an armature is usually made of twisted wire. After the basic skeleton has been attached to a base, you can decorate it with details or cover it with papier-mâché. Plan your work before you begin. Think about how you can use your sculpture to make a difference in the way people think about the world. What subject matter might catch people's attention? How can you inspire viewers to think about your subject matter differently?

### 8.3 Global View

#### Check Your Understanding

1. What are the four areas of art production that have made a difference in the way we think about African art?
2. What are some traditional forms of African art?
3. Why do people buy tourist art?
4. How does the art of the new African artists differ from other art-making communities in Africa's history?

*Making a Difference*

267

## Teaching Through Inquiry

**Art History** Help students search the Internet for information about art schools, museums, and art galleries in African countries; and about artists who live and work in Africa today. Have students post the information on a bulletin board.

## Assessment Options

**Teacher** Ask students to categorize each of the following African art forms as either traditional or nontraditional: textiles, mobiles, masks, oil paintings, ritual power figures, graphic design, ceremonial objects, computer art, sculptural heads, nonobjective sculpture.

## Prepare

### Pacing
Three to four 45-minute class periods

### Objectives
- Explore the process of relief printing to achieve desired effects.
- Create a relief print that conveys a positive idea about a natural community.

### Vocabulary
**linoleum cut** A relief print that is made from a linoleum block. The linoleum is cut away. The uncut relief areas are covered with ink, paper is placed on top, and the print is made by rubbing the back of the paper.

### Supplies
- science books, animal models
- lightweight paper
- soft pencils
- carbon paper
- linoleum blocks, 4" x 6" or larger, 1/student
- linoleum cutters
- water-soluble printing ink
- inking slabs (pie pans, cookie sheets, Formica)
- brayers
- assortment of papers
- large spoons (optional)

### National Standards
8.4 Studio Lesson

**1b** Use media/techniques/processes to communicate experiences, ideas.

**2b** Employ/analyze effectiveness of organizational structures.

**3b** Use subjects, themes, symbols that communicate meaning.

**4a** Compare artworks of various eras, cultures.

**6b** Describe ways other disciplines are interrelated to art.

---

Printmaking in the Studio
# Making Relief Prints

## Art That Makes a Difference

### Studio Introduction
In this studio experience, you will make a relief print of a natural environment that is in danger of being destroyed. **Create an image that will show the environment in a positive way.** Pages 270 and 271 will tell you how to do it.

Look around you. There are natural environments everywhere. A seaside beach is an environment of crabs, seaweed, and barnacles. A garden is an environment of flowers, vegetables, animals, and insects. A marsh is an environment of grasses, cattails, and waterfowl. Some natural environments are in danger of being destroyed. How can you show an endangered environment in a positive way? You might think of a slogan that sums up what you want to say about this environment. Then try to illustrate your thought.

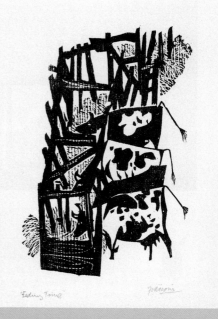

Fig. 8–24 This artist created a woodcut, a relief print made from a block of wood. Notice how the areas of black (ink) and white (paper) create the main shapes. If you didn't know this was a woodcut, would you still be able to tell the image was cut from a block of wood? How? Antonio Frasconi, *Feeding Time*, ca. 1960s.
Woodcut on cream wove paper, 6 9/16" x 4 3/4" (16.7 x 12.1 cm). Brooklyn Museum of Art. 1997.45 Gift of Judith Rappaport.

## Studio Background

### Introducing the Relief Print
Do you remember the first time you accidentally left a fingerprint of ink or paint on a sheet of paper? You may not have realized it at the time, but you had just made a relief print. The fine lines of the print were made by the ridges or raised areas of the fingertip itself. The recessed areas between the ridges were probably free of paint or ink and remained the color of the paper when printed.

When an artist makes a **linoleum cut**, a relief print made from a linoleum block, he or she uses cutting tools, such as gouges, veiners, and knives, to cut an image on the block. Gouges and veiners can be wide or narrow. Knives can range from X-acto knives and mat knives to sharp pocket knives.

268

---

### Resources

Teacher's Resource Binder
  Studio Master: 8.4
  Studio Reflection: 8.4
  A Closer Look: 8.4
  Find Out More: 8.4
Large Reproduction 16
Slides 8f

### Meeting Individual Needs

**Adaptive Materials** For easier carving, provide softer linoleum. If you do use regular linoleum, warm it with a blow dryer. Have students use bench hooks to hold linoleum in place. To avoid using knives, provide Styrofoam sheets and pencils instead of linoleum and cutters.

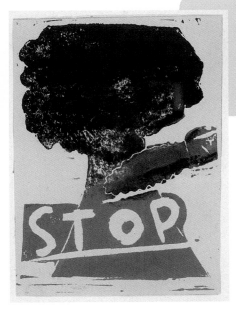

Fig. 8–25 The artist has created a block print design with an unmistakable message. He says, "Some parts that were easy were cutting out the open spaces. The difficult place was cutting out the chainsaw." Rich Holtquist, *STOP*, 1999. Block print, ink, 4 1/2" x 6" (11.5 x 15cm). Antioch Upper Grade School, Antioch, Illinois.

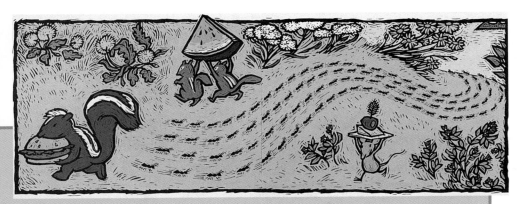

Depending on the size of the cutting tool, an artist can make thick or thin lines, or remove entire areas of the block's surface. He or she might create a design with simple shapes and fine details or textures. The areas that are left uncut will be covered with a thin coat of ink. When the print is made, the areas of the block that are cut away will be the color of the paper.

Fig. 8–26 Some artists create relief prints to illustrate stories. Notice how this artist used several different colors. Do you think she used a wide or narrow cutting tool to create texture and detail? Why do you think so? Bonnie Mackain, Illustration from *One Hundred Hungry Ants* by Elinor J. Pinczes. Illustration copyright © 1993 by Bonnie Mackain. Reprinted by permission of Houghton Mifflin Company. All rights reserved.

Making a Difference

269

## Teach

### Engage
Show students examples of block prints, such as Hokusai's *Fukagawa Mannembashi* (Fig. 4–18), and Hiroshige's *Night Snow at Kambara* (Fig. 4–19). Tell students that they will create their own block print.

### Using the Text
**Art Production** Have students read pages 268 and 269. Discuss what plants, animals, and landforms are found in specific natural communities. Explain that words or images carved on a block must be a mirror image of the intended outcome when printed.

### Using the Art
**Perception Ask:** Where are the strong value contrasts of light against dark? Where are the negative shapes? What are the textures? Where have they been repeated?

### Critical Thinking
Challenge students to compare the style of these prints to those mentioned in Engage. **Ask:** How did the artists simplify shapes? How did they fill the picture plane? What was each artist's feeling about nature? How did they emphasize their message?

## Teaching Through Inquiry

**Art Production** Have students work in pairs or small groups to analyze and compare the formal elements in the *Turtle* (Fig. 8–17), on page 263, and the two prints here. Students can record their findings on a chart, including the title of each work, subject matter, kinds of colors, lines, textures, shapes, values and contrast, and the printmaking process used. Have them prepare an explanation of the process used to create the characteristic features of each print, and of the extent to which these features are the result of the particular process; then, discuss their findings as a class.

## More About...

**Tips for relief prints** To transfer an image, carefully place paper over the printing block, and then apply pressure with hands or the convex side of a large wooden spoon. Rub the entire surface, beginning at the center and working toward the edges. Alternatively, stack several layers of newspaper on the floor, place the paper with the block facedown on top, and slowly apply pressure by stepping down.

## Using the Large Reproduction

16

**Looking Closer**
Note how the artist used color, shape, and line. What is emphasized in this work?

# Making Relief Prints

## Studio Experience

1. As students draw their design with pencil on lightweight paper the size of their block, remind them to indicate textures of plants, animals, and land or water in their chosen environment. Before they carve, suggest that they consider what shapes and lines will be the color of the paper, and what will be ink. Encourage students to consider value contrasts; and whether to carve the whole shape of an object, just the lines around it, or the background around it.

2. Demonstrate cutting the linoleum, emphasizing safety; rolling ink until it is smooth and tacky; pressing paper on the block; rubbing by hand or with a spoon or clean brayer; and pulling a clean print.

3. After students have printed with one ink color, encourage them to experiment with two colors and with a variety of papers. Suggest that they consider creating strong contrasts between the color of the ink and that of the paper.

## Idea Generators

Lead the class in developing a list of natural environments to draw, and the plants and animals found in each. Provide science and nature books and animal models for reference.

## Studio Tips

- Remind students that simple shapes will create a better print, and that the final print will be a mirror image of the sketch.

- Textural effects and patterns can be created by lightly tapping a texture into the surface of the block with a hammer. Try using nails, a metal screen, or gravel.

### Printmaking in the Studio

## Making Your Relief Print

### You Will Need

- thin paper
- soft pencil
- carbon paper
- linoleum block
- cutting tools
- ink, inking slab, and brayer
- printing paper

**Safety Note**
Cutting tools must be handled with extreme caution. Always hold the block securely and point the cutting edge of the tool away from your hands, fingers, and body. Work slowly. Wear safety goggles.

### Try This

1. Choose an endangered environment to show in a relief print. Think of ways to simplify the main shapes of the subject you choose. Sketch your image on thin paper that is the same size as your printing block. When you are finished, turn your sketch over and hold it up to a strong light. This will show you what your final print will look like.

2. Use carbon paper to transfer your design onto the block. Place the carbon paper face down on your block. Lay your design face up over the carbon paper. Carefully trace over the design.

3. With your pencil, lightly fill in the areas on your block that you want to print in a color. Check your design when you are finished. Make changes as needed.

4. Carefully cut away the areas you do not want to print.

5. With a brayer, apply a thin even coat of ink to the raised areas of your design.

6. Carefully place the printing paper over the block. Gently rub the paper with your hand. When you can see your design faintly through the back of the sheet, slowly pull the print away from the block.

### Check Your Work

What does your print say about the natural environment you've shown? How might it make a difference in the way viewers think about the environment? How did you create textures in your block?

## Teaching Options

### Teaching Through Inquiry

**Art Production** Ask students to explore new ways of creating prints. Explain that contemporary artists often combine several traditional techniques (relief and silkscreen, for example) in a single print. Some artists combine printmaking techniques with other media. Others create prints that look like sculpture or become elements for a collage. Many of the new directions in printmaking also involve new media and technologies. For example, some printmakers use color photocopiers to make color copies of an image, thereby creating a new kind of monoprint. Have students experiment with new printmaking techniques and keep records, in their sketchbook, of what they did, what effects they created, and how they might use these new processes.

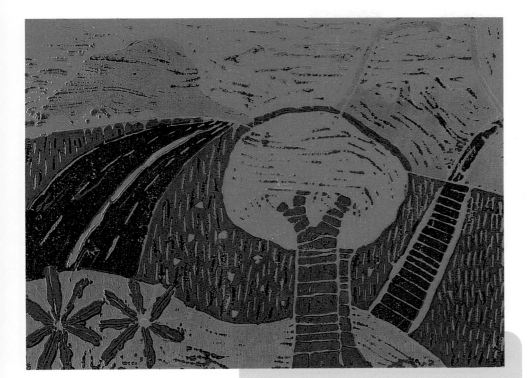

Fig. 8–27 **"The idea came to me as I was looking through a book about my home country of Japan."** Atsushi Sato, *Travelling Through Nature*, 1999.
Linoleum block print, 5 1/4" x 7 1/2" (14 x 19 cm). Plum Grove Junior High School, Rolling Meadows, Illinois.

### Sketchbook Tip
Encourage students to use a viewfinder in order to choose small areas of their subject and sketch them large as close-up natural shapes. Combine these shapes with views from farther away in a series of thumbnail sketches.

### Computer Option
ClarisWorks and AppleWorks have a feature for resolution and depth to create a four-level black-and-white image. Photoshop, Color It, and Painter have a "posterize" option that produces a similar effect. Students may also repeat the "sharpening" effect in Dabbler or Painter Classic. Encourage students to select dark areas and make them solid black, and to select light areas and make them all white (negative space); use the image in a repeat design; save a version and invert it (black areas become white; white areas become black); and alternate and repeat the positive and negative images as a pattern.

### Computer Option
Create a high-contrast image that has the look and feel of a block print. Import a photo or art image of the natural world into a paint or digital-imaging program. Convert the image to grayscale or to 256 or fewer levels of gray. Choose the "posterize" option or two levels of black and white. Increase the contrast and sharpen the edges to separate the areas of the image into "black and white." Then use the resulting image as a pattern for a block print.

### Sketchbook Connection
Use your sketchbook to experiment with different slogans or sayings that describe the natural environment you will show in your print. Observe and sketch images from this environment that relate to your slogan. Select images that you think will catch people's attention and best convey your message. Try combining images in different ways as you plan your print.

Making a Difference

271

## Assess

### Check Your Work
Ask students to write a statement about what their print says about a natural environment, and to display the statement with their print.

## Close

Have students arrange a class display of the prints according to the environments that are depicted. Ask students to explain their message and point out textures in their print.

### More About...

**Multicolored relief prints** can be made in several ways. For the most complex method, the artist cuts a separate block for each color. After making several prints and letting them dry, the artist reprints them with the next color. In all multicolored prints, lighter colors are printed first. For a less-complex method, the artist uses only one block, and applies different-colored inks, one at a time, with a brush. After printing one color, the artist cuts a stencil and places it over the print. By inking the block with another color and printing over the first color, the stenciled area remains unchanged.

### Assessment Options

**Peer** Have students create criteria for judging the quality of completed relief prints. Display the criteria. Ask students to meet in groups of three to use the established criteria to discuss their completed artworks. Encourage students to offer positive comments and to offer suggestions for improvement, as appropriate. If time allows, give students the opportunity to incorporate suggestions in the creation of an additional print.

## Daily Life

Charitable organizations must make the public aware of their activities and encourage people to donate to their cause. They also must often compete against other charities and maintain their visibility through newspaper and television ads, mailings, and brochures. Share and discuss examples of such materials, and then have small groups of students each choose a charity for which they design a fundraising campaign that includes a logo, brochure, and newspaper ad.

## Language Arts

A Web site's graphic design, site architecture or structure, and organization and significance of content are critical to the site's success. The visual impact of the home page tends to determine whether visitors will go further into the site. Well-designed site architecture is necessary for the graphic elements, page layouts, page titles, and navigation systems to work smoothly together. The organization of significant content in meaningful ways determines the effectiveness of information design. Discuss these components of Web-site design, and then have students write their own criteria to evaluate the design and content of several Web sites.

# Connect to...

## Careers

How might you use a camera to make a difference? You might choose a career in one of many areas of photography—for example, education, entertainment, or advertising. Or you might choose photojournalism. **Photojournalists** work for newspapers, TV stations, magazines, and news services. A series of photographs can tell a news story, and when they accompany written copy, they bring people a more complete understanding of the news. Photojournalists might be assigned to cover a particular story, usually with a reporter; or they might cover an event alone, working to create a photo-essay, a story in pictures. By capturing an image artfully and using the elements and principles of design to compose a shot, a photographer can make a powerful statement.

## Other Arts

### Theater

The tradition of **artists' working to serve their communities** is not unique to the field of visual art. During the first decade of the twentieth century, cities and towns across the United States began to establish community theaters to serve local interests and needs. Early on, many community theaters staged large pageants in which huge numbers of people could participate and learn about theater. However, such productions became too large, and community theaters began staging smaller productions that were to entertain as well as educate. Challenge students to name ways that the community might benefit from a local theater.

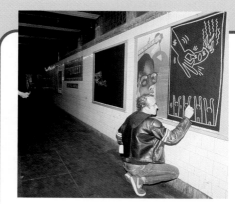

## Daily Life

What can each of us do to **make our world a better place**? By combining our efforts with those of others, we *can* make a difference. For instance, you can volunteer in a hospital or a food bank, donate clothing to organizations such as the Salvation Army and Goodwill, and help prepare or deliver meals to the sick or a family in need. Can you think of any other charitable efforts you could make?

Fig. 8–28 Art can be used to inform people or to change their minds about particular topics. Keith Haring often used public spaces for his art—in this case a subway station. What message does this artwork seem to send? *Keith Haring photographed by Chantal Regnault in NYC subway*, 1981. ©The Estate of Keith Haring.

## Teaching Options

### Resources

Teacher's Resource Binder
 Using the Web
 Interview with an Artist
 Teacher Letter

### Video Connection

Show the Davis art careers video to give students a real-life look at the career highlighted above.

### Community Involvement

Familiarize students with local agencies or institutions that work to make a difference. Invite representatives to talk about their community work and tell how students might become involved.

## Other Subjects

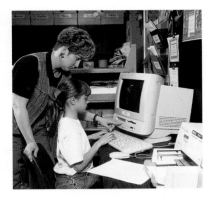

Fig. 8–29 **Does your school or local library have computers available for student use? Do you think it's important to know how to use a computer?**
Photo courtesy *SchoolArts*.

### Language Arts

Do you consider yourself to be computer literate? Do you have access to computers at school or at home? Why, do you think, do some people believe that **computers** will have an impact on learning equal only to the separate inventions of the alphabet and movable type? Software for composing and publishing text and graphics has made a huge contribution to language arts; competition among ever-increasing numbers of Web sites promotes the development of meaningful content and exceptional graphic design. However, to be successful in our information age, students must develop both linguistic and visual literacy. What do you think will happen to students who do not have access to computers? How might such students get access?

### Social Studies

Do you think it is possible to effect social or political change through the use of humor? The Guerilla Girls, an anonymous group of women artists, learned quickly that humor attracts people's interest and is an effective weapon against discrimination: they have been practicing peaceful activism for over ten years, in an effort to make the art world and the public aware that most influential galleries and museums exhibit very few women artists. The members of the group hide their identities under gorilla masks and "identify" themselves by the names of dead women artists and writers so as to reinforce their place in history. The anonymity also directs the focus to the issues rather than their personalities or artwork. The Guerilla Girls stage peaceful demonstrations and express—on billboards, posters, and buses—their opinions about sexism and racism in our culture. Why, do you think, do they call themselves the "Guerilla Girls, Conscience of the Art World"?

Fig. 8–30 **This is a model of the double-strand DNA molecule. The two strands twist around each other like a spiral staircase, a form called a double helix (***HE-lix***).** *Model of a DNA Molecule.*
©Digital Art/CORBIS.

### Science

Have you heard of the Human Genome Project? It is an international research effort begun in 1990 to determine the sequence of all the approximately 100,000 genes of the human genome, the complete instructions within our genes for making a human being. With such knowledge, **genetic-engineering techniques** could possibly manipulate the genetic material of DNA—deoxyribonucleic acid—to "reprogram" the genetic code. Scientists hope that discoveries that grow out of the project will aid in the treatment of diseases and the adjustment of harmful hereditary traits.

What are some reasons that critics have raised ethical questions about the use of genetic engineering?

**Internet Connection**
For more activities related to this chapter, go to the Davis website at **www.davis-art.com.**

### Science

Display magazine or textbook illustrations of DNA and other topics of science and medicine. Explain that the Human Genome Project is the biggest undertaking ever in biology. Encourage students to consider why scientific illustrations are needed and what criteria might be required for such images.

### Other Arts

If there is a community theater in your town, invite the artistic director to discuss how the theater serves your community. Students might ask: What is the goal of the theater? How is the theater funded? How can volunteers get involved? If your area does not have a community theater, have students access the Web site of the American Association of Community Theatres, at: www.aact.org. Here they can find a listing of community theaters and their Web sites. Students can find out about the performances these groups produce.

Making a Difference

## Internet Resources

### Guerilla Girls
http://www.guerrillagirls.com/
At this site, learn more about the Guerilla Girls' use of humor to effect social and political change in the art world.

### The AIDS Memorial Quilt
http://www.AIDSQuilt.org
Browse or search thousands of homemade quilted panels.

### Robert Rauschenberg
http://www.artsnetmn.org/whatsart/rausch.html
This ArtsNet Minnesota site hosts a unit on Rauschenberg written for middle-school students.

## Interdisciplinary Planning

• Work with your colleagues to find ways for students to experience the literature, drama, dance, and music of African cultures, and to ensure that students are familiar with the geography and political boundaries of Africa.

• Pool resources with teachers of social studies, language arts, science, and other arts to help students make connections between the arts and social, political, and environmental issues.

## Museum Connection

Many museums have programs in which young people volunteer as junior docents. Invite a museum representative to discuss how to become involved.

## Talking About Student Art

When talking with students about their artworks, ask them to talk about the decisions they made. If students worked with one or more of their peers, ask all involved to discuss how collaboration influenced their decision-making process. **Ask:** What aspects of collaboration do you think are positive? What about collaboration might be negative?

## Portfolio Tip

As students remove works from their portfolio, encourage them to consider various storage and preservation options. Suggest to students that they not discard artworks, but recycle them in mixed-media paintings and collages.

## Sketchbook Tip

Remind students to think about sketchbook assignments as sources for future artwork ideas and out-of-class studio projects.

# Portfolio

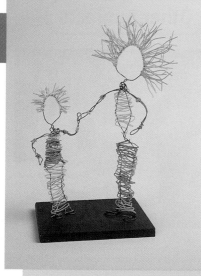

"When creating this piece of artwork, we wanted to show a friendly relationship between people of all races. We tried to demonstrate the evolution that Martin Luther King, Jr., and Rosa Parks evoked on our society."
**Whitney Davis and Debbie Grossman**

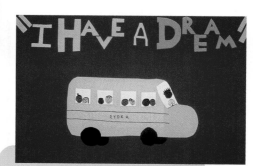

Fig. 8–32 Whitney Davis and Debbie Grossman, *I Have a Dream*, 1999.
Cut-paper collage, 18" x 24" (46 x 61 cm). Winsor School, Boston, Massachusetts.

Fig. 8–31 Micale Mitchell, *Mother and Child*, 1999.
Wire, wood base, 11 ½" (29 cm) high. Desert Sands School, Phoenix, Arizona.

"I wanted to somehow represent my mother in this sculpture. I constructed us holding hands to represent the closeness that I always want to have with her." **Micale Mitchell**

**CD-ROM Connection**
To see more student art, check out the Community Connection Student Gallery.

"My picture delivers an important message. We need to start treating our environment better because if we don't we won't be happy with our lives and the world we live in."
**Thomas Reid**

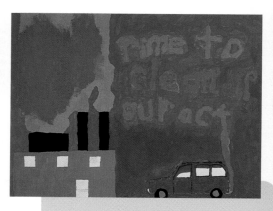

Fig. 8–33 Thomas Reid, *Time to Clean Up Our Act*, 1999.
Poster, 18" x 24" (46 x 61 cm). Jordan-Elbridge Middle School, Jordan, New York.

274

## Teaching Options

### Resources

Teacher's Resource Binder
   Chapter Review 8
   Portfolio Tips
   Write About Art
   Understanding Your Artistic Process
   Analyzing Your Studio Work

### CD-ROM Connection

For students' inspiration, for comparison, or for criticism exercises, use the additional student works related to studio activities in this chapter.

# Chapter 8 Review

### Recall

Why did Picasso create the painting *Guernica*?

### Understand

Use examples to explain how art can be used to try to make a difference in the way people think about important issues.

### Apply

How might you use printmaking to address a problem in your own school community? What problem would you address? What kind of print would you make?

### Analyze

Find an artwork in this chapter that sends a positive message in an attempt to make a difference in the way people think or behave. Tell how the artist used subject matter, materials and techniques, and the elements of art to convey the positive message.

### Synthesize

In what ways is artists' collaboration to make artworks a good thing? In what ways might it be difficult?

### Evaluate

Consider the *Homeless Vehicle* (Figure 8-9, *shown below*). Do you think this vehicle is a good solution for helping the homeless? Why or why not? Do you think this is a good work of art? Why or why not? Select and rank three artworks from this chapter that you think should be in a twentieth-century art hall of fame. Justify your number one choice.

Page 257

### For Your Portfolio

Keep your portfolio in good order. Once in a while, check the contents, and choose what to keep in your portfolio and what to remove. Check that each entry is well presented and identified with your name, date, and title of work. Protect each entry with newsprint or tissue paper.

### For Your Sketchbook

Think about your portfolio artworks in terms of how they might make a difference. Do any express an opinion? What ideas do you explore most often? How might some of your works be changed to be more "opinionated"? Use a page for your sketchbook to describe your findings.

## Family Involvement

Hold a family day for which students plan art-appreciation activities for family members. Students might lead discussions about specific artworks or take part in theatrical productions that tell about the lives of certain artists.

## Advocacy

Have students design bumper stickers on the theme "Art Makes a Difference." Select one or more to have printed and distributed to members of the school and local community.

## Chapter 8 Review Answers

### Recall

Picasso created *Guernica* to show the anguish and horrible confusion that occurred after the bombing of the Spanish village of Guernica.

### Understand

Answers will vary. Look for evidence that students understand that artists make artworks to address issues.

### Apply

Answers will vary. Look for evidence that students understand the characteristics and potential of printmaking to send a message.

### Analyze

Answers will vary. Examples of artworks that convey positive messages are Schapiro's *Wonderland* (Fig. 8–4) and Lynne Hull's *Raptor Roost* (Fig. 8–8). Look for understanding of how subject matter, materials and techniques, and the elements of art contribute to the positive message.

### Synthesize

Answers will vary. Collaboration allows for more people, who can share their ideas and expertise, to be involved; however, so many people may have difficulty reaching agreement about the social issue to be addressed, the subject matter, the materials and methods to create the artwork, and the way the artwork should be organized.

### Evaluate

Answers will vary. Look for reasons that address the design of the vehicle and the plight of the homeless; and also for reasons concerning what the student believes good art should be.

### Reteach

Ask students to think of popular music in which the lyrics seem to be aimed toward making a difference in the way people think or behave. Then have students find an artwork in the chapter that has a similar message. Discuss how the structure of the music and the artwork helps convey the message.

Summarize by reminding students that people in communities often try to find ways to make the world a better place and that they often use artworks to help them in their efforts.

# Chapter Organizer

## Chapter Focus

**Chapter 9
Looking
Beyond**

Chapter 9 Overview
pages 276–277

- **Core** Artists help communities design objects, artworks, and places for the future. Artists use traditional and nontraditional media and techniques to create new art forms.
- **9.1** New Directions in Art: 1980–?
- **9.2** New Media
- **9.3** Meeting Global Challenges
- **9.4** Making a Videotape

## Chapter National Standards

1 Understand media, techniques, and processes.
2 Use knowledge of structures and functions.
3 Choose and evaluate subject matter, symbols, and ideas.
4 Understand arts in relation to history and cultures.
5 Assess own and others' work.

---

**9 weeks: 3   18 weeks: 3   36 weeks: 3**

### Objectives

**Core Lesson
Beyond the Present**
page 278
Pacing: Three 45-minute periods

- Identify ways that artists help communities imagine what might be possible.
- Explain the role of fantasy worlds and creatures in community traditions.

### National Standards

**2b** Employ/analyze effectiveness of organizational structures.
**5b** Analyze contemporary, historical meaning through inquiry.

---

**Core Studio
Art That Looks Beyond**
page 282

- Use collage techniques to create an image of a fantasy world.

**3b** Use subjects, themes, symbols that communicate meaning.

---

**36 weeks: 3**

### Objectives

**Art History Lesson 9.1
New Directions in Art**
page 284
Pacing: Three to four 45-minute periods

- Identify ways that artists explored new possibilities at the end of the twentieth century.
- Consider possibilities for art in the future.

### National Standards

**2b** Employ/analyze effectiveness of organizational structures.
**3b** Use subjects, themes, symbols that communicate meaning.
**4c** Analyze, demonstrate how time and place influence visual characteristics.

---

**Studio Connection**
page 286

- Select media and combine ideas in an imaginative drawing.

**1a** Select/analyze media, techniques, processes, reflect.

---

**36 weeks: 3**

### Objectives

**Forms and Media
Lesson 9.2
New Media**
page 288
Pacing: Three 45-minute class period

- Describe ways that artists have used new media to create nontraditional art forms.

### National Standards

**4c** Analyze, demonstrate how time and place influence visual characteristics.
**5b** Analyze contemporary, historical meaning through inquiry.

---

**Studio Connection**
page 289

- Use a paint or draw program to design a community on Mars.

**1b** Use media/techniques/processes to communicate experiences, ideas.
**2c** Select, use structures, functions.
**3b** Use subjects, themes, symbols that communicate meaning.

## Featured Artists

Magdalena Abakanowicz
Mary Adams
Stephen Bingler
Santiago Calatrava
Francois Colos
Arturo Elizondo
Barnaby Evans
Pete Evaristo/Jodi Tucci

Ann Hamilton
Robert Haozous
Bill Henderson
Joe Herrera
Jenny Holzer
Mark Innerst
Paul Klee
Liza Lou

James Luna
Rene Magritte
Raymond C. Prado
Sandy Skoglund
Pat Steir
Roxanne Swentzell
Bill Viola

## Chapter Vocabulary

activism
computer art
global community
global style
installations
multimedia
Performance Art
storyboard
video art

---

## Teaching Options

Meeting Individual Needs
Teaching Through Inquiry
More About... Jenny Holtzer
Wit and Wisdom
More About...Paul Klee
Using the Large Reproduction
Using the Overhead

## Technology

CD-ROM Connection
    e-Gallery

## Resources

Teacher's Resource Binder
    Thoughts About Art:
        9 Core
    A Closer Look: 9 Core
    Find Out More: 9 Core
    Studio Master: 9 Core
    Assessment Master:
        9 Core

Large Reproduction 17
Overhead Transparency 18
Slides 9a, 9b, 9c

---

Meeting Individual Needs
Teaching Through Inquiry
More About...Magritte
Assessment Options

CD-ROM Connection
    Student Gallery

Teacher's Resource Binder
    Studio Reflection: 9 Core

---

## Teaching Options

Meeting Individual Needs
Teaching Through Inquiry
More About...Pat Steir
Using the Overhead

## Technology

CD-ROM Connection
    e-Gallery

## Resources

Teacher's Resource Binder
    Names to Know: 9.1
    A Closer Look: 9.1
    Map: 9.1
    Find Out More: 9.1
    Assessment Master: 9.1

Overhead Transparency 17
Slides 9d

---

Teaching Through Inquiry
More About... Installations
More About...*WaterFire*
Assessment Options

CD-ROM Connection
    Student Gallery

Teacher's Resource Binder
    Check Your Work: 9.1

---

## Teaching Options

Teaching Through Inquiry
More About... Bill Viola
Using the Overhead
Assessment Options

## Technology

CD-ROM Connection
    e-Gallery

## Resources

Teacher's Resource Binder
    Finder Cards: 9.2
    A Closer Look: 9.2
    Find Out More: 9.2
    Assessment Master: 9.2

Overhead Transparency 17

---

CD-ROM Connection
    Student Gallery

Teacher's Resource Binder
    Check Your Work: 9.2

# Chapter Organizer continued

| | | |
|---|---|---|
| | | **3** |

## Objectives | National Standards

**Global View Lesson 9.3**
**Meeting Global Challenges**
page 290
Pacing: Three
45-minute periods

- Justify the importance of preserving traditions.
- Understand the issues and concerns expressed by contemporary Native-American artists.

**2b** Employ/analyze effectiveness of organizational structures.
**4c** Analyze, demonstrate how time and place influence visual characteristics.
**5b** Analyze contemporary, historical meaning through inquiry.

---

**Studio Connection**
page 292

- Create a small-scale sculpture on the theme of continuity and change.

**1a** Select/analyze media, techniques, processes, refle
**3b** Use subjects, themes, symbols that communicate meaning.

---

## Objectives | National Standards

**Studio Lesson 9.4**
**Making a Video**
page 294
Pacing: Eight to nine
45-minute periods

- Explain the process involved in making a film.
- Analyze the structure of various types of TV programming.

**1b** Use media/techniques/processes to communicate experiences, ideas.
**2b** Employ/analyze effectiveness of organizational struct
**3b** Use subjects, themes, symbols that communicate me
**4c** Analyze, demonstrate how time and place influence v characteristics.
**5b** Analyze contemporary, historical meaning through in

---

## Objectives | National Standards

**Connect to...**
page 298

- Create a videotape that tells a simple story or makes a presentation.

**6** Make connections between disciplines.

---

## Objectives | National Standards

**Portfolio/Review**
page 300

- Learn to look at and comment respectfully on artworks by peers.
- Demonstrate understanding of chapter content.

**5** Assess own and others' work.

## Teaching Options

Meeting Individual Needs
Teaching Through Inquiry
More About…Roxanne Swentzell
Using the Large Reproduction

## Technology

CD-ROM Connection
e-Gallery

## Resources

Teacher's Resource Binder
A Closer Look: 9.3
Map: 9.3
Find Out More: 9.3
Assessment Master: 9.3

Large Reproduction 18
Slides 9e

---

Teaching Through Inquiry
More About… James Luna
Assessment Options

CD-ROM Connection
Student Gallery

Teacher's Resource Binder
Check Your Work: 9.3

## Teaching Options

Meeting Individual Needs
Teaching Through Inquiry
More About…Motion pictures
Using the Overhead
More About…Storyboard artists
Assessment Options

## Technology

CD-ROM Connection
Student Gallery
Computer Option

## Resources

Teacher's Resource Binder
Studio Master: 9.4
Studio Reflection: 9.4
A Closer Look: 9.4
Find Out More: 9.4

Slides 9f

## Teaching Options

Interdisciplinary Tip
Curriculum Connection
Museum Connection

## Technology

Internet Resources
Video Connection
CD-ROM Connection
e-Gallery

## Resources

Teacher's Resource Binder
Using the Web
Interview with an Artist
Teacher Letter

## Teaching Options

Family Involvement
Advocacy

## Technology

CD-ROM Connection
Student Gallery

## Resources

Teacher's Resource Binder
Chapter Review 9
Portfolio Tips
Write About Art
Understanding Your Artistic Process
Analyzing Your Studio Work

## Chapter Overview

### Theme

People living in communities—through their stories and legends of fantasy worlds and creatures—imagine other ways of living. Art provides people in communities with depictions of these worlds, and also helps them imagine objects and environments for the future.

### Featured Artists

Magdalena Abakanowicz
Mary Adams
Stephen Bingler
Santiago Calatrava
Francois Colos
Arturo Elizondo
Barnaby Evans
Pete Evaristo/Jodi Tucci
Ann Hamilton
Robert Haozous
Bill Henderson
Joe Herrera
Jenny Holzer
Mark Innerst
Paul Klee
Liza Lou
James Luna
Rene Magritte
Raymond C. Prado
Sandy Skoglund
Pat Steir
Roxanne Swentzell
Bill Viola

### Chapter Focus

This chapter features ways that art helps communities imagine other worlds, and how artists help communities design objects, artworks, and places for the future so as to provide a visual record. Students learn how

# Looking Beyond

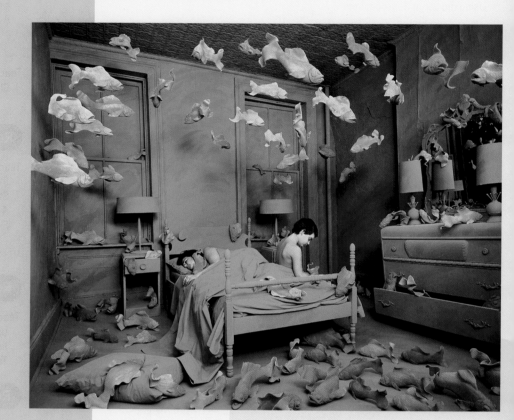

Fig. 9–1 **When we look at this image, it's easy to think that we're viewing someone's dream. Whose dream might it be? What might it mean?** Sandy Skoglund, *Revenge of the Goldfish*, 1981. Cibachrome color photograph, 30" x 40" (76.1 x 101.6 cm), ©1981, Sandy Skoglund.

### National Standards Chapter 9 Content Standards

1. Understand media, techniques, and processes.
2. Use knowledge of structures and functions.
3. Choose and evaluate subject matter, symbols, and ideas.
4. Understand arts in relation to history and cultures.
5. Assess own and others' work.

## Teaching Options

### Teaching Through Inquiry

**Aesthetics** Have students write reasons with their answer to each question: Which is the artwork—Skoglund's arranged scene, or the photograph of the scene? Both? Does Skoglund create a new artwork every time she sets up a new scene? Can something be an artwork if it doesn't last? How does Skoglund's artwork fit with your ideas about what art is? Does it challenge you to think differently about what art is? After students have written their responses, have them share their ideas in groups of three.

### More About...

**Sandy Skoglund** (b.1946) does not use her own night-time images: "I dream about ordinary life . . . going shopping, to the hairdresser." After sculpting the 126 fish for *Revenge of the Goldfish*, Skoglund felt they reminded her of flames, so she painted them a vivid orange for a "hot" look that turned them into "gold" fish.

## Focus

- How do people look to the future and imagine possibilities?
- How can art help people imagine worlds beyond the present and familiar?

Let's face it. The image shown in Fig. 9–1 is strange. Parts of it are familiar: a bedroom, a person sleeping. But everything is blue-green except the people and those fish. What are they doing there? Is this scene underwater? Are the fish flying in the air? This is the sort of image that could take place only in a dream.

Artist Sandy Skoglund created this scene and others that are equally bizarre. She carves and paints objects and arranges them with people in environments that she also creates. Finally, she photographs the scene. Her artworks come in two forms. Usually, she sets up her scenes in a gallery or museum space. Viewers experience them in true-to-life scale. She also exhibits her large color photographs of the scenes. What makes Skoglund's artworks so unsettling is that they combine what we know with fantasy and imagination.

Since early times, artists have helped people imagine other worlds. Sometimes, these worlds remain fantasy. Other times, the dreams of artists and community members become reality in the future. Every invention begins as an idea of what someone imagines for the future.

## What's Ahead

- **Core Lesson** Discover how artists help people imagine unfamiliar, fantasy, and future worlds.
- **9.1 Art History Lesson** Explore the new possibilities and challenges that artists face at the beginning of the twenty-first century.
- **9.2 Forms and Media Lesson** Learn how artists use traditional and nontraditional media and techniques to create new art forms.
- **9.3 Global View Lesson** Investigate how artists around the world preserve traditions while exploring new directions in art.
- **9.4 Studio Lesson** Create a videotape that explains an idea.

## Words to Know

| | |
|---|---|
| installations | multimedia |
| activism | global community |
| performance art | global style |
| computer art | storyboard |
| video art | |

artists have used traditional and nontraditional media and techniques to create new art forms, and they see that artists worldwide are exploring these new directions. The final studio lesson of the book invites students to create a videotape. Students examine this traditional and nontraditional approach to art by taking a closer look at contemporary Native-American art.

## Chapter Warm-up

Encourage students to tell each other their most fantastic dream. Ask volunteers to share a few of the wildest. Tell students that they will see how artists lead people to imagine the impossible.

## Using the Text

**Art Criticism** Have students read the text to learn how Sandy Skoglund creates her dreamlike art. **Ask:** How did Skoglund produce two art forms with this work? (She made an installation and photographed it.)

## Using the Art

**Art Criticism** As students study Skoglund's *Revenge of the Goldfish*, ask them to describe what they see. **Ask:** Where is the setting? What clues suggest this is a dream? What does the title suggest about the artist's vision?

## Extend

- Suggest to students that they draw one of their dreams and then write an explanation of it.
- Assign students to research other examples of Sandy Skoglund's art. Have them show the class a copy of a piece that appeals to them.

## Graphic Organizer
### Chapter 9

**9.1 Art History Lesson**
New Directions in Art: 1980-?
page 284

**9.2 Forms and Media Lesson**
New Media
page 288

## Core Lesson
Beyond the Present

### Core Studio
**Art That Looks Beyond**
page 282

**9.3 Global View Lesson**
Meeting Global Challenges
page 290

**9.4 Studio Lesson**
Making a Videotape
page 294

## CD-ROM Connection

For more images relating to this theme, see the Community Connection CD-ROM.

# Beyond the Present

## Prepare

### Pacing

Three 45-minute periods: one to consider art and text; one to cut out photographs; one to arrange and glue collage

### Objectives

- Identify ways that artists help communities imagine what might be possible.
- Explain the role of fantasy worlds and creatures in community traditions.
- Use collage techniques to create an image of a fantasy world.

### Vocabulary

**installations** Temporary arrangements of art objects in galleries, museums, or outdoors.

**Pre-Studio Assignment:** Students can collect interesting photographs, photocopies, and magazine images.

## Teach

### Engage

**Ask:** If you could design a new school, what would it be like? Would there be classrooms? What would be the largest space? Where would students keep their stuff? Where would students eat?

### New Ideas

Have you ever wished for a machine that could do your homework, walk your dog, or make your lunch? Artists help whole communities imagine what might be possible. They design futuristic objects and environments for us to contemplate. Leonardo da Vinci, for example, created drawings of flying machines. For him and others who lived in the late fifteenth and early sixteenth centuries, such machines could exist only on paper or in dreams. We know, of course, that what once seemed beyond the possible is now reality. Airplanes take us to all points around the globe. We can fly to the moon and, possibly, even beyond.

People in communities dream about how they can make their environment better. They ask architects and other artists to help in their planning. In some cases, teams of people who represent various groups in a community will help imagine these new places. What would you tell such a team if the goal was to create a totally new school? Students, parents, and other community members all worked together to create the plan of the school in Fig. 9–4. The students wanted the school to have separate buildings and to be like a farm.

### New Kinds of Art

As artists explore new ways of making art, they help us look beyond what we think of as artwork. Contemporary artists around the world experiment with new materials and technology to create new kinds of art forms. Like Sandy Skoglund, many contemporary artists create environments, or **installations**—temporary arrangements of objects in galleries, museums, and outdoors. Installations give viewers an art experience that is different from viewing a painting or sculpture. Some artists include sound and video or computer technology in an installation, such as the work by Jenny Holzer

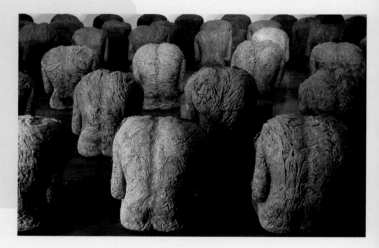

Fig. 9–2 The backs that this artist created are life-size. Imagine seeing eighty of them at one time. If you could see this artwork in real life, how might it make you feel? Magdalena Abakanowicz, *Backs* (group of 80 figures), 1976–80. Burlap and resin, 3 different sizes: 24" x 19 5/8" x 21 5/8", 27 1/4" x 22" x 26", 28 1/4" x 23 1/4" x 27 1/4" (61 x 50 x 55 cm; 69 x 56 x 66 cm; 71.8 x 59 x 69.2 cm). © Magdalena Abakanowicz, courtesy Marlborough Gallery, New York.

278

## Teaching Options

### Resources

Teacher's Resource Binder

  Thoughts About Art: 9 Core

  A Closer Look: 9 Core

  Find Out More: 9 Core

  Studio Master: 9 Core

  Studio Reflection: 9 Core

  Assessment Master: 9 Core

Large Reproduction 17

Overhead Transparency 18

Slides 9a, 9b, 9c

### Meeting Individual Needs

**Multiple Intelligences/Linguistic**
**Ask:** How did the artists of Figs. 9–1, 9–2, 9–5, and 9–7 go beyond reality? Have students select one of the images and write a poem that captures the work's sense of fantasy, unreality, or future vision. **Ask:** What words create images in the mind of a world that does not seem to exist?

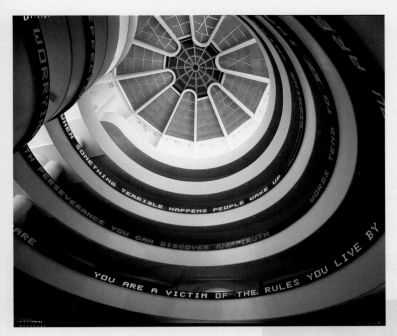

(Fig. 9–3). Occasionally, an artist will become part of the artwork, engaging in a kind of performance.

Some artists use traditional materials in nontraditional ways. Magdalena Abakanowicz, for example, works in fiber and often builds her structures on a loom. But those are the only traditional aspects of her work. To make the artwork shown in Fig. 9–2, she molded burlap and glue to create forms that look like the backs of seated humans. She has installed them at different sites, including a room and a hillside. The forms suggest a different mood, depending on where and how they are positioned.

Fig. 9–3 **How might the experience of seeing this installation be different from the experience of seeing a painting? How does this work change your ideas about what art is?** Jenny Holzer, *Untitled* (Selections from Truisms, Inflammatory Essays, The Living Series, The Survival Series, Under a Rock, Laments, and Child Text), 1989.
Extended helical tricolor L.E.D. electronic-display signboard, dimensions subject to change with installation. Solomon R. Guggenheim Museum, NY. Partial gift of the artist, 1989. Photo by David Heald © The Solomon R. Guggenheim Foundation, NY. (FN89.3626)

Fig. 9–4 **Which parts of this school resemble a farm?** Stephen Bingler, *Lincoln High School Environmental Resource Center*, 1996.
Digital graphic illustration. Courtesy Concordia Architects.

Looking Beyond

279

## Using the Text

**Art History** Have students read pages 278–279 to learn how artists have imagined new art. **Ask:** What did Leonardo imagine that is now a reality? *(airplanes)* How is an installation different from a painting or sculpture?

## Using the Art

**Perception** Challenge students to read Holzer's electronic display sign on the railings of the Guggenheim Museum. Explain that, in this museum, a ramp spirals around the central foyer. **Ask:** Why would someone consider this sign to be an artwork?

**Art Criticism Ask:** What is missing from the figures in Abakanowicz's *Backs*? What might be the meaning, or symbolism, of figures without heads? How did the artist create harmony and unity in this installation? What mood or feeling is produced by repeating the same form? What is the message? How would you describe the texture?

## Critical Thinking

Lead students in imagining *Backs* in a different setting, such as a school or the roof of a building. **Ask:** How would the message change? Challenge students to suggest another setting that would create a different meaning.

## Journal Connection

Encourage students to reflect on their definition of art. **Ask:** What artwork in this chapter challenges your idea of art? Why might another person think of that artwork as art?

## Teaching Through Inquiry

**Art Production** Tell students that, at a 1998 meeting, educators, architects, and city planners drafted six guidelines for future design of schools. One guideline stated that a school should be like a "new version of the old town square—a community hub." It further stated that schools should be designed to serve learners of all ages and to encourage community use, day and night, year-round, for public meetings and recreation. Have students work in small groups to design a school that meets these requirements, then have them share their design with the class.

## More About...

While in graduate school, **Jenny Holtzer** (b. 1950) abandoned her abstract paintings in order to work with captioned diagrams. She found herself more drawn to words than images, and has used language as an artistic medium ever since. Holtzer began her *Truism* series by plastering posters around downtown Manhattan. She then expanded to electronic media to convey her pointed, anonymous statements.

## Wit and Wisdom

The building of large high schools was proposed early in the twentieth century. Henry Ford was one of the foremost proponents of the "factory" model of schools to replace one-room schoolhouses.

## Using the Text

**Art Criticism** Have students read Beyond the Familiar to learn about fantasy art. **Ask:** What animals are combined in the fantastic monster Chimera? *(lion, goat, snake)* What artist suggested taking a walk with line to see where it leads? *(Klee)* Lead a discussion of other artworks students have seen that might be fantasy art.

## Using the Art

**Art Criticism** Ask students to locate three heads in Fig. 9–6. Note the unusual mane and face of the lion. **Ask:** Do you think the artist had ever seen a lion? How would you describe the textures on this sculpture?

**Perception Ask:** What is the scene in Klee's *Fish Magic*? What art elements are most important? *(color, line)*

**Art Criticism Ask:** How did Elizondo indicate time in *Nostalgia*? *(size, placement on the page)* What unites the figures? *(background)* How would you describe the textures? What is the mood?

## Critical Thinking

Have students compare Klee's *Fish Magic,* Fig. 9–5, to Skoglund's *Revenge of the Goldfish,* Fig. 9–1. **Ask:** What do these have in common? How does color contribute to the emotion in each piece? What is the mood of each?

## Beyond the Familiar

Think about the legends and stories you know. Remember *Paul Bunyan, The Wizard of Oz, Alice in Wonderland,* and *Peter Pan*? Humans like to imagine fantasy worlds and creatures. Throughout history, artists have illustrated the stories and legends of their communities. In cultures around the world, stories passed down through generations have inspired artists to create imaginary monsters and other creatures. They appear as decorations for buildings, on everyday objects, and in paintings and sculptures.

The sculpture in Fig. 9–6 is of an imaginary fire-breathing monster with three heads: a lion's and a goat's, with a snake's head as its tail.

Artists also create their own fantasy worlds for others to consider. Artist Paul Klee created worlds in which creatures, plants, and people floated as if in a dream. Klee explained that many of his images resulted from allowing himself to draw freely with line. In one of his writings, he encourages others to "take a walk" with line and see where it leads. His imaginary worlds show that he not only drew with line but

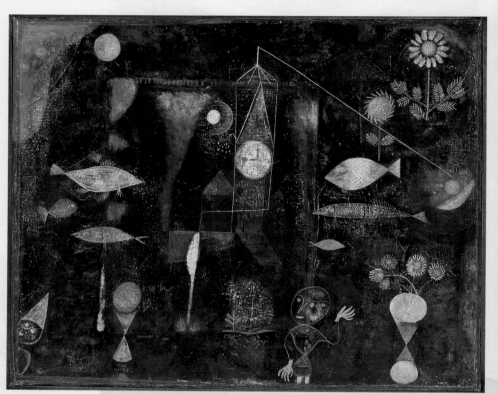

Fig. 9–5 Paul Klee was very interested in the drawings he made as a child. He also studied those made by his son, Felix. How is this image like those made by children you know? Paul Klee, *Fish Magic,* 1925.
Oil on canvas, mounted on board, 30 3/8" x 38 1/2" (77.3 x 97.8 cm). Philadelphia Museum of Art, The Louise and Walter Arensberg Collection. Photo by Graydon Wood, 1994. Acc. # '50-134-112 © 2000 Artists Rights Society (ARS), New York / VG Bild-Kunst, Bonn.

## Teaching Options

### Teaching Through Inquiry

**Art History** Have students investigate artworks about fantasy worlds and creatures. Among Western artists, students might choose Miró, Bosch, Escher, Kahlo, Cheryl Laemmle, Rousseau, Chagall, or Laurie Simmons. Guide students to create a plan for carrying out their investigation, and have them refer to page 54 for art-historical inquiry questions. Ask students to create a display of their findings.

### More About...

**Paul Klee** (1879–1940) believed that creativity is an intuitive act, although influenced by an artist's past experiences. Klee rooted his images in fantasy and often looked to children's art, including his own youthful renderings, for inspiration. Klee's childhood drawing of a trout and perch became the basis for a series of fish paintings, including *Fish Magic.*

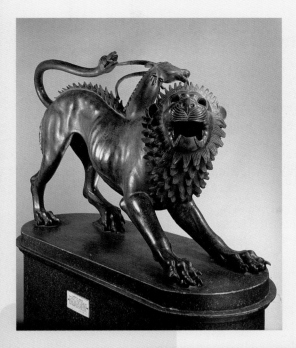

also scratched lines into painted surfaces, revealing the colors underneath (Fig. 9–5).

Just as in dreams, where people, objects, and events are mixed in unlikely ways, some artists create artworks by placing things together as if by chance. In *Nostalgia* (Fig. 9–7), for example, the artist placed a chunk of watermelon in a bare landscape. The watermelon does not seem to have much to do with what's happening in the scene. Yet it is in the foreground of the picture.

Fig. 9–6 Chimera was a Greek mythical creature. What creatures from mythology are you familiar with? How might they be shown in an artwork? Etruscan, *Chimera of Arezzo*, 6th century BC. Bronze. Museo Archeologico, Florence, Italy. Scala/Art Resource, New York.

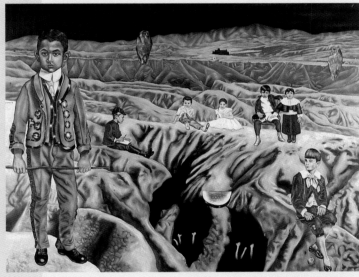

Fig. 9–7 How would you describe the landscape inhabited by these people and other objects or creatures? Does the title help you understand the meaning of this artwork? How? Arturo Elizondo, *Nostalgia*, 1995. Oil on canvas, 78" x 103 ¼" (198 x 262 cm). Courtesy Galeria OMR, Mexico City.

## Journal Connection

Assign students to select one of the artworks on pages 278–281, write a string of descriptive words that come to mind, and use the words in a fantasy story based on the artwork.

## Extend

- After students discuss *Chimera of Arezzo*, ask them to create their own monster by combining features of several animals. Students may form their work from clay or carve it in plaster. For other examples of fictional animals, show students medieval gargoyles.

- Direct students to begin drawing animals on large sheets of paper. After about five minutes, have students change seats and continue drawing on an animal begun by a classmate. Have students repeat this process a few more times, encouraging them to draw an environment for each beast. When the drawings are complete, ask students to write descriptions of the fantastic beasts. Hold a class discussion of this experience. **Ask:** How did you feel about giving up ownership of your art to someone else?

Looking Beyond

## Using the Large Reproduction

### Talk It Over

**Describe** Describe the colors, shapes, textures, and placement of the glass forms in this installation.

**Analyze** How does the sculptural form contrast with the setting in which it is placed?

**Interpret** Given the setting, what feelings or ideas are conveyed by this sculpture?

**Judge** Would you like to see this in person? What features of the artwork are most—and least—pleasing to you?

**17**

## Using the Overhead

### Think It Through

**Ideas** From where, do you suppose, did the artist get her ideas for this work?

**Materials** What materials did she use? Note the dimensions.

**Techniques** How might the artist have used layered glass? How might she have used the computer?

**Audience** What would an audience need to know in order to better understand this artwork?

**18**

## Supplies

- cardboard or oak tag
- magazine images, photographs, photocopies
- scissors
- white glue
- assorted papers

## Using the Text

**Art Production** Have students read the first paragraph to begin planning their collage. For the background, guide students to use photographs that have implied texture. Discuss ways that students can include a background, middle ground, and foreground in their collage, and ask each student what will be the main idea or theme of his or her collage.

**Art History** Have students read Studio Background. Ask them to describe Surrealism in their own words.

## Using the Art

**Art Criticism Ask:** What is the most important art element in Fig. 9–8? *(line)* How did the artist use lines to indicate depth in the foreground? *(Nearer lines are farther apart.)*

**Art Criticism** Direct students' attention to Fig. 9–9, and lead them in discussing answers to the caption questions. **Ask:** What movies and stories do you know that involve changes in scale? (Alice in Wonderland; Gulliver's Travels; Honey, I Shrunk the Kids; The Fantastic Voyage)

## Assess

## Check Your Work

Display the collages, and have students point out both the fantastical and everyday parts of their artworks.

---

## Collage in the Studio
# Art That Looks Beyond

In this studio experience, you will use collage techniques to create a world of your dreams. What kind of fantasy world for the future can you create? Think about a theme or main idea for your imaginary world. What images will you include? How will you combine similar and different images to create an unreal scene? How can you show realistic and unrealistic elements? What will be in the background, middle ground, and foreground areas of your collage?

### You Will Need

- lightweight cardboard
- scissors
- glue
- a variety of papers
- magazine or other photographs

## Try This

**1.** Plan your collage. Collect magazine, newspaper, or photocopied images that will help show your ideas. Cut or tear other shapes from construction paper, colored tissue, foil, or patterned papers.

**2.** Carefully arrange your shapes and photos. Create unity in your artwork by repeating shapes, colors, or images. Try different arrangements before choosing the one you like best.

**3.** Carefully glue the images to the cardboard background.

[figure of surrealist landscape illustration]

Fig. 9–8 How is this image like a collage? Which part or parts might the artist have drawn himself? Francois Colos, Illustration from *The Student Who Became King in Spite of Himself*, 1974.
© 1974 by Francois Colos. Reprinted by permission of Henry Holt and Company, LLC.

## Studio Background

### Imaginary Worlds in Art

Artists sometimes put objects or images that we don't expect to see together side by side. Sometimes the objects or images are in different sizes than we expect. These artworks might show parts of a world that seem real and other parts that don't seem normal to us. This style of art is called *Surrealism*. Surrealist artists create artworks that look beyond what is real. They show fantasy or imaginary worlds where realistic objects are combined in unusual ways or with unfamiliar scenes.

Figures 9–8 and 9–9 have elements that seem perfectly normal, yet something makes them look odd. Figure 9–8 is a children's book illustration by the graphic artist Francois Colos. What makes this illustration look real and unreal? In Magritte's paint-

---

## Teaching Options

## Meeting Individual Needs

**Focusing Ideas** Have students focus on a scene from a story they've read, a movie they've seen, or a song they've heard.

**Adaptive Materials** Provide glue sticks for attaching images to the cardboard.

## Teaching Through Inquiry

**Art Criticism** *Explain that Surrealism* typically involves the use of transformation, scale change, juxtaposition, levitation, dislocation, dreams, nightmares, puzzling situations, the bizarre, and the strange. Ask students to investigate and then discuss the meaning of each element, and to compare the Magritte and Colos images. Challenge students to point out where and how the artists incorporated some or all of these elements.

## Check Your Work

Display your completed collage with each of your classmates'. Discuss the different worlds you've created. Note the elements in the collages that are part of what we see in daily life. Note how each collage suggests a world that is beyond what we normally experience.

### Check Your Understanding

1. Identify two ways that artists help communities imagine what might be possible.
2. Explain the role of fantasy worlds and creatures in community traditions.
3. What challenges would a community face if all its members got together to plan a new school?
4. How could you use what you know about Surrealism to explain Sandy Skoglund's work in Fig. 9–1 to someone who did not understand it?

Fig. 9–10 **"I started the project by finding things I liked, for instance clothes, cologne, etc. Then I changed my whole idea and was a little discouraged. Then I thought of a mirror-imaging idea, and that is what I came up with. It was rather challenging to make, but I used a little perseverance and got it done."** Craig Delaney, *The Sky*, 1999. Magazine cutouts and paper collage, 14" x 16" (35.5 x 40.5 cm). Isleboro School, Isleboro, Maine.

ing, the apple is shown realistically, just as we might expect to see it in our own home. However, by making it unusually large, the artist creates a dreamlike world of an ordinary object.

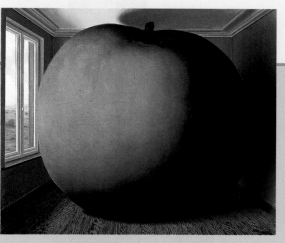

Fig. 9–9 Rene Magritte has exaggerated the scale, or size, of the apple in this painting. Do you think the painting would be as interesting if the apple was a normal size? Why or why not? Rene Magritte, *La chambre d'écoute* (The Listening Chamber), 1952. Oil on canvas, 17 ⁵/₈" x 21 ⁵/₈" (45 x 55 cm.) The Menil Collection, Houston. Gift of Philippa Friedrich. Photographed by Paul Hester, Houston. © Charly Herscovici, Brussels / Artist Rights Society (ARS), New York.

Looking Beyond

283

### Check Your Understanding: Answers

**1.** Artists help communities imagine objects or environments of the future. They also invite communities to imagine new art possibilities.

**2.** featured in legends and stories, appear as decorations for community buildings, objects, paintings, and sculptures

**3.** Answers will vary. Look for consideration of the challenges regarding reorganization of spaces, types of teaching and learning, numbers of students enrolled, and so on.

**4.** Surrealism involves the combination of objects and images that we don't expect to see together, showing some things that seem real and others that are not what we think of as normal. Skoglund's artworks follow this tradition, because she places the unreal with the real; the expected with the unexpected.

## Close

Lead a discussion of the different kinds of art students have seen and thought about in this lesson. **Ask:** Which artists do you think are most effective in creating a fantasy? Why do you think so? What art forms and media have the most possibility for showing new ideas and leading viewers beyond the ordinary? Ask students to give reasons for their answers.

## More About...

**René Magritte** (1898–1967) began his career by designing wallpaper, posters, sheet-music covers, and catalog illustrations. Later, like other Surrealist painters, he created works that startled viewers' expectations. He took ordinary objects or scenes and altered their relationship in terms of size and location. The resulting absurd and often witty combinations typically raised more questions than they answered, despite the fact that Magritte painted each element in a highly realistic style.

## Assessment Options

**Teacher** Ask students to imagine that they have been asked to take the opposition in a debate in which the other side claims that art shows us only what is really in the world. Guide students to prepare notes for the debate and be ready to offer examples. Look for evidence that artists help communities imagine possible objects or environments for the future, that they invite communities to imagine new possibilities for art, and that they help communities illustrate fantasy worlds and creatures featured in traditional legends and stories.

## Prepare

### Pacing

Three to four 45-minute periods

### Objectives

- Identify ways that artists explored new possibilities at the end of the twentieth century.
- Consider possibilities for art in the future.
- Select media and combine ideas in an imaginative drawing.

### Vocabulary

**activism** The practice of working to change attitudes or beliefs.

**Performance Art** A form of visual art closely related to theater that combines any of the creative forms of expression.

### Using the Time Line

Ask students to name some events that set "new directions" during the 1980s and 1990s. **Ask:** Where would these be placed on the time line?

### National Standards
### 9.1 Art History Lesson

**1a** Select/analyze media, techniques, processes, reflect.

**2b** Employ/analyze effectiveness of organizational structures.

**3b** Use subjects, themes, symbols that communicate meaning.

**4c** Analyze, demonstrate how time and place influence visual characteristics.

**9.1 ART HISTORY LESSON**

# New Directions in Art: 1980–?

| 1991–95 | 1997 | 1999 |
| Lou, *Kitchen* | Steir, *The Brueghel Series* | Innerst, *Parade* |

American Social Causes page 258

**American Art Since 1980**

?

| 1996 | 1998 |
| Evans, *WaterFire Providence* | Evariston and Tucci, *On the Avenue, Brian* |

### History in a Nutshell

In the closing decades of the twentieth century, many people became caught up in the pace of contemporary life. In this Information Age, people had multiple and instant ways of communicating with others in their communities and beyond. Cell phones, portable computers, e-mail, and the Internet made it possible for people to be in constant touch with families, friends, business connections, and worldwide news and events. Suddenly, a person's community extended beyond his or her local geographic area to encompass the world.

### New Approaches

You've probably said to yourself many times, after a thrilling roller-coaster ride or other exciting adventure, "Where do we go from here?" Well, that's probably what many artists in the United States were thinking at the end of the twentieth century.

In the last decades of the twentieth century, artists all over the world challenged many traditional ideas about art and explored new possibilities. They tried many new technologies as tools and materials for making art.

Fig. 9–11 Celebration is a common theme in art. This artist shows it in a new way. How does this painting compare to Jacob Lawrence's painting of the same title (Fig. 7–9, page 231)? Mark Innerst, *Parade*, 1999. Acrylic on board, 45 3/8" x 23 3/8" (115 x 59.4 cm). Courtesy Paul Kasmin Gallery.

284

## Teaching Options

### Resources

Teacher's Resource Binder

Names to Know: 9.1

A Closer Look: 9.1

Map: 9.1

Find Out More: 9.1

Check Your Work: 9.1

Assessment Master: 9.1

Overhead Transparency 17

Slides 9d

### Meeting Individual Needs

**English as a Second Language** Ask students to imagine that they are ladybugs flying in and around Liza Lou's *Beaded Kitchen*. What English words would describe the feeling they might have as creatures experiencing this different world?

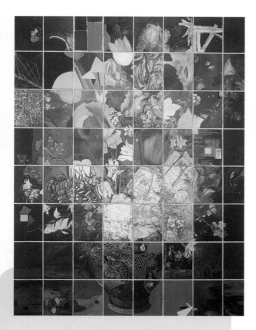

Fig. 9–12 Look carefully at each panel that makes up this artwork. Do you see styles and techniques in each that remind you of other artists you have studied? Pat Steir, *The Brueghel Series* (A Vanitas of Styles), 1997. Oil on Canvas, 64 panels, each panel 28 ½" x 22 ½" (72.4 x 57.2 cm). Courtesy the artist.

They displayed and exhibited their work in new settings and situations. They even recycled the art of the past. At the turn of this century, the world of art includes revivals of traditional styles, humorous copies of classical works, and new looks at familiar images. Pat Steir, for example, created her own interpretation of the artwork of Dutch master Jan Brueghel (Fig. 9–12).

## Working Without Boundaries

Since 1980, artists have created work that spans a wide range of styles, materials, and techniques. From realistic to abstract, technical perfection to wild abandon, serious, humorous, soothing, and shocking, the world of art became a world with no boundaries. Some of the artwork from this time was large-scale outdoor art created with industrial equipment. Other art was handcrafted work with many tiny details. The artworks of Liza Lou, for example, are made entirely of beads (Fig. 9–13). Notice the message in the art. What do you think it means?

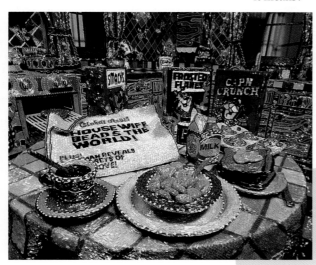

Fig. 9–13 Each of the objects in this life-sized room is made of tiny beads. The artist also created a yard from beads. What words can you think of to describe this work?. Liza Lou, *Kitchen*, 1991–95 (detail). Mixed media with glass beads, 168 sq. ft. (51.3 m). Courtesy the artist.

Looking Beyond

285

## Teach

### Engage

**Ask:** What inventions and objects have changed your life in the last four or five years? How has the way you communicate changed? Have telephones or computers changed? How has transportation changed? How has clothing changed? Explain to students that art has also changed, and that they will consider some of art's new directions.

### Using the Text

**Art History** Assign students to read New Approaches. **Ask:** How did artists near the close of the twentieth century challenge traditional art ideas? *(They used new technology as art media and tools, exhibited in new settings, and recycled past art.)*

### Using the Art

**Art Criticism Ask:** What artists' styles do you recognize in Fig. 9–12? Explain that the styles of sixty artists are included in this reinvention of Dutch master Jan Brueghel's still life. Ask students to compare textures and brushstrokes of various panels.

### Extend

Suggest to students that they experiment with painting styles by using several artists' techniques to recreate an artwork in this book.

## Teaching Through Inquiry

**Art History** Have students work in cooperative-learning groups to identify the historical styles used by Steir in *The Breughel Series*. Have groups research some artists who influenced Steir, find and photocopy an artwork that clearly shows the style of each, and create a display around a copy of Pat Steir's work.

**Art Production** Have students select an artwork. Enlarge it, and divide into grids so that there is one grid portion for each student. Have each student render his or her grid in the style of an artist studied in this book.

## More About...

As part of her contemporary work, **Pat Steir** (b. 1938) sometimes explores great artists of the past. She states: "I'm really interested in the lineage of influence and identification in art, because when you find an artist you identify with, it's like finding a father, or a mother."

## Using the Overhead

**Investigate the Past**

**Describe** What do you see in this artwork?

**Attribute** How do we know this artwork was not made 100 years ago?

**Interpret** What does this artwork seem to be about?

**Explain** What twentieth-century developments have made this artwork possible?

17

## New Directions in Art

## Using the Text

**Art History** Have students read Community Involvement. **Ask:** In what ways have artists involved communities in art? *(through collaboration, activism, and performance art)* If you were to design banners for your community, what might you put on them?

• Have students read The Future of Art to consider what new media artists are using. Ask students to explain why handmade artworks might become more valuable than art forms produced with new technologies.

## Using the Art

**Aesthetics** As students study the artworks on pages 286–287, lead them in imagining how communities might have been involved in creating each piece. **Ask:** From each artwork, what do you know or feel about the community? Ask students to imagine that they serve on a committee planning a community celebration. **Ask:** How would you convince the city government to provide money for community artworks?

## Studio Connection

Lead students in imagining opposites—of animals, objects, and qualities of objects (such as a furry, instead of a smooth, teacup). Suggest ways to set the opposites in a dreamlike landscape, and discuss how students will use line, shape, color, and texture to emphasize the meaning in their art.

Provide a choice of drawing materials: pencils, colored pencils, markers, ink, pastels; and 12" x 18", or larger, drawing paper. When students have almost completed their drawing, suggest that they step back to see if they should add finishing touches to make their message more understandable. Have students write a title for their art.

**Assess** See Teacher's Resource Binder: Check Your Work 9.1.

## Community Involvement

At the end of the twentieth century, artists continued to challenge the idea that art should be made by individual artists working alone. Through collaboration, activism, and performance art, artists found ways to involve communities, groups, and the general public in the creation of artworks. **Activism** is the practice of working to change attitudes or beliefs related to politics or other issues within a community. **Performance art** combines any of the creative forms of expression, such as poetry, theater, music, architecture, painting, film, slides, and the like. Through such interaction, artists can emphasize the importance

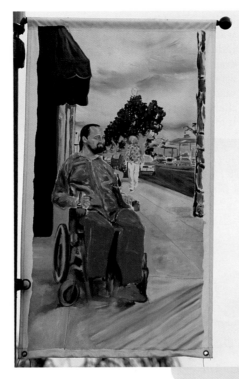

of art in community life. Looking at and creating art adds joy to many people's lives, whether they are artists or not.

Does your community hang banners along busy streets to celebrate events or holidays? Who creates these banners? What makes them unique to your community? Banner projects are one example of community involvement in the creation of art. Across the country, more and more communities participate in the design and production of banners about their neighborhoods or business districts. Such banners are usually two or three silkscreen designs that are produced in great numbers and hung to decorate public spaces. The banner in Fig. 9–14 was created as part of a banner project in the Kensington and Normal Heights neighborhoods of San Diego, California. Local artists created a total of 110 banners that celebrate the work of community members to clean up and rejuvenate the area.

## The Future of Art

What's in store for the world of art? To help answer that, try to imagine the possibilities and challenges artists might have to meet. Imagine combining computer and video technologies with traditional art forms. Imagine developing artworks in which viewers experience new realities of time, space, and form.

Fig. 9–14 The banners that were created for this project show people who have made a difference in the community. Before the banners were made, the artists talked to the subjects about their histories, local politics, and the community in general. Pete Evaristo and Jodi Tucci, *On the Avenue, Brian*, from Adams Avenue, one of 110 unique street banners, 1998. Mixed media on canvas, 27" x 48" (68.6 x 121.9 cm). Courtesy of the artists.

## Teaching Options

### Teaching Through Inquiry

**Art Production** Have students design and produce **banners** for different neighborhoods or districts.

**Aesthetics** Have groups of students use cards from the Teacher's Resource Binder pertaining to beliefs about art. They are to consider the works in this lesson. Have each group, based on their role description, select one artwork to display for the school as the best example of what art should be. Ask students to discuss how their personal preferences are similar to or different from those of the role they played. Encourage students to consider how their ideas about art have changed due to their study of art during this year.

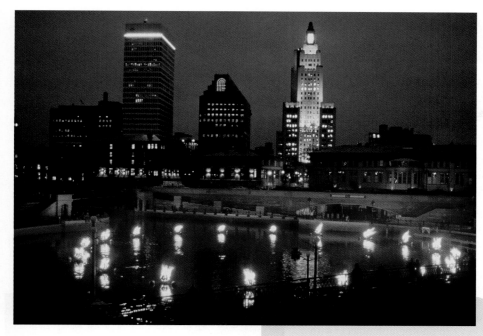

**Sketchbook Tip**
Encourage students to sketch views of a futuristic city.

As exciting as these possibilities are, technology also challenges artists to preserve pride in craftsmanship and traditional skills. As new technologies make it easier for artists to produce a large variety of art forms, handmade objects may increase in value. And we hope that the value of individual skill and accomplishment will never be lost.

Fig. 9–15 Artist Barnaby Evans uses water as his medium to create artworks. The mark he leaves is in viewers' memories of his work. Why might people consider this a work of art? What does it suggest about the kinds of art that might be produced in the future? Barnaby Evans, *WaterFire Providence*, Water Place Park, Providence, Rhode Island, various dates, June 1996–present.
200" x 30000" x 30" (508 x 76200 x 76.2 cm.) © Barnaby Evans, 1999.

## Assess

### Check Your Understanding: Answers

**1.** They adopted a wide variety of new technologies, displayed and exhibited their work in new settings and situations, and recycled art of the past.

**2.** computer and video art, installations, large-scale outdoor works

**3.** through collaboration, activism, and performance art

**4.** the creation of new realities of time, space, and form in art

### 9.1 Art History

#### Check Your Understanding
1. What are some of the ways that artists challenged traditional ideas and explored new possibilities at the end of the twentieth century?
2. Name different kinds of art created at the end of the twentieth century.
3. How do artists involve communities in collaborative art projects?
4. What are some of the possibilities for art in the future?

**Studio Connection**
One way to explore new directions in art is to try imaginative drawing. In an imaginative drawing, you can combine unrelated ideas. These can be found by thinking of opposites. For example, you might combine parts of different kinds of animals (bird, fish, insect) into an imaginative creature. Suppose that people were small and insects were large. Imagine a world of soft, smooth surfaces and prickly or jagged vegetation. Select a drawing medium that will help you express an imaginative idea. Your work might be bold and startling or include lots of details. It might be filled with patterns or rhythms.

## Close

As students view a display of their drawings, have them explain the unusual combinations in their art. **Ask:** Which art elements and principles are most important in the drawings? Discuss students' answers to Check Your Understanding, and lead students in imagining possibilities for art in the future.

Looking Beyond

287

### More About...

Some **installations** use traditional art media and forms, combining painting, sculpture, and photography; others incorporate new media. Computers, videotapes, audio recordings, and the like are often part of an installation. Some media can provide the viewer with a 360-degree experience. Instead of looking at a two- or three-dimensional artwork, viewers might be inside the work.

### More About...

On New Year's Eve 1994, Barnaby Evans first created the multimedia work *WaterFire*. The work continues to be performed several times per year, with volunteers in boats tending fires from sunset to midnight. Audio speakers installed along the riverfront amplify music for the duration. As viewers stroll along the river walk, the crackling flames, the smell of burning logs, and the music immerse them in the art experience.

### Assessment Options

**Teacher** Give each student a copy of Biography of an Artist, from the Teacher's Resource Binder. Ask students each to select a contemporary artist whose work they admire, and to use the handout to direct their research. Ask students to write a report of their findings and explain how the artist explored new possibilities.

**Self** Have students identify, in writing, two skills they would want to develop if they were to prepare for an art career. Also have them identify two things that they have learned in this course that they feel will be the most helpful to them.

## Prepare

### Pacing
Three 45-minute periods

### Objectives
- Describe ways that artists have used new media to create nontraditional art forms.
- Use a paint or draw program to design a community on Mars.

### Vocabulary
**computer art** Art for which the primary medium is the computer.

**video art** Art created by or using video technology.

**multimedia** Artworks that use the tools and techniques of more than one medium.

## Teach

### Engage
**Ask:** What art have you seen this week? Remind students that most of what they see on TV and video is designed by artists.

### Using the Text
**Art Production** Have students read pages 288 and 289. **Ask:** What are some examples of multimedia art? What makes these multimedia?

### Using the Art
**Perception Ask:** What seems unusual about the scene in Hamilton's *Mantle*?

### National Standards
### 9.2 Forms and Media Lesson

**1b** Use media/techniques/processes to communicate experiences, ideas.

**2c** Select, use structures, functions.

**3b** Use subjects, themes, symbols that communicate meaning.

**4c** Analyze, demonstrate how time and place influence visual characteristics.

**5b** Analyze contemporary, historical meaning through inquiry.

# New Media

As you have learned, some artists use traditional media to create artworks in new ways. Other artists explore nontraditional media, such as computer and video technology, for making new kinds of artworks.

## Computer Art

What do most people use a computer for? Your answer might include school, work, games, e-mail, or access to the Internet. Some artists use computers to create **computer art**. "Paint" and "draw" software allows artists to create original computer images. Artists can also scan other images into the computer. Or they can photograph objects with a digital camera, then import the photos into the computer. Once the images are on the computer, artists can edit them, change the colors, "draw" or "paint" on them, create a collage effect ... The possibilities seem endless!

Some computer art is intended for viewing on a monitor. Other works are printed as two-dimensional images.

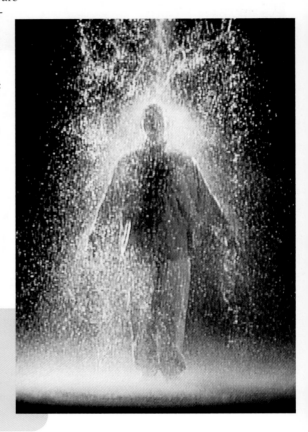

Fig. 9–16 This is one *frame*, or image, from a video and sound installation. Look at it carefully. What qualities does this image have that you probably wouldn't see in a painting or drawing? Bill Viola, *The Crossing*, 1996. Video / sound installation. Courtesy of the artist. Photo by Kira Perov.

## Video Art

Video allows us to record and view images immediately. Many artists use video technology to create movies, documentaries, individual images, and other kinds of **video art**. Once they have collected their video images, artists can take out or rearrange parts, blur, or distort the images.

Some artists incorporate videotapes in their installations. Video artists have projected their artworks on the sides of buildings, large sheets of fabric hanging from a ceiling, the inside of aluminum buckets, or in the corners of a gallery. Some artists, such as Bill Viola (Fig. 9–16), combine video and sound in their work.

## Teaching Options

### Resources
Teacher's Resource Binder
Finder Cards: 9.2
A Closer Look: 9.2
Find Out More: 9.2
Check Your Work: 9.2
Assessment Master: 9.2
Overhead Transparency 17

### Teaching Through Inquiry
**Aesthetics** Call students' attention to the fact that although Figs. 9–16 and 9–17 are single images, they are each part of an artwork with moving imagery. Point out that most museums are designed with many galleries for showing two-dimensional artworks on the walls. Sculptures are exhibited in galleries, gardens, or other spaces designed to show sculpture. **Ask:** How might museums be designed to allow viewers to best experience new media?

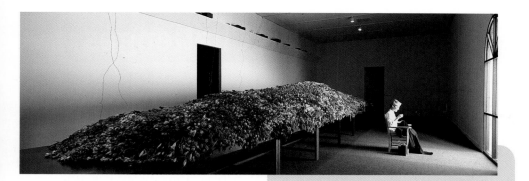

# Multimedia Art

Many artists can express their ideas best when they use **multimedia**, the tools and techniques of more than one medium. For instance, an artist might display videotapes on several monitors. In *Technology* (Fig. 6–1, page 198), artist Nam June Paik arranged monitors to create a sculpture. Many installations combine sculpture and architecture. Some computer software programs allow artists to create multimedia presentations. An artist can create a single computer document, or file, that includes still and moving images, words, and sound.

### 9.2 Forms and Media

**Check Your Understanding**
1. Identify three kinds of new media used by artists in the late twentieth century.
2. Describe ways that artists have used new media to create nontraditional art forms.

Fig. 9–17 The elements of this installation include 60,000 flowers, eleven shortwave radios, a ten-foot-high window, wool coats, and the artist herself. Do these seem like things you would normally see together? Why or why not? Can you guess what this installation means? Ann Hamilton, *Mantle*, 1998.
Installation view, Miami Art Museum, April 2 – June 7, 1998. Courtesy Miami Art Museum. Photo by Thibault Jeanson.

**Studio Connection**
Use a paint or draw program on a computer to design a community on Mars. How will that community be different from yours on Earth? What might you want or need to survive in a community on Mars? Experiment with the painting and drawing tools in the art program you are using. If you have access to a scanner, try scanning an image into your file and changing it to fit your design. Save your ideas in separate files. Decide which ones you like best, then cut and paste them into your final design. Print your design and share it with others in the class. Discuss the different features of your communities.

## Studio Connection

You will need computers with paint or draw software, paper, and printer. Discuss the planet Mars (rugged landscapes, volcanoes, deep canyons, temperatures from −17°F to −130°F). Encourage students to emphasize a part of their artwork by making it larger, having lines lead to it, or contrasting value, color, and texture. Have students print their final artwork.

**Assess** See Teacher's Resource Binder: Check Your Work 9.2.

## Assess

### Check Your Understanding: Answers

1. computers, video, multimedia

2. Artists use: computers, to create images; scanners, digital cameras, sound, and video, along with computers, to create new kinds of artworks; videos, projected in unexpected places; more than one medium (multimedia) to create artworks.

## Close

Ask volunteers to tell what art elements and principles help communicate their ideas.

---

## More About...

Using sophisticated multimedia equipment, **Bill Viola** (b. 1951) creates video installations that surround viewers in sound and image. Viola's work—influenced by both Eastern and Western spiritual practices and philosophies—is meant to touch the viewer on a personal level, despite the use of technology.

## Using the Overhead

**Write About It**

**Describe** Describe in detail what you see when you look at this artwork.

**Analyze** Write two or three sentences about the artist's use of distortion and exaggeration. Consider how placement creates emphasis in an artwork.

17

## Assessment Options

**Self** Share the lesson objectives with students. Ask students to consider the objectives and then tell, in writing, how well they learned what they were expected to learn. Encourage them to use examples to help make their points. Suggest to students that they list questions they have about what they have studied, and indicate how they might find the answers to the questions.

# Meeting Global Challenges

## Prepare

### Pacing

Three 45-minute periods: one to consider art and text; two to make art

### Objectives

- Justify the importance of preserving traditions.
- Understand the issues and concerns expressed by contemporary Native-American artists.
- Create a small-scale sculpture on the theme of continuity and change.

### Vocabulary

**global community** The interaction and sharing of ideas and knowledge of people worldwide.

**global style** A style of art that cannot be linked to just one culture or tradition of art. Global style originates with exchanges of ideas among artists of many nations and cultures.

**Pre-Studio Activity:** Have students research a cultural, ethnic, religious, or shared-interest tradition.

### Using the Map

Inform students that maps can impact our understanding of who we are as compared to people who live in other regions of the world. Point out that the world map on page 306 is just one way to visually organize a map. Have students research projections such as Mercator, Peters, and Dymaxion™. **Ask:** What does each projection emphasize?

### Global Glance

In the **global community** (or worldwide community) of today, ideas cross cultural and geographic boundaries quickly. Advances in transportation and communication technologies, motion pictures, television, and satellites have challenged artists around the world to see and think differently about their own art and the artwork of others. Increasingly, artists are working in what might be called a **global style**. A global style cannot be linked to just one culture or tradition of art. It comes from the exchange of ideas among artists of many nations and cultures around the world.

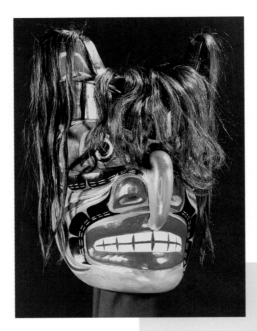

## Preserving Traditions

Remembering the past while anticipating the future is an important part of the human experience. Preserving cultural, ethnic, and religious heritage is just as important to artists as the challenge of breaking new ground. Within the history of art, countless artistic treasures and the techniques and processes used to create them have been lost. As cultures change, traditional art forms are often forgotten and then lost forever. If people and artists do not continue to use the traditional techniques and media of their communities, these art forms can disappear from our cultures.

In gallery and museum exhibitions of today's Native-American art, you can find artists who work in a variety of traditional styles. In some cases, artists continue to create art that is directly related to the artistic traditions and traditional beliefs of their cultures. In other instances, artwork might reflect only some of their artistic traditions, such as the use of traditional media, themes, or qualities of design. The Native-American artworks in Figs. 9–18 and 9–20 were made recently, but they preserve the techniques and images of ceremonial costumes and rituals within the artists' communities.

Fig. 9–18 The *Bookwus*, or Wildman of the Woods, is an exciting figure of Pacific Northwest Coast legend. The Bookwus lives deep in the woods but also hunts for food on deserted beaches. What features of this mask might be traditional? What features might be contemporary? Bill Henderson, Bookwus Mask: *Wildman of the Woods*, 1999. Painted red cedar with real hair, 13" x 9" (33 x 22.9 cm). Courtesy of the artist.

290

### National Standards
### 9.3 Global View Lesson

**1a** Select/analyze media, techniques, processes, reflect.

**2b** Employ/analyze effectiveness of organizational structures.

**3b** Use subjects, themes, symbols that communicate meaning.

**4c** Analyze, demonstrate how time and place influence visual characteristics.

**5b** Analyze contemporary, historical meaning through inquiry.

## Teaching Options

### Resources

Teacher's Resource Binder
  A Closer Look: 9.3
  Map: 9.3
  Find Out More: 9.3
  Check Your Work: 9.3
  Assessment Master: 9.3
Large Reproduction 18
Slides 9e

### Meeting Individual Needs

**Multiple Intelligences/Musical** Have student teams research the individual cultures of the artists whose work appears on pages 290–293, and use the information to identify traditional aspects of the culture within the artwork. If possible, play examples of traditional music from Northwest and Pueblo Native-American peoples. **Ask:** What connections can you make between the music and the art of these cultures?

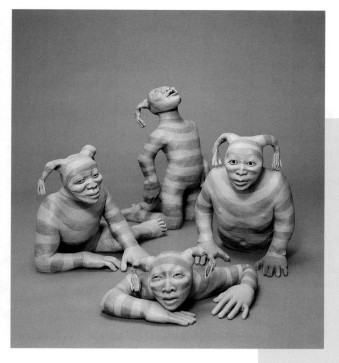

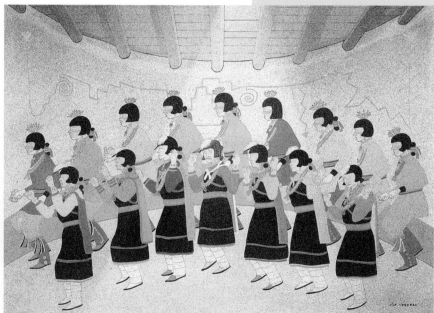

Fig. 9–19 Swentzell's sculptures capture gestures, poses, and facial expressions that seem to look different each time you look at them. The clown images recall traditional Native-American ceremonial costumes. Roxanne Swentzell, *The Emergence of the Clowns*, 1988. Mixed media clay, 7" x 19" x 11" (17.8 x 48.3 x 27.9 cm). Shared Visions Collection, Heard Museum, Phoenix, Arizona.

Fig. 9–20 Herrera's combination of the dancer motifs with the nonobjective spattering technique brings a freshness and new vitality to this commonly portrayed subject. Joe Herrera, *Spring Ceremony for Owah*, 1983. Watercolor on paper, 29" x 37" (73.7 x 94 cm). Courtesy Shared Visions Collection, Heard Museum, Phoenix, Arizona.

## Teach

### Engage

**Ask:** What do you know about Native-American art traditions? Explain that students will learn how contemporary Native-American artists combine traditions with new media and techniques.

### Using the Text

**Art History** Assign students to read Preserving Traditions. **Ask:** Why is it important to continue traditional art forms?

### Using the Art

**Art Criticism Ask:** How have these contemporary artists used their Native-American art traditions? How have they varied them?

### Extend

Challenge students to redesign their school mascot or other school symbol to better reflect the school's current community. As students draw, suggest that they try to preserve the school's tradition but update the symbol to reflect the twenty-first century.

Looking Beyond

291

## Teaching Through Inquiry

**Art Production** Ask students to research traditional Native-American *weaving* techniques and patterns, construct a simple loom, and collect found materials. Guide students to create a weaving that incorporates contemporary or unusual materials (such as plastic dry-cleaner bags).

## More About...

**Roxanne Swentzell** (b. 1962) recalls that, as a child, "I had a speech impediment so I had to communicate in other ways, and I started making figures that would depict what I meant. I hated going to school so I made a clay figure of a little girl crying to explain how I felt. I am still communicating with figures. I want to symbolize women, and my culture, and humanity."

## Using the Large Reproduction

**Consider Context**

**Describe** What is this? How was it made? What materials were used?

**Attribute** Is this artwork part of a cultural tradition? Why do you think it is, or is not?

**Understand** What is this artwork about?

18

**Explain** How does this artwork reflect the time and place where it was made?

## Meeting Global Challenges

## Using the Text

**Aesthetics** Have students read Breaking New Ground. **Ask:** What are some of the issues that Native-American artists are addressing in their art? *(identity, how they fit into the world, and relating to one another)*

## Using the Art

**Art Criticism Ask:** How do the artworks on these pages combine traditional and nontraditional media and techniques? *(Adams creates a European cake with Mohawk and Iroquois basket weaving. Haozous joins airplanes and pueblos. Luna combines a new art form with cultural traditions.)* Discuss the symbolism in Haozous's *Portable Pueblo.*

## Studio Connection

**Ask:** What art forms are associated with the heritage and traditions of the community you have chosen? Do the art forms have a common style? In what media are they usually created? Motivate students to use traditional or nontraditional materials—or both—to create their sculpture. Guide students to consider changing some traditions to reflect new ideas. Provide students with appropriate tools and a choice of sculpture media (clay, plaster, wood) or found objects for assemblages. After students have completed their sculpture, assign them to write a description of it and explain the tradition on which it is based.

**Assess** See Teacher's Resource Binder: Check Your Work 9.3.

## Breaking New Ground

Many Native-American artists today, like other artists around the world, are using art to express their ideas about issues such as identity, how they fit into the world, and how people relate to one another. These artists are working with new materials. They are meeting the challenge of new trends, and know that art will continue to change. Through their works, they invite us to examine the past and to question the present. They challenge us to envision better worlds for the future.

The contemporary Native-American artworks shown here combine traditional and nontraditional media and techniques. The artists make strong statements about their

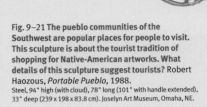

Fig. 9–21 The pueblo communities of the Southwest are popular places for people to visit. This sculpture is about the tourist tradition of shopping for Native-American artworks. What details of this sculpture suggest tourists? Robert Haozous, *Portable Pueblo*, 1988.
Steel, 94" high (with cloud), 78" long (101" with handle extended), 33" deep (239 x 198 x 83.8 cm). Joselyn Art Museum, Omaha, NE.

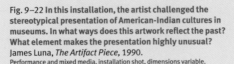

Fig. 9–22 In this installation, the artist challenged the stereotypical presentation of American-Indian cultures in museums. In what ways does this artwork reflect the past? What element makes the presentation highly unusual? James Luna, *The Artifact Piece*, 1990.
Performance and mixed media, installation shot, dimensions variable.

## Teaching Options

## Teaching Through Inquiry

**Art Criticism** Provide students with Art Criticism Inquiry Cards from the Teacher's Resource Binder. Have each student select one of the works in this lesson and use the cards to write a critical review of it, with a focus on the questions about judgment. Ask students to work in small groups to share the first draft and then to rewrite their report based on points raised and peers' suggestions.

**Art History** Have students work in small groups to create a time line that spans the period from the art of the Hohokam, Mogollon, and Anasazi (Theme 1, Lesson 1.1) to the art of present-day Native Americans. Guide students to write, on the time line, the names and dates of the artworks in Lessons 1.1 and 9.3. Help students identify other Native-American artworks in the book, and encourage them to place these on the time line. Have students do further research to find historic Native-American events and add these to the time line. Encourage students to illustrate their time line. Ask each group to use the time line to explain changes in Native-American art.

cultural traditions and the changes they see in their communities. Mary Adams's *Wedding Cake Basket* (Fig. 9–23) blends traditions of several cultures from different parts of the world. In Robert Haozous' *Portable Pueblo* (Fig. 9–21), the artist adorned an image of a traditional pueblo with symbols of twentieth-century transportation. In his performance installation, artist James Luna puts himself on display as an artifact (Fig 9–22). His work makes a statement about how Native-American art is presented in museums.

As in the past, the direction of art will depend on social, moral, and political changes within communities. New developments will come from new sets of ideas that are shared by using far-reaching technology. Certainly, artists will continue the tradition of observing and interpreting the world around them. The challenge of mastering skills and techniques, old and new, remains unchanged since the earliest times.

### Studio Connection

Make a small-scale sculpture in any medium that preserves or changes a tradition in your community. In planning your sculpture, think about the cultural, ethnic, religious, or shared interest traditions of a community you belong to. Research the heritage of these traditions by talking to others in your community. You might choose to continue the traditions of the past or to combine traditional and nontraditional materials and techniques in your sculpture. How can your sculpture show the importance of the traditions and heritage of your community? Think about ways you might change these traditions to reflect new ideas about your community.

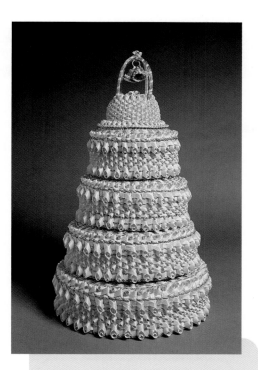

Fig. 9–23 **This artist used traditional Mohawk and Iroquois basketweaving techniques to create the form of a traditional wedding cake. What might the artwork suggest about the relationship between Native-American and European cultures?** Mary Adams (b. 1920s), *Wedding Cake Basket*, 1986. Woven sweet grass and ash splints, 25 ¹/₂" x 15 ³/₄" (64.8 x 40 cm). Gift of Herbert Waide Hemphill, Jr., National Museum of American Art, Smithsonian Institution, Washington, DC. / Art Resource, NY.

### 9.3 Global View

#### Check Your Understanding
1. What is meant by a global style?
2. Why is it important for artists to continue to look to the past when creating their art?
3. How are Native-American artists using their art to meet the challenge of living in a global community?
4. What challenge for artists remains unchanged since the earliest times?

Looking Beyond

293

### Extend

Motivate students to create a drawing or painting that shows how their geographic community has changed during the past few years. Lead them in discussing the changes. **Ask:** Are new homes, industries, or businesses in the area? Are there more or fewer people in the community? How is the community connected to the rest of the world? How have traditions been preserved as the community has changed?

## Assess

### Check Your Understanding: Answers

**1.** a style that mixes ideas from many nations and cultures around the world

**2.** so that art forms and traditions do not disappear from our cultures

**3.** by expressing ideas about identity, how things fit into the world, and how people relate; by combining traditional and nontraditional materials and techniques to make statements about cultural traditions and change

**4.** the challenge of mastering skills and techniques

## Close

Display the sculptures, and ask students to identify community traditions and heritage in the artworks.

### More About...

In his performances, **James Luna** (b.1950) asks viewers to consider issues of identity and commercialized spirituality, and the way mainstream society stereotypes individuals, specifically Native Americans. His work also examines prejudices within minority communities themselves. By calling attention to these issues, Luna invites us to look deeply within ourselves.

### Assessment Options

**Teacher** Have students each design a poster that sends a clear message to others about the importance of preserving Native-American artistic traditions.

293

## Prepare

### Pacing

Eight to nine 45-minute periods: one to learn about video;* one to plan; one to draw storyboard; one to write script;* one to rehearse; two to videotape; one to edit

*may be completed outside of class

### Objectives

- Explain the process involved in making a film.
- Analyze the structure of various types of TV programming.
- Create a videotape that tells a simple story or makes a presentation.

### Vocabulary

**storyboard** Sketches made to plan a motion picture or TV program. Each sketch shows a scene in the story.

### Supplies

- pencils
- sketch paper
- costumes, props
- musical instruments or cassette tape and player
- camcorder/batteries
- tripod (optional)

### National Standards
### 9.4 Studio Lesson

**1b** Use media/techniques/processes to communicate experiences, ideas.

**2b** Employ/analyze effectiveness of organizational structures.

**3b** Use subjects, themes, symbols that communicate meaning.

**4c** Analyze, demonstrate how time and place influence visual characteristics.

**5b** Analyze contemporary, historical meaning through inquiry.

---

# Making a Videotape

## Art That Looks Beyond

### Studio Introduction

In this studio experience, you will work with classmates to create a videotape that tells a simple story or makes a presentation. Pages 296–297 will show you how to do it.

Become familiar with various types of television programs. These will be your models for your videotape. For instance, watch a news program. How does it begin? How is each feature introduced? Note the setting and how it changes. Notice how the camera moves in for close-ups and out for long (distant) shots. Note how the camera *pans*, or follows, the action or view of a scene. Examine other types of television programs, such as situation comedies (sitcoms), cartoons, dramas, music videos, and commercials. Use one of the formats when you make your videotape.

## Studio Background

### The Filmmaking Process

Many people collaborate to make a film or movie. First, the screenwriter writes the script. Then, the director casts the film, or hires the actors. Meanwhile, a producer raises money to pay for the whole production. He or she rents or buys the cameras, lights, and other necessary equipment, and hires a film crew. The film crew operates the cameras and lighting and helps the actors with their costumes, makeup, and props.

Before filming can begin, film artists sketch **storyboards** that show each scene in the order it will appear. The storyboard in Fig. 9–25 was drawn for a movie about football, called *The Program*.

When the storyboard is finished, filming begins. Each day, everyone views the *dailies*, or the film shot the day before; then they shoot the footage for that day and prepare for the following day's filming. Shooting a film can last for months. After the film is shot, film editors perform the final step. They look at all the film footage along with the storyboard and find the best shots. Then they put these shots together so that they look seamless, as if the entire movie had been filmed without stopping.

Fig. 9–24 This crew is discussing the plans for a film they are about to shoot. Why might it be important for the people in a film crew to work well together?
Photo courtesy Linda Freeman, L&S Video.

---

## Teaching Options

### Resources

Teacher's Resource Binder
- Studio Master: 9.4
- Studio Reflection: 9.4
- A Closer Look: 9.4
- Find Out More: 9.4
- Overhead Transparency 17
- Slides 9f

### Meeting Individual Needs

**Focusing Ideas** Help students break down this assignment into small tasks on a structured time line. So that students may best use their skills and also feel they are an important part of the group and its decision-making, match each student to specific tasks.

Fig. 9–26 What simple story do you think these students told in their videotape? Deborah Mduruwa, Curtis Breer, Orion Stand-Grai, Noah Abrahams, *Low Rider*, 1999. Videotape, Samford Middle School, Auburn, Alabama.

Fig. 9–25 A storyboard is made up of hundreds of small, quick sketches like these. Raymond C. Prado, *The Program*. Illustration storyboard. Courtesy of the artist.

Looking Beyond

## Teach

### Using the Text

**Art Production** Have students read page 294. Show a clip of a TV news program. Then challenge students to list jobs involved in making a movie.

### Using the Art

**Art Production** Encourage students to guess the role of each person in Fig. 9–24.

**Art Production** As students study the storyboard in Fig. 9–25, ask how the artist indicated motion. **Ask:** Where are the close-up shots? The distant shots? Where is the camera for each frame?

### Critical Thinking

Have students watch a movie or TV show and take notes about how art elements and principles determine the mood of a scene. Guide students to note the music, as well as lighting, shadows, colors, and the placement of the main subject within the frame.

### Journal Connection

Have students reflect on how TV editors' knowledge and beliefs about world events determine what is presented to viewers. **Ask:** Have you ever witnessed an event that was later reported on TV or in the newspaper? How accurately was it reported?

295

## Teaching Through Inquiry

**Art Production** Discuss the various roles that people play in the process of filmmaking, and, as students consider these roles, have them decide which ones would be important in the making of their own videotape. Have students work in groups to assign responsibilities for creating their videotape. Discuss what new roles, if any, they will have to assign to complete additional work. Ask groups to share and discuss their ideas with the rest of the class.

## More About...

**Motion pictures** are a series of recorded images that appear to move when played through a film projector or a videotape player. In 1893, Thomas Edison displayed the first motion-picture camera and made the first "movie" when he recorded his assistant, Fred Ott, a year later. The first western, *The Great Train Robbery*, was made in 1903. In the first Academy Awards ceremony in 1928, the Best Picture award went to *Wings*.

## Using the Overhead

**Looking Closer**

Notice the way the artist created an eerie feeling by showing a close-up image of a face. He does not show a hairline, neck, or ears. How might a close-up view of something convey an eerie feeling? What objects could you videotape up close to achieve a similar mood?

17

## Studio Experience

Divide the class into film crews (co-operative-learning groups) so that each student has a job, such as director, props manager, scriptwriter, camera or sound person. After students have chosen their format and planned their video, have them draw a storyboard, write a script, choose actors, secure props and music, and rehearse.

Once students are taping, encourage them to rotate jobs so that everyone in the group can use the camcorder and appear in the video.

## Idea Generators

**Ask:** What format will you use to deliver your information? Will it be similar to a news show, situation comedy, *Sesame Street*, or action/adventure?

## Extend

Have students digitize parts of their video by importing into a computer. They can create a multimedia presentation, adding graphics and sound.

### Computer Option

Students may use video-editing programs such as Adobe Premiere, Avid Cinema, and Final Cut Pro (Apple). MovieMaker can aid some video-editing tasks; Apple QuickTime VR Studio allows for creation of virtual-reality movies; and Adobe After Effects allows for the creation of special effects. See how some other students created desktop videos at www.apple.com/applemasters/imovie/vidkids.html.

## Film Arts in the Studio
### Making Your Videotape

### You Will Need

- pencil and paper
- costumes and props
- source of music or other sounds
- camcorder
- videotape
- tripod (optional)

### Try This

**1.** As a group, choose a simple story or a presentation that you would like to videotape. Will your story have one, two, or three characters? Will you show and narrate a real-life event? What other ideas can you think of?

**2.** Plan your presentation. Decide on a sequence of events. List the images that come to mind as you discuss your ideas. Create an outline from your list of images.

**3.** Using your outline as a guide, create a storyboard. Base your storyboard on a television format. Indicate whether the camera should zoom in for a close-up, zoom out for a long shot, or pan the scene.

**4.** Write a script for your video. Will there be any dialogue? Or will you use a single narrator?

**5.** Select whatever actors, costumes, props, and music or other sounds you need.

**6.** Shoot the videotape scene by scene. When you are finished, view it with your group. Edit the video as needed. Then make the final tape.

### Check Your Work

Plan a time for viewing your completed videotape along with each of your classmates'. Discuss how the videos tell a simple story or make a presentation that teaches viewers something. How does the selected television format add to or detract from each video?

### Sketchbook Connection

Use your sketchbook to make visual notes as you examine different television formats. Try sketching a storyboard for a television program as you watch it or from your memory of it later. Do this for several different types of programs. This exercise may help you decide which type of programming you want to use for your video.

### Computer Option

On the computer, input and edit a short video.

## Teaching Options

### Teaching Through Inquiry

**Art Criticism** Divide the class into six groups, and assign each group one type of TV program: sitcom, cartoon, drama, music video, news program, commercial. Explain to students that the members of each group will become "experts" about the typical content and structure of their assigned type of program. Guide groups to prepare a visual display—a chart, poster, or computer presentation—for sharing their findings with the rest of the class.

### More About...

A **storyboard artist** (sometimes called a production illustrator or sketch artist) translates the main action scenes of a film into a series of sketches. Taken together, the artist's sketches resemble a giant comic strip, and they highlight the film's key narrative moments. Storyboards are essential for animation, complex special-effects sequences, and TV commercials.

Fig. 9–27 Students collaborated to show the life cycle of a plant as though it were equal to one single day (note the sun rising and setting). Alison Oakes, Jamie Armstrong, Maggie Khouney, *Life of a Flower*, 1999. Videotape, Samford Middle School, Auburn, Alabama.

Looking Beyond

297

## Assess

### Check Your Work

Allow time for students to watch all of the videotapes. Use the questions in Check Your Work to guide a discussion about the videos and whether the composition of individual shots was effective. Have students each write a critique of the experience, including a description of the videotape's message; an assessment of whether it was understandable; and an explanation of what they would do differently if they made a similar video.

## Close

Review the process of making a videotape. **Ask**: What type of TV programming did you use? Was this an effective format for your subject?

## Assessment Options

**Peer** Have students each write a letter to a friend in which they explain what they have learned about creating a videotape. Guide students to include information about how TV programming formats can be used as models for designing the content and structure of a videotape. Have students share their letter with a peer. Ask the peer reviewers to write positive comments, indicating parts of the letter they believe are exceptionally helpful, and to make suggestions for improvement.

## Daily Life
Ask students each to design a car they would like to "drive" twenty-five years from now.

## Language Arts
Work with students to compile a list of books and artworks that they think should be included on the Project Gutenberg Web site.

## Social Studies
Work with students to develop criteria for the contents of a time capsule to be opened 100 years from now. Encourage students to consider which objects they would most like to represent their generation.

# Connect to...

## Daily Life

How do you think daily life will be different in 100 years? One intriguing prediction is that cars will essentially drive themselves: they will run on automatic pilot, guided by magnetic sensors to keep them in their lane, control their speed, and avoid obstacles. Another prediction is that cars will customize themselves for individual drivers, automatically adjusting the seat, steering column, and mirrors to each driver's preferences. In the case of an accident, the automobile's computers will call for the police and an ambulance. Future cars will likely be equipped with voice-operated computers that can receive e-mail and faxes, play videos, and access the Internet. How do you think the **cars of the future** will look in your lifetime?

## Other Arts

### Video and Performance Art
Theater, like art, can help people imagine the unfamiliar. In theater, the telling of a story can help people imagine what characters feel, what another time was like, or what the future may hold. **Performance artist** Anna Deavere Smith does just this—through the medium of video performance. In *Fires in the Mirror: Crown Heights, Brooklyn and Other Identities* (1992), Smith helps viewers gain an understanding of one community's conflicts. The work explores issues of race, ethnicity, and identity via role-playing by the people who actually experienced the events.

## Careers

Have you ever drawn a picture of an astronaut, a spaceship, or an alien? If so, you may share the passion of **space artists**—artists who use astronomy and space exploration as inspiration and subject for their art. Space artists may be science, science-fiction, or fantasy illustrators, or even fine-art painters, but they all share a fascination about the possibilities of space exploration. NASA artist Robert T. McCall and astronaut Alan Bean paint "spacescapes" in response to ideas and images that have arisen from over forty years of space exploration. Television programs and movies, such as the *Star Wars* trilogy, have not only encouraged public interest in space but have also employed computer graphic artists, background painters, and modelmakers who are specialists in space art. What do you think might be a twenty-first-century discovery in space? Whatever is discovered, space artists will be ready to record it.

Fig. 9–28 **Astronaut Alan Bean has experienced firsthand the "spacescapes" he paints. Your imagination can lead you to create your own artworks based on the theme of space exploration.** *Alan Bean in His Studio.* Photograph by David Nance. ©The Greenwich Workshop, Inc. Courtesy Alan Bean.

## Teaching Options

### Resources
Teacher's Resource Binder
  Using the Web
  Interview with an Artist
  Teacher Letter

### Interdisciplinary Tip
Inform colleagues about your efforts to incorporate new media in your art class. If you create a Web site to showcase your students' work, invite other teachers to contribute related student work.

### Video Connection

Show the Davis art careers video to give students a real-life look at the career highlighted above.

### Curriculum Connection
**Language Arts** Help students identify literary works with futuristic themes, then develop illustrations for the works.

## Other Subjects

### Social Studies

Have you ever made a time capsule? The beginning of a millennium is when many groups prepare **time capsules** for future generations. But time capsules will be successful only with careful planning, record keeping, a durable capsule, and archival-quality documents. Not only is the time-worthiness of proposed items especially important, but so too is their media: newsprint paper deteriorates quickly; color photographs and slides tend to fade and discolor; computer disks, CD-ROMs, and videotapes, although they might seem like good items to include, may not

be playable when the capsule is opened, because the machines needed to play them will be long gone. What items would you include in a time capsule that represented your community? How long would you want it to remain sealed?

Fig. 9–29 Each of this millennium capsule's four sections opens up for storage. Once objects are placed inside and it is sealed, it won't be opened again until the year 3000. If you could design a time capsule, what would it look like? What would you put inside? Santiago Calatrava, *The* New York Times *Capsule* (model), 1999–2000. Actual work: stainless steel, 5' x 5' x 5' (1.5 x 1.5 x 1.5 m). Stored at the American Museum of Natural History, NY. ©Santiago Calatrava. Photo courtesy Davies + Starr, New York.

### Language Arts

Have you ever read a book online? That possibility is now available through **Project Gutenberg**. Named for Johannes Gutenberg, the developer of movable type and the printing press, the project is an online effort to make 10,000 of the most-read books available in electronic form by the end of 2001. Available at no cost, Project Gutenberg allows anyone who has

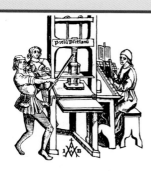

Fig. 9–30 Johannes Gutenberg began using movable type—individual letters made from metal—in Europe around 1438. This new process revolutionized the printing of books.

access to the Internet to read online books and other documents in the public domain. The project directors hope eventually to add art and music to the site. What books would you choose to make available through the site? What artworks?

### Science

Can you imagine a computer no larger than a human cell? Such an invention is likely in your lifetime. One of the most anticipated scientific fields is **nanotechnology**, the science of miniaturized manufacturing by the use of nanoscale tools capable of manipulating one atom or molecule at a time. Technological advances in electronics, chemistry, and biology are fueling research in this field, encouraging scientists to discover ways to turn atoms and molecules into transistors, motors, pumps, and computer chips whose size is measured in billionths of a meter. If atoms can be manipulated individually, they could be placed exactly as needed to produce a desired structure. Medicine-bearing nanoparticles designed to interact only with diseased cells could eliminate most forms of disease or even slow the aging process. Can you think of any ethical issues that might be raised in response to nanotechnology?

**Internet Connection**
For more activities related to this chapter, go to the Davis website at **www.davis-art.com.**

Looking Beyond

299

### Other Arts

Preview *Fires in the Mirror: Crown Heights, Brooklyn and Other Identities*. Since there are twenty-four characters and scenes, you may wish to select only a few. Those that might be of most interest are the sections titled "Lousy Language," "7 Verses," "Isaac," and "Stitches." As students watch the clips, they should consider these questions:

What is Smith trying to say or do in this work? How is this work different from an interview you might see on the evening news? How is Smith's use of role-playing different from a stage or film actor's role-playing? What were the issues in the Crown Heights uprising? Smith has said: "I'm an actor and playwright but many people refer to me as a reporter." Do you agree? Why or why not?

*Fires in the Mirror: Crown Heights, Brooklyn and Other Identities* is available from the Public Broadcasting System. Doubleday publishes the play text.

## Internet Resources

**Jenny Holzer**
http://adaweb.walkerart.org/
Enter the artist's constantly changing interactive Web project.

### Space Art Through the Ages
http://www.artsednet.getty.edu/ArtsEd Net/Resources/Space/index.html
Discover how space exploration and astronomy have inspired artists in the past and present. Includes lesson plans, images, and more.

**Roxanne Swentzell**
http://www.artsednet.getty.edu/ArtsEd Net/Read/4p/clowns.html
Read a discussion about Swentzell's work from the perspectives of an artist, an art historian, an art critic, and an aesthetician.

**Bill Viola**
http://www.cnca.gob.mx/viola/
This site lets you experience the artist's video/sound installations.

## Museum Connection

Invite a member of a local museum's education department to speak about the challenges that many contemporary artworks present to traditional methods of exhibiting and conserving art. The guest might discuss how—or if—the museum collects and exhibits installation art; and what changes in technology the museum has had to make so as to accommodate new art forms.

## Talking About Student Art

When talking with students about their artworks, invite them to discuss ways that they might send similar messages with new media, such as computer technology, the Internet, video, light and sound, or installation or performance art.

## Portfolio Tip

 Plan a day for students to share their portfolios with classmates. Invite artists or a representative from a local university or art school to critique portfolio efforts. Two or three students might volunteer their portfolios for use in a mock critique/interview by a college admissions representative.

## Sketchbook Tip

 Plan a sketchbook day for students to share their sketchbooks with classmates. Invite a guest artist from the community to provide comments on student work. Also invite a writer or a language-arts colleague to talk to students about writing tips and journaling.

# Portfolio

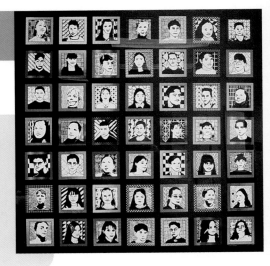

Fig. 9–31 In this unique "digital quilt," portraits of students were taken using a digital camera, then downloaded into a computer. Each student manipulated his or her own portrait to create a high-contrast image, then enlarged it and carved it into a linoleum block. The finished 12" x 12" prints were assembled, like a quilt, on a school wall for display. Students of Summit Ridge Middle School, *Digital Quilt*, 1999. Littleton, Colorado.

"I was inspired to draw this picture by one of my old sketches of a bug. I thought it would be cool to make the picture look like a scene from an old horror movie. The area I was most concerned about was the color and having the bug catch your eye." **Ben Kwiatkowski**

Fig. 9–32 Ben Kwiatkowski, *Attack (Insects in City)*, 1998. Colored pencil, 12" x 18" (30 x 46 cm). Verona Area Middle School, Verona, Wisconsin.

"This piece shows the van in the Grand Canyon. The symbols on the side of the van add an ancient desert feeling to the picture, and the sandal on top represents the hot climate. The warm colors and antique appearance give the whole picture a sunset glow." **Leigh Jurevic**

 **CD-ROM Connection**
To see more student art, check out the Community Connection Student Gallery.

Fig. 9–33 In a class project, an art teacher gave her students a digital image of her mini-van to manipulate in unusual ways. Leigh Jurevic, *Grand Canyon 4 Ever*, 1998. Computer art, 7" x 5 1/4" (18 x 13 cm). Riverdale School, Portland, Oregon.

300

## Teaching Options

### Resources

Teacher's Resource Binder
Chapter Review 9
Portfolio Tips
Write About Art
Understanding Your Artistic Process
Analyzing Your Studio Work

### CD-ROM Connection

For students' inspiration, for comparison, or for criticism exercises, use the additional student works related to studio activities in this chapter.

# Chapter 9 Review

### Recall

Identify an artist from the past who envisioned flying machines long before the invention of air travel as we know it today.

### Understand

Use examples to explain the main features of Surrealism.

### Apply

You have studied how contemporary artists use new technology, how they create new art forms based on old traditions, and how they envision imaginary worlds in their artworks. Think about developments in your own world. In what other areas, besides art, are people using new technologies, changing traditions, and envisioning imaginary worlds? Provide examples to support your answers.

### Analyze

Select an artwork from this chapter. Tell about its message and describe how the artist used the art elements to convey the main ideas.

### Synthesize

In the 1850s, a group of people called Luddites (named after Ned Lud, an active member of the group) tried to prevent the introduction of new technology in factories, claiming that technology would destroy their community's way of life. Even today, there are people who oppose the introduction of technology. Write a dialogue between a modern-day Luddite and one of the artists featured in this chapter who uses new technology as an important part of his or her artworks. How would the Luddite feel about introducing technology into the world of art making? What would the Luddite want to preserve? How would your selected artist respond?

### Evaluate

What do you think about installations as an art form? (*See example below.*) Is the installation a good way to express ideas? Is an installation a better form of communication than a painting, for instance? Why?

Page 279

**For Your Portfolio**
Your portfolio includes evidence of all you have learned through your study of art. Select four examples of artwork from the theme chapters in this book to demonstrate your ability to create artworks with meaningful themes. For each artwork, write a paragraph to explain how the piece is a good example of your skill and ability to focus on a theme.

**For Your Sketchbook**
Study the artworks in the global lessons in each chapter of this text. Design a page in your sketchbook on which you design a series of masks in the style of a particular culture or with some distinguishing characteristic associated with a cultural area.

### Family Involvement

Family members may be willing to work with students to create video presentations. Ask family members—when they visit art exhibitions, sculpture gardens, or historic places—to videotape the sights to share with your class.

### Advocacy

Create a Web site to showcase the art and other work of your students. Create a flyer announcing the site and inviting community members to visit it.

## Chapter 9
## Review Answers
### Recall

Leonardo da Vinci

### Understand

Surrealist artworks combine objects or images that we don't expect to see together. They also suggest parts of a world that seem real and other parts that we would not consider normal. Examples will vary but might include works by Skoglund, Magritte, or Colos.

### Apply

Answers will vary. Examples might include new technology in music, cars run by electricity, and fantasy worlds in movies.

### Analyze

Answers will vary. Look for plausible interpretations of meaning and an understanding of formal arrangement of art elements to convey ideas.

### Synthesize

Answers will vary. Look for evidence that students understand how uses of new technology in art provide new experiences for viewers or new ideas about our lives.

### Evaluate

Answers will vary. Look for evidence that students know what an installation is. Also note the extent to which reasons offered support each student's opinion.

### Reteach

Ask students to list some of the technological inventions they have witnessed in their lifetime. Have them note how—or if—artists have used these inventions in making art. Discuss how new technologies might be incorporated into artworks of the future.

Summarize by reminding students that artists use available technology to convey ideas, push the boundaries of art, and suggest worlds and creatures as visual records of our dreams, fantasies, stories, and legends.

# Acknowledgments

We wish to thank the many people who were involved in the preparation of this book. First of all, we wish to acknowledge the many artists and their representatives who provided both permission and transparencies of their artworks. Particular thanks for extra effort go to Michael Slade at Art Resource, The Asian Art Museum, Roberto Prcela at The Cleveland Museum of Art, Anne Coe, Kenneth Haas, Charles McQuillen, Paul Nagano, Claes Oldenburg/Coosje Van Bruggen Studio, Bonnie Cullen at The Seattle Art Museum, and Bernice Steinbaum.

For her contributions to the Curriculum and Internet connections, we wish to thank Nancy Walkup. For contributing connections to the performing arts, we thank Ann Rowson, Kathy Blum, and Lee Harris of the Southeast Institute for Education in the Arts. A special thanks for the invaluable research assistance provided by Kutztown University students Amy Bloom, Karen Stanford, Kate Clewell, and Joel Frain and the staff at Kutztown University Library. Abby Remer's and Donna Pauler's writing and advice were greatly appreciated. Sharon Seim, Judy Drake, Kaye Passmore and Jaci Hanson were among the program's earliest reviewers, and offered invaluable suggestions. We also wish to acknowledge the thoughtful and dynamic contributions made to the Teacher's Edition by Kaye Passmore.

We owe an enormous debt to the editorial team at Davis Publications for their careful reading and suggestions for the text, their arduous work in photo and image research and acquisition, and their genuine spirit of goodwill throughout the entire process of producing this program. Specifically, we mention Colleen Strang, Jane Reed, Mary Ellen Wilson, Nancy Burnett, and Nancy Bedau. Carol Harley, our consistently upbeat "point person" on the project, provided thoughtful and substantive assistance and support.

Our editors, Claire Golding and Helen Ronan, carefully guided the creation of the program, faithfully attending to both its overall direction and the endless stream of details that emerged en route to its completion. We thank them for their trust and good faith in our work and for the spirit of teamwork they endorsed and consistently demonstrated.

For his trust in us, his vision and enthusiasm for the project, and for his willingness to move in new directions, we thank Wyatt Wade, President of Davis Publications.

Although neither of us has had the privilege of being her student in any formal setting, we owe our grounding in the theory and practice of art education to the scholarship of Laura Chapman. She has been both mentor and friend to each of us throughout the years and especially in this project. We thank her for her loyal support and for providing us the opportunity to continue her work in art curriculum development in this program for the middle school.

We offer sincere thanks to the hundreds of art teachers who have inspired us throughout the years with their good thinking and creative teaching. We also acknowledge our colleagues at Kutztown University, Penn State University, Ohio State University, and other institutions who have contributed to our understanding of teaching and learning.

Finally, we wish to thank our families, especially Adrienne Katter and Deborah Sieger, who have provided loving support and balance in our lives during the preparation of this book.

*Eldon Katter*
*Marilyn Stewart*

**Educational Consultants**

Numerous teachers and their students contributed artworks and writing to this book, often working within very tight timeframes. Davis Publications and the authors extend sincere thanks to:

Lori Atchue, West Tatnuck School, Worcester, Massachusetts

Anita Cook, Thomas Prince School, Princeton, Massachusetts

Louisa Brown, Atlanta International School, Atlanta, Georgia

Monica Brown, Laurel Nokomis School, Nokomis, Florida

Will Caez, Logan Fontenelle Middle School, Bellevue, Nebraska

Kate Cross, Frank Borman Middle School, Phoenix, Arizona

Cappie Dobyns, Sweetwater Middle School, Sweetwater, Texas

Judith Durgin, Merrimack Valley Middle School, Penacook, New Hampshire

Suzanne Dyer, Bryant Middle School, Dearborn, Michigan

Elaine Gale, Sarasota Middle School, Sarasota, Florida

Catherine Gersich, Fairhaven Middle School, Bellingham, Washington

Rachel Grabek, Chocksett Middle School, Sterling, Massachusetts

Ann Gurek, Remington Middle School, Franklin, Massachusetts

Mary Ann Horton, Camels Hump Middle School, Richmond, Vermont

Leon Hoysepian, Burncoat High School, Worcester, Massachusetts

Anne Jacques, Hayfield Secondary School, Alexandria, Virginia

Alice S.W. Keppley, Penn View Christian School, Souderton, Pennsylvania

Bunki Kramer, Los Cerros Middle School, Danville, California

Karen Larson, Plum Grove Junior High School, Rolling Meadows, Illinois

Marguerite Lawler-Rohner, Wescott Junior High School, Westbrook, Maine

---

*Publisher:*
Wyatt Wade

*Editorial Directors:*
Claire Mowbray Golding, Helen Ronan

*Editorial/Production Team:*
Nancy Burnett, Carol Harley, Mary Ellen Wilson

*Editorial Assistance:*
Laura Alavosus, Frank Hubert, Victoria Hughes, David Payne, Lynn Simon

*Illustration:*
Susan Christy-Pallo, Stephen Schudlich

Karen Lintner, Mount Nittany Middle
School, State College, Pennsylvania
Betsy Logan, Samford Middle School,
Auburn, Alabama
Sara Macaulay, Winsor School, Boston,
Massachusetts
Patricia Mann, T.R. Smedberg Middle
School, Sacramento, California
Shannon McBride, Riverdale Grade
School, Portland, Oregon
Mary Ann McFarland, City View School,
Worcester, Massachusetts
Phyllis Mowery-Racz, Desert Sands
Middle School, Phoenix, Arizona
Debbie Myers, Colony Middle School,
Palmer, Alaska
Kaye Passmore, Notre Dame Academy,
Worcester, Massachusetts
Sandy Ray, Johnakin Middle School,
Marion, South Carolina
Amy Richard, Daniel Boone Area Middle
School, Birdsboro, Pennsylvania
Pat Rucker, Summit Ridge Middle
School, Littleton, Colorado
Susan Rushin, Pocono Mountain
Intermediate School South,
Swiftwater, Pennsylvania
Roger Shule, Antioch Upper Grade
School, Antioch, Illinois
Betsy Menson Sio, Jordan-Elbridge
Middle School, Jordan, New York
Sharon Siswick, Islesboro School,
Islesboro, Maine
Karen Skophammer, Manson Northwest
Webster, Barnum, Iowa
Evelyn Sonnichsen, Plymouth Middle
School, Plymouth, Minnesota
Ann Titus, Central Middle School,
Galveston, Texas
Sindee Viano, Avery Coonley School,
Downers Grove, Illinois
Karen Watson-Newlin, Verona Area
Middle School, Verona, Wisconsin
Shirley Whitesides and Karen Hawkin,
Asheville Middle School, Asheville,
North Carolina
Cynthia Wiffin, Roosevelt School,
Worcester, Massachusetts

Photo Acquisitions:
Colleen Strang, Jane Reed,
The Visual Connection, Mary Ellen
Wilson, Rebecca Benjamin

Student Work Acquisitions:
Nancy Bedau

Design:
Douglass Scott, Cara Joslin,
WGBH Design

Manufacturing:
Georgiana Rock, April Dawley

# Artist Guide

**Abbott, Berenice** (AB-bet, BER-a-nees) US, 1898–1991
**Abakanowicz, Magdalena** (ah-bah-kah-noe-vits, mahg-de-lay-nah) Poland, b. 1930
**Adams, Mary** US, b.1920s
**Ahearn, John** (A-hern) US, b. 1951
**Al-fuzula, Miftah** 15th century
**Ali, M.** 1500s
**Amish** (AH-mish) US
**Anasazi** (ah-nah-SAH-zee) Southwestern US
**Ashevak, Kenojuak** Canada, b. 1927
**Apsit, Alexander** Latvia, 1880–1844
**Audubon, John James** (AW-deh-bahn) US, 1785-1851
**Aztec** (AZ-tek) Mexico

**Barthé, Richmond** (BAR-tay) US, 1901-1989
**Bearden, Romare** (BEER-den, ro-mar-AY) US, 1912 or 1914–1988
**Beg, Farrukh** Kabul/Mughal Empire, 2nd half of 16th century-early 17th century
**Bellows, George** (BELL-lows) US, 1882–1925
**Benin** (beh-NEEN) Nigeria
**Benton, Thomas Hart** US, 1889–1975
**Berkeley, Wayne** Trinidad and Tobago, b. 1940
**Bierstadt, Albert** (BEER-stat) Germany, 1830–1902
**Bingler, Steven** US, b. 1948
**Bishop, Isabel** US, 1902–1988
**Blank, Harrod** US, 21st century
**Brack, John** Australia, b. 1920
**Brown, Grafton Tyler** US, 1841–1918
**Browning, Colleen** Ireland/US, b. 1929
**Butterfield, Deborah** US, b. 1949

**Calder, Alexander Sterling** US, 1898–1976
**Callot, Jacques** (kal-low, zhak) France, 1592–1635
**Carter, Dennis Malone** US, 1827–1881
**Celtic** (KELL-tik) Western and Central Europe
**Chagall, Marc** (sha-GAHL) Russia/France, 1887–1985
**Chin, Mel** US, b. 1951
**Chola Dynasty** (CHO-la) India
**Coe, Sue** British/American, b. 1951
**Copley, John Singleton** (KOPP-lee) US, 1738–1815
**Cover, Sallie** US, 1853–1936
**Cuna** (koon-ah) Panama

**Das, Manohar** India, 1500s–1600s
**Davies, Arthur B.** US, 1862–1928
**Davis, Joseph H.** US, active 1832–1837
**De Maistre, Roy** (de MEER-stra) Australia/England, 1894–1968
**Delaunay, Robert** (de-low-nay, roh-bair) France, 1885–1941
**Delano, Pablo** (de-LAN-o) Puerto Rico, b. 1954
**Denes, Agnes** Hungary, b. 1938
**Dewing, Maria Oakey** US, 1845–1927
**Dike, Philip Latimer** US, b. 1906
**Duncanson, Robert Scott** US, 1821–1872
**Durand, Asher Brown** US, 1796–1886

**Edo** (eh-DO) Nigeria
**Elizondo, Arturo** Mexico, 21st century
**Escobar, Marisol** Venezuela, b. 1930
**Estes, Richard** (ES-teez) US, b. 1932
**Etruscan** (eh-TRUSS-ken) ancient Etruria
**Evans, Barnaby** US, b. 1953
**Evaristo, Pete and Jodi Tucci** (eh-VAR-ist-o) (TOOCH-ee) US, b. 1955, b. 1956

**Fakeye, Lamidi O.** (fay-KAY-yay, la-MEE-dee) Nigeria, b. 1927
**Fischer, Ernst Georg** Germany, 1815–1874
**Francis, Sam** US, b. 1923
**Frasconi, Antonio** Argentina, b. 1919
**Frazer, Jim** US, b. 1949
**Fuller, Meta Warrick** US, 1877–1968

**Gehry, Frank** (GEH-ree) US, b. 1929
**Gherin, Jules** (geh-rahn, zhool) 1800s-1900s
**Giacometti, Alberto** (jah-koe-MET-tee) Switzerland, 1901–1966
**Gilbert, Cass** US, 1911-1913
**Glackens, William** US, 1870-1938
**Goncharova, Natalia** (gehn-cheh-ROVE-eh, nah-TAL-ya) Russia, 1881-1962
**Gordon, David S.** US, b. 1955
**Greenough, Horatio** US, 1805-1852
**Grooms, Red** US, b. 1937

**Hamilton, Ann** US, b. 1956
**Hanson, Ann** US, b. 1959
**Hanson, Duane** US, b. 1925
**Haozous, Robert** (HAU-zoos) Apache/Navajo, b. 1943
**Hartigan, Grace** US, b. 1922
**Hartley, Marsden** US, 1877-1943
**Hausa** Nigeria, Giwa
**Heade, Martin Johnson** US, 1814 or 1819-1904
**Henderson, Bill** Canada, b. 1950
**Henri, Robert** (HEN-rye) US, 1865-1929
**Herd, Stan** US, b. 1950
**Herrera, Joe** US-Cochiti Pueblo, 21st century
**Heward, Prudence** Canada, 1896-1947
**Hicks, Sheila** US, b. 1934
**Hine, Lewis** US, 1874-1940
**Hiroshige, Utagawa** (hee-ro-shee-gay, oo-tah-gah-wah) Japan, 1797-1858
**Hockney, David** England, b. 1937
**Hohokam** (ho-HO-kahm) Southwestern US

**Hokusai, Sakino** [also known as Katsushika Hokusai] (ho-koo-sy, sah-keeno) Japan, 1760-1849
**Holzer, Jenny** (HOLT-ser) US, b. 1950
**Hornell, Sven** (hor-NELL) Sweden, 1919-1992
**Huebner, George** (HUBE-ner) US, 1757-1828
**Hull, Lynn** US, 21st century

**Innerst, Mark** (INN-erst) US, b. 1957
**Inuit** (INN-yoo-it) N. America, esp. Arctic Canada and Greenland
**Iroquois** (EER-oh-coy) Northeastern US

**Jacobson, Margareta** Sweden, 21st century
**Jean-Gilles, Joseph** (zhon-zheel, zhozef) Haiti, b. 1943
**Jefferson, Thomas** US, 1743-1826
**Jiménez, Luis** US, b. 1940
**Johnson, Philip** US, b. 1906
**Johnson, William H.** US, 1901-1970
**Jones, Cleve** US, b. 1964
**Jones, Lois Mailou** (jones, LOW-is MI-loo) US, b. 1905

**Karan, Khem** (KAR-on, kame) India, 1500s-1600s
**Kirchner, Ernst Ludwig** (KIRK-ner, ernst LOOT-vik) Germany, 1880-1938
**Kiyotada, Torii** (kee-oh-tah-dah, toh-ree) Japan, active 1720-1750
**Klee, Paul** (clay) Switzerland, 1879-1940
**Kline, Franz** US, 1910-1962
**Kogge, Robert** US, b. 1953
**Krimmel, John Lewis** US, 1789-1821
**Kuhn, Justus Engelhardt** (coon, YOU-stus) Germany, active 1708, d. 1717

**Lane, Fitz Hugh** US, 1804-1865
**Lamb, A.A.** US, active 1864 and after
**Lawson, Ernest** US, 1873-1939
**Le Moyne, Jacques** (luh moin, zhak) France, active 1564-1588
**Lee, Russell** US, 20th century
**Lehman, Amanda** (LAY-man) US, 21st century
**Leicester, Andrew** (LES-ter) Britain, b. 1948
**Lenape** (len-AH-pay) N. Amer. orig. from Delaware R. Valley, US
**Leonardo da Vinci** (lay-oh-nar-doe da VIN-chee) Italy, 1452-1519

**Lin, Maya** US, b. 1959
**Lou, Liza** (loo, LIE-za) US, 21st century
**Luks, George** (LOUKS) US, 1867–1933
**Luna, James** US, b. 1950

**Mackain, Bonnie** US, 21st century
**Magafan, Ethel** (MAG-a-fahn) US, b. 1916
**Magritte, Rene** (mah-greet, ren-ay) Belgium, 1898–1967
**Manutuke** New Zealand, Gisborne
**Maori** (mou-ree) New Zealand
**Malevich, Kazimar** (ma-LAY-vich) Russia, 1878–1935
**Manley, Edna** Jamaica, b. 1900
**Martinez, Maria Montoya** US, 1887–1980
**Masanobu, Okumura** (mah-sahn-o-boo, oh-koo-moor-a) 1686–1764
**Matchitt, Paratene** New Zealand, 21st century
**Mayan** (my-en) Mexico
**Meyer, Blackwell** 19th century
**Mies van der Rohe, Ludwig** (mees van der roe, loot-vik) Germany, 1886-1969
**Mimbres** (mim-brayz) Southwestern US
**Minshall, Peter** Trinidad, 21st century
**Mitchell, Joan** US, 1926–1992
**Mixtec** (MISH-tek) Mexico
**Mogollan** (MOH-gull-on) Southwestern US
**Mohawk** (MOE-hock) Northeast US, Southern Canada
**Moore, Henry** England, 1898–1986
**Moses, Anna Mary Robertson** (a.k.a. Grandma Moses) US, 1860–1961
**Motley, Archibald Jr.** US, b. 1981
**Mughal School** (MOH-gull) India, c. 1690–1710
**Mukhina, Vera** (moo-KEE-nah, vair-ah) USSR/Russia
**Munch, Edvard** (moongk, ED-vart) Norway, 1863–1944

**Nagano, Paul T.** US, 21st century
**Nakashima, Tom** (nah-kah-shee-mah) US, b. 1944
**Navajo** (NAV-ah-ho) Southwestern US
**Njau, Elimo** (nn-jaow, eh-lee-mo) East Africa
**Noguchi, Isamu** (noh-goo-chee, ees-sah-moo) Japan/US, 1904-1988
**Normil, Andre** (nor-mill) Haiti, b. 1934

**O'Keeffe, Georgia** US, 1887–1986
**Otter, Thomas P.** US, 1832–1890

**Paik, Nam June** (pike) Korea, b. 1932
**Peale, Charles Willson** US, 1741–1827
**Pergola, Linnea** (per-GOLE-ah, linn-AY-ah) US, b. 1953
**Petrosky, Jeanne** (peh-TROE-skee, jeen) US, b. 1957
**Picasso, Pablo** (pee-KAHS-oh, PAH-blo) Spain, 1881–1973
**Pierce, Elijah** US, 1892–1984
**Prendergast, Maurice** (PREN-der-gast) US, 1859–1924

**Quick-to-See Smith, Jaune** (kwik-too-see smith, zjhohn) US, b. 1940
**Qin dynasty** (chin) China

**Rasjasthan, Jaipure,** India
**Rauschenberg, Robert** (RAU-shen-berg) US, b. 1925
**Reinders, Jim** US, 21st century
**Revelle, Barbara Jo** (reh-VELL) US, b. 1946
**Revere, Paul** US, 1735–1818
**Riis, Jacob** (rees) b. Denmark, then US 1849-1914
**Rivera, Diego** (re-VAY-rah) Mexico, 1886-1957
**Rodchenko, Aleksandr** (ROTE-chen-ko) Russia, 1891–1956
**Rodia, Simon** (roh-dee-ah) Italy, 1875–1965
**Rodin, Auguste** (roh-dan, oh-goost) France, 1840–1917
**Romero, Frank** (ro-MAY-ro) US, b. 1941
**Rosenberg, Nelson** US, b. 1941
**Rosenquist, James** (ro-zen-kwist) US, b. 1933

**Saint-Gaudens, Augustus** (saynt-GOD-enz) US, 1848–1907
**Schapiro, Miriam** (shuh-PEER-o, MEER-ee-um) US/Canada, b. 1923
**Schofield, David** US, b. 1958
**Segal, George** (SEE-gel) US, b. 1924
**Shinn, Everett** US, 1876–1953
**Skoglund, Sandy** (Skoh-glend) US, b. 1946
**Sloan, John** US, 1871–1951
**Smith, Kevin Warren** Cherokee, b. 1958
**Spencer, Niles** US, 1893–1952
**Steinberg, Saul** Rumania/US, b. 1914
**Steir, Pat** (steer) US, b. 1938
**Suikei, Sesson** (soo-ee-kay, sess-ahn) Japan, 1504–1589
**Sullivan, Louis** US, 1856–1924
**Swentzell, Roxanne** US, b. 1962

**Tansey, Mark** (TAN-zee) US, b. 1949
**Tennis, Kara Johns** US, b. 1954
**Tiffany, Louis Comfort** US, 1848–1933
**Thomas, Alma Woodsey** US, 1891–1978
**Thiebaud, Wayne** (TEE-bo) US, b.1920
**Tianren, Wang, Ge Demao** China, 21st century
**Twachtman, John Henry** (TWOKT-men) US, 1853–1902

**Ukeles, Miere Laderman** (yoo-kell-ees, meer) US, b. 1939
**Utzon, Joern** (ootz-ahn, yorn) Netherlands, b. 1918

**van Gogh, Vincent** (vahn-GO, VIN-sent) Netherlands, 1853–1890
**Van Der Zee, James** US, 1886–1983
**Vennerberg, Gunnar Gunnarson** Sweden, active late 19th-early 20th century
**Viola, Bill** (vie-OH-la) US, b. 1951

**Walters, Joe** US, b. 1952
**Waner, Elisabeth** US, active 19th century
**Wegman, William** US, b. 1943
**Wei Dynasty** (way) China
**West, Benjamin** US, 1738-1820
**White, John** England, active 1585–1593
**Wodiczko, Krzysztof** (vo-DEECH-koe, SHIS-tof) Poland, b. 1943
**Wood, Grant** US, 1892–1942

**Yellow Nose** Cheyenne-Arapaho Reservation, late 19th century

**Zalce, Alfredo** (SAL-say, al-FRAY-tho) Mexico, b.1908
**Zorn, Anders** Sweden, 1860–1920

# World Map

The best way to see what the world looks like is to look at a globe. The problem of showing the round earth on a flat surface has challenged mapmakers for centuries. This map is called a Robinson projection. It is designed to show the earth in one piece, while maintaining the shape of the land and size relationships as much as possible. However, any world map has distortions.

This map is also called a *political* map. It shows the names and boundaries of countries as they existed at the time the map was made. Political maps change as new countries develop.

**Key to Abbreviations**

| | |
|---|---|
| ALB. | Albania |
| AUS. | Austria |
| B.-H. | Bosnia-Hercegovina |
| BELG. | Belgium |
| CRO. | Croatia |
| CZ. REP. | Czech Republic |
| EQ. GUINEA | Equatorial Guinea |
| HUNG. | Hungary |
| LEB. | Lebanon |
| LITH. | Lithuania |
| LUX. | Luxembourg |
| MAC. | Macedonia |
| NETH. | Netherlands |
| RUS. | Russia |
| SLOV. | Slovenia |
| SLCK. | Slovakia |
| SWITZ. | Switzerland |
| YUGO. | Yugoslavia |

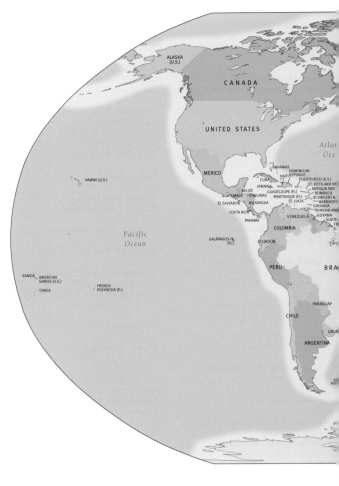

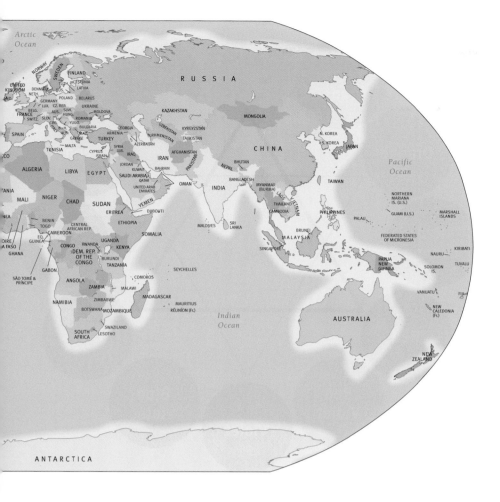

# Color Wheel

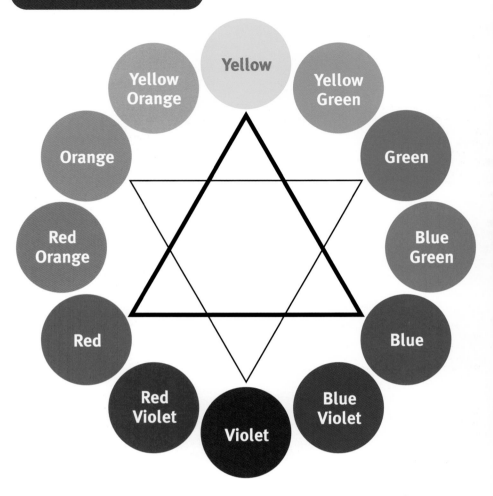

For easy study, the colors of the spectrum are usually arranged in a circle called a color wheel. Red, yellow, and blue are the three primary colors or hues. All other hues are made by mixing different amounts of these three colors.

If you mix any two primary colors, you will produce one of the three secondary colors. From experience, you probably know that red and blue make violet, red and yellow make orange, and blue and yellow make green. These are the three secondary colors.

The color wheel also shows six intermediate colors. You can create these by mixing a primary color with a neighboring secondary color. For example, yellow (a primary color) mixed with orange (a secondary color) creates yellow-orange (an intermediate color). Mixing the primary and secondary colors creates the six intermediate colors shown. Mixing different amounts of these colors produces an unlimited number of hues.

# Bibliography

## Aesthetics

Grimshaw, Caroline. *Connections: Art.* Chicago, IL: World Book, 1996.

Magee, Brian. *The Story of Philosophy.* NY: DK Publishing, 1998.

Varnedoe, Kirk. *A Fine Disregard: What Makes Modern Art Modern.* NY: Harry N. Abrams, Inc., 1994.

Weate, Jeremy. *A Young Person's Guide to Philosophy.* NY: DK Publishing, 1998.

## Art Criticism

Antoine, Veronique. *Artists Face to Face.* Hauppauge, NY: Barron's, 1996.

Cumming, Robert. *Annotated Art.* NY: DK Publishing, 1998.

Franc, Helen M. *An Invitation to See: 150 Works from the Museum of Modern Art.* NY: Harry N. Abrams, Inc., 1996.

Greenberg, Jan and Sandra Jordan. *The American Eye.* NY: Delacorte, 1995.

---------------. *The Painter's Eye.* NY: Delacorte, 1991.

---------------. *The Sculptor's Eye.* NY: Delacorte, 1993.

Richardson, Joy. *Looking at Pictures: An Introduction to Art for Young People.* NY: Harry N. Abrams, Inc., 1997.

Rosenfeld, Lucy Davidson. *Reading Pictures: Self-Teaching Activities in Art.* Portland, ME: J. Weston Walch, 1991.

Roukes, Nicholas. *Humor in Art: A Celebration of Visual Wit.* Worcester, MA: Davis Publications, 1997.

Welton, Jude. *Looking at Paintings.* NY: DK Publishing, 1994.

Yenawine, Philip. *How to Look at Modern Art.* NY: Harry N. Abrams, Inc., 1991.

## Art History
### General

Barron's Art Handbook Series. *How to Recognize Styles.* Hauppauge, NY: Barron's, 1997.

Belloli, Andrea. *Exploring World Art.* Los Angeles, CA: The J. Paul Getty Museum, 1999.

D'Alelio, Jane. *I Know That Building.* Washington, DC: The Preservation Press, 1989.

Gebhardt, Volker. *The History of Art.* Hauppauge, NY: Barron's, 1998.

Hauffe, Thomas. *Design.* Hauppauge, NY: Barron's, 1996.

Janson, H.W. and Anthony F. Janson. *History of Art for Young People.* NY: Harry N. Abrams, Inc., 1997.

Remer, Abby. *Pioneering Spirits: The Life and Times of Remarkable Women Artists in Western History.* Worcester, MA: Davis Publications, 1997.

Stevenson, Neil. *Annotated Guides: Architecture.* NY: DK Publishing, 1997.

Thiele, Carmela. *Sculpture.* Hauppauge, NY: Barron's, 1996.

Wilkinson, Philip and Paolo Donati. *Amazing Buildings.* NY: DK Publishing, 1993.

## Ancient World

Corbishley, Mike. *What Do We Know About Prehistoric People.* NY: Peter Bedrick Books, 1994.

Cork, Barbara and Struan Reid. *The Usborne Young Scientist: Archaeology.* London: Usborne Press, 1991.

Crosher, Judith. *Ancient Egypt.* NY: Viking, 1993.

Fleming, Stuart. *The Egyptians.* NY: New Discovery, 1992.

Giblin, James Cross. *The Riddle of the Rosetta Stone.* NY: Thomas Y. Crowell, 1990.

Haslam, Andrew, and Alexandra Parsons. *Make It Work: Ancient Egypt.* NY: Thomsom Learning, 1995.

Millard, Anne. *Pyramids.* NY: Kingfisher, 1996.

Morley, Jacqueline, Mark Bergin, and John Hames. *An Egyptian Pyramid.* NY: Peter Bedrick Books, 1991.

Powell, Jilliam. *Ancient Art.* NY: Thomsom Learning, 1994.

## Classical World

Avi-Yonah, Michael. *Piece by Piece! Mosaics of the Ancient World.* Minneapolis, MN: Runestone Press, 1993.

Bardi, Piero. *The Atlas of the Classical World.* NY: Peter Bedrick Books, 1997.

Bruce-Mitford, Miranda. *Illustrated Book of Signs & Symbols.* NY: DK Publishing, 1996.

Chelepi, Chris. *Growing Up in Ancient Greece.* NY: Troll Associates, 1994.

Cohen, Daniel. *Ancient Greece.* NY: Doubleday, 1990.

Corbishley, Mike. *Ancient Rome.* NY: Facts on File, 1989.

Corbishley, Mike. *Growing Up in Ancient Rome.* NY: Troll Associates, 1993.

Hicks, Peter. *The Romans.* NY: Thomson Learning. 1993.

Loverance, Rowena and Wood. *Ancient Greece.* NY: Viking, 1993.

MacDonald, Fiona. *A Greek Temple.* NY: Peter Bedrick Books, 1992.

McCaughrean, G. *Greek Myths.* NY: Margaret McElderry Books, 1992.

Roberts, Morgan J. *Classical Deities and Heroes.* NY: Friedman Group, 1994.

Wilkinson, Philip. *Illustrated Dictionary of Mythology.* NY: DK Publishing, 1998.

Williams, Susan. *The Greeks.* NY: Thomson Learning, 1993.

## The Middle Ages

Cairns, Trevor. *The Middle Ages.* NY: Cambridge University Press, 1989.

Caselli, Giovanni. *The Middle Ages.* NY: Peter Bedrick Books, 1993.

Chrisp, Peter. *Look Into the Past: The Normans.* NY: Thomson Learning. 1995.

Corrain, Lucia. *Giotto and Medieval Art.* NY: Peter Bedrick Books, 1995.

Howarth, Sarah. *What Do We Know About the Middle Ages.* NY: Peter Bedrick Books, 1995.

MacDonald, Fiona. *A Medieval Cathedral.* NY: Peter Bedrick Books, 1994.

Mason, Antony. *If You Were There in Medieval Times.* NY: Simon & Schuster, 1996.

Robertson, Bruce. *Marguerite Makes a Book.* Los Angeles, CA: The J. Paul Getty Museum, 1999.

## Renaissance

Corrain, Lucia. *Masters of Art: The Art of the Renaissance.* NY: Peter Bedrick Books, 1997.

Di Cagno, Gabriella et al. *Michelangelo.* NY: Peter Bedrick Books, 1996.

Dufour, Alessia Devitini. *Bosch.* ArtBook Series. NY: DK Publishing, 1999.

Fritz, Jean, Katherine Paterson, et. al. *The World in 1492.* NY: Henry Holt & Co., 1992.

Giorgi, Rosa. *Caravaggio.* ArtBook Series. NY: DK Publishing, 1999.

Harris, Nathaniel. *Renaissance Art.* NY: Thomson Learning, 1994.

Herbert, Janis. *Leonardo da Vinci for Kids.* Chicago: Chicago Review Press, 1998.

Howarth, Sarah. *Renaissance People.* Brookfield, CT: Millbrook Press, 1992.

---------------. *Renaissance Places.* Brookfield, CT: Millbrook Press, 1992.

*Leonardo da Vinci.* ArtBook Series. NY: DK Publishing, 1999.

McLanathan, Richard. *First Impressions: Leonardo da Vinci.* NY: Harry N. Abrams, Inc., 1990.

---------------. *First Impressions: Michelangelo.* NY: Harry N. Abrams, Inc., 1993.

Medo, Claudio. *Three Masters of the Renaissance: Leonardo, Michelangelo, Raphael.* Hauppauge, NY: Barron's, 1999.

Milande, Veronique. *Michelangelo and His Times*. NY: Henry Holt & Co., 1995.

Muhlberger, Richard. *What Makes a Leonardo a Leonardo?* NY: Viking, 1994.

---------------. *What Makes a Raphael a Raphael?* NY: Viking, 1993.

Murray, Peter and Linda. *The Art of the Renaissance*. NY: Thames and Hudson, 1985.

*Piero della Francesca*. ArtBook Series. NY: DK Publishing, 1999.

Richmond, Robin. *Introducing Michelangelo*. Boston, MA: Little, Brown, 1992.

Romei, Francesca. *Leonardo da Vinci*. NY: Peter Bedrick Books, 1994.

Spence, David. *Michelangelo and the Renaissance*. Hauppauge, NY: Barron's, 1998.

Stanley, Diane. *Leonardo da Vinci*. NY: William Morrow, 1996.

Wood, Tim. *The Renaissance*. NY: Viking, 1993.

Wright, Susan. *The Renaissance*. NY: Tiger Books International, 1997.

Zuffi, Stefano. *Dürer*. ArtBook Series. NY: DK Publishing, 1999.

Zuffi, Stefano and Sylvia Tombesi-Walton. *Titian*. ArtBook Series. NY: DK Publishing, 1999.

**Baroque and Rococo**

Barron's Art Handbooks. *Baroque Painting*. Hauppague, NY: Barron's, 1998.

Bonafoux, Pascal. *A Weekend with Rembrandt*. NY: Rizzoli, 1991.

Jacobsen, Karen. *The Netherlands*. Chicago, IL: Children's Press, 1992.

Muhlberger, Richard. *What Makes a Goya a Goya?* NY: Viking, 1994.

---------------. *What Makes a Rembrandt a Rembrandt?* NY: Viking, 1993.

Pescio, Claudio. *Rembrandt and Seventeenth-Century Holland*. NY: Peter Bedrick Books, 1996.

Rodari, Florian. *A Weekend with Velázquez*. NY: Rizzoli, 1993.

Schwartz, Gary. *First Impressions: Rembrandt*. NY: Harry N. Abrams, Inc., 1992.

Spence, David. *Rembrandt and Dutch Portraiture*. Hauppauge, NY: Barron's, 1998.

*Velázquez*. ArtBook Series. NY: DK Publishing, 1999.

*Vermeer*. ArtBook Series. NY: DK Publishing, 1999.

Wright, Patricia. *Goya*. NY: DK Publishing, 1993.

Zuffi, Stefano. *Rembrandt*. ArtBook Series. NY: DK Publishing, 1999.

**Neoclassicism, Romanticism, Realism**

*Friedrich*. ArtBook Series. NY: DK Publishing, 1999.

*Goya*. Eyewitness Books. NY: DK Publishing, 1999.

Rapelli, Paola. *Goya*. ArtBook Series. NY: DK Publishing, 1999.

**Impressionism & Post-Impressionism**

Barron's Art Handbooks. *Impressionism*. Hauppauge, NY: Barron's, 1997.

Bernard, Bruce. *Van Gogh*. Eyewitness Books. NY: DK Publishing, 1999.

Borghesi, Silvia. *Cézanne*. ArtBook Series. NY: DK Publishing, 1999.

Crepaldi, Gabriele. *Gauguin*. ArtBook Series. NY: DK Publishing, 1999.

---------------. *Matisse*. ArtBook Series. NY: DK Publishing, 1999.

*Kandinsky*. ArtBook Series. NY: DK Publishing, 1999.

*Monet*. Eyewitness Books. NY: DK Publishing, 1999.

Muhlberger, Richard. *What Makes a Cassatt a Cassatt?* NY: Viking, 1994.

---------------. *What Makes a Degas a Degas?* NY: Viking, 1993.

---------------. *What Makes a Monet a Monet?* NY: Viking, 1993.

---------------. *What Makes a van Gogh a van Gogh?* NY: Viking, 1993.

Pescio, Claudio. *Masters of Art: Van Gogh*. NY: Peter Bedrick Books, 1996.

Rapelli, Paola. *Monet*. ArtBook Series. NY: DK Publishing, 1999.

Sagner-Duchting, Karin. *Monet at Giverny*. NY: Neueis Publishing, 1994.

Skira-Venturi, Rosabianca. *A Weekend with Degas*. NY: Rizzoli, 1991.

---------------. *A Weekend with van Gogh*. NY: Rizzoli, 1994.

Spence, David. *Cézanne*. Hauppague, NY: Barron's, 1998.

---------------. *Degas*. Hauppague, NY: Barron's, 1998.

---------------. *Gauguin*. Hauppague, NY: Barron's, 1998.

---------------. *Manet: A New Realism*. Hauppague, NY: Barron's, 1998.

---------------. *Monet and Impressionism*. Hauppague, NY: Barron's, 1998.

---------------. *Renoir*. Hauppague, NY: Barron's, 1998.

---------------. *Van Gogh: Art and Emotions*. Hauppague, NY: Barron's, 1998.

Torterolo, Anna. *Van Gogh*. ArtBook Series. NY: Dk Publishing, 1999.

Turner, Robyn Montana. *Mary Cassatt*. Boston, MA: Little, Brown, 1992.

Waldron, Ann. *Claude Monet*. NY: Harry N. Abrams, Inc., 1991.

Welton, Jude. *Impressionism*. NY: DK Publishing, 1993.

Wright, Patricia. *Manet*. Eyewitness Books. NY: DK Publishing, 1999.

**20th Century**

Antoine, Veronique. *Picasso: A Day in His Studio*. NY: Chelsea House, 1993.

Beardsley, John. *First Impressions: Pablo Picasso*. NY: Harry N. Abrams, Inc., 1991.

Cain, Michael. *Louise Nevelson*. NY: Chelsea House, 1990.

*Children's History of the 20th Century*. NY: DK Publishing, 1999.

Faerna, Jose Maria, ed. *Great Modern Masters: Matisse*. NY: Harry N. Abrams, Inc., 1994.

Faerna, Jose Maria, ed. *Great Modern Masters: Picasso*. NY: Harry N. Abrams, Inc., 1994.

Gherman, Beverly. *Georgia O'Keeffe: The Wideness and Wonder of Her World*. NY: Simon & Schuster, 1994.

Greenberg, Jan and Sandra Jordan. *Chuck Close Up Close*. NY: DK Publishing, 1998.

Heslewood, Juliet. *Introducing Picasso*. Boston, MA: Little, Brown, 1993.

Paxman, Jeremy. *20th Century Day by Day*. NY: DK Publishing, 1991.

Ridley, Pauline. *Modern Art*. NY: Thomson Learning, 1995.

Rodari, Florian. *A Weekend with Matisse*. NY: Rizolli, 1992.

---------------. *A Weekend with Picasso*. NY: Rizolli, 1991.

Spence, David. *Picasso: Breaking the Rules of Art*. Hauppauge, NY: Barron's, 1998.

Tambini, Michael. *The Look of the Century*. NY: DK Publishing, 1996.

Turner, Robyn Montana. *Georgia O'Keeffe*. Boston, MA: Little, Brown, 1991.

Woolf, Felicity. *Picture This Century: An Introduction to Twentieth-Century Art*. NY: Doubleday, 1993.

**United States**

Howard, Nancy Shroyer. *Jacob Lawrence: American Scenes, American Struggles*. Worcester, MA: Davis Publications, 1996.

---------------. *William Sidney Mount: Painter of Rural America*. Worcester, MA: Davis Publications, 1994.

Panese, Edith. *American Highlights: United States History in Notable Works of Art*. NY: Harry N. Abrams, Inc., 1993.

Sullivan, Charles, ed. *African-American Literature and Art for Young People*. NY: Harry N. Abrams, Inc., 1991.

---------------. *Here Is My Kingdom: Hispanic-American Literature and Art for Young People*. NY: Harry N. Abrams, Inc., 1994.

---------------. *Imaginary Gardens: American Poetry and Art for Young People*. NY: Harry N. Abrams, Inc., 1989.

**Native American**

Burby, Liza N. *The Pueblo Indians.* NY: Chelsea House, 1994.

D'Alleva, Anne. *Native American Arts and Culture.* Worcester, MA: Davis Publications, 1993.

Dewey, Jennifer Owings. *Stories on Stone.* Boston, MA: Little, Brown, 1996.

Garborino, Merwyn S. *The Seminole.* NY: Chelsea House, 1989.

Gibson, Robert O. *The Chumash.* NY: Chelsea House, 1991.

Graymont, Barbara, *The Iroquois.* NY: Chelsea House, 1988.

Griffin-Pierce, Trudy. *The Encyclopedia of Native America.* NY: Viking, 1995.

Hakim, Joy. *The First Americans.* NY: Oxford University Press, 1993.

Howard, Nancy Shroyer. *Helen Cordero and the Storytellers of Cochiti Pueblo.* Worcester, MA: Davis Publications, 1995.

Jensen, Vicki. *Carving a Totem Pole.* NY: Henry Holt & Co., 1996.

Littlechild, George. *This Land Is My Land.* Emeryville, CA: Children's Book Press, 1993.

Moore, Reavis. *Native Artists of North America.* Santa Fe, NM: John Muir Publications, 1993.

Perdue, Theda. *The Cherokee.* NY: Chelsea House, 1989.

Remer, Abby. *Discovering Native American Art.* Worcester, MA: Davis Publications, 1996.

Sneve, Virginia Driving Hawk. *The Cherokees.* NY: Holiday House, 1996.

**Art of Global Cultures**
**General**

Bowker, John. *World Religions.* NY: DK Publishing, 1997.

*Eyewitness World Atlas.* DK Publishing (CD ROM)

Wilkinson, Philip. *Illustrated Dictionary of Religions.* NY: DK Publishing, 1999.

*World Reference Atlas.* NY: DK Publishing, 1998.

**Africa**

Ayo, Yvonne. *Africa.* NY: Alfred A. Knopf, 1995.

Bohannan, Paul and Philip Curtin. *Africa and Africans.* Prospect Heights, IL: Waveland Press, 1995.

Chanda, Jacqueline. *African Arts and Culture.* Worcester, MA: Davis Publications, 1993.

---------------. *Discovering African Art.* Worcester, MA: Davis Publications, 1996.

Gelber, Carol. *Masks Tell Stories.* Brookfield, CT: Millbrook Press, 1992

La Duke, Betty. *Africa: Women's Art. Women's Lives.* Trenton, NJ: Africa World Press, 1997.

---------------. *Africa Through the Eyes of Women Artists.* Trenton, NJ: Africa World Press, 1996.

McKissack, Patricia and Fredrick McKissack. *The Royal Kingdoms of Ghana, Mali, and Songhay.* NY: Henry Holt & Co., 1994.

**Mexico, Mesoamerica, Latin America**

Baquedano, Elizabeth, *Eyewitness Books: Aztec, Inca, and Maya.* NY: Alfred A. Knopf, 1993.

Berdan, Frances F. *The Aztecs.* NY: Chelsea House, 1989.

Braun, Barbara. *A Weekend with Diego Rivera.* NY: Rizzoli, 1994.

Cockcroft, James. *Diego Rivera.* NY: Chelsea House, 1991.

Goldstein, Ernest. *The Journey of Diego Rivera.* Minneapolis, MN: Lerner, 1996.

Greene, Jacqueline D. *The Maya.* NY: Franklin Watts, 1992.

Neimark, Anne E. *Diego Rivera: Artist of the People.* NY: Harper Collins, 1992.

Platt, Richard. *Aztecs: The Fall of the Aztec Capital.* NY: DK Publishing, 1999.

Sherrow, Victoria. *The Maya Indians.* NY: Chelsea House, 1994.

Turner, Robyn Montana. *Frida Kahlo.* Boston, MA: Little, Brown, 1993.

Winter, Jonah. *Diego.* NY: Alfred A. Knopf, 1991.

**Asia**

Doherty, Charles. *International Encyclopedia of Art: Far Eastern Art.* NY: Facts on File, 1997.

Doran, Clare. *The Japanese.* NY: Thomson Learning, 1995.

Ganeri, Anita. *What Do We Know About Buddhism.* NY: Peter Bedrick Books, 1997.

---------------. *What Do We Know About Hinduism.* NY: Peter Bedrick Books, 1996.

Lazo, Caroline. *The Terra Cotta Army of Emperor Qin.* NY: Macmillan, 1993.

MacDonald, Fiona, David Antram and John James. *A Samurai Castle.* NY: Peter Bedrick Books, 1996.

Major, John S. *The Silk Route.* NY: Harper Collins, 1995.

Martell, Mary Hazel. *The Ancient Chinese.* NY: Simon & Schuster, 1993.

**Pacific**

D'Alleva, Anne. *Arts of the Pacific Islands.* NY: Harry N. Abrams, 1998.

Haruch, Tony. *Discovering Oceanic Art.* Worcester, MA: Davis Publications, 1996.

Niech, Rodger and Mick Pendergast. *Traditional Tapa Textiles of the Pacific.* NY: Thames and Hudson, 1998.

Thomas, Nicholas. *Oceanic Art.* NY: Thames and Hudson, 1995.

**Studio**

*Drawing Basic Subjects.* Hauppauge, NY: Barron's, 1995.

Ganderton, Lucinda. *Stitch Sampler.* NY: DK Publishing, 1999.

Grummer, Arnold. *Complete Guide to Easy Papermaking.* Iola, WI: Krause Publications, 1999.

Harris, David. *The Art of Calligraphy.* NY: DK Publishing, 1995.

Horton, James. *An Introduction to Drawing.* NY: DK Publishing, 1994.

*Learning to Paint: Acrylics.* Hauppauge, NY: Barron's, 1998.

*Learning to Paint: Drawing.* Hauppauge, NY: Barron's, 1998.

*Learning to Paint: Mixing Watercolors.* Hauppauge, NY: Barron's, 1998.

*Learning to Paint in Oil.* Hauppauge, NY: Barron's, 1997.

*Learning to Paint in Pastel.* Hauppauge, NY: Barron's, 1997.

*Learning to Paint in Watercolor.* Hauppauge, NY: Barron's, 1997.

Lloyd, Elizabeth. *Watercolor Still Life.* NY: DK Publishing, 1994.

Slafer, Anna and Kevin Cahill. *Why Design?* Chicago, IL: Chicago Review Press, 1995.

Smith, Ray. *An Introduction to Acrylics.* NY: DK Publishing, 1993.

---------------. *An Introduction to Oil Painting.* NY: DK Publishing, 1993.

---------------. *An Introduction to Watercolor.* NY: DK Publishing, 1993.

---------------. *Drawing Figures.* Hauppauge, NY: Barron's, 1994.

---------------. *Oil Painting Portraits.* NY: DK Publishing, 1994.

---------------. *Watercolor Color.* NY: DK Publishing, 1993.

Wright, Michael. *An Introduction to Pastels.* NY: DK Publishing, 1993.

Wright, Michael and Ray Smith. *An Introduction to Mixed Media.* NY: DK Publishing, 1995.

---------------. *An Introduction to Perspective.* NY: DK Publishing, 1995.

*Perspective Pack.* NY: DK Publishing, 1998.

# Glossary

**abstract** Art that is based on a subject you can recognize, but the artist simplifies, leaves out, or rearranges some elements so that you may not recognize them. (*arte abstracto*)

**activism** The practice of working to change attitudes or beliefs related to politics or other issues within a community. (*activismo*)

**aesthetician** (*es-tha-TISH-un*) A person who wonders about art or beauty and asks questions about why art was made and how it fits into society. (*estético*)

**analogous colors** (*an-AL-oh-gus*) Colors that are closely related because they have one hue in common. For example, blue, blue-violet, and violet all contain the color blue. Analogous colors appear next to one another on the color wheel. (*colores análogos*)

**appliqué** (*ah-plee-KAY*) A process of stitching and/or gluing cloth to a background, similar to collage. (*aplicación*)

**armature** (*AR-mah-chur*) A system of support, similar to a skeleton, used to make a sculpture. (*armadura*)

**art critic** A person who expresses a reasoned opinion on any matter concerning art. (*crítico de arte*)

**art form** A technique or method that is used to create an artwork, such as painting, photography, or collage. (*forma artística*)

**art historian** A person who studies art—its history and contributions to cultures and societies. (*historiador de arte*)

**artist** A person who makes art. (*artista*)

**art media** The materials used by the artist to produce a work of art. (*medios artísticos*)

**Art Nouveau** (*art noo-VOH*) 1900–1915. A French phrase that means "New Art." A design style that explored the flowing lines, curves, and shapes of nature. (*art nouveau*)

**Ash Can School** 1908–1914. A group of American artists who painted pictures of real scenes of city life. The group's original name was "The Eight." (*escuela "Ash Can"*)

**assemblage** (*ah-SEM-blij*) A sculpture made by combining discarded objects such as boxes, pieces of wood, parts of old toys, and so on. (*ensambladura*)

**asymmetrical** (*ay-sim-MET-tri-kal*) A type of visual balance in which the two sides of the composition are different yet balanced; visually equal without being identical. Also called informal balance. (*asimétrico*)

**avant-garde** (*ah-vant-GARD*) An art term that describes art that is original and different from traditional styles of art. Avant-garde artists often experiment with new materials and ways of expressing ideas. (*vanguardismo*)

**balance** A principle of design that describes how parts of an artwork are arranged to create a sense of equal weight or interest. An artwork that is balanced seems to have equal visual weight or interest in all areas. Types of balance are symmetrical, asymmetrical, and radial. (*equilibrio*)

**bisqueware** (*BISK-wair*) Ceramic that has been fired once but not glazed. (*bizcocho de porcelana*)

**cause** A belief or issue that moves people to action. (*causa*)

**celebration** An observation of an event or local tradition with other members of a community. (**celebración**)

**ceramics** (*sir-AM-miks*) The art of making objects from clay, glass, or other minerals by baking or firing them at high temperatures in an oven known as a kiln. Ceramics are also the products made in this way. (*cerámica*)

**Christian art** A type of art that began in Africa in the fifteenth century and continues today. The primary aim of mission art is to teach people in African communities about Christian religions. (*arte cristiana*)

**cinematography** The art of making "moving" or motion pictures. (*cinematografía*)

**cityscape** An artwork that shows a view of a city (buildings, streets, shops) as subject matter. (*paisaje urbano*)

**codex** A type of book whose pages are hinged together at both sides, similar to an accordion. (*códice*)

**collaborate** To work together with others. (*colaborar*)

**collage** (*coh-LAHZ*) A work of art created by gluing bits of paper, fabric, scraps, photographs, or other materials to a flat surface. (*collage*)

**color** Another word for hue, which is the common name of a color in or related to the spectrum, such as yellow, yellow-orange, blue-violet, green. See hue. (*color*)

**color scheme** A plan for selecting or organizing colors. Common color schemes include: warm, cool, neutral, monochromatic, analogous, complementary, split-complementary and triad. (*combinación de colores*)

**commemorate** (*co-MEM-or-ate*) To honor or remember a person or event. (*conmemorar*)

**communication** The exchange of information, thoughts, feelings, ideas, opinions, and so on, either in spoken, written, or visual form. (*comunicación*)

**communism** A form of government in Russia whose main idea was to create communities in which people worked together. (*comunismo*)

**complementary** (*com-ple-MEN-tah-ree*) Colors that are directly opposite each other on the color wheel, such as red and green, blue and orange, and violet and yellow. When complements are mixed together, they make a neutral brown or gray. When they are used next to each other in a work of art, they create strong contrasts. (*complementarios*)

**computer art** Art whose main medium is the computer. (*arte generado por computadora*)

**contour drawing** A drawing that shows only the edges (contours) of objects. (*dibujo de contorno*)

**cool colors** Colors often connected with cool places, things, or feelings. The family of colors ranging from the greens through the blues and violets. (*colores frescos*)

**crafts** Works of art, either decorative or useful, that are skillfully made by hand. (*artesanías*)

**Cubism** 1907–1914. An art history term for a style developed by the artists Pablo Picasso and Georges Braque. In Cubism, the subject matter is broken up into geometric shapes and forms. The forms are put back together into an abstract composition. Often, three-dimensional objects seem to be shown from many different points of view at the same time. (*cubismo*)

**Dada** 1915–1923. An art movement that was known for rejecting traditional art styles and materials. These artists created artworks based on chance, and often used found objects to create new art forms. Many artists involved in the Dada movement became leaders of Surrealism and other new styles of art. (*dadaísmo*)

**dailies** The film shot each day during a film shoot. (*toma del día*)

**designers** Artists who plan the organization and composition of an artwork, object, place, building, and so on. Designers plan clothing (fashion design), outdoor spaces (landscape design), indoor spaces (furniture and interior design), signs and ads (graphic design), and so on. (*diseñadores*)

**document** (*DOK-you-ment*) To make or keep a record of. (*documentar*)

**dry media** Art materials such as pencils, chalk (pastels), and crayons that are not wet and do not require the use of a liquid. (*medios secos*)

**Earth Art** An art movement in which land and earth are important as ideas or used as a media for expression. (*arte Tierra*)

**earthworks** Any work of art in which land and earth are important media. See earth art. (*earthworks*)

**elements of design** The visual "tools" artists use to create art. The elements include color, value, line, shape, form, texture, and space. (*elementos de diseño*)

**emphasis** Areas in a work of art that catch and hold the viewer's attention. These areas usually have contrasting sizes, shapes, colors, or other distinctive features. (*acentuación*)

**form** An element of design. Any three-dimensional object such as a cube, sphere, pyramid, cylinder. A form can be measured from top to bottom (height), side to side (width), and front to back (depth). Form is also a general term that means the structure or design of a work. (*forma*)

**found objects** Materials that artists find and use for artwork, such as scraps of wood, metal, or ready-made objects. (*objetos encontrados*)

**frame** A single image from a video or sound installation. (*cuadro*)

**fresco** (*FRES-coh*) A technique of painting in which pigments are applied to a thin layer of wet plaster so that they will be absorbed. The painting becomes part of the wall. (*fresco*)

**geometric** A shape or form that has smooth, even edges. Geometric shapes include circles, squares, rectangles, triangles, and ellipses. Geometric forms include cones, cubes, cylinders, slabs, pyramids, and spheres. (*geométricas*)

**gesture drawing** A quick drawing that captures the gestures or movements of the body. (*dibujo gestual*)

**global community** The interaction and sharing of ideas and knowledge of people and populations worldwide. (*comunidad global*)

**global style** A style of art that cannot be linked to just one culture or tradition of art. Global style comes about from exchanges of ideas among artists of many nations and cultures around the world. (*estilo global*)

**graphic design** A general term for artwork in which letter forms (writing, typography) are an important part of the artwork. (*diseño gráfico*)

**graphic designer** An artist who designs such things as packages, wrapping papers, books, posters, and greeting cards. (*diseñador gráfico*)

**Harlem Renaissance** (*HAR-lem ren-eh-SAHNSS*) 1920–1940. A name of a period and a group of artists who lived and worked in Harlem, New York City. They used a variety of art forms to express their lives as African Americans. (*Renacimiento de Harlem*)

**horizon line** The flat line where water or land seems to end and the sky begins. It is usually on the eye level of the observer. If the horizon cannot be seen, its location must be imagined. (*línea de horizonte*)

**hue** Another word for color. See color. (*tonalidad*)

**immigrants** People who move from one country to another. (*inmigrantes*)

**implied line** The way objects are set up so as to produce the effect of seeing lines in a work, but where lines are not actually present. (*línea implícita*)

**implied texture** The way a surface appears to look, such as rough or smooth. (*textura implícita*)

**Impressionists** 1875–1900. A group of artists who worked outside and painted directly from nature. Impressionist artists used rapid brushstrokes to capture an impression of light and color. (*impresionistas*)

**installations** Temporary arrangements of art objects in galleries, museums, or outdoors. (*instalaciones*)

**intaglio print** (*in-TAH-lee-oh*) A print in which the artist scratches lines into a smooth metal plate, inks the plate, and then pulls the print using a printing press to apply even pressure between the plate and the paper. (*impresión en huecograbado*)

**intermediate color or hue** A color made by mixing a secondary color with a primary color. Blue-green, yellow-green, yellow-orange, red-orange, red-violet, and blue-violet are intermediate colors. (*color intermedio*)

**kinetic art** (*kih-NET-ick*) A general term for all artistic constructions that include moving elements, whether actuated by motor, by hand crank, or by natural forces as in mobiles. (*arte cinético*)

**kinetic sculpture** A sculpture that moves or has moving parts. The motion may be caused by many different forces, including air, gravity, and electricity. (*escultura cinética*)

**kivas** The rounded ceremonial rooms in an Anasazi pueblo. (*escultura cinética*)

**limner** (*LIM-ner*) An early American self-taught artist who painted signs, houses, and portraits. (*limner*)

**line** A mark with length and direction, created by a point that moves across a surface. A line can vary in length, width, direction, curvature, and color. Line can be two-dimensional (a pencil line on paper), three-dimensional (wire), or implied. (*línea*)

**linear perspective** (*lin-EE-er per-SPEK-tiv*) A technique used to show three-dimensional space on a two-dimensional surface. (*perspectiva lineal*)

**linoleum cut** A relief print that is made from a linoleum block. The linoleum is cut away. The uncut relief areas are covered with ink, paper is placed on top, and the print is made by rubbing the back of the paper. (*impresión en linóleo*)

**lithographic print** (*lith-oh-GRAF-ik*) A print made when an artist draws an image on a flat slab of stone (or a special metal plate) with a greasy crayon or paint. A special acid removes the part of the stone not covered with crayon. The crayoned part is then inked, and the print is made using a printing press. (*litografía*)

**maquette** (*mah-KET*) A small-scale model of a larger sculpture. (*maqueta*)

**memorial** Artworks or other objects that help people remember things, such as important events or people. (*obra conmemorativa*)

**miniature** A very small, detailed painting. (*miniatura*)

**mixed media** Any artwork that is made with more than one medium, such as ink and watercolor, painting and collage, and so on. (*medios mixtos*)

**mobile** (*MOH-beel*) A hanging balanced sculpture with parts that can be moved, especially by the flow of air. Invented by Alexander Calder in 1932. (*móvil*)

**Modern architecture** 1900–1970. A style of architecture that used steel, concrete, and glass to create tall buildings. Modern architecture was characterized by simple lines and a lack of decoration. (*estilo arquitectónico moderno*)

**monochromatic** (*mah-no-crow-MAT-ik*) Made of only a single color or hue and its tints and shades. (*monocromático*)

**monoprint** A printing process in which one image is transferred from a painted or inked surface onto a sheet of paper. Monoprinting usually involves creating one unique print instead of many. (*monoimpresión*)

**montage** (*mon-TAHJ*) An artwork created by combining photographic images onto a flat surface. (*montaje*)

**monument** An artwork created for a public place that preserves the memory of a person, event, or action. (*monumento*)

**mosaic** (mo-ZAY-ik) Artwork made by fitting together tiny pieces of colored glass or tiles, stones, paper, or other materials. These small materials are called tesserae. (mosaico)

**motif** (moh-TEEF) A single or repeated design or part of a design or decoration. (motivo)

**movement** A way of combining visual elements to produce a sense of action. This combination of elements helps the viewer's eye to sweep over the work in a definite manner. (movimiento)

**multimedia** Artworks that use the tools and techniques of more than one medium. (multimedia)

**mural movement** A movement begun by American artists in the 1970s that focused on adding beauty to city neighborhoods through the creation of large, public paintings, often on the walls of public buildings. (movimiento muralista)

**negative shape/space** The empty space surrounding shapes or solid forms in a work of art. (forma o espacio negativo)

**Neoclassical** 1776–1860. A style of art inspired by ancient Greek and Roman art. (estilo neoclásico)

**neutral colors** A color not associated with a hue, such as black, white, gray, or brown. (colores neutros)

**nonobjective art** A style of art that does not have a recognizable subject matter; the subject is the composition of the artwork. Nonobjective is often used as a general term for art that contains no recognizable subjects. Also known as non-representational art. (arte no figurativo)

**organic** A shape or form that is irregular in outline, such as things in nature. (orgánicas)

**pan** The movement of the camera during filming. (panorámica)

**pattern** A choice of lines, colors, or shapes, repeated over and over in a planned way. A pattern is also a model or guide for making something. (patrón)

**Performance Art** A form of visual art closely related to theater that combines any of the creative forms of expression, such as poetry, theater, music, architecture, painting, film, slides, and so on. (arte de la representación)

**pigments** Coloring materials made from earth, crushed minerals, plants, or chemicals. Pigments are mixed with a liquid or binder (such as glue, egg, wax, or oil) to make paint, ink, dyes, or crayons. (pigmentos)

**planned pattern** Patterns thought out and created in a systematic and organized way. Whether manufactured or natural, they are precise, measurable, and consistent. (patrón planificado)

**pointillism** 1880–1900. A style of painting in which small dots of color are placed side by side. When viewed from a distance, the eye tends to see the colors as mixed. (puntillismo)

**Pop Art** 1940 to the present. A style of art whose subject matter comes from popular culture (mass media, advertising, comic strips, and so on). (arte pop)

**portrait** An artwork that shows a specific person or group of people. (retrato)

**portraiture** The art of creating portraits. (retratismo)

**positive space/shape** The objects in a work of art, not the background or the space around them. (espacio o forma positiva)

**Post-Modern architecture** 1970–present. A style of architecture that combined some styles from the past with more decoration, line, and color. (arquitectura postmoderna)

**pre-Columbian** An art history term used to describe the art and civilizations in North and South America before the time of the Spanish conquests. (precolombino)

**primary color or hue** One of three basic colors (red, yellow, and blue) that cannot be made by mixing colors. Primary colors are used for mixing other colors. (color primario)

**principles of design** Guidelines that help artists to create designs and control how viewers are likely to react to images. Balance, contrast, proportion, pattern, rhythm, emphasis, unity, and variety are examples of principles of design. (principios de diseño artístico)

**Productivists** A group of Russian avant-garde artists who believed that art is useful to society. They felt that combining art, craftsmanship, and industry could help build a better world. (productivistas)

**proportion** The relation of one object to another in size, amount, number, or degree. (proporción)

**proportions** The relation between one part of the body and another in terms of size, quantity, and degree. (proporciones)

**pueblo** A Native-American village of the southwestern United States. (pueblo)

**pulp** Mashed up material, usually wood or plant fibers, used to make paper. (pulpa)

**radial** A kind of balance in which lines or shapes spread out from a center point. (radial)

**random pattern** Patterns caused by accidental arrangement or produced without consistent design. Random patterns are usually asymmetrical, non-uniform, and irregular. (patrón aleatorio)

**Realistic style** 1850–1900. A style of art that shows people, scenes, and events as the eye sees them. It was developed in the mid-nineteenth century by artists who did not follow the style of Neoclassicism and the drama of Romanticism. See Neoclassical, Romantic style. (estilo realista)

**redware** A general term for pottery made from clay that has a red color due to high levels of iron. Also a specific term for the unfired pottery of Pennsylvania that has the red color of the natural clay in this region. (barro cocido)

**Regionalist** An artist whose artworks focus on a specific region or section of the country. (regionalista)

**relief print** A print created using a printing process in which ink is placed on the raised portions of the block or plate. (impresión en relieve)

**relief sculpture** A sculpture with parts that are raised from a background. (escultura en relieve)

**rhythm** A type of visual or actual movement in an artwork. Rhythm is a principle of design. It is created by repeating visual elements. Rhythms are often described as regular, alternating, flowing, progressive, or jazzy. (ritmo)

**Romantic style** 1815–1975. A style of art in which foreign places, myths, and legends and imaginary events were popular subjects. (estilo romántico)

**scientific record** Accurate and highly detailed artworks or written works, used to help document or classify species. (récord científico)

**sculpture** An artwork that has three dimensions: height, width, and depth or thickness. (escultura)

**secondary color or hue** A color made by mixing equal amounts of two primary colors. Green, orange, and violet are the secondary colors. Green is made by mixing blue and yellow. Orange is made by mixing red and yellow. Violet is made by mixing red and blue. (color secundario)

**serigraph** (SEHR-i-graf) A print, also known as a silkscreen print, made by squeezing ink through a stencil and silk-covered frame to paper below. (serigrafía)

**sgrafitto** (sgra-FEET-toh) A pottery technique in which designs are scratched onto a clay object through a thin layer of colored slip before the pottery is glazed and fired. (esgrafiado)

**shade** Any dark value of a color, usually made by adding black. (sombra)

**shading** A gradual change in value from dark to light. (*sombreado*)

**shape** A flat figure created when actual or implied lines meet to surround a space. A change in color or shading can define a shape. Shapes can be divided into several types: geometric (square, triangle, circle) and organic (irregular in outline). (*figura*)

**skyscrapers** High-rise buildings. (*rascacielos*)

**slurry** A watery mixture used to make paper. (*lechada*)

**space** The empty or open area between, around, above, below, or within objects. Space is an element of art. Shapes and forms are made by the space around and within them. Space is often called three-dimensional or two-dimensional. Positive space is filled by a shape or form. Negative space surrounds a shape or form. (*espacio*)

**split complement** A color scheme based on one hue and the hues on each side of its complement on the color wheel. Orange, blue-violet, and blue-green are split complementary colors. (*complemento fraccionario*)

**still life** Art based on an arrangement of objects that are not alive and cannot move, such as fruit, flowers, or bottles. The items are often symbols for abstract ideas. A book, for example, may be a symbol for knowledge. A still life is usually shown in an indoor setting. (*naturaleza muerta*)

**storyboard** A set of words and sketches that are made to plan a motion picture or television program. Each sketch shows a scene in the story. (*guión sinóptico*)

**style** The result of an artist's means of expression—the use of materials, design qualities, methods of work, and choice of subject matter. In most cases, these choices show the unique qualities of an individual, culture, or time period. The style of an artwork helps you to know how it is different from other artworks. (*estilo*)

**stylize** To simplify shapes or forms found in nature. (*estilizar*)

**subject** A topic or idea shown in an artwork, especially anything recognizable such as a landscape or animals. (*tema*)

**subtractive process** Sculptural process in which material (clay, for example) is carved or cut away to create form. In an additive process, material is added to create form. (*proceso de substracción*)

**Surrealism** A style of art in which dreams, fantasy, and the human mind are the source of ideas for artists. Unrelated

objects and situations are often set in unnatural surroundings. Artists who work in this style are known as Surrealists. (*surrealismo*)

**symmetrical** (*sim-MET-ri-kal*) A type of balance in which both sides of a center line are exactly or nearly the same, like a mirror image. For example, the wings of a butterfly are symmetrical. Also known as formal balance. (*simétrico*)

**technology** The art of creating things to make human life easier. (*tecnología*)

**texture** The way a surface feels (actual texture) or how it may look (implied texture). Texture can be sensed by touch and sight. Textures are described by words such as rough, silky, pebbly. (*textura*)

**theme** The artist's interpretation of a subject or topic of a work of art. For example, a landscape can have a theme of the desire to save nature, or to destroy nature. A theme such as love, power, or respect can be shown through a variety of subjects. (*idea central*)

**thumbnail sketches** Small, quick sketches that record ideas and information for a final work of art. (*esquemas*)

**tint** A light value of a pure color, usually made by adding white. For example, pink is a tint of red. (*matiz claro*)

**tohunga** (*toh-HUN-gah*) A Maori term that means "craftsman-priest." A great master carver of the Maori of New Zealand.

**trade art** Art that is created primarily for sale to tourists or for export to foreign markets. (*intercambio de arte*)

**traditional art** Artwork created in almost the same way year after year because it is part of a culture, custom, or belief. (*arte tradicional*)

**traditions** Customs, actions, thoughts, or beliefs that are passed on or handed down from generation to generation, either by word of mouth or by example. (*tradiciones*)

**triad** (*TRY-ad*) Three colors spaced equally apart on the color wheel, such as orange, green, and violet. (*triada*)

**two-point perspective** A method of creating the illusion of deep space on a flat surface. In two-point perspective there are two vanishing points on the horizon line. (*perspectiva de dos puntos*)

**ukiyo-e** (*oo-key-OH-eh*) Japanese pictures of the ""floating world" district of Edo. These were first made in paint, but were more commonly produced in editions of woodcuts of many colors. They are the unique creation of the Edo period (1603–1868). (*ukiyo-e*)

**unity** A feeling that all parts of a design are working together as a team. (*unidad*)

**value** An element of art that means the darkness or lightness of a surface. Value depends on how much light a surface reflects. Tints are light values of pure colors. Shades are dark values of pure colors. Value can also be an important element in works of art in which there is little or no color (drawings, prints, photographs, most sculpture and architecture). (*valor*)

**variety** The use of different lines, shapes, textures, colors, and other elements of design to create interest in a work of art. (*variedad*)

**video art** Art created by or using video technology. (*arte generado por video*)

**warm colors** Colors that are often associated with fire and the sun and remind people of warm places, things, and feelings. Warm colors range from the reds through the oranges and yellows. (*colores cálidos*)

**wet media** Drawing and painting materials which have a fluid or liquid ingredient. (*medios húmedos*)

**whole-to-part drawing** A drawing in which the largest shapes are drawn first, and then details are gradually filled in. (*dibujo del todo a las partes*)

# Spanish Glossary

**acentuación** Parte de una obra artística que captura y retiene la atención del espectador. Por lo general, esta área exhibe contrastes en tamaño, forma, color u otros rasgos distintivos. (*emphasis*)

**activismo** La práctica de tratar de cambiar las actitudes, creencias políticas u otros asuntos en una comunidad. (*activism*)

**aplicación** Proceso parecido al collage en el cual trozos de tela se cosen y/o se pegan a un fondo. (*appliqué*)

**armadura** Un conjunto de piezas, similar a un esqueleto, que sirve de soporte para hacer una escultura. (*armature*)

**arquitectura postmoderna** 1970–actualidad. Un estilo arquitectónico que toma como base algunos estilos del pasado y los combina con más decoración, líneas y colores. (*Post-Modern architecture*)

**arte abstracto** Arte que se basa en un tema reconocible pero en el que el artista ha simplificado, excluido o reordenado algunos elementos de modo que no podamos reconocerlos. (*abstract*)

**arte cinético** Término general que se usa para describir cualquier construcción artística que incluya elementos móviles, ya sea mediante un motor, una manivela o fuerzas naturales, como en el caso de los móviles. (*kinetic art*)

**arte cristiana** Estilo artístico que se originó en África en el siglo XV y que continúa existiendo en la actualidad. El objetivo principal de este estilo artístico es enseñar las religiones cristianas a los pueblos africanos. (*Christian art*)

**arte de la representación** Una forma de arte visual estrechamente relacionada con el teatro que integra cualquiera de las formas creativas de expresión, como la poesía, el teatro, la música, la arquitectura, la pintura, el cine, la fotografía, etc. (*Performance art*)

**arte generado por computadora** Arte creado principalmente con una computadora. (*computer art*)

**arte generado por video** Arte que se crea usando la tecnología de video. (*video art*)

**arte no figurativo** 1917–1932. Estilo de arte que no posee un tema reconocible; el tema es la composición de la obra artística. A menudo, se usa como un término general para el arte que contiene temas irreconocibles. También se le conoce como arte abstracto. (*nonobjective art*)

**arte pop** De 1940 hasta el presente. Tendencia artística cuyos temas provienen de la cultura popular (medios de comunicación, publicidad y tiras cómicas, entre otros). (*Pop Art*)

**artesanías** Obras de arte, con valor tanto decorativo como útil, que han sido hábilmente hechas a mano. (*crafts*)

**arte Tierra** Movimiento artístico en el cual el suelo y la Tierra son ideas importantes o se emplean como medios de expresión. (*Earth Art*)

**arte tradicional** Arte que se crea casi de manera idéntica año tras año, debido a que es parte de una cultura, costumbre o creencia. (*traditional art*)

**artista** Persona que hace arte. (*artist*)

**art nouveau** 1900–1915. Un término que en francés significa "arte nuevo". Un estilo de diseño que exploraba las líneas, curvas y formas de la naturaleza. (*Art Nouveau*)

**asimétrico** Tipo de equilibrio visual en el cual los dos lados de una composición son diferentes pero están equilibrados; son iguales visualmente pero no idénticos. También se denomina equilibrio irregular. (*asymmetrical*)

**barro cocido** Término que se usa para denominar la cerámica hecha con arcilla que tiene un color rojizo debido a su alto contenido de hierro. Su equivalente en inglés, redware, también se emplea para referirse a la cerámica sin hornear de Pennsylvania, que es del color rojizo natural de la arcilla que se encuentra en esa región. (*redware*)

**bizcocho de porcelana** Cerámica que ha sido horneada una vez pero no esmaltada. (*bisqueware*)

**causa** Una creencia o asunto que lleva a las personas a tomar algún tipo de medida. (*cause*)

**celebración** La observación de un suceso o tradición local con otros miembros de la comunidad. (*celebration*)

**cerámica** Arte de fabricar objetos de barro, vidrio u otros minerales cociéndolos o quemándolos a altas temperaturas en un horno de secar. La palabra también se refiere a los productos que se forman de esta manera. (*ceramics*)

**cinematografía** El arte de la reproducción fotográfica de imágenes en movimiento. (*cinematography*)

**códice** Un tipo de libro cuyas páginas están unidas en los dos lados, como un acordeón. (*codex*)

**colaborar** Trabajar junto con otros. (*collaborate*)

**collage** Una obra de arte que se crea pegando trocitos de papel, tela, recortes, fotografías u otros materiales sobre una superficie plana. (*collage*)

**color intermedio** Color que se produce al mezclar un color secundario con un color primario. El azul-verde, el verde-amarillo, el amarillo-anaranjado, el rojo-anaranjado, el rojo-violeta y el azul-violeta son colores intermedios. (*intermediate color*)

**color** Otro término para denominar el matiz, que es el nombre común de un color que está en el espectro o que está relacionado con él, por ejemplo, amarillo, amarillo anaranjado, azul violeta y verde. (*color*)

**color primario** Uno de los tres colores básicos (amarillo, rojo y azul) que no se puede producir mezclando colores. Los colores primarios se usan para formar otros colores. (*primary color*)

**color secundario** Color que se produce al mezclar dos colores primarios en cantidades iguales. El verde, el anaranjado y el violeta son colores secundarios. El verde es la combinación de azul con amarillo. El anaranjado se obtiene al mezclar el rojo y el amarillo. El color violeta se produce al mezclar el rojo con el azul. (*secondary color*)

**colores análogos** Colores estrechamente relacionados debido a un matiz que comparten en común. Por ejemplo, el azul, el azul-violeta y el violeta contienen el color azul. En la rueda de colores, los colores análogos se encuentran uno al lado del otro. (*analogous color*)

**colores cálidos** Reciben este nombre porque a menudo se les asocia con el fuego y el Sol. Asimismo, nos recuerdan lugares, cosas y sensaciones cálidas. Los colores cálidos van desde distintas tonalidades de rojo hasta el anaranjado y amarillo. (*warm colors*)

**colores frescos** Colores que se relacionan, a menudo, con lugares, cosas o sentimientos que proyectan frescura. Familia de colores que va del verde al azul y violeta. (*cool colors*)

**colores neutros** Aquellos colores que no se asocian con una tonalidad, como el negro, el blanco, el gris o el café. (*neutral colors*)

**combinación de colores** Plan para seleccionar u organizar los colores. Entre las combinaciones de colores comunes se encuentran las siguientes: cálido, fresco, neutro, monocromático, análogo, complementario, complementario fraccionado y tríada. (*color scheme*)

**complementarios** Colores directamente opuestos entre sí en la rueda de colores. Por ejemplo, el rojo y el verde, el azul y el anaranjado, el violeta y el amarillo. Cuando los colores complementarios se mezclan, el resultado es un color marrón o gris neutro. Cuando se usan uno al lado del otro en una obra artística, producen contrastes intensos. (*complementary*)

**complemento fraccionario** Combinación de colores que se basa en un matiz y en los matices de cada lado de su complemento en la rueda de colores. El anaranjado, el azul-violeta y el azul-verde son colores complementarios fraccionados. (*split complement*)

**comunicación** El intercambio de información, pensamientos, sentimientos, ideas, opiniones, etc., de forma oral, escrita o visual. (*communication*)

**comunidad global** La interacción e intercambio de ideas y conocimientos entre los pueblos y comunidades de todo el mundo. (*global community*)

**comunismo** Una forma de gobierno que se aplicó en Rusia, la cual se basaba en la idea de crear pequeñas comunidades donde las personas compartieran el trabajo. (*communism*)

**conmemorar** Honrar o recordar a una persona o acontecimiento. (*commemorate*)

**crítico de arte** Persona que expresa una opinión razonada acerca de cualquier asunto relacionado con el arte. (*art critic*)

**cuadro** Una sola imagen de un video o instalación de sonido. (*frame*)

**cubismo** 1907–1914. Término de arte que denota un estilo desarrollado por Pablo Picasso y Georges Braque. En el cubismo, el tema se descompone en formas y figuras geométricas. Éstas se analizan y luego se vuelven a juntar en una composición abstracta. A menudo, da la impresión de que los objetos tridimensionales se están mostrando desde muchos puntos de vista diferentes al mismo tiempo. (*Cubism*)

**dadaísmo** 1915–1923. Un movimiento artístico que rechazaba los materiales y estilos artísticos tradicionales. Los integrantes de este movimiento creaban obras de arte en base al azar, y a menudo usaban objetos encontrados para crear nuevas formas artísticas.

Muchos de los artistas que participaron en este movimiento se convirtieron en líderes del surrealismo y de otros estilos artísticos nuevos. (*Dada*)

**dibujo de contorno** Un dibujo que muestra sólo los bordes (el contorno) de los objetos. (*contour drawing*)

**dibujo del todo a las partes** Un dibujo en el cual primero se hacen los objetos más grandes y después se van agregando gradualmente los detalles. (*whole-to-part drawing*)

**dibujo gestual** Un dibujo que se realiza rápidamente para captar los gestos o movimientos del cuerpo. (*gesture drawing*)

**diseñador gráfico** Un artista que diseña objetos tales como paquetes, papel de envolver, libros, carteles y tarjetas de felicitaciones. (*graphic designer*)

**diseñadores** Artistas que se encargan de planear la organización y composición de una obra de arte, objeto, lugar, edificio, etc. Hay diseñadores de prendas de vestir (diseñadores de modas), de espacios al aire libre (diseñadores de exteriores), de espacios dentro de los edificios (diseñadores de muebles y de interiores), diseñadores de carteles y anuncios (diseñadores gráficos), etc. (*designers*)

**diseño gráfico** Un término general que designa aquellas obras de arte en las cuales la forma de las letras (escritura, tipografía) cumple un papel importante. (*graphic design*)

**documentar** Llevar un registro de algo. (*document*)

**earthworks** Cualquier obra de arte en la que el suelo y la Tierra son medios importantes. Ver arte Tierra.

**elementos de diseño** Las "herramientas" visuales que los artistas usan para crear arte. Entre los elementos se incluyen el color, el valor, la línea, la figura, la forma, la textura, y el espacio. (*elements of design*)

**ensambladura** Una escultura hecha con objetos que se han desechado, como cajas, trozos de madera, partes de juguetes viejos, etc. (*assemblage*)

**equilibrio** Principio de diseño que describe la manera en que se encuentran ordenadas las partes de una obra artística con el fin de crear la sensación de igual peso o interés. Una obra artística equilibrada ofrece un peso visual o un interés igual en todas sus áreas. Los tipos de equilibrio son simétrico, asimétrico y radial. (*balance*)

**escuela "Ash Can"** 1908–1914. Un grupo de artistas estadounidenses que pintaban escenas de la vida real en la ciudad. Originalmente este grupo se dio a conocer con el nombre de "el grupo de los ocho". (*Ash Can School*)

**escultura cinética** Una escultura que se mueve o que tiene partes móviles. El movimiento puede ser el resultado de distintas fuerzas, como el aire, la gravedad y la electricidad. (*kinetic sculpture*)

**escultura en relieve** Una escultura en la cual algunas partes sobresalen del fondo. (*relief sculpture*)

**escultura** Una obra de arte que tiene tres dimensiones: altura, anchura y profundidad. (*sculpture*)

**esgrafiado** Una técnica que se emplea en cerámica mediante la cual se graba un diseño en un objeto de arcilla a través de una cinta delgada de color, mientras que el objeto todavía está húmedo, antes de esmaltarlo y hornearlo. (*sgrafitto*)

**espacio** La extensión vacía o abierta que se encuentra entre objetos, alrededor de ellos, encima de ellos, debajo de ellos o dentro de los mismos. El espacio es un elemento artístico. Las figuras y las formas se producen debido al espacio que existe a su derredor y dentro de ellas. A menudo nos referimos al espacio como tridimensional o bidimensional. Una figura o una forma llenan el espacio positivo mientras que el espacio negativo rodea una figura o una forma. (*space*)

**espacio o forma positiva** Los objetos de una obra artística que no constituyen ni el fondo ni el espacio que se halla a su alrededor. (*positive space/shape*)

**esquemas** Bosquejos pequeños y rápidos que se realizan para anotar ideas e información con el fin de usarlos en la obra de arte final. (*thumbnail sketches*)

**estético** Persona que se dedica al estudio del arte o la belleza. Persona que cuestiona cómo se produce el arte y el papel que juega en la sociedad. (*aesthetician*)

**estilizar** Simplificar las formas de la naturaleza. (*stylize*)

**estilo arquitectónico moderno** 1900–1970. Un estilo arquitectónico que emplea acero, hormigón y vidrio para la construcción de edificios altos. Las líneas simples y la falta de decoración son características del estilo arquitectónico moderno. (*Modern architecture*)

**estilo global** Un estilo artístico que no se puede relacionar con una sola cultura o tradición artística. El estilo global es el resultado del intercambio de ideas entre los artistas de distintas naciones y culturas del mundo. (*global style*)

**estilo neoclásico** 1776–1860. Un estilo artístico inspirado en los antiguos artes griego y romano. (*Neoclassical*)

**estilo realista** 1850–1900. Un estilo artístico que representa a las personas, los lugares y los sucesos tal como los percibe el ojo humano. Este estilo fue desarrollado a mediados del siglo XIX por artistas que no seguían el estilo del neoclasicismo y el dramatismo del romanticismo. *Ver* estilo neoclásico, estilo romántico. (*Realistic style*)

**estilo** Resultado de los medios de expresión de un artista: el uso de materiales, la calidad del diseño, los métodos de trabajo y la selección del tema. En la mayoría de los casos, estas selecciones muestran las cualidades singulares de un individuo, una cultura o un período de tiempo. El estilo de una obra artística nos ayuda a distinguirla de otras obras de arte. (*style*)

**estilo romántico** 1815–1975. Un estilo artístico en el cual los lugares lejanos, los mitos, las leyendas y los sucesos imaginarios son temas comunes. (*Romantic style*)

**figura** Forma plana que se crea cuando se juntan líneas implícitas o reales que cierran un espacio. Un cambio de color o una sombra pueden definir una figura. Las figuras se pueden dividir en varios tipos: geométricas (cuadrado, triángulo, círculo) y orgánicas (contornos irregulares). (*shape*)

**forma artística** Técnica o método utilizado en la creación de una obra artística, como una pintura, una fotografía o un collage. (*art form*)

**forma o espacio negativo** El espacio vacío que rodea las formas o los cuerpos geométricos en una obra artística. (*negative shape/space*)

**formas orgánicas** Formas cuyos perfiles son irregulares, como por ejemplo, los objetos que se hallan en la naturaleza. (*organic shapes*)

**fresco** Técnica de pintura mural que consiste en aplicar pigmentos a una capa delgada de yeso húmedo. El yeso absorbe los pigmentos y la pintura se convierte en parte de la pared. (*fresco*)

**geométricas** Figuras o formas que parecen mecánicas. También se pueden usar fórmulas matemáticas para describir algo que es geométrico. (*geometric*)

**guión sinóptico** Conjunto de texto y bosquejos que se crean para planear una película o programa de televisión. Cada bosquejo muestra una escena del guión. (*storyboard*)

**historiador de arte** Persona que estudia el arte: su historia y aportaciones a las culturas y sociedades. (*art historian*)

**idea central** Tema o tópico de una obra artística. Por ejemplo, un paisaje puede tener como idea central el deseo de salvar la naturaleza o de destruirla. Una idea central como el amor, el poder o el respeto se pueden mostrar a través de una variedad de temas. Por lo general, la frase "idea central y variaciones" se usa para expresar varias maneras de mostrar una idea. (*theme*)

**impresión en huecograbado** Un tipo de impresión que se logra cuando el artista graba líneas sobre una placa lisa de metal, recubre la placa de tinta y después crea la lámina con una imprenta que ejerce presión de manera uniforme entre la placa y el papel. (*intaglio print*)

**impresión en linóleo** Un tipo de impresión en relieve que se hace con un clisé o bloque de linóleo. Primero se recorta el linóleo y se recubren de tinta las partes no recortadas. Después se coloca una hoja de papel encima del linóleo y la estampa se imprime frotando el reverso de la hoja de papel. (*linoleum cut*)

**impresión en relieve** Impresión que se crea al usar un proceso de imprimir en el cual se coloca tinta en las partes elevadas del clisé topográfico. (*relief print*)

**impresionistas** 1875–1900. Grupo de artistas que trabajaban al aire libre y pintaban directamente observando la naturaleza. Los pintores impresionistas usaban rápidas pinceladas para reproducir el efecto de la luz y el color. (*impressionists*)

**inmigrantes** Personas que se mudan de un país a otro. (*immigrants*)

**instalaciones** Arreglos temporales de objetos de arte en galerías, museos o al aire libre. (*installations*)

**intercambio de arte** Arte que ha sido creado principalmente para vender a los turistas o para exportar al extranjero. (*trade art*)

**kivas** Las cámaras ceremoniales circulares de los anasazi. (*kivas*)

**lechada** Una mezcla acuosa que se usa para hacer papel. (*slurry*)

**limner** Un artista estadounidense autodidacta de la época temprana del país, que pintaba carteles, casas y retratos. (*limner*)

**línea de horizonte** Línea de nivel donde parece que el agua o la tierra terminan y comienza el cielo. Por lo general, se encuentra al nivel de los ojos del espectador. Si el horizonte no se puede ver, entonces se debe imaginar su ubicación. (*horizon line*)

**línea implícita** Manera en que se arreglan los objetos con el fin de producir el efecto de que se vean líneas en una obra, aunque estas líneas en realidad no están presentes. (*implied line*)

**línea** Trazo que muestra longitud y dirección, creado por un punto que se mueve por una superficie. Una línea puede variar en longitud, ancho, dirección, curvatura y color. Puede ser bidimensional (una línea hecha con un lápiz sobre papel), tridimensional (alambre) o puede estar implícita. (*line*)

**litografía** Un tipo de impresión que se logra cuando un artista dibuja una imagen en una losa de piedra plana (o una lámina de metal especial) con un carboncillo aceitoso o con pintura. Con ácido especial se quita la parte de la piedra que no está cubierta por la pintura o carboncillo. Después se recubren de tinta las partes pintadas con el carboncillo y se hace la estampa con una imprenta. (*lithographic print*)

**maqueta** Modelo, a escala reducida, de una escultura. (*maquette*)

**matiz claro** Valor leve de un color puro, que se produce generalmente al añadir blanco. Por ejemplo, el rosado es un matiz claro del rojo. (*tint*)

**medios artísticos** Material o medios técnicos para realizar una expresión artística. (*art media*)

**medios húmedos** Materiales de dibujo o materiales para pintar que tienen un ingrediente líquido. (*wet media*)

**medios mixtos** Toda obra de arte que está compuesta por más de un medio, como tinta y acuarelas, pintura y collage, etc. (*mixed media*)

**medios secos** Materiales de arte, como lápices, tiza (pasteles) y lápices de cera, que no son húmedos y que no requieren el uso de ningún líquido. (*dry media*)

**miniatura** Una pintura muy pequeña y con mucho detalle. (*miniature*)

**monocromático** Hecho de un solo color o matiz y sus tintes y tonos. (*monochromatic*)

**monoimpresión** Proceso de impresión en el cual se transfiere una imagen de una superficie pintada o recubierta de tinta a una hoja de papel. Por lo general, el resultado de este proceso es la creación de una sola y exclusiva estampa, en lugar de muchas a la vez. (*monoprint*)

**montaje** Obra de arte que resulta de la combinación de varias imágenes fotográficas sobre una superficie plana. (*montage*)

**monumento** Una obra de arte que ha sido creada para exhibir en un lugar público con el fin de recordar a una persona, un suceso o una acción. (*monument*)

**mosaico** Obra artística compuesta de pequeños trozos de vidrio o azulejos, piedras, papel u otros materiales, de diversos colores. Estos materiales reciben el nombre de teselas. *(mosaic)*

**motivo** Un diseño, o parte de un diseño o decoración, que se repite una o muchas veces. *(motif)*

**móvil** Escultura equilibrada en suspensión que tiene partes que pueden entrar en movimiento, especialmente por la acción del viento. Ideada por Alexander Calder en 1932. *(mobile)*

**movimiento** Manera de combinar elementos visuales con el fin de producir una sensación de acción. Gracias a esta combinación de elementos, los ojos del espectador recorren la obra de arte de una manera definida. *(movement)*

**movimiento muralista** Un movimiento que iniciaron los artistas estadounidenses en los años 70 con el propósito de embellecer los vecindarios urbanos mediante la creación de grandes pinturas, a menudo en las paredes de los edificios públicos. *(mural movement)*

**multimedia** Obras de arte que usan las herramientas y las técnicas de varios medios. *(multimedia)*

**naturaleza muerta** Arte que se basa en un arreglo de objetos inertes e inmóviles, como por ejemplo, frutos, flores o botellas. Estos objetos expresan, a menudo, ideas abstractas. Por ejemplo, un libro puede representar un símbolo para el conocimiento. Por lo general, una naturaleza muerta se muestra en un ambiente interior. *(still life)*

**objetos encontrados** Materiales que los artistas encuentran y usan en sus obras de arte, como recortes de madera, metal u otros objetos ya acabados. *(found objects)*

**obra conmemorativa** Obra de arte u otro objeto que ayuda a las personas a recordar algo, como un suceso o una persona importante. *(memorial)*

**orgánicas** Formas cuyos perfiles son irregulares, como por ejemplo, los objetos que se hallan en la naturaleza. *(organic)*

**paisaje urbano** Una obra de arte cuyo tema es una vista de una ciudad (edificios, calles, tiendas). *(cityscape)*

**panorámica** El movimiento de la cámara durante la filmación. *(pan)*

**patrón aleatorio** Patrones originados por arreglos accidentales o que se reproducen sin un diseño consistente. Por lo general, los patrones aleatorios son asimétricos, irregulares y no uniformes. *(random pattern)*

**patrón planificado** Patrón desarrollado y creado de manera sistemática y organizada. Ya sean manufacturados o naturales, estos patrones son precisos, mensurables y consistentes. *(planned pattern)*

**patrón** Selección de líneas, colores o formas, que se repiten constantemente de manera planificada. Un patrón es también un modelo o guía para realizar algo. *(pattern)*

**perspectiva de dos puntos** Un método para crear la ilusión de profundidad en una superficie plana. En la perspectiva de dos puntos hay dos puntos de fuga en la línea del horizonte. *(two-point perspective)*

**perspectiva lineal** Técnica que se utiliza para mostrar un espacio tridimensional sobre una superficie bidimensional. *(linear perspective)*

**pigmentos** Materiales para colorear que se hacen con tierra, minerales triturados, plantas o productos químicos. Los pigmentos se mezclan con un líquido o substancia aglutinante (como pegamento, huevo, cera o aceite) para hacer pintura, tinta, colorantes o lápices de cera. *(pigments)*

**precolombino** Un término que se usa en historia del arte para describir el arte y las civilizaciones de América del Norte y del Sur, anteriores a la época de la conquista española. *(pre-Columbian)*

**principios de diseño artístico** Directrices que ayudan a los artistas a componer diseños y a controlar la manera cómo los observadores puedan reaccionar con las imágenes. El equilibrio, el contraste, la proporción, el patrón, el ritmo, el énfasis, la unidad, y la variedad son principios de diseño. *(principles of design)*

**proceso de substracción** En escultura, proceso mediante el cual se talla o se recorta el material (arcilla, por ejemplo) para crear la forma. En un proceso de adición, por el contrario, se agrega material para crear la forma. *(subtractive process)*

**productivistas** Un grupo de artistas rusos vanguardistas que sostenían que el arte es útil para la sociedad. Creían que podíamos lograr un mundo mejor mediante la combinación del arte, las labores artesanales y la industria. *(Productivists)*

**proporción** Relación de un objeto con otro en cuanto a tamaño, cantidad, número o grado. *(proportion)*

**proporciones** La relación entre dos partes del cuerpo en cuanto a su tamaño, cantidad y grado. *(proportions)*

**pueblo** Una tribu de indígenas del sudoeste de los Estados Unidos. *(pueblo)*

**pulpa** Material triturado, por lo general fibra de madera o de plantas, que se usa para hacer papel. *(pulp)*

**puntillismo** 1880–1900. Un estilo de pintar en el que se colocan pequeños puntos de colores uno junto a otro. Cuando la obra se observa desde lejos, el ojo tiende a ver los colores mezclados. *(pointillism)*

**radial** Especie de equilibrio en el cual las líneas o las formas se extienden a partir de un punto central. *(radial)*

**rascacielos** Edificios muy altos. *(skyscrapers)*

**récord científico** Obras de arte u obras escritas que cuentan con un nivel muy alto de exactitud y de detalle, utilizadas para documentar o clasificar las especies. *(scientific record)*

**regionalista** Artista cuyo arte está orientado hacia una región o sección en particular del país. *(Regionalist)*

**Renacimiento de Harlem** 1920–1940. Nombre de un período y de un grupo de artistas que vivieron y trabajaron en Harlem, en la ciudad de Nueva York. Estos artistas expresaron de distintas formas su experiencia como afroamericanos. *(Harlem Renaissence)*

**retratismo** El arte de hacer retratos. *(portraiture)*

**retrato** Una obra de arte que muestra a una persona o un grupo de personas en particular. *(portrait)*

**ritmo** Tipo de movimiento visual o real en una obra artística. El ritmo es un principio de diseño. Se crea mediante la repetición de elementos visuales. A menudo, el ritmo se describe como regular, alternativo, fluido, progresivo o animado. *(rhythm)*

**serigrafía** Un tipo de impresión que se logra haciendo pasar la tinta a través de una pantalla de seda hasta el papel que se encuentra debajo, donde se imprime la estampa. *(serigraph)*

**simétrico** Tipo de equilibrio en el cual los dos lados de una línea central son exactamente o casi iguales, como un reflejo exacto. Por ejemplo, las alas de una mariposa son simétricas. A este tipo de equilibrio también se le denomina equilibrio formal. *(symmetrical)*

**sombra** Cualquier pigmento oscuro de un color que, por lo general, se crea al añadir negro. *(shade)*

**sombreado** Un cambio gradual en la intensidad, de más oscuro a más claro. *(shading)*

**surrealismo** Un estilo artístico en el cual los sueños, la imaginación y la mente humana son la fuente de inspiración artística. A menudo, objetos y situaciones que normalmente no están relacionados entre sí confluyen en un mismo ambiente no natural. Se conoce como surrealistas a los artistas de esta escuela. (*Surrealism*)

**tecnología** El arte de crear cosas para hacernos la vida más fácil. (*technology*)

**tema** Tópico o idea que se muestra en una obra artística, en particular cualquier cosa que sea reconocible, como un paisaje o los animales. (*subject*)

**textura implícita** Manera en que parece verse una superficie: áspera o lisa. (*implied texture*)

**textura** Manera en que se siente una superficie (textura real) o cómo se ve (textura implícita). Podemos sentir la textura gracias al tacto y a la vista. Palabras como áspera, sedosa, rugosa se usan para describir la textura. (*texture*)

**tohunga** Un término de la tribu maori que significa "sacerdote artesano". Un maestro escultor de la tribu maori de Nueva Zelanda. (*tohunga*)

**toma del día** La filmación que se realiza en un día durante el rodaje de una película. (*dailies*)

**tonalidad** Matiz de color. (*hue*)

**tradiciones** Costumbres, acciones, pensamientos o creencias que se transmiten de una generación a otra, ya sea de forma oral o mediante el ejemplo. (*traditions*)

**tríada** Tres colores igualmente espaciados entre sí en la rueda de colores, como por ejemplo, el anaranjado, el verde y el violeta. (*triad*)

**ukiyo-e** Dibujos japoneses que representan el "mundo flotante" del distrito de Edo. Al comienzo se hacían con pintura, pero son más comunes las xilografías de diversos colores. Son una creación exclusiva del período Edo (1603–1868). (*ukiyo-e*)

**unidad** Sensación de que todas las partes de una obra artística funcionan juntas como un conjunto. (*unity*)

**valor** Elemento artístico que denota el grado de oscuridad o claridad de una superficie. El valor depende de la cantidad de luz que puede reflejar una superficie. Los matices claros son valores leves de los colores puros. Las sombras son valores oscuros de los colores puros. El valor también tiene importancia como elemento en las obras artísticas que muestran una cantidad mínima o inexistente de color (dibujos, grabados, fotografías, la mayor parte de la escultura y la arquitectura). (*value*)

**vanguardismo** Un término que describe las manifestaciones artísticas originales y que se distinguen de los estilos artísticos tradicionales. Los artistas vanguardistas a menudo experimentan con nuevos materiales y nuevas formas de expresar sus ideas. (*avant-garde*)

**variedad** Uso de diferentes líneas, formas, texturas, colores y otros elementos del diseño con el fin de crear interés en la obra artística. (*variety*)

# Index

Index

331

# Teacher's Reference Material

Photo courtesy Karen Miura, Kalakaua Middle School, Honolulu, Hawaii.

# Program Overview

## Why Themes?

We believe that art is inescapably linked to the experience of being human. As humans throughout the world and over time have sought ways to understand the world and their place within it, they have created objects and rituals to assist them. The series draws upon the activities and inclinations that humans have in common. It makes the connection between those commonalities and the art that people have made in the past and continue to make in the present.

The themes found throughout the program are informed by the ideas of educator Ernest Boyer, who proposed a list of shared human experiences. Boyer generally proposed that all humans experience life cycles, develop symbols, respond to the aesthetic dimension of experience, and develop various forms of bonding together socially. He claimed that humans have the capacity to recall the past and anticipate the future. Humans are inseparably a part of nature and, as such, are connected to the ecology of the planet. Humans share a tendency to produce—to work—and to consume. Boyer also proposed that all humans seek to live their lives with a sense of meaning and purpose. Boyer proposed that a quality curriculum might be grounded in a recognition of these shared human needs and interests—that all school subjects include directly-related content and inquiry modes.

In the chapters throughout the series, art is presented as an inseparable part of each of these common human themes. Art is an important way in which people communicate their ideas while seeking to live a meaningful life. In cultures throughout the world, people develop ways to communicate through visual symbols. The ideas are tied to cultural value and belief systems, as are the specific purposes that art serves within the culture. Art forms vary according to traditions within the culture. Changes in tradition occur when cultures connect, or when individuals and groups seek to expand ideas and techniques central to art-making practice. Understanding art made throughout the world and over time is inextricably linked to the study of culture and tradition.

## Curriculum Structure

The art curriculum presented in *Art and the Human Experience* builds upon student learning in relation to expression through and response to art. Students learn to create artworks and to express their experiences visually. They also learn how and why artists of the past and present have created art. Students learn to perceive, think, talk and write about art they encounter—their own artworks, those made by their classmates, and those created by others throughout the world and over time. Students become aware of beauty in the environment, understanding the importance of art and design in everyday life. They learn about careers in art and community art resources. Students learn to truly enjoy the processes involved in creating and responding to art.

### Text Organization

The texts are organized into two major parts. **"Foundations"** includes an overview of basic content in and inquiry approaches to art. Depending upon your students' prior knowledge, you may wish to use the Foundations chapters as a way of reviewing or, in some cases, introducing this content. **"Themes"** approaches the content through multi-layered themes drawn from Boyer's list of human commonalities. The Core Lesson of each chapter introduces the theme and its art-related key ideas. The additional four lessons of the chapter explore the theme in more depth, considering the ideas through art history, art foundations, global connections, and studio production. Depending upon the structure for teaching art in your school, you may only have the opportunity to explore the Core Lesson of each chapter. Alternatively, you may be able to include one or more of the additional lessons, providing your students with opportunities for gaining deeper understanding of the thematic content.

### Creating and Responding to Art

Art is above all a creative activity, one that develops students' abilities to visually express their experiences. Throughout the many studio experiences in the program, students are encouraged to be purposeful as they make artworks. They are helped to generate ideas and to develop skills in the use of materials and techniques to achieve desired effects.

Photo courtesy Betsy Logan, Samford Middle School, Auburn, Alabama.

Learning to perceive artworks with an active eye and responsive mind is the foundation for a lifelong interest in, and appreciation of, art. The program is designed so that students gain new insights as they examine and investigate artworks and offer possible interpretations about their meaning. They learn from each other in discussing important questions about art. Talking about art provides students with opportunities to voice their opinions and hear those of their classmates. Writing about art also provides them with opportunities to clarify their own thinking about the artworks they encounter.

## The Disciplines of Art

The content of *Art and the Human Experience* is based upon knowledge in the various disciplines of art. These include the creation of art (art production), art history, aesthetics and art criticism. The content is informed by research in related areas of inquiry such as art education, the psychology of art, the sociology of art, and cultural anthropology. Students are introduced to central ideas and perspectives of the disciplines as well as to the characteristic methods of disciplinary inquiry.

**Art Production** The program includes many opportunities for students to express their ideas and feeling by using a variety of materials and techniques. As students observe the world, recall and reflect upon past experience, and use imagination to engage purposefully in the creation of their own artworks, they learn that reflection is an important part of the art-making process. Through discussion and self-reflection, students consider the ways their artworks reflect their ideas and feelings. They consider the decisions they make during the creative process, focusing on their ideas, their choice of materials, their ways of using materials, as well as their work habits. Reflection upon the creation of art involves consideration of artworks students have made in the past and how their current work builds upon or departs from past art-making experiences. Reinforcing the notion that much of what humans make reflects memories of, preferences for, or connections to certain artworks or art traditions, students consider the influences that other artworks have had on their art-making decisions.

**Art History** Students learn to seek information regarding the social and historical context in which artworks are made. The study of human history and cultures reveals how humans have created and used art for important social and individual purposes. Students study themes, styles, traditions, and purposes of art throughout the world and over time. They learn about individual artists and how their artworks reflect or influence ideas and beliefs of the time in which they were created. Using art-historical inquiry processes, students learn to consider their own perceptions of artworks along with contextual information, and to propose historical explanations.

**Art Criticism** Art criticism is critical thinking about individual artworks or groups of artworks. Students learn how to carefully observe and describe details in artworks. They learn how to analyze the structure and organization of artworks. Interpretation involves making inferences about possible meanings of artworks. Students learn how to offer interpretations of artworks, supported by what they perceive, relevant contextual information, and their own experiences and points of view. As they learn how to offer interpretations, they also learn how to make judgments about the plausibility of those offered by others. Students also learn how to judge the merit and significance of artworks, using standards from individual and socio-cultural beliefs, values, purposes and traditions.

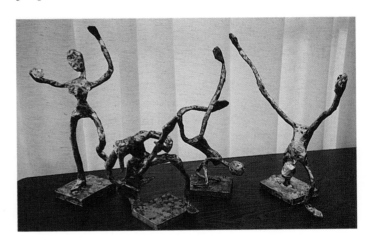

Photo courtesy Bunki Kramer, Los Cerros Middle School, Danville, California.

**Aesthetics** Aesthetics is a branch of philosophy that developed out of an interest in explaining the concept of beauty. It has evolved into a discipline in which a wide range of philosophical questions are addressed. Rarely do students engage in inquiry about the meaning or merits of particular artworks, about the history of art, or about the processes involved in making art without asking questions that are essentially philosophical questions. Students wonder what art is, why people create it, why people in some cultures are considered artists while others are not, what counts as good art, and how we can know what an artwork means. In *Art and the Human Experience*, students are provided opportunities to raise and address philosophical questions related to their art

study. They are encouraged to reflect on their ideas about art in general and to keep track of their changing ideas. Through reflection and discussion, students learn that ideas about art vary among individuals and cultures. They are encouraged to respect alternative points of view. They learn to listen to and learn from their classmates as they engage in the study of art of the past and present from around the world.

## Multicultural and Global Content

As we become increasingly aware of cultural and ethnic diversity in our nation and increasingly aware of the broad spectrum of artistic expression throughout the world, teachers of art are challenged to create ways in which this diversity can be recognized and understood by our students. We must provide students the opportunity to gain insights about themselves, about others, and about the world in which they live by attending to diversity in artistic expression. *Art and the Human Experience* addresses this task in two ways: 1. through the study of art that reflects ethnic and cultural diversity within our own culture, and 2. through the study of art with a global perspective. The disciplines of art provide lenses through which students learn to understand and appreciate the richness of artistic expression close to home and throughout the world.

## The Importance of Contemporary Art

If students are to understand and appreciate the integrative role that art plays in their lives, they need to see, study, and appreciate artworks made by people living along with them in their local and worldwide communities. The study of art from the past helps students understand the origins of and traditions associated with contemporary artworks. They learn that artists today, as in the past, respond to ideas, needs, issues, and events in the time and place in which they live. *Art and the Human Experience* includes many examples of contemporary art from close to home and around the world. It proposes that students be encouraged to seek out contemporary artworks and to learn from local artists.

## Content Knowledge, Disciplined Inquiry, and Learning for Life

When students construct knowledge, they organize, synthesize, interpret, explain, or evaluate information. To do this well, they must build upon prior knowledge that others have produced—the content knowledge in the art disciplines. As students assimilate prior knowledge, they hone their skills through guided practice in producing artworks, conversation, and writing. *Art and the Human Experience* encourages thoughtful use and application of content knowledge.

Disciplined inquiry is important cognitive work. It employs the facts, concepts, and theories that other inquirers have produced. Students are encouraged to develop in-depth understanding of problems as they raise questions and explore issues, relationships, and complexities within focused topics and themes.

Through the construction of knowledge through disciplined inquiry, students are offered opportunities to produce artwork and discourse that have aesthetic, useful, and personal meaning and value beyond demonstration of success in school. *Art and the Human Experience* proposes connections to life in the school and local community, to the performing arts, and to other curriculum areas.

## Program Fundamentals

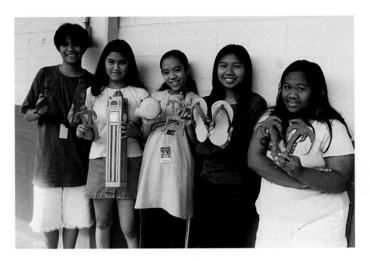

Photo courtesy Karen Miura, Kalakaua Middle School, Honolulu, Hawaii.

## The Importance of Inquiry

Teaching strategies within *Art and the Human Experience* are aimed toward developing deep understanding. Toward this end, we have included many opportunities for students to raise and address questions prompted by the chapter content. Such opportunities can be found in the student book where questions are posed in the body of text, in captions, and in review questions in the lessons and at the end of each chapter. The teacher's edition includes many suggestions for engaging students in inquiry. These can be found in sections such as "Using the Text," "Using the Art," and "Teaching Options." We believe that inquiry is enhanced when students collaborate with each other. Many teaching suggestions include activities in which students collaborate in pairs or in small or large groups.

## Creating an Environment for Learning

We know that teachers want their artrooms to be safe places—places where students feel comfortable sharing their ideas, concerns, fears, and dreams. Students need to know that they are respected as learners. They need to know that their ideas are valued, that what they have to say will be heard. They need to trust that they will not be put down by their peers. If students are to be comfortable raising and addressing questions, they need to

know that they are free to voice their concerns and their ideas—that their opinions matter.

The learning environment must be a place where inquiry is encouraged and where curiosity is important. These aspects not only need to be valued, but they also need to be modeled. Teachers who want their students to ask and address questions must be willing to ask questions themselves. Learners are far more likely to engage authentically in inquiry when their teacher assumes the role of a fellow inquirer, someone who is curious and who shares with students that sense of wonder that is at the root of all learning.

The teacher's role is as a facilitator or "coach" in the learning process. Breaking away from the role of one who has most of the answers is not always easy. It means shifting away from the experience of our own schooling, where the teacher knew the answers and we saw the teacher as one who imparts truth. In many cases, it means being willing to admit to not having all the answers. This takes confidence, and it takes commitment to the belief that students learn best when they are addressing questions that stem from their own experiences.

## Instructional Strategies

In *Art and the Human Experience*, students are engaged in the fundamental activities of learning; along with art-making, they are engaged in reading, listening, speaking, and writing. Suggested strategies aim toward helping students acquire, evaluate, organize, interpret, and communicate information. You will note that many suggested strategies involve helping students to learn to reach beyond resources in the school for information.

**Reading the Text** Students' interests and abilities in reading vary within and across classes. It is important to recognize that reading in art, like reading in other subjects, is a tool for learning and a means of communication. Students who are still learning to read may not be able to acquire information from the text rapidly. Even so, slow readers are often fascinated with art texts precisely because the written text is a supplement to the visual information.

Throughout the student text, captioned images, bold-face headings and topically coherent page layouts have been used to aid students. Many captions also contain questions to guide perception and reflective thinking.

**Preparation for Reading** Always plan ahead and read each chapter before making any assignments. You might assign a full lesson or divide it into manageable and meaningful units. When you give a reading assignment within a new lesson, first have students **preview** the text. Have students scan the reading assignment to understand the main ideas in each part. They should look at the introduction, headings, subheadings and images. If review questions come at the end of the section, students can use them to help identify main points of the reading assignment.

Students should next **analyze** the text. A useful strategy to help students understand the purpose of a particular section is to have them turn a heading into a question. If the heading is, "Artists Show Us at Work and Play," recast it as the question, "How do artists show us at work and play?" The question helps readers search for supporting details in the text. As students carefully **read** the text, they can jot down and try to find answers to questions they have about the topic.

As they read, they can **evaluate** the material in the text, taking notes about main ideas. Show students how to take brief notes that are clear enough to understand when they return to them. The teacher's text has many suggestions for discussing the ideas presented in the student text.

**Review** is the final important step in the reading process. Students should review their notes to make sure they have highlighted the most important information. They may need to reread a section to clarify the main ideas. Help students make connections, asking them how the new information challenges, refutes, supports, or enlarges their understanding of the subject.

One way to help students make sense of what they have read is to have them create **graphic organizers**. The Teacher's Resource Binder (TRB) has blank concept maps and other organizers to assist students in this process. In completing a concept map, students can put the main idea in the center of the map and draw spokes to connect related ideas. Graphic organizers can be used to study or to take notes for discussions, art-making experiences, and written or oral work. The teacher's text periodically suggests that students create graphic organizers to help understand or explain the major ideas in a lesson.

Class time devoted to reading can be reduced by assigning sections of chapters as homework, by assigning teams to read and report on sections, and by selective oral or silent reading within the text. Oral reading by students is most effective when it is preceded by silent reading. This gives students time to become familiar with the content and try out unfamiliar vocabulary.

**Writing Assignments** Written assignments can be an integral part of learning about art. Writing is a form of reflective thinking, and is especially helpful for developing vocabulary, practicing art criticism, and reflecting about artwork, and keeping a journal. Various assignments engage students in descriptive, persuasive, expository, narrative, and imaginative writing. Students can apply what they have learned in other subjects about preparing drafts, revising, and completing finished work. Throughout the program, they are encouraged to share their writing with peers.

Photo courtesy Betsy Logan, Samford Middle School, Auburn, Alabama.

**Talking About Art** Throughout the program, you will find suggestions for having students engage in discussions about specific artworks and issues related to art. At times, we suggest large group discussions in which the teacher functions as the facilitator. Eventually, students can assume the facilitator role, using the teacher as a model. Talking about art also takes place in small groups or in pairs of students. Students who are reluctant to contribute to large group discussions often will gain confidence by working in smaller groups. We can help students to hone their listening skills and their skills in providing cogent arguments for their positions. Through these discussions, students gain insights about their own thinking as well as that of their peers. These insights are important to their experiences in meaningful art making.

## Assessment

As we encourage students to acquire deep understanding of important concepts and skills associated with art, it is important to establish means for determining the extent to which students have developed such understandings. The objectives within *Art and the Human Experience* are aligned with national standards. The content of the student text and the instructional strategies in the teacher's edition are aligned with these standards and the lesson objectives. There are opportunities throughout the program to assess student learning. For example, each lesson is followed by a Check Your Understanding component, aimed at helping students identify the main ideas of the lesson. In addition, the Teaching Options within the teacher's edition contain suggestions for assessment. In some cases, the assessment strategies are designed so that the teacher reviews the work and determines the extent of learning on the part of the student. Such strategies are marked as "Teacher Assessment." Strategies are also designed for "Peer" or "Self" Assessment. In every case, criteria are embedded in the description of the assessment strategy.

We suggest that teachers discuss the learning objectives for each lesson with the students. Students and teachers can plan and negotiate activities that will pave the road to achievement. Inform students about what they are expected to know and be able to do as a result of their engagement. The road to achievement should be clearly marked so as to avoid the appearance of a guessing game or treasure hunt—a frustrating state of affairs for all involved.

The questions in each Chapter Review are based on the commonly used system for asking questions and developing tests, *The Taxonomy of Educational Objectives: Handbook I: Cognitive Domain* (White Plains, NY: Longman 1956, 1977). Higher-order thinking is used increasingly as students move through questions requiring them to recall important information, show that they understand key ideas, apply their understanding to new situations, analyze information, synthesize and communicate what they have learned, and make judgments based upon criteria. Negotiate which of the items students will complete in order to demonstrate their understanding.

Teaching suggestions and options provide opportunities to engage in Formative Assessment, judging the extent to which students understand key ideas and demonstrate important skills stated in the objectives. In addition, each chapter contains a Reteach component, with suggestions for reviewing major concepts and skills.

## Meeting Individual Needs

The lessons in *Art and the Human Experience* were designed with attention to the challenge that teachers face in adapting instruction to the needs of all learners. After defining and identifying students' areas of strength, teachers can adapt suggested strategies in the lessons to address the different ways in which their students best learn.

**Kinesthetic Learners** Some students learn best when actively engaged in hands-on approaches, body-movement activities, and other tactile experiences.

**Verbal Learners** Verbal or auditory learners seem to learn most readily through speaking and listening activities.

**Logical Learners** Some students seem to learn best when engaged in problem-solving or step-by-step explorations. Logical learners tend to seek quantitative results.

**Spatial Learners** Spatial learners tend to explore the world around them. They are visually oriented and learn best with pictures, three-dimensional props, and with activities that require them to translate verbal or written materials into visual terms.

**Musical Learners** Some students learn best when they have the opportunity to listen to or create rhythms. Such students tend to be musically inclined.

**Gifted and Talented Learners** Students who learn at an accelerated pace or show a particular talent need assignments that challenge their abilities. When working with these students, teachers can employ the strategies suggested for all of the learning styles above.

**ESL Learners** Students acquire English as a second language in successive stages, from nonverbal understanding to fluency. To aid these students, consider using picture clues, real-life scenarios, and peer work with English-speaking classmates. Students who are learning English as a second language may exhibit characteristics of any of the above learning styles.

## Other Special Needs

To the extent possible, introduce the regular curriculum to students with special needs.

**Visual impairments** These students can respond to discussions of artwork, especially themes related to the students' experiences and imagination. For studio work, create tactile, kinesthetic artwork out of materials such as clay, textured paper and cloth, small boxes or wood blocks to arrange.

**Speech and hearing impairments** Slow down the process of verbal communication, and use nonverbal means of communication. Have students point out what they see or encourage them to use pantomime to express their responses. Present information through diagrams, charts, and other visual aids. These nonverbal forms of communication are valuable for all students.

**Impaired mobility and medical problems** These students may require the use of alternate tools and materials for some activities. In most instances, rehabilitation specialists can help you solve unique problems. A number of special tools—such as scissors and a mouthpiece that holds a pencil or brush—are available for students who have physical impairments.

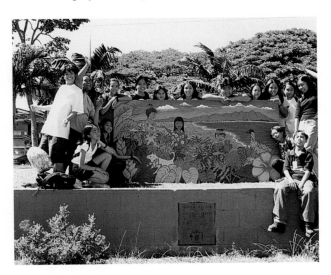

**Photo courtesy Karen Miura, Kalakaua Middle School, Honolulu, Hawaii.**

# Relating Other Subjects to Art

The subject of art is a distinct and important part of the total curriculum. Just as the study of art can enrich students' understanding of other subjects, so, too, can their studies of other subjects be linked to art. A few of these possibilities are outlined here.

## Language Arts

**1.** Develop the art vocabulary of students.
• Write art terms and concepts on the chalkboard. Refer to them during the entire lesson.
• Develop lists of adjectives and adverbs to describe art elements and moods in artworks: Lines can seem lazy, energetic, or bold. (A useful resource is the set of Expressive Word Cards found in the Teacher's Resource Binder.)
• Ask for complete and complex descriptions: "I see a large, red square near the center of the painting."
**2.** Encourage reflective inquiry into art.
• Engage students in analysis and comparison: "This large, simple form seems to balance this small, patterned form." "This drawing has many more details than that one."
• Develop skills in critical thinking. Ask for interpretations of visual evidence, explanations based on "visual facts." Hypothesize about what an artist wanted us to see, feel, and imagine.
**3.** Have students read about art.
• Encourage oral and written reports on favorite artworks and artists.
• Create original art based on poems or stories.
• Study the arts of book illustration, alphabet design, and calligraphy.

## Social Studies

**1.** Teach students about the role of art in everyday life.
• Acquaint students with places where they can see art in their community: parks, malls, and plazas; outstanding examples of architecture; and art museums and galleries.
• Study the useful products artists design, such as advertisements, illustrations in books and magazines, dinnerware, appliances, automobiles, and clothing.
• Introduce students to careers in art and to people in their communities whose primary work centers on art and design.
**2.** Teach students about the rich heritage of art, past and present.
• Stress the process of looking at art and reasons people around the world create art. Appreciation of varieties of art is more important than names, dates, and technical information.
• Make students aware of the accomplishments of men and women and specific cultural groups.

## Science, Mathematics, and Technology

**1.** Teach students how artists interpret the natural world and use scientific knowledge.

• Emphasize the importance of careful observation in art and in science, identifying things by their shape, size, texture, color, weight, and so on.

• Explore the many ways artists have expressed their ideas and feelings about the natural world—changing seasons, weather, the beauty of forms in nature, etc.

• Have students create original artwork based on their observations of the subtle colors, textures, patterns, and movement of natural forms, plants, animals, and clouds.

**2.** Teach students how skills in mathematics and computer technologies apply to art.

• Emphasize how artists use their knowledge of measurement and geometric shapes and forms in designing architecture, in planning beautifully proportioned vases, and in many other aspects of art.

• Demonstrate the many uses of computers in creating art and in research on art.

## Other Arts

A complete education in the arts will include studies of the visual arts along with the language arts (written and oral expression) and performing arts (music, dance, and theater). Each art form provides a unique avenue for sharing ideas and feelings with others.

**1.** Teach concepts that apply to all the arts.

• In each art form, there are creative originators of ideas—composers of music, choreographers of dance, playwrights, poets, and authors.

• All artists explore and master their chosen media. Artists transform sounds into music, movements into dance, interactions of people into theater, qualities of paint into images, and words into meaningful poems and stories.

• Every art form has compositions, designs, or arrangements that are unique to its medium. This explains why each artwork and each art form is unlike others.

**2.** Illustrate relationships among the arts.

• Note how terms from music are sometimes used to describe things we see: "loud" colors, "rhythmic" patterns of shapes, and "harmonious" designs.

• Relate the qualities of movement in dance to actual or implied movement in visual art: A line may seem to "twist and turn" in space, as if it is "dancing."

• Have students create masks, puppets, and plays. Discuss the visual qualities of these elements, including stage scenery, makeup and costumes, as important facets of the art of theater.

• Help students appreciate how television, video, and film, major art forms of our time, uniquely combine other art forms: music, choreography, etc.

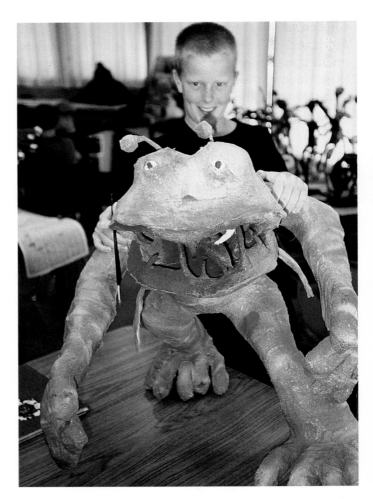

Photo courtesy Bunki Kramer, Los Cerros Middle School, Danville, California.

## Building Support for the Art Program

It is important to have support for your program. Educate teachers, administrators, counselors, parents, and community groups about your program. Prepare information on how they can assist your efforts. Organize a parent or business group to give special support by volunteering—arranging field trips, collecting recyclable materials, or sponsoring special events.

Develop a teacher-student art newsletter or Web page. It might include samples of artworks, aesthetic observations, special requests for the art program, invitations to see exhibits, and the like.

Develop a plan and timetable for student involvement in exhibitions within and beyond the school. Delegate some of the responsibilities to students. For example, rotate student work in main offices, the teacher's lounge, and halls. Always include captioned descriptions of the art concepts or student descriptions of the ideas and processes.

There are several periods during which you may plan special exhibits and related activities to focus attention on the art program. In the United States, for example, March has been designated Youth Art Month by the National Art Education Association. At this time, teachers in all schools are urged to make parents and the community aware of the enthusiasm young people have for art and the ways they are engaging in creating and studying art. In addition, many teachers in North America have special exhibitions near the end of the year, when students are best able to demonstrate what they have learned.

Develop skills in preparing press releases and contacting the news media, so that exceptionally newsworthy or timely activities can be reported to the community.

Participate in art education and art associations. They are the most valuable paths to professional growth, renewal, and awareness of developments that might help you in your work.

Find out about artists-in-education programs available in your community. Art supervisors and arts councils can provide information. Find out about the educational programs offered by art museums and what is required of you and your students to take advantage of them.

## Maintaining the Artroom

### Safety

Concerns about safety make it essential for you and your students to be particularly aware of hazardous art materials or processes. Safety glasses, dust masks or respirators, and rubber gloves are among the most common items you should have on hand.

Throughout *Art and the Human Experience*, Safety Notes are highlighted. However, the responsibility for safety in your artroom rests first and foremost with you. Review all safety procedures required for an art activity with students. Before you allow them to begin, make sure all students understand safety precautions and the reasons for them. Written safety rules with tests and active demonstrations of understanding are especially important prior to beginning any activity that involves chemicals, fumes, dust, heat, cutting tools, or electricity.

Art programs utilize all kinds of specialized equipment, materials and tools. Precautions must be taken to insure that working with art materials does not lead to student illness or injury. Failure to take necessary precautions may result in litigation if students become ill or are injured in the artroom. While restrictions are necessary, the teacher should be assured that nontoxic materials can usually be substituted for toxic ones with little or no extra cost, and good artroom management will prevent accidents.

Under the art material labeling law passed by Congress in October, 1988, every manufacturer, distributor, retailer and some purchasers (schools) have a legal responsibility to comply with this law. The law amended the Federal Hazardous Substances Act to require art and craft materials manufacturers to evaluate their products for their ability to cause chronic illness and to place labels on those that do.

The Art and Craft Materials Institute, Inc. has sponsored a certification program for art materials, certifying that CP, AP, and HL labeled products are nontoxic and meet standards of quality and performance.

CP (Certified Product) are nontoxic, even if *ingested, inhaled* or *absorbed*, and meet or exceed specific quality standards of material, workmanship, working qualities and color.

AP (Approved Products) are nontoxic, even if *ingested, inhaled* or *absorbed*. Some nontoxic products bear the HL (Health Label) seal with the wording, "Nontoxic," "No Health Labeling Required." Products requiring cautions bear the HL label with appropriate cautionary and safe use instructions.

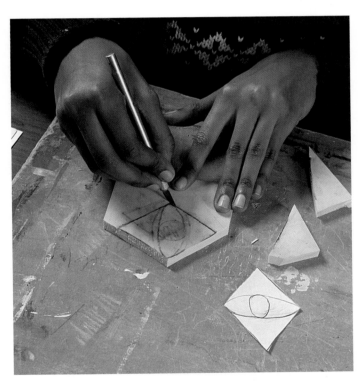

**Photo courtesy Sara Grove Macauley and Sharon Gorberg, Winsor School, Boston, Massachusetts.**

Teachers should check with their school administrators to determine if the state board of education has prepared a document concerning art and craft materials that cannot be used in the artroom, and listed products that may be used in all grade levels. If no list is locally available, contact The Art and Craft Materials Institute, Inc., 715 Boylston Street, Boston, MA, 02116 for a list of art products bearing the CP, AP, or HL/Nontoxic Seal.

In addition to determining that only nontoxic media are available in the classroom, the teacher is responsible for instruction in how to use all tools and equipment correctly and safely.

Make sure that the artroom has accident-preventing items such as the following:
• Signs on or near all work areas and equipment where injury might occur if students are careless, or should have instruction prior to use of the equipment.
• Protective equipment such as safety glasses, respiratory masks and gloves.
• A first aid kit containing antiseptics, bandages and compresses.
• Adequate ventilation to exhaust fumes.
• Safety storage cabinets and safety cans for flammable liquids. It is preferable not to keep them in the classroom.
• Self-closing waste cans for saturated rags.
• Soap and water wash-up facilities.
• Lock cabinets for hazardous tools and equipment.
• Rules posted beside all machines.

Precautions the teacher may take:
• Always demonstrate the use of hand and power tools and machines.
• During demonstrations, caution students concerning any potential hazards related to incorrect use of equipment.
• Give safety tests before permitting students to use tools and machines, and keep the tests on file.
• Establish a safety zone around all hazardous equipment.
• Establish a dress code for safety indicating rules about clothing, jewelry and hair in order to prevent accidents.
• Establish a code of behavior conducive to the safety of individuals and their classmates, and enforce it.
• Keep aisles and exits clear.
• Be aware of any special problems among students such as allergy, epilepsy, fainting or handicap.

Some "Do Nots" for the Safety Conscious Art Teacher:

• Do not absent yourself from the studio when pupils are present.
• Do not ignore irresponsible behavior and immature actions in the artroom.
• Do not make the use of all tools and machines compulsory.
• Do not permit students to work in the artroom without supervision.
• Do not permit pupils that you believe to be accident prone to use power equipment. Check on the eligibility of some mainstreamed students to use power tools.

Teachers should demonstrate constant concern for safety in the artroom, and teach by example to help students accept responsibility for accident prevention. For a thorough discussion of health and safety hazards associated with specific media and procedures see *Safety in the Artroom* by Charles Qualley, 1986.

# Finding and Organizing Resources

Most teachers realize that the environment of the artroom should announce its purpose and be pleasing and functional. The following ideas may help achieve these goals.

**Room-Organizing Resources** Save sections of newspapers with colored advertising, and unusual black-and-white photographs of people, places, and events. Picture-dominated magazines that can be cut up will be useful for a variety of activities. Old newspapers should be available in quantity for covering tables or other uses. Save and develop a file of all news and magazine articles related to art.

Color-code storage bins and boxes. Cover the boxes with contact paper or paint them (with interior house paint) so they reflect definite color schemes.

Reserve space in the room for display of student work, art reproductions, and related teaching aids. If you want to feature biographies and works by selected artists on a regular basis, develop a weekly or monthly plan that provides for balance among art forms, and among men, women, and art from various cultures.

**Visual Resources** Images are essential for teaching about the world of art. A few of the most common types of resources are described below.

**Collections of everyday objects.** Use ordinary objects to help students understand basic art concepts. Reserve an area for display of still-life items. Stacked wood or plastic crates can double as shelves for the items. Move and rearrange the crates and items within them. Living or dried plants, shells, pinecones, and other intriguing natural forms are valuable resources for drawing, design, and other activities.

Photo courtesy Sara Grove Macauley and Sharon Gorberg, Winsor School, Boston, Massachusetts.

**Field trips to see original art.** Plan carefully for trips to art museums and artists' studios as well as tours to study architecture, murals, public sculpture, and the like. To enhance the educational value of such trips, plan several lessons that focus on the purpose of the trip and what students should notice during it. Always follow district rules and procedures for trips beyond school grounds.

Many art museums have special programs for schools. Some programs offer an orientation to the museum so students are well-prepared for their first visit. Other programs introduce students to the process of looking at artworks and acquaint students with the differences between original works and reproductions.

**Visiting experts on art.** You may also invite local artists, craftsworkers, designers, and architects to school for special demonstrations. Arrangements for this should be made with your art supervisor or state or local arts council. Always interview guests in advance to assess their qualifications and ability to present ideas related to your educational goals.

**Reproductions of artwork.** Photographic reproductions of works of art are available in different sizes. Although they are not a substitute for seeing original works of art, every teacher should have access to a library of art prints. Larger prints can be displayed to make part of the room resemble an art museum. Intermediate sizes are excellent for study at a table or desk. Use smaller postcard prints for matching and sorting games.

**Art resource books for students.** Your library or resource center should routinely order art books for students. (See the bibliography in the student text, page 309, for ideas.) Students should also be introduced to the artistry of book design and illustration.

### Publisher's Acknowledgments

**Publisher:** Wyatt Wade

**Editorial Directors:** Claire Mowbray Golding, Helen Ronan

**Fabrication:** C.S. McQuillen

**Editorial/Production Team:** Nancy Bedau, Nancy Burnett, Carol Harley, Colleen Strang, Mary Ellen Wilson

**Editorial Assistance:** Laura Alavosus, Frank Hubert, Victoria Hughes, David Payne, Lynn Simon

**Illustration:** Susan Christy-Pallo, Stephen Schudlich

**Design:** Douglass Scott, Cara Joslin, WGBH Design

**Manufacturing:** Georgiana Rock, April Dawley

# Teacher Bibliography

## Teaching and Learning

Alger, Sandra L.H. *Games for Teaching Art*. Portland, ME: J. Weston Walch, 1995.

Barton, James and Angelo Collins. *Portfolio Assessment*. Reading, MA: Addison-Wesley, 1996.

Beattie, Donna Kay. *Assessment in Art Education*. Worcester, MA: Davis Publications, 1997.

Comstock, Charles W. Jr. *How to Organize and Manage Your Art Room*. Portland, ME: J. Weston Walch, 1995.

Cook, Ande. *Art Starters*. Worcester, MA: Davis Publications, 1994.

Ervin, Barbara Mickelsen. *Making Connections: Interdisciplinary Art Activities for Middle School*. Portland, ME: J. Weston Walch, 1998.

Greer, W. Dwaine. *Art as a Basic: The Reformation in Art Education*. Bloomington, IN: Phi Delta Kappa, 1997.

Greh, Deborah. *New Technologies in the Artroom*. Worcester, MA: Davis Publications, 1999.

Hume, Helen D. *Art History & Appreciation Activities Kit*. Paramus, NJ: Prentice Hall, 1992.

Hume, Helen D. *A Survival Kit for the Secondary School Art Teacher*. Paramus, NJ: Prentice Hall, 1990.

Hume, Helen D. *The Art Teacher's Book of Lists*. Paramus, NJ: Prentice Hall, 1998.

Lazear, David. *Multiple Approaches to Assessment*. Tucson, AZ: Zephyr Press, 1998.

Levi, Albert William and Ralph A. Smith. *Art Education: A Critical Necessity*. Chicago, IL: University of Illinois Press, 1991.

Qualley, Charles. A. *Safety in the Artroom*. Worcester, MA: Davis Publications, 1986.

Thompson, Kimberly and Diana Loftus. *Art Connections: Integrating Art Throughout the Curriculum*. Reading, MA: Addison-Wesley, 1994.

Walkup, Nancy Reynolds. *Art Lessons for the Middle School: A DBAE Curriculum*. Portland, ME: J. Weston Walch, 1992.

Watson, George. *Teacher Smart: 125 Tested Techniques for Classroom Management & Control*. Paramus, NJ: Prentice-Hall, 1996.

## Aesthetics

Dissanayake, Ellen. *What is Art For?* Seattle, WA: University of Washington Press, 1988.

Parsons, Michael J. and H. *Gene Blocker*. Aesthetics and Education. Chicago, IL: University of Illinois Press, 1993.

Parsons, Michael J. *How We Understand Art*. NY: Cambridge University Press, 1987.

Stewart, Marilyn. *Thinking Through Aesthetics*. Worcester, MA: Davis Publications, 1997.

## Art Criticism

*Artchart Poster Series: Elements and Principles of Design Posters*. Glenview, IL: Crystal Productions.

Barrett, Terry. *Talking About Student Art*. Worcester, MA: Davis Publications, 1997.

Barrett, Terry. *Criticizing Art. Understanding the Contemporary*. Mountain View, CA: Mayfield Publishing Co., 1994.

Hobbs, Jack and Richard Salome. *The Visual Experience*. Worcester, MA: Davis Publications, 1995.

Wolff, Theodore F. and George Geahigan. *Art Criticism and Education*. Chicago, IL: University of Illinois Press, 1997.

## Art History

### General

Addiss, Stephen and Mary Erickson. *Art History and Education*. Chicago, IL: University of Illinois Press, 1993.

*Art: A World History*. NY: DK Publishing, 1997.

*Artchart Poster Series: Know the Artist Posters: Sets 1 and 2*. Glenview, IL: Crystal Productions.

Brommer, Gerald F. *Discovering Art History*. Worcester, MA: Davis Publications, 1997.

Cerrito, Joan, ed. *Contemporary Artists*. Detroit, MI: St. James Press, 1996.

Chilvers, Ian, Harold Osborne and Dennis Farr. *The Oxford Dictionary of Art*. NY: Oxford University Press, 1994.

Cumming, Robert. *Annotated Guides: Great Artists*. NY: DK Publishing, 1998.

*Chronicle Encyclopedia of History*. DK Publishing. (CD-ROM)

*Chronicle of the 20th Century*. DK Publishing. (CD-ROM)

*Eyewitness History of the World 2.0*. DK Publishing. (CD-ROM)

Janson, H.W. *History of Art*. NY: Harry N. Abrams, Inc., 1995.

Sister Wendy Beckett. *Sister Wendy's 1000 Masterpieces*. NY: DK Publishing, 1999.

Sister Wendy Beckett. *Sister Wendy's Story of Painting*. NY: DK Publishing, 1997.

Stokstad, Marilyn. *Art History*. NY: Harry N. Abrams, Inc., 1995.

Strickland, Carol and John Boswell. *The Annotated Mona Lisa: A Crash Course in Art History from Prehistoric to Post-modern*. Kansas City, MO: Universal Press Syndicate Co., 1992.

## Time Lines

Bridges, Barbara and Peter Furst. *Arts of Mexico Timeline.* Tucson, AZ: Crizmac.

Mackey, Maureen. *Ceramic Innovations: Global Art Timeline.* Worcester, MA: Davis Publications, 1997.

Millard, Anne. *A Street Through Time.* NY: DK Publishing.

*Millennium Timeline Sticker Book.* NY: DK Publishing, 1999.

Scarre, Chris. *Smithsonian Timelines of the Ancient World.* NY: DK Publishing, 1993.

*Time Line of Culture in the Nile Valley and its Relationship to Other World Cultures.* NY: Metropolitan Museum of Art, 1979.

## Ancient World

Arnold, Dorothea. *An Egyptian Bestiary.* Metropolitan Museum of Art, 1995.

Burenhult, Goran, ed. *The First Humans.* San Francisco: Harper San Francisco, 1993.

Celenko, Theodore, ed. *Egypt in Africa.* Indianapolis Museum of Art, 1996.

Chauvet, Jean-Marie, Eliette Brunel Deschamps, and Christian Hillaire. *Dawn of Art: The Chauvet Cave: The Oldest Known Paintings in the World.* NY: Harry N. Abrams, Inc., 1994.

Clottes, Jean and Jean Courtin. *The Cave Beneath the Sea: Paleolithic Images at Cosquer.* NY: Harry N. Abrams, Inc., 1991.

Haynes, Joyce L. *Nubia: Ancient Kingdom of Africa.* Boston: Museum of Fine Arts, 1992.

O'Halloran, Kate. *Hands-on Culture of Ancient Egypt.* Portland, ME: J. Weston Walch, 1997.

Reeves, Nicholas. *The Complete Tutankhamun.* NY: Thames and Hudson, 1995.

Rhodes, Toni. *Wonders of World Cultures: Exploring Near & Middle East.* Portland, ME: J. Weston Walch, 1999.

Sandison, David. *The Art of Ancient Egypt.* San Diego, CA: Laurel Glen Publishing, 1997.

Taylor, Tim & Mick Aston. *The Atlas of Archaeology.* NY: DK Publishing, 1998.

## Classical World

Boardman, John. *Greek Art.* NY: Thames and Hudson, 1996.

Boardman, John. *Greek Sculpture.* NY: Thames & Hudson, 1985.

Boardman, John, Ed. *The Oxford Illustrated History of Classical Art.* NY: Oxford University Press, 1993.

Moatti, Claude. *In Search of Ancient Rome.* NY: Harry N. Abrams, Inc., 1993.

O'Halloran, Kate. *Hands-on Culture of Ancient Greece & Rome.* Portland, ME: J. Weston Walch, 1998.

Philip, Neil. *Myths & Legends.* NY: DK Publishing, 1999.

Ramage, Nancy H. and Andrew. *Roman Art: Romulus to Constantine.* NY: Harry N. Abrams, Inc., 1991.

Wheeler, Mortimer. *Roman Art and Architecture.* NY: Thames and Hudson, 1985.

## The Middle Ages

Biedermann, Hans. *Dictionary of Symbolism.* NY: Facts On File, 1998.

Favier, Jean. *The World of Chartres.* NY: Harry N. Abrams, Inc., 1990.

Ferguson, George. *Signs and Symbols in Christian Art.* NY: Oxford University Press, 1972.

Korn, Irene. *A Celebration of Judaism in Art.* NY: Todtri, 1996.

*Treasures of the Holy Land: Ancient Art from the Israel Museum.* NY: Metropolitan Museum of Art. 1986.

## Renaissance

Labella, Vincenzo. *A Season of Giants.* Boston, MA: Little, Brown, 1990.

Vasari, Giorgio. *The Lives of the Artists.* NY: Oxford University Press, 1991.

## Impressionism & Post Impressionism

Adriani, Gotz. *Cezanne: Paintings.* NY: Harry N. Abrams, Inc., 1995.

Bade, Patrick. *Degas: The Masterworks.* NY: Portland House, 1991.

Barnes, Rachel, ed. *Degas by Degas.* NY: Alfred A. Knopf, 1990.

Barnes, Rachel, ed. *Monet by Monet.* NY: Alfred A. Knopf, 1990.

Cachin, Francoise, et al. *Cezanne.* Philadelphia, PA: Philadelphia Museum of Art, 1996.

Effeny, Alison. *Cassatt: The Masterworks.* NY: Portland House, 1991.

Feaver, William. *Van Gogh.* NY: Portland House, 1990.

Forge, Andrew. *Monet.* NY: Harry N. Abrams, Inc., 1995.

Freches-Thory, Claire, et al. *Toulouse-Lautrec.* New Haven, CT: Yale University Press, 1992.

Herbert, Robert L., et. al. *Georges Seurat.* NY: Metropolitan Museum of Art, 1991.

Loyette, Henri. *Degas: The Man and His Art.* NY: Harry N. Abrams, Inc., 1995.

Mathews, Nancy Mowll. *Mary Cassatt: A Life.* New Haven: Yale University Press, 1998.

Sutton, Denys. *Degas: His Life and Work.* NY: Abbeville Press, 1991.

Tucker, Paul Hayes. *Claude Monet: Life and Art.* New Haven, CT: Yale University Press, 1995.

Witzling, Mara R. *Mary Cassatt: A Private World.* NY: Universe, 1991.

Zemel, Carol. *Vincent Van Gogh.* NY: Rizzoli, 1993.

## 20th Century

Christo & Jeanne-Claude, *Wrapped Reichstag, Berlin, 1971–1995.* Benedikt Taschen, Cologne, Germany, 1995.

Elderfield, John. *Henri Matisse: A Retrospective.* NY: Museum of Modern Art, 1992.

Eldredge, Charles C. *Georgia O'Keeffe: American and Modern.* New Haven, CT: Yale University Press, 1993.

Herrera, Hayden. *Matisse: A Portrait.* NY: Harcourt Brace, 1993.

Kordich, Diane. *Images of Commitment: 20th Century Women Artists.* Tucson, AZ: Crizmac, 1994.

Paul, Stella. *Twentieth Century Art: A Resource for Educators.* NY: Metropolitan Museum of Art, 1999.

Phillips, Lisa. *The American Century, Art & Culture, 1950–2000.* Whitney Museum of American Art, New York and W. W. Norton, New York,1999.

## Popular Culture

Ash, Russell. *Factastic Millennium Facts.* NY: DK Publishing, 1999.

Hamilton, Jake. *Special Effects in Film and Television.* NY: DK Publishing, 1998.

Karney, Robyn. *Chronicle of the Cinema.* NY: DK Publishing, 1997.

*1000 Makers of the Millennium.* NY: DK Publishing, 1999.

Thorgerson, Storm and Aubrey Powell. *100 Best Album Covers.* NY: DK Publishing, 1999.

## Art in the United States, Multicultural

Albany Institute of History and Art. *The Natural Palette: The Hudson River Artists and the Land.* Tucson, AZ: Crizmac, 1997.

*Hispanic Folk Art and the Environment: A New Mexican Perspective.*

National Museum of American Art. *African American Artists: Affirmation Today.* Glenview, IL: Crystal Productions, 1994.

National Museum of American Art. *Latino Art & Culture in the United States.* Glenview, IL: Crystal Productions, 1996.

National Museum of American Art. *Land & Landscape: Views of America's History and Culture.* Glenview, IL: Crystal Productions, 1997.

National Museum of American Art. *Public Sculpture: America's Legacy.* Glenview, IL: Crystal Productions, 1994.

## Native American

*America's Fascinating Indian Heritage.* Pleasantville, NY: Reader's Digest Association, Inc., 1990.

Feder, Norman. *American Indian Art.* NY: Harry N. Abrams, Inc., 1995.

Hill, Tom and Richard W. Hill Sr., eds. *Creation's Journey.* Washington DC: Smithsonian Institution Press, 1994.

Jacka, Lois Essary. *Enduring Traditions: Art of the Navajo.* Flagstaff, AZ: Northland Publishing, 1994.

Jonaitis, Aldona. *From the Land of the Totem Poles.* Seattle, WA: University of Washington Press, 1991.

Penney, David W. and George C. Longfish. *Native American Art.* Southport, CT: Hugh Lauter Levin Associates, 1994.

Rosenak, Churck and Jan. *The People Speak: Navajo Folk Art.* Flagstaff, AZ: Northland Publishing, 1994.

Stewart, Hilary. *Totem Poles.* Seattle, WA: University of Washington Press, 1993.

# Art of Global Cultures
## General

Bowker, John. *World Religions.* NY: DK Publishing, 1997.

Chalmers, F. Graeme. *Celebrating Pluralism: Art, Education, and Cultural Diversity.* Los Angeles, CA: The Getty Education Institute for the Arts, 1996.

Mack, Stevie and Deborah Christine. *Tribal Design.* Tucson, AZ: Crizmac, 1988.

Museum of International Folk Art. *Recycled, Re-Seen: Folk Art From the Global Scrap Heap.* NY: Harry N. Abrams, Inc., 1996.

*World Reference Atlas.* NY: DK Publishing, 1998.

Eyewitness World Atlas. DK Publishing (CD-ROM)

## Africa

Courtney-Clarke, Margaret. *African Canvas: The Art of West African Women.* NY: Rizzoli, 1990.

National Museum of African Art. *The Art of West African Kingdoms.* Washington, DC: Smithsonian Institution Press, 1987.

O'Halloran, Kate. *Hands-on Culture of West Africa.* Portland, ME: J. Weston Walch, 1997.

Rhodes, Toni. *Wonders of World Cultures: Exploring Africa.* Portland, ME: J. Weston Walch, 1999.

Robbins, Warren M. and Nancy Ingram Nooter. *African Art in American Collections.* Washington, DC: Smithsonian Institution Press, 1989.

## Mexico, MesoAmerica, Latin American

Herrera, Hayden. *Frida Kahlo.* NY: Harper Collins, 1991.

Lowe, Sarah M. *The Diary of Frida Kahlo.* NY: Harry N. Abrams, Inc., 1995.

Poupeye, Veerle. *Caribbean Art.* NY: Thames and Hudson, 1998.

Mack, Stevie. *Gente del Sol.* Tucson, AZ: Crizmac, 1991.

Mack, Stevie, Amy Scott Metcalfe with Nancy Walkup. *Days of the Dead.* Tucson, AZ: Crizmac, 1999.

Mack, Stevie and Jennifer Fiore. *Oaxaca, Valley of Myth and Magic.* Tucson, AZ: Crizmac, 1995.

Mack, Stevie and Jennifer Fiore. *World Beneath a Canopy: Life and Art in the Amazon.* Tucson, AZ: Crizmac, 1997.

Miller, Mary Ellen. *The Art of MesoAmerica.* NY: Thames and Hudson, 1996.

O'Halloran, Kate. *Hands-on Culture of Mexico and Central America.* Portland, ME: J. Weston Walch, 1998.

Poupeye, Veerle. *Caribbean Art.* NY: Thames and Hudson, 1998.

Rochfort, Desmond. *Mexican Muralists: Orozco, Rivera, Siqueiros.* NY: Universe Publishing, 1994.

Stebich, Ute. *A Haitian Celebration: Art and Culture.* Milwaukee, WI: Milwaukee Art Museum, 1992.

Walkup, Nancy and Judy Godfrey. *Haitian Visions.* Tucson, AZ: Crizmac, 1994.

Walkup, Nancy and Sharon Warwick. *Milagros: Symbols of Hope.* Tucson, AZ: Crizmac, 1996.

## Asia

Baker, Joan Stanley. *Japanese Art.* NY: Thames and Hudson, 1984.

Berinstain, Valerie. *Discoveries: India and the Mughal Dynasty.* NY: Harry Abrams, 1998.

Cooper, Rhonda and Jeffery. *Masterpieces of Chinese Art.* London: Tiger Books International, 1997.

Craven, Roy C. *Indian Art.* NY: Thames and Hudson, 1997.

Fong, Wen C. and James C.Y. Watt. *Possessing the Past: Treasures from the National Palace Museum, Taipei.* NY: Harry N. Abrams, Inc., 1996.

Kerry, Rose, ed. *Chinese Art and Design: Art Objects in Ritual and Daily Life.* NY: Viking, 1992.

O'Halloran, Kate. *Hands-on Culture of Japan.* Portland, ME: J. Weston Walch, 1997.

O'Halloran, Kate. *Hands-on Culture of Southeast Asia.* Portland, ME: J. Weston Walch, 1998.

Pearlstein, Elinor L. and James T. Ulak. *Asian Art in The Art Institute of Chicago.* Chicago, IL: The Art Institute of Chicago, 1993.

Rawson, Jessica, Ann Farrer, Jane Portal, Shelagh Vainker, and Carol Michaelson. *The British Museum Book of Chinese Art.* NY: Thames and Hudson, 1993.

Rhodes, Toni. *Wonders of World Cultures: Exploring Asia & The Pacific Rim.* Portland, ME: J. Weston Walch, 1999.

Zephir, Thierry. *Khmer: The Last Empire of Cambodia.* NY: Harry Abrams, 1998.

## Pacific

Nordin, Julee and Pat Johnson. *Australian Dreamings.* Tucson, AZ: Crizmac, 1996.

Pacific Resources for Education and Learning. *Island Worlds: Art and Culture in the Pacific.* Tucson, AZ: Crizmac, 1999.

## Art Studio

*Artchart Poster Series: Drawing Posters.* Glenview, IL: Crystal Productions.

*Artchart Poster Series: Watercolor Posters.* Glenview, IL: Crystal Productions.

*Artchart Poster Series: Ceramics Posters.* Glenview, IL: Crystal Productions.

Brown, Maurice and Diana Korzenik. *Art Making and Education.* Chicago, IL: University of Illinois Press, 1993.

McKim, Robert. *Thinking Visually.* Palo Alto, CA: Dale Seymour Publications, 1997.

Roukes, Nicholas. *Art Synectics.* Worcester, MA: Davis Publications, 1982.

# Internet Resources

## American Museum of Natural History

www.amnh.org/
Use this site to inspire students about the natural world, or check out art-related special features.

## Andy Warhol Museum

www.clpgh.org/warhol/
Take an online tour of the seven floors of the special exhibitions and permanent collection of this museum devoted to the premier Pop Artist Andy Warhol.

## Any1CanFly

www.artincontext.com/artist/ringgold/
This site has images of Faith Ringgold's art, information about her life and work, and more.

## Artonline: Printmaking Techniques

www.nwu.edu/museum/artonline/resources/prints.html
Printmaking processes are explained on this site.

## Art Learner Guides

http://schools.brunnet.net/crsp/general/art/
Developed for secondary students, these extensive PDF files are available on a wide variety of media and techniques.

## ArtLex Visual Arts Dictionary

www.artlex.com/
This online dictionary provides definitions of more than 3,100 art terms, along with numerous illustrations, pronunciation notes, artist quotations, and links to other resources on the Web.

## ArtsEdNet

www.artsednet.getty.edu
Developed by the Getty Education Institute for the Arts, this site offers a wealth of information on art and artists, an image bank, suggested activities, and more.

## Asian Art Museum of San Francisco

www.asianart.org/
The Asian Art Museum is one of the largest museums in the Western world devoted exclusively to Asian art. The museum is a public institution whose mission is to lead a diverse global audience in discovering the unique material, aesthetic, and intellectual achievements of Asian art and culture.

## Bill Viola

www.cnca.gob.mx/viola/
Experience the artist's video/sound installations.

## Canadian Museum of Civilization

www.civilization.ca/cmc/cmceng/welcmeng.html
Take a virtual tour of the halls; investigate diverse works of art from Japanese kimonos to African ritual figurines.

## Chaco Culture National Historical Park

www.nps.gov/chcu/
Learn about the architecture and pottery of Chaco Canyon, a major Pueblo cultural center A.D. 850–1250.

## Christo and Jeanne-Claude

www.beakman.com/christo/
This fascinating site includes many images of the diverse projects these artists have worked on and are currently working on; also plenty of background information.

## Color Theory

www.presscolor.com/library/ctindex.html
Learn more about the physics of color theory and concepts of light.

## Cooper-Hewitt, National Design Museum

www.si.edu/ndm/
The Museum's collection encompasses graphic design, applied arts and industrial design, architecture, urban planning, and environmental design.

## Dia Center for the Arts

www.diacenter.org/
Check out artists' Web projects, environmental art, earthworks, and installations, along with contemporary works using more traditional art forms.

## Diego Rivera Virtual Museum

www.diegorivera.com/diego_home_eng.html
Available in both Spanish and English versions, this extensive site highlights the artwork and life of the celebrated Mexican muralist Diego Rivera.

## Drawing Grids and Tile Floors in Perspective

pc38.ve.weber.k12.ut.us/art/ChalkBoard/lp-grids.htm
Diagrams and text explain linear and atmospheric perspective, shading, and composition.

## Drawing in One-Point Perspective

www.olejarz.com/arted/perspective/
A step-by-step guide with interactive features and explanatory text.

## Exploring Leonardo

www.mos.org/sln/Leonardo/LeoHomePage.html
Visit this extensive site to discover more about Leonardo da Vinci's futuristic inventions and use of perspective. Lesson ideas are also to be found here.

## George Segal

www.artcyclopedia.com/artists/segal_george.html
This directory includes the artist's work in museum collections, exhibitions, and image archives online.

## Georgia O'Keeffe Museum

www.okeeffemuseum.org/
This Santa Fe museum offers online a biography of the artist and images from its collections and exhibitions.

## Getty Museum

www.getty.edu/museum/
Take an architecture tour of the Getty Center, investigate the museum's collections and history, and more.

## Glenbow Museum

www.glenbow.org/home.htm
Located in Calgary, Alberta, the Glenbow showcases Canada's Native and Inuit art in their online Art Gallery.

## Guerilla Girls

www.guerrillagirls.com/
Learn more about the Guerilla Girls' use of humor to effect social and political change in the art world.

## Guggenheim Museum, Bilbao

www.guggenheim-bilbao.es/idioma.htm
Investigate the museum's breathtaking architecture, its exhibitions and permanent collection.

## Hayward Gallery on the South Bank, London

www.hayward-gallery.org.uk/
Visit this contemporary arts center that contains the largest and most versatile temporary exhibition space in London.

## Ho-Am Art Museum

www.hoammuseum.org/english/index.html
Browse the collection of more than 15,000 artifacts and artworks belonging to the largest private museum in Korea.

## Hints and Tips from Grumbacher

www.sanfordcorp.com/grumbacher/hints_and_tips_from_grumbacher.htm
Advice on using watercolor, oil, and acrylic paints.

## Jacob Lawrence Catalogue Raisonné Project

www.jacoblawrence.org/
This online archive and education center provides images and documentation of the entire body of Lawrence's work.

## Japan Ukiyo-e Museum

www.cjn.or.jp/ukiyo-e/index.html
Compare works by Hokusai and Hiroshige, plus see other works of ukiyo-e artists, at this museum.

## Jaune Quick-To-See Smith

www.nmwa.org/legacy/bios/bjqsmith.htm
Learn more about this renowned Native American artist on her biographical page at the National Museum of Women in the Arts.

## Jenny Holzer

http://adaweb.walkerart.org/
Enter the artist's elegant and constantly changing interactive Web project.

## Louis Comfort Tiffany

www.artcyclopedia.com/artists/tiffany_louis_comfort.html
Explore the work of Louis Comfort Tiffany.

## Louvre Museum Paris, France

http://mistral.culture.fr/louvre/louvrea.htm
In a virtual tour of one of the most famous museums in the world, you will find a broad spectrum of subjects, styles, and themes of art, including the *Mona Lisa*.

## Mary Cassatt, WebMuseum, Paris

http://sunsite.icm.edu.pl/wm/paint/auth/cassatt/
This site offers biographical information and links about Mary Cassatt.

## Modern Art Museum of Fort Worth

www.mamfw.org/menu.htm
Search the collections and view the special exhibitions that focus on modern and contemporary art.

## Moravian Pottery and Tile Works

www.libertynet.org/bchs/TileWork.htm
An elegantly-designed introduction to Henry Chapman Mercer's life and work, including Fonthill Museum (Mercer's home in the early twentieth century).

## MuralArt.com

www.MuralArt.com/
This site features murals in various categories, including a mural of the month.

## Museum of Indian Arts and Culture Laboratory of Anthropology

www.miaclab.org
Extensive information about the Museum's collections of Indian pottery, paintings, textiles and clothing, basketry, and jewelry, and archeology is presented here.

## Museum of Modern Art

www.moma.org/
The Museum of Modern Art in New York City houses the world's first curatorial department devoted to architecture and design, established in 1932. The design collection contains more than 3,000 everyday objects that are both functional and well-designed, including furniture, tableware, tools, sports cars, and even a helicopter.

## Nam June Paik

www.reynoldahouse.org/leonardo.htm
Investigate further the work of Nam June Paik, a leader in the art movement of video art.

## Nasjonalgalleriet

www.museumsnett.no/nasjonalgalleriet/eng/index.html
This Oslo museum houses the largest collection in the world of artwork by Edvard Munch. See selected paintings and descriptions online.

## National Gallery of Canada

http://national.gallery.ca/
Search the exhibitions and collections; experience CyberMuse.

## National Museum of African Art

www.si.edu/organiza/museums/africart/nmafa.htm
Experience online tours of current exhibitions as well as the permanent collection.

## National Museum of American Art

www.nmaa.si.edu/

The NMAA in Washington, D.C. is home to American paintings, sculptures, graphics, folk art, and photographs from the eighteenth century to the present. Browse the online collection of more than 3,000 digitized images classified by subject and artist.

## National Museum of the American Indian

www.si.edu/nmai/

Explore the Smithsonian's National Museum of the American Indian online. See artifacts and find links to other Native American Web sites.

## National Museum of Natural History

www.mnh.si.edu/

The seven scientific departments of the National Museum of Natural History offer comprehensive collections and research information online.

## Nelson-Atkins Museum of Art

www.nelson-atkins.org/

This Kansas City museum includes a sculpture park with works by many modern masters. Don't miss *Shuttlecocks*, four larger-than-life sculptures of badminton "birdies."

## Oakland Museum of Art

www.museumca.org/

Check out past, present, and upcoming exhibitions such as *What is Art For?* and *Women of Taste: A Collaboration Celebrating Quilt Artists and Chefs*.

## Picasso Museum

www.musexpo.com/english/picasso/index.html

Tour the Paris museum dedicated to Pablo Picasso.

## Pueblo Cultural Center

www.indianpueblo.org/

Visit the eight Northern Pueblos in New Mexico to compare cultural traditions specific to each pueblo. See twelve outstanding artworks (with explanations) completed for the Mural Project.

## Roxanne Swentzell

www.artsednet.getty.edu/ArtsEdNet/Read/4p/clowns.html

Read a discussion about Swentzell's work from the perspectives of an artist, an art historian, an art critic, and an aesthetician.

## Roy Lichtenstein Foundation

www.lichtensteinfoundation.org/

Browse through this site to learn more about the artist's paintings, sculpture, and drawings, along with ongoing exhibitions, publications and photographs.

## Sandy Skoglund

www.artsednet.getty.edu/ArtsEdNet/Images/Skoglund/gallery1.html

ArtsEdNet offers images, activities, artist interviews, an online discussion, analysis, and interpretive questions—all related to Skoglund.

## Save Outdoor Sculpture! (SOS!)

www.heritagepreservation.org

Save Outdoor Sculpture! is a collaborative effort to document, repair, and preserve public monuments and outdoor sculpture in the United States. Inventories on the site detail public art from every state being preserved. There are also interactive activities for students and teachers.

## Space Art through the Ages

www.artsednet.getty.edu/ArtsEdNet/Resources/Space/index.html

Discover how space exploration and astronomy have inspired artists in the past and present. Includes lesson plans, images, and more.

## Statue of Liberty and Ellis Island Monument

www.nps.gov/stli/mainmenu.htm

Tour these two national monuments to learn more about American immigration.

## Sydney Opera House

www.soh.nsw.gov.au/

View Australia's international cultural landmark designed for its harbor setting. Explore *The Past* for planning and construction details.

## Teaching About Architecture and Art

www.artsednet.getty.edu/ArtsEdNet/Resources/Maps/Sites/index.html

World cultural heritage places are featured in detail on this site, including Trajan's Forum, Rome; Pueblo Bonito, Chaco Canyon, New Mexico; Great Mosque, Djenné; Katsura Villa, Kyoto; and the Sydney Opera House.

## The AIDS Memorial Quilt

www.AIDSQuilt.org

Browse or search thousands of homemade quilted panels. Find answers to your questions about the quilt.

## The Art Gallery of New South Wales

www.artgallery.nsw.gov.au/about/index.html

The Collection of Aboriginal Art and Torres Strait Islander Art, the largest collection of the Art Gallery of New South Wales' collections in Australia, includes a wide range of artworks from historic bark paintings to contemporary sculptures.

## The Bayeux Tapestry: The Battle of Hastings 1066

http://battle1066.com/index.html

This site documents an important artwork that has survived from the eleventh century. Individual highlights and the complete tapestry are included. There is a section on tapestry construction.

## The British Museum

www.british-museum.ac.uk/

The British Museum is particularly notable for its collection that includes the Greek world from the beginning of the Bronze Age, Italy and Rome from the Bronze Age; and the whole of the Roman Empire except Britain under the Edict of Milan (AD 313). You can visit the Egyptian Antiquities department; this site includes extensive information and images.

Also at the British Museum: *Cracking Codes: The Rosetta Stone and Decipherment.* The Rosetta Stone is the remains of a stele in three scripts; hieroglyphic, a cursive form of ancient Egyptian, and ancient Greek. The Stone is a cultural icon of script and decipherment, and is one of the most sought-after displays at the British Museum.

## The Civilized Explorer: Art on the Internet

www.cieux.com/Arthome.html

This is worth a visit simply for the annotated listing of fascinating Web sites that originate outside the United States—but there is much, much more, including experimental sites, galleries, and museums. Have fun!

## The Electric Franklin

www.ushistory.org/franklin/index.htm

Browse for resources, interactive games, a time line, and streaming videos about Benjamin Franklin. See Franklin's print shop, artworks, and other artifacts at Franklin Court.

## The Labyrinth: Resources for Medieval Studies

www.georgetown.edu/labyrinth/

Everything medieval is here, including manuscripts, music, mythology, maps, fonts that recreate medieval handwriting, a virtual tour of a medieval city, and more.

## The Metropolitan Museum of Art

www.metmuseum.org

The world-renowned Metropolitan Museum of Art houses a collection of over three million objects. The site is an excellent one to explore, especially for the Museum's Egyptian and Byzantium collections. A time line of museum objects, highlighted by thumbnail images, is particularly useful.

## The Periodic Table of Comic Books

www.uky.edu/~holler/periodic/periodic.html

This clever table of periodic elements links each element to comic book pages involving that element.

## The Photography of Lewis Hine

www.ibiscom.com/hnintro.htm

View photos of miners, mill workers, and newsboys taken by Lewis Hine while investigating child labor practices. Includes some of Hine's field notes.

## The Saint Louis Art Museum

www.slam.org/

This beautifully designed site has examples of works from the collections, plus information about the current Featured Exhibition.

## The Victoria and Albert Museum, London

www.vam.ac.uk/

Explore the Victoria and Albert Museum in London, the world's finest museum of the decorative arts. Founded in 1852, the Museum's vast collections include sculpture, furniture, fashion and textiles, paintings, silver, glass, ceramics, jewelry, books, prints and photographs.

## The White House

www.whitehouse.gov/

Visit "White House History and Tours: Art in the White House" to view artwork from the White House collection.

## Uffizi Gallery

www.uffizi.firenze.it/welcomeE.html

Take a virtual tour of the Uffitzi Gallery in Florence, Italy. Enter the gallery and click on the floor maps to discover which artworks are in each room.

## UNESCO World Heritage List

www.its.caltech.edu/~salmon/world.heritage.html

Visit more than 500 sites which have been designated as deserving of protection and preservation.

## University of British Columbia Museum of Anthropology

www.voice.ca/tourism/moa/anthrop.htm

Art and artifacts in the Museum of Anthropology illustrate the achievements of the First Peoples of the Northwest Coast.

## Vietnam Veteran's Memorial Homepage

www.nps.gov/vive/index2.htm

Learn more about the three Vietnam veterans' memorials in Washington, D.C.

## WebMuseum, Paris

www.oir.ucf.edu/wm/

This site delivers more than ten million documents, with special focus on artist biographies, works of art, and art history concepts.

## William Wegman World

www.wegmanworld.com/index2.html

Learn everything you want to know about William Wegman and his celebrity Weimaraner dogs.

## Winsor & Newton

www.winsornewton.com/

Visit the site of a major manufacturer of artist materials, the inventor of the world's first moist watercolor pan. Take an online factory tour and browse an encyclopedia of hints, tips, and techniques for using pastels and watercolor, acrylic, and oil paints.

## World Art Treasures

http://sgwww.epfl.ch/BERGER/

Browse a significant collection of images and theme-based "itineraries" that concentrate on art history, art criticism, and aesthetics.

# National Visual Arts Standards

**1. Content Standard:** Understanding and applying media, techniques, and processes
**Achievement Standard:**
**a.** Students select media, techniques, and processes; analyze what makes them effective or not effective in communicating ideas; and reflect upon the effectiveness of their choices.
**b.** Students intentionally take advantage of the qualities and characteristics of art media, techniques, and processes to enhance communication of their experiences and ideas.

**2. Content Standard:** Using knowledge of structures and functions
**Achievement Standard:**
**a.** Students generalize about the effects of visual structures and functions.
**b.** Students employ organizational structures and analyze what makes them effective or not effective in the communication of ideas.
**c.** Students select and use the qualities of structures and function of art to improve communication of their ideas.

**3. Content Standard:** Choosing and evaluating a range of subject matter, symbols, and ideas
**Achievement Standard:**
**a.** Students integrate visual, spatial, and temporal concepts with content to communicate intended meaning in their artworks.
**b.** Students use subjects, themes, and symbols that demonstrate knowledge of contexts, values, and aesthetics that communicate intended meaning in artworks.

**4. Content Standard:** Understanding the visual arts in relation to history and cultures
**Achievement Standard:**
**a.** Students know and compare the characteristics of artworks in various eras and cultures.
**b.** Students describe and place a variety of art objects in historical and cultural contexts.
**c.** Students analyze, describe, and demonstrate how factors of time and place (such as climate, resources, ideas, and technology) influence visual characteristics that give meaning and value to a work of art.

**5. Content Standard:** Reflecting upon and assessing the characteristics and merits of their work and the work of others
**Achievement Standard:**
**a.** Students compare multiple purposes for creating works of art.
**b.** Students analyze contemporary and historic meanings in specific artworks through cultural and aesthetic inquiry.
**c.** Students describe and compare a variety of individual responses to their own artworks and to artworks from various eras and cultures.

**6. Content Standard:** Making connections between visual arts and other disciplines
**Achievement Standard:**
**a.** Students compare the characteristics of works in two or more art forms that share similar subject matter, historical periods, or cultural context.
**b.** Students describe ways in which the principles and subject matter of other disciplines taught in the school are interrelated with the visual arts.

# Notes

# Notes

# Notes

# Notes